ART AT THE TURN OF THE MILLENNIUM

ART AT THE TURN OF THE MILLENNIUM

EDITORS **BURKHARD RIEMSCHNEIDER** **UTA GROSENICK** AUTHORS *LARS BANG LARSEN*
CHRISTOPH BLASE *YILMAZ DZIEWIOR* *JEAN-MICHEL RIBETTES* *RAIMAR STANGE* *SUSANNE TITZ*
JAN VERWOERT *ASTRID WEGE*

TASCHEN

KÖLN LONDON MADRID NEW YORK PARIS TOKYO

CONTENTS *SOMMAIRE*

PREFACE *PRÉFACE*

"Art at the Turn of the Millennium" is the first publication to offer an authoritative overview of art and artists of the 1980s and 1990s. Totalling 576 pages and covering the work, careers and credos of 137 artists, it is lavishly illustrated with over 1,200 reproductions and features pithy introductory commentaries by a team of seven experts.

Contemporary art is taken to mean work by artists whose active output, barring a handful of exceptions, goes back no more than twenty years and is still evolving. The youngest of the artists featured have been exhibited internationally for only a year or so. All of the artists featured come from the West; it proved impossible to cast a global net, so in the present volume other cultural provenances have not been represented.

"Art at the Turn of the Millennium" is not just a retrospective of two highly productive and invigorating decades; it focuses on the future. In reviewing the art of the 1980s, for example, it relates the history than traces influences forwards into the 1990s. In one sense the past may be over, but in another it is actively present, as each new artistic idiom is adopted and adapted from predecessors. In that sense, and in that spirit, as the 1990s too slip into the past, "Art at the Turn of the Millennium" looks to the new millennium and asks what may await us on the art scene in the decade ahead.

A publication such as this cannot create or manipulate trends in art, nor can or should that be its aim. Our purpose is solely to review recent and current developments that have been showcased in galleries, which now play the central part in advancing and communicating new art. Movements and trends in art exist

Avec « Art at the Turn of the Millennium », le lecteur trouvera pour la première fois un livre présentant les artistes les plus importants des années 80 et 90.

Sur 576 pages, nous présentons 137 positions artistiques différentes illustrées par plus de 1200 reproductions. Sept auteurs familiarisés avec les artistes respectifs ont écrit une brève introduction informative sur leurs œuvres.

Si le livre « Art at the Turn of the Millennium » traite de l'art contemporain, de l'art d'aujourd'hui, nous entendons par là – à quelques exception près – des artistes dont l'œuvre couvre une période inférieure à vingt ans et se trouve donc encore en pleine évolution. Parmi ces artistes, les plus jeunes ne sont présents que depuis quelques années dans le circuit international des expositions.

Le monde occidental constitue le point de départ de notre sélection, dans laquelle nous n'avons pas fait entrer les artistes appartenant à d'autres zones culturelles. La lunette à travers laquelle nous considérons les deux dernières décennies de la création artistique n'est pas tournée vers le passé, mais vers l'avenir, vers le prochain millénaire. Pour ce qui concerne les années 80, « Art at the Turn of the Millennium » n'entend pas en donner une vision historique, mais présenter les influences multiples et variées qu'elles ont exercé sur les artistes des années 90, dont le travail sur les positions passées a créé un nouveau langage artistique. Nous souhaitons ainsi donner au lecteur un aperçu de ce qui pourrait se passer sur la scène de l'art dans les dix années à venir.

Cette préface nous semble tout indiquée pour signaler que notre

within a public space, and the market that influences their form and content cannot be ignored. Art is, of course, always in a state of flux, and in producing "Art at the Turn of the Millennium" we had to confront the difficulty of communicating it in book form. Much of that difficulty has to do with the limitations of the book as medium. When an artwork incorporates movement or sound, when it is interactive in conception or uses a multimedia approach, it is beyond the reach of the book: it can only be reproduced statically, shorn of its atmosphere.

A fundamental principle of this publication from its inception has been to forgo value judgements and pigeon-holing. These may have their place in reviewing the art of the past, but it would be premature and presumptuous to preempt the verdict of posterity. Instead, "Art at the Turn of the Millennium" is conceived as

a guide, and the artists are presented in alphabetical order. This seemed preferable for a number of reasons.
– First, a linear or chronological approach would be unlikely to illuminate the sheer vitality and diversity of the many kinds of artistic phenomena that now co-exist on the art scene.
– Second, art in the 1980s and 1990s has broadened its scope, unembarrassed at crossing borders into neighbouring areas such as design, the media, advertising, architecture, cinema, theatre, dance and music. Art can have a social agenda, it can be about communication; some believe it has therapeutic values and functions, while others deny it any societal role and insist on the autonomy of art. The positions adopted are many and various.
– And, third, "Art at the Turn of the Millennium" is primarily

propos n'est pas de générer des tendances, mais de présenter des positions déjà représentatives, même si ces positions sont encore toutes jeunes. Les galeries, qui sont aujourd'hui les principaux relais des nouvelles tendances, jouent à cet égard un rôle de premier plan. Les courants décrits prennent en compte le caractère public de l'art et par conséquent un marché qu'on ne saurait ignorer.

Lors de la conception du présent ouvrage, la question qui nous a préoccupés a été de savoir comment un domaine aussi ouvert que celui de l'art contemporain pouvait être représenté de manière adéquate dans un livre, qui ne permet de rendre le mouvement, le son, le multimédia et l'interactivité que de façon statique, sans l'atmosphère particulière qui le caractérise.

Notre présentation a écarté d'emblée les classements et les

jugements de valeur, ceux-ci relevant en effet davantage du travail de l'historien d'art qui se penche sur des époques révolues. Nous avons finalement opté pour un ouvrage dans lequel les artistes sont tous présentés par ordre alphabétique. Cette option se justifie par les motifs suivants :
– Une présentation linéaire – voire chronologique – ne peut rendre compte de la vitalité de la scène artistique contemporaine ni de l'apparition simultanée de certains phénomènes.
– L'art des années 80 et 90 se présente comme une vaste cohabitation de positions extrêmement diverses qui toutes ont droit de cité, le champ d'intervention de l'art s'étant étendu à des domaines comme le design, les médias, la publicité, l'architecture, le cinéma, le théâtre, la danse et la musique. Certains artistes poursuivent des stratégies sociales où l'artiste est

PREFACE *PRÉFACE*

intended as a guide to an imaginary exhibition, where each artist has been allocated the same amount of space and his or her position determined purely by alphabetical chance.

The works chosen for this imaginary exhibition highlight the attitudes and strengths of each artists. They were selected in consultation with the artists themselves or with their galleries. The layout of the pages treats every body of work as a unit, and attempts to approach each artistic personality on its own terms. "Art at the Turn of the Millennium" is full of diverse information. As well as reproductions of works, commentaries and statements, there are photographs of the artists (where they agreed to this), selective lists of exhibitions, and bibliographical references. A glossary at the back of the book defines key words, concepts and technical terms.

Inevitably the selection is a subjective one, despite all our efforts to cast an objective eye over the international art scene. Even so, we feel that this overview is fair and representative, and will enable users of the guide to form some idea of where art is heading as it enters the new millennium.

médiateur de communication, acteur social, voire guérisseur. D'autres en revanche dénient à l'art toute fonction sociale et se retirent sur un point de vue autonomiste.

– « Art at the Turn of the Millennium » se veut un guide à travers une exposition imaginaire dans laquelle tous les artistes se voient donner un même espace de présentation et où l'emplacement de chacun est le résultat fortuit de la première lettre de son nom.

Les travaux présentés documentent de manière exemplaire l'œuvre de chaque artiste. Ils ont été sélectionnés en étroite collaboration avec les artistes ou les galeries qui les représentent. La mise en page traite chaque position comme une unité fermée et tente une approche différenciée de la personnalité de chaque artiste.

On trouvera dans ce livre un grand nombre d'informations de différentes natures : reproductions d'œuvres, textes concis, une déclaration et – selon son choix – un portrait de l'artiste, une liste des expositions et des références bibliographiques. A la fin de l'ouvrage, un glossaire reprend certains mots clés, concepts et expressions spécialisées pour en expliciter la signification. Il va de soi que notre choix ne peut qu'être subjectif, même si nous nous sommes efforcés de porter un regard objectif sur les événements internationaux de l'art. Nous sommes convaincus que la somme des présentations individuelles établie par nos soins propose un panorama représentatif de la création artistique contemporaine et qu'elle donne un aperçu de l'art à l'avènement du nouveau millénaire.

Our thanks are due first and foremost to the artists, without whose support this book would not have been possible. We also wish to thank Andy Disl, who handled the graphic design of this substantial publication; and all at Taschen who worked so hard on this project, most particularly Yvonne Havertz and Nina Schmidt (editorial) and Ute Wachendorf (production), and our authors, Lars Bang Larsen, Christoph Blase, Yilmaz Dziewior, Jean-Michel Ribettes, Raimar Stange, Susanne Titz, Jan Verwoert and Astrid Wege.

Uta Grosenick and Burkhard Riemschneider

We would also like to thank the galleries, museums, institutions and individuals who generously made available the excellent illustrative material and gave us their invaluable assistance and advice:

Nos remerciements vont en premier lieu à tous les artistes, sans le soutien desquels ce projet ambitieux n'aurait pu être mené à bien. Nous remercions ensuite Andy Disl, qui s'est chargé de la conception graphique de ce vaste ouvrage, ainsi que tous les collaborateurs de l'édition qui ont participé à sa réalisation. Nous souhaitons nommer ici Yvonne Havertz et Nina Schmidt (lectorat), Ute Wachendorf (fabrication), ainsi que les auteurs, Lars Bang Larsen, Christoph Blase, Yilmaz Dziewior, Jean-Michel Ribettes, Raimar Stange, Susanne Titz, Jan Verwoert et Astrid Wege.

Uta Grosenick et Burkhard Riemschneider

Nous souhaitons par ailleurs remercier tous les galeries, musées, institutions et toutes les personnes qui ont si généreusement mis à notre disposition l'excellent matériau visuel et nous ont assistés de leurs conseils et de leurs acte:

PREFACE *PRÉFACE*

American Fine Arts, Daniel McDonald, Colin de Land/Galerie Paul Andriesse, Christel Vesters/Arndt & Partner, Petra Gördüren/Arnolfini, Bristol, Josephine Lanyon/Staatliche Kunsthalle Baden-Baden/Donald Baechler Studio, Ingrid Dinter/Kunsthalle Basel, Madeleine Schuppli/Museum für Gegenwartskunst Basel/Galerie Bruno Bischofberger, Tobias Mueller/Ross Bleckner Studio, Seth Ferris/Museum Boijmans Van Beuningen Rotterdam/Bonner Kunstverein/Mary Boone Gallery, Ron Warren/Boros Collection/Gavin Brown's enterprise, Kirsty Bell, Gavin Brown/Galerie Daniel Buchholz, Christopher Müller, Daniel Buchholz/Galerie Gisela Capitain, Stefanie Jansen, Gisela Capitain/Galleria Massimo De Carlo/Mehdi Chouakri/Sadie Coles HQ, Pauline Daly, Sadie Coles/Contemporary Fine Arts, Nicole Hackert/Paula Cooper Gallery, Annabel Macrae/Galerie Chantal Crousel, Sophie Pulicani/daadgalerie, Berlin/Deichtorhallen Hamburg, Annette Sievert/Deitch Projects, Elizabeth Iarrapino, Jeffrey Deitch/Atelier Wim Delvoye, Christoph Neerman /Atelier Thomas Demand, Ariane Beyn/FLUX, Maria Wettergren, Cyrille Putman/Galeria Foksal/Raymond Foye/Atelier Katharina Fritsch, Gregor Jansen/Klemens Gasser & Tanja Grunert, Tanja Grunert/Barbara Gladstone Gallery, Rainald Schumacher/Robert Gober Studio, Claudia Carson/Sammlung Goetz, Ingvild Goetz, Christoph Kölbl/Nan Goldin Studio, Renée Padt/Marian Goodman Gallery, Catherine Belloy/ Gorney Bravin + Lee, Rodney Hill/Galerie Bärbel Grässlin, Michael Neff/Peter Halley Studio, Cory Reynolds/Kunstverein in Hamburg/Kunstverein Hannover/Hara Museum of Contemporary Art, Tokyo, Aya Matsuura, Becky Mikalson/Galerie Hauser & Wirth, Cornelia Providoli, Arthur Miranda/Thilo Heinzmann/Atelier Herold, Jutta Küpper/Galerie Max Hetzler, Caroline Käding, Wolfram Aue/Jenny Holzer Studio, Rachel Barenblat/Interim Art, James Lavender/

Jablonka Galerie, Corina Rütten, Rafael Jablonka / Galerie Michael Janssen / Galerie Johnen & Schöttle, Markus Lüttgen / Georg Kargl / Büro Kippenberger, Johannes Wohnseifer / Kölnischer Kunstverein / Jeff Koons Studio, Samantha Peale / Atelier van Lieshout, Rian van Rijsbergen / Lisson Gallery, Annette H. Mantero, Elly Ketsea / Luhring Augustine, Michele Maccarone, Claudia Altman-Siegel / Matthew Marks Gallery, Andrew Leslie / Allan McCollum Studio, Charmaine Wheatley / Metro Pictures, Jeff Gauntt / Victoria Miro Gallery, Andrew Silewicz / Paul Morris Gallery / Museum Morsbroich / Matt Mullican Studio, Liz Dalton / Galerie Christian Nagel, Christian Nagel / Galerie NEU, Alexander Schröder / neugerriemschneider, Tim Neuger, Jochen Volz, Rebekka Ladewig / Anthony d'Offay Gallery / Galerie Bob van Orsouw / Galerie Roger Pailhas, Laurent Godin, Roger Pailhas / Friedrich Petzel Gallery / Portikus, Frankfurt / Robert Prime, Gregorio Magnani / Regen Projects, Lisa Overduin, Suzanne Unrein / Anthony Reynolds Gallery, Bénédicte Delay / Andrea Rosen Gallery, Michelle Reyes, John Connelly, Andrea Rosen / Rupertinum, Salzburg / Schipper & Krome, Esther Schipper, Michael Krome / Galerie Aurel Scheibler, Flavia Sommer, Aurel Scheibler / Tony Shafrazi Gallery, Joshua Briggs / Sonnabend Gallery, Antonio Homem / Sprengel Museum Hannover, Thomas Weski / Monika Sprüth Galerie, Jörn Bötnagel / Haim Steinbach Studio, Mike Wodkowski / Rochelle Steiner / Galerie Micheline Szwajcer, Jan-Willem Poels / Galerie Wilma Tolksdorf, Ortrud Mittler / Bill Viola Studio, Kira Perov, Dianna Pescar / Jeff Wall Studio, Daniel Congdon / Galleri Nicolai Wallner, Jacob Fabricius, Nicolai Wallner / Büro Franz West, Ines Turian / White Cube, Honey Luard / Wiener Secession / Kunstmuseum Wolfsburg, Holger Broeker, Dagny Pennewitz / Donald Young Gallery, Andrea Moody / Zeno X Gallery, Wim Peeters / Kunsthalle Zürich, Bettina Marbach / David Zwirner, Angela Choon.

ARTISTS

ABSALON

"I long for a perfect world..." « J'aspire à un monde parfait... »

At the age of twenty-three, Absalon went to Paris from Israel. At first, he made little white boxes from cardboard, cork or wood and created apparently random, white architectural miniatures inside them. He exhibited these "Cellules (En Silence)" as early as 1987, before beginning a series of anonymous objects called "Compartiments" that were uniformly covered in plaster. The matt white of the plaster gives the structures an undifferentiated appearance and bathes the whole space in a stifled silence, as if they constituted a kind of void in the middle of the world. From 1989, with his "Propositions d'habitation", Absalon established the minimum living space, measured exactly against the human body and intended for himself. These relics of living accomodation or designs for cities of the future appear to be devoted to arresting, or even obviating, the physical decay to which human beings are subject. Absalon's austere conception of space became even more radical in the works "Cellules", 1991, and "Solutions", 1992, which present self-contained survival units on a human scale. These rigorously economical spaces of solitude, in which the artist intended to live, are entirely white and coldly illuminated with neon lighting – a reduction to minimal functions. Sleeping is restricted to a horizontal board, eating to a simple bench for sitting on, and washing to a basin at which one can stand upright. Absalon's œuvre can be seen only in absolute terms; without recourse to the devices of representation, it strives for a unity of being, a transparency of life and an ethic of self-transcendence.

En arrivant à Paris, à l'âge de 23 ans, Absalon exécute, selon un rituel d'abord sans but, d'obsessionnelles petites boîtes blanches de carton ou de liège abritant des réductions d'architectures (« En silence », 1987), puis une série composite d'objets anonymes et aphasiques, uniformément recouverts de plâtre (« Compartiments », 1988). Le blanc mat qui indifférencie ces structures alignées au sol impose une sorte de silence étouffé à l'ensemble de l'espace qu'elles occupent comme si elles étaient un non-lieu du monde. A partir de 1989, ses « Propositions d'habitation » définissent à l'exacte mesure du corps un espace minimal de survie, que l'artiste ne destine qu'à lui-même. Ces volumes recouverts de plâtre blanc, mat et lisse dessinent un environnement minimaliste, élémentaire, homogène, silencieux, qui projette la dimension matérielle du corps dans un espace mental, méditatif et austère. Ces vestiges d'habitat semblent avoir pour seul but de suspendre toute décomposition physique. Son art se radicalise encore avec les « Cellules », 1991, et les « Solutions », 1992, qui sont des unités de survie autonomes, construites en format réel, à l'échelle 1/1. Cet espace de solitude, ce blanc dure-ment rehaussé par le néon, et dans lequel l'artiste aspire à vivre, dessine une prison infaillible et librement consentie, une intraitable totalité qui n'admet que des gestes – dormir, manger, se laver – réduits à leurs limi-tes. A la fin de sa vie, Absalon décide de construire dans six villes six « Cellules » différentes (de 4 x 9 m²) et de les habiter. Dans ses « Cellules » comme dans ses vidéos, le corps de l'artiste est, sans répit et sans issue, aux prises avec l'ombre, avec la mort, et avec sa propre résis-tance par laquelle il s'éprouve en vie. Cette œuvre, qui se propose comme un absolu sans alternative, n'aspire – par delà toute représentation – qu'à une unité de l'être, à une transparence de la vie, à une éthique du dépassement.

J.-M. R.

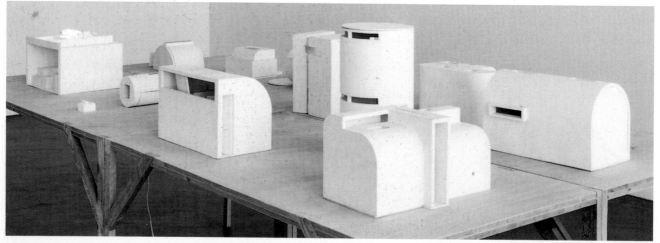

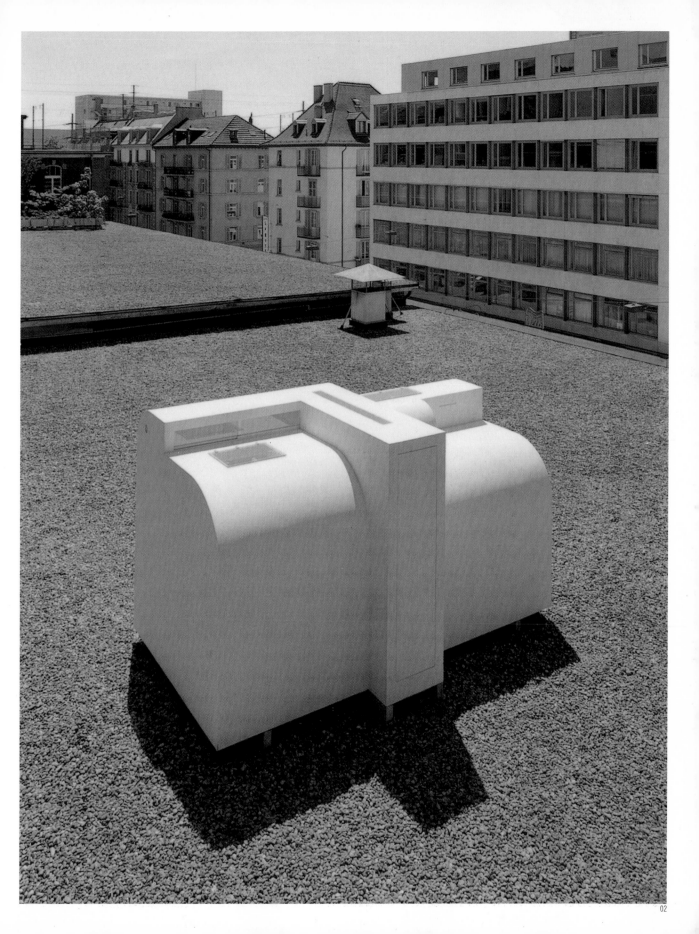

ABSALON

SELECTED EXHIBITIONS: *1992* documenta IX, Kassel, Germany /// *1993* "Cellules", Musée d'Art Moderne de la Ville de Paris, Paris, France /// *1994* Kunstverein in Hamburg, Hamburg, Germany /// Stichting De Appel, Amsterdam, The Netherlands /// *1997* Kunsthalle Zürich, Zurich, Switzerland **SELECTED BIBLIOGRAPHY:** *1990 Absalon*, Musée Sainte-Croix, Poitiers, France /// *1992 Absalon*, Tel Aviv Museum of Art, Tel Aviv, Israel /// *1993 Absalon, Cellules*, Musée d'Art Moderne de la Ville de Paris, Paris /// *1994 Absalon*, Carré d'Art, Nîmes, France; Stichting De Appel, Amsterdam /// *1995 Absalon*, Tel Aviv Museum of Art, Tel Aviv

03

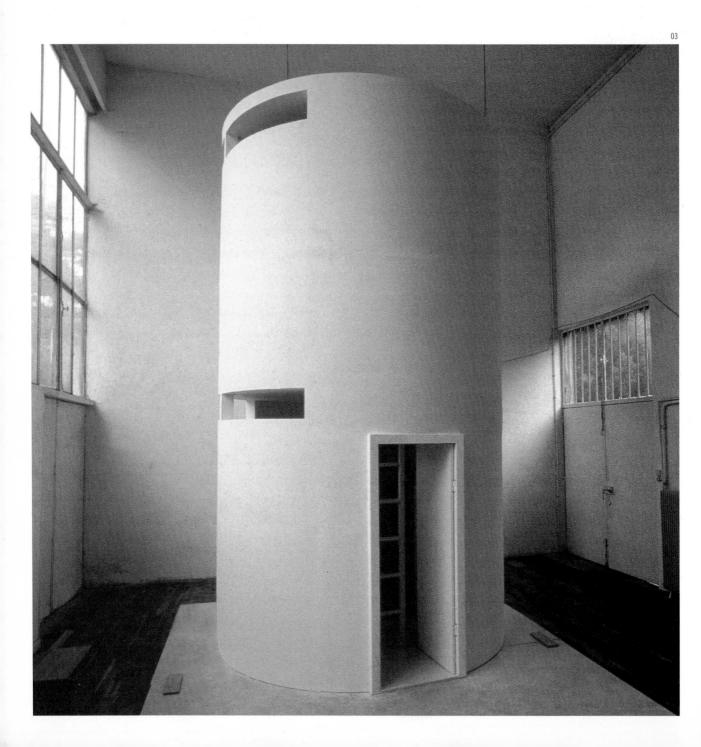

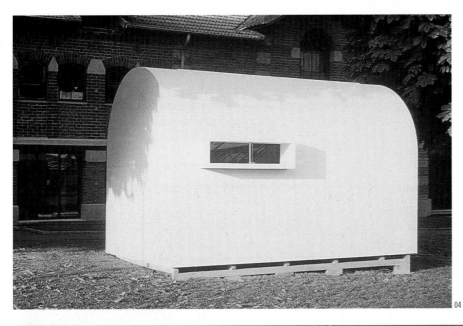

04

05

Pages 014 / 015: **01 SMALL SCALE MODELS (CELLS),** 1991. Cardboard, white paint. Installation view, Kunsthalle Zürich, Zurich, Switzerland, 1997. **02 CELLULE N° 2 (POUR ZÜRICH) — RÉALISATION HABITABLE,** 1992/93. Wood, cardboard, white waterproof paint. Installation view, Kunsthalle Zürich, Zurich, Switzerland, 1997.
Pages 016 / 017: **03 CELLULE N° 5 (PROTOTYPE),** 1992. Wood, cardboard, white paint. 400 x ø 240 cm. **04 CELLULE N° 1 (POUR PARIS) — RÉALISATION HABITABLE,** 1993. Wood, white waterproof paint, sanitary and kitchen equipment. Installation view, "Maisons-Cerveaux", La Ferme Du Buisson, France, 1995. **05 COMPARTIMENTS,** 1989. Arrangement of ready-made objects coated with plaster. Installation view, "Pas à côté pas n'importe où-4", Villa Arson, Nice, France, 1989.

FRANZ ACKERMANN

1963 born in Neumarkt St. Veit, Germany / lives and works in Berlin, Germany

"What is conveyed is not the the touristic minutiae of where and how but rather a kind of distilled travel record. This feeds on recollection and present experience." « Ce qui est proposé, ce ne sont pas les états d'âme touristiques des sentiers battus, mais plutôt une sorte de protocole de voyage qui se nourrit de mémoire et de vécu présent. »

Franz Ackermann demonstrates that artistic concern with the present can be handled not only in photography, film, Conceptual and installation art, but also in painting. In large-scale, sometimes expansive paintings, he operates suggestively with our perception of the outside world, its association-laden structures, colours, forms, illusions and clichés. The central source of experience in Ackermann's work is travel. He began to develop as a painter in the early 1990s during a one-year stay in Hong Kong. Further trips to Asia, South America and Australia followed. Initially he made "mental maps" – little pocket-size watercolours that already indicate Ackermann's interest not in copying, but in mentally absorbing these cultural regions. Back in the studio, he worked up paintings that carried over cartographic drawings into exploded projections. Since 1997, Ackermann has been working increasingly with the totality of painting. Individual paintings are drawn together by the contours of the space or applied direct to the walls, linked up in a spatial panorama like an endless film loop. In the project "Songline", 1998, he designed a transportable space module that circles round and draws in the viewer. Photos originating from travel advertisements and the daily press, which convey the media's view of the world and its problems, are reflected in mirrored surfaces. The fascinating critical dimension of these recent co-ordinates of experience has been present in Ackermann's approach from the start. Now, however, it is placed in spatially, politically and visually demanding confrontations that challenge the viewer to respond.

Franz Ackermann fait la preuve que le travail artistique sur l'époque contemporaine n'a pas lieu seulement dans le domaine de la photographie, du cinéma, de l'art conceptuel ou de l'installation, mais aussi dans la peinture. Dans ses grands formats, qui occupent parfois la totalité de l'espace, il travaille de manière suggestive sur la perception du monde extérieur, sur ses structures, ses couleurs, ses formes, ses illusions et ses clichés lourds d'associations. L'expérience décisive de l'œuvre d'Ackermann est le voyage. Ackermann a développé la base de ses conceptions picturales au début des années 90, lors d'un séjour d'un an à Hongkong, qui fut suivi d'autres voyages en Asie, en Amérique latine et en Australie. Il a d'abord réalisé des « Mental Maps », petites aquarelles en format de « poche » qui montrent déjà qu'Ackermann n'était pas intéressé seulement par la représentation, mais aussi par la perception mentale de ces espaces culturels. Depuis 1997, Ackermann travaille de plus en plus avec un concept de peinture totale. Certaines peintures sont comprimées par des lignes du mur, ou bien elles sont portées directement au mur, intégrées en un panorama spatial qui fait l'effet d'une boucle cinématographique sans fin. Ainsi, dans le projet « Songline », 1998, Ackermann développait un module spatial transportable encerclant et enfermant totalement le spectateur. A ce travail s'ajoutent également des photographies publicitaires empruntées aux agences de voyage ou à la presse quotidienne, ainsi que des miroirs fixant les suggestions médiatiques de l'expérience du monde et leur problématique. Ces nouvelles coordonnées et cette dimension critique étaient présentes dès le début dans la perspective d'Ackermann. Aujourd'hui, l'artiste les replace dans des confrontations spatiales suscitant des observations réfléchies. S. T.

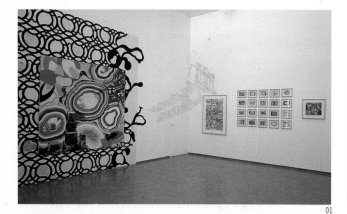

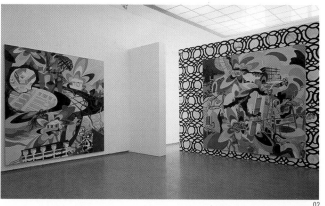

01

02

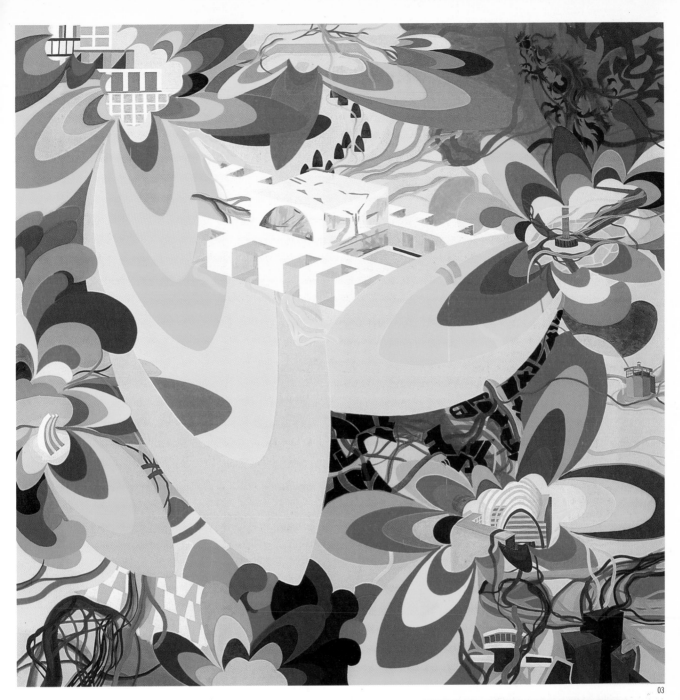

01 / 02 **INSTALLATION VIEW,** Portikus, Frankfurt/M., Germany, 1997. **03 UNTITLED (MENTAL MAP: EVASION III),** 1996. Oil on canvas, 280 x 285 cm. **04 UNTITLED (MENTAL MAP: EVASION IV),** 1996. Oil on canvas, 260 x 290 cm.

FRANZ ACKERMANN

SELECTED EXHIBITIONS: *1996* neugerriemschneider, Berlin, Germany /// *1997* Portikus, Frankfurt/M., Germany /// "Unexpected", Gavin Brown's enterprise, New York (NY), USA /// *1998* "Pacific", White Cube, London, England /// "Songline", Neuer Aachener Kunstverein, Aachen, Germany /// *1999* Camargo Vilaça, São Paulo, Brazil **SELECTED BIBLIOGRAPHY:** *1997 Atlas Mapping*, Offenes Kulturhaus Linz und Kunsthaus Bregenz/Magazin 4, Vienna, Austria /// *Mental Maps*, Portikus, Frankfurt/M. /// *Franz Ackermann, unerwartet*, Städtische Galerie Nordhorn, Nordhorn, Germany

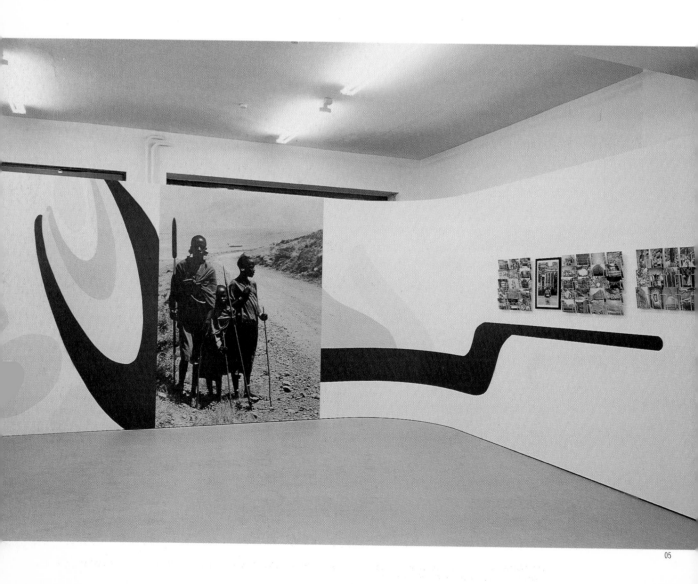

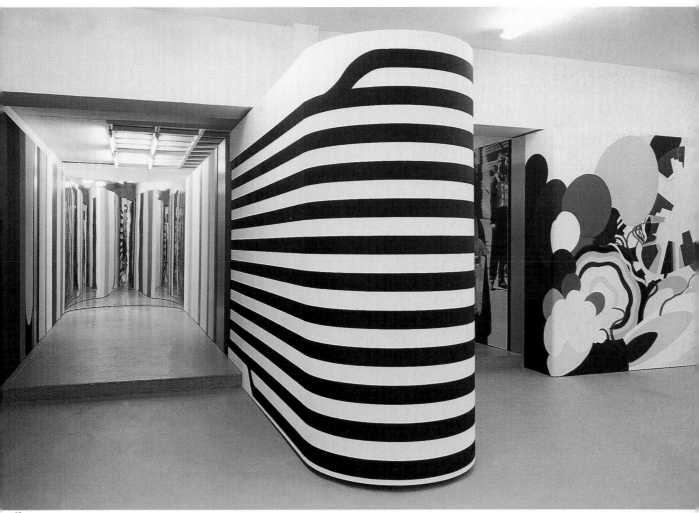

05 "SONGLINE", installation view, Neuer Aachener Kunstverein, Aachen, Germany, 1998. **06 INSTALLATION VIEW,** Portikus, Frankfurt/M., Germany, 1997. **07 "SONGLINE",** installation view, Neuer Aachener Kunstverein, Aachen, 1998.

EIJA-LIISA AHTILA

1959 born in Hämeenlinna, Finland / lives and works in Helsinki, Finland

Since the mid-1990s, Eija-Liisa Ahtila has been as much in evidence at international film festivals as on the art scene. She has always deliberately shown her films and videos in various different contexts. The same work, for example, may be shown in a 35 mm version in the cinema or video-projected to create large spatial installations in the gallery. On one occasion, three 90-second works were screened both on monitors that stood casually on tables in an art exhibition, and between commercials on television. In terms of content, Ahtila always comes back to the theme of relationships – between generations, between the sexes, and with herself. Her stories, which often run in parallel using several split-screen images, appear to be authentic reportage, but in fact the dialogues derive from Ahtila's own experience and research, played out as fictitious narrative sequences by actors. The soundtrack is Finnish with English subtitles. In her to date best-known work "If 6 was 9", 1995, a group of young girls talk about their experiences. Accompanying the question "What should you do when every cool guy offers you his body?", are three images. In the central one a girl plays the piano; on the right, she smiles flirtatiously, and on the left she is flipping unenthusiastically through a magazine. Ahtila lets her subjects relate both their positive and negative experiences in a natural way that is neither sensationalist nor coy. They might as well be talking about playing the piano or basketball as discussing sex. The world is packed with information, Ahtila seems to suggest. Before experiences come, one has already learnt all about them, so what is there to get excited about?

Depuis le milieu des années 90, Eija-Liisa Ahtila est aussi présente dans les grands festivals de cinéma que dans le domaine de l'art. Très consciemment, elle avait prévu dès le début de présenter ses films et ses vidéos dans différents contextes. Ses œuvres passent en 35 mm au cinéma, mais les mêmes films servent à produire de grandes installations dans le contexte de l'art. Trois histoires brèves de 90 secondes ont ainsi été vues aussi bien sur des moniteurs négligemment posés sur des tables dans des expositions d'art, qu'entre deux spots publicitaires à la télévision. Sur le plan du contenu, Ahtila tourne sans cesse autour du thème « relations », rapports entre les générations, entre les sexes et avec elle-même. Ses histoires, qui passent souvent en simultané dans des images fractionnées, font l'effet d'authentiques reportages. Les dialogues reposent certes sur les expériences et les recherches d'Ahtila, mais ils sont joués ensuite par des acteurs professionnels comme les éléments fictifs d'un récit. La bande son est en version originale finlandaise, les films sont sous-titrés en anglais. Dans son œuvre la plus célèbre à ce jour, « If 6 was 9 », 1995, des jeunes filles relatent leurs expériences. « What should you do, when every cool guy offers you his body? », y dit-on. En même temps, on peut voir trois images cinématographiques simultanées : au milieu, la jeune fille joue du piano, à droite, elle sourit en flirtant, à gauche elle s'ennuie en feuilletant une revue. Ahtila fait raconter aux filles leurs expériences positives aussi bien que négatives d'une manière ni choquée, ni timide, mais tout à fait normale. Elles pourraient ainsi parler de piano ou de basket. Le monde est plein d'informations. Avant que les expériences surviennent, on sait déjà tout sur elles. Pourquoi alors s'émouvoir en les racontant?　　　*C. B.*

01 TODAY/TÄNÄÄN, 1997. Film still, 35 mm, 1:1, 85, 10 mins. **02 TODAY/TÄNÄÄN,** 1997. Video stills, colour, sound, 3 betacam-tapes, 3 episodes, 10 mins. Video installation, "Today", Klemens Gasser und Tanja Grunert, Cologne, Germany, 1997.

EIJA-LIISA AHTILA

SELECTED EXHIBITIONS: *1996* Cable Gallery, Helsinki, Finland /// "NowHere", Louisiana Museum of Modern Art, Humlebæk, Denmark /// "Found Footage", Klemens Gasser und Tanja Grunert, Cologne, Germany /// *1997* Raum Aktueller Kunst, Vienna, Austria /// Kunsthalle Basel, Basle, Switzerland /// *1998* Museum Fridericianum, Kassel, Germany /// *1999* Kunstverein Hannover, Hanover, Germany /// *2000* Kunsthaus Glarus, Glarus, Switzerland **SELECTED BIBLIOGRAPHY:** *1994 Identity – selfhood*, The Museum of Contemporary Art, Helsinki, Finland /// *1996 Art & Video in Europe: Finnish Digital Sauna*, Statens Museum for Kunst, Copenhagen, Denmark /// *1997 Body as a Membrane*, Kunsthallen Brandts Klædefabrik, Odense, Denmark /// *NowHere*, Louisiana Museum of Modern Art, Humlebæk

03 CASTING PORTRAITS V, 1995–1997. 3 b/w photographs, passe-partout, 35 x 79 cm (framed); photographs, 26 x 21 cm, 24 x 22 cm, 26 x 21 cm. **04 CASTING PORTRAITS VI**, 1995–1997. 4 b/w photographs, passe-partout, 39 x 97 cm (framed); photographs, 27 x 20 cm (each). **05 IF 6 WAS 9**, 1995. Split screen video installation, colour, betacam-tapes, each tape 10 mins., running simultaneously.

03

04

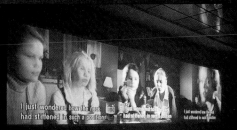

KAI ALTHOFF

1966 born in Cologne / lives and works in Cologne, Germany

Kai Althoff's first exhibition, held in 1991, took the form of a happening, and bore the title "Eine Gruppe von Befreundeten trifft sich in einem Ladenlokal auf dem Friesenwall, Köln, um Masken herzustellen" (Some friends meet in a Cologne pub to make masks). Many of his installations, drawings, videos, collages and performances evoke memories of childhood and youth, mainly owing to the materials and methods he uses. For instance, he draws with felt pens, makes figures in clay, or, as in the installation "Modern wird lahmgelegt" of 1995, creates free-standing sculptures from cardboard. In the short text accompanying this work, Althoff explains that two of these figures are film stars from the 1930s, who are being watched through the window by a third, a Nazi storm-trooper. In many of his exhibitions, these quasi-literary texts contain references to the associations he has in mind, making it easier to interpret the works on display. His protagonists are often linked with social or political events. Althoff has also staged performances with his artist colleague Cosima von Bonin, later using the scenery and props as exhibits. Equally important is his membership of the "Workshop" band. He designs their CD and record sleeves, and the fictitious names in his exhibitions often crop up in the group's lyrics. Neither his works nor the "Workshop" pieces can be clearly pigeon-holed to one particular style, despite occasional echoes from the 1970s. In both areas, Althoff conjures up independent worlds in which his memories and inventions intermingle.

La première exposition de Kai Althoff avait un caractère de happening et le titre en était « Un groupe d'amis se retrouve dans l'arrière-boutique d'une rue de Cologne pour fabriquer des masques », 1991. Nombre des installations, dessins, vidéos, collages et performances d'Althoff évoquent des souvenirs d'enfance et de jeunesse, et cela surtout du fait des matériaux et des méthodes de fabrication employés par l'artiste. Ainsi, Althoff dessine par exemple avec des feutres, réalise des figures en terre cuite ou des sculptures en carton, comme pour son installation « La modernité au rancart », 1995. Dans un court texte accompagnant cette œuvre, l'artiste présente deux de ces figures comme des stars du cinéma des années 30, stars qu'un membre des S.A. observe à travers une fenêtre. Dans d'autres expositions aussi, des textes aux relents littéraires fournissent des indications quant aux associations de l'artiste, ouvrant ainsi à l'interprétation des œuvres exposées. Souvent, les protagonistes s'y intéressent à des événements sociaux ou politiques. Althoff a présenté avec une autre artiste, Cosima von Bonin, des performances dont les décors et les accessoires serviront ensuite comme pièces d'exposition. Un autre aspect tout aussi important que son travail en collaboration avec Bonin est l'appartenance d'Althoff au groupe « Workshop », dont il réalise les pochettes de CD et de disques. De plus, certains noms fictifs issus de ses expositions apparaissent parfois dans les chansons du groupe. Nonobstant des références sporadiques aux années 70, ni les œuvres d'Althoff, ni les pièces de « Workshop » ne peuvent cependant être classées dans une tendance stylistique déterminée. Dans les deux domaines de son activité artistique, Althoff fait émerger des mondes autonomes dans lesquels souvenirs et inventions de l'artiste sont inextricablement mêlés.

Y. D.

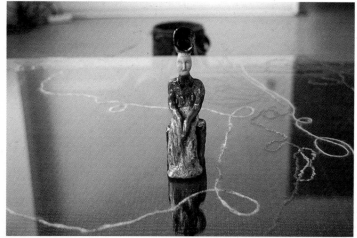

01 HAKELHUG. Installation view, Galerie Christian Nagel, Cologne, Germany, 1996.
02 UWE: AUF GUTEN RAT FOLGT MISSETAT, 1993. Coloured pencil on paper, c. 30 x 20 cm.

01

KAI ALTHOFF

SELECTED EXHIBITIONS: *1994* "Uwe: Auf guten Rat folgt Missetat", Lukas & Hoffmann, Cologne, Germany /// *1995* "Hast du heute Zeit – ich aber nicht", Künstlerhaus Stuttgart, Stuttgart, Germany (with Cosima von Bonin) /// *1996* "Hakelhug", Galerie Christian Nagel, Cologne /// *1996–1997* "Heetz, Nowak, Rehberger", Städtisches Museum Abteiberg, Mönchengladbach, Germany; Museu de Arte Contemporânea da USP, São Paulo, Brazil (with Cosima von Bonin and Tobias Rehberger) /// *1997* Robert Prime, London, England **SELECTED BIBLIOGRAPHY:** *1995 Wild Walls*, Stedelijk Museum, Amsterdam, The Netherlands /// *1997 Time Out*, Nuremberg, Germany

03

04

05

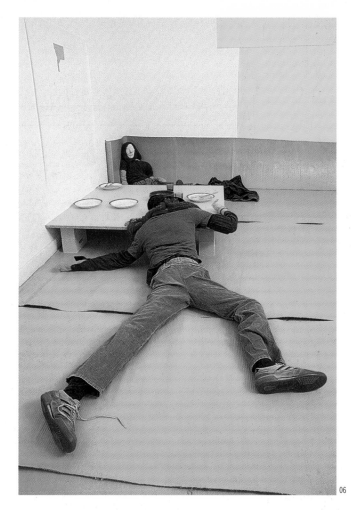

06

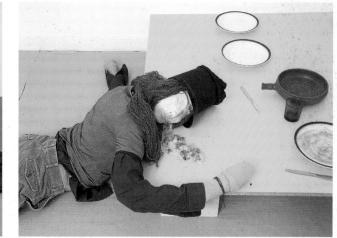

03 30 MILLIONS D'AMIS, 1994. Video stills. Städtisches Museum Abteiberg, Mönchengladbach, Germany (with Cosima von Bonin). 04 BERND, EERIC + OLIVER PROBEN FÜR "GRENZEN AM RANDE DER NEUSTADT", 1993. Videostill. Lukas und Hoffmann, Berlin, Germany, 1993. 05 UNTITLED, 1993. Silhouette, cardboard, coloured pencil, watercolours, pencil on paper, 135 x 100 cm. 06 REFLUX LUX, 1998 (details). Installation views, Galerie NEU, Berlin, 1998.

JANINE ANTONI

"I'm interested in everyday body rituals and converting the most basic sort of activities – eating, bathing, mopping – into sculptural processes." **« Je m'intéresse aux rituels quotidiens du corps ; mon propos est de convertir les actes les plus basiques – manger, prendre un bain, faire le ménage – en processus sculpturaux. »**

Janine Antoni's objects aim to be minor substitutes for sculpture which, though they formally resemble art, owe their existence to other motives. Made of fat, chocolate or soap, they are the products of processes that one associates with feminine obsession – the craving for beauty and cleanliness, the desire for love, the emotion of self-hatred. In one piece, Antoni nibbled the corners of blocks of chocolate and fat originally weighing 300 kilograms. From the chewed and spat-out mass of chocolate emerged a box of candy creams; from the fat, mixed with pigment, a collection of 300 lipsticks. For another work, Antoni narcissistically and manically created self-portrait busts by licking her features into chocolate and soap ("Lick and Leather", 1993/94). In the performance "Loving Care", 1992, named after the dye with which she coloured her long hair before sweeping it across the gallery floor, Antoni combined hair-dyeing, cleaning and painting into a single action with multiple meanings. Her emotional approach remains present in the objects she creates – physically, tactilely and frequently olfactorily. The "female" becomes deliberately and assertively stereotyped. She often gives form to the feminine sense of time in a basic image of waiting and isolation. For "Slumber", 1994, she slept at night in the exhibition room and during the day wove a warm blanket the pattern of which emerged from the computer recordings of her dreams. She is now developing her reinterpretation of form in photographic compositions: in the mask-like manipulation of the photograph of her parents ("Mom and Dad", 1994), for example, or in the photograph of her mother ("MoMe", 1995), which, by virtue of a third foot beneath the dress, also turns out to be a self-portrait.

Les objets de Janine Antoni visent à être perçus comme des formes inférieures d'ersatz de sculpture. Formellement, elles rappellent certes l'art, mais sont nées d'autres motivations. Elles sont constituées de graisse, de chocolat ou de savon, et résultent de processus associés aux abîmes du fantasme féminin de beauté et de propreté, au besoin d'amour et à la haine de soi. Antoni a mangé les coins du chocolat et la graisse manquant sur les cubes rognés, qui pesaient à l'origine 300 kg. Le chocolat mâché et recraché a servi à la réalisation d'une boîte de chocolats ; mélangée à des pigments, la graisse a donné une collection de 300 bâtons de rouge à lèvres. Antoni a léché les portraits de chocolat et de savon, les propres traits de son visage ont été travaillés de façon maniaque et narcissique (« Lick and Leather », 1993/94). Dans la performance « Loving care », exécutée sur le sol d'une galerie avec un shampooing colorant du même nom, Antoni unifiait le shampooing, le ménage et la peinture en une action unique et polysémique. Dans ses objets, la forme qu'Antoni donne à son travail demeure présente, physiquement, tactilement et le plus souvent aussi en tant qu'odeur. Le « féminin » y devient signal stéréotypé, citation volontairement incisive. Ainsi, Antoni donne forme à l'expérience féminine du temps, archétype de l'attente et de l'isolement. Pour « Slumber », 1994, elle dormait la nuit dans l'exposition et travaillait le jour au tissage d'une chaude couverture dont les motifs découlaient du traitement informatique de ses rêves en valeurs numériques. La réinterprétation de la forme se poursuit avec la mise en scène photographique : manipulation formelle du masque dans la photo de ses parents (« Mom and Dad », 1994) ou celle de sa mère (« MoMe », 1995), qui se révèle être un autoportrait avec le troisième pied qui dépasse de la robe.

S. T.

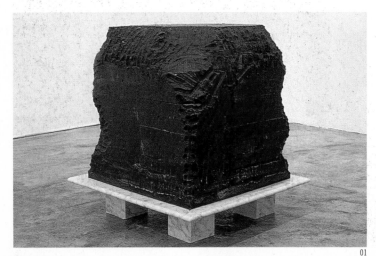

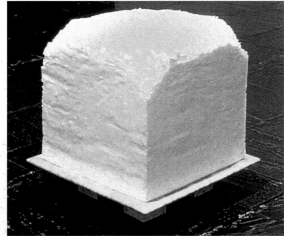

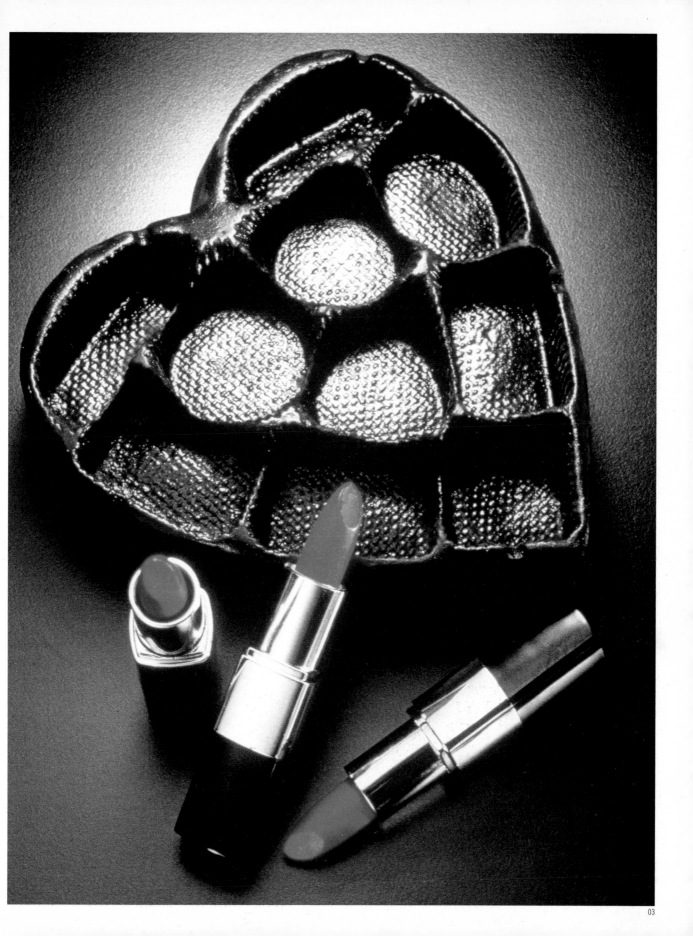

JANINE ANTONI

SELECTED EXHIBITIONS: *1993* Aperto 93, XLV Esposizione Internationale d'Arte, la Biennale di Venezia, Venice, Italy /// Biennial Exhibition, Whitney Museum of American Art, New York (NY), USA /// *1994* "Slumber", Anthony d'Offay Gallery, London, England /// *1998* "Swoon", Whitney Museum of American Art, New York **SELECTED BIBLIOGRAPHY:** *1995 Slip of the Tongue*, Centre for Contemporary Arts, Glasgow, Scotland; Irish Museum of Modern Art, Dublin, Ireland /// *1997 Rrose is a Rrose is a Rrose*, Solomon R. Guggenheim Museum, New York /// *Identity Crisis: Self-Portraiture at the End of the Century*, Milwaukee Art Museum, Milwaukee (WI), USA /// *Exhibition catalogue*, Istanbul Biennial, Istanbul, Turkey

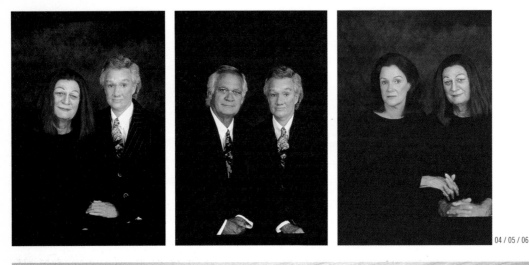

04 / 05 / 06 07

Pages 030/031: **01 CHOCOLATE GNAW,** 1992. 600 lbs. before biting. **02 LARD GNAW,** 1992. 600 lbs. before biting. **03 LIPSTICK DISPLAY,** 1992 (detail). Phenylethylamine: chocolate, lipstick: lard, pigment and wax. Pages 032/033: **04 / 05 / 06 MOM AND DAD,** 1994. Mother, father and make-up, triptych 61 x 51 cm (each). **07 SLUMBER,** 1994 (detail of performance). Loom, yarn, bed, nightgown, EEG machine & artist's REM readings. **08 LOVING CARE,** 1992 (detail of performance). Performance "I soaked my hair in hair dye and mopped the floor with it", Anthony d'Offay Gallery, London, England, 1992.

08

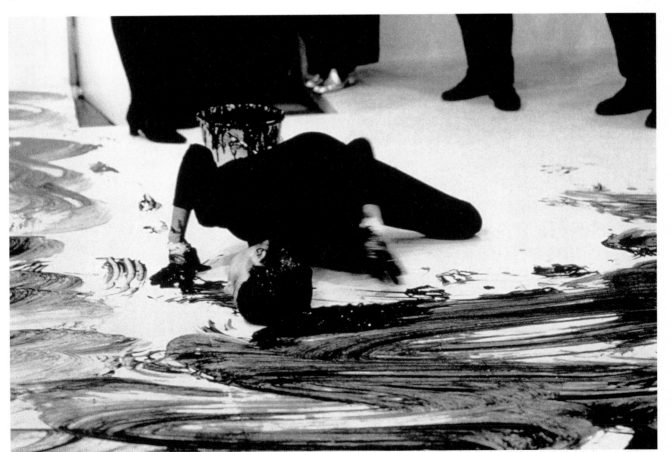

NOBUYOSHI ARAKI

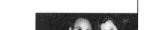

"I do not claim that my photos are true…" « **Je ne prétends pas que mes photos sont véridiques…** »

Nobuyoshi Araki has published some hundred photo albums in the space of 25 years. He became famous through his first work "Un Voyage sentimental", which he and his wife Yoko published in 1971. This photographic series shows a succession of banal moments, intimate situations and passing days during their honeymoon. Yoko is pictured sitting in a train, in a hotel room, sleeping, or having an orgasm. An insignificant street scene is photographed from the hotel window, or the platform of a provincial railway station is documented. This systematic exposure of Araki's private life reached its climax in 1990 with the death of his wife, which yielded the material for a further album. Araki manically photographed every moment of each day: Yoko sitting at a table, lying in bed, stepping out on to the street or looking up at the sky. The photographs that have become emblematic of Araki's work, however, are his portraits of young women – prostitutes and schoolgirls – either dressed or naked, hanging from the ceiling or thrown to the ground, their hands tied together, their legs apart, or even during the sexual act. But these works are not so much intended to examine the eroticism of submission as to explore an aesthetic of fictitious truth. They show women who remain untouchable despite their subjection, despite the ropes and the pain. They are putting on an act, and only too often their gaze – rendered erotic by the camera's presence – confronts the viewer with a dispassionate arrogance. The vast number of pictures and publications produced by Araki indicates that, for him, the act of photography represents an everyday business like eating or sex. They reveal, both in their triviality and their vitality, the intimate and mundane nature of the passage of time. This breathtaking amassing of photos touches on the deeper meaning of an art that is totally synchronised with the duration of life as it is lived.

01

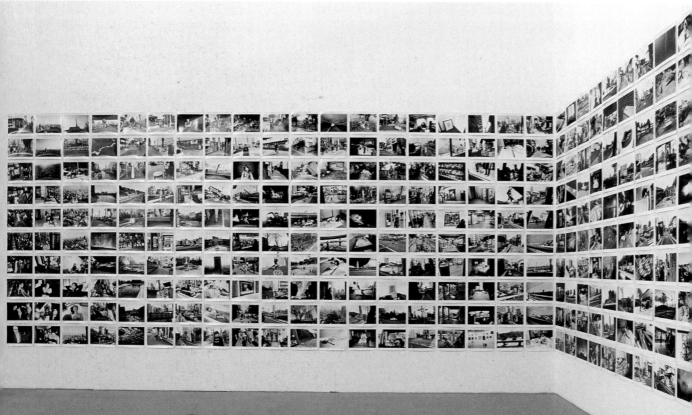

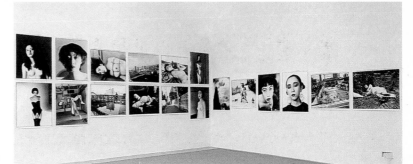

01 **"TOKYO SHIJYO – TOKYO – MARKT DER GEFÜHLE"**, installation view, Deichtorhallen Hamburg, Hamburg, Germany, 1998. 02 **"TOKYO COMEDY"**, installation view, Wiener Secession, Vienna, Austria, 1997. 03 **"TOKYO SHIJYO – TOKYO – MARKT DER GEFÜHLE"**, installation view, Deichtorhallen Hamburg, Hamburg, 1998.

En 25 années, Araki aura publié une centaine de recueils de photographies, dont il compose les maquettes comme un montage de film avec un enchaînement heurté d'images irréconciliables. « Un voyage sentimental », en 1971, le rend aussitôt célèbre. Cette œuvre aura bouleversé en montrant, sans emphase ni grandiloquence, sa femme Yoko pendant leur voyage de noces, assise dans le train, dans une chambre d'hôtel, nue dans un lit, un paysage insignifiant, les rues ordinaires de la ville, le quai d'une gare de province, Yoko en train de faire l'amour, de jouir, de dormir, succession d'instants banals, de moments familiers et des jours qui passent. Dans cette mise à nu systématique de son intimité, l'artiste vécut encore, en 1990, une expérience culminante avec la mort de sa femme, objet d'un nouveau livre. Depuis, et sur un rythme phénoménal, Araki photographie des jeunes femmes, prostituées ou lycéennes, habillées ou nues, ligotées au plafond ou jetées à terre, les poignets attachés ou les jambes écartées, exhibant leur sexe ou faisant l'amour. Ces images, devenues emblématiques de son œuvre, montrent des femmes fondamentalement inentamées en dépit de leur assujettissement, en dépit des cordes et de la douleur consentis : elles jouent, elles font semblant, et leur regard, le plus souvent serein, défie le spectateur. Dans le même temps, tous les jours et à chaque instant, à table ou au lit, en sortant dans la rue ou en fixant le ciel, Araki photographie sa vie, avec une ferveur régulière. Le geste, à la fois trivial et vital, du photographe ne dit que l'intime et banale vérité du temps en train de s'écouler : la signification essentielle de son art s'est réellement identifiée avec la durée de la vie vécue.

J.-M. R.

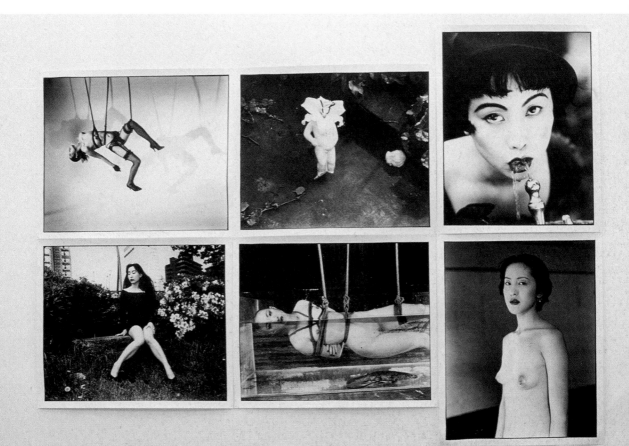

NOBUYOSHI ARAKI

SELECTED EXHIBITIONS: *1995* "Journale Intime", Fondation Cartier, Paris, France /// "Tokyo Novelle", Kunstmuseum Wolfsburg, Wolfsburg, Germany /// *1996* "Private Tokyo", Museum für Moderne Kunst, Frankfurt/M., Germany /// *1997* "Tokyo Comedy", Wiener Secession, Vienna, Austria /// *1998* "Tokyo Shijyo", Deichtorhallen Hamburg, Hamburg, Germany **SELECTED BIBLIOGRAPHY:** *1995 Tokyo Novelle*, Kunstmuseum Wolfsburg, Wolfsburg /// *1997 Tokyo Comedy*, Wiener Secession, Vienna /// *Tokyo Lucky Hole*, Benedikt Taschen Verlag, Cologne, Germany /// *1998 Tokyo Shijyo*, Deichtorhallen Hamburg, Hamburg

04 "TOKYO SHIJYO – TOKYO – MARKT DER GEFÜHLE", installation view, Deichtorhallen Hamburg, Hamburg, Germany, 1998.
05 UNTITLED (TOKYO NOVELLE), 1995. Installation view, "Tokyo Novelle", Kunstmuseum Wolfsburg, Wolfsburg, Germany, 1995.

05 ►

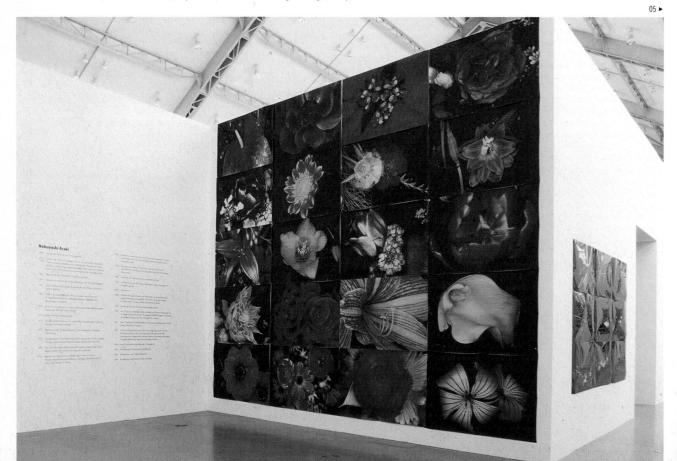

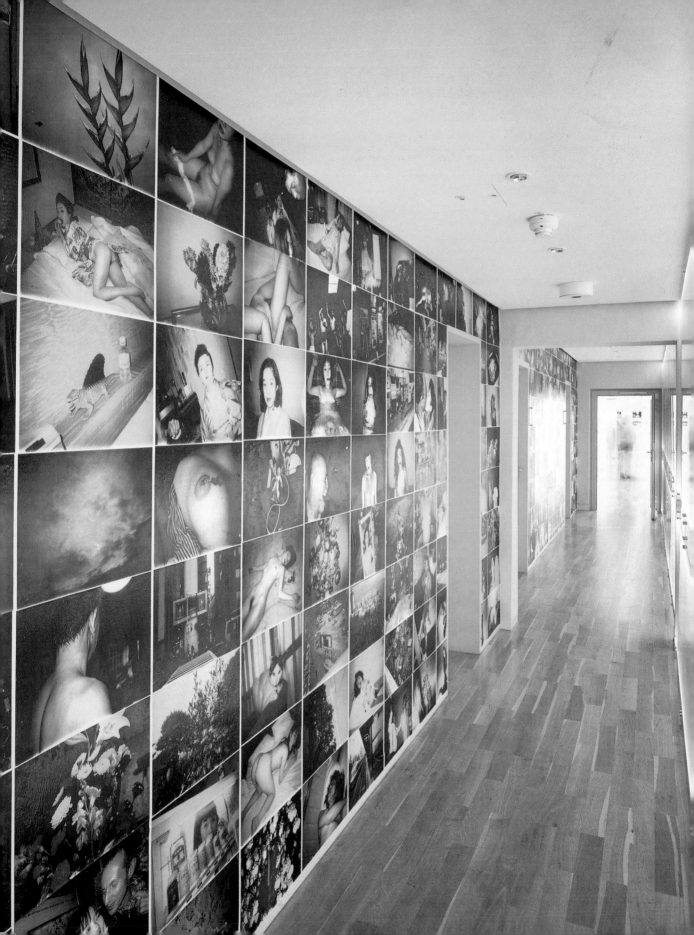

JOHN M ARMLEDER

1948 born in Geneva / lives and works in Geneva, Switzerland, and New York (NY), USA

"Our work is delicious, like our culture and the state it is in, having acceded to the B-movie status where each act, each thought, each scene is played on a support not conceived for it and where nothing is agreed or proper." **« Notre travail est aussi délectable que l'état de notre culture, qui a accédé au statut de série B, dans laquelle chaque acte, chaque pensée, chaque scène sont joués sur un fond non conçu pour cela et où plus rien n'est accepté ni juste. »**

John M Armleder calls the culture of late modernism a B-movie, that is, a second-rate film in which the high ideal of modern art and design has got lost and décor is all that is left. In contrast to other cultural analysts, Armleder accepts the state of affairs and actually likes this "second-hand presentation of modernism". In the early 1980s he painted abstract patterns on chairs, which recalled the avant-garde unity of art and life, aesthetics and function. Later he began to put together pictures from pieces of furniture – disassembled bedroom furniture combined to form a two-dimensional composition on a wall (1990), or tables screwed alongside one another on a wall as an abstract colour area (1995). But he also went in the opposite direction from art to décor, for instance with his actionistic drip-paintings and geometrical abstractions, which quoted every idea of art as spatial configuration from *art informel* and

Suprematism right up to Op Art and Daniel Buren. Though we know that Armleder's borrowings are in line with Pop design and its rediscovery today, it is only in his works that the total irony of realised modernism becomes apparent. More recently Armleder refined his strategy. He placed two "pictures" from sophisticated domestic interiors together ("Ne dites pas non", 1996/97). His first point is to be seen in the familiar combination of good designer furniture, select works of art and equally carefully selected films (running on the TV as videos). The second point is concealed in the contiguity of the two interiors, which are interchangeable variants in exactly the same pattern. This or that designer chair, this or that abstract painting, some nice B-movie which one had hardly noticed before.

John M Armleder définit la culture de la modernité finissante comme un film de série B, un film de seconde catégorie dans lequel le grand idéal de l'art moderne et du design s'est perdu et ne subsiste plus que comme décor. Contrairement à d'autres observateurs du monde culturel, Armleder a accepté cet état de fait, et même il l'aime comme une « mise en scène de seconde main de la modernité ». Au début des années 80, il couvrait des chaises de motifs abstraits rappelant l'unité avant-gardiste entre l'art et la vie, l'esthétique et la fonction. Puis il allait commencer à mettre en scène des tableaux réalisés à partir de meubles : mobilier désossé de chambre à coucher s'agençant en une composition plane accrochée au mur, 1990, tables vissées côte à côte contre le mur et produisant un champ chromatique abstrait, 1995. Mais Armleder a également suivi l'itinéraire inverse – de l'art à la décoration : par exemple avec ses tableaux actionnistes, déversoirs de l'abstrait, et ses abstrac-

tions géométriques qui citaient l'art comme décoration intérieure – du suprématisme à Daniel Buren en passant par l'informel et l'Op Art. On sait que les citations d'Armleder correspondent au pop-design et à sa redécouverte actuelle, mais seules ses œuvres ont la capacité de montrer toute l'ironie de la modernité. Dans ses œuvres les plus récentes, Armleder a affiné sa stratégie. Il a ainsi exposé deux « tableaux », mises en scène d'intérieurs de haut standing (« Ne dites pas non », 1996/97). La première ironie réside dans la combinaison familière entre des meubles design de qualité, des œuvres d'art choisies et des films tout aussi choisis (vidéos qu'on peut voir passer à la télévision). La deuxième réside dans la juxtaposition des deux intérieurs, qui représentent des variantes interchangeables conçues très exactement sur le même modèle : tel ou tel meuble design, telle ou telle peinture abstraite, tel ou tel beau film de série B dont on n'avait guère pris conscience auparavant. S. T.

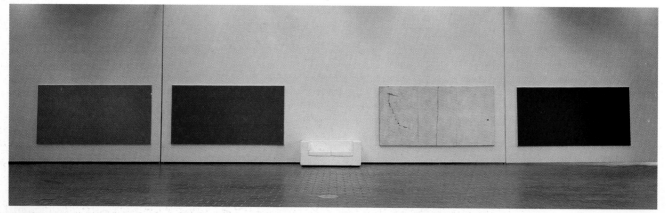

01 UNTITLED, FURNITURE – SCULPTURE NO. 244, 1990. Acrylic on canvas and leather sofa, 150 x 1800 cm. Installation view, "Armleder, Artschwager, Bickerton, Vercruysse", Pori Art Museum, Pori, Finland, 1992. **02 UNTITLED**, 1998 (background). Acrylic glass, blue. **UNTITLED**, 1998 (foreground). Acrylic glass, yellow. **UNTITLED**, 1998. Wall painting. Installation view, "Rewind, Fast-Forward, Any Speed", Mehdi Chouakri, Berlin, Germany, 1998.

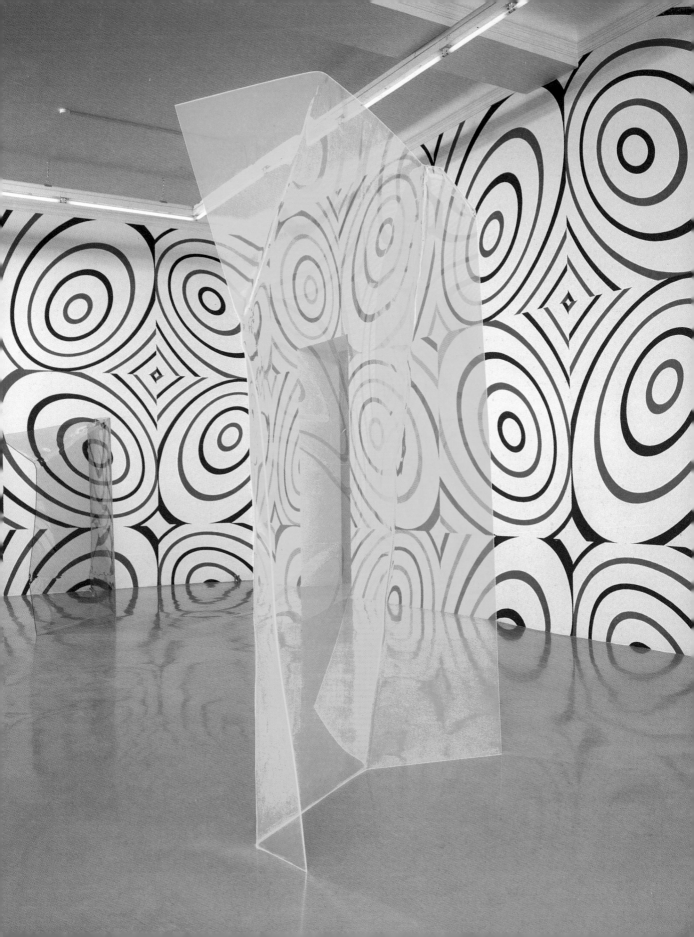

JOHN M ARMLEDER

SELECTED EXHIBITIONS: *1986* XLII Esposizione Internationale d'Arte, la Biennale di Venezia, Venice, Italy, Swiss Pavilion /// *1987* Musée d'Art Moderne de la Ville de Paris, Paris, France /// *1993* Wiener Secession, Vienna, Austria /// Villa Arson, Nice, France /// *1998* Staatliche Kunsthalle Baden-Baden, Baden-Baden, Germany /// *1999* "Frieze", The Institute of Contemporary Art, Boston (MA), USA /// Artspace, Auckland, New-Zealand **SELECTED BIBLIOGRAPHY:** *1987 John Armleder*, Kunstmuseum Winterthur, Winterthur, Switzerland /// *1990 John Armleder, Furniture Sculptures 1980–1990*, Musée Rath, Geneva, Switzerland /// *1994 John Armleder*, Centre d'Art Contemporain de Fréjus, Fréjus, France /// *1998 L'Œuvre Multipliée*, Geneva /// *Wall Paintings 1967–1998*, La Box, Bourges, France; Le Casino, Luxembourg, Luxemburg /// *Complete Writings & Interviews*, Le Consortium, Dijon, France

03 UNTITLED, FURNITURE – SCULPTURE NO. 247, 1990. Acrylic on canvas, wood, 230 x 695 x 16 cm. Installation view, Galerie Susanna Kulli, St. Gallen, Switzerland, 1990. **04 UNTITLED, FURNITURE – SCULPTURE NO. 159,** 1987. Acrylic on canvas, gold-plated Blessing French horns, 193 x 242 x 41 cm. Installation view, John Gibson Gallery, New York (NY), USA, 1987. **05 UNTITLED, FURNITURE – SCULPTURE NO. 196,** 1988. Acrylic on canvas, steel and aluminium US diner peg-stools with sparkle PVC seats, 92 x 245 x 60 cm. Installation view, John Gibson Gallery, New York, 1988.

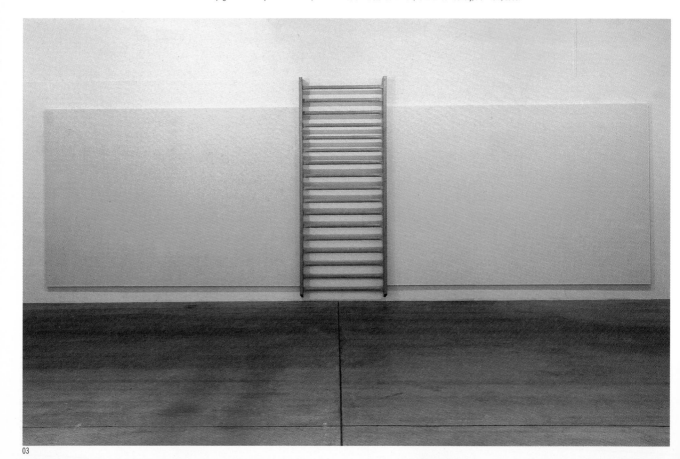

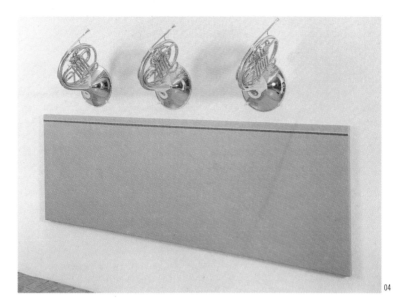

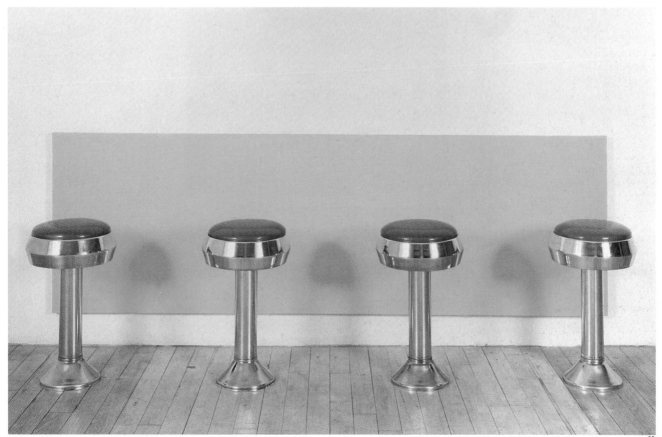

ART CLUB 2000

"Consumption determines production." « **La consommation conditionne la production.** »

Discovering what artistic production can currently offer is the central theme of Art Club 2000, a grouping of artists set up in 1992. Their first exhibition, "Commingle", 1993, a confrontation with an advertising campaign by the US clothing manufacturer GAP, was a sensation. The (then) seven-man collective produced a series of wicked photographs parodying the uniformity of the images supposedly embodying the lifestyle of their generation. Appropriating and reflecting tongue in cheek how both pop culture and art function, using their paradigms and codes, is a feature of later work by the Club. "SoHo So Long", 1996, was a study of the process of gentrification evident in the move of numerous galleries from SoHo to Chelsea. The theme of the "1970" exhibition in 1997 was the influence of the art produced around 1970, especially Conceptual Art, on today's artistic output. Interviews with leading figures of the time,

or a questionnaire in the style of Hans Haacke's "Polls", 1969–1973, quoted artistic strategies of the 1970s that have been picked up and reinforced in the 90s. Using repetition, appropriation and alterations to existing procedures, projects by Art Club 2000 have also altered the meaning of the concept of authorship. The very title of "Night of the Living Dead Author", 1998, links the cult horror film "Night of the Living Dead" with Roland Barthes's controversial thesis of the "death of the author". The art world is portrayed as a police state in which artists (represented by members of Art Club 2000) eke out their existences as zombies after the death of the author. Without abandoning a critical distance from the mechanism of the art business, which appropriates even criticism all too readily, the group present the ambivalence and interconnection of their position with highly effective humour.

01

02

03

01 UNTITLED (GROUP PORTRAIT/SEARS PORTRAIT CENTER 1), 1992. C-print, 20 x 25 cm. 02 UNTITLED (ART IN AMERICA LIBRARY 2), 1992/93. C-print, 20 x 25 cm. 03 UNTITLED (DONUT SHOP 1), 1992/93. C-print, 20 x 25 cm. 04 UNTITLED (PARAMOUNT NUDE), 1992/93. C-print, 20 x 25 cm. 05 UNTITLED (INDUSTRIA SUPERSTUDIOS 1), 1992/93. C-print, 20 x 25 cm. 06 UNTITLED (INDUSTRIA SUPERSTUDIOS 1), 1992/93. C-print, 20 x 25 cm. 07 UNTITLED (LIMBO CAFE 1), 1992/93. C-print, 20 x 25 cm.

04

Que nous propose actuellement la production artistique ? Voilà le thème central du groupe artistique Art Club 2000, fondé en 1992, et qui devait susciter un vif intérêt en 1993 avec sa première exposition, « Commingle », un travail sur les campagnes publicitaires du fabricant de prêt-à-porter américain GAP. Dans une série de photographies, le collectif alors composé de sept artistes, parodiait l'uniformité des images censées incarner le style de vie de sa génération. L'appropriation ironique et la réflexion sur les modes de fonctionnement, les paradigmes, les codes de la culture pop, mais aussi sur le fonctionnement de l'art, caractérise également le travail ultérieur d'Art Club 2000. En 1996, « SoHo So Long » était une étude du processus d'aristocratisation qui pouvait être déduit des nombreux déménagements de galerie de SoHo à Chelsea. L'influence de l'art vers 1970 – en particulier celle de l'art conceptuel – sur le travail artistique contemporain sera ensuite le thème de l'exposition « 1970 »,

1997 : interviews avec des protagonistes de l'époque, sondage à base de questionnaires dans le style des « Polls » conçus et utilisés par Hans Haacke entre 1969 et 1973, citaient certaines stratégies artistiques des années 70, stratégies qui ont été reprises et renforcées dans les années 90. Par la répétition, l'appropriation et l'altération d'images et de démarches existantes, les projets d'Art Club 2000 induisent également un changement dans la signification du concept de paternité artistique. Dans son titre déjà, « Night of the Living Dead Author », 1998, associe le film culte « La nuit des morts-vivants » et la célèbre thèse de Roland Barthes concernant la mort de l'auteur : le monde de l'art est représenté et mis en scène comme un État policier dans lequel, après la mort de l'auteur, les artistes mènent une existence de zombies représentée par les membres d'Art Club 2000. Le groupe présente sa position ambivalente et ses propres interconnexions avec un humour décapant. A. W.

06

05

07

ART CLUB 2000

SELECTED EXHIBITIONS: *1993* "Commingle", American Fine Arts, New York (NY), USA /// *1995* "Milanarian", Galleria Facsimilie, Milan, Italy /// *1996* "Global Tekno 2", capc Musée d'art contemporain, Bordeaux, France /// *1997* "Heaven", P.S. 1, Long Island City (NY), USA /// *1998* "Night of the Living Dead Author", American Fine Arts, New York /// *1999* American Fine Arts, New York **SELECTED BIBLIOGRAPHY:** *1994* "Blood and Guts After High School", *Frieze*, London, England /// *1996* "Art Club 2000 S.A.L.E.S. Roma", *Flash Art*, Milan /// *1998* "Night of the Living Dead Author", *The New York Times*, New York

09

08

10

08 UNTITLED (COOPER UNION/SNAKE), 1994. C-print, 102 x 76 cm. 09 UNTITLED (WOOSTER ST./GAP VAMPIRES), 1992/93. C-print, 20 x 25 cm. 10 UNTITLED (CONRAN'S 1), 1992/93. C-print, 20 x 25 cm (framed). 11 EARTHRISE/LIBERTY SCIENCE CENTER, 1993. Digital photograph. 12 UNTITLED (COOPER UNION/SKUNK), 1994. C-print, 102 x 76 cm. 13 UNTITLED (7–11), 1994. C-print, 39 x 50 cm. 14 UNTITLED (COOPER UNION 1), 1994. C-print, 41 x 51 cm.

11

12

13

14

DONALD BAECHLER

1956 born in Hartford (CT) / lives and works in New York (NY), USA

"I tend to be interested, for my own purposes, in things I find on the street or things drawn on toilet walls or things drawn by someone I meet in a bar..." « (...) J'ai tendance à m'intéresser, pour mon propre plaisir, aux choses que je trouve dans la rue ou aux choses dessinées sur les murs des toilettes ou aux choses dessinées par quelqu'un que je rencontre dans un bar... »

Each one of Donald Baechler's works is a declaration in favour of the hybrid. Generally, he juxtaposes acrylic paints mixed with oil and *papiers collés* on the same canvas to make assemblages. This technique becomes a distinguishing feature of an "aesthetic of mixing", which is intended to permeate or overcome the gulf between different styles and genres. The spirit of appropriation lies at the basis of Baechler's art. In paintings characteristic of 1980s and 90s Postmodernism, he combines Expressionism and Bad Painting, references and quotations, *art brut* and naive painting, high and low, realism, gestural painting and flat masses of colour. Quotations, borrowings and historical references form the basis of a body of work that singles out these diverse elements in order to underline their eclecticism. As a passionate collector, he takes an interest in the way different cultures make drawings. Asking people he meets by chance to draw for him, he sticks the results, along with his own sketches, on to canvas, complementing them with texts or photographs. His series of flowers, fruits, trees, balls or simple geometric forms are painted with an affected clumsiness and a bogus naivety. In this way, his work develops an "aesthetic of simplicity" and pays ironic tribute to a kind of primitivism, which is meant to cast doubt on, and overturn, what Baechler considers to be academic conventions and the affectations of Minimalist and Conceptual Art.

Chaque peinture de Baechler est un manifeste en faveur de l'hybridation, de l'impureté et du mélange. L'artiste pratique une peinture hétérogène faite de collages et d'assemblages : le tableau est un carrefour de citations et de genres, un alliage de styles et de références. Cet art, parfaitement représentatif du postmodernisme des années 80–90, mélange expressionnisme et Bad Painting, art brut et peinture naïve, high et low, fa presto et réalisme, gestualité et aplats de couleur... à travers cette esthétique de la mixité, il ne veut que perturber et subvertir le clivage des styles et la séparation des genres. La citation, l'emprunt ou la référence historiques font tout naturellement partie des matériaux de base de cette peinture qui ne recycle des éléments épars que pour en exalter l'éclectisme. Plus largement, l'art de Baechler relève d'une attitude appropriationniste. Le peintre observe la façon dont les gens dessinent dans différentes cultures : il collecte, à travers le monde, des dessins qu'il fait exécuter à des personnes de rencontre et qu'il n'hésite pas à coller directement sur la toile, parmi ses propres esquisses, avec divers textes ou photos. Il s'attache à peindre des séries de fleurs, de fruits, de ballons, de formes géométriques simples ou à réinterpréter les œuvres des artistes du passé avec une maladresse feinte ou une inauthentique naïveté. Cette esthétique de la simplicité cultive avec ironie une sorte de primitivisme qui ne vise qu'à contredire ce que l'artiste perçoit comme les conventions académiques et les afféteries de l'art minimal ou conceptuel.

J.-M. R.

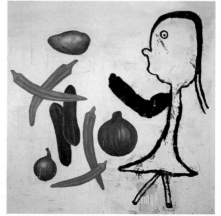

DONALD BAECHLER

SELECTED EXHIBITIONS: *1987* São Paulo Biennial, São Paulo, Brazil /// *1989* "Einleuchten: Will, Vorstell und Simul in HH", Deichtorhallen Hamburg, Hamburg, Germany /// *1995* "Donald Baechler: York House Suite", Fundaçao Calouste Gulbenkian, Lisbon, Portugal /// *1997* "Flowers", Tony Shafrazi Gallery, New York (NY), USA /// *1998* Kunsthalle Basel, Basle, Switzerland
SELECTED BIBLIOGRAPHY: *1989 Donald Baechler: Flowers and Trees*, Galleri Lars Bohman, Stockholm, Sweden /// *Donald Baechler, Paintings – ArTRANDOM*, Kyoto Shoin, Kyoto, Japan /// *1993 Donald Baechler*, UMKC Gallery of Art, Kansas City (KS), USA /// *1997 Donald Baechler, Flowers*, Tony Shafrazi Gallery, New York /// *1998 Donald Baechler: Works on Paper*, Locks Gallery, Philadelphia (PA), USA

05

06

05 PRICELESS, WORDLESS, LOVELESS, 1987. Acrylic and collage on canvas, 282 x 168 cm. **06 FLOWERS #18–97 (LARGE VERSION),** 1997. Acrylic and fabric collage on canvas, 254 x 203 cm. **07 "DONALD BAECHLER: DES FLEURS",** installation view, Galerie Thaddaeus Ropac, Paris, France, 1994/95. **08 CROWD PAINTING #1,** 1996. Acrylic and fabric collage on canvas, 244 x 244 cm.

MIROSLAW BALKA

"For me the history of materials is more important than the history of art." « **Pour moi, l'histoire des objets est plus importante que l'histoire de l'art.** »

Miroslaw Balka's contribution to the Venice Biennale of 1990 was a strange sculpture ("94 x 64 x 164") resembling a bed, which was so inconspicuously placed in the room that people almost passed it by. It seemed too small for a grown-up and too big for a child. At its head was a dirty electric cushion, which gave off a feeble warmth to the touch. And yet this sculpture was so impressive and so subtle that it could not be overlooked. With this work, Balka initiated a rapid succession of exhibitions that took place in major institutions during the following year, to which he gave the overall title "My body cannot do everything I ask for". This only partially referred to his sudden success. It also pointed to the fact that Balka's works are often related to his body measurements, by which means the sculptures lose the randomness of rusty steel plates and acquire human dimensions with which the viewer can identify. Similarly, the objects seem to have their own specific history: they were not found by chance but derived from the world of Balka's personal experience. This was particularly apparent in his early figurative works, but even in his later sculptures the viewer cannot escape the impression that the artist has elaborated a piece of his biography into a work that stands for many different experiences. Balka is one of the few contemporary artists with the ability to express the range of feelings that lie between helplessness and strength without bogus pathos or sentimentality.

A la Biennale de Venise de 1990, on pouvait voir une sculpture ressemblant à un lit, et qui se trouvait là de manière si naturelle et anodine dans la salle, qu'on passait presque à côté d'elle sans la voir. Le lit semblait trop petit pour un adulte, trop grand pour un enfant. En tête de lit, il y avait un coussin chauffant sali ; à son contact, on ressentait une chaleur modérée. Et pourtant cette sculpture était si explicite, si sensible et d'une actualité si brûlante – un mois après l'ouverture de l'Est –, qu'il était impossible de ne pas la voir. Ce travail marqua pour Miroslaw Balka le début d'une ascension si fulgurante à travers les plus grandes institutions, que dès 1991, il intitulait chacune de ses expositions « My body cannot do everything I ask for ». Ceci n'était que partiellement une allusion à ce succès soudain. D'un autre côté, les œuvres de Balka se réfèrent en effet souvent aux mesures de son propre corps. L'artiste ôte ainsi à ses sculptures réalisées en plaques d'acier rouillées l'aspect aléatoire ; elles prennent une taille humaine et le spectateur perçoit lui-même ces dimensions. De même, les objets semblent avoir une histoire, ils ne sont pas des objets trouvés fortuitement, mais sont issus du monde d'expérience personnel de Balka. Si cet aspect était déjà manifeste dans ses premières œuvres figuratives, en présence des œuvres plus récentes, le spectateur ne peut jamais se soustraire à l'impression que l'artiste a travaillé sur un morceau d'autobiographie qui se veut le représentant de nombreuses expériences. Balka est ainsi l'un des rares artistes capables de traduire aujourd'hui en termes artistiques, sans sentimentalisme ni coquetterie, des sentiments oscillant entre l'impuissance et la force. C. B.

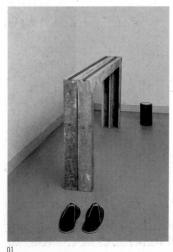

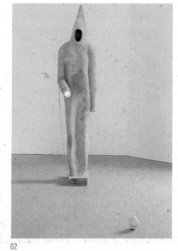

01 ø 16 x 27.2 x (190 x 93 x 13), 2 x (30 x 10 x 13), 1991. Wood, steel, concrete, felt, dimensions same as title in cm. **02 SHEPHERDESS**, 1988/89. Concrete, glass, wood and wire, 217 x 55 x 62 cm. **03 REMEMBRANCE OF THE FIRST HOLY COMMUNION**, 1985. Steel, cement, marble, textile, wood, ceramic and photo, 170 x 90 x 105 cm.

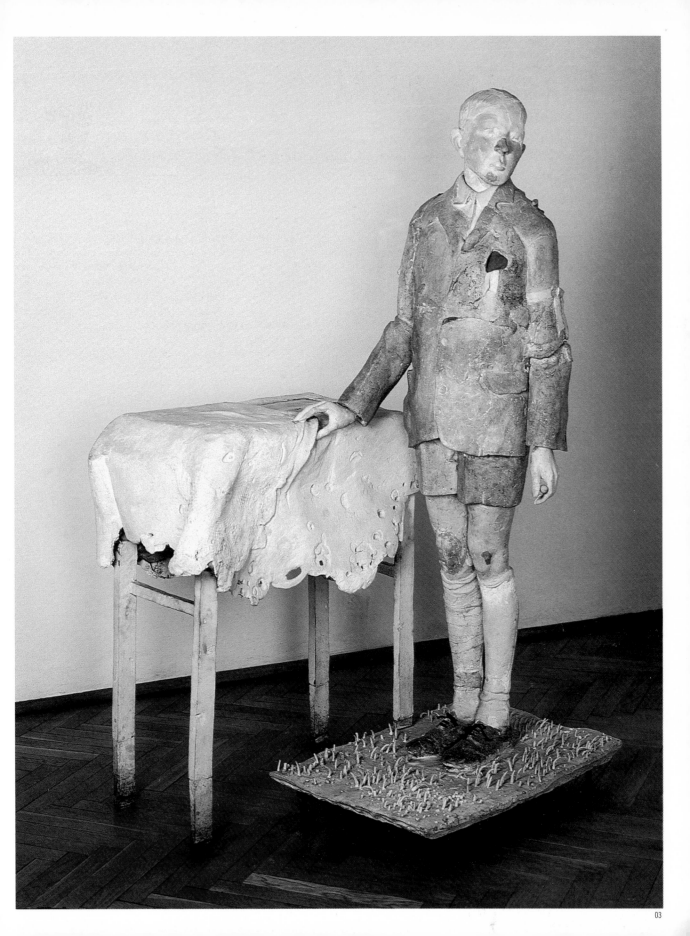

MIROSLAW BALKA

SELECTED EXHIBITIONS: *1992* documenta IX, Kassel, Germany /// *1993* "37,1", XLV Esposizione Internationale d'Arte, la Biennale di Venezia, Venice, Italy, Polish Pavilion /// *1994* "Laadplatform", Stedelijk Van Abbemuseum, Eindhoven, The Netherlands /// *1995* "Dawn", Tate Gallery, London, England /// *1997* "Revision (1986–1997)", IVAM, Centre del Carme, Valencia, Spain **SELECTED BIBLIOGRAPHY:** *1992* "Metamorphosen zum Tod", in: *Polnische Avantgarde 1930–1990*, Neuer Berliner Kunstverein, Berlin, Germany; Muzeum Sztuki, Lódz, Poland /// *1992–1993* "Polish Haiku", in: *36.6*, The Renaissance Society at the University of Chicago, Chicago (IL); MIT – List Visual Arts Center, Cambridge (MA), USA /// *1994* "Miroslaw Balka – Arranged events (a first draft)", in: *Die Rampe*, Stedelijk Van Abbemuseum, Eindhoven; Muzeum Sztuki, Lódz /// *1995* "Miroslaw Balka", in: *Rites of Passage*, Tate Gallery, London /// *1998* "Sculpture, Materiality and Memory in an Age of Amnesia", in: *Displacements*, Art Gallery of Ontario, Toronto, Canada

04

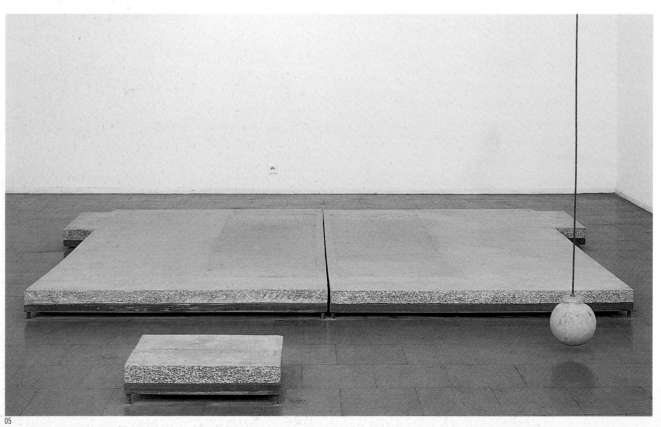

05

04 190 x 60 x 70; 2 x (8 x 11 x 10), 1996. Steel, linoleum, ash, dimensions same as title in cm. **05 "RAMPA"**, installation view, Muzeum Sztuki, Lódz, Poland, 1994. **06 "DAWN"** (detail), installation view, Tate Gallery, London, England, 1995.

STEPHAN BALKENHOL

1957 born in Fritzlar, Germany / lives and works in Karlsruhe, Germany, and Meisenthal, France

"... I'm perhaps proposing a story and not telling the end ..." « ... **je peux par exemple exposer une histoire aux gens, sans raconter la fin... »**

Stephan Balkenhol attracted international attention in 1987 with his contribution to "Skulptur Projekte in Münster". He placed a sculpture of a male figure in a green shirt and white trousers on an exterior wall over a tobacconist's shop. In the art scene of the 1980s, conditioned by the influence of Minimal Art and Conceptual Art, this switch to the figurative came as a surprise. Balkenhol's wooden sculptures re-evaluate human representation on the basis of Modernism, and at the same time they are differentiated from its self-imposed limitations. In contradistinction to classical, neo-expressionist or abstract sculpture with its typical idealisation, emotionalism and fragmentation, Balkenhol's colourfully painted wood sculptures and reliefs show people in mundane everyday guise – young men and women in stereotyped dress, with relaxed and somewhat bored expressions, without any explicit reference to profession, function or

social status. The attempt to avoid narrative references is emphasised by Balkenhol through descriptive titles and the seemingly casual display of his sculptures in architectural niches or on crudely carved pedestals. In spite of individual characteristics, his figures become types through repetition. Balkenhol's unconcern with meticulous realism is corroborated by his emphasis on the production process, which can be perceived in the evidence of a usually hasty handling of the surface. Moreover, since 1990 a surrealistic element has been introduced in his juxtapositions of a small male figure with animals of approximately the same size. In spite of these fanciful encounters, the human figure retains its composed facial expression, thereby presumably exciting from many viewers precisely that mixture of matter-of-factness and irritation which Balkenhol is aiming at.

Stephan Balkenhol devait se faire remarquer par la scène internationale en 1987 avec sa contribution à la manifestation « Skulptur. Projekte in Münster » (« Sculpture Projets à Münster ») : sur la façade d'une maison, au-dessus d'un débit de tabac, l'artiste avait placé la sculpture d'une figure masculine en chemise verte et pantalon blanc. Dans une scène artistique des années 80 dominée par le Minimal Art et l'art conceptuel, ce retour à la figuration provoqua la surprise. Les sculptures en bois de Balkenhol visent à une nouvelle évaluation de la représentation de l'homme sur les bases du modernisme tout en se démarquant des limites que celui-ci entend s'imposer. A la différence des sculptures classiques, (néo)expressionnistes ou abstraites, avec leur tendance à la sublimation idéalisatrice, leur pathos ou leur fragmentation, les sculptures et les reliefs de bois polychrome réalisés par Balkenhol montrent l'homme dans son quotidien le plus profane : jeunes hommes et jeunes femmes

en habit stéréotypé, la mine détendue, un peu marquée par l'ennui, sans indication explicite de métier, de fonction ou de position sociale. Balkenhol souligne sa volonté d'éviter les références narratives en donnant à ses œuvres des titres descriptifs et par une présentation – en apparence accessoire – de ses sculptures dans des niches architectoniques ou sur des socles taillés grossièrement. Le désintérêt de Balkenhol pour le détail réaliste est confirmé par l'accentuation du processus de fabrication, qui apparaît dans les traces d'un traitement de surface le plus souvent désinvolte. Depuis 1990, on observe l'apparition d'un élément surréaliste avec la combinaison de petites figures humaines accompagnées d'animaux de taille à peu près équivalente. Malgré ces rencontres « fantastiques », la figure humaine conserve l'expression placide du visage – déclenchant sans doute chez bien des spectateurs ce mélange d'évidence et d'irritation que Balkenhol cherche précisément à atteindre. A. W.

01

Pages 054/055: **01 ZWÖLF FREUNDE,** 1988. Wood, 100 x 70 x 10 cm (each). **02 DREIERGRUPPE,** 1985. Beech wood, painted, 150 cm (h) (each). Pages 056/057: **03 MAN ON A BUOY,** 1992. Oak, painted, c. 220 cm (h). Installation view, "Double-take", Hayward Gallery, London, England, 1992. **04 TANZENDE PAARE,** 1996. 10 pieces, wawa wood, painted, 160 x 24 x 34 cm (each). **05 57 PINGUINE,** 1991 (foreground); **LETTNER-PAAR,** 1991 (background). Installation view, Galerie Johnen & Schöttle, Cologne, Germany, 1991.

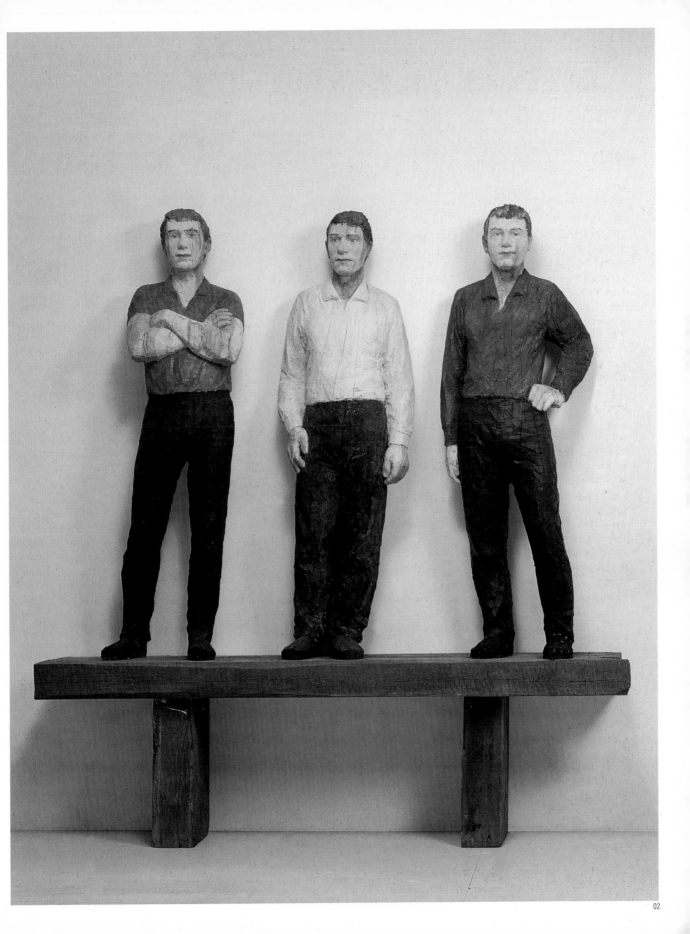

STEPHAN BALKENHOL

SELECTED EXHIBITIONS: *1988–1989* Portikus, Frankfurt/M., Germany /// *1992* Kunsthalle in Hamburg, Hamburg, Germany /// Witte de With, Centre for Contemporary Art, Rotterdam, The Netherlands /// *1994* Neue Nationalgalerie, Berlin, Germany /// *1995* "Stephan Balkenhol: Sculptures and Drawings", Hirshhorn Museum and Sculpture Garden, Washington, D.C., USA
SELECTED BIBLIOGRAPHY: *1988 Stephan Balkenhol*, Kunsthalle Basel, Basle, Switzerland /// *1994 Stephan Balkenhol: Skulpturen*, Neue Nationalgalerie, Berlin /// *1995 Stephan Balkenhol: Sculptures and Drawings*, Hirshhorn Museum and Sculpture Garden, Washington, D.C. /// *1996* "The Company of Strangers", in: *Stephan Balkenhol at the Saatchi Gallery*, London, England /// *1998 Stephan Balkenhol*, The Arts Club of Chicago, Chicago (IL), USA /// *Stephan Balkenhol, Skulpturen*, Von der Heydt-Museum, Wuppertal, Germany

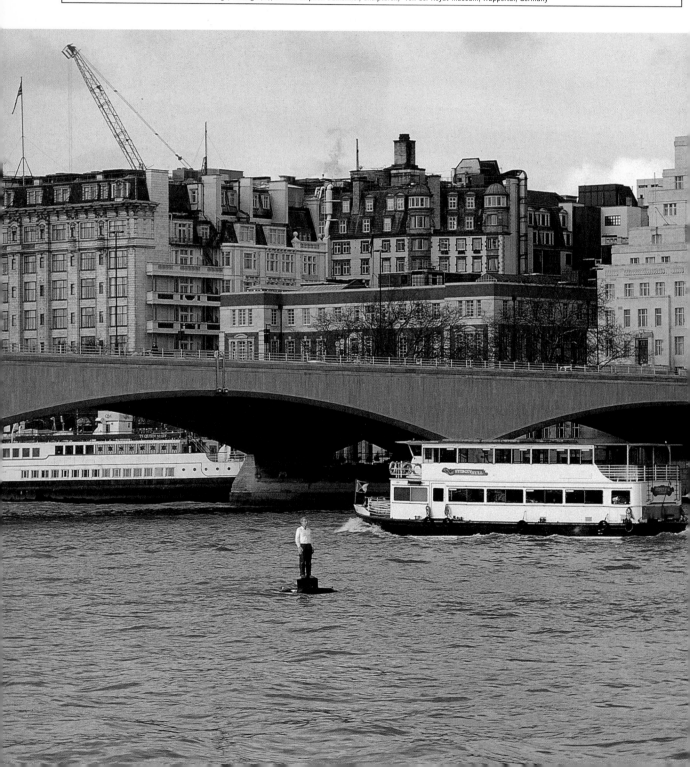

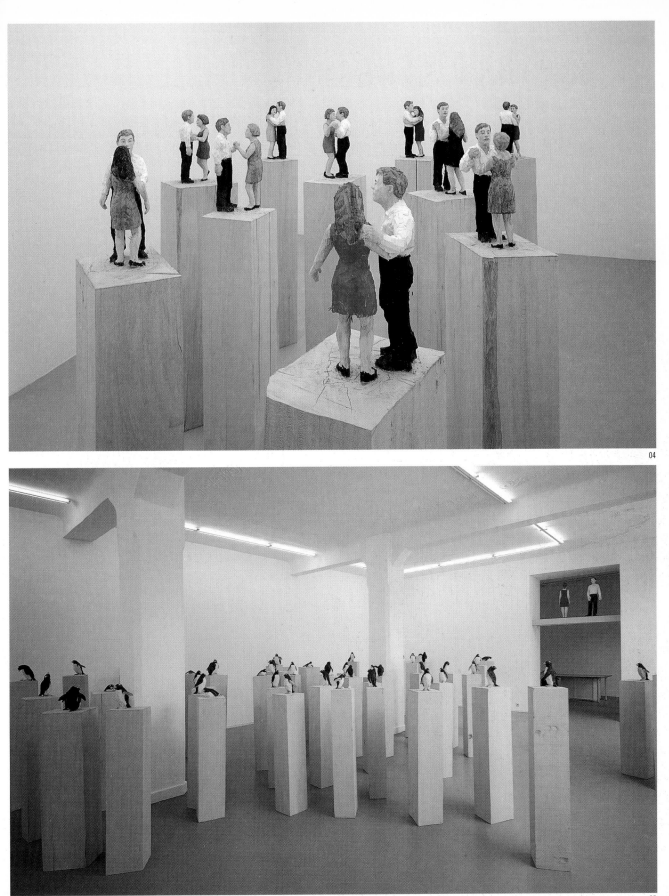

04

MATTHEW BARNEY

1967 born in San Francisco (CA) / lives and works in New York (NY), USA

"The forms don't really take on life for me until they've been 'eaten', passed through the narrative construction." « Les formes ne prennent vraiment vie pour moi qu'une fois qu'elles ont été ‹ digérées ›, passées au moulin de la construction narrative. »

Matthew Barney stages timeless fictions in the form of hybrid installations, filmed performances and stylised videos. Barney's works are peopled by artfully made-up, extravagantly dressed models, mutants padded out with cushions, unidentifiable shapes made of synthetic material, a greasy slime made of Vaseline, roaring racing cars and horned satyrs. Overcharged with imagination, the effect of the art worlds conjured up by the one-time medical student is both epic and aseptic. Of his work to date, the high point is the "Cremaster" series of five films, of which three ("Cremaster 4", 1994, "Cremaster 1", 1995/96, and "Cremaster 5", 1997) have been made so far. The first of these takes place on the Isle of Man, where the celebrated Tourist Trophy Motorbike Races have been held every year since the 1960s. The races form a central motif of the film. The second film shows a football stadium over which two airships float, while the third takes us to the Budapest of the past, with the Chain Bridge, baroque opera house and Art Nouveau baths. The as yet unrealised "Cremaster 3" and "Cremaster 2" are due to be filmed on an ice field in Canada and in the Chrysler Building in New York respectively. Barney's approach is always the same: first the approximately hour-long video is played in public cinemas, then large installations, objects, photos and drawings from the relevant imaginary world are displayed in museums and galleries, and at the same time an art book containing the pictures from the film is published. The title of the series is derived from the cremaster muscle in the male genitals from which the testicles are suspended, and which is retracted in a reflex movement produced by cold or fear inside the body.

Barney met en scène d'intemporelles fictions sous forme d'installations d'objets hybrides, de performances filmées réalisées sans public et, surtout, de vidéos baroques, d'une virtuosité visuelle saisissante et peuplées de nus mutants, de choses fabriquées, de « sculptures » en gel de silicone, de viscosités en plastique autolubrifiant, de formes non identifiables blanches gelées dans de la cire de paraffine, de bolides rugissants, d'androïdes élégants, de satyres velus au poil roux. Les trois films formant la série des « Cremaster », qui en comptera finalement cinq, forment sans aucun doute l'expression la plus aboutie de cet antinaturalisme dandy qui se présente comme une métaphore de l'appareil psychique et, en même temps, une troublante exploration de l'intériorité physiologique, où le thème de l'« orifice clos » fonctionne comme un leit-motiv : « La formation définitive du cercle parfaitement hermétique, c'est quand vous êtes capables de coller votre tête sur votre derrière. » « Cremaster 4 », réalisé en 1994 (42"), « Cremaster 1 », réalisé en 1995 (40"), « Cremaster 5 », réalisé en 1998 (54"). Dans ces fictions sans dialogues, où Barney revêt tour à tour différents rôles, les protagonistes sont présentés comme les expressions de dualités irrésolues, de pulsions en compétition, d'énergies polymorphes. Le récit de chacun de ces films se conforme à un tracé symétrique à celui que décrit le mouvement interne qu'effectuent dans le corps de l'homme les muscles de Cremaster : c'est par le mouvement réflexe de ces muscles suspenseurs que le système reproductif masculin contrôle la température des testicules en les rétractant à l'intérieur du corps, en cas de froid – ou de peur. J.-M. R.

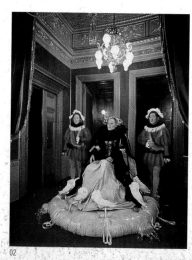

01 CREMASTER 4: THE LOUGHTON CANDIDATE, 1994. Colour photograph, 50 x 45 cm.
02 CREMASTER 5, 1997. Production still. **03 THE EHRICH WEISS SUITE,** 1997 (detail).
Acrylic, prosthetic plastic, vivak, pyrex, internally lubricated plastic, sterling silver, c-prints and gelatin silver print in acrylic frames, graphite, acrylic and petroleum jelly on paper in acrylic and prosthetic plastic frame, Jacobin pigeons.

01 02 03 ►

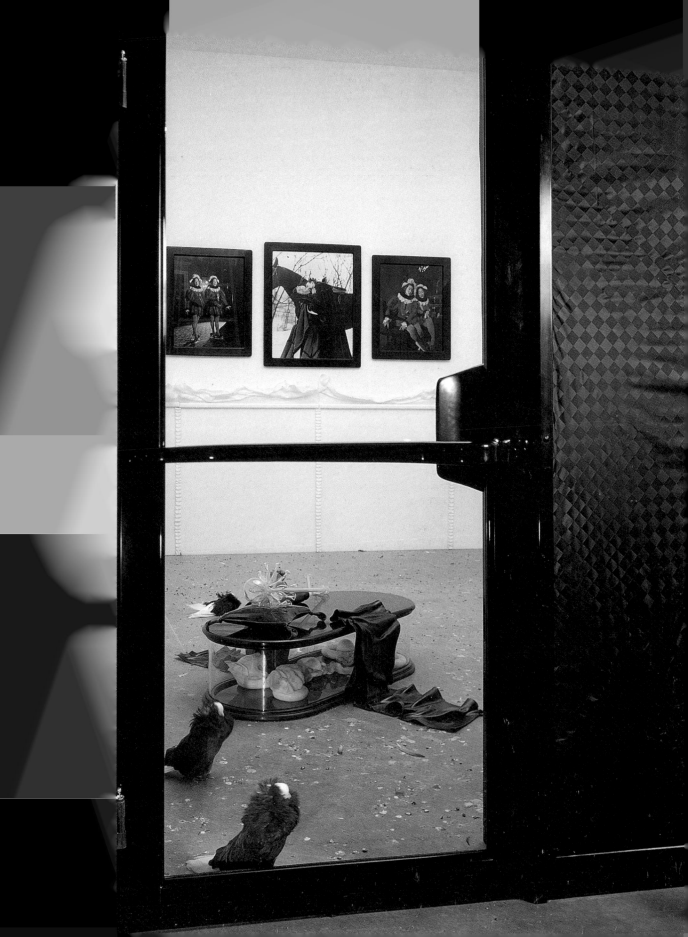

MATTHEW BARNEY

SELECTED EXHIBITIONS: *1992* documenta IX, Kassel, Germany /// *1995* Fondation Cartier, Paris, France /// Tate Gallery, London, England /// *1995–1996* "PACE CAR for the HUBRIS PILL", Museum Boijmans Van Beuningen, Rotterdam, The Netherlands; capc Musée d'art contemporain, Bordeaux, France; Kunsthalle Bern, Berne, Switzerland /// *1996* "Transsexualis and REPRESSIA", "CREMASTER 1 and CREMASTER 4", San Francisco Museum of Modern Art, San Francisco (CA), USA /// *1997* "CREMASTER 5", Portikus, Frankfurt/M., Germany /// *1999* "CREMASTER 2", Walker Art Center, Minneapolis (MN), USA /// *2001* "CREMASTER 1–5", Guggenheim Art Gallery, New York (NY), USA **SELECTED BIBLIOGRAPHY:** *1991 Matthew Barney: New Work*, San Francisco Museum of Modern Art, San Francisco /// *1995 Matthew Barney: PACE CAR for the HUBRIS PILL*, Museum Boijmans Van Beuningen, Rotterdam /// *Matthew Barney: CREMASTER 4*, Fondation Cartier, Paris /// *1997 Matthew Barney: CREMASTER 5*, Portikus, Frankfurt/M. /// *CREMASTER 1*, Kunsthalle Wien, Vienna; Museum für Gegenwartskunst Basel, Basle, Switzerland

04 CREMASTER 1, 1995. Installation view, Kunsthalle Wien, Vienna, Austria, 1997. **05 CREMASTER 1: GOODYEAR FIELD,** 1996 (detail). Self-lubricating plastic, prosthetic plastic, petroleum jelly, silicone, Astroturf, pearlescent vinyl, cast tapioca, cast polyester, polyester ribbon, costume pearls, speculae and Pyrex, 823 x 681 x 137 cm. Installation view, "Cremaster 1", Museum für Gegenwartskunst Basel, Basle, Switzerland, 1998.

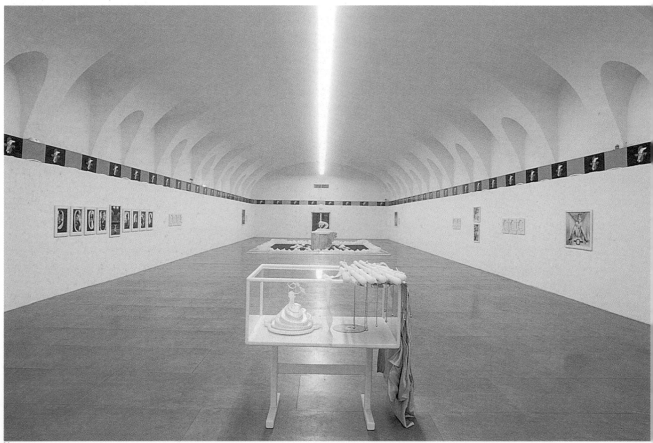

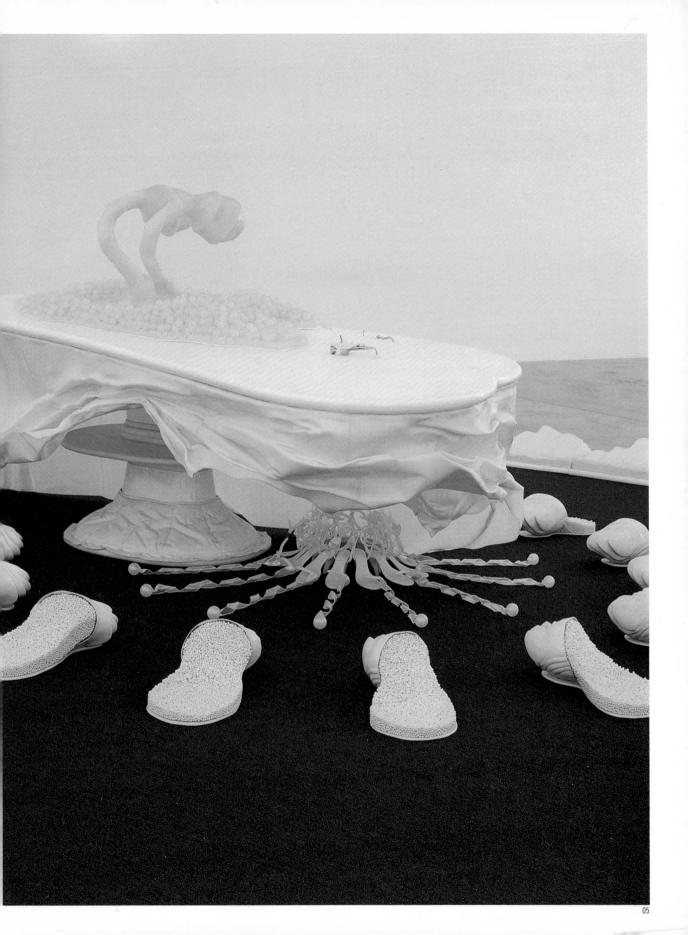

JEAN-MICHEL BASQUIAT

"My work has nothing to do with graffiti. It is painting and always has been." « **Mon travail n'a rien à voir avec le graffiti. C'est de la peinture et ça l'a toujours été.** »

Basquiat soared into the heavens of art like a shining star, and then in 1988 at the age of 28 he died of an overdose. His explosive new aesthetic – iconoclastic and obscene – shook the puritan WASP art world from its prolonged slumber. In less than eight years Basquiat succeeded in establishing new figurative and expressive elements alongside the Conceptual Art and Minimal Art that had dictated the style of America and Europe. Faced with the enthusiasm with which his work was greeted, particularly in Europe, America found itself obliged to shake off its initial indifference and for the first time to recognise a black artist as the symbol of the creative potential of the ethnic minorities. The meteoric rise of the young painter, whose mother came from Puerto Rico and father from Haiti, shocked America. Basquiat was black, had no art training and came from the New York underground. From the age of eighteen he had covered house walls in SoHo and carriages on the underground railway with angry, frantic images. His iconography was brutal, destructive, without hierarchy and rules, virtuoso, furious and seductive. It took its bearings from Haiti, Puerto Rico, an imaginary Africa and Pop Art. With his gigantic works – in which he combined crucifixes and Voodoo totems, birds and skulls, grilles and feathers, threateningly gaping mouths and top hats – he opened art up to dissolution and instability, to the "other" and to the "negative". During the ten years in which he had a decisive influence on art, the most successful black American painter embodied the New Wave version of the epoch-making figure of the accursed artist.

Mort d'une overdose à l'âge de 28 ans, Basquiat aura été un météore pénétrant le ciel de l'art avec une fulgurance prodigieuse. Le fracas d'une esthétique nouvelle, fondée sur le métissage et l'impureté, avait déchiré le voile somnambule d'un art protestant et puritain. Sa peinture aura fécondé une culture alors entièrement dominée, en Amérique comme en Europe, par une esthétique conceptuelle et minimaliste. Pour la première fois, la reconnaissance d'un artiste noir devenu le parfait symbole des ressources créatrices des minorités ethniques s'imposait à une Amérique qui n'en demandait pas tant. La soudaine starisation de ce très jeune peintre né à Brooklyn choque : l'artiste, qui n'a jamais suivi d'enseignement artistique, pratique avec une détermination rageuse une peinture sauvage et gratuite sur les murs de SoHo et les wagons du métro. Son iconographie – brutale, tourmentée, sans hiérarchie, déréglée, virtuose et violente, inspirée de Haïti, de Porto Rico, d'une Afrique imaginaire ou du pop art – promeut l' « autreté » et la « négativité », dans des compositions discontinues, qui combinent, sur d'immenses formats, crucifix et totems vaudous, oiseaux et têtes de mort, bouches dentées et hauts de forme... Le nom qu'il s'est choisi pour ses premiers tags SAMO © (SAMe Old shit) est accompagné d'une couronne stylisée. Il signera encore ses toiles avec d'autres noms, empruntés au vocabulaire des insultes racistes : Pig, Pork, Swine, Ass... (« Porc, Cul... »). Le plus adulé des artistes noirs américains aura – pendant la décennie dont il fut la puissante locomotive – incarné la figure new wave d'une intemporelle passion, celle de l'artiste maudit. *J.-M. R.*

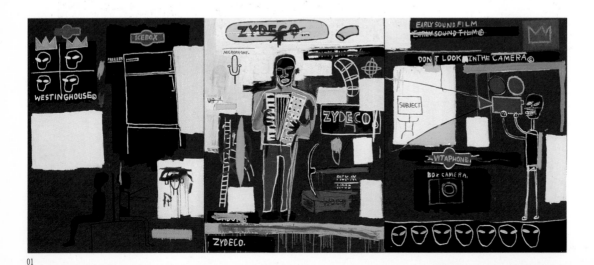

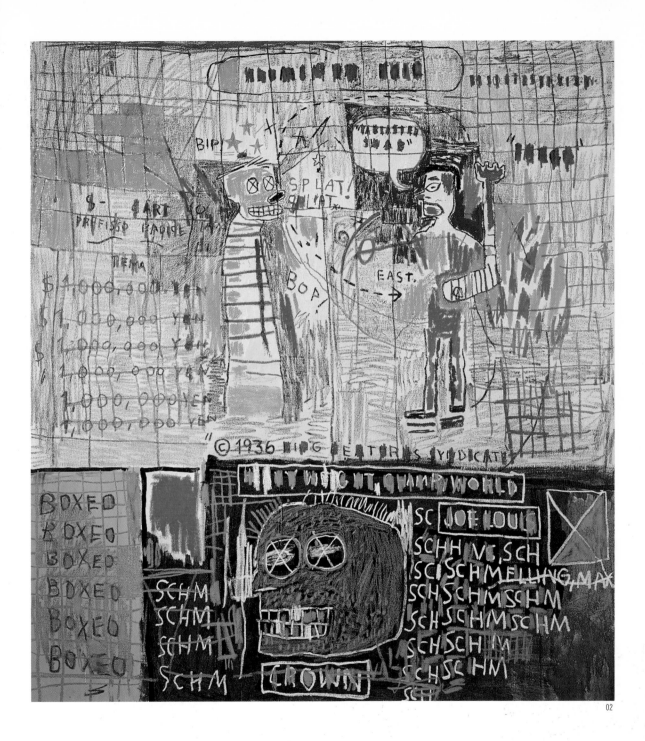

01 ZYDECO, 1984. Acrylic and oil crayon on canvas, 219 x 518 cm (3 panels). **02 NAPOLEONIC STEREOTYPE,** 1983. Acrylic and oilstick on canvas, 168 x 152 cm.

JEAN-MICHEL BASQUIAT

SELECTED EXHIBITIONS: *1992* "Jean-Michel Basquiat – Une Rétrospective", Musée Cantini, Marseille, France /// *1993* Whitney Museum of American Art, New York (NY), USA /// *1995* "Jean-Michel Basquiat. The blue ribbon series", The Andy Warhol Museum, Pittsburgh (PA), USA /// *1996* Serpentine Gallery, London, England /// Galerie Bruno Bischofberger, Zurich, Switzerland
SELECTED BIBLIOGRAPHY: *1992* Jean-Michel Basquiat, ArTRANDOM, Kyoto Shoin, Kyoto, Japan /// *Jean-Michel Basquiat – Une Rétrospective*, Musées de Marseille, Marseille /// *1996* *Collaborations Warhol, Basquiat, Clemente*, Museum Fridericianum, Kassel; Museum Villa Stuck, Munich, Germany; Castello di Rivoli, Rivoli (TO), Italy

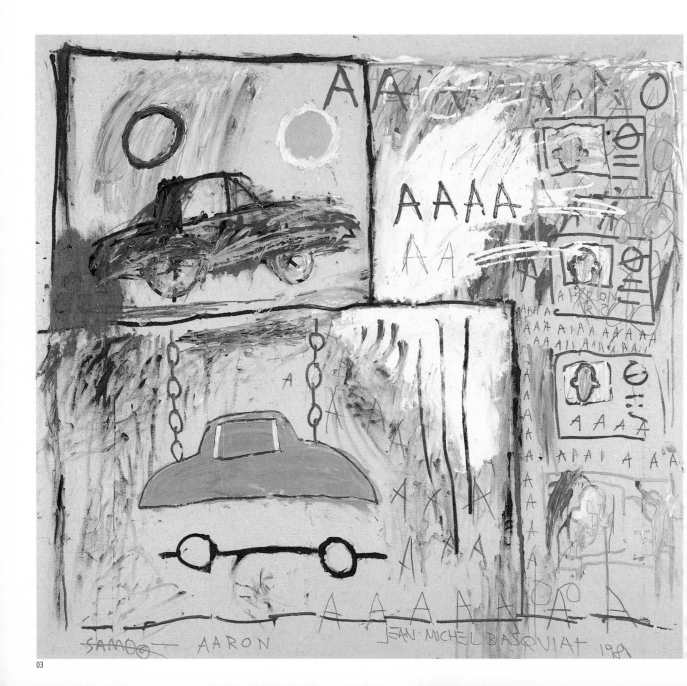

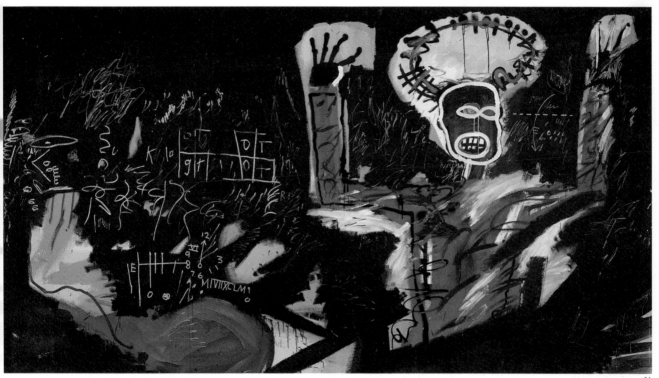

04

03 **CADILLAC MOON,** 1981. Acrylic and oil crayon on canvas, 162 x 173 cm. **04 PROFIT I,** 1982. Acrylic on canvas, 220 x 400 cm. **05 INSTALLATION VIEW,** Galerie Bruno Bischofberger, Zurich, Switzerland, 1996.

05

VANESSA BEECROFT

1969 born in Genoa, Italy / lives and works in New York (NY), USA

"I am interested in the difference between what I expect and what actually happens." « **Je m'intéresse à la différence entre ce que j'attends et ce qui se passe réellement.** »

Since the mid-1990s, Vanessa Beecroft has been parading before us a succession of scantily clad girls. Recently, they've been appearing with nothing on at all. In Beecroft's performances and exhibition openings they silently take up their positions, moving very little, standing before the public like living pictures. Remaining as evidence of these events are polaroid photographs and videos, which Beecroft calls "the least interesting part for me" – for documentation only comes alive with the idea that one might have been present oneself. Wholly in keeping with the late 20th century happening culture, Beecroft is offering something that obviously cannot be conveyed through the media. And yet she is playing in her mind with the very images communicated by the media. Some of her ensembles of girls and women recall Pippi Longstocking, while others bring to mind Helmut Newton's coolly posed compositions, or fashion shows and theatrical or filmic scenes. But there's little indication which of these associations comes closest to Beecroft's intentions. The girls are usually all dressed and made-up in exactly the same way so that their individuality seems to be blotted out. In one performance they may appear vulnerable, in another, impressively strong. There is a charged and yet restrained atmosphere created by the tension between broken taboos and ancient ideals of beauty, between eroticism and the charm of naked shop-window dummies. Neither the models nor the public show any emotion; what is going on in their imaginations is a total mystery. No comment is made. The participants all have their own ideas and perceptions, but they keep them to themselves.

Les jeunes filles que Vanessa Beecroft présente depuis le milieu des années 90 ont toujours été chichement vêtues. Depuis quelque temps, elles ne portent plus rien ; elles prennent position dans les performances de l'artiste, ne parlent pas, ne bougent que très peu et sont le plus souvent debout face aux spectateurs pendant les vernissages comme des tableaux vivants. Ce qui en reste, ce sont des Polaroïds et des vidéos qui, comme le dit Beecroft, représentent pour elle « la part la moins intéressante ». Car la documentation elle-même repose encore sur l'idée qu'on aurait pu être présent. Tout à fait dans le sens de la culture de l'événement en cette fin de vingtième siècle, quelque chose est offert qui ne peut visiblement être communiqué par les médias. Pourtant, Beecroft ne manque pas de jouer avec les images véhiculées par les médias. Ses groupes de filles et de femmes tranquilles rappellent parfois la petite héroïne Pippi Langstrumpf, mais aussi les froides mises en scène des photos de Newton, les présentations de mode, ainsi que des scènes de théâtre ou de cinéma. Mais on ne trouve guère d'indications pour nous dire laquelle de ces associations pourrait être la bonne. De plus, les filles sont le plus souvent habillées et maquillées à l'identique, leur identité semble disparaître. Elles apparaissent parfois comme des créatures fragiles ; dans d'autres représentations, leur force impose le respect. L'atmosphère est électrique et retenue, entre tabou brisé et idéal de beauté antique, entre excitation érotique et charme de mannequins de vitrine dénudés. Dans la mesure où les modèles comme le public ne montrent guère d'émotion, ce qui se passe dans l'imaginaire des différents intervenants reste parfaitement incertain. On en parle d'ailleurs très peu. Chacun a une idée, un sentiment, et chacun le conserve en son for intérieur.

C. B.

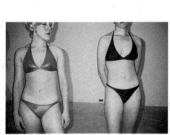

01

01 PERFORMANCE-DETAILS, The Institute of Contemporary Art, University of Pennsylvania, Philadelphia (PA), USA, 1996. **02 PERFORMANCE-DETAILS**, Deitch Projects, New York (NY), USA, 1996.

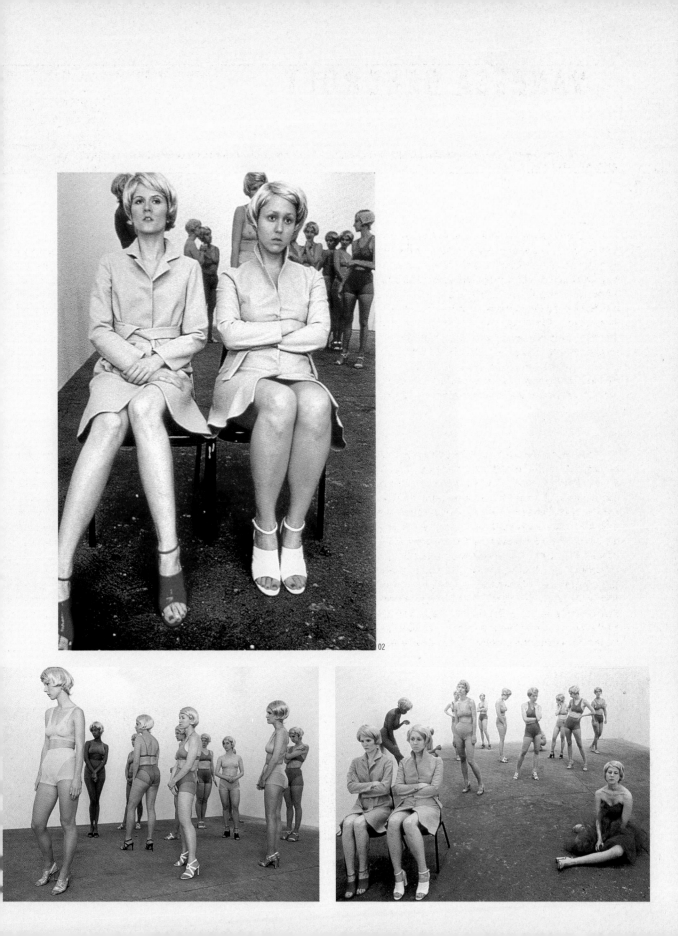

VANESSA BEECROFT

SELECTED EXHIBITIONS: *1995* "Show must go on", Fondation Cartier, Paris, France /// *1996* Deitch Projects, New York (NY), USA /// *1997* Milwaukee Art Museum, Milwaukee (WI), USA /// "Future, Present, Past" Corderie dell'Arsenale, Venice, Italy **SELECTED BIBLIOGRAPHY:** *1996 Persona*, Kunsthalle Basel, Basle, Switzerland; The Renaissance Society at the University of Chicago, Chicago (IL), USA /// *ID*, Stedelijk Van Abbemuseum, Eindhoven, The Netherlands /// *1997 Enterprise*, The Institute of Contemporary Art, Boston (MA), USA /// *Persona X*, Salzburger Kunstverein, Salzburg, Austria /// *Ein Stück vom Himmel – Some Kind of Heaven*, Kunsthalle Nürnberg, Nuremberg, Germany; South London Gallery, London, England

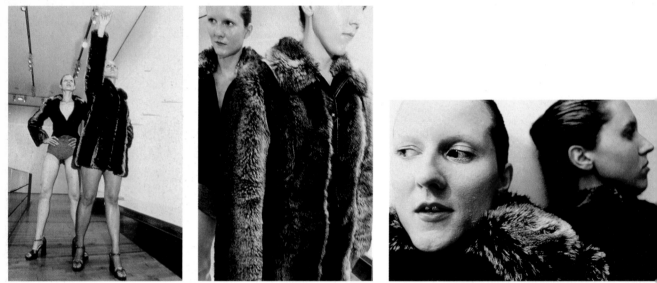

03

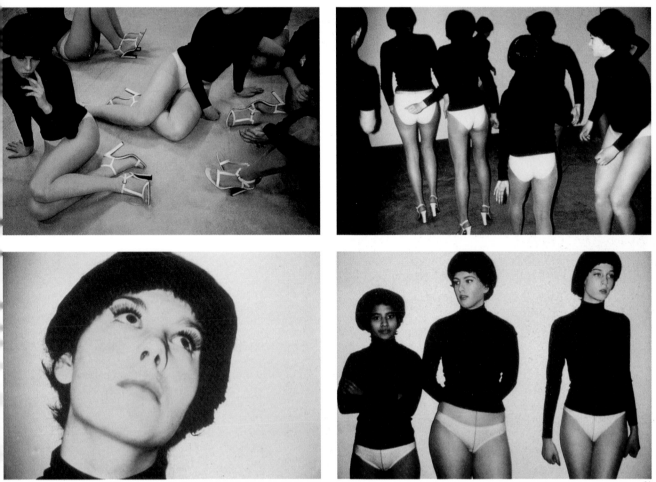

03 PERFORMANCE-DETAILS, MIU MIU. Shopping exhibition, New York (NY), USA, 1996. **04 PERFORMANCE-DETAILS,** Stedelijk Van Abbemuseum, Eindhoven, The Netherlands, 1996.

ASHLEY BICKERTON

1959 born in Barbados / lives and works in Bali, Indonesia

"I should like to carry out my future work in the interplay between Robert Smithson's uncompleted project and Michael Jackson's face." « **Je veux** réaliser mes œuvres futures dans le jeu alternatif entre le projet inachevé de Robert Smithson et le visage de Michael Jackson. »

Ashley Bickerton's work is characteristic of the Conceptual Art of a generation of New York artists that has close ties with popular culture. The symbols of the industrial age provide the main focus of his objects and images, as do the urban semiotics of brand signs and labels and signs standing for triviality, kitsch and sexual clichés. In the early 1980s he made pictures composed of large ornamental letters. Now, at the end of the 1990s, he is painting self-portraits in the form of large nudes – caricatured, distorted sexual stereotypes that show the artist as hell's angel, body-building champion, Californian surfer or New York whore. In the 1980s Bickerton also built a series of black containers called "Self-Portraits (Commercial Pieces)" and "Anthropospheres". These imposing boxes, with their sophisticated, impersonal appeal, are designed as survival capsules equipped with floats, handles and a ventilation system. They appear to be intended to conserve for posterity highly secret data or important information for the preservation of mankind: various industrial components, arbitrary specimens of the biosphere, rocks, a little soil, some food, a handful of seeds to saw... These technological relicts, ironic witnesses of the impending end of the world, encapsulate traces of an age programmed for destruction. They speak of a time in which nature, being reduced, perverted and afflicted with merciless viruses, will condemn mankind to extinction.

L'œuvre d'Ashley Bickerton est très représentative de l'art conceptuel de cette génération d'artistes new-yorkais, à laquelle rien de ce qui touche à la culture de masse n'est étranger : la sémiologie urbaine et les grandes marques industrielles, le trivial et le kitsch, les représentations populaires et les stéréotypes sexuels forment la matière même de son œuvre. Ses peintures, au début des années 80, se composent de larges lettres ornementales ; à la fin des années 90, de grands « Autoportraits » prennent l'aspect de nus tourmentés aux stéréotypes sexuels caricaturaux, dans lesquels le peintre se représente en Hell Angel ou en championne de culturisme, en surfeur californien ou en prostituée newyorkaise... Dans les années 80, l'artiste a construit une importante série de « Self-Portraits (Commercial Pieces) » et d'Anthropospheres, imposants caissons noirs à l'esthétique high-tech et sophistiquée. Par leur design de capsules de survie en aluminium anodisé, avec leurs flotteurs ou leurs vitres étanches, leurs poignées recouvertes de caoutchouc antidérapant et leur système d'aération, ces réservoirs semblent conçus pour soustraire à la corruption du temps des données « top secret » essentielles à la survie de l'humanité : des composants industriels disparates ou de modestes échantillons de la biosphère, des morceaux de roche, un peu de terre, quelque nourriture, une poignée de graines à replanter... Ces reliquaires technologiques, qui témoignent avec ironie de l'imminente fin de toute chose, scellent les vestiges d'un présent programmé pour sa propre néantisation : ils parlent d'un temps où, sans équivoque, la nature, pervertie et dégradée, humiliée et contaminée par d'implacables virus, condamne, à terme, l'homme à disparaître. J.-M. R.

01

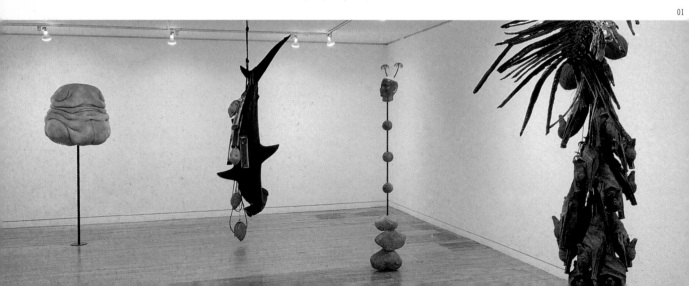

01 **INSTALLATION VIEW,** Sonnabend Gallery, New York (NY), USA, 1993.
02 **TORMENTED SELF-PORTRAIT (SUSIE AT ARLES),** 1988. Mixed media construction with black padded leather, 229 x 175 x 46 cm. **03 INSTALLATION VIEW,** Sonnabend Gallery, New York, 1989.

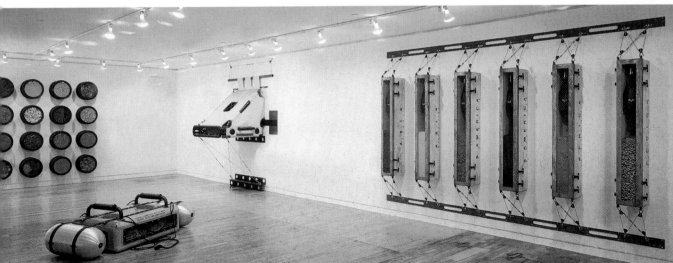

ASHLEY BICKERTON

SELECTED EXHIBITIONS: *1986* International with Monument, New York (NY), USA /// *1988* Sonnabend Gallery, New York /// *1997* White Cube, London, England /// *1998* Galerie Philomene Magers, Cologne, Germany **SELECTED BIBLIOGRAPHY:** *1987 NY Art Now: The Saatchi Collection,* London /// *1990 Mind over Matter: Concept and Object,* Whitney Museum of American Art, New York /// *1996 The Dakis Joannou Collection,* DESTE Foundation, Centre for Contemporary Art, Athens, Greece /// *Ashley Bickerton,* Palacete del Embarcadero, Santander, Spain

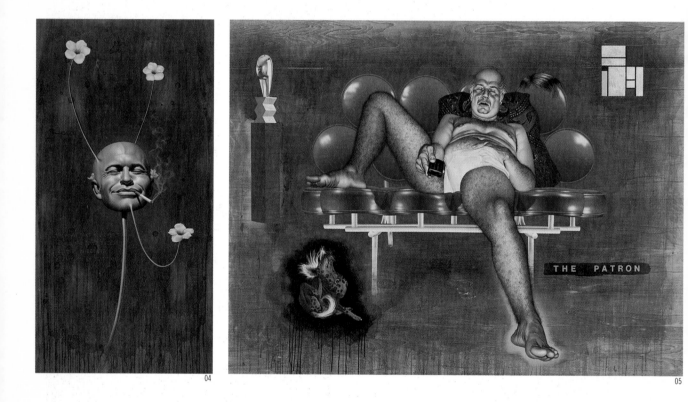

04

05

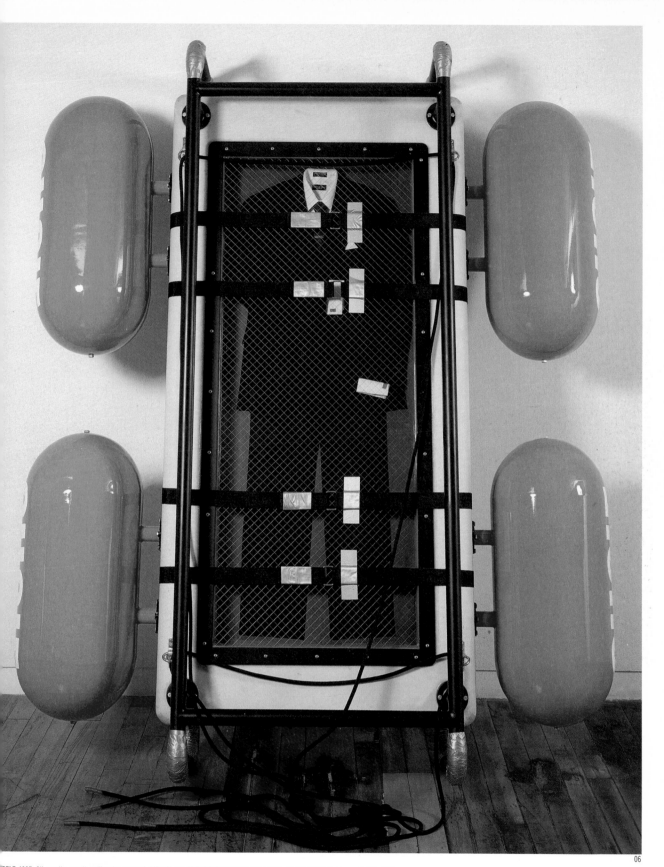

SELF, 1997. Oil, acrylic, pencil, aniline dye on wood, 117 x 61 cm. **05 THE PATRON,** 1997. Oil, acrylic, pencil, aniline dye on wood, 168 x 229 cm.
SEASCAPE: FLOATING COSTUME TO DRIFT FOR ETERNITY I, 1991. Suit, glass, aluminum, wood, chalk, fibreglass, enamel, canvas webbing, 234 x 206 x 105 cm.

ROSS BLECKNER

1949 born in New York / lives and works in New York (NY), US

"I try to achieve a painting that is as complex as life and thought." « **Je tente de créer une peinture qui soit aussi complexe que la vie et la pensée.** »

For Ross Bleckner the metaphysics of painting are of decisive importance. In his strongly expressive, mysterious works he strives for a transcendency that also contains esoteric components. His large-format pictures alternate between the abstract and the representational. At the beginning of the 1980s Bleckner was close to the Neo-Geo movement. He did not however apply a critically new interpretation to Minimal Art and Op Art, but rather used their visual techniques to reach a spiritual plane. For example, birds, cages, grilles, drops of water and oceans are represented in front of an abstract background. For Bleckner the canvas is "a place where countless different meanings cross and enter into relationship with one another". In the "Atmosphere" series – neo-Symbolist pictures with Expressionist elements – he also turned back to the pictorial techniques of the nineteenth century. Candelabras, urns full of flowers, injured hands, daggers, chalices, wounds and skeletons warn of the transitoriness of time and the world. In his melancholy "Nocturnes", vanitas motifs – holes, shadows and fissures bathed in whitish patches of light – symbolise the finiteness of life and its disappearance in the realm of shadows. Beyond that, Bleckner created works orientated on a strict geometrical formalism – for instance, his series "Architecture of the Sky" from the 1990s, whose main purpose is the representation of the optical effect of light, of infinite space or the transcendency of the stratosphere. He applies his "Allegory" as a direct means of expressing his pain and fury over AIDS, the atomic threat and the inescapability of death.

Ross Bleckner vise à une peinture métaphysique. L'artiste cherche à atteindre, par un art expressif et mystérieux, à une transcendance qui n'est pas dénuée d'ésotérisme. Sa peinture, réalisée dans des formats très grands, marque une oscillation, qui est précisément celle de tout l'art de notre siècle, entre abstraction et expression. Le peintre a pu être associé, au début des années 80, au mouvement Neo-Geo. Cependant, sa peinture ne revisite pas le minimalisme ou l'Op Art dans une visée critique, elle ne mélange les techniques visuelles que pour produire avec efficacité une signification spirituelle. Sa série d'« Atmosphères » évoque avec nostalgie la fuite du temps ou la perte d'un monde en train de disparaître. Ses « Nocturnes », toiles mélancoliques peuplées de halos de lumière blanchâtre, relèvent des peintures de Vanité : elles peignent l'altération et la caducité en désignant ce que le temps va défaire et disent les trous et les ombres, les déchirures et les lacunes, la prolifération biologique de la mort et la dissolution de l'être dans le néant des ténèbres. A côté de toiles symbolistes et expressionnistes, sa peinture peut recourir à un formalisme très géométrique pour traduire – par exemple dans la série des « Architectures du ciel » des années 90 – les effets optiques de la lumière, le sentiment d'infini de l'espace ou la dimension de transcendance du firmament. C'est indéniablement la fonction de l'allégorie qui donne à l'ensemble de l'œuvre sa signification centrale de deuil et de fureur à l'encontre de la désolation du sida, des menaces du nucléaire ou de l'inéluctable promesse de la mort. J.-M.

01

01 HANDS AND FACES, 1994. Oil on canvas, 244 x 305 cm. **02 BOTANICAL STUDY,** 1993. Oil on canvas, 1.5 x 1.5 m.

02

ROSS BLECKNER

SELECTED EXHIBITIONS: *1991* Kölnischer Kunstverein, Cologne, Germany /// *1995* Solomon R. Guggenheim Museum, New York (NY), USA /// Astrup Fearnley Museet for Moderne Kunst, Oslo, Norway /// *1996* Galerie Kyoko Chirathivat, Bangkok, Thailand /// *1998* Galeria Aglutinador, Havana, Cuba **SELECTED BIBLIOGRAPHY:** *1989 Ross Bleckner*, Milwaukee Art Museum, Milwaukee (WI), USA /// *1990 Ross Bleckner*, Kunsthalle Zürich, Zurich, Switzerland /// *1997 Ross Bleckner*, Bawag Foundation, Vienna, Austria /// *1998 Ross Bleckner: Watercolor*, Santa Fe (NM), USA

3 MEMORIAL I, 1994. Oil on linen, 244 x 305 cm. **04 WHITE HOUSE,** 1994. Oil on canvas, 269 x 234 cm.

COSIMA VON BONIN

1962 born in Mombasa, Kenya / lives and works in Cologne, Germany

Cosima von Bonin's works have their origin in the creative tension between private, subjective values and social concerns. Among her themes in her installations, objects, films and videos are the discursive associations and external influences that give rise to her works. These include other artists and her immediate social environment, along with her own personal experiences. It was an approach already evident in her first exhibition (1990), in which she showed balloons inscribed with the names, dates of birth and debut exhibition dates of the artists represented in Harald Szeemann's legendary exhibition "When Attitudes Become Form", 1969. The "first exhibition" theme is thus taken as a biographical point of departure, and related to recent art-historical events. Von Bonin often uses her own exhibitions as a forum for the presentation of works by valued friends and colleagues, which in turn leads to social events such as concerts, film evenings, discussions and exhibitions. Her open-handedness in fact challenges the mechanisms of art presentation, creating a crossover between the visual arts and other artistic activities. She has often put on joint performances with Kai Althoff, exhibiting the props and fittings in an accompanying show. Her most recent installations ("Löwe im Bonsaiwald" [Lion in the Bonsai Forest], 1997, for example) often have a theatrical atmosphere enriched with private metaphors which defy rational explanation and specific classification, in spite of the many clues provided.

Les œuvres de Cosima von Bonin naissent dans le champ de tension entre les règles privées, subjectives, et les rapports sociaux. Avec ses installations, objets, films et vidéos, Bonin thématise entre autres le rapport discursif et les autres influences déterminantes dans la genèse de son travail. Outre ses propres expériences, on y retrouve aussi la confrontation avec d'autres artistes, hommes et femmes, ainsi que son entourage immédiat. Cette démarche s'était manifestée de façon exemplaire dès sa première exposition, 1990, dans laquelle elle présentait des ballons portant des inscriptions : les nom, date de naissance et date des premières expositions des artistes représentés dans la mythique exposition de Harald Szeeman : « When Attitudes Become Form », 1969. Le thème « première exposition » est ainsi compris comme une origine biographique et mis en relation avec l'histoire de l'art récente.

Souvent, Bonin se sert de ses expositions pour présenter des amis et des collègues qu'elle estime. Elle génère ainsi des opportunités d'événements mondains tels que des concerts, des soirées cinéma, des débats et des expositions. Par cette démarche, elle remet en question les mécanismes du contexte de l'art et établit un système d'interrelations entre les arts plastiques et d'autres domaines artistiques. Bonin a plusieurs fois réalisé des performances avec Kai Althoff, dont les décors et les accessoires ont ensuite servi de pièces pour leurs expositions respectives. Ses dernières installations (par exemple « Lion dans la forêt de bonsaï », 1997) baignent souvent dans une atmosphère de décor de théâtre enrichie de métaphores privées et, malgré la diversité des références, elles échappent à l'explication rationnelle et à un classement récupérateur. Y. D.

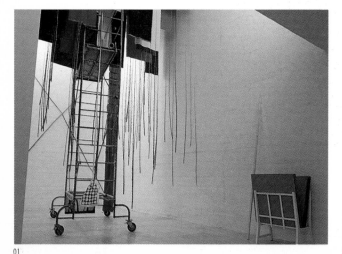

01

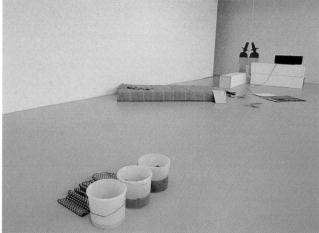

02

INSTALLATION VIEW, Villa Arson, Nice, France, 1997. **02 HAST DU HEUTE ZEIT – ICH ABER NICHT.** Installation view, Künstlerhaus Stuttgart, Stuttgart, Germany, 1995
th Kai Althoff). **03 ROBBING PETER TO PAY PAUL,** 1998. Wood, foam material, felt, c. 150 (h) cm.

COSIMA VON BONIN

SELECTED EXHIBITIONS: *1995* "Hast du heute Zeit – ich aber nicht", Künstlerhaus Stuttgart, Stuttgart, Germany /// *1996–1997* "Heetz, Nowak, Rehberger" Städtisches Museum Abteiberg, Mönchengladbach, Germany; Museu de Arte Contemporânea da USP, São Paulo, Brazil (with Kai Althoff and Tobias Rehberger) /// *1998* "Löwe im Bonsaiwald", Palais Attens, Steirischer Herbst 98, Graz, Austria /// *1999* Kunsthalle St. Gallen, St. Gallen, Switzerland **SELECTED BIBLIOGRAPHY:** *1993 Musée Autodemolition*, Kunstraum Daxer, Munich, Germany /// *1996 Heetz, Nowak, Rehberger*, Städtisches Museum Abteiberg, Mönchengladbach /// *1997 Heetz, Nowak, Rehberger*, Museu de Arte Contemporânea da USP, São Paulo

04 "HEETZ, NOWAK, REHBERGER", performance, Städtisches Museum Abteiberg, Mönchengladbach, Germany, 1996. **05 – 08 "LÖWE IM BONSAIWALD"** (details), installation views, Galerie Christian Nagel, Cologne, Germany, 1997.

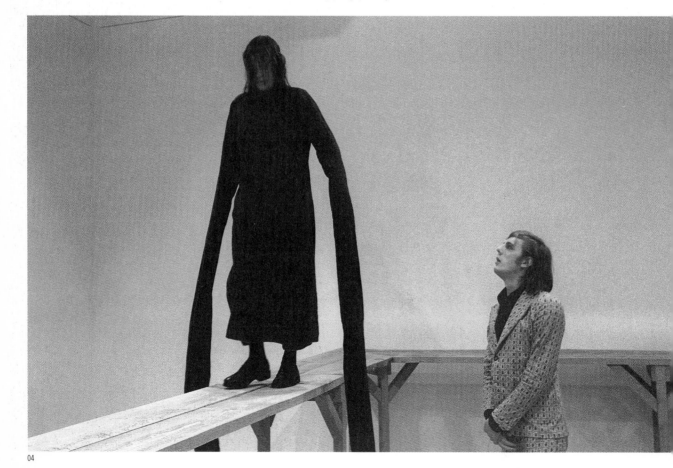

04

05

06

07

08

ANGELA BULLOCH

1966 born in Fort Frances, Canada / lives and works in London, England

"The viewer is a collaborator in the sense that she defines or perceives meaning in her own terms." **« La spectatrice est une collaboratrice en ceci qu'elle définit, perçoit le sens dans ses propres termes. »**

The big, coloured spheres of light work like signals. You can't help trying to fathom the system that makes them go on and off, and to understand its meaning. Some of these light installations are triggered by movement, others by music; several follow a rhythm of their own. You find yourself exposed to a stimulus and you respond to it with a reflex, whether by turning your gaze on a particular sphere at a certain moment, or by repeating your movement to trigger off the mechanism again. This principle of rewarding the viewer for a trivial action is typical of Angela Bulloch's approach, and since the early 1990s has continually found new forms of expression. Sometimes you're required to take a seat on a simple bench, which sets off a sequence of noises, or causes a painting machine to start drawing on the wall, or a computer game to begin. Other installations work with hidden contacts on the floor, where large round cushions invite you to stay. Then there are the seemingly incongruous inscriptions on the wall or the floor that contain rules of conduct from different areas of life. This "Rules Series" confirms that Bulloch is concerned with systems governing human behaviour. A complex world needs rules in order to function, but these should always demonstrate their purpose in an atmosphere of tolerance and reason. This idealistic sense of social concord is a constant theme in Bulloch's installations. Thus she presents something in the context of art that is only too often counteracted in everday life.

RULES SERIES

1. The rules are lists of rules that pertain to particular places, practices or principles.
2. Each list is an individual work; however it is also part of a series.
3. Each list is a unique piece with no fixed form; however a collection of ten lists has been produced as a printed edition of 20.
4. Each unique piece is accompanied by this list, which becomes a certificate when titled and signed by the artist.
5. The unique pieces have no form; buying one confers the right to produce or reproduce the piece in a form or medium.
6. A rules series edition may be photocopied; buying one confers the right to photocopy the lists in any size or colour.
7. The artist asserts the usual moral rights and copyrights.

02

Ces grandes boules lumineuses et colorées ressemblent à des signaux. Involontairement, on cherche à saisir le rythme de leur allumage et de leur extinction, ainsi que son sens. Certaines de ces installations lumineuses sont commandées par des détecteurs de mouvement, d'autres par de la musique, d'autres encore obéissent à leur propre rythme. Le spectateur se voit exposé à un stimulus auquel il répond par un réflexe, qu'il dirige son regard à un moment donné vers une boule particulière ou qu'il refasse son mouvement pour redéclencher la même séquence. Ce principe de récompense par une petite action est une caractéristique spécifique des œuvres d'Angela Bulloch, caractéristique qu'on retrouve depuis le début des années 90 dans des développements toujours nouveaux. Souvent, il s'agit de prendre place sur un simple banc, sur quoi des bruits se font entendre, une machine commence à peindre au mur ou un jeu informatique se met en marche. D'autres instal-lations fonctionnent avec des détecteurs cachés dans le sol, tandis que de grand coussins ronds invitent simplement à s'attarder sur place. D'autres œuvres ressemblent en revanche contredire la règle, comme les écritures au mur et au sol, qui incluent des règles de comportement issues de différents domaines de la vie. Mais ces « Rules Series » ren-voient précisément au fait que chez Bulloch, il est toujours question de systèmes qui commandent le comportement humain. Un monde com-plexe a besoin de règles pour fonctionner. Et il serait bon néanmoins que ce type de règles démontrent leur bien-fondé dans une atmosphère de tolérance et de modération. C'est cette résonance à un idéal social qu'Angela Bulloch ne cesse de produire dans ses installations, mettant ainsi en scène dans le contexte de l'art ce que la vie normale contredit chaque jour.

C. B.

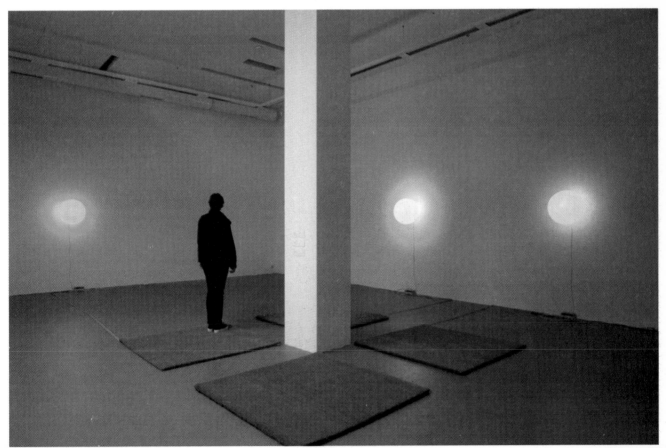

ANGELA BULLOCH

SELECTED EXHIBITIONS: *1993* Aperto 93, XLV Esposizione Internationale d'Arte, la Biennale di Venezia, Venice, Italy /// *1994* Kunstverein in Hamburg, Hamburg, Germany /// *1997* "Vehicles", Le Consortium, Dijon, France /// *1998* "Superstructure", Migros Museum für Gegenwartskunst Zürich, Zurich, Switzerland **SELECTED BIBLIOGRAPHY:** *1994 Angela Bulloch,* Centre de Création Contemporaine, Tours; Fonds Regional d'Art Contemporain Languedoc-Roussillon, Montpellier, France; Kunstverein in Hamburg, Hamburg /// *1997 Art from the UK,* Sammlung Goetz, Munich, Germany /// *1998 Satellite,* Migros Museum für Gegenwartskunst Zürich, Zurich; Le Consortium, Dijon

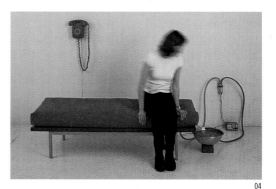

04 WORK BENCH, 1996. **05 "VEHICLES",** installation view, Le Consortium, Dijon, France, 1997. **06 BETAVILLE,** 1994.

04

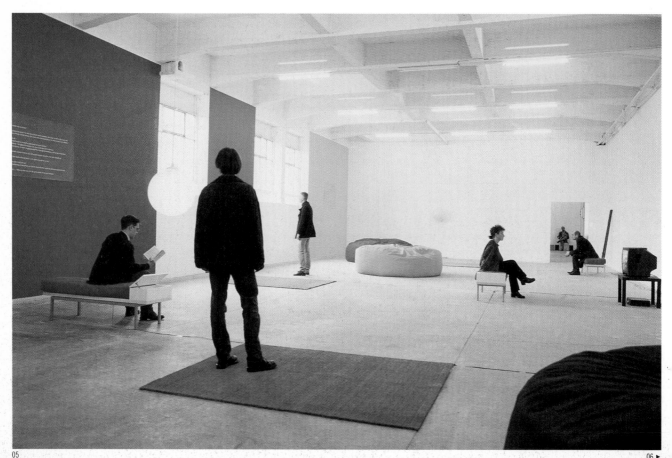

JEAN-MARC BUSTAMANTE

1952 born in Toulouse / lives and works in Paris, France

"Work on limits, spatial limits, but also psychological." « **[Un]** travail sur les limites, les limites spatiales, mais aussi psychologiques. »

Jean-Marc Bustamante's work is marked by an enigmatic, minimalistic formalism. This may seem to keep the viewer at a distance, but in the resulting tension, which amounts to a reversal of seduction, the works assert their cool presence. Bustamante's ambivalent aesthetic stems from his desire to create a link between figuration and abstraction, the geometrical and the organic, industrial perfection and manual insufficiency. He searches for a precarious equilibrium, an ambivalent correspondence between the descriptive "actuality" of his large photo series, "Tableaux" (1977), his metal sculptures painted with red oxide that run along walls, and the horizontal concrete floor sculptures. He calls these non-figurative forms "paysages" (landscapes), "sites" (places) or "intérieurs" (interiors). In his "Tableaux photographiques", which show sprawling town boundaries, fallow land and indefinable transitional zones between town and country, it is not speed or movement that is conveyed, but the vibrations of the air and the slow progress of change, which according to Bustamante leads to decivilisation. Providing a counterbalance to the photographs, the "paysages" are not meant to present a picture; they demonstrate their neutrality through the choice of material (concrete appears here as a generic substance) or colour (red oxide is merely an undercoat, a non-colour). The presence of these objects and images gives expression to the nuances of meaning, right up to the point where they no longer signify anything.

L'œuvre de Bustamante adopte un formalisme énigmatique et minimaliste qui se veut l'envers de la séduction et semble tenir le regardeur comme à distance. Son esthétique ambiguë tient à l'ambition d'unir les limites contradictoires de la géométrie et de l'organique, de l'intemporel et de l'accidentel, du fini industriel et de l'imperfection manuelle. L'artiste cherche à établir un équilibre équivoque entre la frontalité factuelle et descriptive de ses grands tirages photographiques – qu'il baptise « Tableaux » (1977) – et ses sculptures non figuratives, qu'il intitule « Paysages », « Sites » ou « Intérieurs » : métal peint au minium qui court le long des murs, ou béton qui s'étend à l'horizontale sur le sol. En représentant la lisière incertaine des villes, les terrains vagues, les espaces urbains transitoires ou instables, ces « Tableaux photographiques » entendent fixer la lenteur tellurique, les tremblements de l'air, les métamorphoses progressives qui déconstruisent le monde et ces glissements graduels que l'artiste appelle la « décivilisation ». Quant à la décision d'indifférence dont témoignent ses « Paysages », elle affirme avant tout la volonté de ne pas faire image. La présence pleine de ces œuvres n'énonce rien d'autre que le vacillement de toute signification : elle dit l'évanouissement d'un être tel qu'il ne se signifie que là où il n'est plus. L'œuvre, qui n'ouvre sur aucun au-delà, ne tente de sortir de l'image et d'avancer dans l'abstraction que pour mettre en évidence la place d'un corps absent faisant face à un regard qui manque à sa place.
 J.-M. R.

01

01 SERENA, 1993–1995. Steel and rubber, 11.5 m (h), ø 7 cm. Permanent sculpture, Rijksmuseum Kröller-Müller, Otterlo, The Netherlands, 1995. **02 SUSPENSION III**, 1997. 3 cages with living birds, metal, paint, 180 x 130 x 46 cm; 175 x 130 x 46 cm; 170 x 130 x 46 cm. Installation view, Galerie Xavier Hufkens, Brussels, Belgium, 1998.

JEAN-MARC BUSTAMANTE

SELECTED EXHIBITIONS: *1990* "Paysages, intérieurs", Musée d'Art Moderne de la Ville de Paris, Paris, France /// *1992* Stedelijk Van Abbemuseum, Eindhoven, The Netherlands /// *1994* "A world at a time", Kunstmuseum Wolfsburg, Wolfsburg, Germany /// *1996* Galerie Nationale du Jeu de Paume, Paris /// *1997* documenta X, Kassel, Germany **SELECTED BIBLIOGRAPHY:** *1989 Der Landschafts-Ort*, Kunsthalle Bern, Berne, Switzerland /// *1993 The Image, the Place/Parcours*, The Renaissance Society at the University of Chicago, Chicago (IL), USA; Art Gallery of York University, Toronto, Canada /// *Un désir de distance et de proximité*, Stedelijk Van Abbemuseum, Eindhoven /// *1994 Jean-Marc Bustamante im Kunstmuseum Wolfsburg*, Kunstmuseum Wolfsburg, Wolfsburg

03 SITE I, 1991 (foreground). Steel, antirust paint, 456 x 430 x 4 cm. **11 TABLEAUX,** 1991 (background). Cibachromes, 147 x 127 cm. Installation view, "A world at a time", Kunstmuseum Wolfsburg, Wolfsburg, Germany, 1994. **04 DES LIMITES,** 1988 (foreground). Concrete, 150 x 75 x 5 cm. **LUMIÈRES,** 1991 (background). Silkscreen on plexiglass, 140 x 189 cm.

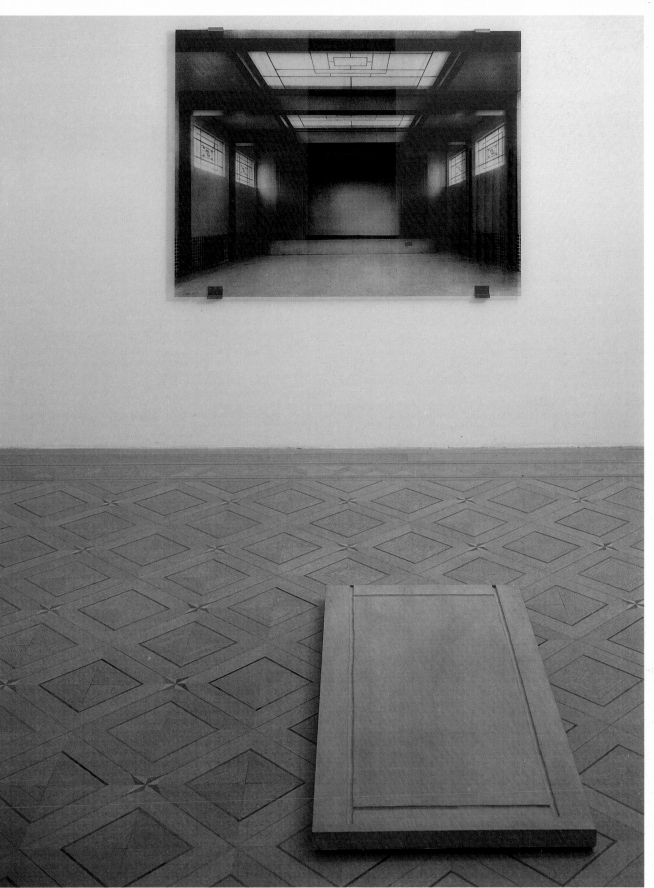

SOPHIE CALLE

"It wouldn't be true to say I became an artist consciously. I try to find my own way out, which is my personal therapy. The fact that it's art protects me – it gives me the right to do things like that." « Il n'est pas vrai que je sois devenue une artiste consciemment. Je tente de trouver des solutions pour moi-même, c'est ma thérapie personnelle. Le fait que ce soit de l'art me protège – l'art me donne le droit de faire ce genre de choses. »

Even Sophie Calle's early works adopt a parasitical approach: she attempts to dissolve the boundaries between life and art, private and public, voyeurism and participation, exhibitionism and secrecy, fiction and reality. In 1979, for example, she recorded in photographs and texts the intimate lives of 45 people whom she invited to sleep in her bed in eight-hour shifts. Her works are usually presented as the results of enquiries, or reports of spot checks. But they can also be seen as experiments, documentaries, or parts of fictitious and real biographies. Calling herself a "narrative artist", Calle followed strangers, spied on them, interrogated them, involved them in her game and invented stories and situations ("Le Bronx", 1980; "Suite vénetienne", 1980; "Autobiographies", 1980; "L'Hôtel", 1981; "Le Carnet", 1983; "Anatoli", 1984; "Les Aveugles", 1986; "Les Tombes", 1990; "Color Blind", 1991). In order to bring out the poetry inherent in ambiguity, she slips into the role of a spy, chambermaid or stripper, and through the exposure of her own intimate life or that of others, creates an osmosis of fiction and truth, invention and reality, imagination and observation. Her work "Die Entfernung – The Detachment" of 1996, gives aesthetic form to the process of recollection. In the former East Berlin, Calle photographed sites where socialist monuments used to stand during the period of the German Democratic Republic. Later, she asked people living there about their memories of these monuments. In the resulting exhbition, the photographs and recorded answers complement one another to constitute a subjective and yet documentary reconstruction of transience.

Sophie Calle entend faire de la vie un roman, transfigurer le passage du temps, convertir l'existence en œuvre d'art. Elle construit des situations qui parasitent la vie ordinaire et n'aspirent qu'à pervertir ou corrompre la séparation entre la vie vécue et l'expérimentation artistique. Ses premières œuvres se présentent d'emblée comme une appropriation qui entreprend d'abolir l'opposition entre voyeurisme et participation, ou entre fabulation et réalité... En 1979, l'artiste présenta, sous la forme d'un reportage constitué de photographies et de textes purement informatifs, son audacieuse appropriation de l'intimité d'inconnus venus, à sa demande, se relayer toutes les huit heures, pour dormir chez elle dans son lit. Ses souvenirs prennent la forme de fictions, ses fictions prennent la forme d'enquêtes. Ses œuvres sont des compte rendus d'expériences réelles, des reportages et des morceaux de biographies fictives : l'artiste suit ou espionne des passants, elle les questionne et les fait rentrer dans son jeu, elle invente des histoires et des situations (« Le Bronx », 1980 ; « Suite vénitienne », 1980 ; « Autobiographies », 1980 ; « L'Hôtel », 1981 ; « Le Carnet », 1983 ; « Anatoli », 1984 ; « Les Aveugles », 1986 ; « Les Tombes », 1990 ; « Color Blind », 1991...). Dans l'ex-Berlin-Est, Calle a photographié des lieux où à l'époque de la RDA se dressaient des monuments socialistes, interrogeant ensuite les personnes du quartier sur le souvenir qu'ils avaient de ces monuments. Dans le contexte de l'exposition, les photographies et les réponses consignées se complètent en une reconstruction aussi subjective que documentaire du temps qui passe.

J.-M. R.

CHAMBRE 28

Lundi 16 Février 1981. J'entre dans la chambre 28 (bois peint, couleurs à dominantes vert et rose). Un seul lit est défait. Je découvre, à droite le long du mur, une impressionnante quantité de bagages. Quatre valises «Vuitton» empilées, trois sacs de voyage, un alignement de chaussures; huit paires pour la femme (pointure 38) et cinq paires pour l'homme (pointure 42). J'ouvre les armoires. À droite, des vêtements d'homme dont trois nouvelles paires de chaussures dans des housses en feutrine, un chapeau, deux slips blancs et un pantalon à grosses bretelles. L'ensemble est de bonne qualité. J'imagine les gens âgés, aisés. Dans la salle de bains, rien à signaler sauf une chemise de nuit rose en pilou. Je me parfume avec leur «Chanel N° 5». J'ouvre furtivement une des valises. J'entrevois le journal «The Economist», des bananes dans un sac en plastique. La chambre faite, je sors.

Mardi 17. Les deux lits sont défaits. Dans la poubelle, les peaux de bananes, une bouteille d'eau et une paire d'escarpins noirs à talons, à peine usagés (ils me vont, je les prends). Sur la chaise, un pantalon de pyjama en épais coton blanc. On peut maintenant voir sur la table de nuit gauche: des bonbons à la menthe, une grille de mots croisés et des chaussons roses à portée de la main. Sur celle de droite: un réveil, une lampe électrique, un rouleau de «Scotch», trois paires de lunettes, un livre «Games with Love and Death» d'Arthur Schnitzler. Dans le tiroir supérieur de la commode, je trouve deux sacs à main, des colliers de perles dans un sac en plastique et dix petites boîtes identiques, pleines de pilules blanches, dans une housse de chaussures «Fitzgerald». Les deux tiroirs inférieurs contiennent des vêtements féminins, des chemisiers en soie, des foulards aux tons pastel.

Mercredi 18. Les deux lits sont défaits. La grille de mots croisés entamée hier a progressé. La culotte de pyjama est toujours à la même place. Je soupèse les valises: trois d'entre elles semblent pleines. Je les ouvre. Dans la première, je trouve un nécessaire de toilette, dans la seconde un assortiment de chemises identiques à rayures bleues et blanches de chez «Brooks». Dans la troisième: un livre «Artists in Crime» de Marsh, un «Minox», un dentier (mâchoire inférieure), une photo 18×24 cm en couleurs représentant un voilier sur la mer, une réservation au Carlton de Milan pour le 19 février, un portrait du Pape, une enveloppe adressée à Mrs. H., Baltimore... avec au verso les indications suivantes: Jean-Paul Belmondo, rue de la Paix, Paris 3e (le numéro de la rue n'est pas mentionné, l'arrondissement est faux, le tampon de la poste a été repassé au stylo à bille), une série de fiches cartonnées avec des colonnes de chiffres (les cours de la Bourse?)... J'entends du bruit, referme hâtivement la valise et fais le lit.

Jeudi 19. Midi. Ils sont partis. Ils m'ont rien laissé. Je photographie une dernière fois les lits défaits. Le souvenir que je garderai d'eux est l'image obscène de ce pantalon de pyjama, bêtement posé sur la chaise.

01 LES DORMEURS, 1979. 176 photographs, 15 x 20 cm (each), 23 texts, 15 x 20 cm (each), overall dimensions, 152 x 402 cm. 02 L'HÔTEL, CHAMBRE N° 28, 1981. Colour photographs and text, diptych, 102 x 142 cm (each).

SOPHIE CALLE

SELECTED EXHIBITIONS: *1991* "Sophie Calle, à suivre...", Musée d'Art Moderne de la Ville de Paris, Paris, France /// *1994* "Absence", Museum Boijmans Van Beuningen, Rotterdam, The Netherlands /// *1996* "Sophie Calle, True Stories", Tel Aviv Museum of Art, Tel Aviv, Israel /// *1997* "Trade Routes: History and Geography", Johannesburg Biennial, Johannesburg, South Africa /// *1998* Tate Gallery, London, England /// *1999* Camden Art Center, Camden, England **SELECTED BIBLIOGRAPHY:** *1991 Sophie Calle, à suivre...*, Musée d'Art Moderne de la Ville de Paris, Paris /// *1994 Absence*, Museum Boijmans Van Beuningen, Rotterdam /// *1996 Sophie Calle, True Stories*, Tel Aviv Museum of Art, Tel Aviv /// *Die Entfernung – The Detachment*, Galerie Arndt & Partner, Berlin, Germany /// *Relatos*, Fundació "La Caixa Galicia", Madrid, Spain

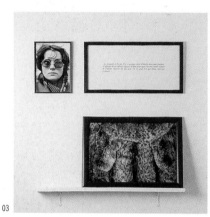

03

03 LES AVEUGLES N°7 (LE LYNX), 1986. 2 photographs and text, board, 120 x 150 cm. 04 LES AVEUGLES, 1986. Installation view, Fred Hoffman Gallery, Santa Monica (CA), USA, 1989. 05 WILHELM-PIECK-STRASSE, 1996. Colour photograph and book, 88 x 112 cm. 06 ANATOLI, 1984. Wall text and 265 photos, 18 x 23 cm (each) and 1 text, 70 x 56 cm (framed). Installation view, Fred Hoffman Gallery, Santa Monica, 1989.

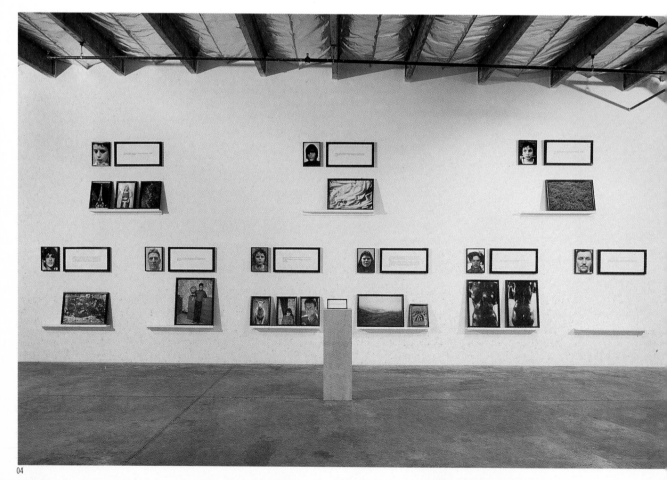

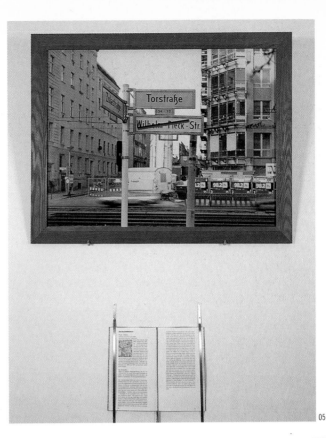

05

My love, I got on board the Trans-Siberian in Moscow, on my way to Vladivostok. It was October 29, 1984, 2:20 p.m. I had car 7, compartment 6. After class, fog took berth number 3. The other traveller was in berth 4. I sat down, waited for him. At 2:50 he walked in. A man in his sixties who glares at me and shouts out, surprised. He speaks in Russian, I tell him in French that I don't understand. Another shout, he says, De Gaulle. Then after a silence, he pleads further, harder. Kasparov. He wants to know whether I play chess. I shake my head. No. He covers his face with his hands in mock despair. A few minutes later, he begins negotiations, to exchange me for a more compatible companion. One by one, he introduces the entire population of the neighbouring compartments. They look me over, discuss, hesitate. In the end they always say no. The man gives up, stashes his eight suitcases in our quarters. Finally, seated across from me, he introduces himself. Anatoli Vassili Liebanovich, President Baldheire Vladivostock. I tell him my name, Sophie, and make appropriate gestures indicating that I am a writer and photographer. Anatoli thinks he understands. Saphir, he says. L'Humanité? So begins communal life in our 4 square meters. Anatoli wants me to sit down. He opens one of his suitcases, dumps the contents onto the small table between our beds. There are hardboiled eggs, meatballs, tomatoes, chocolate, bread, sausages, boiled potatoes, tangerines, and five quarts of vodka. I am to eat. It is an order. We begin our first conversation. Our shared vocabulary is small. Anatoli knows how to say: Communist, Fascists, Marchais, Mitterrand, Thorez, L'Humanité, De Gaulle. And I can reply with koracho (all right), zavtra (tomorrow), gazette (newspaper), and cartoshki (potatoes). Our routine begins. Anatoli decides when the day is to start. To wake me up, he shouts Saphir! at the top of his lungs. Then he looks at his watch and gives me exactly five minutes to get dressed. My time up, he harries me, without troubling to knock. He has set up breakfast for me on a little table and he intimates the order: eat. There is a dash of vodka, cold cuts, two tomatoes. It is always Anatoli who sets the table, organizes the meals. (Six of his eight suitcases are crammed with food.) As for me I decide when we go to bed. Once Anatoli, moving in so dramatic are we agree that I have the right to a thirty minute lead time when it comes to going to sleep.) I also do the beds, wash up our few dishes, clean up the compartment. When the train stops, Anatoli drags me out, down to the entrance of the railway station for a quick look at the unknown city. Then we dash back to the train. Last night Anatoli's sobs woke me up. He was in tears. I switched on the light, looked at him and he said, Fascists, poum, poum, poum, Indira Ghandi. That's all. And today he didn't want to play chess, he broke his glasses, and lost the winder on his watch. From time to time Anatoli mutters a word such as Mitterrand, or Paris, just like that, for the pleasure of being understood. Or he peers at me and asks, Saphir, communist? And I smile back. At night I sing Le temps des cerises for him (it's his favorite) or The Partisans' Song. When he isn't eating, or sleeping, or reading, Anatoli plays chess with our neighbour in compartment 5 and 8. When he wins, I hear the shout of triumph in the corridor. Championni Vladivostock! When his usual partners have had enough, Anatoli settles me down in front of his board and moves my pieces for me. He always makes me lose. Anatoli drinks a quart of vodka a day. And between swigs frequently makes the sign of the cross. Anatoli hides his money beneath a pillow. Anatoli wears three furs, poum. When we talk he spends a lot of time slapping his forehead with his hands in disbelief and annoyance. But those same hands have also informed me that Anatoli is 68, that he has two daughters, born in 1951, and 1953, that he divorced his wife and that she lives in Moscow, and that he has had two heart attacks, one in 1978, the other in 1980…

06

MAURIZIO CATTELAN

1960 born in Padova, Italy / lives and works in New York (NY), USA

"I think that the real situation that has to be unhinged is the interior one: the more my work turns to the exterior, the more I believe I talk about my problems and my interior." « Je pense que la situation qui peut vraiment vous faire perdre la tête, c'est la situation intérieure : plus mon œuvre se tourne vers l'extérieur, plus j'estime parler de mes problèmes et de ma vie intérieure. »

In a subversive and humorous way, Maurizio Cattelan manages to breach the rules of the art world, delivering ironic comments on socially controversial subjects. Racist tendencies in Italy or the influence of the mafia are just as likely to provide the themes of his occasionally interventionist work as intrinsically 'artistic' topics are. Since he is skilled at exploiting the workings of the art business, his methodology is often described as "parasitic". In one work, for example, he gave his place in an exhibition to a perfume manufacturer, who used it to display a poster advertising his products. Cattelan often uses symbols representing escape from the exhibition, in the form of knotted bed sheets, for instance, or a big hole dug in the gallery floor. It is against this background that his portraits should be interpreted. These were drawn by a police draughtsman from descriptions of Cattelan's friends and relatives; the resulting works resemble mug shots of criminals. Cattelan is adept at using simple means to register his objections to exhibition conditions. Invited by the Vienna Secession to organise a show in their basement, he installed a pair of bicycles, which were pedalled by two invigilators whenever a visitor entered, to generate the meagre light of a 15-watt bulb. The point was not only to make a critical comment on the low, windowless cellar rooms but also to embarrass the viewer, since the staff only had to activate the dynamos when someone came into the room. In this way, Cattelan creates convincing symbols for the hierarchies and dependencies of the art world.

Dans ses œuvres, Maurizio Cattelan parvient à déjouer les règles du jeu du marché de l'art d'une façon subversive et humoristique en produisant des commentaires ironiques et critiques sur des sujets sociaux brûlants. Les tendances racistes en Italie ou l'influence de la mafia peuvent être les thèmes d'une démarche aux connotations parfois interventionnistes, aussi bien que les interrogations immanentes à l'art. Dans la mesure où Cattelan sait parfaitement utiliser les données existantes du marché de l'art, sa démarche est souvent décrite comme parasitaire. Un acte comme la location de sa place d'exposant à un créateur de parfums, qui y installe une affiche publicitaire pour ses produits, doit être interprétée dans ce sens. Souvent, Cattelan se sert des symboles de la fuite de l'exposition concernée : ce sont des draps noués les uns aux autres, ou bien l'artiste creuse un grand trou dans le sol de la salle d'exposition. C'est sur cette toile de fond qu'il convient d'interpré-ter aussi ses propres portraits, que Cattelan a fait établir par un dessina-teur de la police d'après les descriptions d'amis et de parents, et qui doi-vent faire l'effet de portraits-robots. Cattelan s'entend à condamner une situation muséale avec des moyens simples. Invité à réaliser une exposi-tion dans les sous-sols de la Sécession viennoise, il installe deux bicy-clettes au moyen lesquelles, lorsque le spectateur entre dans la salle, deux gardiens produisent l'énergie nécessaire à une ampoule de 15 watts. Avec cette installation, Cattelan exprimait non seulement son mécontentement à l'égard d'espaces d'exposition trop bas, dépourvus d'ouvertures, confinés au sous-sol, il mettait aussi le spectateur dans l'embarras, les gardiens ne devant en effet actionner les dynamos qu'à son entrée dans la salle. Cattelan visualise ainsi d'une façon convaincante les hiérarchies et les contingences du monde de l'art. Y. D.

01 **A.C. FORNITURE SUD VS CESENA 12 TO 47,** 1991. Table football, 7 x 1.2 x 1 m.
02 **LOVE LASTS FOREVER,** 1997. Skeletons, 210 x 120 x 60 cm. Installation view, Skulptur. Projekte in Münster 1997, Münster, Germany, 1997.

MAURIZIO CATTELAN

SELECTED EXHIBITIONS: *1993* Aperto 93, XLV Esposizione Internationale d'Arte, la Biennale di Venezia, Venice, Italy /// *1994* "L'hiver de l'amour", Musée d'Art Moderne de la Ville de Paris, Paris, France; P.S.1, Long Island City (NY), USA /// *1997* XLVII Esposizione Internationale d'Arte, la Biennale di Venezia, Venice, Italian Pavilion (with Enzo Cucchi and Ettore Spalletti) /// Wiener Secession, Vienna, Austria /// *1998* "Projects 65: Maurizio Cattelan", The Museum of Modern Art, New York (NY), USA /// Manifesta 2, Luxembourg, Luxemburg /// Kunsthalle Basel, Basle, Switzerland **SELECTED BIBLIOGRAPHY:** *1997 Skulptur. Projekte in Münster 1997*, Stuttgart, Germany /// *1998 Manifesta 2*, Luxembourg, Luxemburg

04

05

LITTLE SPERMS, 1997. Painted latex, 10 x 5 x 5 cm (each). **04 ERROTIN LE VRAI LAPIN,** 1994. Costume. **05 BIDIBIDOBIDIBOO,** 1996. Animal stuffed, miniature kitchen.

JAKE & DINOS CHAPMAN

Jake Chapman **1962** born in London
Dinos Chapman **1966** born in Cheltenham, England
Both live and work in London, England

"We are sore-eyed scopophiliac oxymorons… We are artists." **« Nous sommes des oxymores scopophiles aux yeux de plaies… nous sommes des artistes. »**

The Chapman brothers' life-sized resin and fibre-glass figures appear realistic at first sight. Only from close up can the viewer tell that they are hermaphrodites with all sorts of genetic anomalies manifested in absurd combinations of arms, heads, legs and torsos, with the nose, ears or mouth replaced by an anus, a vulva or an erect penis ("Fuck-face", 1994, "Cock-shitter", 1997, …). These fantastic biological growths are not only upsetting but hold a certain fascination, though we may not like to admit it. And it is exactly the ubiquitous sex organs that make these almost child-like figures incapable of reproduction. The obscene creatures, unrestrained and full of irony are the products of an inner convulsion, a transgression. They are not clones but unique biological entities. Jake and Dinos Chapman's human figures are not meant to glorify aberration; they are simply assemblages with endless possible permutations. Unlike Sol LeWitt and Carl Andre – artists to whom they make frequent references – the Chapman brothers take the parts of the human body rather than geometric abstraction as their starting point. They see their monstrous creations as puzzles, mathematical variations, an ironic combination of wordplay and bad taste. The stated cynical intent of the two artists is to attempt to reach a cultural value of nil, to create an aesthetic of insensitivity and indifference. Therein lies the tragic dimension of their œuvre.

Les poupées faussement réalistes que les frères Chapman construisent en résine et fibre de verre présentent, en grandeur nature, des hermaphrodites cumulant toutes sortes d'anomalies génétiques, multipliant d'absurdes combinatoires de bras, de têtes, de jambes et de torses, à la jointure desquels s'insèrent anus, vulves ou pénis turgescents qui prennent la place du nez, des oreilles ou de la bouche (« Fuck-face », « Cock-shitter »…). Cette prolifération biologique fantastique déconcerte et exerce une inavouable fascination. La multiplication même de leurs caractères sexuels exclut simultanément ces jeunes corps de tout principe de génération. De telles créatures – issues d'une convulsion, d'une transgression, d'une obscénité jubilatoires et ironiques – ne sont pas des clones, mais une combinaison biologique unique, qui ne saurait se reproduire. A travers cette approximation de l'être humain, les artistes n'entendent pas exalter l'anomalie : leur art est une pure combinatoire, qui choisit de faire à l'infini des variations, non avec des géométries abstraites comme un Sol LeWitt ou un Carl Andre, auxquels les deux frères se réfèrent volontiers, mais avec des parties du corps humain. Ces créations monstrueuses ne veulent qu'être un jeu combinatoire, une variation mathématique, un ironique assemblage de calembour et de mauvais goût. La véritable dimension tragique de l'œuvre tient au cynisme de l'ambition, qui est explicitement d'atteindre à une « valeur culturelle nulle » : ici, l'art ne vise qu'à produire une esthétique de l'inertie, de l'indifférence, du détachement.

J.-M. R.

Pages 098/099: **01 ZYGOTIC ACCELERATION, BIOGENETIC, DE-SUB-LIMATED LIBIDINAL MODEL (ENLARGED X 1000)**, 1996. Fibreglass, resin, paint, artificial hair. **02 FOREHEAD,** 1997. Fibreglass, resin, paint, artificial hair, shoes, 135 x 60 x 45 cm. **03 GREAT DEEDS AGAINST THE DEAD,** 1994. Fibreglass, resin, paint, artificial hair, 277 x 244 x 152 cm. Pages 100/101: **04 TRAGIC ANATOMIES,** 1996. Installation view, "Chapmanworld", Institute of Contemporary Arts, London, England, 1996.

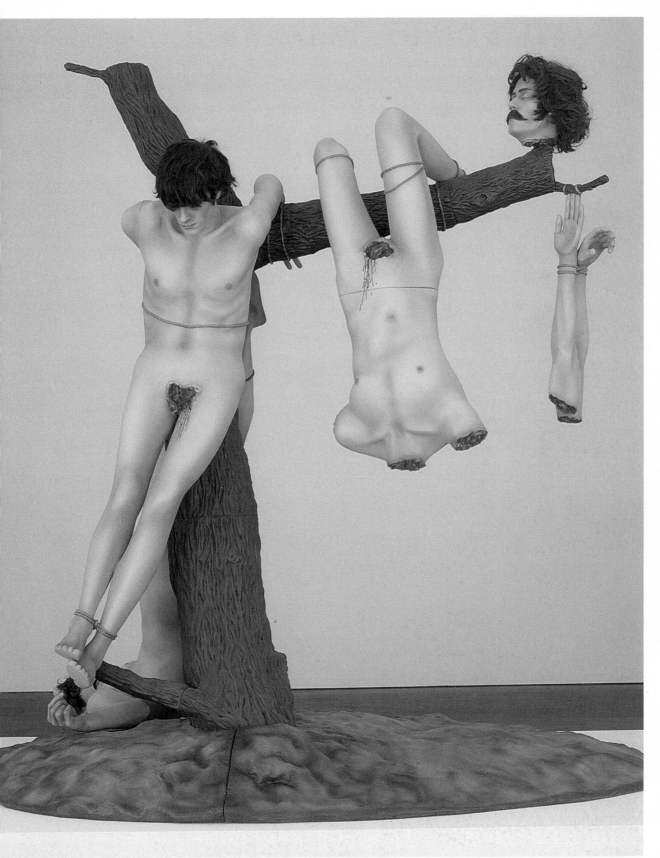

JAKE & DINOS CHAPMAN

SELECTED EXHIBITIONS: *1995* "Brilliant!", Walker Art Center, Minneapolis (MN), USA /// *1996* "Life/Live", Musée d'Art Moderne de la Ville de Paris, Paris, France /// "Chapmanworld", Institute of Contemporary Arts, London, England /// *1997* "Future, Present, Past", Corderie dell'Arsenale, Venice, Italy /// "Sensation", Royal Academy of Arts, London **SELECTED BIBLIOGRAPHY:** *1995 Brilliant!: New Art from London*, Walker Art Center, Minneapolis /// *1996 Chapmanworld*, Institute of Contemporary Arts, London /// *1997 Unholy Libel*, Gagosian Gallery, New York (NY), USA /// *Sensation*, Royal Academy of Arts, London

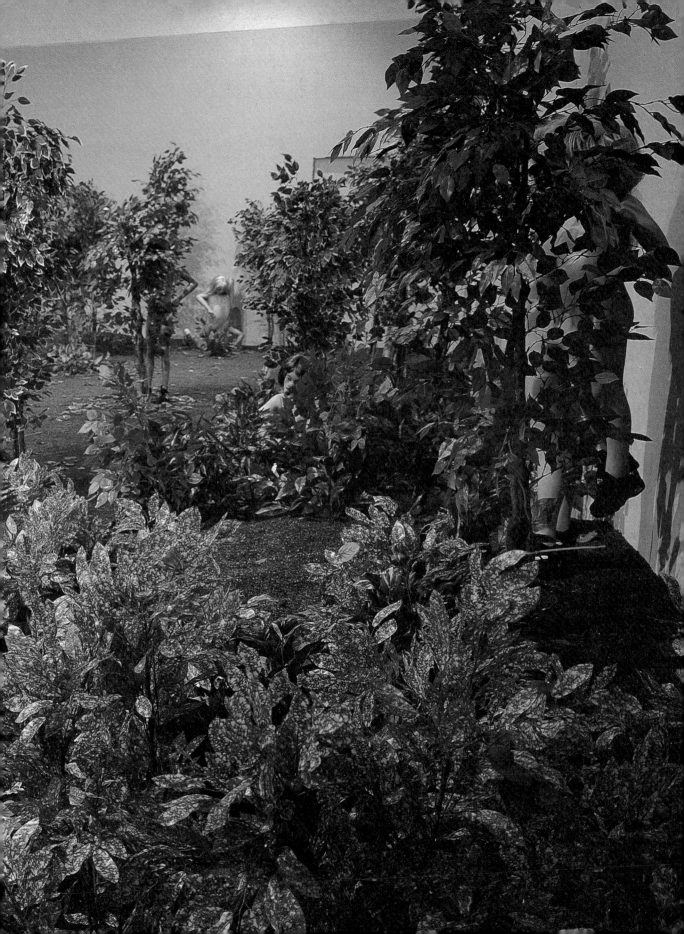

LARRY CLARK

"Since I became a photographer I always wanted to turn back the years." « Depuis que je suis devenu photographe, j'ai toujours voulu inverser le cours du temps. »

Larry Clark's first book "Tulsa" appeared in 1971 and made him famous at a stroke. It contained black and white photographs and some film sequences from the years 1963, 1968 and 1971 depicting the life of his friends, and indirectly himself, in the provincial town of Tulsa, Oklahoma. As a participating observer, Clark documents their longing to escape from their confines and their attempts to widen their consciousness, mainly through sex and drugs. Without moral judgement, Clark's photos also show the side-effects of this hippie utopia, such as prostitution, crime and violence. Clark returned to these themes in his next publication, "Teenage Lust – An Autobiography by Larry Clark", 1983. This combined photographs from the time of "Tulsa" with more recent ones from the 1980s. Its protagonists, such as the rent-boys on New York's 42nd Street, were already part of a successive generation of

teenagers. Since the beginning of the 1990s the trend in Clark's work towards narration has strengthened, increasingly displacing the initial documentary approach. Using photographic sequences, video recordings, statues from television footage, collages from newspaper articles and photographs taken by himself and others, he drew in "The Perfect Childhood", 1993, the picture of conflicted youth. By identifying with his characters, Clark seems to want to relive the utopian dimension of this teenage phase of life, which he claims to have missed and seeks out in each new generation. But his presentation of youth is often fixated on extreme situations and contains an element of danger: accompanying the escape from social norms is the threat of self-destruction, as is evident in Clark's much-discussed feature film "Kids", 1994/95.

En 1971, Larry Clark publiait son premier livre, « Tulsa », qui rendit l'artiste célèbre du jour au lendemain : ce livre contenait des photos noir et blanc et quelques séquences filmées des années 1963, 1968 et 1971, séquences qui évoquaient la vie de ses amis – et indirectement sa propre vie – dans la ville de province de Tulsa, Oklahoma. A la fois observateur et acteur, Clark illustrait leur désir de dépassement et d'élargissement du champ de conscience, les moyens employés étant avant tout le sexe et la drogue. Sans porter de jugement moral, les photos de Clark montrent également les effets secondaires de ces utopies (hippies) : prostitution, criminalité, violence. Dans sa seconde publication, « Teenage Lust – An Autobiography by Larry Clark », 1983, Clark revenait sur les mêmes thèmes, combinant des photos de l'époque de « Tulsa » avec des photos plus récentes datant des années 80 : photos dont les protagonistes, de jeunes prostitués de la 42ème rue à New York par

exemple, appartenaient déjà à la génération « suivante » de teenagers. Depuis le début des années 90, l'œuvre de Clark dénote une tendance de plus en plus marquée à l'anecdotique. Dans « L'Enfance parfaite », 1993, à travers des séquences photographiques, des montages vidéo, des portraits d'émissions télé, des collages composés d'articles de journaux et de photographies personnelles ou étrangères, il dessine l'image d'une jeunesse souvent conflictuelle. Par son identification avec les personnes représentées, Clark semble vouloir (re)vivre la dimension utopique de cette phase de vie que – selon ses propres déclarations – il n'aurait pas vécue et qu'il cherche à retrouver dans chaque génération de jeunes. L'image de la jeunesse que présente Clark comporte toujours un facteur de mise en péril : le principe de franchissement des normes sociales qu'on lui attribue menace de se transformer en (auto)destruction, comme dans « Kids », le film très controversé réalisé par Clark en 1994/95. A. W.

01

02

03

Pages 102/103: **01 UNTITLED,** 1963. B/w photograph, 20 x 25 cm. **02 UNTITLED,** 1963. B/w photograph, 20 x 25 cm. **03 UNTITLED,** 1963. B/w photograph, 25 x 20 cm. **04 UNTITLED,** 1972. B/w photograph, 17 x 25 cm. **05 UNTITLED,** 1967. B/w photograph, 20 x 25 cm. **06 TULSA PORTFOLIO,** 1972. 10 gelatin silver prints, 20 x 25 cm (each). Pages 104/105: **07 UNTITLED (KIDS),** 1995. 15 C-prints, 27 x 40 cm (each).

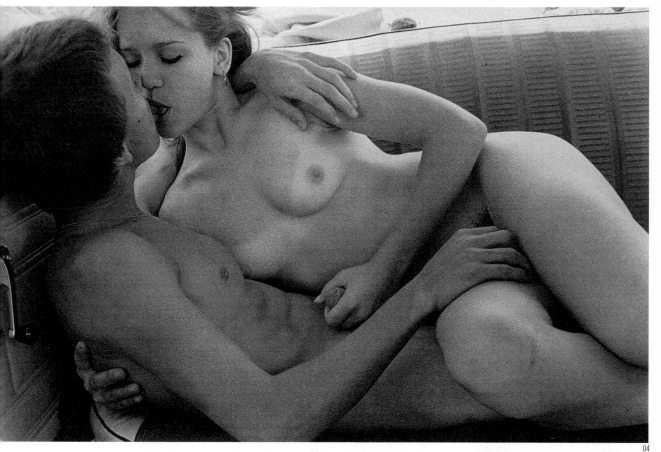

04

05

06

LARRY CLARK

SELECTED EXHIBITIONS: *1992* Kunstmuseum Luzern, Lucerne, Switzerland /// *1994* "L'hiver de l'amour", Musée d'Art Moderne de la Ville de Paris, Paris, France /// *1996* Wiener Secession, Vienna, Austria /// Milwaukee Art Museum, Milwaukee (WI), USA /// *1998* "Vintage Prints 1962–1972", Luhring Augustine, New York (NY), USA **SELECTED BIBLIOGRAPHY:** *1993 The Nightshade Family*, Museum Fridericianum, Kassel, Germany /// *Real Sex*, Salzburger Kunstverein, Salzburg, Austria /// *1994 Nobuyoshi Araki, Larry Clark*, Sala Parpallo, Valencia, Spain /// *1995 Public Information: Desire, Disaster, Document*, San Francisco Museum of Modern Art, San Francisco (CA), USA

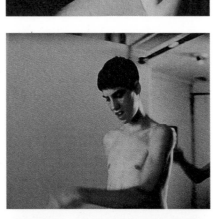

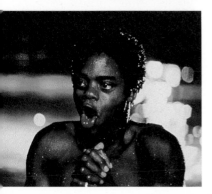

CLEGG & GUTTMANN

Michael Clegg **1957** born in Dublin, Ireland
Martin Guttmann **1957** born in Jerusalem, Israel
Both live and work in New York (NY) and San Francisco (CA), USA

"One of the most important tasks of art in our opinion is the making of portraits while reflecting on the process." **« A notre sens, une des tâches primordiales de l'art est la production de portraits accompagnée d'une réflexion simultanée sur ce processus… »**

The works of Michael Clegg and Martin Guttmann are an examination, continuation, and expansion of the portrait genre by means of photography, installation, collection of materials, interviews and videos. They are less concerned, however, with accurately portraying the physiognomy of an individual than with presenting collective structures and social relationships. Building on the historical convention of the group picture, their portrait photos of the 1980s bring out the social power relationships governing codes of influence, possessions and status. The "Open Library" project, which has been implemented in several cities since 1991, turns the concept of the portrait into a process effected by the interaction of its users. Clegg & Guttmann placed books for loan or exchange in unsupervised cupboards and boxes in different parts of town. The changes in the book-stock reflected the reading habits of the inhabitants of each urban district, and thus provided a model for a largely unregulated form of communication. In contrast to this, the observation of human behaviour in controlled situations was the common theme of "Verité",1994, and "The Sick Soul", 1996. As in sociological methods of observation, different reactions were recorded in a model situation. Clegg & Guttmann's artistic experimental procedures show that contextual circumstances play a decisive part in the significance of the results, and that the concept of "verité" (i.e. truth), depends in every case on the interests of the actors and observers. This scepticism has provoked political controversy, particularly in their handling of the history of Zionism in "Zionism as Separatism", 1997.

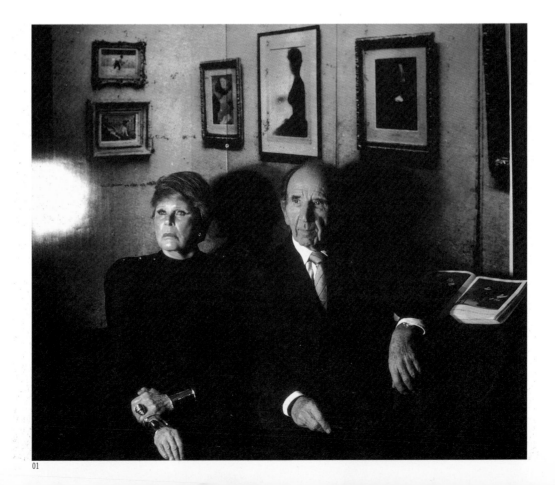

01

02

MATRIMONIAL PORTRAIT, 1987 (a rejected commission). Cibachrome, 153 x 179 cm. **02 AN AMERICAN FAMILY,** 1986. Cibachrome, 25 x 175 cm. **03 THE MARRIAGE CONTRACT,** 1986. Cibachrome, 101 x 153 cm.

Les œuvres de Michael Clegg et Martin Guttmann sont des prolongements, des développements et des analyses du genre du portrait avec les moyens de la photographie, de l'installation, de l'agencement de matériaux, de l'interview et de la vidéo. Dans le cadre de ce propos, leur intérêt porte moins sur la représentation exacte de la physionomie individuelle que sur la mise en évidence de structures collectives et d'interrelations sociales. Prenant pour point de départ les conventions historiques et artistiques du portrait de groupe, leurs portraits photographiques des années 80 mettent en scène les rapports de force sociaux à l'aide des codes de l'influence, de la propriété et du statut social. Le projet de «Bibliothèque ouverte» réalisé depuis 1991 dans plusieurs villes déplace le concept de portrait vers un domaine processuel : le portrait naît de l'interaction de ses utilisateurs. En différents endroits d'une ville, Clegg & Guttmann proposaient des livres au prêt ou à l'échange dans des armoires ou des boîtes de distribution non surveillés. La nouvelle composition de la bibliothèque reflétait ensuite le comportement des lecteurs d'un quartier et devenait le modèle d'une communication échappant à toute réglementation. En revanche, le sujet commun de «Vérité», 1994, et de «The Sick Soul», 1996, était l'observation du comportement humain soumis à des prescriptions rigoureuses. Les différentes réactions produites par une situation modèle furent consignées en se servant de techniques apparentées aux méthodes d'observation sociologiques. Les modèles d'expérience proposés par Clegg & Guttmann mettent en évidence le fait que le cadre défini joue un rôle déterminant dans la production de sens et que le concept de «Vérité» est lié aux intérêts des acteurs et des observateurs. Ce scepticisme a provoqué une controverse politique, particulièrement dans leur travail sur l'histoire du sionisme : «Le sionisme comme séparatisme», 1997. A. W.

03

CLEGG & GUTTMANN

SELECTED EXHIBITIONS: *1992* "From the Index of Commissioned and Non-Commissioned Photographic Portraits: Gazes in the Direction Perpendicular to the Picture Plane, Placed in a Sequence According to their Intensity, and Accompanied by Varying Postures and Hand Arrangements", P.S.1, Long Island City (NY), USA /// *1993* "The Open Public Library, Hamburg", Kunstverein in Hamburg, Hamburg, Germany /// *1994* "The Transformation of Data into Portraiture", Kunstraum der Universität Lüneburg, Lüneburg, Germany /// *1996* "The Sick Soul II", Galerie Christian Nagel, Cologne, Germany /// *1997* "1897 – The First Zionist Congress in Basel", Kunsthalle Basel, Basle, Switzerland **SELECTED BIBLIOGRAPHY:** *1990 Clegg & Guttmann*, Württembergischer Kunstverein, Stuttgart, Germany /// *1992 The Outdoor Exhibition Space Munich – San Francisco*, Kunstraum Daxer, Munich, Germany /// *1994 Die offene Bibliothek*, Kulturbehörde der Freien Hansestadt Hamburg, Hamburg /// *1996 The Sick Soul, Morbid Fascination and Behavioural Research in Sociology*, Grazer Kunstverein, Graz, Austria

04

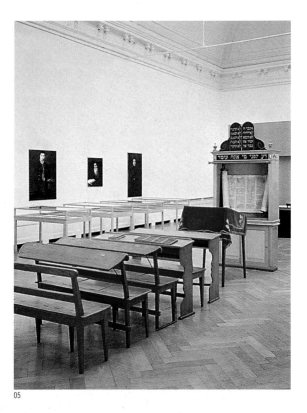

05

04 SALON. Installation view, "1897 – The First Zionist Congress in Basel", Kunsthalle Basel, Basle, Switzerland, 1997. **05 SYNAGOGE.** Installation view, "1897 – The First Zionist Congress in Basel", Kunsthalle Basel, Basle, 1997. **06 DIE OFFENE BIBLIOTHEK.** Installation view, Kirchdorf/Hamburg, Germany, 1993.

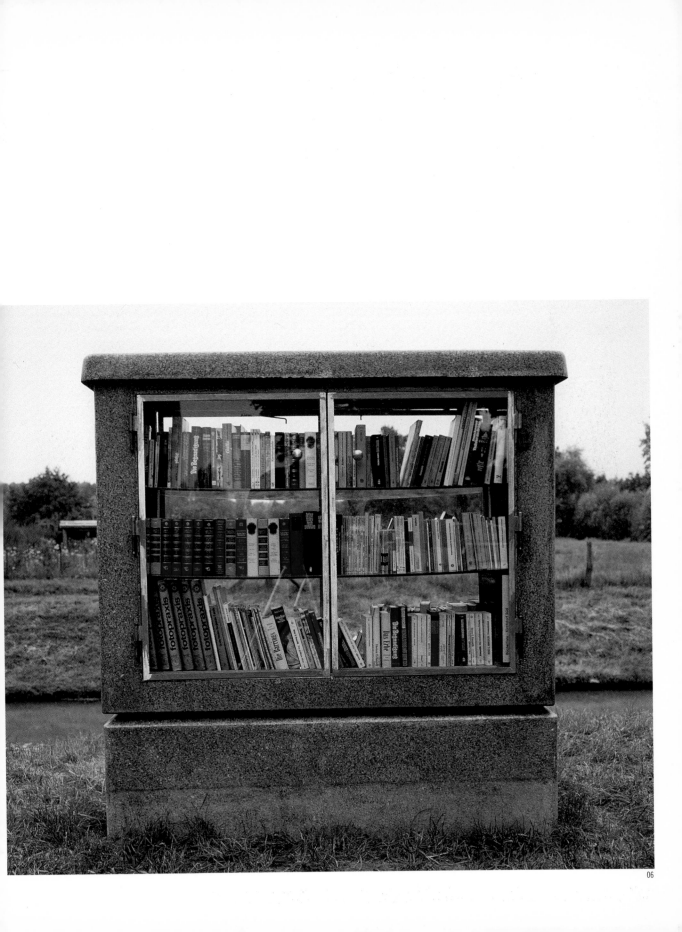

JOHN CURRIN

1962 born in Boulder (CO) / lives and works in New York (NY), USA

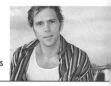

"Life presents itself to me in those kinds of terms: staring at women, staring at the sky, staring at something." **« La vie se présente à moi dans les termes suivants : regarder les femmes, regarder le ciel, regarder quelque chose. »**

John Currin's earliest paintings include a series of portraits of young girls based on photos from a high-school yearbook. The pupils of the girl's eyes are black discs, giving their gaze a dull, empty expression; the blank faces permit no interpretation of their character. In a subsequent series, Currin painted a group of older, strikingly thin women who assume the poses of models. Both grotesque and touching, these portraits convey a sense of the longings of the ageing women dressed in tight-fitting, youthful clothing. Currin is not concerned here with an ironic exposure of his subjects, but with analytical observation. In his pictures of couples, young women gaze respectfully up at middle-aged male dandies in flashy, vulgar clothing. There is evidence in these works that Currin is less interested in the representation of individual personality than in dealing with stereotyped clichés. His latest series features women with huge breasts, their torsos and hands emphasised by thick brush strokes ("The Bra Shop", 1997, for example). Currin restricts himself almost entirely to this caricatured realism, though he borrows poses from Botticelli's paintings or presents the sky in the style of a Rococo painting. Given the virtuosity of his painting technique, it is also clear that Currin has a pronounced interest in the long tradition of painting and is confidently attempting to find a slot for his pictures in it.

Parmi les tout premiers tableaux de John Currin, on trouve des portraits de jeunes filles réalisés d'après les photos d'un album scolaire. Les pupilles des jeunes filles étant peintes comme des disques entièrement noirs, leurs regards prennent une expression hébétée. Ces visages ne permettent en rien de déduire le caractère ou la nature des modèles. Dans la série suivante, Currin peint des femmes déjà âgées qui frappent par leur maigreur et dont la pose de top models est encore soulignée par des habits moulants. Ces portraits à la fois grotesques et pleins de sensibilité donnent une idée des désirs de ces femmes vieillissantes mais portant des vêtements juvéniles. Le propos de Currin n'est pas ici la mise à nu ironique des femmes, mais l'observation analytique. Dans ses tableaux de couples, des jeunes femmes lèvent humblement les yeux vers des hommes accoutrés de vêtements bigarrés qui les font ressembler à des dandys sur le retour. Ces tableaux montrent eux aussi que Currin recherche moins la représentation de la personnalité individuelle que la mise en évidence de stéréotypes. Dans une série plus récente, qui compte par exemple « The Bra Shop », 1997, Currin peint des femmes aux poitrines opulentes, insistant tout particulièrement sur le buste et les mains par l'emploi d'une facture extrêmement pâteuse. Dans ses tableaux, Currin se limite le plus souvent à un réalisme qui confine à la caricature. Il reprend des attitudes physiques empruntées à l'œuvre de Botticelli ou réalise ses ciels dans un style rococo. Indépendamment de ces aspects – de la virtuosité picturale par exemple –, ses œuvres manifestent un intérêt flagrant pour la longue tradition de la peinture, dans laquelle l'artiste tente de s'intégrer souverainement avec ses tableaux.

Y. D.

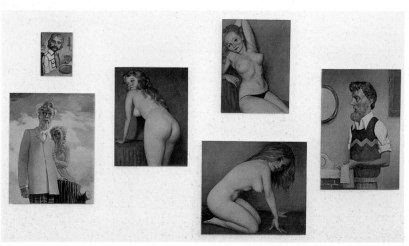

01 THE NEW GUY; AUTUMN LOVERS; NUDE; BLONDE NUDE; NUDE WITH BLACK SHOES; THE OLD GUY, all 1994 (from left to right). Oil on canvas. Installation view, Galerie Jennifer Flay, Paris, France, 1994. **02 ANN-CHARLOTTE,** 1996. Oil on canvas, 122 x 97 cm.

JOHN CURRIN

SELECTED EXHIBITIONS: *1993* Aperto 93, The XLV Esposizione Internationale d'Arte, la Biennale di Venezia, Venice, Italy /// *1995* Fonds Regional d'Art Contemporain du Limousin, Limoges, France /// *1995–1996* Institute of Contemporary Arts, London, England /// *1997* "The Tate Gallery Selects: American Realities. Views from Abroad. European Perspectives on American Art 3", Whitney Museum of American Art, New York (NY), USA /// "Projects 60: Currin, Peyton, Tuymans", The Museum of Modern Art, New York **SELECTED BIBLIOGRAPHY:** *1993 Critical Distance*, Ado Gallery, Antwerp, Belgium /// *1995 John Currin Œuvres/works 1989–1995*, Fonds Regional d'Art Contemporain du Limousin, Limoges /// *1997 Projects 60: Currin, Peyton, Tuymans*, The Museum of Modern Art, New York

03

05

04

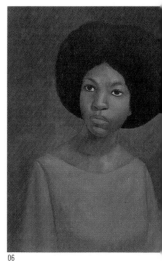

06

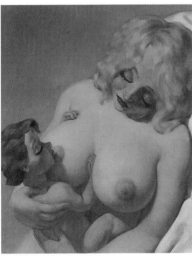

07

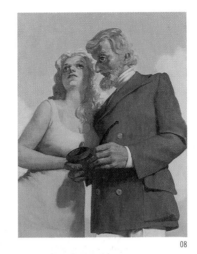

08

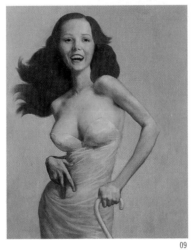

09

10

03 MS. OMNI, 1993. Oil on canvas, 122 x 97 cm. **04 THE BRA SHOP,** 1997. Oil on canvas, 122 x 97 cm. **05 HAPPY LOVERS,** 1993. Oil on canvas, 76 x 66 cm.
06 UNTITLED, 1990. Oil on canvas, 76 x 71 cm. **07 THE NURSERY,** 1994. Oil on canvas, 81 x 66 cm. **08 LOVERS IN THE COUNTRY,** 1993. Oil on canvas, 132 x 102 cm.
09 THE CRIPPLE, 1997. Oil on canvas, 112 x 91 cm. **10 THE MOVED OVER LADY,** 1991. Oil on canvas, 117 x 97 cm.

WIM DELVOYE

1965 born in Wervik, Belgium / lives and works in Ghent, Belgium, and London, England

"I am a tennis player, playing on both sides of the net, and I guess that this is true for everything I have done so far." « **Je suis un joueur de tennis qui joue des deux côtés du filet, et je pense que cela est vrai pour tout ce que j'ai pu faire jusqu'à ce jour.** »

The eclectic art of Wim Delvoye seems to be aimed above all at making us laugh. A football goal in leaded glass and another in porcelain, a concrete mixer carved in wood and a tiled floor with faecal motifs, bricks with baroque decoration all take the viewer by surprise. There is both frustration and irony to be found in a gas cylinder and circular saw made of Delft faïence, velvet-lined containers for bucket and spade, tattooed pig-skins, a fountain in the form of an angel turning round and urinating in the wind, ironing boards decorated with blazonry, a urinal crowned with the framed picture of the king of the Belgians. Delvoye's objects can be read as *bon mots*, and what even the most ordinary, hackneyed and vulgar have in common is that they are all the products of considerable craftsmanship, resulting in a highly developed form of popular art. While reverting to the craft tradition in order to defy any particular development of taste, Delvoye's art attempts to reconcile the middle class penchant for kitsch through popular humour. His works break the taboos of the avant-garde, who systematically renounce beauty in execution, every form of craftsmanship and every aesthetic concession to bourgeois taste. Delvoye recalls the power of paintings and the richness of Baroque ornamentation and would rather go along with the unshakeable tenets of catholicism than with Protetant theology. For him, art, good taste and aesthetics are all signs of the decline of civilisation that has long since broken up and been supplanted. The Fleming sees himself first and foremost as a provincial artist who wishes to explore the foundations of his own culture, and as someone whose pleasing decorations will, he hopes, brighten up life in his country where Modernism has no place.

01

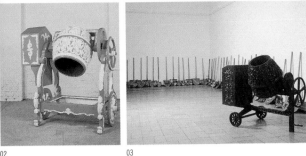

02

03

01 MUM, KEYS ARE ..., 1996. Laser ink jet paint on canvas, 300 x 400 cm. 02 WEDGEWOOD (I), 1992. Carved wood, enamel paint, 179 x 190 x 112 cm. 03 INSTALLATION MIT EINER BETONMISCHMASCHINE UND 76 SCHAUFELN, 1991. Mahogany, shovels, enamel paint, concrete mixer. Installation view, Kunsthalle Nürnberg, Nuremberg, Germany, 1992. 04 SUSAN, OUT FOR A PIZZA, ..., 1996. Laser ink jet painting on canvas, 500 x 740 cm.

L'art de Delvoye, à travers les expressions les plus éclectiques, semble avoir choisi pour première ambition de faire rire : un but de football en vitrail, un autre en porcelaine, une bétonneuse en bois sculpté, un carrelage de sol avec un motif d'étron, une bonbonne de gaz ou une scie circulaire en faïence de Delft, une fontaine composée d'un ange girouette qui pisse dans le vent, des planches à repasser affublées de blasons, un urinoir surmonté de la photo encadrée du roi de Belgique... Ces objets, y compris le plus vulgaire, le plus éculé, le moins chic, fonctionnent à la façon d'un mot d'esprit. Ils ont en commun d'en appeler chacun à la grande tradition artisanale pour décliner, en fin de compte, une histoire du goût directement liée aux pratiques aviliés de la banlieue moderne. Cet art choisit de se concilier le goût des classes moyennes pour le kitsch et un humour populaire. Il s'oppose à tous les tabous avant-gardistes, systématiquement ennemis de la belle facture, du travail à la main et de toute connivence esthétique avec les goûts de la petite-bourgeoisie. L'artiste s'appuie sur de solides certitudes catholiques pour affirmer, contre la théologie protestante, la prédominance de l'image et la richesse baroque de l'ornement. L'art, le bon goût, l'esthétique ne sont pour lui que les indices de la déchéance d'une civilisation, de sa faillite, de son vieillissement. Ce Flamand se veut d'abord un artiste régionaliste, un artiste « ethnique » explorant les présupposés de sa propre culture, un artiste qui imaginerait d'embellir la vie quotidienne par un plaisant décor en un pays où le modernisme ne se serait jamais implanté.

J.-M. R.

04

WIM DELVOYE

SELECTED EXHIBITIONS: *1991* Castello di Rivoli, Rivoli (TO), Italy /// *1992* documenta IX, Kassel, Germany /// *1994* Center for the Arts at Yerba Buena Gardens, San Francisco (CA), USA /// *1997* Open Air Museum of Sculpture Middelheim, Antwerp, Belgium　　**SELECTED BIBLIOGRAPHY:** *1992 Wim Delvoye – Fünf Arbeiten*, Kunsthalle Nürnberg, Nuremberg, Germany /// *1997 Wim Delvoye*, Open Air Museum of Sculpture Middelheim, Antwerp /// *Wim Delvoye*, Tinglado 2, Tarragona, Spain

05 ST.-STEPHEN (II), 1990. Stained glass, metal, paint, 200 x 300 x 110 cm. **06 TATTOOED PIG SKIN (JULIANNE),** 1995. Tattooed pig skin, c. 150 x 110 cm. **07 / 08 PIGS,** 1994–1997 (detail). 4 live tattooed pigs. Installation view, Open Air Museum of Sculpture Middelheim, Antwerp, Belgium, 1997.

05

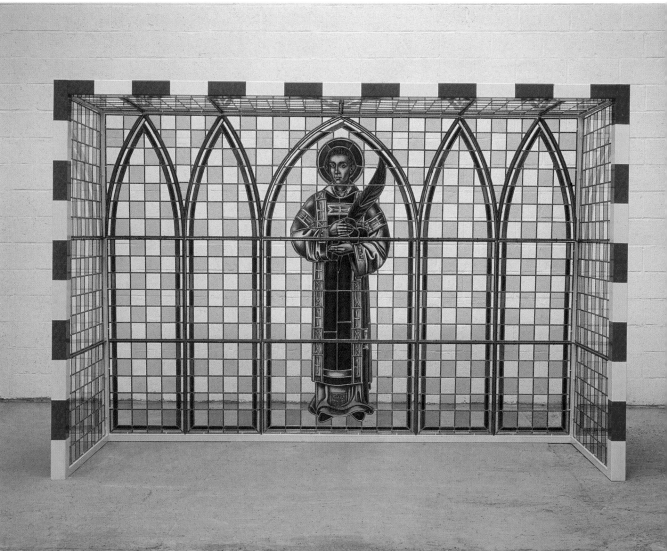

THOMAS DEMAND

1964 born in Munich / lives and works in Berlin, Germany, and London, England

"I think photography is less about representing than constructing its objects." « Je pense qu'en photographie, il ne s'agit pas de représenter quelque chose, mais de construire les objets de la représentation. »

Thomas Demand explores photographs as visual traps. In his pictures, an office, a staircase or a motorway bridge are not what they seem. They do not show anything real, but structures of paper and cardboard. Without recognisable dimensions, they appear genuine at first because they are meticulously constructed, but, devoid of human figures, signs and language, their very immaculateness soon betrays them as fakes. The piled-up cardboard boxes have nothing printed on them and the sheets of paper on the desk are blank. Demand builds these models only for the purpose of photographing them, never including them in his exhibitions. The photos impress through their abstract, formal composition and colour, displaying perfect photographic solutions. The statement

made by his subjects cannot be reduced to a common denominator. They denote the typical dull, grey aesthetic of modern administration – the office, the civic building, the landing. And in the end, the allusion seems so familiar that the question arises as to an authentic document, a real basis for the model. These bases do exist: biographical places ("Ecke", 1996), sites rich with history ("Archiv", 1995), or crime scenes ("Flur", 1995), chosen deliberately by Demand from historical, political and criminological documentary photographs. However, in the last few years he has refused to identify his sources, claiming that knowledge of these would only restrict interpretation of his work.

Les photos comme pièges visuels. Les prises de vues réalisées par Thomas Demand dans un bureau, une cage d'escalier ou sur un pont autoroutier ne répondent pas à ce qu'on attend d'elles. Ce qu'elles montrent n'est pas réel, on n'y voit en effet que des figures de papier et de carton. Ce sont des constructions sans dimensions clairement identifiables, qui semblent d'abord formidablement véridiques – parce que minutieusement combinées –, avant de produire l'effet global d'un leurre : propreté, perfection, absence de gens, mais aussi de signes et de mots. Des empilements de cartons ne présentent pas la moindre écriture, les feuilles posées sur le bureau sont toutes blanches. Les messages de ces motifs, que Demand construit en vue d'un propos purement photographique, ne peuvent être ramenés à un unique dénominateur commun. Les photos séduisent par leur composition chromatique et formelle

abstraite, citations de solutions photographiques parfaites. Elles caractérisent l'esthétique grise-opaque de l'administration moderne : le bureau, les archives, le couloir d'étage dans leur manifestation par trop quotidienne. Pour finir, la citation semble si familière qu'on s'interroge sur le document authentique, le modèle réel. Ces modèles existent, et Demand les choisit délibérément dans la photographie documentaire de l'histoire, de la politique et de la criminalistique. Depuis quelques années, l'artiste refuse cependant de dévoiler ses sources. On trouve des lieux biographiques (« Coin », 1996), des lieux chargés d'histoire (« Archives », 1995) et des lieux de crimes (« Couloir », 1995), dont la connaissance, selon Demand, ne ferait que restreindre le champ d'interprétation ouvert par son travail. S. T.

01 STUDIO (STUDIO), 1997. C-print, diasec, 184 x 355 cm. 02 SPRUNGTURM (DIVING BOARD), 1994. 150 x 120 cm.

THOMAS DEMAND

SELECTED EXHIBITIONS: *1995* Victoria Miro Gallery, London, England /// *1996* "New Photography", The Museum of Modern Art, New York (NY), USA /// *1997* Monika Sprüth Galerie, Cologne, Germany /// *1998* Kunsthalle Zürich, Zurich, Switzerland /// 303 Gallery, New York /// Schipper & Krome, Berlin, Germany **SELECTED BIBLIOGRAPHY:** *1998 Thomas Demand*, Kunsthalle Zürich, Zurich; Kunsthalle Bielefeld, Bielefeld, Germany

03 PARKGARAGE (CAR PARK), 1996. C-print, diasec, 135 x 164 cm. 04 ECKE (CORNER), 1996. C-print, diasec, 144 x 200 cm.
05 ARCHIV (ARCHIVE), 1995. C-print, diasec, 184 x 233 cm.

04

05

RINEKE DIJKSTRA

1959 born in Sittard, The Netherlands / lives and works in Amsterdam, The Netherlands

"I am not concerned with the way people think about themselves. I should like to show a particular intensity, a particular tension, that is present in themselves." « Je ne m'intéresse pas à ce que les gens pensent d'eux-mêmes. Je souhaite montrer une certaine intensité, une certaine tension qui existe en eux. »

Rineke Dijkstra makes photographic portraits of teenagers and young adults in the Netherlands – her home country – as well as in Poland, England, Portugal and the USA. Starting out as a professional photographer, she produced various series that through the early 1990s steadily gained in artistic form and now go far beyond social documentation. The first in the series was "Beaches", 1992–1996, on the theme of young people on the beach. They were photographed from various spots, but the camera always points towards the sea. Dijkstra's subjects approach the viewer so directly that their insecurity is legible on their faces and bodies. Despite the tell-tale characteristics of dress and hairstyle, they retain their own individual mystery. By her choice of subjects and naming of their home towns, she raises questions of identity, but does not answer them – either in the case of the girls in an English disco or their presumed college counterpart, nor in the juxtaposition of two photographs of the same woman taken in rapid succession. The photographs do not encourage direct identification with their subjects, for Dijkstra keeps them in a distant perspective. In her choice of subjects she aims at a particular element that catches every eye: all the people she has photographed – whether teenagers, young bull-fighters or women who have just given birth – are vulnerable, sensitive individuals in a stage of transition. This situation is reflected in their insecurity, their pose, their dress, even their skin. In Dijkstra's recent switch to video, a temporal dichotomy arises: a period of real time in addition to the fixed time of the photographic camera, and under scrutiny this takes on the profundity of a behavioural study.

Rineke Dijkstra fait le portrait d'adolescents et de jeunes adultes dans sa patrie hollandaise, mais aussi en Pologne, en Angleterre, au Portugal et aux Etats-Unis. Au début des années 90, les séries de cette photographe de formation prennent de plus en plus une forme artistique et dépassent largement le cadre de la documentation sociale. Ceci se manifeste pour la première fois dans la série « Beaches », 1992–1996, avec le motif des jeunes sur la plage photographiés dans les lieux les plus divers et dans des positions toujours identiques par rapport à la mer : avec leurs incertitudes si aisément décelables dans leurs visages et dans leurs corps, les modèles approchent de si près le spectateur qu'on peut détailler tous les éléments significatifs du vêtement ou de la coiffure. Pourtant, le caractère inexplicable de l'individu demeure. Par le choix des modèles et l'indication précise de leur lieu de résidence, Dijkstra touche à des questions d'identité, sans pour autant y répondre : *pas plus lorsqu'il s'agit de jeunes filles dans une discothèque anglaise et leurs homologues du College, que dans le cas d'une juxtaposition de deux prises de vues successives de la même femme. Les photos défient tous les classements directs qui permettraient de conclure de l'image à la personne, Dijkstra les ramène à une perspective de la distance. Par le choix de ses modèles, elle vise cependant à un moment particulier capable de diriger le regard quel qu'il soit. Tous les êtres photographiés par elle, qu'il s'agisse d'adolescents, de jeunes toreros ou de parturientes, sont des individus fragiles, sensibles, dans un état transitoire que reflètent leur manque d'assurance ou leur pose, leur vêtement ou et leur peau. Dans les récentes prises de vues réalisées en vidéo, il en ressort une double image de l'époque : avec les prises de vues de plusieurs minutes devant la caméra apparaît un bout de « temps réel » qui se concentre sous le regard en un portrait pénétrant du comportement.* S. T

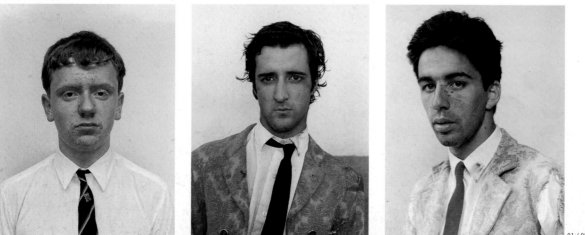

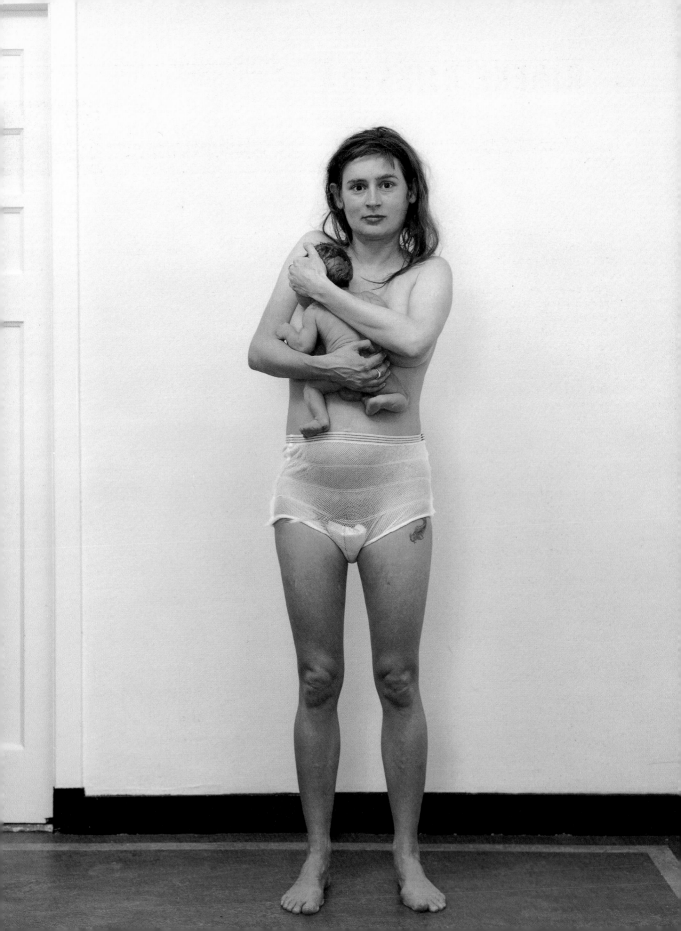

RINEKE DIJKSTRA

SELECTED EXHIBITIONS: *1997* "Future, Present, Past", Corderie dell'Arsenale, Venice, Italy /// "New Photography 13", The Museum of Modern Art, New York (NY), USA /// *1998* "Menschenbilder", Museum Folkwang Essen, Essen, Germany /// "About the World", Sprengel Museum Hannover, Hanover, Germany /// "Photography after Modernism: Extensions into Contemporary Art", San Francisco Museum of Modern Art, San Francisco (CA), USA /// *1998–1999* Museum Boijmans Van Beuningen, Rotterdam, The Netherlands **SELECTED BIBLIO-GRAPHY:** *1996 Rineke Dijkstra. Beaches*, Zurich, Switzerland /// *1997 Location*, The Photographers' Gallery, London, England /// *1998 Menschenbilder*, Museum Folkwang Essen, Essen /// *Exhibition catalogue*, Galerie in der Hochschule für Grafik und Buchkunst, Leipzig, Germany

Pages 122/123: **01 THE NUGENT, R.C. HIGH SCHOOL, LIVERPOOL, ENGLAND, NOVEMBER 11,** 1994. **02 MONTEMOR, PORTUGAL, MAY 1,** 1994. **03 VILLA FRANCA, PORTUGAL, MAY 8,** 1994. **04 JULIE, DEN HAAG, THE NETHERLANDS, FEBRUARY 29,** 1994. Pages 124/125: **05 JALTA, UKRAINE, JULY 30,** 1993 **06 DUBROVNIK, CROATIA, JULY 13,** 1996. **07 LONG ISLAND, N.Y., U.S.A., JULY 1,** 1993. **08 ODESSA, UKRAINE, AUGUST 4,** 1993. **09 HILTON HEAD ISLAND, S.C., U.S.A., JUNE 24,** 1992. **10 DE PANNE, BELGIUM, AUGUST 7,** 1992.

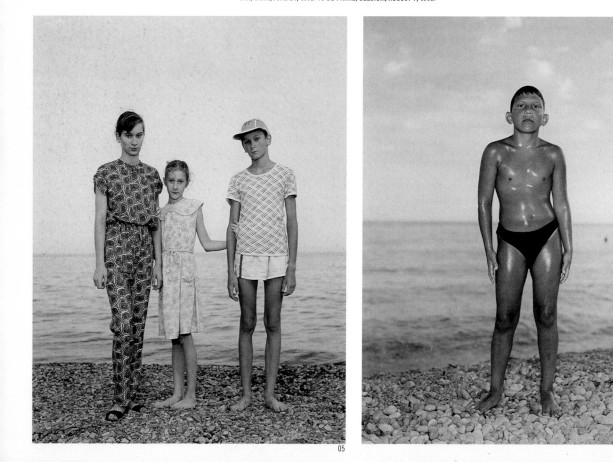

05

06

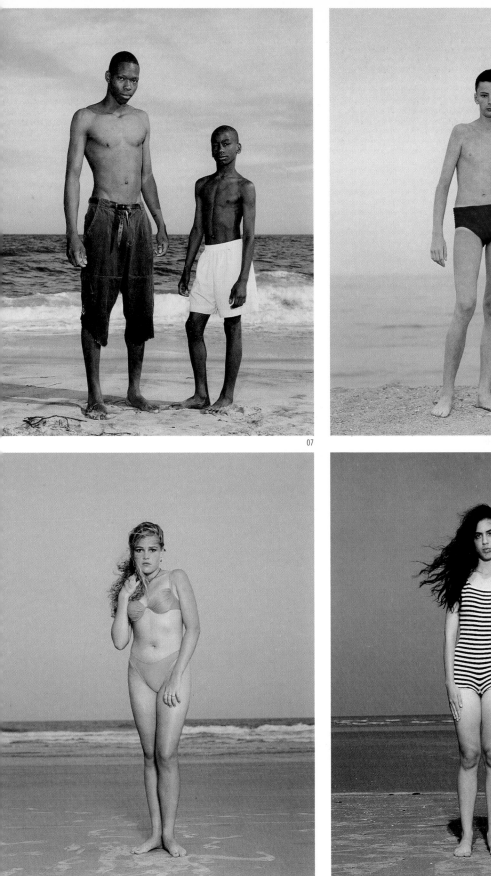

07

08

09

10

MARK DION

1961 born in New Bedford (MA) / lives in Beach Lake (PA), USA, and works worldwide

"Taxonomy, i.e. the classification of the natural world, is a system of order imposed by man and not an objective reflection of nature. Its categories are actively applied and contain the assumptions, values and associations of human society." **« La taxonomie, c'est-à-dire la classification du monde naturel, est un système d'ordonnancement imposé par l'homme, non un reflet objectif de la nature. Ses catégories sont appliquées activement et contiennent des hypothèses, des jugements de valeur et des associations de la société humaine. »**

According to Mark Dion, "nature" is a cultural construct. It is, as the quotation (see above) for his portrait of the nature researcher Georges Cuvier – "Taxonomy of Non-endangered Species", 1990 – makes clear, a projection area for human notions. Dion approaches the question of the representation of nature from different angles. In doing so, he often links up with the historical moment in the late seventeenth and early eighteenth centuries when the subjective arrangement of the cabinet of curiosities gave way to the rational organization of the museum. The natural history museum therefore takes on a central role in his work as the scene of those new systems of classification. The scientific processes of nomenclature and categorisation are also always acts of control, and in this they follow the dominant ideology of their time.

Whereas works such as "Extinction Series, Black Rhino with Head", 1989, saw the threat to the environment and to the abundance of species as a result of colonialism and industrialization, Dion's installations from the early 1990s onwards deal with the politics of representation, especially in the museums. In his role as a nature and field researcher Dion treats this problem in such works as "On Tropical Nature", 1991, "A Meter of Meadow", 1995, or "A Tale of Two Seas: An Account of Stephan Dillemuth's and Mark Dion's Journey along the Shores of the North Sea and Baltic Sea and What They Found There", 1996. With ironical exaggeration, Dion adduces the processes of collecting, curating, presenting and recording, and he carries current classification systems ad absurdum.

Pour Mark Dion, la « nature » est une construction culturelle, comme l'éclaire une citation accompagnant son portrait du zoologiste Georges Cuvier – « Taxonomy of Non-endangered Species », 1990, un écran de projection des conceptions humaines. Dion approche par plusieurs angles la question de la représentation de la nature. En ceci, il se rattache thématiquement et formellement à ce tournant historique des 17ème et 18ème siècles, lorsqu'à l'ordre subjectif de la chambre au trésor se substitua progressivement l'ordre rationnel du musée. Le musée d'histoire naturelle comme lieu de ces nouveaux systèmes de classification occupe de ce fait une place centrale dans son œuvre : les processus (scientifiques) de la désignation et du classement sont toujours entre autres des actes de contrôle – et sont de ce fait conformes à l'idéologie dominante de leur époque. Tandis que des œuvres comme « Extinction Series, Black Rhino with Head », 1989, mettaient en lumière

la menace qui pèse sur l'environnement et la diversité des espèces comme une conséquence du colonialisme et de l'industrialisation, les installations réalisées par Dion depuis le début des années 90 réfléchissent sur la politique de la représentation, en particulier celle qui se joue dans les musées. Endossant le rôle de l'explorateur (et voyageur) de la nature et du terrain, Dion circonscrit cette thématique dans des œuvres comme « On Tropical Nature », 1991, « A Meter of Meadow », 1995, ou « A Tale of Two Seas : An Account of Stephan Dillemuth's and Mark Dion's Journey Along the Shores of the North Sea and Baltic Sea and What They Found There », 1996. Avec un sens aigu de l'ironie, Dion pousse jusqu'à l'absurde les processus de la collecte, de la conservation, de la présentation et de l'archivage, de même que les systèmes de classification habituels. A. W

01 WHEN DINOSAURS RULED THE EARTH (TOYS 'Я' U.S.), 1995. Mixed media. Installation view, American Fine Arts, New York (NY), USA, 1995. **02 POLAR BEARS AND TOUCANS (FROM AMAZONAS TO SVALBARD)**, 1991. Stuffed toy polar bear, Sony Sports cassette player, cassette recorded in Venezuela-Amazonas territory, wash tub, tar, crate, orange electrical cord, 231 x 112 x 75 cm.

MARK DION

SELECTED EXHIBITONS: *1998* "Cabinet of Curiosities for the Wexner Center for the Arts", Wexner Center for the Arts, Columbus (OH), USA /// "The Tasting Garden", Storey Institute Lancaster, England /// *1999* "Two Banks (Tate Dig)", Tate Gallery, London, England /// "The Museum as Muse", The Museum of Modern Art, New York, (NY), USA **SELECTED BIBLIOGRAPHY** *1993 The Great Munich Bug Hunt*, Kunstraum Daxer, Munich, Germany /// *1997 Concrete Jungle, Dion*, New York /// *1998 Mark Dion*, London /// *Theatrum Mundi, Dion*, Cologne, Germany

03 **THE DEPARTMENT OF MARINE ANIMAL IDENTIFICATION OF THE CITY OF NEW YORK (CHINATOWN DIVISION),** 1992. Mixed media installation. Process view, American Fine Arts, New York (NY), USA, 1992. **04 LIFE RAFT (ZURICH),** 1995. Tree, leaves, plants, grass, stones, taxidermic animals, wooden bird house with shingles, wooden planks, metal barrels 3.5 x 3.5 x 4.5 m. Installation view, "Platzwechsel", Kunsthalle Zürich, Zurich, Switzerland, 1995. **05 THE LIBRARY FOR THE BIRDS OF ANTWERP,** 1993. 18 African finches, tree, cer mic tiles, books, photographs, birdcages, bird traps, chemical containers, rat and snake preserved in liquid, shot gun shells, axe, nets, Audubon prints, bird nests, wax fruit, assorte objects. Installation view, "On taking a normal situation", Museum van Hedendaagse Kunst, Antwerp, Belgium, 1993.

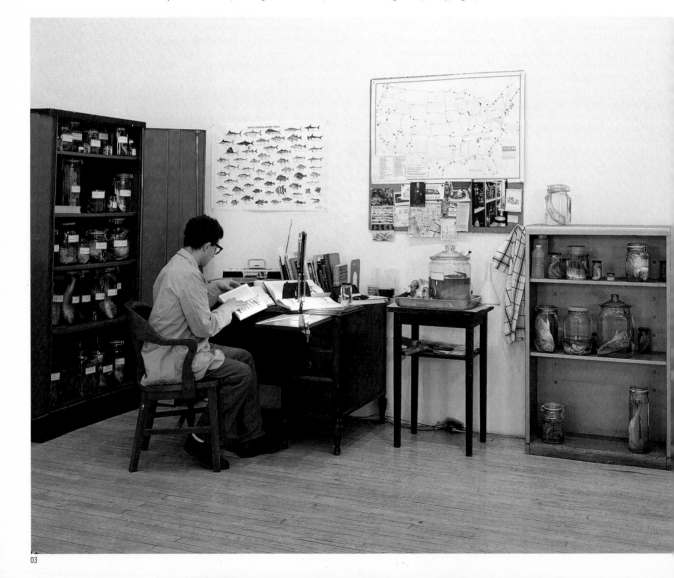

04

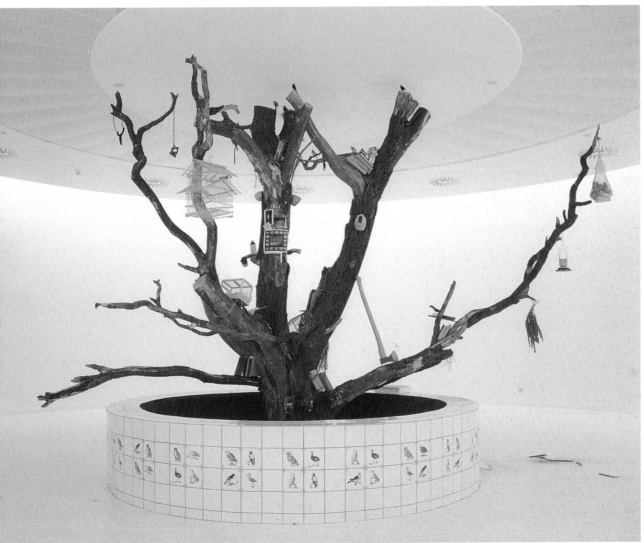

STAN DOUGLAS

"One of the most important things I learned from the different camps of conceptual artists in the 70s, and something they all shared, was that you don't need to use art material to make art." **« Une des choses les plus importantes que j'ai apprise des différents artistes conceptuels des années 70, et c'est quelque chose qu'ils avaient tous en commun, c'est qu'il n'est pas nécessaire d'utiliser du matériel d'art pour faire de l'art. »**

It could be said that Stan Douglas has set the standard for video art in the 1990s. Nothing in his films seems to be left to chance. His hallmark is the kind of perfection that does not betray the effort of its achievement and yet can be felt at every turn. The lighting, the colours and the sound effects are convincing, the narrative rhythm works, and the presentation is exact. This precision in the formal composition has its counterpart in the content itself. In his "Monodramas", 1991, Douglas condensed clichéd sequences from the TV world into 30-to-60-second pieces in which everything and yet nothing happens. In "Hors-champs", 1992, two black-and-white films of a free-jazz concert, taken with two cameras, are projected on both sides of a screen suspended loosely in the room. On the front of the screen is the final cut, while on the back is the material that was edited out. The first is more accomplished; the second more human. One wouldn't like to miss either of them. This idea of bringing together different levels in one work was continued in 1996 with the work, "Nu'tka". Pictures of the Canadian landscape run into one another line by line while voices emanate from loudspeakers, telling historical stories out of sync. It is only in the brief moments when the pictures melt into one another that the voices are synchronised, speaking the same text. One is rarely so conscious that one sees with two eyes and hears with two ears.

01

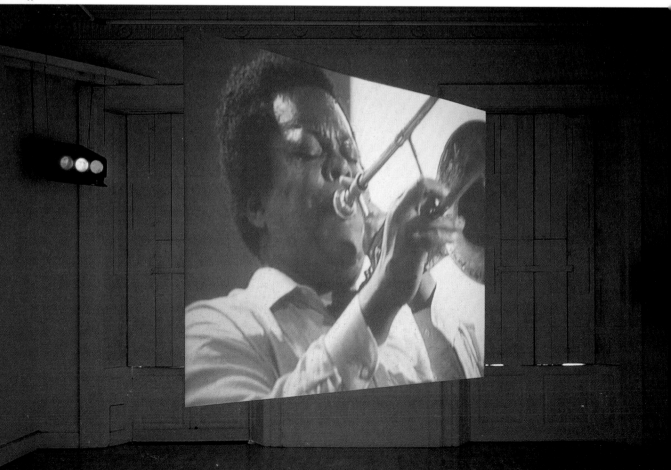

02

Rien ne semble laissé au hasard dans les vidéos de Stan Douglas.
n art se caractérise par une sorte de perfection qui ne laisse rien
ercevoir des moyens mis en œuvre, mais dont l'aboutissement total se
ssent à chaque seconde. Tout y est juste : la lumière, les couleurs et
s bruits ; le rythme de la narration fonctionne, la présentation est exacte.
râce à ce style impeccable et avec un nombre d'œuvres restreint,
ouglas a posé de nouveaux jalons pour l'art de la vidéo des années 90.
la précision de la composition formelle correspond une précision tout
ussi rigoureuse sur le plan du contenu. Dans les « Monodrames », 1991,
ouglas comprimait des séquences de clichés de l'audiovisuel en pièces
e 30 à 60 secondes, dans lesquelles tout a lieu et rien n'a lieu. Dans
Hors-champs », 1992, les films en noir et blanc d'un concert de free-jazz
nregistré à l'aide de deux caméras sont projetés sur un écran suspendu
dans le vide au milieu de la salle. La face avant de l'écran présente un
montage parfait, la face arrière les séquences qui n'ont pas servi. La
première réalisation est d'un effet parfaitement maîtrisé, la seconde est
plus humaine ; mais on ne souhaite se priver d'aucun des deux points de
vue. Douglas a encore perfectionné ce principe consistant à combiner
plusieurs niveaux dans un même travail. Dans « Nu'tka », 1996, les ima-
ges du paysage canadien se fondent linéairement, tandis que des voix
sortent de haut-parleurs dont les récits historiques se superposent à
l'image. Seulement pendant les courts instants où les images fusionnent
en une seule, les voix disent aussi le même texte en synchronie. Il est
rare que le spectateur prenne aussi nettement conscience qu'il a deux
yeux pour voir et deux oreilles pour entendre.
 C. B.

03

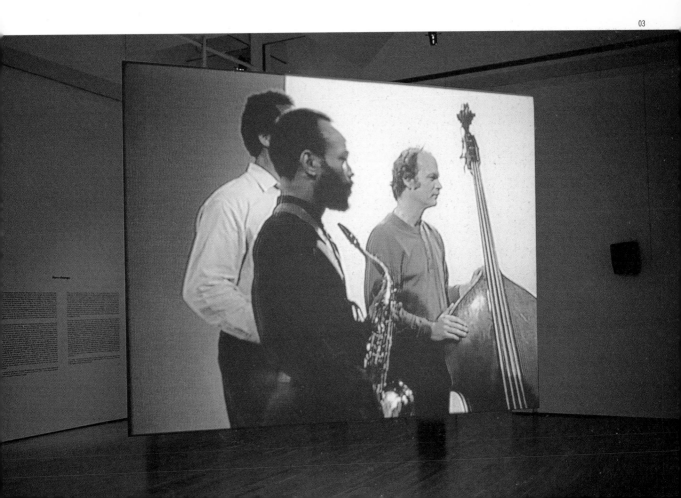

STAN DOUGLAS

SELECTED EXHIBITIONS: *1996* Musée d'Art Contemporain de Montréal, Montreal, Canada /// Museum Haus Lange – Museum Haus Esters, Krefeld, Germany /// *1997* documenta X Kassel, Germany /// Skulptur. Projekte in Münster 1997, Münster, Germany /// *1998* Salzburger Kunstverein, Salzburg, Austria /// *1999* Dia Center for the Arts, New York (NY), USA **SELECTE** **BIBLIOGRAPHY:** *1996 Stan Douglas. Potsdamer Schrebergarten. Der Sandmann*, Museum Haus Lange – Museum Haus Esters, Krefeld /// *Stan Douglas*, Musée d'Art Contemporain de Montréa **Montreal /// *1998 Stan Douglas*, London, England

04

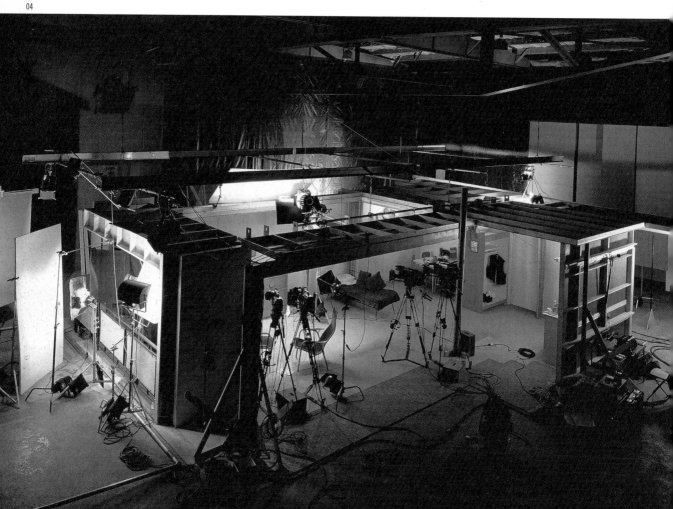

05 UNTITLED (SET FOR "WIN, PLACE OR SHOW"), 1998 (details). Cibachrome, 76 x 102 cm (each).

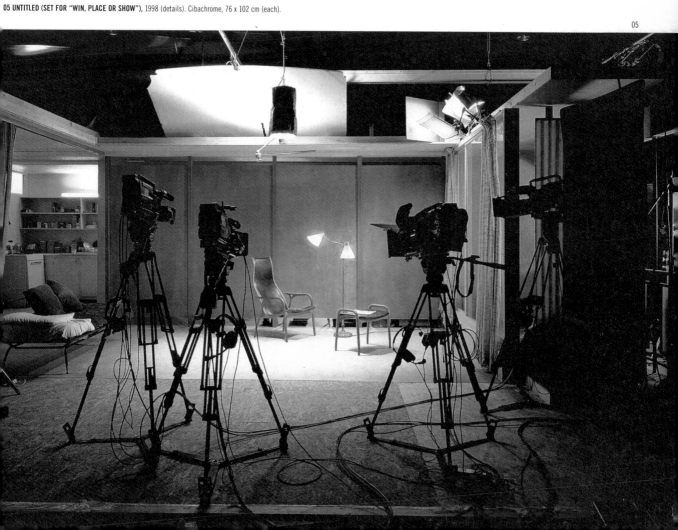

MARLENE DUMAS

1953 born in Capetown, South Africa / lives and works in Amsterdam, The Netherlan▮

"Art doesn't point fingers or serve 'the good'." **« L'art ne montre pas du doigt, il n'est pas au service du ‹bien›. »**

The representation of people is central to Marlene Dumas' paintings and drawings. The face attracts her special attention, and she regards this as the decisive focus of her compositions. She works from photographic material, either culled from magazines, as in the hundred-part "Models" series, 1994, or taken by herself, as with "The Painter", 1994, which is based on a photo of her daughter Helena. Other subjects for her – usually glazed – pictures are borrowed from the heritage of art history, like her series "Maria Magdalena", 1995. What most of these heterogeneous models have in common is that they already were and still are the objects of numerous gazes before undergoing Dumas' artistic treatment. She therefore concerns herself less with the recognisability of the subject than with the emotional effect produced by the pictures, avoiding the precise reproduction of details and pictorial backgrounds. She reflects both the status of the works as pictures and their percep-

tion by the viewer, who is always looking for meaning. She avoids com▮ mitting herself, although she tries to limit the possible interpretations ▮ her pictures through their titles, accompanying words and passages o▮ text in the pictures. One work of 1988, for example – the representatio▮ of a girl lying down and pulling up her skirt so that the viewer's glance falls between her legs – was entitled "Miss Interpreted". With this, she left it to her interpreters to decide how far pornographic or fetishist characteristics are to be found in her pictures. She has also distanced▮ herself from the view of some critics who saw in her portraits of colou▮ people (for instance in the installation "Black Drawings", 1991/92), an indictment of the position of blacks in South Africa. As Dumas said in ▮ interview in 1998: "Everyone has his own face, his own skin colour. W▮ interests me is what I see."

Au centre de l'œuvre pictural et graphique de Marlene Dumas se trouve la représentation de l'homme. Son attention porte plus parti-culièrement sur le visage, qu'elle considère comme le point d'attraction déterminant de ses travaux. Dumas travaille d'après des modèles photo-graphiques choisis dans des revues – comme dans les cent parties de son cycle « Models », 1994 – ou réalisés par elle-même, comme c'est le cas de « The Painter », 1994, qui s'appuie sur une photo de sa fille Helena. D'autres motifs de ses tableaux réalisés le plus souvent dans une technique de glacis, sont issus du fonds de l'histoire de l'art, par exemple pour la série « Marie-Madeleine », 1995. Tous ces modèles hétérogènes ont en commun qu'ils ont déjà été l'objet de nombreux regards, le sont encore, et qu'ils ne le deviennent pas seulement mainte-nant par le travail artistique de Dumas. Concernant ce point, le propos de l'artiste est moins la possibilité d'identification de la personne repré-

sentée que l'effet émotionnel produit par les tableaux : Dumas renonce▮ de ce fait à préciser les détails et les arrière-plans. Son travail est une réflexion sur le statut de l'œuvre en tant qu'image et sur sa perceptio▮ par un spectateur constamment en recherche de sens. La représenta-tion d'une jeune fille allongée, relevant sa jupe de sorte que le regard ▮ spectateur tombe sur son entrejambe, est intitulée « Miss Interpreted »▮ 1988. Dumas évite de se fixer, même si elle s'efforce de restreindre l▮ possibilités d'interprétation de ses tableaux par les titres, des textes d'accompagnement ou des citations. C'est ainsi qu'elle a pris ses dis-tances à l'égard de la conception de certains critiques qui voyaient da▮ ses portraits de gens de couleur une dénonciation de la situation des noirs en Afrique du Sud : comme le déclarait Dumas dans une intervie▮ de 1998, « chaque homme a son propre visage, sa propre couleur de peau – c'est ce que je vois, c'est ce qui m'intéresse. » A.

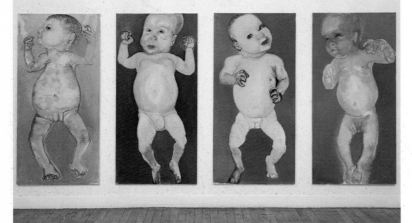

01 THE FIRST PEOPLE (I–IV) (THE FOUR SEASONS), 1990. Oil on canvas, 4 parts, 180 x 90 cm (each). 02 HET KWAAD IS BANAAL, 1984. Oil on canvas, 125 x 105 cr▮

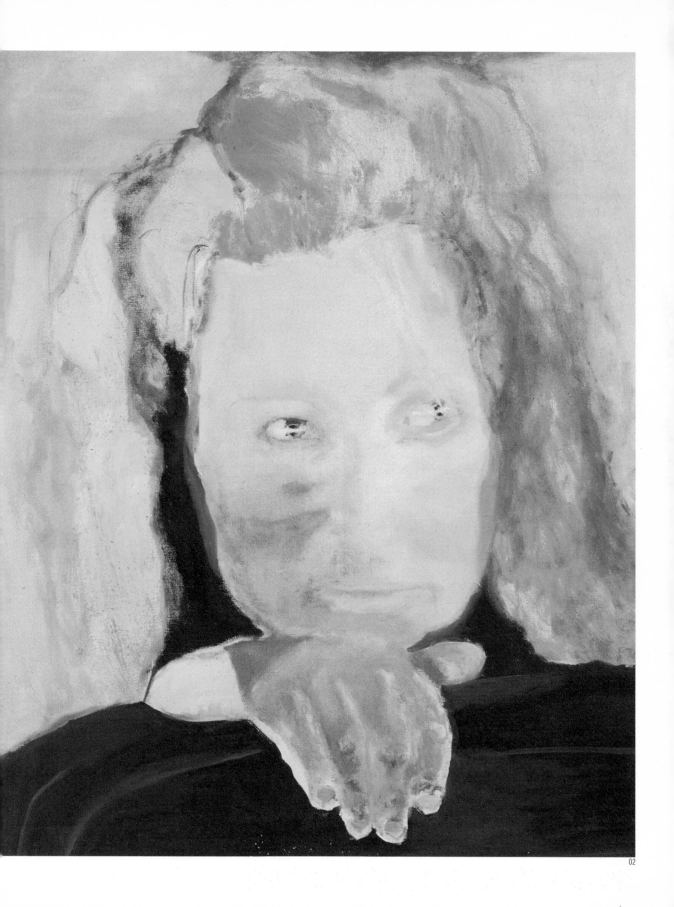

MARLENE DUMAS

SELECTED EXHIBITIONS: *1995* Portikus, Frankfurt/M., Germany /// *1995–1996* Johannesburg Biennial, Johannesburg, South Africa /// Carnegie International 1995, Carnegie, Pittsburgh (PA), USA /// *1996* Tate Gallery, London, England /// *1998* Museum für Moderne Kunst, Frankfurt/M. /// *1999* Museum van Hedendaagse Kunst Antwerpen, Antwerp, Belgium
SELECTED BIBLIOGRAPHY: *1992 Miss Interpreted*, Stedelijk Van Abbemuseum, Eindhoven, The Netherlands /// *1995 Marlene Dumas Models*, Salzburger Kunstverein, Salzburg, Austria /// *Marlene Dumas, Francis Bacon*, Malmö Konsthall, Malmö, Sweden /// *1999 Marlene Dumas*, London

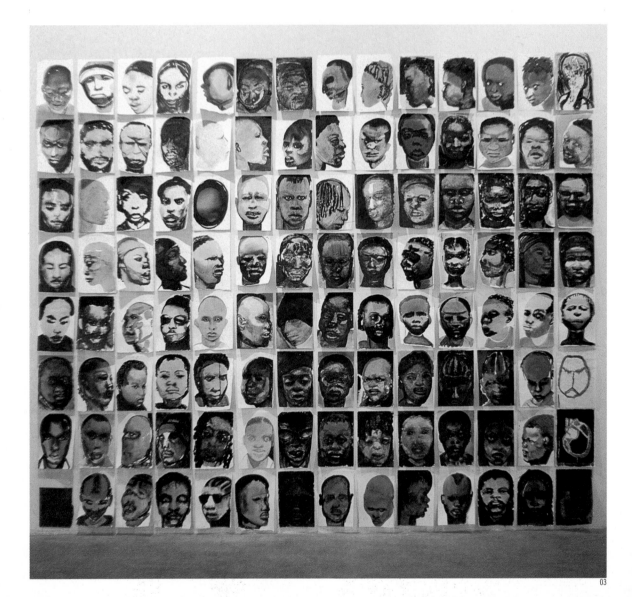

BLACK DRAWINGS, 1991/92. Mixed media on paper, 112 parts, 25 x 18 cm (each). **04 IVORY BLACK,** 1997. Oil on canvas, 200 x 100 cm. **05 MAGDALENA,** 1996. Ink on paper, 125 x 70 cm.

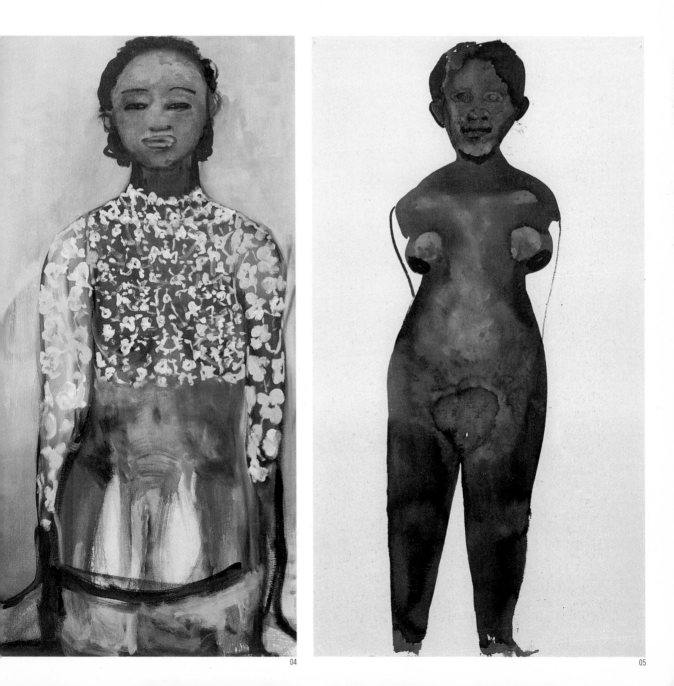

KEITH EDMIER

1967 born in Chicago (IL) / lives and works in New York (NY), US

"The process is always some kind of support. And I want to make things that make me feel better." « Le processus est toujours une sorte de soutien. **Et je veux faire des choses qui me font me sentir mieux. »**

The American sculptor Keith Edmier favours the narrative power of an identifiable objective realism over minimalism or abstraction. Before becoming an artist, he worked in films as a special-effects expert, and he uses these experiences in the images and metaphors he employs, sometimes to hyper-realistic effect, sometimes with biomorphic, surreal results. He deliberately obstructs unambiguous interpretations of his sculptures, but it can be assumed that a central aspect of his work is processing traumatic childhood experiences. Edmier's "Siren" of 1995, for example, a silver stand supporting two enlarged yellow megaphones made of synthetic resin, harks back to a factory siren that plagued Edmier with its deafening noise when he was a child in Chicago. The title

also recalls Odysseus's adventure with the beguiling but deadly song of the sirens. A network of allusions is the result, which mixes biographical components with historical and mythological narrative threads in a typically Postmodern style. The combination of different sources can also be traced in Edmier's sculpture "Jill Peters", 1997/98. The life-size, white wax figure no doubt represents an American high-school student, but the female figure in shorts and a roll-neck pullover is also adapted from a well-known sex symbol of the 1970s. Again, diverse myths of everyday life enter into an enigmatic symbiosis. "Jill Peters" might have sprung from a bewildering daydream, but it is also charged with a touch of sublime eroticism. That too, is typical of Edmier's work.

Plutôt que sur le minimalisme ou l'abstraction, le sculpteur américain Keith Edmier mise sur la charge narrative d'une figuration apparemment susceptible d'être reconnue. Edmier qui, avant d'entreprendre sa carrière d'artiste, a été un spécialiste des effets spéciaux au cinéma, se sert de l'expérience acquise dans ce domaine pour créer des inventions et des métaphores mises en scène de manière tantôt hyperréaliste, tantôt biomorphe et surréaliste. L'artiste rejette en cela toute interprétation univoque et sémantique de ses sculptures. Un aspect dominant de l'interprétation tourne néanmoins autour du travail sur les traumatismes de son enfance. La « Sirène » de Keith Edmier, 1995, un support argenté pourvu de deux pavillons acoustiques jaunes surdimensionnés en résine synthétique, fait référence à la sirène d'usine dont l'artiste entendit le hurlement pendant son enfance à Chicago. Le titre de

l'œuvre renvoie de plus à l'aventure d'Ulysse avec le chant séduisant, mais funeste, des sirènes. Il en découle une trame d'interrelations dont la stratégie typiquement post-moderne mêle les composantes biographiques de la sculpture et des éléments narratifs historiques et mythologiques. « Jill Peters », 1997/98, une autre sculpture d'Edmier, peut également être lue comme une combinaison de différents modèles. Le personnage en cire blanche représente certes l'écolière en grandeur nature d'une high school américaine, mais avec son short et son pullover à col roulé, cette figure féminine est aussi à l'image d'un célèbre sex-symbol des années 70. Une fois encore, différents mythes du quotidien entrent en symbiose. « Jill Peters », qui pourrait être issue d'une troublante rêverie, comporte en outre une note d'érotisme sublime, trai qui est également une caractéristique de l'œuvre de Keith Edmier. R.

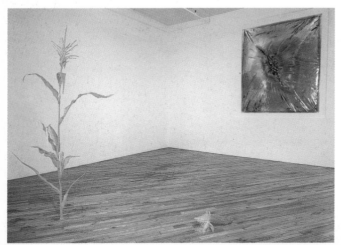

01 **NOWHERE (INSIDEOUT) AND BLISTER,** 1995. Installation view, Friedrich Petzel Gallery, New York (NY), USA, 1995. **02 SUNFLOWER,** 1996. Acrylic and polymer, 333 x 107 x 66 cm. Installation view, University of South Florida Contemporary Art Museum, Tampa (FL), USA, 1997.

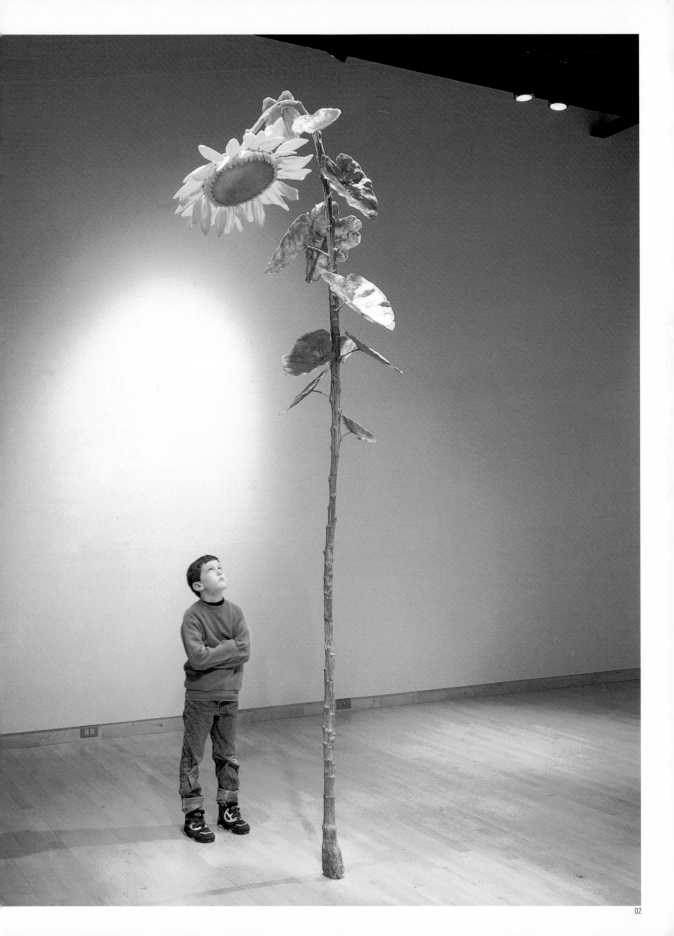

KEITH EDMIER

SELECTED EXHIBITIONS: *1993* Petzel/Borgmann Gallery, New York (NY), USA /// *1995* neugerriemschneider, Berlin, Germany /// *1997* University of South Florida Contemporary Art Museum, Tampa (FL), USA /// *1998* Douglas Hyde Gallery at Trinity College, Dublin, Ireland /// Sadie Coles HQ, London, England /// *1999* Friedrich Petzel Gallery, New York **SELECTED**
BIBLIOGRAPHY: *1997 Exhibition catalogue*, University of South Florida Contemporary Art Museum, Tampa /// *1998 Keith Edmier*, Douglas Hyde Gallery at Trinity College, Dublin

03 JILL PETERS & VICTORIA REGIA (FIRST NIGHT BLOOM), 1998. Installation view, Metro Pictures, New York (NY), USA, 1998. **04 SIREN,** 1995 (foreground). Aluminium, resin, lacquer, 235 x 240 x 65 cm. **NOWHERE (YELLOW),**1995 (background, detail). Resin, 195 x 165 cm. Installation view, neugerriemschneider, Berlin, Germany, 1995. **05 VICTORIA REGIA (SECOND NIGHT BLOOM) & VICTORIA REGIA (FIRST NIGHT BLOOM),** 1998. Polyester resin, silicone rubber, acrylic, polyurethane, pollen, steel, 284 x 325 x 338 cm (each).

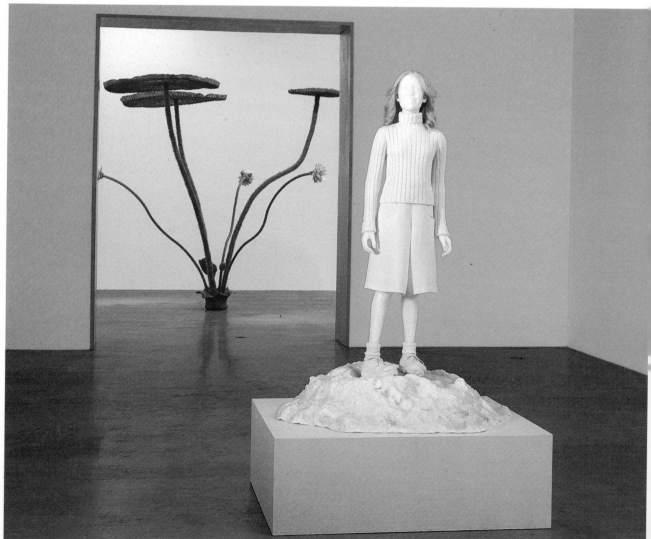

04

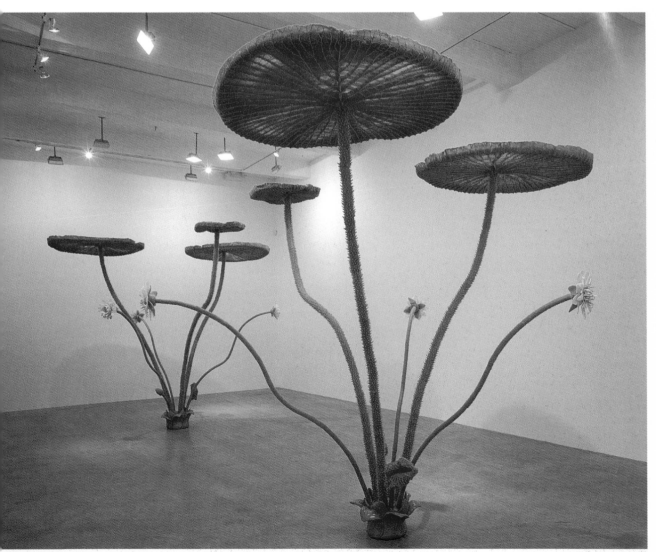

05

OLAFUR ELIASSON

"For me a romantic idea or vision expresses a sort of belief in the worthwhileness of making art today, with a somewhat optimistic and anti-apocalyptic content." « Pour moi, une idée ou une vision romantique est l'expression de la croyance que cela vaut la peine de faire de l'art aujourd'hui avec un peu d'optimisme et de contenu anti-apocalyptique. »

Olafur Eliasson's "Beauty", 1993, is a perforated hosepipe emitting water and illuminated by a light. From certain angles the viewer is able to see a rainbow. In this early installation, some of the fundamental elements in Eliasson's work are already visible. Among them is his presentation or imitation of natural phenomena as art, while at the same time obviously revealing the technique used to recreate it without diminishing the impressively subtle effect. Eliasson is not primarily interested in the distinction between nature and machine but in the viewer's relationship to both. Just how fleeting the effects of his apparatuses can be, is seen in the way he projects stroboscopic light on to a water fountain, creating the impression that, for a few seconds, the water stands weightless and frozen in the air. However, he does not confine himself to optical phenomena. In his installation "The Curious Garden" (Kunsthalle Basel, 1997), he bathed a large, empty room in yellow light. The result was that no other colours could be perceived because of their different specific wavelengths. A narrow passage, a kind of small-scale arbour covered with a blue tarpaulin, led into a little room containing a blackthorn hedge. Cool air was supplied by an open window and a ventilator hanging from the ceiling. Again and again, using elements such as light, cold, heat, water and wind, Eliasson calls forth in the viewer an alternating range of rational reflections and spontaneous emotions.

Le travail « Beauty », 1993, d'Olafur Eliasson consiste en un tuyau d'arrosage crevé par les trous duquel s'écoule de l'eau. Ce tuyau est éclairé de manière que sous certains angles, le spectateur aperçoit un arc-en-ciel. Dans cette installation déjà ancienne, on pouvait relever quelques traits caractéristiques de l'œuvre d'Eliasson. Parmi ceux-ci, il convient de mentionner la présentation, plus exactement la reproduction de phénomènes naturels dans le contexte de l'art, accompagnée d'une mise à nu de la technique employée, qui est le plus souvent aisée à saisir, ce qui ne diminue en rien la beauté sublime de l'impression produite. Le propos premier d'Eliasson n'est pas la différence entre nature et machine, mais la réflexion sur le rapport entre le spectateur et ces deux domaines. La fugacité des résultats de ses appareils apparaît très clairement lorsque Eliasson projette une lumière stroboscopique sur une fontaine, produisant ainsi le sentiment que l'eau se fige dans l'air en un moment d'apesanteur. Cependant, le travail d'Eliasson ne se limite pas aux phénomènes d'ordre optique. Dans une installation comme « The Curious Garden » (Kunsthalle Basel, 1997), il plonge une salle vide dans une lumière jaune, ce qui empêche de percevoir certaines couleurs en raison de leur fréquence. Un corridor exigu, sorte de tonnelle basse couverte d'une bâche bleue, mène le spectateur jusqu'à une petite pièce où se trouve un buisson de prunellier. Dans la salle suivante, une fenêtre ouverte et un ventilateur suspendu assurent une arrivée d'air frais. Et toujours des facteurs tels que la lumière, le froid, la chaleur, l'humidité et le vent permettent à Eliasson de soumettre le spectateur à une douche écossaise de réflexions rationnelles et de sentiments spontanés.

Y. D.

01 / 02 / 03 / 04 THE CURIOUS GARDEN. Installation view, Kunsthalle Basel, Basle, Switzerland, 1997.

OLAFUR ELIASSON

SELECTED EXHIBITIONS: *1996* Malmö Museet, Malmö, Sweden /// *1997* "The Curious Garden", Kunsthalle Basel, Basle, Switzerland /// *1998* Galerie für Zeitgenössische Kunst Leipzig, Leipzig, Germany /// São Paulo Biennial, São Paulo, Brazil /// Sydney Biennial, Sydney, Australia **SELECTED BIBLIOGRAPHY:** *1997* The Curious Garden, Kunsthalle Basel, Basle //. *1998 User*, São Paulo Biennial, São Paulo

05

07

08

09

05 **RAIN PAVILION,** 1998. Steel, sprinkler, water. Installation view, Kjarvalstadir Museum Iceland, Reykjavik, Iceland, 1998. **06 THOKA,** 1995. Light, fog. Installation view, Kunstverein in Hamburg, Hamburg, Germany, 1995. **07 YOUR WINDLESS ARRANGEMENT,** 1997. Ventilators, wood. Installation view, "New Art from Denmark and Skåne", Louisiana Museum of Modern Art, Humlebæk, Denmark, 1997. **08 REMOTE CONNECTIONS,** 1996. Light. Installation view, Neue Galerie, Graz, Austria, 1997. **09 YOUR STRANGE CERTAINTY STILL KEPT,** 1996. Water, strobe lighting, sprinkler, dimensions variable. Installation view, Tanya Bonakdar Gallery, New York (NY), USA, 1996.

TRACEY EMIN

1963 born in London / lives and works in London, England

"I really cannot carry on living with all that stuff stuck inside of me." « Je ne peux vraiment pas continuer de vivre avec toutes ces choses que j'ai en moi. »

"Happy as an adolescent girl – I wish". A happy youth would have been lovely, but since it wasn't like that, Tracey Emin channels the resulting fury, sadness and bruised ego into her works. The facts of her life story are presented with a sharp directness – whether the loss of her virginity at the age of 13 through rape ("Exploration of the Soul", 1993), or the names of all the people she has ever shared a bed with ("Everyone I Have Ever Slept With 1963–1995", 1995). Symbols of salvaged passionate and painful experiences, the names were embroidered on the inside of a tent, which represented both shelter and restlessness. Her memories provide her material, the form dictated by her living them down. She has sewn names, words, whole texts onto fabrics or cushions in a manic gesture of inner integration. These pieces and her videos, her journeys of remembrance to the scenes of her youth, bring to light a long-forgotten function of art that emerges so abruptly that it upsets. It is, as Emin herself has often emphasised, spiritual. "Exorcism of the Last Painting I Ever Made", 1997/98, was a gallery presentation of her studio: sketches, paintings, texts, everyday odds and ends, photos, souvenirs, a cassette recorder, books, a bed and underwear on clothes lines. During the opening she sat on the bed, conducting on video an ecstatic painting performance, an exorcism with paint and the naked body. Emin's exhibitionism is less embarrassing than it is stimulating and constructive. Memorable and intense, her work poses the question of the meaning of art today.

01 FANTASTIC TO FEEL BEAUTIFUL AGAIN, 1997. Neon, 107 x 127 x 10 cm.
02/03 WHY I NEVER BECAME A DANCER, 1995. Video projection and sound,
6 mins., 40 secs. 04 EVERYONE I HAVE EVER SLEPT WITH 1963–1995,
1995. Appliquéd tent, mattress and light, 122 x 245 x 215 cm.

02

03

«Happy as an adolescent girl – I wish». Une jeunesse heureuse eut été une belle chose. Mais il n'en fut rien. C'est donc sur ses œuvres que Tracey Emin reporte sa colère, sa tristesse et sa frustration. Elle présente les faits de son histoire personnelle avec une immédiateté sans concessions : défloration – violée – à l'âge de 13 ans («Exploration of the Soul», 1993), ou les noms de tous les gens avec qui elle s'est retrouvée dans un même lit («Everybody I Ever Slept With», 1963–1995, 1995). Emblèmes d'expériences cachées, passionnées et douloureuses, ils furent réunis sur les murs intérieurs d'une tente de voyage qui symbolisait en même temps la chaleur du nid et le nomadisme. Les souvenirs sont le matériau, leur maîtrise fournit la forme : dans un travail obsessionnel sur soi, les noms, les mots, des textes entiers furent cousus sur des tissus ou collés sur des caisses. Ces pièces, mais aussi les vidéos réalisées par Emin, ses voyages commémoratifs sur les lieux de sa jeunesse, font émerger une fonction longtemps oubliée de l'art, qui est exprimée de façon si brusque qu'elle nous atteint de plein fouet. Comme Emin l'a souvent souligné, cette fonction est d'ordre spirituel. Le titre d'une mise en scène d'exposition dans son atelier a ainsi été «Exorcism Of the Last Painting I Ever Made», 1997/98 : croquis, tableaux, textes et bric-à-brac quotidien, photographies, souvenirs, un radiocassette, des livres, un lit et des pinces à linge avec des sous-vêtements. Pendant l'inauguration, Emin elle-même était assise sur le lit, présentant en vidéo une performance picturale extatique, exorcisme à coup de couleurs et de corps nu. L'exhibitionnisme d'Emin n'a rien d'embarrassant. Il est plutôt provocant et constructif, et pose d'une façon remarquablement intense la question du sens de l'art aujourd'hui. S. T.

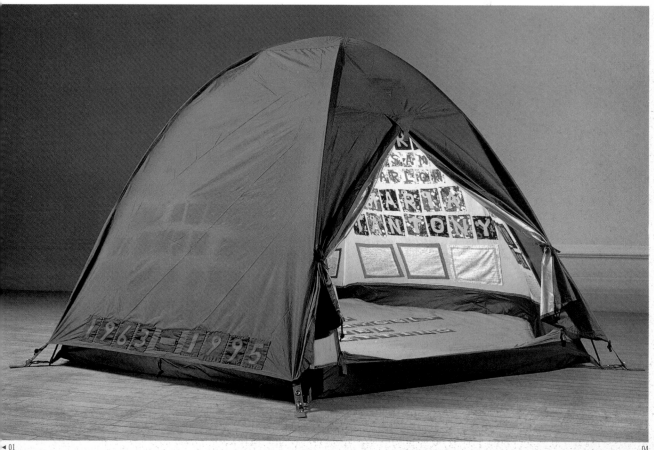

◄ 01

04

TRACEY EMIN

SELECTED EXHIBITIONS: *1994* "My Major Retrospective", White Cube, London, England /// *1997* "Sensation", Royal Academy of Arts, London /// *1997–1998* "I Need Art Like I Need God", South London Gallery, London; Neues Museum Weserburg, Bremen, Germany /// *1998* Sagacho Exhibition Space, Tokyo, Japan **SELECTED BIBLIOGRAPHY:** *1997 Always Glad to See You*, London /// *1998 Tracey Emin. Holiday Inn*, Gesellschaft für Aktuelle Kunst, Bremen /// *Tracey Emin*, White Cube, London

05

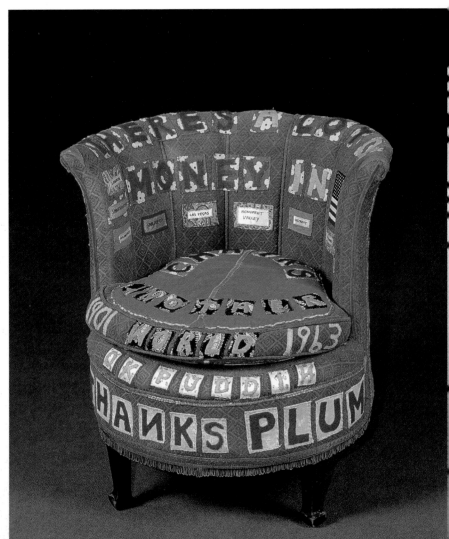

06

5 MONUMENT VALLEY (GRAND SCALE), 1995. Photograph on vinyl, 122 x 183 cm. 06 THERE'S A LOT OF MONEY IN CHAIRS, 1994. Appliquéd armchair, 9 x 54 x 50 cm. 07 I USE TO HAVE A GOOD IMAGINATION, 1997. Monoprint, 59 x 73 cm. 08 WHAT THE FUCK DO YOU KNOW, 1997. Monoprint, 59 x 79 cm. 9 EXORCISM OF THE LAST PAINTING I EVER MADE. Installation view, "Ca-Ca Poo-Poo", Kölnischer Kunstverein, Cologne, Germany, 1997/98.

07 / 08

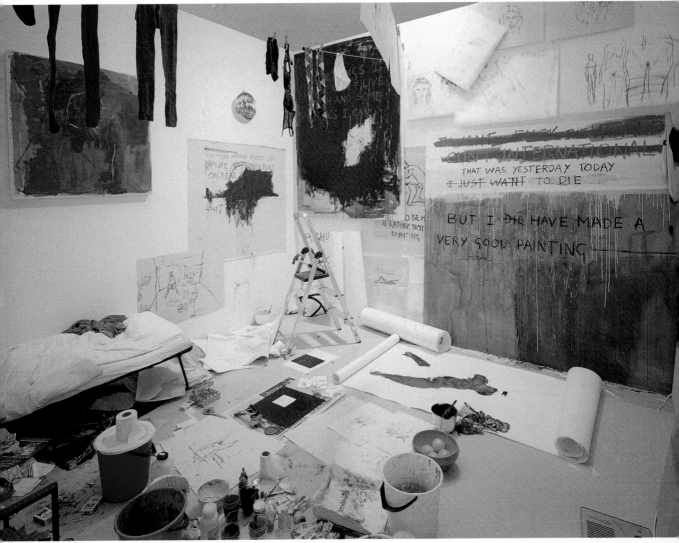

PETER FISCHLI/DAVID WEISS

Peter Fischli
1952 born in Zurich, Switzerland
David Weiss
1946 born in Zurich, Switzerland
Both live and work in Zurich

David Weiss: "Usually we decide to get down to work the next day. Then about ten we meet up in some café, and go from there to the studio…" Peter Fischli: "… and talk." **David Weiss:** « Ordinairement, nous décidons de ne travailler que le lendemain. A dix heures, nous nous rencontrons dans un café, puis, nous allons à l'atelier… » **Peter Fischli:** « … et on se met à parler. »

The world of Peter Fischli and David Weiss is the world of the mundane. But they take it very seriously, analyse it, reproduce it, and in doing so, modify it a little before placing it in a new guise in an artistic context. This process is echoed in the title of their best-known video film, "Der Lauf der Dinge" (The Way Things Go), 1985–1987, presented with a mischievous smile. Just as the film shows the chain reactions that follow a set experimental order but are still fraught with hidden risk, so their art deals with chain reactions that take place when artists begin to explore the world. Their creations are disconcerting, because they are so closely linked to the materials employed. At first, the world seemed to be arranged in little clay scenarios, then a series of rubber objects appeared, and finally the artists produced large, spatial installations made of hard foam-plastic, lovingly and realistically painted. The works always pretended to be objects, often placed irrelevantly in group exhibitions, looking like things that had been mislaid. But anyone who wanted to see was drawn to them by some mysterious attraction. Then, over the last few years, Fischli/Weiss moved away from the world of objects and ever closer to the world of banal images. They photographed tourist attractions, airports, mountains, and snapped and filmed in distant countries as though they were tourists. But this stance was a pretence: in fact what they produced was top-quality art disguised as amateur material. These pictures now feature in two-hour video loops, leisurely fading from one picture to the next. What we see may be banal, but the perception with which it has been taken is magnificent.

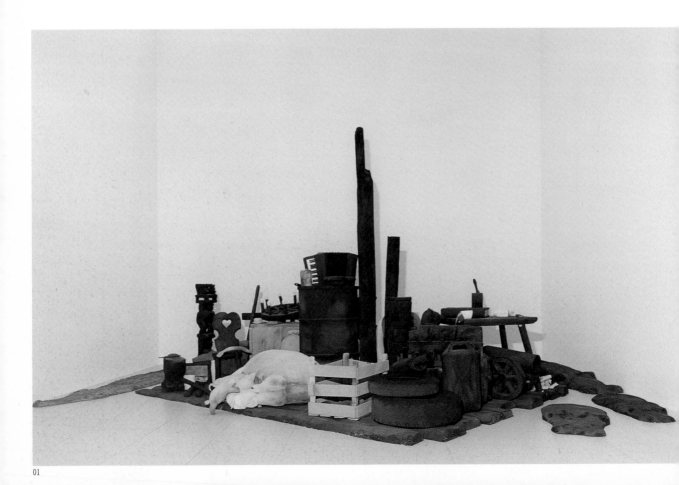

1 DAS FLOSS, 1982. Polyurethane foam, painted, c. 500 x 300 x 350 cm. Installation view. 02 KÄSTCHEN, 1987. Rubber (Beracryl). 03 SCHALL-PLATTE, 1989. Acryl, ø 30 cm. 04 TISCH, 1992/93. Table with c. 750 polyurethane objects, 76 x 330 x 900 cm. Installation view, "check in! eine Reise im Museum für Gegenwartskunst", Museum für Gegenwartskunst Basel, Basle, Switzerland, 1997/98.

02

03

Le monde de Peter Fischli et David Weiss est celui du quotidien. Mais les deux artistes prennent ce quotidien très au sérieux ; ils l'analysent et le reproduisent pour le transformer et le réintroduire légèrement modifié dans le contexte de l'art. C'est là – pour citer le titre du plus célèbre film vidéo de Fischli/Weiss – «Le cours des choses», 1985–1987, lequel nous est présenté avec un sourire complice. De même que ce film traite de réactions en chaîne qui suivent une procédure expérimentale définie tout en ménageant encore un facteur de risque, leur art traite des réactions en chaîne qui se déclenchent lorsque des artistes se mettent à explorer le monde. Ils irritent avec des interventions minimes ou par les matériaux qu'ils utilisent : le monde semblait ordonné en petites scènes de terre cuite, puis est apparue une série d'objets en caoutchouc, et pour finir, les deux artistes ont produit de grandes installations en mousse synthétique légère, peinte avec grand soin et de manière

réaliste. Les objets simulent toujours leur propre caractère d'objet ; souvent, ils sont là, totalement insignifiants dans des expositions de groupes. Ils se présentent comme des choses qu'on oublie. Mais celui qui veut voir en est toujours attiré comme par magie. Au cours des dernières années, Fischli/Weiss, partis du monde des objets, se sont de plus en plus fortement rapprochés du monde des images banales, photographiant des hauts lieux touristiques, des aéroports, des montagnes, prenant des photos ou filmant dans des pays lointains comme s'ils étaient des touristes. Mais cette démarche est seulement celle du regard ; eux-mêmes produisent en fait du faux matériel d'amateur de la meilleure qualité artistique. Ces images se retrouvent aujourd'hui dans d'interminables vidéos de deux heures, dans lesquelles on passe lentement d'une image à l'autre. Ce qu'on y voit est une fois encore banal ; le regard qui l'a capté est néanmoins grandiose. C. B.

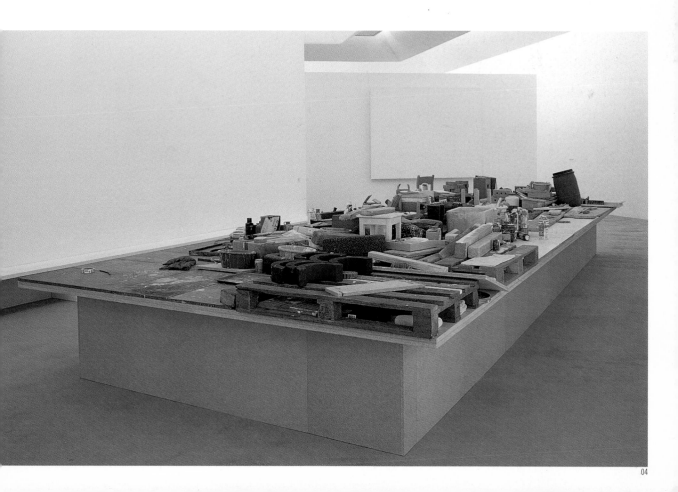

PETER FISCHLI/DAVID WEISS

SELECTED EXHIBITIONS: *1987* Skulptur Projekte in Münster 1987, Münster, Germany /// documenta 8, Kassel, Germany /// *1992* Musée national d'art moderne, Centre Georges Pompidou, Paris, France /// *1996–1997* "In a Restless World", Walker Art Center, Minneapolis (MN), USA; Serpentine Gallery, London, England; Kunsthaus Zürich, Zurich, Switzerland
SELECTED BIBLIOGRAPHY: *1987 Peter Fischli/David Weiss*, MIT–List Visual Arts Center, Cambridge (MA), USA; Institute of Technology Cambridge, Cambridge /// *1992 Peter Fischli et David Weiss*, Musée national d'art moderne, Centre Georges Pompidou, Paris /// *1995 Peter Fischli/David Weiss, Raum unter der Treppe*, Museum für Moderne Kunst, Frankfurt/M.; Stuttgart, Germany /// *1998 Arbeiten im Dunkeln*, Kunstmuseum Wolfsburg, Wolfsburg, Germany

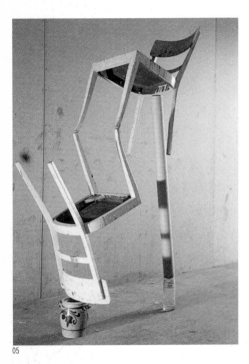

05

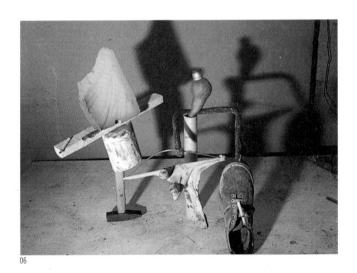

06

05 DIE GESETZLOSEN (FROM: STILLER NACHMITTAG), 1984/85. Colour photograph. 06 FRAU BIRNE BRINGT IHREM MANN VOR DER OPER DAS FRISCHGEBÜGELTE HEMD.
DER BUB RAUCHT (FROM: STILLER NACHMITTAG), 1984/85. Colour photograph. 07 DER LAUF DER DINGE, 1985–1987. Film stills, 16 mm. 08 DER UNFALL (FROM: WURSTSERIE),
1979. Colour photograph. 09 IN DEN BERGEN (FROM: WURSTSERIE), 1979. Colour photograph.

07

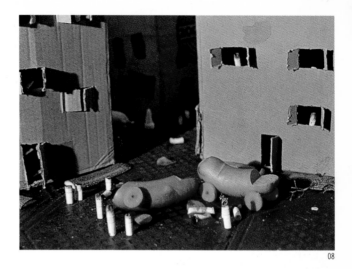

SYLVIE FLEURY

1961 born in Geneva / lives and works in Geneva, Switzerland

"I show things as they are. In this way I also exhibit the instruments and mechanisms that make them what they are." « Je montre les choses telles qu'elles sont. Et de cette manière, j'expose aussi les instruments et mécanismes qui font d'elles ce qu'elles sont. »

Sylvie Fleury is super-elegant in appearance. She is always expensively well-dressed, radiating a luxury that is like something from the advertising world come to life. Just as naturally, she presents the attributes of luxury as works of art. She exhibits collections of ladies' shoes, the carrier bags of exclusive boutiques, works in neon lettering with advertising slogans for wickedly expensive skin creams, or builds huge rockets to Venus covered with shaggy fur. Both her appearance and her works give the impression that she is quite unable to distance herself from the glittering world of consumerism. She thwarts the general expectation that artists should, on principle, behave critically towards our commercial consumer society. Sooner or later this throws up the question of whether she is really so naive or whether perhaps there is more to this work than meets the eye. And this is the point at which her subtle provocation comes into play. By transferring desirable accessories such as Chanel perfumes into the context of art, she gives the impression that she places them on the same level as art itself. In art, as in cosmetics, there are considerable differences in quality, and the awareness of this is steered by marketing initiatives. The art market is small in comparison with that for luxury goods, but the criteria that determine success or failure suddenly seem very similar in the light of Fleury's world.

Sylvie Fleury est une personnalité hyper-élégante. Toujours richement vêtue, il émane d'elle un luxe qui fait l'effet d'un monde publicitaire devenu réalité. Et c'est avec le même naturel qu'elle présente les attributs de ce monde de luxe comme son œuvre personnelle. Elle expose des collections entières de chaussures de femme, les pochettes et les sacs des boutiques les plus en vue, écrit au néon des slogans publicitaires pour des crèmes cosmétiques hors de prix ou construit d'immenses fusées pour Vénus habillées d'une fourrure moelleuse. Son comportement et ses œuvres donnent à croire qu'elle n'a pas la moindre distance à l'égard du monde étincelant des produits commerciaux. Sylvie Fleury déjoue ainsi l'attente habituelle selon laquelle les artistes auraient à occuper une position fondamentalement critique à l'égard de la société de consommation. Tôt ou tard, ce comportement appelle la question de savoir s'il s'agit d'une naïveté de sa part ou s'il y a là quelque chose de plus. C'est précisément à ce stade qu'entre en jeu une provocation subtile. En transposant les accessoires séduisants dans le contexte de l'art sans rien leur ôter de leur séduction, Sylvie Fleury donne l'impression de mettre les parfums de Chanel sur le même plan que l'art. Dans les domaines de l'art comme des cosmétiques, il existe d'importantes différences de qualité ; le marketing prend toutes les dispositions nécessaires pour les faire percevoir. Comparé à celui des articles de luxe, le marché de l'art est sans doute plutôt restreint, mais les structures qui décident du succès ou de l'échec semblent soudain très similaires lorsqu'on regarde le monde de Fleury.

C. B.

01

02

03

01 LONDON, 1991. Various shopping bags with content. Installation view, "Vital Perfection", Galerie Philomene Magers, Bonn, Germany, 1991. **02 COCO,** 1990. Mixed media, dimensions variable. **03 KEEP IT SIMPLE,** 1992. Photograph, 160 x 120 cm. **04 MOISTURIZING IS THE ANSWER,** 1996. Neon, 14 x 250 cm. **FIRST SPACE-SHIP ON VENUS,** 1996 (right and left). Installation view, Mehdi Chouakri, Berlin, Germany, 1996. **05 BEDROOM ENSEMBLE,** 1997. Artifical fell, wood construction. Installation view, Mehdi Chouakri, Berlin, 1997.

04

05

SYLVIE FLEURY

SELECTED EXHIBITIONS: *1995* "Glamour", Museum of Contemporary Art, Chicago (IL), USA /// "Bahnwärterhaus", Galerie der Stadt Esslingen, Esslingen/N., Germany /// *1996* "First Spaceship on Venus", Musée d'Art Moderne et Contemporain, Geneva, Switzerland /// *1998* São Paulo Biennial, São Paulo, Brazil /// Migros Museum für Gegenwartskunst Zürich, Zurich, Switzerland **SELECTED BIBLIOGRAPHY:** *1991 Vital Perfection*, Galerie Philomene Magers, Bonn, Germany /// *1993 The Art of Survival*, Neue Galerie am Landesmuseum Joanneum, Graz, Austria /// *1996 First Spaceship on Venus*, Musée d'Art Moderne et Contemporain, Geneva; Mehdi Chouakri, Berlin, Germany /// *1998 Exhibition catalogue*, Migros Museum für Gegenwartskunst Zürich, Zurich

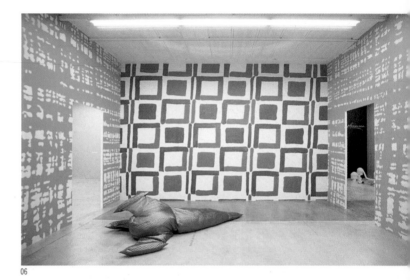

06

07

SPRING SUMMER, 1996 (background). Acrylic paint on wall, dimensions variable. **FIRST SPACESHIP ON VENUS,** 1995 (foreground). Installation view, Musée d'Art Moderne et ntemporain, Geneva, Switzerland, 1996. **07 UNTITLED,** 1997. Acrylic paint on wall, dimensions variable. Installation view, "Spring", Galerie Philomene Magers, Cologne, Germany, 97. **08 SKIN CRIME NO. 303,** 1997 (foreground); **SKIN CRIME NO. 601,** 1997 (background). Car, car painting, c. 390 x 190 x 50 cm (each). Installation view, Galerie Bob van Orsouw, rich, Switzerland, 1997.

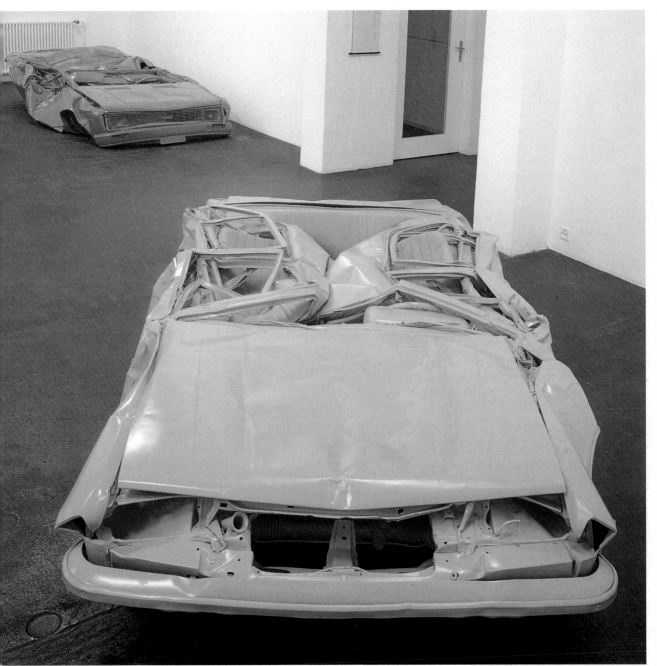

GÜNTHER FÖRG

"What I like doing is reacting to things." **« J'aime réagir à des choses. »**

The painter, photographer and sculptor Günther Förg sprints through the ideas of Modernism in art at a fair lick, while at the same time giving them a workover. Piet Mondrian, the Bauhaus and the Russian avant-garde at the beginning of this century, but also more contemporary figures such as Barnett Newman, Jean Fautrier and the legendary film-maker Jean-Luc Godard, are as it were the "ancestors" of his art, which often takes the form of closely related installations. This artistic strategy of conscious quotation from the past became apparent in one of his first important museum exhibitions, at the Museum Haus Lange in Krefeld in 1987. Monochrome wall paintings, echoing in their coloring the Wittgenstein House in Vienna, were translated by Förg on to the architecture of Mies van der Rohe. Lively debate ensued concerning the two architectural concepts. Likewise in painting, e.g. his numerous grid paintings of the

1990s reminiscent of the New York works of Mondrian's late period, Förg quotes examples from the classic moderns. He ridicules their unbroken authority in a colloquial, rapid, almost slipshod translation. This critical approach is accentuated in many of Förg's photographic works. An example is the "Architektur Moskau 1923–1941" (Moscow Architecture) series of 1995. Here, he photographed Moscow's badly deteriorating avant-garde architecture as though he were a dispassionate passer-by. Cutting is almost left to chance, and the contours are sometimes fuzzy, but these thirty photos tell of the failure of a utopia. Typically for Förg, they also possess a memorable beauty. In their casual gestural treatment of surfaces, Förg's – usually bronze – sculptures bear witness to a state of transience, which has given rise to his reputation as "a stroller through Modernism".

Le peintre, photographe et sculpteur Günther Förg suit en quelque sorte un parcours accéléré à travers l'art moderne, dont il soumet en même temps le projet à une révision. Piet Mondrian, le Bauhaus et l'avant-garde russe du début du 20e siècle, mais aussi Barnett Newman, Jean Fautrier et le cinéaste légendaire Jean-Luc Godard sont un peu les ancêtres de son art souvent étroitement lié à l'installation. Cette stratégie artistique de la réactualisation consciente est apparue très clairement dès une de ses premières grandes expositions, en 1987 au Museum Haus Lange de Krefeld. Des peintures murales monochromes dont le chromatisme s'appuyait sur celui de la maison Wittgenstein à Vienne, avaient été transposées dans l'architecture de Mies van der Rohe, instaurant un dialogue entre deux concepts architecturaux contradictoires. Dans sa peinture aussi, par exemple dans ses nombreuses « grilles » des années 90, qui rappellent entre autres les peintures new-

yorkaises de Mondrian vers la fin de sa vie, Günther Förg aime citer des modèles classiques de l'art moderne, et il se moque de leur intacte autorité dans une transposition « en langage courant », rapide et presque désinvolte. Cette approche critique resurgit de manière plus exacerbée dans ses nombreuses œuvres photographiques, par exemple dans une série comme « Architecture Moscou 1923–1941 », 1995. Comme sans y prêter d'attention particulière, Förg a ainsi photographié l'architecture de l'avant-garde moscovite, aujourd'hui gravement endommagée par le temps. Le cadrage des images est presque laissé au hasard et les contours sont parfois flous – les trente photos de la série parlent de l'échec d'une utopie. Pourtant, elles sont d'une saisissante beauté. Il en va de même pour les sculptures de l'artiste, le plus souvent des bronzes, dont le traitement désinvolte et gestuel de la surface illustre l'éphémère, ce qui a valu à Förg sa réputation de « flâneur à travers l'art moderne ». R. S

01

GÜNTHER FÖRG

SELECTED EXHIBITIONS: *1988* The Renaissance Society at the University of Chicago, Chicago (IL), USA /// *1991* Musée d'Art Moderne de la Ville de Paris, Paris, France /// *1992* documenta 9, Kassel, Germany /// *1995* "Günther Förg – Paintings 1974–1994", Stedelijk Museum, Amsterdam, The Netherlands /// *1996* Kunstmuseum Luzern, Lucerne, Switzerland /// *1998* Museo Nacional Centro de Arte Reina Sofía, Madrid, Spain **SELECTED BIBLIOGRAPHY:** *1990 Günther Förg*, Wiener Secession, Vienna, Austria /// *1993 Günther Förg: Fotografien 1982–199.* BDA, Frankfurt/M.; Stuttgart, Germany /// *1996 Günther Förg*, Kunstverein Hannover, Hanover, Germany /// *1997 Günther Förg – IG Farben-Haus Frankfurt/M.*, Galerie Bärbel Grässlin, Frankfurt/M

04

KATHARINA FRITSCH

"Anyone should be the audience. Anyone should be able to look at my images and I think that anyone can understand them as well." **« Le public, cela devrait englober tout le monde Tout le monde devrait pouvoir regarder mes images, et je crois aussi que tout le monde peut les comprendre. »**

Throughout the twentieth century, many ordinary objects have been called art. Although at first sight Katharina Fritsch may appear to be part of this tradition, in fact she takes an entirely different approach. Her objects – the "Vases" (1979, 1984, 1987), the "Candlesticks", 1985, the green "Elephant", 1987, the yellow "Madonna", 1987, the huge "Company at Table", 1988, and the even larger "Rat King", 1993, are all specially crafted objects. Every detail, from the smallest edge to the precise colour tone, is subjected to her artistic scrutiny until the ideal state is finally reached. This lavish production process meant that during the 1980s, she produced very few works, creating great anticipation within the art world. Fritsch's works are poised on a knife-edge between the unique and the arbitrary. Because she controls their sculptural appearance so

minutely, reducing them to the minimal forms necessary for recognitio without deviating for a moment into the abstract, they become one-offs that allow no other option. No aspect of her work is allowed to give rise to discussion as to whether a different solution would have been possible In "Tischgesellschaft" (Company at Table), Fritsch extended what she ha begun with objects into communication situations, transferring this principle into the realm of fairy-tale illustration with the sculpture "Rattenköni (Rat King), a group of rodents with knotted tails. Since the perfection of her works was often in blatant contrast to the spacer in which they wer exhibited, she eventually designed an ideal museum for the German pavilion at the Venice Biennale of 1995.

Dans l'art de ce siècle, nombreuses sont les simples mises en regard d'opposition qui ont été déclarées œuvres d'art. C'est précisément ce type d'attitude dont Katharina Fritsch se dissocie absolument – même si un regard superficiel sur ses œuvres peut faire croire le contraire. Ses objets, les vases (1979, 1984, 1987), les chandeliers (1985), l'éléphant vert (1987), la madone jaune (1987), et pour finir la grande tablée (1988) et, plus grand encore, le roi des rats (1993), sont des objets très particuliers. Chaque détail, de la moindre arête à la plus infime nuance de couleur, a été soumis à son regard artistique jusqu'à ce qu'apparaisse le sentiment d'avoir atteint un état idéal qui ne peut plus être surpassé. Cette démarche a eu pour conséquence un mode de production extrêmement laborieux qui fait qu'en 18 ans, seul un petit nombre d'œuvres ont vu le jour, œuvres que la scène artistique a cependant attendues avec d'autant plus de curiosité. Les œuvres de Katharina

Fritsch se tiennent sur le fil du rasoir entre l'unique et l'arbitraire. C'est précisément de ce contrôle si infiniment précis de leur manifestation sculpturale que ces objets tirent l'aura de l'unique de l'évidence. Katharina Fritsch réduit ses sculptures aux formes permettant une identification immédiate, sans pour autant glisser un seul instant vers l'abstrait. Aucun aspect de ses œuvres ne doit laisser de place à la question de savoir si une autre solution aurait pu être envisagée. Ce qui était opposition dans ses œuvres antérieures, Fritsch l'a étendu dans sa « Tablée » à des situations de communication, avant transposer le même principe dans le domaine du conte et de sa représentation avec la sculpture du roi des rats aux queues nouées. Du fait que la perfection de ses œuvres était souvent incompatible avec les salles où elles étaient exposées, l'artiste est allée jusqu'à concevoir le modèle d'un musée idéal en 1995 dans le pavillon allemand de la Biennale de Venise. C.

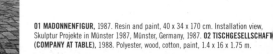

01 MADONNENFIGUR, 1987. Resin and paint, 40 x 34 x 170 cm. Installation view, Skulptur Projekte in Münster 1987, Münster, Germany, 1987. **02 TISCHGESELLSCHAFT (COMPANY AT TABLE)**, 1988. Polyester, wood, cotton, paint, 1.4 x 16 x 1.75 m.

KATHARINA FRITSCH

SELECTED EXHIBITIONS: *1989* Portikus, Frankfurt/M., Germany /// *1993–1994* Dia Center for the Arts, New York (NY), USA /// *1995* XLVI Esposizione Internationale d'Arte, la Biennal di Venezia, Venice, Italy, German Pavilion /// *1996* San Francisco Museum of Modern Art, San Francisco (CA), USA /// Matthew Marks Gallery, New York /// *1997* Museum für Gegenwartskuns Basel, Basle, Switzerland **SELECTED BIBLIOGRAPHY:** *1989 Katharina Fritsch 1979–1989*, Westfälischer Kunstverein, Münster; Portikus, Frankfurt/M.; Cologne, Germany /// *1990 Katharina Fritsch/James Turrell*, *Parkett*, Zurich, Switzerland /// *1995 Katharina Fritsch: Museum*, XLVI Esposizione Internationale d'Arte, la Biennale di Venezia, Venice; Milan, Italy /// *1996 Katharina Fritsch*, San Francisco Museum of Modern Art, San Francisco; Museum für Gegenwartskunst Basel, Basle

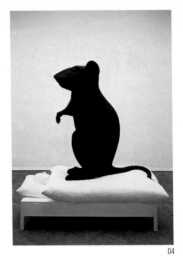

6 **WARENGESTELLE,** 1997. Installation view, Museum für Gegenwartskunst Basel, Basle, Switzerland, 1997. **04 MANN UND MAUS (MAN AND MOUSE),** 1991/92. Polyester d paint, 240 x 135 x 225 cm. **05 RATTENKÖNIG (RAT KING).** Installation view, Dia Center for the Arts, New York (NY), USA, 1993/94.

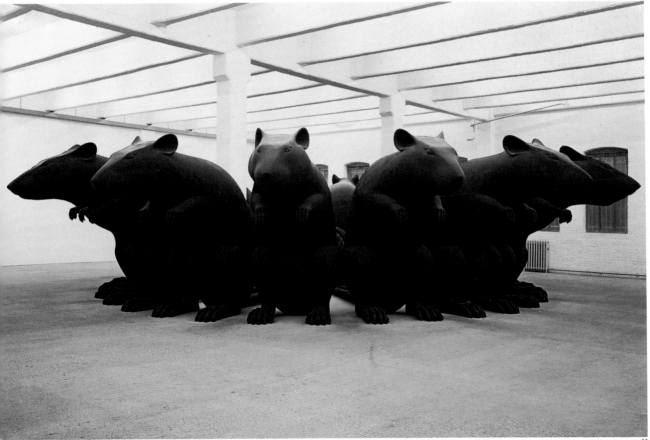

GENERAL IDEA

General Idea was formed in **1969** by AA Bronson, Felix Partz and Jorge Zonta
Jorge Zontal and Felix Partz died of AIDS-related causes in **1994**, thus ending Gene
Idea's production as a collaborative grou
Michael Tims alias AA Bronson: **1946** born in Vancouver, Canada
lives and works in Toronto, Canada, and New York (NY), U
Ronald Gabe alias Felix Partz: **1945** born in Winnipeg, Canada / **1994** die
Slobodan Saia-Levy alias Jorge Zontal: **1944** born in Parma, Italy / **1994** die

"Multiplicity was integral to the process of producing the artwork, as well as to the process of distributing it." **« La pluralité est aussi importante pour le processus de productic
de l'art que pour celui de sa diffusion. »**

A parody game involving artists' identities was one of the elements that led to the founding of this Canadian group in 1968. AA Bronson, Felix Partz, Jorge Zontal (alias Michael Tims, Ron Gabe and Slobodan Saia-Levy) infiltrated the name "General Idea" as a logo into the distribution channels of art and the mass media. They wished to reach out beyond the art world, an objective that they pursued further in their numerous multiples of the 1980s. In their early films, videos, TV contributions, actions, performances, and not least in their publication "FILE. The Megazine", 1970–1989, General Idea took to ironic extremes the clichés of a glamorous artistic career in order to imbue them with subcultural content. Creating an artificial system of their own invention they intermingled the various phenomena of daily life and art. Within this "fake structure" the "1984 Miss General Idea Pavilion" provided the imaginary stage for their various activities; the "Boutique from the 1984 Miss Gene-ral Idea Pavilion" served as a place to present and sell their multiples, including a coat-of-arms. With their "AIDS Project", 1987–1991, General Idea attracted a good deal of media attention. Replacing the word "LOV in Robert Indiana's famous painting of that name with the word "AIDS" they created an emblem that appeared in the form of posters, picture sculptures and installations in cultural institutions and public places. Similarly, the exhibition project "PLA©EBO", 1991/92, combined artist theories and the AIDS theme. The oversized pills whose ineffectiveness is apparent even in the title, may give grounds for hope, but their actua effectiveness cannot be put to the test. As in the installation "Fin de Sièc 1991, the alternation of fiction and reality, so typical of General Idea, gained a shockingly real dimension in the deaths of Felix Partz and Jor Zontal of AIDS-related illness in 1994, which put an end to General Idea artistic output.

Le jeu parodique sur les identités artistiques est une des sources d'inspiration qui conduisit en 1968 à la création du groupe d'artistes canadien « General Idea ». AA Bronson, Felix Partz et Jorge Zontal, alias Michael Tims, Ron Gabe et Jorge Saia allaient faire entrer ce nom dans les canaux de distribution de l'art et des médias comme un logo : leur propos était en effet d'atteindre un plus large public que celui du marché de l'art. Dans les premiers films, vidéos, contributions aux émissions télévisées, actions, performances et enfin dans leur publication « FILE. The Megazine », 1970–1989, General Idea coiffait de gros titres les clichés teintés d'autodérision d'une carrière artistique brillante, pour les remplir de contenus subculturels. Différents phénomènes du quotidien et de l'art furent ainsi mélangés au sein d'un système artistique particulier. Dans cette « fiction de structure », le « 1984 Miss General Idea Pavilion » allait constituer la scène imaginaire de leurs diverses activités. Ainsi, la *« Boutique from the 1984 Miss General Idea Pavilion » servit de lieu d'e position et de point de vente de multiples tels que les blasons. Genera Idea devait acquérir une présence médiatique importante avec son « AIL Project », 1987–1991. Les artistes de General Idea détournèrent le tableau de Robert Indiana, « Love », en remplaçant le titre par le mot « AIDS ». Dans le projet d'exposition « PLACEBO », 1991/92, on assista à la superposition de la réflexion artistique et d'un sujet comme le Sida déjà caractérisés comme inopérants par le titre, les objets-pilules sur-dimensionnés montrés ici peuvent sans doute susciter quelque espoir, mais leur effet réel n'est guère vérifiable. L'alternance spécifique entre fiction et réalité, si caractéristique du travail de General Idea, obtenait ici – un peu comme dans l'installation « Fin de siècle », 1991 – le poids d'une oppressante réalité : en 1994, la mort de Felix Partz et Jorge Zontal allait mettre un terme à la production artistique du groupe. A. W*

01 "GENERAL IDEA 1968–1988", installation view, Galerie Daniel Buchholz, Cologne, Germany, 1989. **02 THE ARMOURY OF THE MISS GENERAL IDEA PAVILION,** 19 40 small and large shields of gouache and gold leaf on wood. Installation view, Setagaya Art Museum, Tokyo, Japan, 1987. **03 THE RUINS OF THE KROMA KEY KLUB,** 19 Polyexpanded styrene, gouache, dimensions variable. Installation view, de Vleeshal, Middelburg, The Netherlands, 19

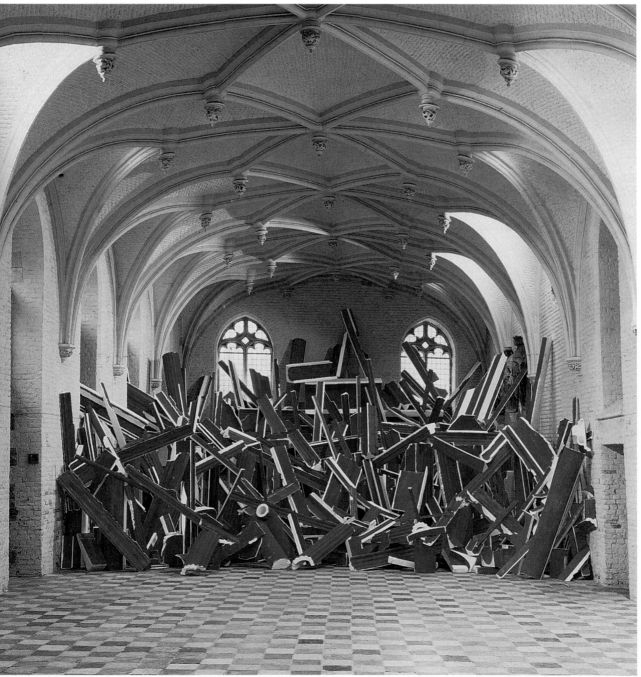

GENERAL IDEA

SELECTED EXHIBITIONS: *1994* "General Idea: Drawings 1989–1994", Stedelijk Museum, Amsterdam, The Netherlands /// *1996* "One Day of AZT/One Year of AZT", The Museum Modern Art, New York (NY), USA /// "Infe©tions", Vancouver Art Gallery, Vancouver, Canada /// *1998* Camden Arts Centre, London, England **SELECTED BIBLIOGRAPHY:** *1984 Gene Idea 1968–1984*, Kunsthalle Basel, Basle, Switzerland; Stedelijk Van Abbemuseum, Eindhoven, The Netherlands; Art Gallery of Ontario, Toronto, Canada; Musée d'Art Contemporain de Montré Montreal, Canada /// *1992 General Idea's Fin de Siècle*, Württembergischer Kunstverein Stuttgart, Stuttgart; Kunstverein in Hamburg, Hamburg, Germany; The Power Plant, Toronto, Canad Wexner Center for the Arts, Columbus (OH); San Francisco Museum of Modern Art, San Francisco (CA), USA /// *1996 General Idea. Die Kanadische Künstlergruppe*, Nuremberg, Germany /// *19 General Idea 1968–1975: The Search for the Spirit*, Art Gallery of Ontario, Toronto

04 **AIDS,** 1987. Acrylic on canvas, 183 x 183 cm. 05 **ONE YEAR OF AZT AND ONE DAY OF AZT,** 1991. 1,825 vacuum-formed plastic elements, 13 x 32 x 6 cm (each), 5 elements of fibreglass, 85 x 213 x 85 cm (each). Installation view, "Fin de Siècle", The Power Plant, Toronto, Canada, 1993. 06 **PLAYING DOCTOR,** 1992. Left to right: AA Bronson, Jorge Zontal, Felix Partz of General Idea. Lacquer on vinyl, 225 x 160 cm.

04

ISA GENZKEN

1948 born in Bad Oldesloe, Germany / lives and works in Berlin, Germany

"...a sculpture, even when it displays architectural elements, remains a sculpture." « ... une sculpture, même lorsqu'elle présente des éléments architectoniques, demeure une sculpture. »

Isa Genzken's work moves between two poles: the claim to artistic autonomy, and reference to the personal, social and institutional. Following on from Russian Constructivism, through Minimalism and Conceptualism, Genzken's sculptures are conditioned by their interrelationship with their surroundings. Thus, she opens up her "Ellipsoiden", 1976–1982, and "Hyperbolos", 1979–1983 – stereometric structures in lacquered wood – by making an incision in their closed form. Similarly, her plaster sculptures, 1985/86, concrete pieces on steel-tube scaffolding (from 1986), and her outside works thematically illustrate the transition between interior and exterior. Many of these works including "ABC", 1987, quote architectural models. The viewer recognises details of the town as if seen through a frame or, as in "Fenster" (Window), 1990, details of the gallery. The choice of materials is of central importance. From 1991, she often used concrete as the typical building material of Modernism.

Subsequently, among other materials, she employed translucent epoxy resin, which leaves the supporting construction visible. Genzken's interest in sculpture also informs works like the X-rays of her head ("X-Ray", 1991) or her photographs of human ears ("Ohren" (Ears), 1980). These, like "Weltempfänger" (Global Receiver), 1982–1987, can be interpreted as metaphors for exchange and communication. In 1994, Genzken varied these subjects with subtle irony: the arrangement of two revolving columns, the lamp-like "Haube I (Frau)" and "Haube II (Mann)", and a replica of the gallery window indicate both self-reference and outside orientation. In her stelae of 1998, she combines personal references with the abstract language of forms: she fitted photographs of a stay in New York and of her Berlin studio into a screen composed of pressboard, marble, mirror and metal.

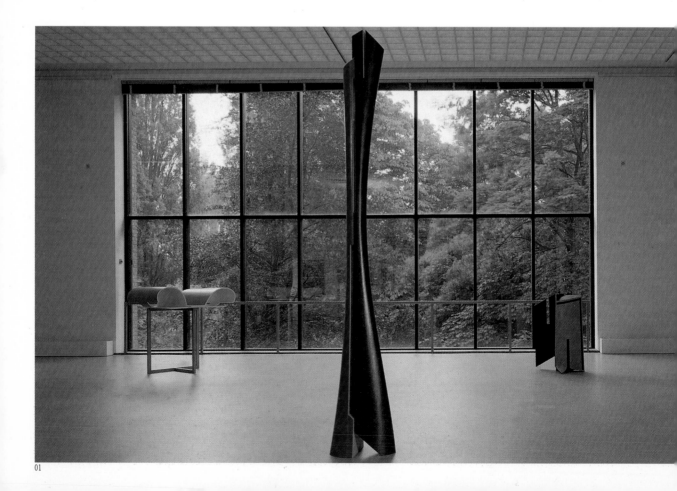

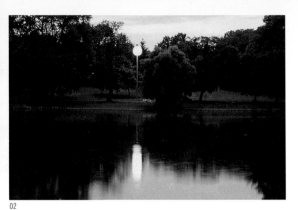

02

01 **INSTALLATION VIEW,** Museum Boijmans Van Beuningen, Rotterdam, The Netherlands, 1989. **02 VOLLMOND,** 1997. Skulptur. Projekte in Münster 1997, Münster, Germany, 1997. **03 INSTALLATION VIEW,** Museum Boijmans Van Beuningen, Rotterdam, 1989.

*La revendication de l'autonomie artistique et l'inclusion de réfé-
nces personnelles, sociales et institutionnelles sont les pôles entre
squels se déploie l'œuvre d'Isa Genzken. Dans le sillage du construc-
risme russe, mais aussi du Minimal Art et de l'art conceptuel, les sculp-
res de Genzken sont déterminées par leur interrelation avec l'espace
vironnant. Ainsi, Genzken ouvre ses « Ellipsoïdes », 1976–1982, et
Hyperbolos », 1979–1983, – des formes stéréométriques en bois laqué
par une entaille dans la forme close. Les sculptures en plâtre, 1985/86,
en béton présentées sur des socles d'acier tubulaire (à partir de 1986)
ses œuvres pour l'espace public thématisent également la transition
tre espaces intérieur et extérieur. Le choix du matériau y joue un rôle
épondérant : après le béton, matériau de construction si caractéristique
l'époque moderne, Genzken se sert depuis 1991 entre autres d'une
sine époxy translucide, qui permet de voir la structure porteuse. L'inté-*

*rêt de Genzken pour les structures est aussi présent dans des œuvres
comme les clichés aux rayons X de sa propre tête (« X-Ray », 1991) ou
les photos d'« Oreilles » humaines, 1980). De même que les « Récepteurs
cosmiques », 1982–1987, ces œuvres peuvent se lire comme des méta-
phores de l'échange et de la communication. En 1994, Genzken varie
ces motifs avec une subtile ironie : la disposition de deux colonnes rota-
tives, les « Casque I (Femme) » et « Casque II (Homme) », qui rappellent
des lampes, ainsi qu'une réplique de la fenêtre de la galerie, signalisent
tout à la fois la référence personnelle et l'orientation extérieure. D'une
façon similaire, Genzken combine dans ses stèles de 1998 les références
personnelles et le langage formel abstrait : dans la trame de surface en
aggloméré, en marbre, en glace et en métal, elle fait entrer les photos
d'un séjour à New York et de son atelier berlinois.* A. W.

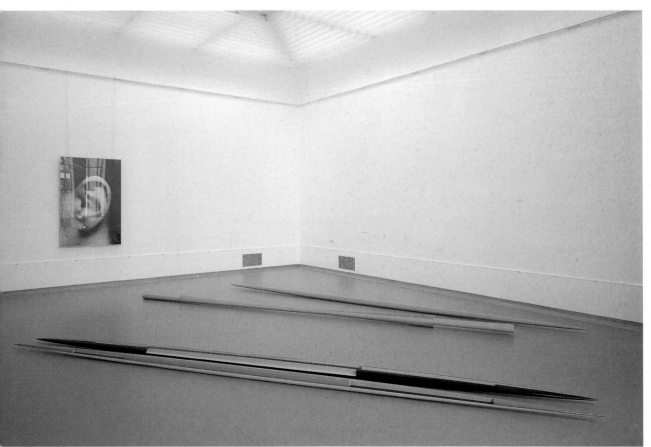

ISA GENZKEN

SELECTED EXHIBITIONS: *1989* Museum Boijmans Van Beuningen, Rotterdam, The Netherlands /// *1992* The Renaissance Society at the University of Chicago, Chicago (IL), USA /// Portikus, Frankfurt/M., Germany /// documenta IX, Kassel, Germany /// *1993* Lenbachhaus, Munich, Germany /// Kunsthalle Bremen, Bremen, Germany /// *1996* Generali Foundation, Vienna, Austria /// *1998* INIT Kunst-Halle, Berlin, Germany **SELECTED BIBLIOGRAPHY:** *1989 Isa Genzken*, Museum Boijmans Van Beuningen, Rotterdam /// *1992 Isa Genzken, Jeder braucht mindestens ein Fenster*, The Renaissance Society at the University of Chicago, Chicago; Portikus, Frankfurt/M. /// *1996 Isa Genzken, MetLife*, Generali Foundation, Vienna /// *1998 Isa Genzken, Caroline van Damme*, Museum Dhont-Dhaenens, Deurle, Belgium

04 METLIFE, 1996. Installation view, Generali Foundation, Vienna, Austria, 1996. **05 ROSE,** 1997. Stainless steel, lacquer, 8 m (h). Permanent sculpture, Messe Leipzig, Leipzig, Germa...

LIAM GILLICK

1964 born in Aylesbury, England / lives and works in London, England, and New York (NY), USA

"I want to reclaim an area of fluidity, that might include elements of the poetic, the informational and pure aesthetics but all of this is framed by a constant play between activity and analysis." « Je souhaite cultiver une aura de fluidité qui pourrait inclure des éléments de poésie, d'information et d'esthétique pure, mais tout ceci est toujours encadré par un jeu constant entre activité et analyse. »

Liam Gillick is one of the most fascinating artists of the 1990s, and at the same time one of the most difficult to understand. His works seem unfinished, both in terms of presentation and of content. The objects, films, screenplays and dramas often relate to one another, which means that the viewer either needs a good deal of knowledge, or should be prepared to think hard. But this excessive requirement is offset by the fact that it constitutes an important component of the work. Gillick presents the diversity of this world as the gulf between reality and utopia. In time-leaps shifting between 1810 and 1997, he moves from McNamara, the American Minister of Defence at the time of the Vietnam War, to Erasmus Darwin (the brother of Charles Darwin, the theorist of natural selection), whom he brings on stage in a musical. He presents coloured wall screens that look like designer furniture but bear the label "Discussion Island Development Screen". The themes and information he delivers are therefore partly real and partly fictitious. Solutions and final conclusions are never on offer. In this way, Gillick reflects the fact that all decisions are made subjectively, according to what is known and of interest at that moment. Their expiry date immediately ensues, and every re-assessment on the basis of new information, whether this is correct or not, can lead to different decisions, which will prove to be more or less sensible. Gillick's works function in precisely the same way: they are never complete, always undergoing a process of alteration. Their validity is of short duration, but in this brief time, they hit the viewers' feelings exactly.

01 DISCUSSION ISLAND BIG CONFERENCE SCREEN, 1997. Aluminium angle, plexiglass, fittings, 240 x 360 x 30 cm. Installation view, "Hospital", Galerie Max Hetzler, Berlin, Germany, 1997. 02 PINBOARD PROJECT (DONKEY), 1992. Chipboard, hessian, wood screws, various papers, 100 x 100 x 4 cm. 03 ERASMUS IS LATE IN BERLIN DRAWING TABLES, 1996 (foreground). 2 blue/grey tables, laser prints on coloured paper, glass, copies of "Erasmus is Late", variable. ERASMUS IS LATE IN BERLIN INFORMATION ROOM, 1996 (background). Clay brown, lime green and light blue walls, halogen spotlights, 12 card boards with collaged information, 4 sheets of text in German, variable. Installation view, "Erasmus is Late in Berlin 'versus' The What If? Scenario", Schipper & Krome, Berlin, 1996.

Liam Gillick est un des artistes les plus fascinants des années 0. Et il est en même temps l'un des plus difficiles à comprendre. Gillick réalise des œuvres apparemment inachevées, tant sur le plan de la présentation que du contenu. A côté de ses objets, on trouve aussi des films, des scénarios ou des pièces de théâtre qui font souvent référence les uns aux autres. Le spectateur est donc censé soit avoir une connaissance approfondie de son œuvre, soit être prêt à beaucoup réfléchir. Mais cette revendication en principe impudente de la part de l'artiste est compensée par le fait que son attente excessive constitue un élément important de son travail. Gillick thématise la diversité de ce monde entre réalité et utopie. Il s'intéresse à McNamara, ministre de la Défense américain pendant la guerre du Vietnam; dans une comédie musicale embrassant une période qui va de 1810 à 1997, il met en scène Erasme Darwin, le frère du théoricien racial Charles Darwin, ou présente des paravents de couleur qui ressemblent à des meubles design, mais qui portent des titres comme «Discussion Island Development Screen». Ainsi sont fournis des thèmes et des informations en partie réels, en partie fictifs. Jamais il n'est proposé de solutions ou de connaissances définitives. Gillick réfléchit ainsi sur le fait que les décisions ne peuvent jamais être prises que subjectivement et sur la base de connaissances et d'intérêts actuels. Leur déclin commence au moment même où elles naissent; toute appréciation s'appuyant sur des informations nouvelles, que celles-ci soient justes ou non, peut déboucher sur d'autres décisions qui s'avèrent elles-mêmes plus ou moins raisonnables. Et les œuvres de Gillick fonctionnent exactement sur le même mode; elles ne sont jamais achevées et subissent de constantes modifications. Leur validité est de courte durée, mais dans ces moments, elles touchent exactement les sentiments du spectateur.

C. B.

LIAM GILLICK

SELECTED EXHIBITIONS: *1993* "Backstage", Kunstverein in Hamburg, Hamburg, Germany /// *1996* "The What If? Scenario", Robert Prime, London, England /// "Documents (with Henry Bond)", Schipper & Krome, Cologne, Germany /// *1997* documenta X, Kassel, Germany /// *1998* Kunstverein in Hamburg, Hamburg **SELECTED BIBLIOGRAPHY:** *1995 Erasmus is Late,* London /// *Ibuka!,* Künstlerhaus Stuttgart, Stuttgart, Germany /// *1997 Liam Gillick, McNamara Papers, Erasmus and Ibuka! Realisations, The What If? Scenarios,* Le Consortium, Dijon, France; Kunstverein in Hamburg, Hamburg /// *Liam Gillick, Discussion Island / Big Conference Centre, Die Diskussion-Insel / Das grosse Konferenzzentrum,* London; Kunstverein Ludwigsburg, Ludwigsburg, Germany; Orchard Gallery, Londonderry, Northern Ireland

04

05 06 / 07

04 "IBUKA!", installation view, Künstlerhaus Stuttgart, Stuttgart, Germany, 1995. **05 THE MAKING OF ERASMUS AND IBUKA! REALISATIONS,** 1997. Film set with copies of "Ibuka!" and "Erasmus is Late". **06 / 07 "IBUKA!",** installation view, Künstlerhaus Stuttgart, Stuttgart, 1995. **08 DISCUSSION ISLAND RESIGNATION PLATFORM,** 1997. Aluminium angle, plexiglas, fittings, 360 x 240 cm.

ROBERT GOBER

1954 born in Wallingford (CT) / lives and works in New York (NY), USA

Socialisation in the bourgeois nuclear family, its mechanisms of repression and stereotypical roles, and particularly the body consciousness that results from this conditioning, are the cornerstones of Robert Gober's art. The artist does not present himself as an uninvolved observer, but as someone who is himself affected as a homosexual and is therefore a member of a marginalised social group. His paintings, sculptures and installations are full of narrative allusions to his own early childhood, the cliché of the "happy home" and the problems of sexual oppression. His child's bed ("Crib", 1986), for example, symbolises in its twisted construction the emotional distortions to which we are subjected during our upbringing. The urinals and washbasins altered by the artist tell of early, subliminal basic experiences such as forced hygiene or regulated bowel movements. As we perceive them, these domestic objects become eerie comments on the human body and its role in the process of civilisation. Robert Gober's installations present the familial home and our imprisonment in its system of rules as nostalgic, surrealistic stage sets. In one installation a "Wedding Gown", 1989, stands in the middle of the room and two packets of cat litter lean against the wall, which is papered with two alternating motifs – a hanged black man and a muscular, sleeping white man. The bourgeois ritual of founding a family and the affectionate care of the pet cat are contrasted with images identifying two marginal groups: blacks and gays. All these elements come together to form an impressive environment in which Gober displays his newly formulated register of emotions.

La socialisation dans la petite famille bourgeoise, ses mécanismes de refoulement et ses jeux de rôles convenus, ainsi que le sentiment corporel né de ce mode de socialisation sont les éléments essentiels de l'art de Robert Gober. Dans ce travail, l'artiste n'intervient pas en qualité d'observateur impartial, mais comme un être concerné au premier titre, et qui se bat pour les groupes sociaux opprimés – par exemple les homosexuels. Car les peintures, sculptures et installations dans l'espace sont pleines d'allusions narratives à sa propre petite enfance, au cliché du « foyer douillet » et aux problèmes liés à la répression sexuelle. Une œuvre comme la construction déformée du « Lit d'enfant », 1987, de Gober, symbolise par exemple les déformations émotionnelles que chacun d'entre nous vit au long de son éducation. Les urinoirs et lavabos détournés par l'artiste racontent eux aussi les expériences fondamentales de l'enfance telles que la contrainte de l'hygiène ou le contrôle de la selle. Dans le processus de leur perception, les objets de la maison deviennent ainsi les paraphrases étranges du corps humain et de son rôle dans le processus de civilisation. Scènes nostalgiques et presque surréelles, les installations de Robert Gober thématisent elles aussi le foyer familial et son système de règles étouffant. Une « Robe de mariée », 1989, se trouve au milieu d'une pièce ; deux paquets de litière pour chat se détachent sur un mur couvert d'un papier peint présentant deux motifs alternants : la pendaison d'un noir et un haltérophile blanc endormi. Le rite bourgeois de la constitution de la cellule familiale et les soins attentionnés apportés à l'animal domestique, un chat, sont confrontés à l'identification, sous forme d'image, avec des « groupes marginaux » comme les noirs et les homosexuels. Ils forment ensemble un impressionnant environnement, dans l'espace duquel Robert Gober reformule son intériorité sentimentale.

R. S.

01 UNTITLED, 1989/90. Beeswax, cotton, wood, leather, human hair, 32 x 13 x 51 cm. **02 DRAIN,** 1989. Cast pewter, ø 11 x 8 cm (d). **03 WEDDING GOWN,** 1989 (foreground); **CAT LITTER,** 1989 (background); **HANGING MAN/SLEEPING MAN,** 1989 (background). Installation view, Paula Cooper Gallery, New York (NY), USA, 198

ROBERT GOBER

SELECTED EXHIBITIONS: *1988* The Art Institute of Chicago, Chicago (IL), USA /// *1990* Museum Boijmans Van Beuningen, Rotterdam, The Netherlands /// *1991–1992* Galerie Nationale du Jeu de Paume, Paris, France; Museo Nacional Centro de Arte Reina Sofía, Madrid, Spain /// *1992–1993* Dia Center for the Arts, New York (NY), USA /// *1995* Museum für Gegenwartskunst Basel, Basle, Switzerland /// *1997* The Museum of Contemporary Art, Los Angeles (CA), USA /// *1999* Walker Art Center, Minneapolis (MN), USA **SELECTED BIBLIOGRAPHY:** *1990 Robert Gober*, Museum Boijmans Van Beuningen, Rotterdam; Kunsthalle Bern, Berne, Switzerland /// *1991 Robert Gober*, Galerie Nationale du Jeu de Paume, Paris /// *1992–1993 Robert Gober*, Dia Center for the Arts, New York /// *1997 Robert Gober*, The Museum of Contemporary Art, Los Angeles; Zurich, Switzerland

04 SITE-SPECIFIC INSTALLATION VIEW, Dia Center for the Arts, New York (NY), USA, 1992/93. **05 UNTITLED,** 1995–1997 (detail).
Cast concrete, bronze, steel, copper, nickel silver, brick, fibreglass, polyurethane, cast plastics, paint, lead, motors, water, 404 x 297 x 239 cm.

NAN GOLDIN

1953 born in Washington, D.C. / lives and works in New York (NY), USA

"My work derives from the snapshot. It is the form of photography that most closely stands for love." " **Mon œuvre est dérivée de l'instantané photographique, qui est la forme photographique la plus proche de l'amour.** »

Nan Goldin must be the most popular female photographer of the 1990s. In the last thirty years she has created a kind of "visual diary". In this the American artist sensitively records her world, above all her friends, lovers, male and female, her trips to Europe and Asia and her crises – often in relationships. Goldin has thus created an intimate panorama of the human condition towards the end of the twentieth century, not only with her photographs but also in her slide shows backed up with music, like "The Ballad of Sexual Dependency", 1981–1996, or her film "I'll Be Your Mirror", 1995. She has repeatedly directed her attention at areas of life in which people's relations to love, sexuality and the division of roles between the sexes are as intense as they are open – lesbian and gay culture as well as the seemingly glamorous world of the transvestites. This is her own world and so she shoots her photos without any voyeuristic indiscretion. Nan Goldin often works in series. She has been photographing many of her "protagonists" over a period of more than twenty years. In order to do justice to the complexity of the human condition between longing and failure, she puts her trust in "the accumulation of portraits as the representation of a person" (Goldin). The "Portfolio Cookie Mueller", 1976, is an important example. In 17 pictures Goldin traces her relationship with this star of several John Waters films, from their early encounters up to the burial of her friend when she died of AIDS. Even the most intimate is here made public, and the boundaries of shame or social taboos are not accepted. Nan Goldin realises that it is precisely those that take new soundings in the patterns of human togetherness who are threatened by social disciplining and supervision. What remains is escaping to the fore, into the floodlight of publicity.

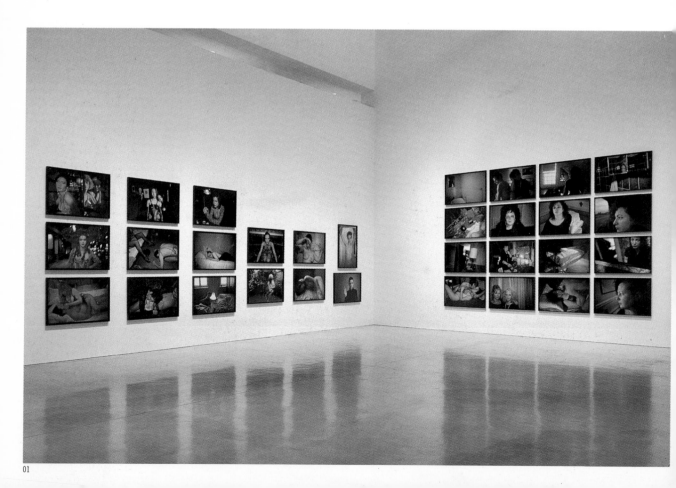

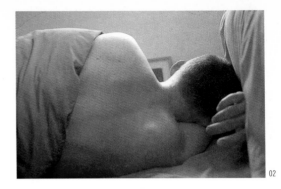

Nan Goldin est sans doute la photographe la plus populaire des
nnées 90. Au cours des trente dernières années, l'artiste américaine a
réé une sorte de «journal visuel» intime, dans lequel elle dresse un pro-
ocole plein de sensibilité de son monde, en particulier de ses amis, de
es amants et amantes, de ses voyages en Europe et en Asie, ainsi que
e ses crises (relationnelles). Dans ses photographies comme dans ses
rojections de diapositives agrémentées d'un accompagnement musical,
omme «The Ballad of Sexual Dependency», 1981–1996, ou encore
ans son film «I'll Be Your Mirror», 1995, Goldin a ainsi dressé un pa-
orama intimiste de la condition humaine en cette fin de 20e siècle. Son
egard se porte sans cesse sur des domaines de la vie dans lesquels le
apport de l'homme à l'amour, à la sexualité et à la répartition des rôles
st tout aussi intense qu'ouvert: regard sur la culture lesbienne ou gay et
ur le monde clinquant des travestis. Dans la mesure où elle vit elle-

même dans ces mondes, la mise en scène de ses photos est exempte
d'indiscrétion et de voyeurisme. Souvent, Nan Goldin travaille en séries.
Nombre de ses «protagonistes» ont été photographiés sur une période
de plus de vingt ans. Pour pouvoir rendre compte de la complexité des
états humains entre le désir et l'échec, l'artiste s'appuie sur «l'accumula-
tion de portraits comme représentation d'une personne» (Goldin). Le
«Portfolio Cookie Mueller», 1996, est à cet égard exemplaire: dans 17
photos, Goldin y dessine l'image de sa relation avec la star de plusieurs
films de John Waters – des premières rencontres à l'enterrement de
l'amie morte du Sida. Les aspects les plus intimes y deviennent publics,
les frontières de la pudeur ou des tabous sociaux n'y sont pas accep-
tées. Comme le sait très bien Nan Goldin: ceux qui cherchent de nou-
veaux modèles de vie entre les êtres sont le plus menacés par le rappel
à l'ordre et la mise sous surveillance par l'entité sociale. R. S.

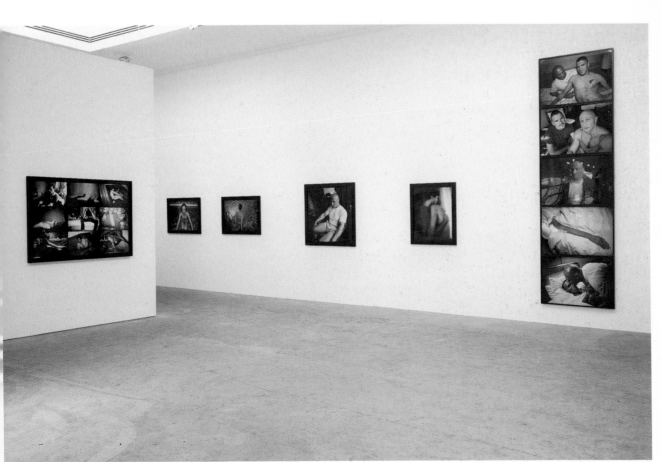

NAN GOLDIN

SELECTED EXHIBITIONS: *1996* Associação Alumni, São Paulo, Brazil /// *1996–1999* Whitney Museum of American Art, New York (NY), USA; Kunstmuseum Wolfsburg, Wolfsburg, Germany; Stedelijk Museum, Amsterdam, The Netherlands, Fotomuseum Winterthur, Winterthur, Switzerland; Kunsthalle Wien, Vienna, Austria; Galerie Rudolfinum, Prague, Czech Republic /// *1998* Matthew Marks Gallery, New York /// Gagosian Gallery, Los Angeles (CA), USA **SELECTED BIBLIOGRAPHY:** *1986 The Ballad of Sexual Dependency*, New York /// *1993 The Other Side*, New York /// *1996 I'll be your mirror*, New York /// *1998 Ten Years After*, New York; Turin, Italy

04 GUIDO ON THE DOCK, VENICE, 1998. 05 THE SKY ON THE TWILIGHT OF PHILIPPINE'S DEATH, WINTERTHUR, SWITZERLAND, 1997. 06 GIGI IN THE BLUE GROTTO WITH LIGHT, CAPRI, 1997.

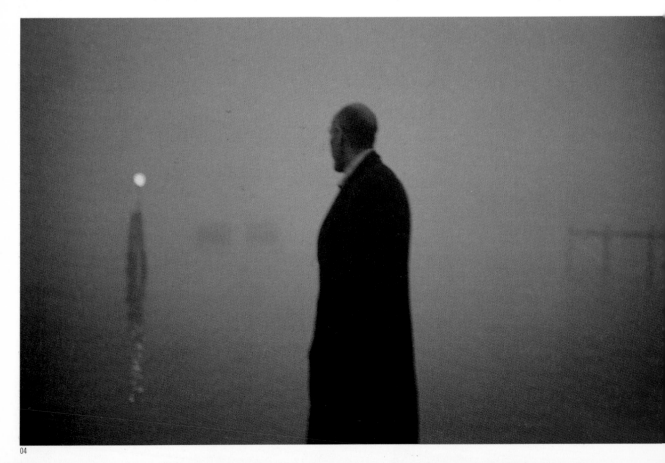

FELIX GONZALEZ-TORRES

1957 born in Güaimaro, Cuba / lived and worked in New York (NY) / **1996** died in Miami (FL), USA

"I tend to think of myself as a theater director who is trying to convey some ideas by reinterpreting the notion of the division of roles: author, public and director." **« Je tends à me considérer comme un metteur en scène de théâtre qui essaie de véhiculer certaines idées en réinterprétant la notion de distribution des rôles : auteur, public et metteur en scène. »**

Felix Gonzalez-Torres subtly combined personal experiences and ideas from art theory with political points of view. He often reflects aspects of his particular position as a gay artist from Cuba, but without falling into banal clichés. His installations of piles of paper and sweets indicate a direct connection with the Conceptual and Minimal Art of the 1960s. But by inviting gallery visitors to help themselves to a sheet of paper or a sweet, these works negate the claim to artistic autonomy that is characteristic of Minimal Art by questioning the uniqueness of the artwork. Everyday things like light bulbs or sweets wrapped in cellophane are invested, simply through their selection and arrangement, with a poetic aura. This is also present now and then in his atmospherically charged reproductions of his posters and puzzles. Ambigiuous images, like footprints in sand dunes or two birds flying past in the cloudy sky, sharpen our awareness of transience or the fear of losing a loved one – a fundamental theme not only in the age of AIDS. The intimate image of a recently slept-in bed, which Gonzalez-Torres stuck on various billboards in New York shortly after the death of his partner, expressed his personal mourning, but like many of his works, also transferred the private emotion into the public arena, making us aware of the general relevance of such themes as illness, death, love and loss.

02

Dans ses œuvres, Felix Gonzalez-Torres combine subtilement expérience personnelle, réflexion sur l'histoire de l'art et prise de position politique. Il n'est pas rare qu'il y rende compte des différentes facettes de sa situation d'artiste homosexuel d'origine cubaine, sans toutefois tomber dans les stéréotypes de la banalité. Ses piles de papier et ses installations de sucreries dénotent une référence claire à l'art conceptuel et au Minimal Art des années 60. Mais de par l'invitation qui est faite au spectateur d'emporter une feuille de papier ou un bonbon, ces travaux réfutent la revendication d'autonomie de l'œuvre si caractéristique du Minimal Art ; elles remettent bien au contraire en cause l'unicité de l'œuvre d'art. Par leur seul choix et par leur disposition, Gonzales-Torres plonge les objets quotidiens – ampoules électriques ou bonbons enveloppés dans du cellophane – dans une atmosphère de poésie qui imprègne aussi parfois l'ambiance de ses affiches et de ses puzzles. Les images polysémiques telles que les traces de pas dans les dunes ou deux oiseaux passant dans le ciel, aiguisent la conscience de la fugacité ou l'angoisse de la perte d'un être aimé, thème qui ne joue pas seulement un rôle fondamental à l'ère du Sida. L'image intimiste d'un lit vide et défait, dont Gonzales-Torres devait animer différents espaces d'affichage à New York peu après la mort de son compagnon, était l'expression de son deuil. Indépendamment de ces aspects, Gonzales-Torres transfère ainsi la sphère privée dans l'espace public et fait prendre conscience de l'universalité des thèmes de la maladie, de la mort, de l'amour et de la perte.

Y. D.

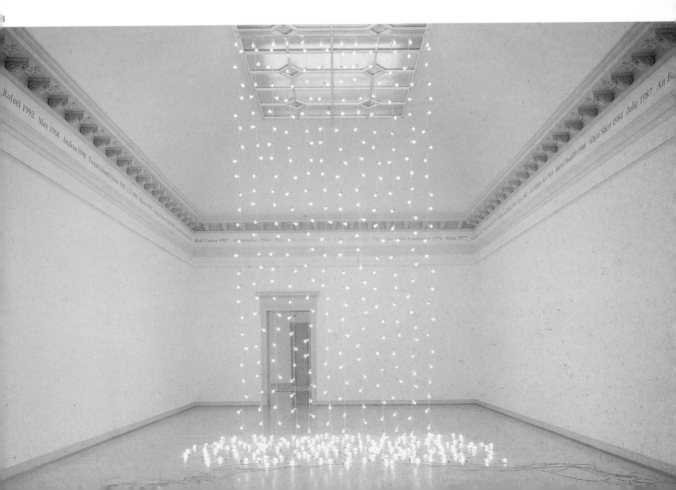

FELIX GONZALEZ-TORRES

SELECTED EXHIBITIONS: *1994* "Traveling", The Museum of Contemporary Art, Los Angeles (CA); Hirshhorn Museum and Sculpture Garden, Smithsonian Institution, Washington, D. C The Renaissance Society at the University of Chicago, Chicago (IL), USA /// *1995–1996* "Felix Gonzalez-Torres (A Possible Landscape)", Centro Gallego de Arte Contemporáneo, Santiago d Compostela, Spain /// *1996* "Felix Gonzalez-Torres (Girlfriend in a Coma)", Musée d'Art Moderne de la Ville de Paris, Paris, France /// *1998* Museum moderner Kunst Stiftung Ludwig Wien, Vienna Austria **SELECTED BIBLIOGRAPHY:** *1994 Traveling*, The Museum of Contemporary Art, Los Angeles /// *1995 Felix Gonzalez-Torres (A Possible Landscape)*, Centro Gallego de Ar Contemporáneo, Santiago de Compostela /// *1996 Felix Gonzalez-Torres (Girlfriend in a Coma)*, Musée d'Art Moderne de la Ville de Paris, Paris /// *1997 Catalogue raisonné*, Sprengel Museu Hannover, Hanover; Stuttgart, Germany

UNTITLED, 1991. Billboard, dimensions variable. Installation view, "Projects 34: Felix Gonzalez-Torres", The Museum of Modern Art, New York (NY), , 1992. **05 UNTITLED (ROSS),** 1991. Candies wrapped in variously coloured cellophane, unlimited supply, ideal weight: 175 lbs, dimensions variable. alled at the home of Karen & Andy Stillpass. **06 UNTITLED (PORTRAIT OF THE STILLPASSES),** 1991. Paint on wall, dimensions variable.

05

DOUGLAS GORDON

1966 born in Glasgow / lives and works in Glasgow, Scotland, and Cologne, German

"The artist as a captor can be quite content to sit in the background, and if everything is running smoothly, he can play an anonymous role in the equation." « L'artiste comme ‹ conquérant › peut se satisfaire d'être assis en coulisse, et si tout se passe sans accroc, il peut jouer un rôle anonyme dans l'équation. »

Douglas Gordon's video work makes impact through its slow pace. Time and again a finger crooks in slow motion as though pulling the trigger of a revolver; time and again a man falls down headlong, or two psychiatrists endlessly try to calm a patient. Gordon often uses snippets from medical films dating from the turn of the century. At that time, film's value as a medium of entertainment had not yet been realised – it was seen rather as a means of scientific documentation. With these works Gordon counteracts the rapid sequence of images in contemporary clips. Every second seems to take on a new meaning through the dragging-out of time, as though things that had been forgotten could be rediscovered in slow motion. When he presents Alfred Hitchcock's film "Psycho" slowed down to run for over 24 hours, the initial effect is that the viewer takes scenes in very gradually. After a while, one remembers one has seen these or similar images before. Gordon employs memorable material, distracting the viewer with its slowness, deflecting one on to other thoughts – where and when did I see these pictures? Who with? Can I bend my finger like that too? A similar idea of personal memory is used in a series of large written works that simply consist of the names of everyone Douglas has ever met. From 1,440 people in the first presentation of 1990, the "List of Names" grew to 2,756 in 1996. Like the life of Gordon himself, it is an ongoing project, made in slow motion.

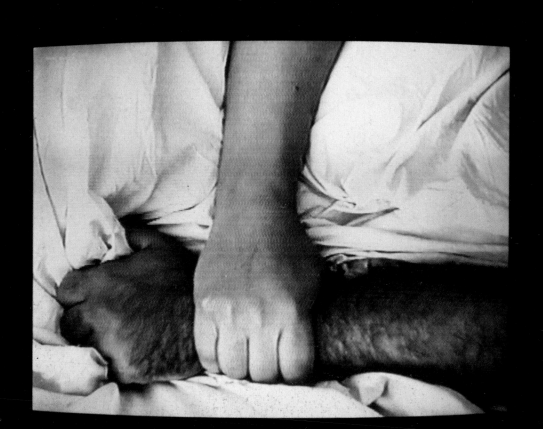

02

01 **A DIVIDED SELF II,** 1996. Video installation, dimensions variable. Installation view, "The Turner Prize 1996", Tate Gallery, London, England, 1996/97. **02 PSYCHO HITCHHIKER,** 1993 (produced in collaboration with Tramway, Glasgow, Scotland). B/w photograph, wood, 46 x 60 cm. **03 REMOTE VIEWING 13.05.94 (HORROR MOVIE),** 1995. Wall painted Pantone 485A; screen size, 400 x 300 cm. Video installation, "Wild Walls", Stedelijk Museum, Amsterdam, The Netherlands, 1995.

L'œuvre vidéo de Douglas Gordon séduit par sa lenteur. En un mouvement réitéré, le doigt se replie au ralenti comme sur la gâchette d'un revolver, un homme se laisse tomber de tout son long, ou bien deux psychiatres tentent de calmer un homme dans son lit. Souvent, Gordon se sert de vieux bouts de pellicule tirées de films médicaux datant des années 1900. A l'époque, la valeur de divertissement du cinéma n'avait pas encore été reconnue, et l'on y voyait plutôt un mode de documentation scientifique. Chaque seconde de ces films semble ainsi prendre une nouvelle signification de par l'allongement du temps, comme si le ralenti permettait de faire resurgir des choses oubliées. En même temps, Gordon va à contre-courant des séquences d'images rapides dans les vidéo-clips d'aujourd'hui. En présentant «Psychose» d'Hitchcock de

manière à le faire durer 24 heures, il provoque avant tout chez le spectateur une assimilation paisible de chaque scène. Après un petit moment, on a l'impression d'avoir déjà vu telle ou telle image. Gordon se sert d'un matériau doué de mémoire, dont la lenteur détourne l'attention et suscite d'autres idées: quand et où ai-je déjà vu ces images? Avec qui? Suis-je moi-même capable de plier mon doigt de la même manière? Un principe similaire de remémoration tout à fait personnelle est aussi appliqué dans une série de grandes écritures qui se bornent à énumérer toutes les connaissances de l'artiste. De 1440 personnes lors de la première présentation en 1990, la «List of Names» est passée à 2756 noms en 1996 et continue de s'accroître comme la propre vie de Douglas Gordon, réalisée au ralenti.

C. B.

DOUGLAS GORDON

SELECTED EXHIBITIONS: *1993* "24 Hour Psycho", Tramway, Glasgow, Scotland; Kunst-Werke, Berlin, Germany /// *1996* "24 Hour Psycho", Akademie der bildenden Künste, Vienna, Austria /// Migros Museum für Gegenwartskunst Zürich, Zurich, Switzerland /// *1996–1997* "The Turner Prize 1996", Tate Gallery, London, England /// *1997* Skulptur. Projekte in Münster 199 Münster, Germany /// *1998* Kunstverein Hannover, Hanover, Germany /// *1999* Centro Cultural de Belém, Lisboa, Portugal **SELECTED BIBLIOGRAPHY:** *1993 24 Hour Psycho,* Tramwa Glasgow; Kunst-Werke, Berlin /// *1996 The Turner Prize 1996,* Tate Gallery, London /// *1998 Douglas Gordon,* Kunstverein Hannover, Hanover

04 10MS⁻¹, 1994. Video installation, screen, 229 x 306 cm. **05 TWENTY FOUR HOUR PSYCHO,** 1993 (detail). Video installation, 24 hour video.
06 TWENTY FOUR HOUR PSYCHO, 1993. Video installation, Tramway, Glasgow, Scotland, 1993.

05
06

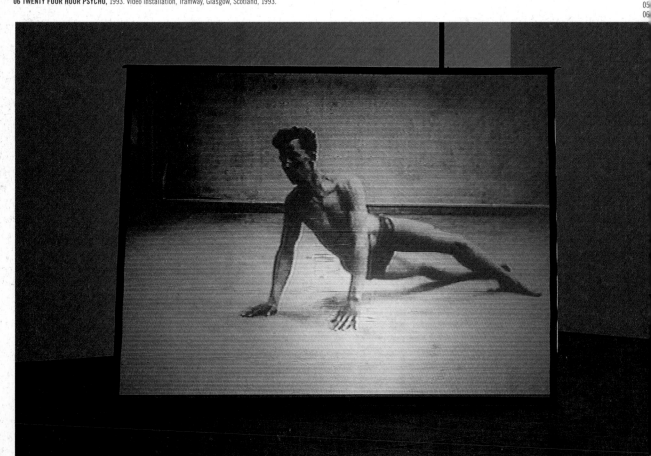

04

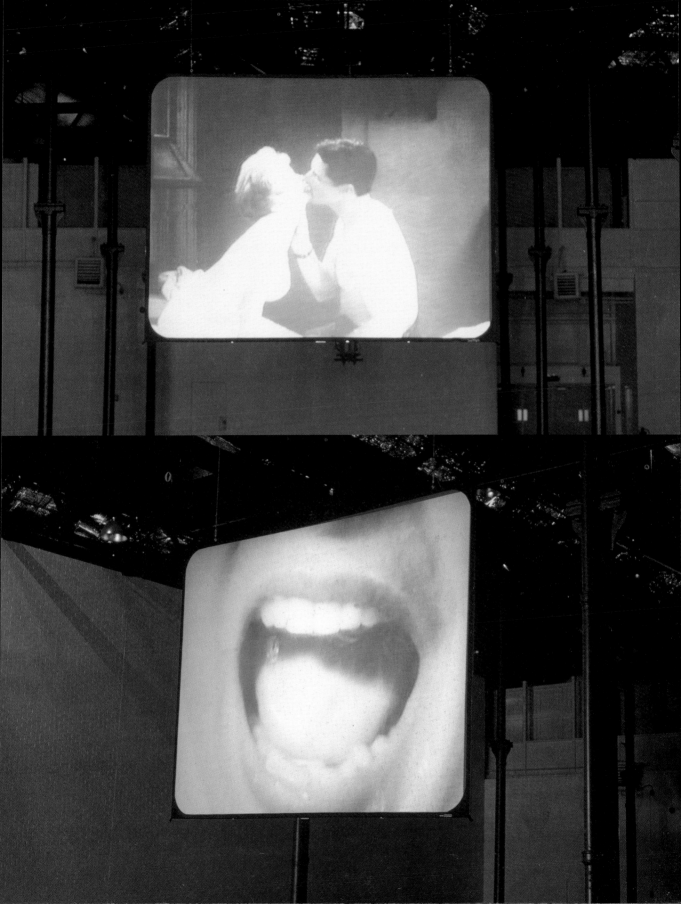

RENÉE GREEN

1959 born in Cleveland (OH) / lives and works in New York (NY), USA, and Vienna, Aust

"My work reflects a fluidity which is about different kinds of relations – personal, cultural, economic, historical, spatial, temporal – and how our perceptions and desires form and shift." « **Mon travail reflète une fluidité qui concerne différents types de relations – personnelles, culturelles, économiques, historiques, spatiales, temporelles – et comment nos perceptions et nos désirs se forment et se décalent.** »

Renée Green's installations challenge cultural conventions, showing them to be possible but not inevitable consequences of their development. Green's concern is above all with the historical and social formation of cultural – including sexual and ethnic – identities. She reconstructs the history of the perception, investigation and definition of "the other", as in "Permitted", 1987, where she examines the penetrating (male) gaze at the historical figure of the "black Venus", or the repressed history of the slave trade in "Mise en Scène", 1991/92. Green is concerned with a critical questioning of the category of "the other" and its function as a mirror, self-assurance and projection space for western civilisation. The action of speaking and naming plays a central role in this as a form of appropriation and valuation. Using diverse methods of observation and narration, she conjoins literary, historical and partly (auto)biograph-ical associations in order to disrupt attributions that are really an expre-sion of power. The transfer of a cultural phenomenon into another context, namely the reception of HipHop in Germany and the shifts of meaning connected with it, provided the theme for "Import/Export Fun Office", 1992. As projects like "Inventory of Clues", 1993, or "Partially Buried", 1996, make clear, meaning is a question of perspective and o the particular social and historical context. This renunciation of clarity and comprehensibility is formally corroborated in Green's installations, composed of various materials and partly designed for their venue, which consist of objects, photographs, videos, films and text quotations. They call for a way of looking that reconstructs the process of research and travel which is both the theme and precondition of her artistic methodology.

Les installations de Renée Green défient les conventions culturel-les, qu'elles représentent comme le résultat contingent, mais non pas nécessaire, de leur genèse respective. Son propos porte pour cela avant tout sur l'identité historique et sociale, et donc aussi sexuelle et ethnique. Green reconstitue l'histoire de la perception, de l'exploration et de la définition de l'« autre » lorsque, dans « Permitted », 1987, par exemple, elle analyse le regard dissecteur (de l'homme) sur la figure historique de la « Vénus noire » ou l'histoire refoulée de la traite des noirs dans « Mise en scène », 1991/92. Green est intéressée par l'interroga-tion critique de l'« autre », de sa fonction comme miroir, assurance et écran de projection de la civilisation occidentale. Le processus du langage, la dénomination comme mode d'appropriation et de jugement, y jouent un rôle prépondérant, comme le montre Green dans « Sites of Genealogy », 1990/91, à l'appui des idées liées aux concepts de « noir » et de « blanc ». Se servant de différentes méthodes d'observation et de narration, elle relie entre elles différentes associations littéraires, histor-ques et en partie aussi (auto)biographiques, en vue de briser les attribu-tions de sens, qui sont l'expression de rapports de force réels. La tran-position d'un phénomène culturel dans un autre contexte, par exemple réception du hip-hop en Allemagne et les glissements de sens qui en découlent, ont été le thème de « Import/Export Funk Office », 1992 : la signification, comme le montrent très clairement aussi des projets tels que « Inventory of Clues », 1993, ou « Partially Buried », 1996, est une question de perspective, de contexte social et historique à une époque donnée. Sur le plan formel, les installations riches en matériaux, partiel-lement rattachées à l'espace environnant, composées d'objets, de photo-graphies, de vidéos, de séquences cinématographiques et de citations, confirment ce refus de tout message univoque et synthétique. A. V

01 **MISCELLANEOUS CONTINUED,** 1995. Mixed media. Installation view, neugerriemschneider, Berlin, Germany, 1995.
02 **MISCELLANEOUS,** 1995. Mixed media. Installation view, daadgalerie, Berlin, 1995. 03 **INSTALLATION VIEW,** Galerie Metropol, Vienna, Austria, 1993.

AMBIENCE

AMBIENCE

RENÉE GREEN

SELECTED EXHIBITIONS: *1993* "World Tour", The Museum of Contemporary Art, Los Angeles (CA), USA /// *1995* "Miscellaneous", daadgalerie, Berlin, Germany /// *1996* "Flow", Fri-A Centre d'Art Contemporain, Fribourg, Switzerland /// "Certain Miscellanies", Stichting De Appel, Amsterdam, The Netherlands /// *1999* "Renée Green: Between and Including", Wiener Secession Vienna, Austria **SELECTED BIBLIOGRAPHY:** *1993 Renée Green, World Tour*, The Museum of Contemporary Art, Los Angeles /// *1994 Renée Green, Camino Road*, Museo Nacional Cent de Arte Reina Sofía, Madrid, Spain /// *Renée Green, After the Ten Thousand Things*, Stroom, The Hague, The Netherlands /// *1996 Renée Green, Certain Miscellanies. Some Documents*, Stichti De Appel, Amsterdam; daadgalerie, Berlin

04 COLLECTANEA, 1993. Installation view, Biennial Exhibition, Whitney Museum of American Art, New York (NY), USA, 1993. **05 / 06 "PARTIALLY BURIED",** installation view (back room), Pat Hearn Gallery, New York, 1996. **07 COLLECTED COLLECTION,** 1996. Books, vitrine, fragment from "Partially Buried Woodshed", map, marble table. Installation view, "Partially Buried", Pat Hearn Gallery, New York, 1996. **08 THE DIGITAL IMPORT/EXPORT FUNK OFFICE,** 1996. CD-ROM. Installation view, "Partially Buried", Pat Hearn Gallery, New York, 1996.

GROUP MATERIAL

Members of Group Materi
and their years of involvemer
Doug Ashford **1982–199**
Julie Ault **1979–199**
Thomas Eggerer **1995–199**
Felix Gonzalez-Torres **1988–199**
Jochen Klein **1995–199**
Mundy McLaughlin **1979–198**
Karen Ramspacher **1989–199**
Tim Rollins **1979–198**

„We invite everyone to question the entire culture we take for granted." **« Nous demandons à chacun de remettre en question l'ensemble de la culture considérée comme évidente. »**

The stated objective of Group Material, a New York artists' collective founded in 1979 and dissolved in 1997, was to query the assumptions behind art and culture. Inspired by their dissatisfaction with selection criteria, commercialization and above all with the alienation of art from its public, this group of artists developed an interventionist exhibition strategy with methodical principles that became a benchmark for politically engaged artistic endeavour in the 1990s. Participation, communication and cultural activism were the crucial concepts. Group Material defined the exhibition formula, the process of its development and at the same time its primacy as the real cultural task, opening it up to political and social questions. There was a corresponding variety of venues, cooperative partners, target audiences and themes. They ranged from cultural and political participation ("Democracy", 1988/89),

AIDS ("Aids Timeline", 1989–1991), the aesthetics of consumer goods ("Market", 1995) to a critique of the institutionalization of projects with marginal social groups at the "Three Rivers Arts Festival" of 1996. A characteristic of Group Material's exhibitions and projects is the equal value given to works of art, documentations, everyday objects, advertising notices, films, videos, lectures and discussions – and also the equal rights of artists and non-artists in their collaboration. This crossover of materials and opinions opened up new cultural connections, enabling a critical approach to each theme. There was a utopian fact in the sometimes contradictory heterogeneity and combination of materials. These anticipated the non-exclusive and unhierarchical structure which Group Material wanted to help realise in the field of art and also on a political level.

03 04

POLITICS & ELECTION, 1988. Installation view, "Democracy", Dia Art Foundation, New York (NY), USA, 1988/89. 02 DA ZI BOAS, 1982. Installation view, Union Square, New York City,
2. 03 "AMERICANA", installation view, Biennial Exhibition, Whitney Museum of American Art, New York, 1985. 04 "THE CASTLE", installation view, documenta 8, Kassel,
many, 1987. 05 CULTURAL PARTICIPATION, 1988. Installation view, "Democracy", Dia Art Foundation, New York, 1988/89.

Interroger les fondements et les conditions de l'art et de la cultu-
a été le but déclaré de «Group Material», un collectif d'artistes new-
rkais fondé en 1979 et dissout en 1997. Partant de son insatisfaction
ant aux critères de choix et de commercialisation, et surtout à partir
l'éloignement de l'art par rapport à son public, ce groupe d'artistes
ait développer une pratique interventionniste dont la méthodologie
ait devenir un modèle pour tous les mouvements artistiques des
nées 90 engagés politiquement. La participation, la communication
l'activisme culturel étaient les notions clés de la démarche du groupe.
oup Material devait ainsi décrire et ouvrir à l'interrogation sociale
cadre «exposition» et le processus de sa genèse, mais aussi son
passement, comme l'objet même de tout travail artistique. Les scènes,
s partenaires, les groupes cibles et des sujets ont donc reflété la même
versité de préoccupations, allant de la participation culturelle et poli-
tique («Democracy», 1988/89), du Sida («Aids Timeline», 1989–1991)
et de l'esthétique des produits industriels («Market», 1995) à une cri-
tique de l'institutionnalisation des projets par des groupes sociaux dits
marginaux lors du «Three Rivers Arts festival», 1996. Une des caracté-
ristiques des expositions et des projets de Group Material est la mise
sur un même plan des œuvres d'art, des documentations, objets quoti-
diens, panneaux publicitaires, films, vidéos, conférences et débats. Ce
«cross over» de matériaux et d'idées devait instaurer de nouveaux rap-
ports de sens culturels et permettre un accès critique au différents
thèmes traités. L'hétérogénéité et la combinaison parfois contradictoire
des matériaux comportait un élément d'utopie. Cette hétérogénéité et
cette combinaison furent annoncées par les structures non exclusives et
non hiérarchiques à la réalisation desquelles Group Material voulait con-
tribuer dans le domaine de l'art tout comme sur le plan politique. A. W.

GROUP MATERIAL

SELECTED EXHIBITIONS: *1987* "The Castle", documenta 8, Museum Fridericianum Kassel, Germany /// *1988–1989* "Democracy", Dia Art Foundation, New York (NY), USA /// *1993–19[...]* "Democracy Wall, Boston", The Museum of Fine Arts, Boston (MA), USA /// *1995* "Market", Kunstverein München, Munich, Germany (with subway project) **SELECTED BIBLIOGRAPH[...]** *1990 Democracy: A Project by Group Material*, Seattle (WA); New York; Dia Art Foundation, New York /// *1991 Biennial Exhibition*, Whitney Museum of American Art, New York /// *1993* "Gro[...] Material: Democracy" in: *Copyshop: Kunstpraxis & politische Öffentlichkeit – ein Sampler von Büro Bert*, Berlin, Germany /// *1995* "Group Material Timeline: Activism as a Work of Art" in: *[...] is it Art? The Spirit of Art as Activism*, Seattle

06 **AIDS TIMELINE (BERKELEY, 1989).** Installation view, "AIDS Timeline (New York, 1991)", University Art Museum, University of California at Berkeley (CA), USA, 1989/90. **07 TIMELINE: A CHRONICLE OF U.S. INTERVENTION IN CENTRAL AND LATIN AMERICA,** 1984. Installation view, P.S.1, Long Island City (NY), USA, 1984. **08 AIDS TIMELINE,** 1991. Installation view, "AIDS Timeline (New York, 1991)", Biennial Exhibition, Whitney Museum of American Art, New York (NY), USA, 1991. **09 "MARKET",** installation view, Kunstverein München, Munich, Germany, 1995.

THOMAS GRÜNFELD

1956 born in Opladen, Germany / lives and works in Cologne, German

"The point is always the same." « Il est toujours question de la même chose. »

"Art is a hybrid" is Thomas Grünfeld's guiding principle. With his works, you constantly wonder whether you are looking at "objects" or "furniture", "art" or "nature", "aesthetics" or "functions". Yet, once you have understood his vocabulary, a new dimension always becomes apparent in each object. With the help of a glass plate and house plant, for example, the mustard-yellow fabric cylinder, which is at first an exercise in form and colour, mutates to a coffee table. The uniformly coloured boxes, which initially appear Minimalist-Constructivist, could also serve as sound-proofed telephone cubicles. With a further shift, a hybrid stuffed cat with large ears, a fruit-bearing apple-cherry tree or a mythological sphinx all look like art. Grünfeld's work is a statement about the general perception of art and design. Both are intrinsically linked to ideals of nature and form.

They aim to resemble nature and to shape structure, and in so shaping it continually refer back to the inner laws of nature and structure. Grünfeld œuvre draws on the collective memories and experiences that precondi tion how we see things: we are reminded of the bourgeois stuffiness of ochre-coloured sitting-room furnishings and the depressing non-design o telephone boxes; of the section for anatomical curiosities in the natura history museum and the constantly evolving possibilities of the latest genetic technologies. We are also reminded of our increasingly bizarre concept of aesthetics, which Grünfeld evokes in a joint installation proje with the fashion designer Rei Kawabuko, suggesting both the trauma of physical deformation and the secret aesthetic thrill of the deformed.

« L'art est un hybride » – c'est là la formule directrice de Thomas Grünfeld. Et de manière très cohérente, la vision de ses œuvres tourne toujours autour des questions « objet ou meuble », « art ou nature », « esthétique ou fonction ». Le vocabulaire issu de l'un de ces domaines est connu, l'autre vient s'y ajouter: par exemple avec le cylindre de tissu jaune moutarde qui est avant tout forme et couleur, et qu'une plaque de verre et une plante d'appartement font muter en table-sofa, des caissons de même couleur apparaissant d'abord comme des identités minimalistes-constructives qui pourraient tout aussi bien fonctionner comme des cabines téléphoniques isolées acoustiquement. Ou encore, de manière très différente, avec les animaux empaillés qui sont doubles, c'est-à-dire hybrides par nature, et qui apparaissent comme de l'art sous la forme d'un chat nocturne aux grandes oreilles, d'un cerisier-pommier ou d'un sphinx mythique. L'œuvre de Grünfeld est une déclaration de principe con-

cernant le regard général porté sur l'art et le design, deux adeptes de déal « nature » et « construction » en ce qu'ils entendent égaler la nature et modeler la construction, tandis que la forme les ramène toujours aux lois constitutives de la nature et de la construction. En même temps, ce œuvre fait appel à la mémoire collective dont le regard est aujourd'hui lourdement grevé : on se rappelle le caractère petit-bourgeois des intérieurs ocre, l'angoissante absence de design des cabines téléphoniques, mais aussi le département des curiosités anatomiques au musée des sciences naturelles. A cela s'ajoute la dimension de plus en plus importante des dernières évolutions de la génétique, mais aussi la dimen sion d'une esthétique de plus en plus désuète qui, dans un projet d'insta lation réalisé en collaboration avec la créatrice de mode Rei Kawabuko, proposent le traumatisme de la déformation et le frisson esthétique comme un attrait mystérieux de la malformation. S.

01

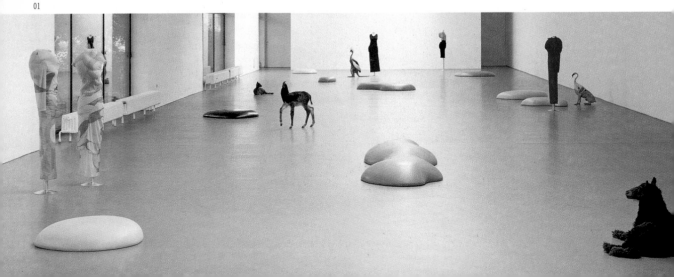

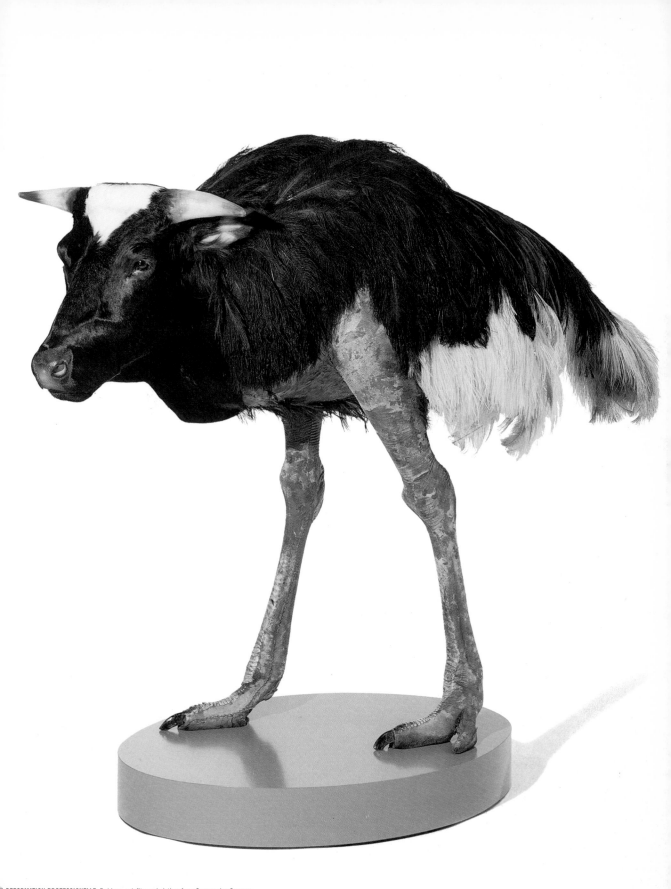

DEFORMATION PROFESSIONELLE. Rubbers, misfits and clothes from Comme des Garçons.
stallation view, Kölnischer Kunstverein, Cologne, Germany, 1997. **02 MISFIT (COW),** 1997. Animal preparation/taxidermy, 170 x 190 x 75 cm.

THOMAS GRÜNFELD

SELECTED EXHIBITIONS: *1989* "Einleuchten: Will, Vorstell und Simul in HH", Deichtorhallen Hamburg, Hamburg, Germany /// *1992* Galerie Jousse Seguin, Paris, France /// *1997* Kölnische Kunstverein, Cologne, Germany /// "New German Art", Saatchi Gallery, London, England /// *1999* Michael Janssen, Cologne **SELECTED BIBLIOGRAPHY:** *1992 Thomas Grünfeld*, Tenerife Spain /// *1995 Thomas Grünfeld, selected works 1986–1995*, Stuttgart, Germany /// *1998 Thomas Grünfeld/Déformation Professionelle*, Kölnischer Kunstverein, Cologne; Stuttgart

03

03 DR. BUISMANN, 1986. Wood, glass, plant, 102 x 211 x 35 cm. **04 UNTITLED (P/TISCH MIT PFLANZE),** 1988. Cushion, glass, plant, 35 x 125 x 125 cm, 2 stools (1997), 40 x ⌀ 40 cm (each). **UNTITLED (P/WANDREGAL),** 1997. Cushion, 45 x 225 x 35 cm. **UNTITLED (P/PARAVENT),** 1997. Cushion, 160 x 40 x 10 cm (each), 5 pieces. Installation view, "musterwohnen", Berlin, Germany, 1997/98.

ANDREAS GURSKY

1955 born in Leipzig, Germany / lives and works in Düsseldorf, German

"There is obviously a common language of the unconscious that everyone can understand..." « Il existe visiblement un langage commun de l'inconscient, compréhensible pour tous les hommes. »

Andreas Gursky's colour photographs of townscapes and land-scapes, assemblies of people, factory floors, motorways and sports facilities combine the documentary approach of the school of Bernd and Hilla Becher with a positively painterly use of colour. His panoramas are photographed from an elevated viewpoint, capturing situations of daily life and recording even the smallest detail. Works made between 1984 and 1988 show people at leisure, normally in the urban neighbourhood recreation grounds. Gursky was exploring the relationship between people and the organisational structures of their environment, a theme that would be central in his later large-scale tableaux. The individual in Gursky's picture compositions recedes into the background, recognisable, as in "Angler, Mülheim", 1989, only as a tiny figure. In "Börse, Tokyo" (Stock Exchange, Tokyo), 1990, and in "May Day", 1997, he is submerged in the mass of brokers or concert-goers. In other works, the individual virtually disappears behind anonymous architecture or the production sites of industrial places. The frontal, latticed structure in "Paris, Montparnasse" 1993, recalls not only the serial sequences of Minimal Art, or Gerhard Richter's coloured paintings, but also picks up on the even spread of Jackson Pollock's all-over canvases. Gursky emphasises this aspect in his picture "Ohne Titel" (Untitled), 1993. The oscillation between the concreteness of his subjects and the aesthetic composition of these "remembered pictures", as Gursky once put it, is characteristic of his work. His is a kind of photographic stock-taking distilled into symbols of Western civilisation.

Les photographies couleur de paysages (urbains), de groupements humains, de halls d'usine, d'autoroutes ou de terrains de sport réalisées par Gursky associent le propos documentaire de l'école de Bernd et Hilla Becher et un emploi nettement pictural de la couleur. Prises d'un point de vue surélevé, ses vues panoramiques, dont la résolution saisit jusqu'au plus infime détail avec une précision d'orfèvre, fixent des situations quotidiennes. Ainsi, les photos que Gursky réalise entre 1984 et 1988 montrent des hommes pendant leurs loisirs, le plus souvent dans des centres de vacances en bordure des villes. On y décèle déjà le thème central de ses grands formats ultérieurs, à savoir le rapport entre les hommes et les structures d'organisation de leur environnement. Les compositions de Gursky relèguent l'individu à l'arrière-plan. Dans « Pêcheur, Mülheim », 1989, l'homme n'est reconnaissable que par la présence d'une minuscule figure. Dans « Bourse, Tokyo », 1990, ou « May Day », 1997, il est fondu dans la masse des courtiers ou des auditeurs d'un concert, ou bien il disparaît presque derrière l'organisation des sites de production industrielle ou les dispositifs architecturaux anonymes. Placée frontalement dans l'image, la structure grillagée de « Paris, Montparnasse », 1993, ne rappelle pas seulement les ordres sériels du Minimal Art ou le Colorfield de Gerhard Richter, mais aussi la répartition uniform de l'allover de Jackson Pollock, aspect que Gursky pousse à l'extrême dans ses œuvres « Sans titre », 1993. Le mouvement de pendule entre l'aspect concret des personnes représentées et la composition esthétique des « images remémorées », comme Gursky les a appelées, est caractéristique de son travail et concentre ses constats d'état photographiques en emblèmes de la civilisation occidentale. A. W

01 PRADA I, 1996. Mixed media, 135 x 226 cm. **02 HONG KONG, GRAND HYATT PARK,** 1994. Mixed media, 210 x 175 cm.

ANDREAS GURSKY

SELECTED EXHIBITIONS: *1995* Portikus, Frankfurt/M., Germany /// *1996* Monika Sprüth Galerie, Cologne, Germany /// *1997* Matthew Marks Gallery, New York (NY), USA /// *1998* Milwaukee Art Museum, Milwaukee (WI), USA /// Kunsthalle Düsseldorf, Düsseldorf, Germany /// "Andreas Gursky 1994–1998", Kunstmuseum Wolfsburg, Wolfsburg, Germany /// *1999* Serpentine Gallery, London, England; Scottish National Gallery of Modern Art, Edinburgh, Scotland; Castello di Rivoli, Rivoli (TO), Italy; Centro Cultural de Belém, Lisbon, Portugal
SELECTED BIBLIOGRAPHY: *1990 Der klare Blick*, Kunstverein München, Munich, Germany /// *1991 Sguardo di Medusa*, Castello di Rivoli, Rivoli (TO), Italy /// *1994 Andreas Gursky*, Deichtorhallen Hamburg, Hamburg, Germany /// *1997 Young German Artists 2*, Saatchi Gallery, London /// *1998 Andreas Gursky 1994–1998*, Kunstmuseum Wolfsburg, Wolfsburg

03 TIMES SQUARE, 1997. Mixed media, 181 x 244 cm. **04 BUNDESTAG**, 1998, Mixed media, 285 x 210 cm.

03

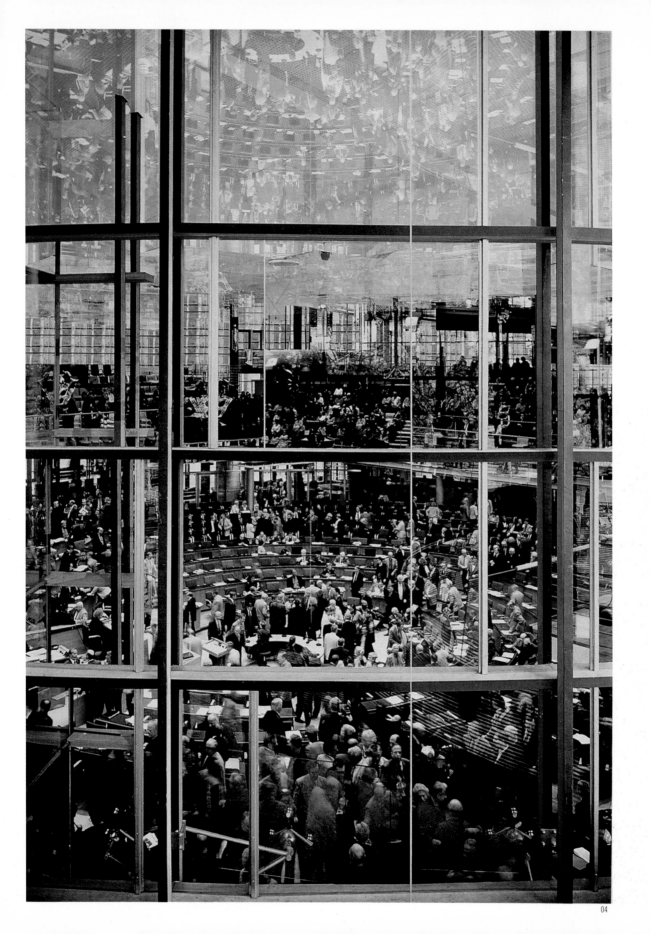

PETER HALLEY

"A painting cannot be topical or about transitory aspects of the social. It's got to be about the absolute essential." « Le tableau ne peut avoir pour objet un thème ou un aspect social éphémère ; il doit y être question de l'essentiel. »

As a student, Peter Halley encountered Guy Debord's Situation Theory, the structuralism of Lacan, Lévi-Strauss, Barthes and Foucault and post-structuralism of Baudrillard and Derrida. From 1984 to 1987 he was a member of the gallery International with Monument, which, founded by Ashley Bickerton, Jeff Koons and Meyer Vaisman and Halley himself, gave rise to the Neo Geo movement. Characterised by Day-Glo fluorescent colours and a synthetic Roll-a-Tex surface rendering, Halley's large geometrical compositions are parodies, postmodern, "simulationist" critiques of Mondrian, Albers, Stella and Judd. He uses his art to challenge both capitalism and the anti-capitalist revolutionary utopias of the 1970s, attempting to strip away the mythology of both the "capitalists" of abstraction and the Conceptualists, and to repudiate division of labour

and class distinctions in any form. Halley had no alternative but to counter the compromises inherent in his art with the leftist concept of an "alternative culture" reflecting his ideals. "Whereas Smithson imposed the symbols of an ideal geometry on the ravaged industrial landscape, I on the contrary should like to help the ideal world of geometrical art to find the trail of a social landscape," he wrote as early as 1981. With his schematic geometry – computer printouts, impressions of computer circuits, drawings of cell structures, plans of motorways or airport runaways – Halley aims to show that the art of abstraction by no means represents a purely self-referential style but clarifies the significance of mathematical modelling, which has established itself in all branches since the beginning of the twentieth century.

L'Université initie Peter Halley au situationnisme théorisé par Guy Debord, au structuralisme élaboré par Jacques Lacan, Claude Lévi-Strauss, Roland Barthes et Michel Foucault, et au poststructuralisme de Jean Baudrillard et Jacques Derrida. De 1984 à 1987, Halley cogère la galerie International with Monument, qu'il vient de créer avec Bickerton, Koons et Vaisman, et qui devait donner naissance au courant Neo-Geo. Ses grandes compositions « néo-géométriques » – caractérisées par l'emploi d'une peinture fluorescente (Day-Glo) et d'un crépi synthétique (Roll-a-Tex) – accomplissent une critique « simulationniste » de Mondrian, Albers, Stella ou Judd. Cet art critique, qui entend dénoncer à la fois le capitalisme et les utopies révolutionnaires des années 70, entreprend de démystifier les présupposés « capitalistes » de l'abstraction gestuelle comme ceux de l'art conceptuel, de récuser la division du travail et la

séparation sociale. L'artiste n'a d'autre recours que de réfuter les propres compromissions de son art avec les idéaux gauchistes d'une « contre-culture », elle-même compromise par son propre idéalisme : « Là où Smithson imprimait sur le paysage industriel dévasté les symboles d'une géométrie idéale, je cherche au contraire à injecter dans le monde idéal de l'art géométrique une trace de paysage social », notait-dès 1981. Avec sa géométrie « diagrammatique » – schémas d'arborescences électroniques, dessins de structures cellulaires, plans d'autoroutes ou de pistes d'aéroport – Halley entend démontrer que l'art de l'abstraction, loin d'être un pur effet autoréférentiel, vise à faire valoir l'importance de la modélisation mathématique qui s'est, depuis le début de ce siècle, imposée dans tous les domaines avec le déchaînement de la science.

J.-M.

01 HISTORY AND MEMORY, 1994. Acrylic, metallic acrylic and Roll-a-Tex on canvas, 215 x 495 cm.
02 OVERTIME, 1997. Day-Glo and metall acrylic, acryl Roll-a-Tex on canvas, 236 x 183 cm.

PETER HALLEY

SELECTED EXHIBITIONS: *1991* capc Musée d'art contemporain, Bordeaux, France /// Biennial Exhibition, Whitney Museum of American Art, New York (NY), USA /// *1993* Jablonka Galerie Cologne, Germany /// *1997* "New Concepts in Printmaking 1/Peter Halley", The Museum of Modern Art, New York /// *1998* "Peter Halley, Painting as Sociogram 1981–1997", The Kitakyushu Municipal Museum of Art, Kitakyushu, Japan **SELECTED BIBLIOGRAPHY:** *1987 Reconstruct/Deconstruct*, John Gibson Gallery, New York /// *1989 Peter Halley*, Museum Haus Esters Krefeld, Germany; Maison de la culture et de la communication de Saint-Etienne, Saint-Etienne, France /// *The Silent Baroque*, Villa Arenberg, Galerie Thaddaeus Ropac, Salzburg, Austria /// *1992 Peter Halley*, Musée d'Art Contemporain, Pully/Lausanne, Switzerland /// *Peter Halley*, Museo Nacional Centro de Arte Reina Sofía, Madrid, Spain

03 INSTALLATION VIEW, International with Monument, New York (NY), USA, 1986. **04 (((0))),** 1993. Acrylic, Day-Glo acrylic, Roll-a-Tex on canvas, 238 x 230 cm. **05 POWDER,** 1995. Acrylic, Day-Glo acrylic, Roll-a-Tex on canvas, 234 x 318 cm. **06 INSTALLATION VIEW,** Galerie Thaddaeus Ropac, Paris, France, 1995.

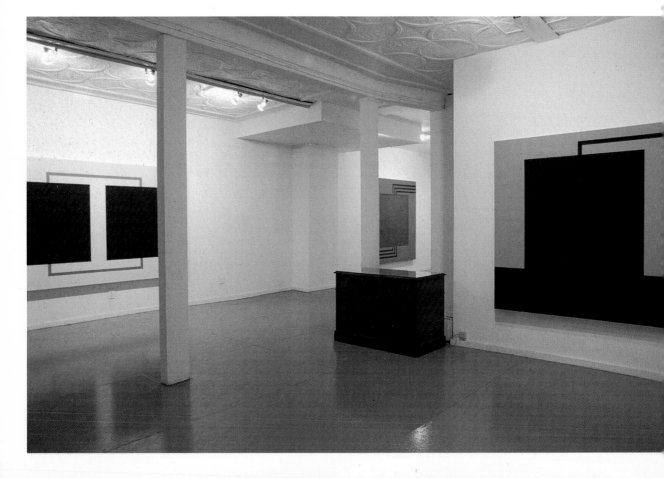

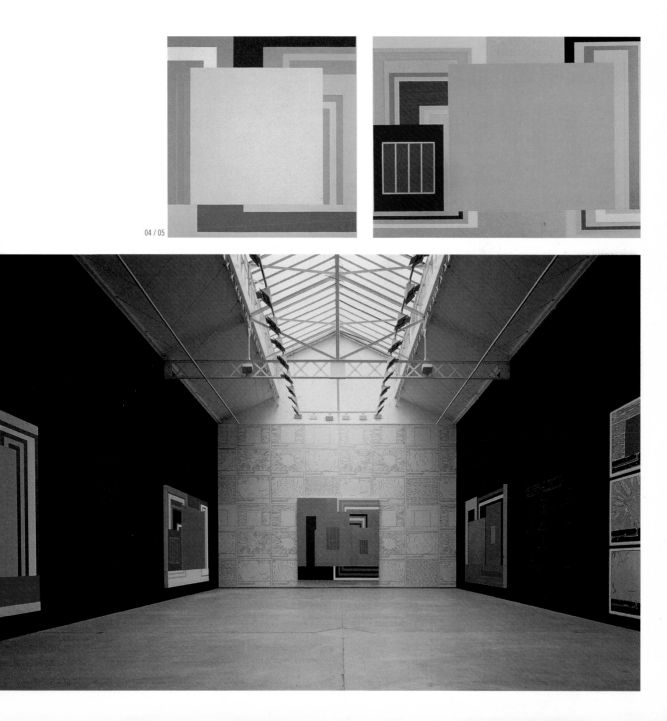

MONA HATOUM

"I wanted to create works that privileges the material, formal, visual aspect of art making and try to articulate the political through the aesthetics of the work." « Je voulais créer une œuvre privilégiant l'aspect matériel, formel, visuel, et tenter d'articuler le politique à travers l'esthétique de l'œuvre. »

Mona Hatoum extends into a traumatic dimension the cool, rational vocabulary of form that established itself in the 1960s with Minimal Art. Her objects and installations are not neutral like their predecessors, but are loaded with associations and are almost oppressively vivid. "Quarters", 1996, a cross-like arrangement of four, ceiling components, is not merely an abstract object in space, but also an image of bunk-bed-style planks, welded on top of one another. What at first appears to be a cube lying on its side, with a rust-brown, contoured-steel upper surface, comes to resemble a coffin due to its shadowy opening ("Divan Bed", 1996). A floor surface that Carl Andre, for example, would have conceived as an area to walk over, mutates into a carpet of nails ("Pin Carpet", 1995). A Palestinian artist born in the Lebanon, Hatoum adopts the idealised art

forms of late Modernism and transforms them into ambivalent and political symbols of individual existence. Consequently, her installations have a disturbing intensity, which cannot be defined in concrete terms. Her homeland may be important, but it is not the theme of her works. Thus "Socle du Monde", 1992/93, a magnetic cube covered in a thick coat of iron filings, is more a description of a psychic condition than a representation of the world. The central reference point in Hatoum's work is the body. This has led her to work in parallel on sculptural objects and performances. Her own body, which she has used in many actions and videos, represents both the female and the threatened body. Viewers should be able to feel the sense of physical menace.

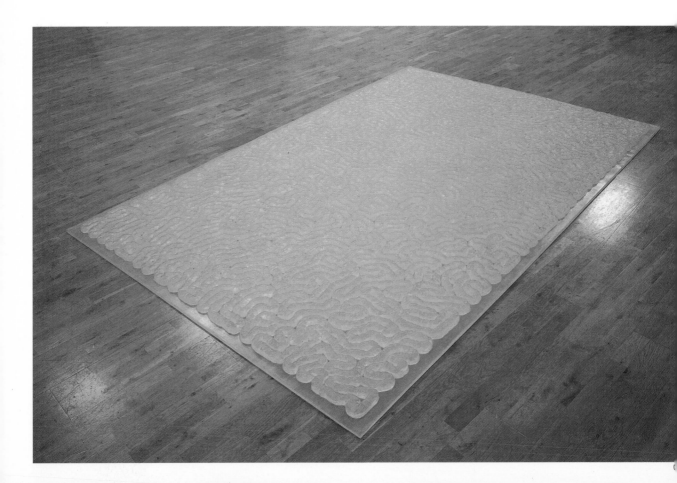

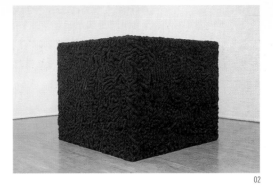

02

Mona Hatoum fait évoluer vers une dimension traumatique la ⋯ideur et le rationalisme du vocabulaire formel qui s'est instauré dans ⋯s années 60 et 70 avec le Minimal Art. Ses objets et installations ne ⋯nt pas neutres, en effet, comme celles des artistes qui l'ont précédée, ⋯ sont chargés d'associations et imagés de manière oppressante. ⋯Quarters », 1996, un agencement en croix de quatre éléments occu⋯nt toute la hauteur de la salle, se présente certes comme un objet ⋯strait dans l'espace, mais aussi comme l'image de civières super⋯sées, soudées les unes au-dessus des autres. Ici, le cube posé sur ⋯e face présente une jointure et la texture de surface couleur rouille ⋯ l'acier profilé qui le font apparaître comme un cercueil (« Divan Bed », ⋯996). Disposée au sol, une surface qu'un artiste comme Carl Andre ⋯rait conçue par exemple comme un espace à parcourir, a muté pour ⋯venir un tapis couvert de clous (« Pin Carpet », 1995). Hatoum, une

palestinienne née au Liban, reprend les formes artistiques idéalisées de la modernité tardive et les transforme en symboles ambivalents, entre autres politiques, de l'existence individuelle. Dans ses installations, cette démarche génère une intensité oppressante qu'on ne peut il est vrai nommer concrètement. Si sa nationalité joue un rôle important, elle n'est pas le thème de ses œuvres. Plus qu'une représentation du monde, le « Socle du Monde », 1992/93, cube magnétique étoffé d'une épaisse fourrure de limaille de fer, est l'expression d'un état comportant une forte charge psychique. Dans l'œuvre de Hatoum, la référence centrale est le corps. Le travail parallèle sur les objets sculpturaux et les performances a donc une importance corrélative. Le propre corps de l'artiste, avec lequel elle travaille dans de nombreuses actions et vidéos, est symbole du corps féminin menacé, que les objets font passer dans celui du spectateur. S. T.

03

MONA HATOUM

SELECTED EXHIBITIONS: *1994* Musée national d'art moderne, Centre Georges Pompidou, Paris, France /// *1995* "Identità e Atterità", Palazzo Grassi, Venice, Italy /// *1997* Museum ⸱ Contemporary Art, Chicago (IL); The New Museum of Contemporary Art, New York (NY), USA /// *1998* Museum of Modern Art, Oxford, England; Scottish National Gallery of Modern Art, Edinburg⸱ Scotland **SELECTED BIBLIOGRAPHY:** *1994 Mona Hatoum*, Musée national d'art moderne, Centre Georges Pompidou, Paris /// *1996 Mona Hatoum*, Stichting De Appel, Amsterdam, Th⸱ Netherlands /// *1997 Mona Hatoum*, London, England /// *Mona Hatoum*, Museum of Contemporary Art, Chicago /// *1998 Mona Hatoum*, Kunsthalle Basel, Basle, Switzerland

04 CORPS ETRANGER, 1994 (detail). Video installation, 350 x ø 305 cm. **05 QUARTERS,** 1996. 12 units, corten and mild steel; individual units, 276 x 81 x 183 cm; overall dimensions, 2.75 x 5.17 x 12.96 m. Installation view, Via Farini, Milan, Italy, 1996. **06 CORPS ETRANGER,** 1994. Video installation, 350 x ø 305 m.

04 / 0⸱

GEORG HEROLD

1947 born in Jena, Germany / lives and works in Cologne, Germany

"Some like it Quark. Some like it canvas." « Certains l'aiment Quark, d'autres toile. »

In producing his pictures, sculptures and installations, Georg Herold consciously renounces elaborate or perfectionist techniques and traditional materials in favour of an assemblage of heterogenous materials such as roof slats, bricks, caviar and wire that are foreign to every established artistic tradition. The themes he tackles range from art history ("Dürerhase", 1984), to society ("No-No/No AIDS – No Heroes", 1990) and politics ("RAF", 1990). His specific concern with language is not only clear from his choice of provocative titles, but is also evident in an on-going, constantly updated glossary that he has been working on for almost twenty years and which regularly appears in his catalogues in a continually enlarged and updated version. In many of his works, Herold refers, in multifarious ways, to the works of other artists. A house made of neon tubes, for instance, captioned "Cyber-Merz", 1995, alludes, according to Herold, to the German artist Gerhard Merz, the Italian Mario Merz and the Merz constructions of Kurt Schwitters. With these references, Herold is not only positioning his own work within art history, but is also ironically questioning our attitude to stylistic features in the marketing system of the art world. He often assimilates scientific discoveries, current political headlines and social and cultural aspects into his pieces, working them up in a Dadaistic style. Brought up in the former German Democratic Republic and emigrating to the West in 1973, Herold also frequently comments on German history in his art.

Pour la réalisation de ses tableaux, sculptures et installations, Georg Herold renonce délibérément aux techniques élaborées et perfectionnistes au profit d'une combinatoire de matières hétérogènes qui se soustraient à toute tradition artistique établie : lattis, briques, caviar, fil de fer. Dans son œuvre, il travaille sur des aspects touchant l'histoire de l'art (« Lapin de Dürer », 1984) ou la société (« No-No/No AIDS – No Heroes », 1990), comme sur des sujets politiques (« RAF », 1990). Chez Herold, le maniement très particulier du langage n'apparaît pas seulement dans le choix (provocant) des titres, mais se lit aussi dans le glossaire auquel il travaille depuis bientôt vingt ans, et dont la version sans cesse élargie et modifiée est régulièrement imprimée dans ses catalogues. Pour certains de ses objets, Herold se réfère de diverses manières aux œuvres d'autres artistes. C'est par exemple le cas pour sa maison en tubes de néon sous-titrée « Cyber-Merz », 1995, ce qui, selon ses déclarations, se réfère tant à l'Allemand Gerhard Merz et à l'Italien Mario Merz qu'au « Merz-Bau » de Kurt Schwitters. Ces références ne servent pas seulement à positionner son propre travail, elles permettent à l'artiste d'interroger aussi très spécifiquement, avec l'ironie qui lui est propre, le maniement des critères générateurs de style au sein du système (du marché) de l'art. Souvent, Herold intègre dans son travail des connaissances scientifiques, des gros titres de l'actualité politique, des aspects socioculturels qu'il soumet à un traitement dadaïste. Un autre thème récurrent de son travail est l'histoire allemande, que cet artiste originaire de l'ex-RDA et passé à l'Ouest en 1973, commente constamment dans ses œuvres.

Y. D

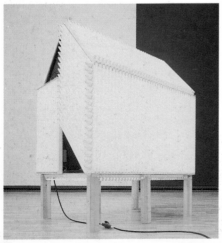

01 HOUSE WITHIN HIS DARKNESS (CYBER-MERZ), 1995. Wood, steel tube, lighting, orange, electrical installations, 325 x 195 x 258 cm.
02 "GELD SPIELT KEINE ROLLE", installation view, Kölnischer Kunstverein, Cologne, Germany, 1990. 03 "JUST DO IT", installation view, Stedelijk Museum, Amsterdam, The Netherlands, 1993/94.

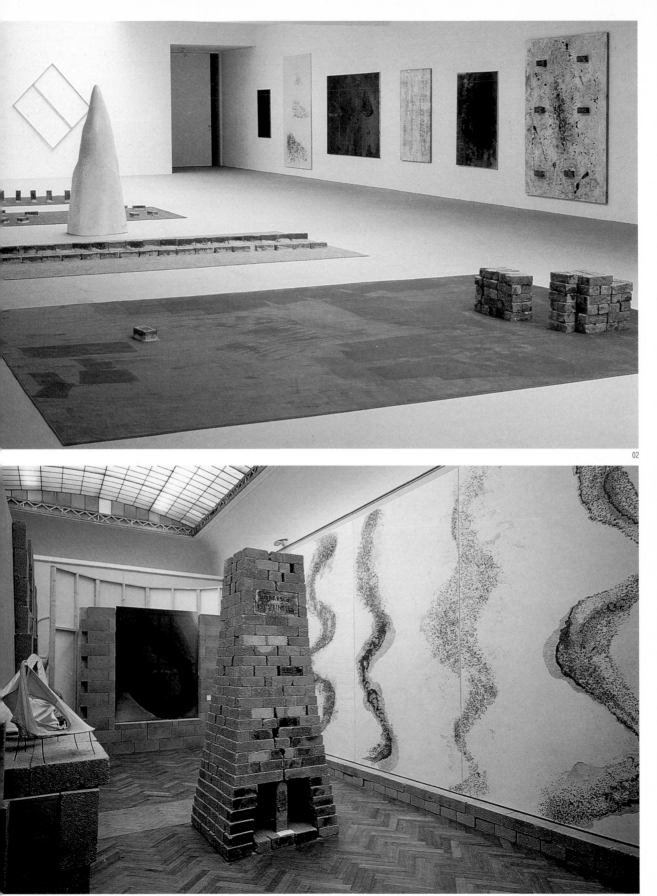

GEORG HEROLD

SELECTED EXHIBITIONS: *1992* "Platzverführung", Kultur Region Stuttgart, Fellbach, Germany /// documenta IX, Kassel, Germany /// *1993–1994* "Just do it!", Stedelijk Museum, Amsterdam, The Netherlands /// *1995* XTOONE, Kunstmuseum Wolfsburg, Wolfsburg, Germany **SELECTED BIBLIOGRAPHY:** *1992 Dirty Data. Sammlung Schürmann*, Ludwig-Forum für Internationale Kunst, Aachen, Germany /// *1993 Herold, Georg: Gekrümmte Poesie*, Stedelijk Museum, Amsterdam /// *1995 XTOONE*, Kunstmuseum Wolfsburg, Wolfsburg /// *1996 Sammlung Speck*, Museum Ludwig, Cologne, Germany /// *1997 STÖRENFRIEDE im öffentlichen Interesse*, Städtische Galerie Nordhorn, Nordhorn, Germany

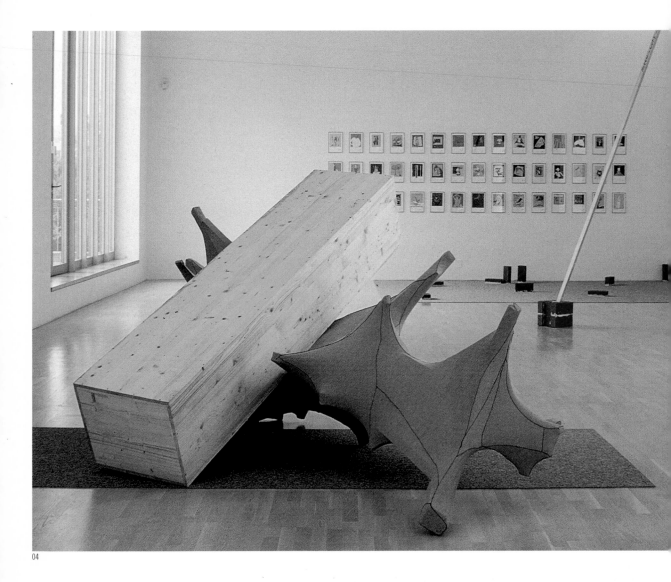

04

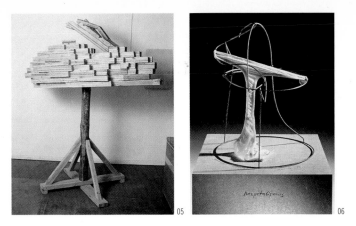

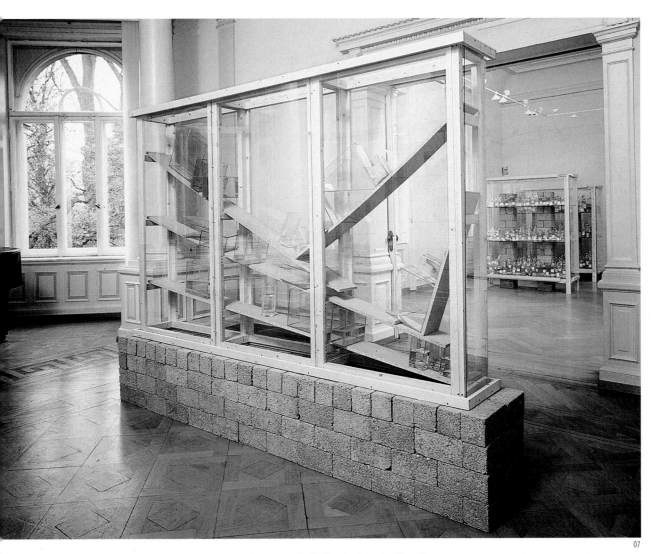

SKULPTUR VOM SOCKEL ERSCHLAGEN, 1992. Slats, thread, wood, canvas, 370 x 120 x 175 cm; plinth, 240 x 55 x 45 cm. Installation view, "Miserere", nsthalle Ritter Klagenfurt, Klagenfurt, Austria (with Werner Büttner), 1993. **05 DÜRERHASE,** 1984. Roof slats, nails, 90 x 75 x 190 cm. **06 HOSPITALISMUS,** 1989. derclothing, wire, chipboard, 39 x 31 x 31 cm. **07 GELANDETE HORIZONTE,** 1996. Distilled water, glass, wood; plinth, 164 x 270 x 39 cm.

GARY HILL

1951 born in Santa Monica (CA) / lives and works in Seattle (WA), US

"And for everything which is visible there is a copy of that which is hidden." **« Et pour tout ce qui est visible, il existe une copie de ce qui est caché. »**

More than any other artist, Gary Hill succeeds in using modern technology to create the aura of physical presence. Many of his video artworks present people who seem so real you have the feeling they're actually in the room with you. In "Tall Ships", 1992, the figures projected on the walls of a long room through which the viewer walks seem to react to one's presence personally, advancing as one approaches and turning away when one moves off again. Contact with the line of slightly larger-than-life workers in "Viewer", 1996 is more direct and thus more eerie. Seventeen men of different races stand silently in front of you, moving a little from time to time. You feel they could start marching at any moment. When Hill presents a little girl reading from Wittgenstein's

"Bemerkungen über die Farbe" (Observations on Colour) in 1994, or, "Circular Breathing" of the same year, projects five images in a breathing rhythm that goes from rapid to slow, he evokes the sensation of direct physical experience. One's reception of the work seems to take place simultaneously with what's happening: you tremble for the little girl with each sentence for she can read the text but clearly cannot understand Similarly in the picture sequences you are tempted to adapt your breathing to the rhythm of the film. Hill recounts momentary scenes, meetings between human beings, which make you almost forget that the others do not actually exist.

La plupart des vidéos d'art réalisées par Gary Hill montrent des
[ho]mmes semblant si véridiques qu'on a souvent le sentiment qu'ils sont
[pré]sents avec nous dans la même pièce. Comme aucun autre artiste,
[il] parvient à créer avec des moyens techniques l'aura d'une présence
[ps]ychique. Ainsi, dans « Tall Ships », 1992, en traversant une pièce longi-
[tud]inale, le spectateur avait constamment l'impression que les person-
[ne]s projetées au mur à sa droite et à sa gauche réagissaient spéciale-
[me]nt à son passage, venaient à sa rencontre lorsqu'il s'approchait, se
[dé]tournaient lorsqu'il s'éloignait. Dans « Viewer », 1996, le contact avec
[un] front d'ouvriers légèrement plus grand que nature était plus direct,
[et] donc plus étrange encore. 17 hommes de toutes races s'y tiennent
[de]bout, rangés face au spectateur, sans dire un mot ; de temps à autre,
[ils] bougent un peu, tout se passe comme s'ils allaient se mettre en

marche d'un moment à l'autre. Et lorsque Hill fait lire à voix haute à une
petite fille les « Remarques sur les couleurs », 1994, de Wittgenstein, ou
que dans les cinq projections de « Circular Breathing », 1994, il présente
des images au rythme d'une respiration d'abord haletante, puis se ralen-
tissant, il déclenche le sentiment d'une expérience corporelle immédiate.
La réception de l'œuvre semble se confondre avec l'événement, on
tremble avec la petite fille dans l'attente de la phrase suivante qu'elle
est certes capable de lire, mais qu'elle est manifestement incapable de
comprendre, et l'on est tenté de calquer son rythme respiratoire sur les
séquences d'images. Gary Hill raconte de petits instants, des rencontres
entre les gens pendant lesquelles les uns oublient presque que les
autres sont purement virtuels. C. B.

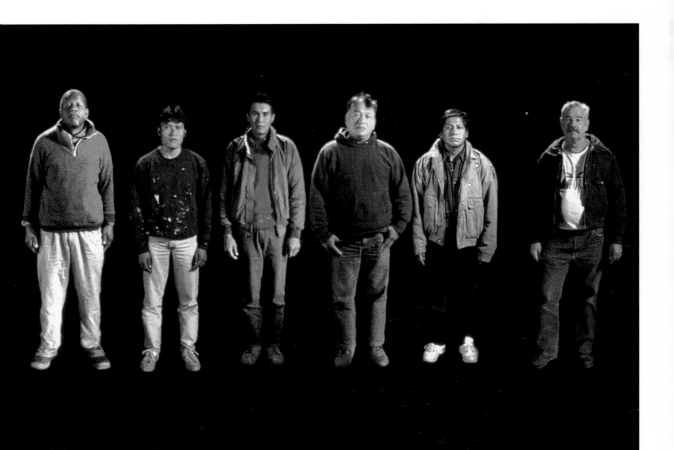

GARY HILL

SELECTED EXHIBITIONS: *1990* The Museum of Modern Art, New York (NY), USA /// *1994* "Imagining the Brain Closer than the Eyes", Museum für Gegenwartskunst Basel, Basl Switzerland /// *1994–1995* Hirshhorn Museum and Sculpture Garden, Washington, D.C.; Henry Art Gallery, Seattle (WA); Museum of Contemporary Art, Chicago (IL); The Museum of Contempora Art, Los Angeles (CA); Guggenheim Museum SoHo, New York (NY); Kemper Museum of Contemporary Art & Design, Kansas City (MO), USA /// Musée d'Art Contemporain de Montréal, Montréa Canada /// *1999* Tel Aviv Museum of Art, Tel Aviv, Israel **SELECTED BIBLIOGRAPHY:** *1992 Gary Hill, Video Installations*, Stedelijk Van Abbemuseum, Eindhoven, The Netherlands /// *Ga Hill – I Believe It Is an Image*, Watari Museum of Contemporary Art, Tokyo, Japan /// *1995 Gary Hill: Imagining the Brain Closer than the Eyes*, Museum für Gegenwartskunst Basel, Basle /// *199 Tall Ships: Gary Hill's Projective Installations – Number 2*, Barrytown (NY), USA /// *Midnight Crossing*, Westfälischer Kunstverein, Münster, Germany

Pages 222/223: **01 VIEWER,** 1996 (detail). 5-channel video installation, 5 laserdisc players, 5 projectors, 5-channel synchronizer. **02 INASMUCH AS IT IS ALWAYS ALREADY TAKING PLACE,** 1990. Sixteen-channel video sound installation, sixteen 1 to 53 cm b/w TV tubes positioned in horizontal inset in wall. Pages 224/225: **03 INCIDENCE OF CATASTROPHE,** 1987 Videotape, colour, stereo sound, 43:51 mins. **04 SUSPENSION OF DISBELIEF (FOR MARINE),** 1992. 4-channel video installation, 30 cm TV tubes mounted on aluminium beam and computer-controlled switching matrix. Installation view, Le Creux de l'Enfer, Centre d'Art Contemporain, Thiers, France, 1992. **05 I BELIEVE IT IS AN IMAGE IN LIGHT OF THE OTHE** 1991/92 (detail). Mixed media installation, 7-channel video, modified TV tubes for projection, books, speaker.

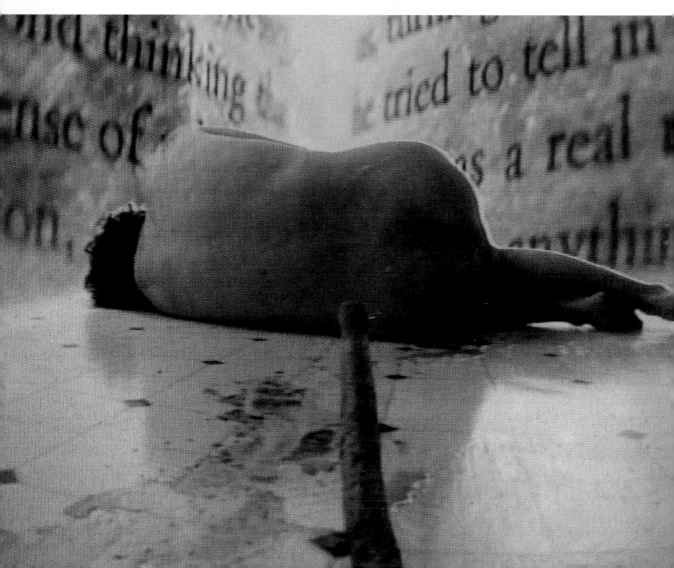

04

...ght illuminates, others it also illuminat... ...it illuminates with an even light. I might... ...lots of interesting details out the window,curious about those things: it's enough for me... ...we're over there. And my curiosity would be mo... ...likely to turn me away from here. It is a great deal to... ...inclined on all sides this way, at every instant, by... ...light that comes from nowhere, that only attrac... ...images, then pushes them away, attracts light though... ...then pushes them away.. I'm sure that brightness h... ...any realtion to you. I'm inclined to believe that do... ...illuminate, that you keep to yourself within confin... ...where the darkness whitens, without another d... ...appearing. I recognize that I'm lying down in that pit... ...light, whose boundaries are so strictly defined except... ...one point. remember: the eyes are shut, and the mou... ...is also shut. It probably happened in the room. Un... ...my eyelids I had the deep black, velvety, rich, a... ...warm, that sleep preserves, that dreams always fe... ...reappearing behind them; and no doubt I was alrea... ...dead in many parts of myself, but the black was st... ...alive. It went on for a long time, maybe forever... ...remained close to the black, maybe in it. I wait... ...without impatience, lightly I watched for the mome... ...when the black would lose its color and inevitably,... ...by losing it, cause the final whiteness to ris. The last da... ...sun of the dead. Maybe this is the very same wh...

DAMIEN HIRST

1965 born in Bristol, England / lives and works in Devon, England

"Art is like medicine — it can heal." **« L'art est comme la médecine, il a le pouvoir de guérir. »**

Damien Hirst became famous overnight at the end of the 1980s, not only as an artist but also as a curator. His group exhibitions "Freeze", 1988, and "Modern Medicine", 1990, launched Young British Art. Hirst has never restricted himself to the traditional image of the artist. In his subsequent career he went on to make commercial music videos, opened a restaurant and produced pop songs. His paintings and sculptures revolve, above all, around the relationship between life, sickness and death. He combines the idioms of Minimal and Pop Art in installations that seem almost aseptic. A dead shark, for instance, is placed in a glass case, suspended in a formaldehyde solution. Presented as if in a natural history museum, it becomes a contradictory metaphor, at once provocative and ostentatious, for aggression and vitality, but also for death and conservation. This contradiction is expressed in the work's title: "The Physical Impossibility of Death in the Mind of Something Living", 1991. His installations, which often include his chemist-shop cupboards arranged according to strict architectural principles, give a dispassionate account of the battle of life against death, and therefore also of recovery and health. Especially shocking are the vitrines in which dead and living creatures encounter one another. In "A Thousand Years", 1990, innumerable flies buzz round a cow's head, busily eating the corpse, which is thereby reincorporated into the life cycle. Damien Hirst's abstract "spot paintings" are less drastic. Arranged in lines on the "pharmaceutical" picture surface, monochrome colour circles resembling a sea of pills appear to have been selected in accordance with some scientific principle ("Ammonium Citrate", 1993). One look at these dots, can, the artist hopes, "heal".

A la fin des années 80, Damien Hirst ne se rendit pas seulement célèbre comme artiste, mais aussi comme commissaire d'expositions. Les expositions organisées par ses soins, « Freeze », 1988, et « Modern Medicine », 1990, marquèrent le début de l'ascension du Young British Art. Plus tard aussi, Damien Hirst ne s'est jamais confiné dans un rôle d'artiste beaucoup trop exigu pour lui. Ses activités l'ont ainsi conduit à réaliser des vidéos musicales, aménager un restaurant et produire des chansons pop. Comme peintre et plasticien, il se consacre aux thèmes de la vie, de la maladie et de la mort. Dans son travail, les langages formels du Minimal Art et du Pop Art se combinent pour former des installations presque aseptisées. On trouve par exemple un gigantesque requin mort plongé dans un immense aquarium de verre rempli de formol. Présenté comme dans un musée d'histoire naturelle, le requin transposé dans le contexte du musée devient une métaphore contradictoire aussi provocante que lapidaire de l'agression et de la vitalité, mais aussi de la mort et de la conservation. Une contradiction que traduit également le titre de l'œuvre : « The Physical Impossibility of Death in the Mind of Something Living », 1991. Une des œuvres les plus choquantes de Hirst est constituée de cages dans lesquelles on assiste à la rencontre d'animaux vivants et morts. Dans « A Thousand Years », 1990, une nuée de mouches bourdonne autour d'une tête de vache. Les mouches mangeant assidûment le cadavre le réintègrent dans le cycle de la nature. Parmi des œuvres moins crues, on trouve les « Spot Paintings » de Hirst. Des cercles de couleur monochromes y sont agencés en trames claires selon des principes pseudo-scientifiques sur une surface picturale « pharmaceutique ». Les innombrables points d'un tableau comme « Ammonium Citrate », 1993, se présentent comme une mer de pilules. Comme l'espère l'artiste, un regard sur ses points « peut guérir ». R. S.

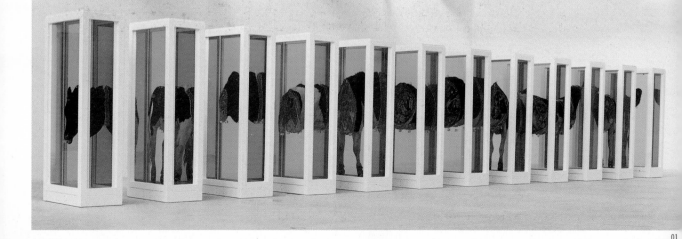

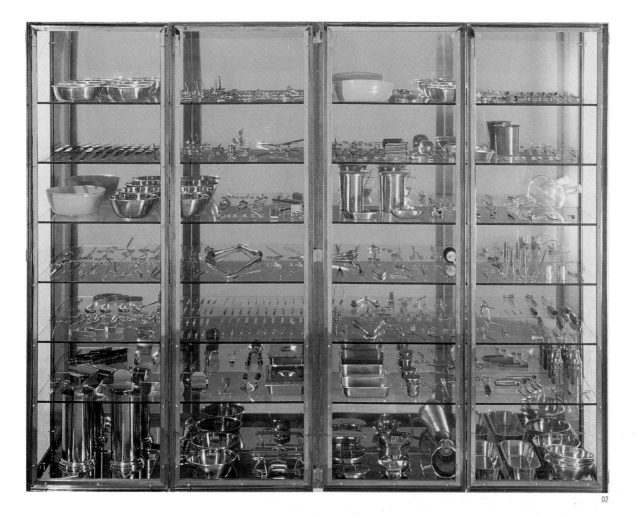

SOME COMFORT GAINED FROM THE ACCEPTANCE OF THE INHERENT LIES IN EVERYTHING, 1996. Steel, glass, cows and formaldehyde solution; tanks, 200 x 90 x 30 cm (each). **02 STILL,** 1994. Glass, stainless steel, surgical equipment, 196 x 251 x 51 cm.

DAMIEN HIRST

SELECTED EXHIBITIONS: *1991* "Internal Affairs", Institute of Contemporary Arts, London, England /// *1993* Aperto 93, XLV Exposizione Internationale d'Arte, la Biennale di Venezia, Venice, Italy /// *1994* "Currents 23", Milwaukee Art Museum, Milwaukee (WI), USA /// *1996* "No Sense of Absolute Corruption", Gagosian Gallery, New York (NY), USA /// *1997* "Sensation", Royal Academy of Arts, London **SELECTED BIBLIOGRAPHY:** *1991* *Internal Affairs*, Institute of Contemporary Arts, London /// *1993* *Damien Hirst*, Jablonka Galerie, Cologne, Germany /// *199. Making Beautiful Drawings*, Galerie Bruno Brunnet Fine Arts, Berlin, Germany /// *1997* *The Beautiful Afterlife*, Galerie Bruno Bischofberger, Zurich, Switzerland /// *I want to spend the rest of m. life everywhere, with everyone, one to one, always, forever, now*, London

03

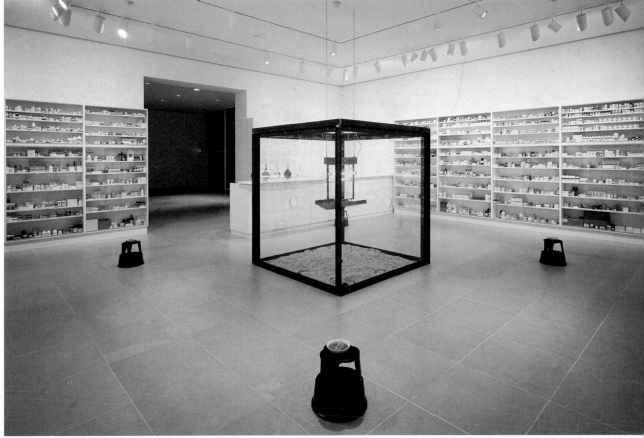

05

COCAINE HYDRO CHLORIDE, 1993. Gloss household paint on canvas, 145 x 145 cm. 04 PHARMACY, 1992. Cabinets, medicine packaging, desks, chairs, thecary bottles, fly zapper, foot stools, bowls, honey, glass, steel cube and rats, dimensions variable. Installation view, Dallas Museum of Art, Dallas (TX), USA, 4. 05 BEAUTIFUL, FOUR CHEESES, SPICY, QUATTRO STAGIONI, FLORENTINE, MICHELANGELO, VENETIAN GLASS, PAMPLONA PAINTING, 1997. Gloss household nt on canvas, ø 213 cm.

CANDIDA HÖFER

1944 in Eberswalde, Germany / lives and works in Cologne, Germar

"I am looking for the similar in public spaces, though what attracts me is the differences between these similarities." **« Dans les espaces, je cherche ce qui se ressemble, en quoi je suis attirée par la différence entre ce qui se ressemble. »**

A former pupil of Bernd Becher, Candida Höfer became known for her colour photographs of public or semi-public interiors. Since 1979 she has devoted herself to this theme, supplemented from 1990 onwards by her "Zoologische Gärten" (Zoos). In this, she has followed an unchanging artistic concept: she works with a small camera, usually without a tripod, a light wide-angle lens and available light only. The photos are generally presented in a 38 x 38 cm or 38 x 57 cm format. Despite this repetitive working principle, Höfer's pictures do not conform to the serial nature of Becher's industrial typologies, for the position of the camera, and thus the composition of the picture, are determined by the individual character of the room. She avoids a centralising composition, preferring to let her gaze flit over apparently incidental places. Her locations – waiting rooms, hotel lobbies, university lecture rooms, libraries,

museums – are public places in which people are exposed to each other's scrutiny, rather like zoo animals in their enclosures. They are places of transit, but also of retention. Different levels of time come together in her works: the history of the architecture, the present functic of the location and the time when the photograph was shot. There is often evidence of the present use of the rooms, which are usually devo of people, but this doesn't detract from their multifunctional arrangement. An unorthodox conception of history emerges. This is not cut and dried, but shifts with the perspective selected. Höfer's compositional openness is therefore more than a principle of style: she opposes the desire for order and control that is often visible in architecture and the organisation of interiors.

Candida Höfer s'est fait connaître par ses photographies couleur d'espaces (intérieurs) publics et semi-publics. Depuis 1979, cette ancienne élève de Bernd Becher se consacre à ce thème, qu'elle a complété depuis 1990 par ses « Jardins zoologiques ». Elle suit pour cela un concept artistique constant, travaillant avec un appareil maniable, le plus souvent sans pied, un objectif léger grand-angle et se servant exclusivement des modes d'éclairage existants. En règle générale, elle présente ses photos en format 38 x 38 ou 38 x 57 cm. Nonobstant la constance de ce principe, les photos de Höfer se distinguent de la sérialité des « typologies » industrielles de Becher. Car la position de l'objectif, et donc la composition de la photo, est déterminée par la spécificité de l'espace dans lequel il se trouve, Höfer évitant toute composition centrale de l'image. Le regard glisse plutôt sur des scènes apparemment secondaires. Les espaces de Höfer – salles d'attente, halls d'hôtel,

amphithéâtres d'université, bibliothèques, musées, ces espaces étant le plus souvent déserts au moment de la prise de vue – sont des lieux d'utilisation collective où l'homme est exposé aux regards des autres comme l'animal dans l'enceinte du zoo, ce sont des lieux de transition, mais aussi de conservation. Il n'est pas rare qu'on y décèle les traces de leur utilisation actuelle, traces qui ne perturbent guère leur aménage ment sériel et fonctionnel. Dans les œuvres de Höfer se superposent d férents niveaux temporels : l'histoire de l'architecture, son utilisation pré sente et l'instant de la prise de vue. C'est ici qu'apparaît une conceptio non canonique de l'histoire. Celle-ci n'est pas fixée une fois pour toutes, elle change selon la perspective choisie. La composition ouverte de Höfer est donc plus qu'un simple principe stylistique : elle s'oppose au désir d'ordre et de domination souvent présent dans l'architecture et la décoration intérieure.

A. V

01

CANDIDA HÖFER

SELECTED EXHIBITONS: *1992* "Räume/Spaces", Portikus, Frankfurt/M., Germany /// *1993* "Photographie II – Zoologische Gärten", Hamburger Kunsthalle, Hamburg, Germany /// *1996* Sonnabend Gallery, New York (NY), USA /// Robert Prime, London, England /// *1998* Kunstverein Wolfsburg, Wolfsburg, Germany /// *1999* Kunsthaus Bregenz, Bregenz, Austria **SELECTED BIBLIOGRAPHY:** *1992 Candida Höfer: Photographie*, Hagener Kunstverein, Hagen, Germany /// *1993 Candida Höfer: Zoologische Gärten*, Munich, Germany /// *1997 New*, New York /// *The Photography Book*, London /// *1998 Candida Höfer*, Kunstverein Wolfsburg, Wolfsburg; Munich

04

CARSTEN HÖLLER

1961 born in Brussels, Belgium / lives and works in Cologne, Germany

"What I was very fond of – even at school – is the new maths, because it is a pre-mathematical process which operates visually and can illustrate connections by means of simple methods." « Ce que j'ai toujours beaucoup aimé – même à l'école –, c'est la théorie des ensembles, parce que c'est un moyen pré-mathématique qui travaille en termes visuels et qui est à même de mettre en évidence des correspondances avec des moyens très simples. »

Carsten Höller has been working as an artist since the beginning of the 1990s, but also has a doctorate in agricultural science and is a specialist in insect behaviour. This confluence of art and science gives his works their particular character. In form, they often remind us of laboratory structures in which the viewer becomes the object of the experiment. His works make it possible to fly round in a circle, emmerse one's head in an aquarium, be propelled across the water or speed down a slope in a soundproofed sledge. In 1997 at documenta X in Kassel, he produced, along with Rosemarie Trockel, the "Haus für Schweine und Menschen" (House for Pigs and People), which revealed not only the life of a pedigree breed of pig but also the behaviour of humans. The two were separated by a glass plate, and each was allotted a pleasant and appropriate environment. The pigs had an excellent sty with access to an enclosure outside, and the human beings a platform with soft mats on which they could devote themselves to relaxed observation. Yet, these worlds of experience staged by Höller do not exist in isolation, but are extended through lectures, symposia and books with theoretical texts. Scientists and philosophers ponder on the processes to which the works give rise. The objects are therefore consciously aimed at provoking confrontations that extend far beyond art alone.

Tout en étant actif comme artiste depuis le début des années 90, Carsten Höller est en même temps un scientifique diplômé en agronomie, spécialiste en outre du comportement des insectes. C'est de cette rencontre entre l'art et la science que résulte le caractère très particulier de ses œuvres, dont la forme évoque souvent à elle seule des installations de laboratoire dans lesquelles le spectateur devient sujet d'expérimentation. Dans ses œuvres, on peut voler en rond, plonger la tête dans un aquarium, se laisser dériver sur l'eau ou dévaler une pente dans un traîneau isolé de tout bruit. En 1997, la « Maison pour les porcs et les hommes » réalisée pour la documenta X en collaboration avec Rosemarie Trockel, présentait non seulement l'existence d'une race porcine noble, mais aussi le comportement des hommes. Séparées par une vitre, les deux espèces se voyaient offrir un environnement confortable en accord avec l'espèce respective. Les porcs possédaient une porcherie modèle dotée d'une évacuation, les hommes une estrade avec des nattes douillettes sur lesquelles ils pouvaient s'adonner à l'observation en toute décontraction. Mais les univers d'expérience mis en scène par Höller n'existent pas pour eux-mêmes, ils sont accompagnés de conférences, de séminaires et de livres comportant des textes théoriques. Scientifiques et philosophes y réfléchissent sur les processus déclenchés par les œuvres. Ainsi, les objets de Höller sont délibérément disposés de manière à susciter des confrontations dépassant largement le cadre de l'art.

C.

01 **KILLING CHILDREN III,** 1994. Plugs, flex and chocolates. Installation view, Ynglingagatan 1, Stockholm, Sweden, 1994. **02 HARD, HARD TO BE A BABY,** 1992. Child's swing. Installation view, "UFO Project", Air de Paris, Nice, France, 1992. **03 "SKOP",** installation view, Wiener Secession, Vienna, Austria, 1996.

CARSTEN HÖLLER

SELECTED EXHIBITIONS: *1993* Aperto 93, XLV Esposizione Internationale d'Arte, la Biennale di Venezia, Venice, Italy /// *1994* "Du You", Schipper & Krome, Cologne, Germany /// *1996* "Glück" Kunstverein in Hamburg, Hamburg; Kölnischer Kunstverein, Cologne, Germany /// "Geluk", Centraal Museum Utrecht, Utrecht, The Netherlands /// *1997* "Ein Haus für Schweine und Menschen" documenta X, Kassel, Germany (in collaboration with Rosemarie Trockel) /// "Pitsch Park", Sprengel Museum Hannover, Hanover, Germany /// *1998–1999* "Neue Welt", Museum fü Gegenwartskunst Basel, Basle, Switzerland **SELECTED BIBLIOGRAPHY:** *1997 Glück/Skop*, Cologne /// *1998 Neue Welt*, Museum für Gegenwartskunst Basel, Basle /// *Carsten Höller Spiele Buch*, Cologne

04 /

04 / 05 EIN HAUS FÜR SCHWEINE UND MENSCHEN, 1997. Installation views, documenta X, Kassel, Germany, 1997 (in collaboration with Rosemarie Trockel). **06 FLUGAPPARAT,** 1996. Installation view, "Glück", Kunstverein in Hamburg, Hamburg, Germany, 1996. **07 AQUARIUM,** 1996; **ANNA SPATZ, 7 UHR MORGENS,** 1996. Installation view, "Glück", Kunstverein in Hamburg, Hamburg, 1996.

JENNY HOLZER

"I am happy when my material is mixed with advertisements or pronouncements of some sort or another." **« Je suis heureuse quand mon matériau se mêle aux affiches publicitaires ou aux annonces de tel ou tel type. »**

Jenny Holzer's works use the structures of the mass media and aesthetics of the current milieu to smuggle messages into the public arena. As these are often directed at the casual viewer, simplicity and media support are important criteria. Holzer's pointed one-liners, which have become her signature, crop up on posters, T-shirts and illuminated advertising boards. Her "Truisms", 1977–1979, were fly-posted anonymously in the streets of Manhattan, and in 1982 were flashed up on an illuminated advertising board in Times Square. She has also displayed, like information notices in public places, metal plates engraved with aphorisms from the "Living" series, 1980–1982. What is provocative about Holzer's work is not just her subject matter – which, as she declared at the Venice Biennale of 1990, always revolves around "sex, death and war" – but her refusal to take up a clear position, an ambiguity that is often associated with the feminist demand for multiple identities. This

semantic indeterminacy also marks Holzer's project "Lustmord" (Sex Murder), conceived in 1993 as a newspaper supplement. The experience of sexual violence and death is depicted from the perspective of the culprit, the victim and the witness, in brief, sometimes aggressive sentences. Subsequently Holzer has shown this work in various different versions, as a 3D-LED installation in Bergen (1994), as illuminated words at the Battle of Leipzig monument in that city (1996), or as a quasi-religious display in the art museum of the Swiss canton of Thurgau (1996). For the latter, she meticulously lined up bones bearing texts on metal strips – a reference to the human urge, both hopeless and macabre, to supervise death. In her wish to touch the viewer's emotions Holzer bravely walks a tightrope between dramatic directness, seductive superficiality and the need for distanced reconsideration.

Les œuvres de Jenny Holzer utilisent les structures des médias et l'esthétique inhérente au sujet choisi pour faire passer – comme en fraude – ses messages au public. Dans la mesure où il n'est pas rare qu'elle s'adresse à des spectateurs de rencontre, le caractère univoque et la présence du médium sont des critères importants pour le choix des moyens. Les gros titres frappants de Holzer se retrouvent entre autres sur des affiches, des T-shirts ou des tableaux d'affichage électroniques. Elle a ainsi affiché ses « Truisms », 1977–1979, anonymement dans les rues de Manhattan avant de les présenter sur un tableau d'affichage électronique dans Times Square, 1982, ou bien elle distribuait des plaques métalliques portant des aphorismes tirés de sa série « Living », 1980–1982, comme des panneaux indicateurs au sein de l'espace public. Le caractère provocateur des œuvres de Holzer ne réside pas seulement dans les sujets choisis. Ceux-ci tournent toujours autour « du sexe, de la mort

et de la guerre », comme l'a expliqué l'artiste lors de la Biennale de Venise en 1990. On est tout particulièrement irrité par le refus de toute prise de position claire ; la critique a ainsi rattaché la diversité de voix de son œuvre à la revendication féministe d'identités multiples. Cette liberté sémantique caractérise aussi le projet « Crime sexuel » conçu en 1993 sous forme de supplément d'un journal. Les expériences de la violence sexuelle et de la mort y sont décrites depuis la perspective du criminel, de la victime et de l'observateur en phrases concises, souvent agressives. Depuis, Holzer a présenté ce travail dans différentes variantes : sous forme d'installation électroluminescente en trois dimensions à Bergen, 1994, comme écriture néon, 1996, sur le « Völkerschlacht-denkmal » (« Monument à la mémoire du massacre des peuples ») de Leipzig, ou comme mise en scène avec des connotations sacrales au Kunstmuseum du canton de Thurgau, 1996. A. W.

01 **INSTALLATION VIEW**, St. Peter, Cologne, Germany, 1993. **02 SURVIVAL 1983–1985.** Spectacolour signboard, 51 x 102 cm. Outdoor installation, "Selection from the Survival Series", Times Square, New York (NY), USA, 1986. **03 KRIEGSZUSTAND**, Leipzig Monument Project. (Völkerschlachtdenkmal). Laser projection. Outdoor installation, Galerie für zeitgenössische Kunst Leipzig, Leipzig, Germany, 1996.

01 02

JENNY HOLZER

SELECTED EXHIBITIONS: *1989–1990* "Jenny Holzer: Laments 1988/89", Dia Art Foundation, New York (NY), USA /// Solomon R. Guggenheim Museum, New York /// *1990* XLIV Esposizion[e] Internationale d'Arte, la Biennale di Venezia, Venice, Italy, United States Pavilion /// *1996* "KriegsZustand", Völkerschlachtdenkmal, Leipzig, Germany (outdoor installation) /// "Jenny Holze[r] LUSTMORD", Contemporary Arts Museum, Houston (TX), USA **SELECTED BIBLIOGRAPHY:** *1989–1990 Laments*, Dia Art Foundation, New York /// *1990 Jenny Holzer*, Solomon R. Guggenhei[m] Museum, New York /// *Exhibition catalogue*, XLIV Esposizione Internationale d'Arte, la Biennale di Venezia, Venice; Albright-Knox Art Gallery, Buffalo (NY), USA /// *1996 KriegsZustand*, Galeri[e] für zeitgenössische Kunst Leipzig, Leipzig /// *1997 Jenny Holzer: "LUSTMORD"*, Contemporary Arts Museum, Houston

04 INSTALLATION VIEW. LED sign, red granite benches. Solomon R. Guggenheim Museum, New York (NY), USA, 1989/[
05 THE VENICE INSTALLATION. LED signs, marble floor. Walker Art Center, Minneapolis (MN), USA, 19[

04

MARTIN HONERT

1953 born in Bottrop, Germany / lives and works in Düsseldorf, Germany

"The only things that interest me are those for which I have ambivalent feelings, the emotional confusion of pathos and embarrassment, seriousness and absurdity, demand and reality, the sad ending of a happy time etc." « Ce qui m'intéresse exclusivement, ce sont les événements à l'égard desquels j'éprouve un sentiment non univoque, la confusion sentimentale de l'émotion et de l'embarras, le sérieux et le ridicule, l'attente et la réalité, la triste fin d'une époque heureuse, etc. »

The art of Martin Honert goes in search of the lost age of child-hood. Memory is therefore at the core of his works, which are usually three-dimensional objects and reliefs. This effort to remember draws its images on the one hand from the artist's own life, and on the other, plugs into the collective memory of society. In "Foto" (Photo), 1993, for instance, he reproduced a snapshot from his family album as a sculpture. The five-year-old Martin sits at a kitchen table, his little legs too short to reach the floor. The boy stares into the camera with obvious astonishment. The artist has even transferred the photo's lighting conditions on to the sculpture with detailed accuracy, giving the object an almost pictorial character. Honert uses the isolation of the photographic act to freeze a moment of his own biography in picture, saving it from oblivion. At the same time he awakens in the viewer recollections of similar childhood experiences: which of us has never sat at a table that is too high, and looked with large questioning eyes into the world of grown-ups? When dealing with impersonal subjects or those that go beyond the individual an artificially lit fireplace (1992), a green linden tree (1990), or the blue and white swimming-badges that were sewn on children bathing costumes (1986) – Honert employs a different strategy for recollection. As "general symbols", these factually and coolly reproduced objects convey the poetic secret that transforms ordinary things into the messengers of a world before language. Honert's works often seem like enlarged children's toys, naive witnesses of psychic processes.

01 EIN SZENISCHES MODELL DES "FLIEGENDEN KLASSENZIMMERS", 1995. Polystyrene, epoxy resin, wood, 400 x 600 x 400 cm.
02 ZIGARRENSCHACHTELBILD, 1988. Oil on wood, 147 x 200 cm. 03 KINDERKREUZZUG, 1985–1987. Painted polyester, oil on canvas,
200 x 160 cm/265 x 430 cm. Installation view, "Szenenwechsel" XII", Museum für moderne Kunst, Frankfurt/M., Germany, 1997/98.

02

Avec son art, Martin Honert se met à la recherche du temps
rdu de l'enfance, de son enfance. Le travail sur la mémoire est donc
 centre de ses objets le plus souvent sculpturaux ou appartenant au
maine du relief. Si ses images ont leur origine dans l'enfance de
rtiste, ce travail sur la mémoire peut aussi se rattacher à la mémoire
llective de notre société. On y trouve par exemple un travail comme
Photo », 1993, dans lequel l'artiste a reproduit sous forme de sculpture
 photo de son album de famille : Martin Honert, âgé de cinq ans, est
sis à une table de cuisine, ses jambes d'enfant bien trop courtes pen-
nt de la chaise. Visiblement étonné, l'enfant regarde fixement l'objectif.
 sculpture reproduit même jusqu'aux moindres détails les conditions
éclairage de la photo, conférant ainsi à l'objet un caractère quasi iconi-
e. En isolant cet instant photographique, Honert fige un moment de sa
opre biographie dans une image et parvient ainsi à le sauver de l'oubli.

En même temps, il stimule chez le spectateur des souvenirs d'enfance
similaires – lequel d'entre nous, assis à une table trop grande, n'a pas
jeté de ses grands yeux un regard interrogateur sur le monde des adul-
tes ? Dans son travail de remémoration, Martin Honert applique une autre
stratégie en choisissant des motifs impersonnels, voire supra-individuels,
par exemple un feu de cheminée éclairé artificiellement, 1992, un tilleul,
1990, ou les écussons, 1986, que nous cousions sur nos maillots de
bain quand nous étions enfants. En tant qu'« emblèmes universels »
(Honert), ces objets représentés de manière objective, quasi distancée,
donnent une information poétique sur le mystère qui fait justement des
objets les plus anodins les messagers d'un monde d'avant le langage.
Les œuvres de Honert, qui font souvent songer à des jouets géants,
deviennent ainsi les témoins naïfs de processus psychiques. R. S.

MARTIN HONERT

SELECTED EXHIBITIONS: *1992* Sydney Biennial, Sydney, Australia /// Museum für Moderne Kunst, Frankfurt/M., Germany /// *1993* "Menschenwelt (Interieur)", Portikus, Frankfurt/M.; Castello di Rivara, Rivara (TO), Italy; Norwich Gallery, Norfolk Institute of Art and Design, Norfolk, England; Württembergischer Kunstverein Stuttgart, Stuttgart; Westfälischer Kunstverein Münster, Germany /// *1995* XLVI Esposizione Internationale d'Arte, la Biennale di Venezia, Venice, Italy, German Pavilion (with Katharina Fritsch and Thomas Ruff) /// *1997* "Young German Artists 2", Saatchi Gallery, London, England **SELECTED BIBLIOGRAPHY:** *1988 Martin Honert*, Johnen & Schöttle, Cologne, Germany /// *1997 Young German Artists 2*, Saatchi Gallery, London /// *1998 Martin Honert*, Institut für Auslandsbeziehungen, Stuttgart, Germany

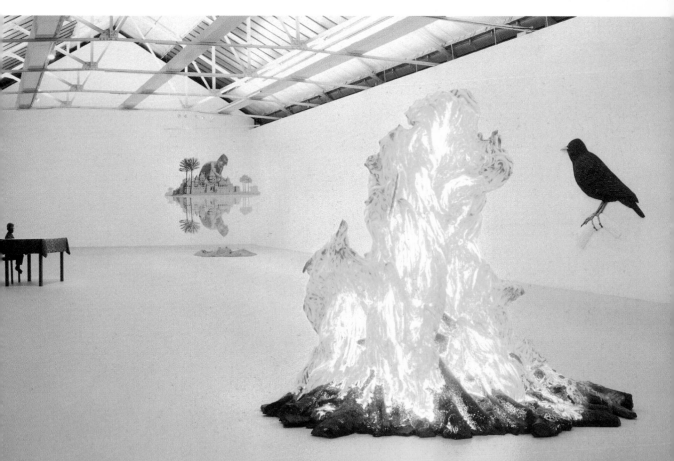

04 FOTO, 1993. Polyester, wood, paint, chair with figure, 107 cm (h); table, 79 x 133 x 86 cm.
05 "YOUNG GERMAN ARTISTS 2", installation view, Saatchi Gallery, London, England, 1997.

RONI HORN

"An object is capable of creating the place in which it is shown." « Un objet a la faculté de créer le lieu où il est présenté. »

Since 1976 Roni Horn has been attempting, in a kind of Minimalist act of conquest, to seize the immeasurable by means of fragility and simplicity, with almost nothing. It is principally her choice of material that gives her work its clear, direct elegance, and she bases her sculptures on the specific physical and psychological qualities of that material. To use the artist's own phrase, the sculptures form a "store of experiences", and are ultimately aimed at confirming the particular nature of the substances she uses. In multifarious combinations, Horn brings out the polarities from which her materials take their definition. The power and strength of steel finds its counterpart in the weight and malleability of lead, the suppleness of rubber or the lightness and fragility of balsa wood. Her sculptures are always placed on the floor, in order to emphasise the different relationships that the various materials seem to have with gravity. Balsa "hovers", lead "flows", gold reflects the rays of light, while coal dust absorbs the light. The artist's photographic work, mainly executed in Iceland, is concerned with the qualities of space. The relationship between place and perception is explored in "Tourists At Gullfoss, Iceland", 1994, while in her photo series "You are the Weather", 1994–1996, Horn concentrates entirely on the moment of perception. A young woman by the water is photographed in an extensive sequence of near-identical images, so that every nuance, each freckle and little hair takes on significance. "The water conveys her image", the artist writes, thus emphasising the interaction of space and perception.

Dans une sorte de dépassement du minimalisme, Horn entreprend depuis 1976 de penser l'incommensurable avec les moyens du presque-rien et de la fragilité. C'est avant tout la matière qui confère à l'œuvre son caractère de clarté, d'immédiateté et d'élégance. La sculpture, que l'artiste voit comme une « provision d'expériences », ne veut au fond qu'affirmer les qualités propres à la substance qui la constitue : la dureté de l'acier qui contredit la souplesse du caoutchouc, la légèreté du balsa qui « flotte » tandis que le plomb « coule », l'or qui réfléchit les rayons lumineux, en opposition à la poussière de carbone qui absorbe toute lumière. La réflexion que ses sculptures engagent sur la façon dont l'environnement influence l'œuvre et dont l'œuvre modifie à son tour l'environnement est prolongée, depuis 1994, par des œuvres photographiques, réalisées le plus souvent en Islande. La série intitulée « Tourists at Gullfoss », Iceland montre comment la présence humaine affecte à la fois la perception de l'espace qu'elle habite et la signification même de cet espace. « You are the weather », qui enregistre simplement les images d'une jeune femme au bord de l'eau, engage un subtil dialogue avec la nature pour révéler comment la moindre nuance – une tache de rousseur, une mèche de cheveux – peut prendre dimension d'événement. Au-delà de leur manifeste fragilité, ses œuvres affirment une sorte d'intemporalité intangible qui maintient le regard à distance et cherche, dans le même temps, à l'apprivoiser. L'artiste, engagée dans la recherche exigeante, paradoxale et incertaine d'un infini sans origine, fait valoir un décentrement sans proximité, une solitude sans absence, une signification sans réplique.

J.-M.

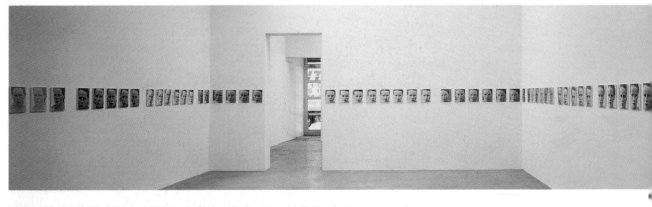

01 YOU ARE THE WEATHER, 1994–1996. Series of 100 photographs (36 b/w and 64 colour photographs), 27 x 21 cm (each).
Installation view, Fotomuseum Winterthur, Winterthur, Switzerland, 1997. **02 YOU ARE THE WEATHER**, 1994–1996 (details).

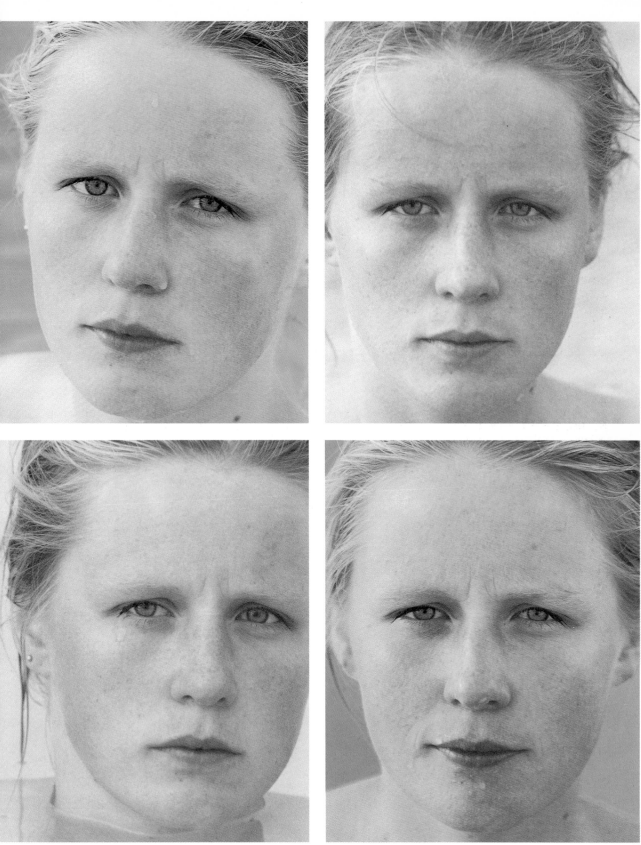

RONI HORN

SELECTED EXHIBITIONS: *1990* The Museum of Contemporary Art, Los Angeles (CA), USA /// *1991* Städtisches Museum Abteiberg, Mönchengladbach, Germany /// *1992* documenta IX, Kassel, Germany /// *1995* "Zeichnungen", Museum für Gegenwartskunst Basel, Basle, Switzerland /// *1997* XLVII Esposizione Internationale d'Arte, la Biennale di Venezia, Venice, Ital
SELECTED BIBLIOGRAPHY: *1989 Prospect 89*, Schirn Kunsthalle Frankfurt, Frankfurt/M., Germany /// *1990 Roni Horn: Surface Matters*, The Museum of Contemporary Art, Los Angeles //
1991 Things Which Happen Again, Städtisches Museum Abteiberg, Mönchengladbach; Westfälischer Kunstverein, Münster, Germany /// *1995 Gurgles, Sucks, Echoes*, Matthew Marks Gallery,
New York (NY), USA; Jablonka Galerie, Cologne, Germany /// *Felix Gonzalez-Torres/Roni Horn*, Sammlung Goetz, Munich, Germany

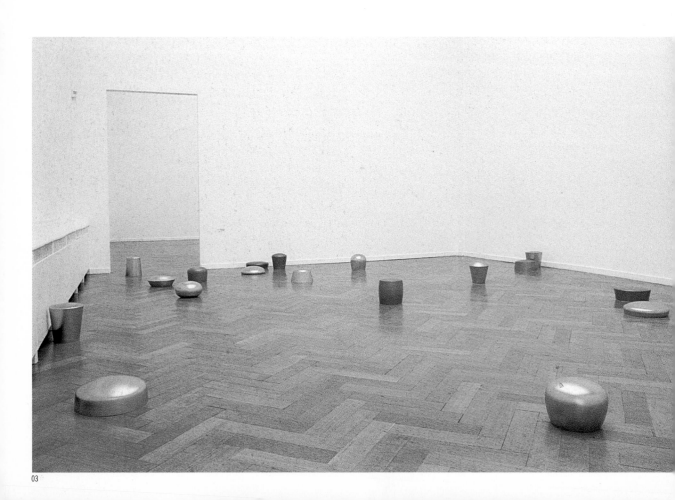

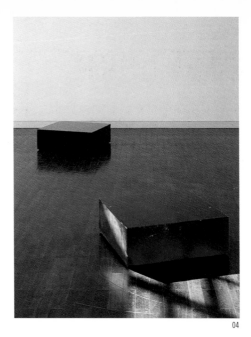

MAKING BEING HERE ENOUGH", installation view, Kunsthalle Basel, Basle, Switzerland, 1995. **04 UNTITLED (FLANNERY),** 1997. 2 blocs BG 26 Schott, glass, c. 28 x 84 x 84 cm (each), ht c. 13,000 lbs (each). Installation view, Ludwig-Forum für Internationale Kunst, Aachen, Germany, 1997. **05 STEVEN'S BOUQUET,** 1991. Plastic, aluminium, 6 parts, 107 x 127 x 38 cm (total). Ilation view, Jablonka Galerie, Cologne, Germany, 1992.

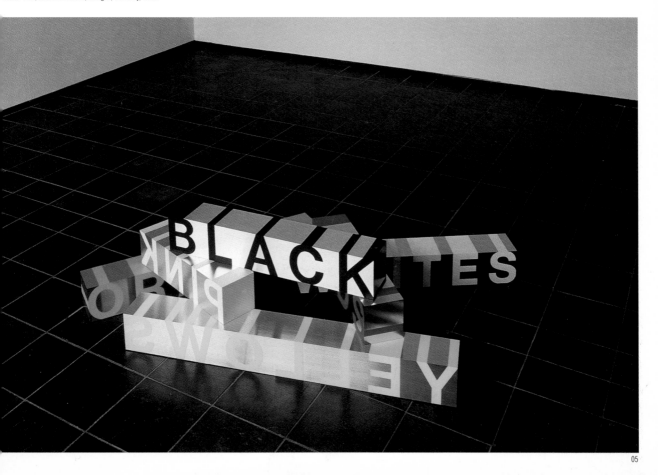

GARY HUME

"I can bear looking at the paintings for days on end, living with them. Beautiful, sensuous and intelligent, hard, deep, soft. That sounded just like sex, didn't it?" **« Je peux regarder les tableaux avec lesquels je vis pendant des jours entiers. Beaux, sensuels et intelligents, durs, profonds, tendres. On aurait dit que je parlais de sexe, pas vrai ? »**

Gary Hume prefers items from everyday life and popular culture both as the subjects of his pictures and as his materials. He uses ordinary commercial, high-gloss domestic paint and has switched from canvas to aluminium and sheets of melamine. His first comprehensive series "Doors", 1988–1992, reproduces the double swing-doors found in hospitals and other public buildings. The size of the pictures – pared down and abstracted to right angles and a few circular shapes – corresponds to the actual size of the doors depicted. From this point of view, Hume's door paintings are also an expression of the confrontation with the difference between representation and what is represented. Following a brief phase in which he created works like "Housewife Sculpture", 1992, from wash basins and wire netting, and made a video ("Me as King Cnut",

1992), Hume turned to figurative pictures. His models are silhouette drawings taken from pop culture reproductions in periodicals, art book porn and fashion magazines, which he prepares on A4-format acetate film. Asked as to the selection of his subjects, he has stated that he chooses these for their ability to depict beauty and feeling. This can be seen particularly clearly in the pictures painted from photographs of sculptures in Mussolini's Olympic stadium in Rome ("Hero", 1993; "Vicious" 1994, and "Love Love's Unlovable", 1994). It is also evident in his fem portraits, plant and animal subjects, and even in his abstract, psycholo ically ambiguous works, which sometimes recall Rorschach tests. In al these works, Hume achieves a conscious balancing act between cultu triviality, emotion and beauty.

Pour ses motifs picturaux et ses matériaux – il emploie des laques surbrillantes du commerce et a remplacé la toile par l'aluminium et les panneaux de Resopal –, Gary Hume privilégie les éléments de la culture populaire et quotidienne. Ainsi, sa première grande série « Doors », 1988–1992, faisait référence aux portes à deux battants qu'on trouve dans les hôpitaux et autres édifices publics. Réduits exclusivement à des formes rectangulaires et – plus rarement – circulaires, les formats de ses tableaux consacrés à l'abstraction du motif correspondent aux formats des portes représentées. En ce sens, les « Portes » de Hume sont aussi l'expression de son travail sur la différence entre le signifiant et le signifié. Après une courte phase pendant laquelle il réalise ses œuvres à partir de cuvettes et de trame de fil de fer (par exemple « Housewife Sculpture », 1992) et tourne une vidéo (« Me as King Cnut », 1992), Hume commence à créer des peintures figuratives. Comme modèles, il se sert

des dessins de contour réalisés par ses soins sur des feuilles d'acéta de format A4 d'après des reproductions de médias culturels (pop) : jo naux, livres d'art, revues porno ou magazines de mode. Répondant à une question sur le choix de ses motifs, l'artiste constatait qu'il les choisissait selon leur aptitude à exprimer la beauté et l'émotion. Ces c tères de choix se vérifient tout particulièrement dans ses tableaux pei d'après certaines sculptures du stade olympique de Mussolini à Rome (« Hero », 1993 ; « Vivious », 1994 et « Love's Unlovable », 1994). De même, dans ses portraits de femmes, ses motifs végétaux ou animau et jusque dans ses œuvres abstraites, psychologiquement polysémiqu et dont certaines rappellent les tests psychologiques constitués de taches, Hume réalise consciemment un parcours sur le fil du rasoir entre culture triviale, émotion et beauté. Y.

01 INSTALLATION VIEW, White Cube, London, England, 1995. **02 AVERY,** 1997. Enamel on aluminium panel, 198 x 164

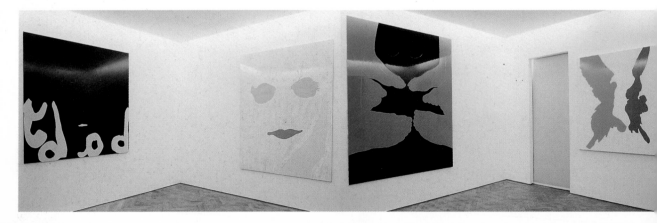

GARY HUME

SELECTED EXHIBITIONS: *1995* Kunsthalle Bern, Berne, Switzerland /// XLVI Esposizione Internationale d'Arte, la Biennale di Venezia, Venice, Italy /// *1996* Bonnefantenmuseum, Maastricht, The Netherlands /// São Paulo Biennial, São Paulo, Brazil /// *1997* "Sensation", Royal Academy of Arts, London, England **SELECTED BIBLIOGRAPHY:** *1995 Gary Hume,* Institute of Contemporary Arts, London; Kunsthalle Bern, Berne /// *1996 Gary Hume,* Bonnefantenmuseum, Maastricht /// *1997 Fiona Rae and Gary Hume,* Saatchi Gallery, London

RACELET, 1997. Enamel paint on aluminium panel, 230 x 161 cm. **04 KATE,** 1996. Gloss paint and paper on aluminium panel, 209 x 117 cm.
ICIOUS, 1994. Enamel paint on aluminium panel, 219 x 180 cm. **06 FALLING,** 1995. Gloss paint on aluminium panel, 201 x 125 cm.

PIERRE HUYGHE

1962 born in Paris / lives and works in Paris, Fran

"Everything you look at, any object whatsoever, or image, has been thought about, selected and been subject to huge activity." « **Tout ce que vous regardez, tout objet, toute image quels qu'ils soient, ont fait l'objet d'une réflexion, d'un choix et d'une immense activité.** »

Films have different realities. We see them in the original language or dubbed; their effect varies when they are first shown and when they are viewed decades later, and they may be cut differently for television and cinema. Pierre Huyghe deals with these aspects, separating out the different levels of the experience of watching films. In "Dubbing", 1996, we see a group of people who are clearly concentrating hard on the dialogue of a film that can be read in subtitles on the lower margin of the screen. We are watching the dubbing of a film, its content revealed only through the lines of text and the lines of the dubbing actors. Though we never actually see the film, we can follow its narrative structure, its gripping moments and quieter episodes. In "Atlantic FRA./GB/D – 1929" of

1997, Huyghe simultaneously shows three versions of the same film i different languages. It dates from the early days of sound film, when there was no dubbing and films had to be made in the appropriate la guage by a different cast of actors using the same sets. Likewise con fusing but in a different spatial and temporal context, are Huyghe's lar billboard works. A picture of a café, for example, is displayed on the outside wall of the same café. Thus Huyghe presents overlays in time. Diverse things happen at diverse moments, even with the same mater or in the same place. Witnessing this process, the viewer begins to rea ise that reality eludes every kind of documentation.

Les films recèlent eux aussi différents niveaux de réalité. Ils sont diffusés dans la langue originale ou en version doublée, l'effet qu'ils pro-duisent change entre l'époque de leur réalisation et quelques décennies plus tard. A la télévision, on les présente parfois en version plus courte qu'au cinéma. Pierre Huyghe travaille sur ce type d'aspects, démontant dans ses œuvres les différents niveaux de certains films. Dans « Dubbing », 1996, on ne voit qu'un groupe de gens visiblement très concentrés sur le texte dialogué d'un film, texte dont on voit passer la bande en bas de l'image. Nous assistons au doublage d'un film dont le contenu ne nous apparaît qu'à travers le texte et les interventions des speakers. Le spec-tateur ne voit jamais le film à proprement parler ; pourtant, il en saisit la structure narrative avec tous les moments d'émotion et de calme. Dans

« Atlantic FRA./GB/D – 1929 », 1997, Huyghe présente côte à côte troi versions d'un film du tout début du cinéma parlant, chacune réalisée dans une autre langue. A l'époque, on ne doublait pas les films, on les tournait directement dans la langue souhaitée en faisant jouer d'autres acteurs. C'est avec la même perturbation de l'identique, mais à une époque différente, que travaillent les grandes affiches qui, sur un pan-neau au-dessus d'un café par exemple, nous montrent le même café u deuxième fois. Ainsi, ce sont essentiellement des sauts dans le temps que visualise Pierre Huyghe. Avec le même matériau ou sur un même site, des choses différentes ont lieu à des moments différents. Le spe tateur devient ainsi le témoin de ce processus et prend conscience qu la réalité vraie échappe à toute documentation. C.

01 LIGHT CONICAL INTERSECT (EVENT, PARIS), 1996. Original ekta and unique digital print, 80 x 120 cm. Installation view, "Statements", GRP-Basel art fair 1996, Basle, Switzerland, 1996. **02 REMAKE,** 1995. Film st film 100 mins.

PIERRE HUYGHE

SELECTED EXHIBITIONS: *1996* "Dubbing", Galerie Roger Pailhas, Paris, France /// *1997* "Storytellers", Le Consortium, Dijon, France /// XLVII Esposizione Internationale d'Arte Biennale di Venezia, Venice, Italy (Fondation Bevilacqua la Masa) /// *1998* Musée d'Art Moderne de la Ville de Paris, Paris /// Manifesta 2, Luxembourg, Luxemburg /// Sydney Biennial, Syd Australia /// "Permises", Guggenheim Museum SoHo, New York (NY), USA /// *1999–2000* Wiener Secession, Vienna, Austria /// The Renaissance Society at the University of Chicago, Chic (IL), USA **SELECTED BIBLIOGRAPHY:** *1995 Exhibition catalogue*, 2ᵉ Biennale de Lyon, Lyons, France /// *1997 Exhibition catalogue*, Johannesburg Biennial, Johannesburg, South Africa *1998 Images, Objets, Scènes*, Le Magasin – Centre National d'Art Contemporain, Grenoble, France

03 RUE LONGVIC (BILLBOARD, DIJON), 1995. Poster offset. Installation view, "Cosmos", Le Magasin – Centre National d'Art Contemporain, Grenoble, France, 1995.
04 "MULTI-LANGUAGE VERSIONS" (ATLANTIC FRA/GB/D – 1929), 1997. Simultaneous triple video projection.

FABRICE HYBERT

"A work can never look forward, it is always here and now." « **Une œuvre ne peut jamais être tournée vers l'avenir. Elle est toujours ici et maintenant.** »

In his endeavour to promote an exchange between industry and art, to channel the logic of marketing into artistic practice and to open up a "commercial dialogue about utopia", Fabrice Hybert founded a limited company in 1994 under the title "UR (Unlimited Responsibility)". His "corporate plan" includes the manufacture of books and catalogues, which are regarded as independent works of art, the production of television programmes (Venice Biennale, 1997) or so-called POFs (Prototypes of Objects in Function – the "result of linguistic and material committees of functioning products"). It also incorporates "Le Bonbon très bon", a sweet, soap and laxative in one, "La Balançoire" with integral vibrators, and "Traduction", 1991. Hybert's work is composed of sketches, drawings, watercolours, oil paintings, photos and graphics, hastily hung on the wall or scattered on tables in order to create the impression of rushed incoherence, similar to the disorder in his own studio. His seemingly unexecuted projects and plans may assume the form of "Monstruosité or "Peintures homíopathiques". His installations, on the other hand, consist of apparently unfinished projects, plans and intentions. The art seems to be searching for a Hybert-speed, with which he hopes to rev lutionise attitudes and instigate new behaviour patterns. To this end, in 1995 he transformed the Musée d'Art de la Ville de Paris into a Hybert market. For him, art means the materialisation of desires, the transformation of terrestrial energy currents, and the networking of people, the ideas and projects. He reaches for the utilisation of all means of produc tion and a political experimentation beyond the boundaries of politics: as the continuation of eroticism by other means.

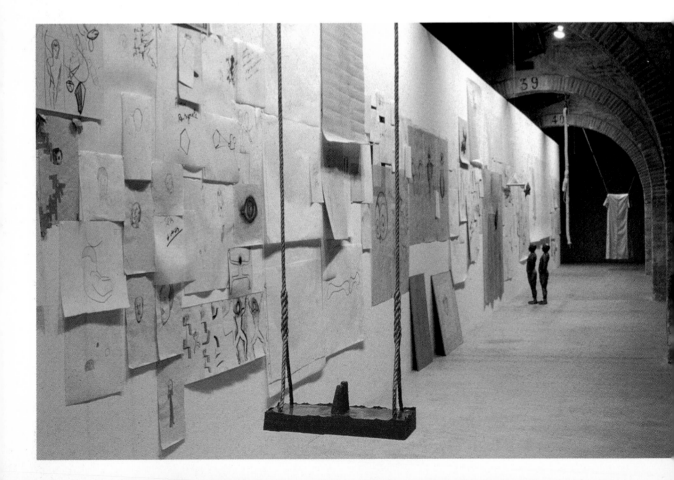

02

Depuis sa première exposition (« Mutation », 1986), Hybert fonde
cohérence de son œuvre dans la notion d'« entreprise », empruntée à
conomie de marché. Il crée, en 1994, une Sarl, société à responsabi-
limitée baptisée « UR (Unlimited Responsability) », dans la visée de
oriser les échanges impurs, faire pénétrer la logique du marketing
ns la recherche artistique, et établir un « dialogue commercial d'utopie ».
IR » ne produit pas seulement des livres et des catalogues élaborés
mme des œuvres, mais aussi une série d'émissions pour la télévision
ennale de Venise, 1997) ou encore des POF (Prototypes d'Objets en
nctionnement, « résultats de dérives linguistiques et matérielles de
oduits fonctionnels », tels que le « Bonbon très bon », qui est à la fois
nbon, savon et laxatif, la « Balançoire à godemichés incorporés », ou

« Traduction , le plus grand savon du monde », 1991). L'artiste, qui
cherche à révolutionner les attitudes et à créer des comportements,
transforme, en guise d'exposition, le MAM de Paris en Hybertmarché,
en 1995. Hybert semble à la recherche d'une Hybertvitesse, qui court-
circuiterait les circuits industriels et apporterait le virus de l'hybridation
au marché de l'art et à l'économie marchande en général. L'art pour lui
est, avant tout, une matérialisation des désirs, une transformation des
énergies du monde, une mise en réseau des gens, de leurs idées ou de
leurs projets, une exploration de tous les moyens de production et une
expérimentation politique hors des limites de la politique : c'est la conti-
nuation de l'érotisme par d'autres moyens.
 J.-M. R.

03

FABRICE HYBERT

SELECTED EXHIBITIONS: *1994* Contemporary Art Centre, Moscow, Russia /// *1995* "1-1=2", Musée d'Art Moderne de la Ville de Paris, Paris, France /// *1996* de Vleeshal, Middelbur The Netherlands /// *1997* "Eau d'or, eau dort, ODOR", XLVII Esposizione Internationale d'Arte, la Biennale di Venezia, Venice, Italy, French Pavilion /// The Institute of Contemporary Art, Bosto (MA), USA /// *1998* Stichting De Appel, Amsterdam, The Netherlands /// Kunsthalle St. Gallen, St. Gallen, Switzerland **SELECTED BIBLIOGRAPHY:** *1993 Fabrice Hybert: Œuvres de 81 à 9* capc Musée d'art contemporain, Bordeaux, France /// *1995 Plus lourd à l'intérieur, Fabrice Hybert*, Musée d'Art Moderne, Saint-Etienne, France /// *1996 I*, Kunsthalle Lophem, Brugge, Belgiu

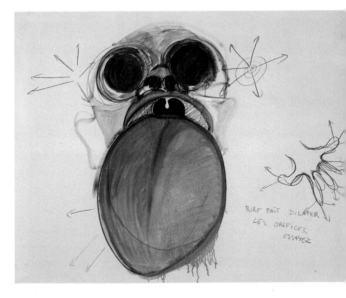

04

PRISE, 1995. Oil and charcoal on canvas, 160 x 130 cm. **05 LE RIRE FAIT DILATER LES ORIFICES,** 1997. Oil and charcoal on canvas, 114 x 146 cm.
IÉTÉTIQUES, 1998. Mixed media, 162 x 130 cm. **07 HYBERTMARCHÉ,** 1995. Installation view, "1–1=2", Musée d'Art Moderne de la Ville de Paris, Paris, France, 1995.

HENRIK PLENGE JAKOBSEN

1967 born in Copenhagen / lives and works in Paris, France, and Copenhagen, Denmar

"For me, art should not restrict itself to formal questions. It should represent an alternative, not an assertion. Maybe I'm idealistic, but I think art should be an instrument of criticism." « A mon avis, l'art ne devrait pas se limiter à des questions formelles. Il devrait être une alternative, pas une affirmation. Je suis peut-être un idéaliste, mais je pense que l'art doit être un instrument de critique. »

Certain themes circulate, almost virally, in Henrik Plenge Jakobsen's works and through his artistic methods. The human body as matter, its relation to authority and to the social body, is a key approach to his world of subversion and ecstasy. These quantities, as constituent parts of the art work's ethical status (or lack of it), are resolved in discussions of the viewer's role and the function of the work. "Laughing Gas Chamber", 1996, is a morbid joke, but also more than just that. It is a plywood chamber where two people at a time can inhale laughing gas through valves in the wall, and get high. The laughing gas changes the viewer's perception. Thus, the fact that the gas chamber is a product of the anti-human forces of industrialization appropiated for programmes of social control raises questions of manipulation and seduction. The beholder's expectation of the work is mechanised by the calculated chemical effect of the laughing gas. Experimental science as an ecstasy of limits is the subject of the "Diary of Plasma", 1996, an ongoing video/publication/installation project. Here the artist presents himself as a kind of latter-day Dr. Frankenstein in a role that has become deadlocked in a blind alley of psychosis. The "Diary of Plasma" is a work that counters the utopian expectations of experimental science. Medical science is associated with capriccio and chaos rather than healing and health. Thus Henrik Plenge Jakobsen's art constitutes a tenacious intervention in the structures that determine systems, and throws doubt on our understanding of the body and its rights in our time a period of rapid and radical change.

Certains thèmes circulent de manière quasiment virale dans l'œuvre de Henrik Plenge Jakobsen. Le corps humain comme matière, son rapport à l'autorité et à la société constituent une des entrées principales de son monde de subversion et d'extase. Comme éléments constitutifs du statut éthique de l'œuvre d'art (ou de son absence), ces valeurs se dissolvent dans les explications sur le rôle du spectateur et la fonction de l'œuvre. « Laughing Gas Chamber », 1996, est une farce macabre, mais aussi quelque chose de plus. Il s'agit d'un caisson en panneaux d'aggloméré dans lequel deux personnes deviennent euphoriques en inhalant simultanément du gaz hilarant entrant par des soupapes ménagées dans les parois du caisson. Le gaz hilarant modifie la perception du spectateur ; les questions de manipulation et de séduction sont ainsi mises au débat, la chambre à gaz étant un produit des forces anti-humaines de l'industrialisation soumises aux programmes de contrôle social. L'attente que le spectateur peut avoir à l'égard de l'œuvre est mécanisée par les effets chimiques calculés du gaz hilarant. La science expérimentale comme extase des limites est le thème de « Diary of Plasma », 1996, un projet d'installation, de publication et de vidéo se trouvant dans un couloir. Dans un jeu de rôles qui a débouché sur une impasse ou une psychose, l'artiste se met lui-même en scène comme une sorte de docteur Frankenstein des temps modernes. « Diary of Plasma » est une œuvre qui s'inscrit en porte-à-faux par rapport aux attentes utopiques nourries à l'égard de la science expérimentale. La médecine est associée au chaos et à l'arbitraire, et non à la guérison et à la santé. C'est ainsi que l'art d'Henrik Plenge Jakobsen intervient constamment dans les structures qui conditionnent les systèmes, dans la compréhension du corps et de ses droits, à une époque de changement rapide et radical.

L. B. B

01 0

TERMINATOR, 1997. Wallpainting. Installation view, "Palace", Beret International Gallery, Chicago (IL), USA, 1997. **02 LAUGHING GAS HOUSE,** 1998. Plastic children's house, laughing gas bottles, ...d, 198 x 160 x 125 cm. **03 EVERYTHING IS WRONG,** 1996. Walldrawing, acrylic paint, c. ø 250 cm. **04 / 05 LAUGHING GAS CHAMBER #1,** 1996. MDF, wood, laughing gas bottles, 4 chairs, 253 x 133 x 220 cm. ...allation view, Galleri Nicolai Wallner, Copenhagen, Denmark, 1996.

HENRIK PLENGE JAKOBSEN

SELECTED EXHIBITIONS: *1996* "Laughing Gas Chamber", Galleri Nicolai Wallner, Copenhagen, Denmark /// "Nitrousoxide", Nordic Art Center, Helsinki, Finland /// "NowHere", Louisiana Museum of Modern Art, Humlebæk, Denmark /// Manifesta 1, Rotterdam, The Netherlands /// "Traffic", capc Musée d'art contemporain, Bordeaux, France /// *1998* Centre National de Photographie, Paris, France /// "Nuit Blanche", Musée d'Art Moderne de la Ville de Paris, Paris **SELECTED BIBLIOGRAPHY:** *1996 NowHere*, Louisiana Museum of Modern Art, Humlebæk /// *Exhibition catalogue*, Manifesta 1, Rotterdam /// *Traffic*, capc Musée d'art contemporain, Bordeaux /// *1998 Nuit Blanche*, Musée d'Art Moderne de la Ville de Paris, Paris

06 / 07
08

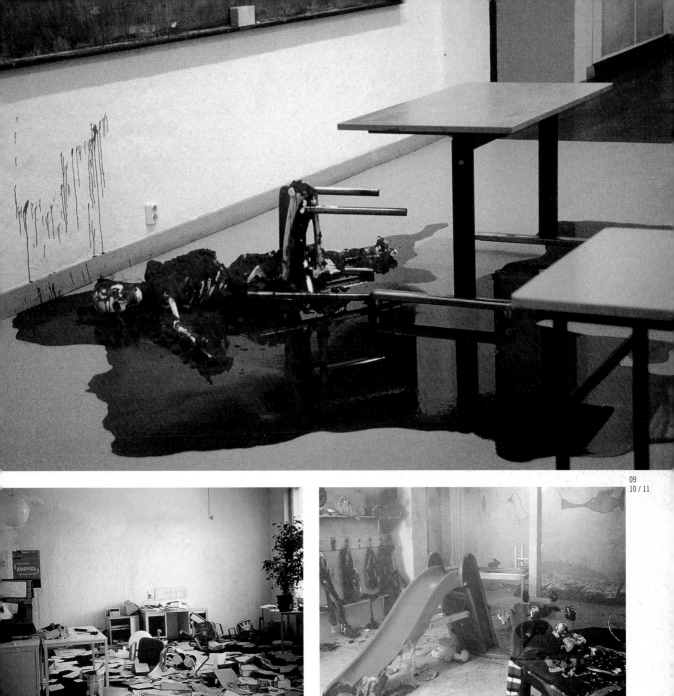

06 DIARY OF PLASMA, 1996. Installation view, "NowHere", Louisiana Museum of Modern Art, Humlebæk, Denmark, 1996. **07 NEUTRON URINEREACTOR,** 1995. Installation view, "Neutron, Aperto", ESAD/FRAC Champagne-Ardennes, France, 1995. **08 NEUTRON,** 1995. Installation view, "Neutron, Aperto", ESAD/FRAC Champagne-Ardennes, 1995. **09 TEACHER,** 1997 (in collaboration with Jes Brinch). Installation view, "Human Conditions", Kunsthalle, Helsinki, Finland, 1997. **10 OFFICE,** 1996 (in collaboration with Jes Brinch). Installation view, "Crap shoot", Stichting De Appel, Amsterdam, The Netherlands, 1996. **11 BURNED OUT KINDERGARTEN,** (in collaboration with Jes Brinch). Installation view, Galleri Nicolai Wallner, Copenhagen, Denmark, 1994.

ILYA KABAKOV

1933 born in the Soviet Union / lives and works in New York (NY), USA, and Paris, Franc

"A total installation is a site of stationary action in which some event took place, takes place or can take place." « **L'installation totale est le lieu d'un acte resté en suspens, où un événement s'est produit, se produit ou peut se produire.** »

Ilya Kabakov's almost documentary-like installations emerge from the way of life in the former Soviet Union, while at the same time serving as a model for a better, utopian world. Rather than constricting himself within the two dimensions of a picture, Kabakov penetrates the three dimensions of space, and then brings in the fourth dimension of time. His installations always require us to spend a little active time in them. This principle is particularly clear in "Treatment with Memories", 1997, in which the artist reconstructed the corridor of a Russian hospital, with various rooms leading off it. These reveal not only hospital beds and basic furniture but also slide projections showing pictures from Kabakov's life. The artist and his wife comment on these images over loudspeakers. The presentation of individual memories therefore becomes a therapeutic treatment in a hospital ward, mingling with the ideas of the viewer and challenging him into almost metaphysical meditation on the world. At th same time, the "original" wards evoke a disturbing memory of life in the former Soviet state. The individual becomes generalised, the past timeless, the everyday and the existential merge. Another of Kabakov's works "Looking up reading the words ...", 1997, actively involves the viewer in the interplay of opposites such as up and down, reality and dream. This work is a broadcasting tower with a poem inscribed in its aerial, installed in a park in Munster. The poem tells us to lie on the grass and look up into the blue of the sky. The earthly suddenly takes on a heavenly quality, and lying in the grass becomes, as the poem says, "the most beautiful thing you have ever seen or done in your life."

L'art d'Ilya Kabakov consiste en premier lieu en des installations de nature apparemment documentaire appartenant au monde quotidien de l'ex-Union soviétique, mais qui sont en même temps conçues comme les modèles d'une vie meilleure, utopique. Plutôt que de rester enfermé dans les deux dimensions de l'image, Kabakov s'avance dans les trois dimensions de l'espace pour y intégrer la quatrième dimension, la dimension du temps. Car ses œuvres requièrent toujours de la part du spectateur une présence prolongée, voire son action. Ce principe de travail apparaît clairement dans une installation comme « Treatment with Memories », 1997. L'artiste y a reconstitué le couloir d'un hôpital russe donnant accès à plusieurs chambres. Dans ces chambres, on peut voir non seulement un lit et un mobilier parcimonieux, mais aussi des projections de diapositives montrant des images de la vie de Kabakov. Des hautsparleurs commentent ces images par la voix de l'artiste et de sa femme.

Le traitement thérapeutique dans les chambres consiste donc dans la présentation de souvenirs personnels qui se mêlent avec les idées du visiteur et invitent à des réflexions quasi métaphysiques sur le monde. De plus, les chambres d'hôpital «originales» suscitent une réminiscenc collective accablante de la vie dans l'ex-Etat soviétique. L'individuel devient ainsi universel, le passé intemporel, le quotidien et l'existentiel se mélangent. L'installation de Kabakov « Tu lèves les yeux et tu lis les mots... », 1997, intègre activement le spectateur dans le jeu alternatif d différentes oppositions telles que haut/bas ou rêve/réalité : dans un par de Münster, l'artiste a installé une tour émettrice dans l'antenne de laquelle est inscrit un poème. Les vers de ce poème invitent à s'allonger dans l'herbe et à contempler le bleu du ciel. Le terrestre reçoit soudain une qualité céleste : comme le dit le poème, être allongé dans l'herbe devient «la plus belle chose que tu aies vue ou faite dans ta vie. » R.

01 / 02 THE TOILET, 1992. Installation view, documenta IX, Kassel, Germany, 1992.
03 THE RED PAVILION, 1993. Installation view, XLV Esposizione Internazionale d'Arte, la Biennale di Venezia, Venice, Italy, 1993.

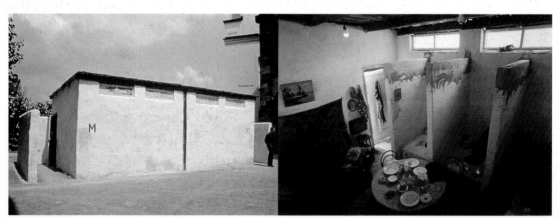

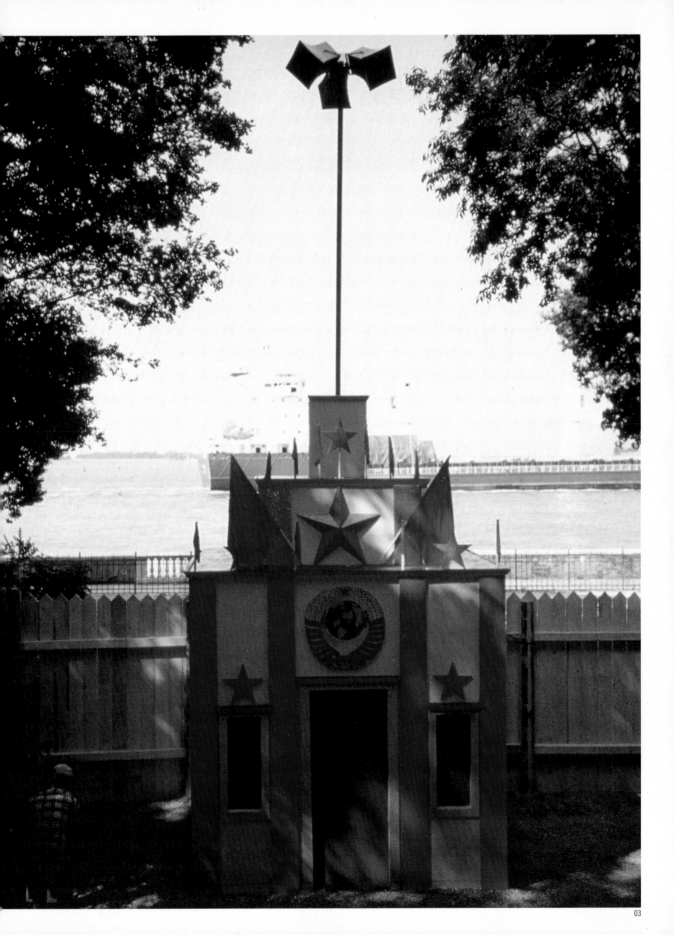

ILYA KABAKOV

SELECTED EXHIBITIONS: *1993* "The Red Pavilion", XLV Esposizione Internationale d'Arte, la Biennale di Venezia, Venice, Italy, Russian Pavilion /// *1995* "C'est ici que nous vivons/We are living here", Musée national d'art moderne, Centre Georges Pompidou, Paris, France /// *1997* "The Artist's Library", Satani Gallery, Tokyo, Japan /// "The Life of Flies", Barbara Gladstone Gallery, New York (NY), USA /// *1998* "16 Installations", Museum of Contemporary Art, Antwerp, Belgium /// *1998–1999* "The History of the Interior", Städelsches Kunstinstitut, Frankfurt/M., Germany /// Museo Nacional Centro de Arte Reina Sofía, Madrid, Spain **SELECTED BIBLIOGRAPHY:** *1995 On the "Total" Installation*, Stuttgart, Germany /// *Ilya Kabakov – Installations 1983–1995*, Paris /// *1996 Die Kunst des Fliehens*, Munich, Germany /// *The Reading Room*, Deichtorhallen Hamburg, Hamburg, Germany /// *Ilya Kabakov – The Man Who Never Threw Anything Away*, New York

04

04 **LOOKING UP READING THE WORDS...**, 1997 (detail). Steel, 15 m (h); text field, 14.45 x 11.3 m. Permanent installation, Skulptur. Projekte in Münster 1997, Münster, Germany, 1997. 05 **DER LESESAAL**, 1996. Installation view, "The Reading Room", Deichtorhallen Hamburg, Hamburg, Germany, 1996. 06 **LOOKING UP READING THE WORDS...**, 1997. Steel, 15 m (h); text field, 14.45 x 11.3 m. Permanent installation, Skulptur. Projekte in Münster 1997, Münster, 1997.

MIKE KELLEY

1954 born in Detroit (MI) / lives and works in Los Angeles (CA), US

"Artists are people who are allowed a certain social privilege to act out in ways that adults aren't supposed to act out." **« Les artistes sont des gens à qui la société accorde un certain privilège, celui d'agir selon des modes qu'on n'attend pas de la part des adultes. »**

A central theme of Mike Kelley's performances, installations, drawings and texts are the "systems of belief", which he calls "propaganda – gone – wrong". His works include a broad spectrum of the most diverse sources ranging from Christian iconography, Surrealism, psychoanalysis and Conceptual Art to the American hippie and punk movement, trash culture, folklore and caricature. Kelley was mainly known as a performer, but achieved international recognition through his multi-part project "Half a Man", 1987–1991. It included worn-out dolls, shabby soft toys, crocheted blankets and ghetto blasters. Kelley saw in the rag toys idealised, sexless models by means of which children were to be adapted to family and social norms. The evidence of intense usage became for Kelley an image for the way compulsions are passed on from one generation to the next. Thus in "Educational Complex", 1995, a minitiaturized

reconstruction of all the educational and training institutions he had passed through, Kelley alluded to the repressed traumas of his own life. This was a form of historiography which, like his project with Tony Oursler about their common experiences with a punk group ("The Poetics Project", 1997), reflects the processes of remembering. For every forgetting seems to have its price. In "Pay for your Pleasure", 1988, the viewer passed along a corridor of portraits and quotations from writers and philosophers only to arrive at the self-portrayal of a mass murderer as a clown. Seemingly established relations between enjoyment and the feeling of guilt, suppression and sublimation, apparent normality, voyeurism and the so called "other", are opened up in Kelley's projects through grotesquely comic exaggerations and shown in their complex contradictoriness.

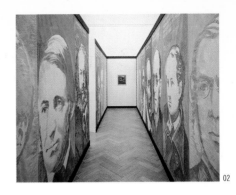

02

Les « systèmes de croyances », qu'il décrit comme une « propa-gande avortée » (propaganda – gone – wrong), sont l'un des thèmes principaux des performances, installations, dessins et textes de Mike Kelley. Les œuvres de Kelley embrassent un vaste champ d'inspiration et des sources extrêmement diverses, qui vont de l'iconographie chrétienne, du surréalisme, de la psychanalyse et de l'art conceptuel aux mouvements hippie et punk, à la culture « trash », au folklore et à la caricature. Kelley, d'abord connu comme performer, devait parvenir à la reconnaissance internationale avec son projet en plusieurs parties, « Half a Man », 1987–1991, qui comportait entre autres des poupées usées, des animaux en peluche élimés, des couvertures au crochet et des « ghetto-blasters ». Kelley voyait dans les animaux en peluche des modèles idéalisés et asexués destinés à faire entrer l'enfant dans le moule des normes familiales et sociales. Dans « Educational Complex », 1995, une reconstitution miniature de toutes les institutions scolaires traversées par Kelley, l'artiste faisait allusion aux traumatismes refoulés de sa propre biographie : une manière d'écrire l'histoire qui, à l'instar de son projet commun avec Tony Oursler ayant pour sujet leur passé commun dans un groupe punk (« The Poetics Project », 1997), réfléchit sur les processus de la remémoration elle-même. Tout oubli semble exiger son prix. Dans « Pay for your Pleasure », 1988, le spectateur passant par un couloir composé de portraits et de citations d'écrivains et de philosophes était conduit jusqu'à l'autoportrait d'un tueur en série américain déguisé en clown. Dans les réalisations de Kelley, les rapports apparemment arrêtés entre le plaisir et le sentiment de culpabilité, le refoulement et la sublimation, la prétendue normalité, le voyeurisme et « l'autre » sont mis à nu à coup d'exagérations grotesques-comiques et exposés dans leur contradictoire complexité.

A. W.

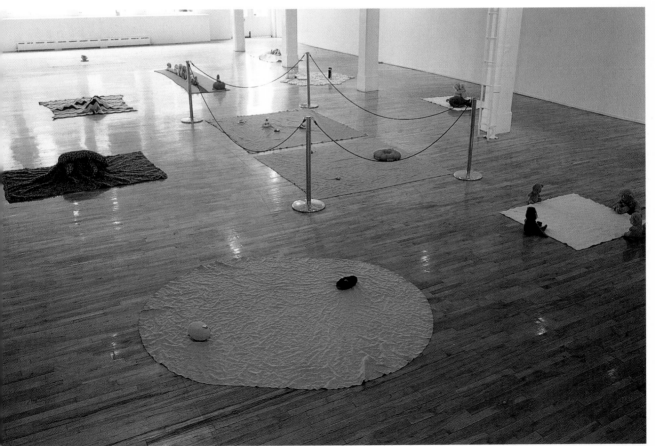

MIKE KELLEY

SELECTED EXHIBITIONS: *1992* Kunsthalle Basel, Basle, Switzerland; Institute of Contemporary Arts, London; capc Musée d'art contemporain, Bordeaux, France /// *1993–1994* "Catholic Tastes", Whitney Museum of American Art, New York (NY); Los Angeles County Museum of Art, Los Angeles (CA), USA; Moderna Museet, Stockholm, Sweden; Haus der Kunst, Munich, Germany /// *1997* Museu d'Art Contemporani, Barcelona, Spain; Rooseum, Center for Contemporary Art, Malmö, Sweden; Stedelijk Van Abbemuseum, Eindhoven, The Netherlands **SELECTED BIBLIO-GRAPHY:** *1993 Mike Kelley: Catholic Tastes*, Whitney Museum of American Art, New York /// *1995 Missing Time: Works on Paper 1974–1976*, Kestner-Gesellschaft Hannover, Hanover, Germany /// *1996 Mike Kelley 1985–1996: Anti-Aesthetik of Excess and Supremacy of Alienation* , Wako Works of Art, Tokyo, Japan /// *1997 Mike Kelley 1985–1996:* Museu d'Art Contemporani, Barcelona; Rooseum, Center for Contemporary Art, Malmö; Stedelijk Van Abbemuseum, Eindhoven

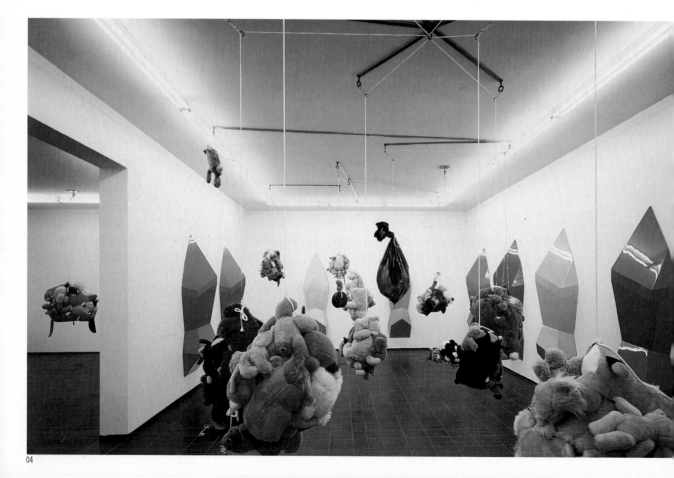

05

06

INSTALLATION VIEW, Jablonka Galerie, Cologne, Germany, 1991/92. **05 MORE LOVE HOURS THAN CAN EVER BE REPAID,** 1987 (background). Stuffed animals, afghan on canvas ing, 244 x 323 x 15 cm. **THE WAGES OF SIN,** 1987 (foreground). Candles on base, 66 x 61 x 61 cm. **06 EDUCATIONAL COMPLEX,** 1995. Acrylic, latex, foamcore, fibreglass, wood, 10 x 81 x 8 cm. UBLEVEL — DIM RECOLLECTION ILLUMINATED BY MULTICOLORED SWAMP GAS. Installation view, Jablonka Galerie, Cologne, 1998.

MARTIN KIPPENBERGER

1953 born in Dortmund, Germany / **1997** died in Vienna, Aust

"You can't cut off your ear every day. Do a Van Gogh here, a Mozart there. It's hard enough just having to keep checking over what you do do."
« Je ne peux pas me couper une oreille tous les jours. Faire le Van Gogh ici, le Mozart là. C'est déjà assez fatigant comme ça de devoir sans cesse passer au crible ce qu'on est en train de faire. »

Martin Kippenberger's multifarious work embraces drawings, paintings, sculptures, installations, artist's books, catalogues, posters, invitation cards, performances and curatorial activities. His approach featured an integrated and participatory process often carried out in collaboration with a close network of assistants, friends and fellow artists. Consciously provocative in his work, he developed an elaborate concept of aesthetics based on bad taste. His preoccupation with particular topics could be triggered off by a variety of different sources. The trivial and the subcultural were for him as relevant as outstanding examples of art history. Thus he was inspired by some of Henry Moore's works to create his own pictures and sculptures, whose titles (e.g. "Familie Hunger" [Hunger Family], 1985) in particular suggest they should be treated as ironic commentaries. He also developed a comprehensive series embr cing different media, with its own catalogue, on the theme "Das Ei in der Kunst und im Alltag" (The Egg in Art and Everyday Life), 1995–199 For his project "Metro-Net. Subway Around the World", 1993–1997, he installed entrances to an imaginary underground railway in various site around the world, for instance on the Cycladean island of Syros and Dawson, Canada. On the occasion of "Skulptur. Projekte in Münster 1997", he placed a huge underground railway ventilation shaft on a gre meadow, which occasionally emitted sounds of passing trains. For doc menta X, he designed another, mobile, entrance to this world-encircli underground railway that existed only in his imagination.

Spargelmesser

02

Parmi les nombreuses facettes de l'œuvre de Martin Kippen-
rger, qui englobe sur un même plan dessins, tableaux, sculptures,
tallations, mais aussi livres d'artiste, catalogues, affiches et cartons
vitation réalisés de sa main, on trouvait également des activités
ant de la performance et de la conservation muséale. Sa démarche
it marquée par une action intégrative et participative se déroulant
uvent dans le tissu relationnel des assistants, des amis et des collè-
s artistes. Kippenberger travaillait consciemment avec des provoca-
ns et une esthétique très poussée du mauvais goût. Les facteurs qui
scitaient son intérêt pour un thème particulier pouvaient être issus des
maines les plus divers – la subculture et la culture triviale étaient pour
tout aussi valides que les grands modèles de l'histoire de l'art. Ainsi,
taines œuvres de Henry Moore lui ont inspiré des tableaux et des

sculptures personnelles que leur titre permet d'interpréter notamment
comme des commentaires ironiques («La Famille Faim», 1985); dans
un autre contexte, il devait développer une vaste série comprenant diffé-
rents médiums, et qu'accompagnait un catalogue sur le thème «L'Œuf
dans l'art et la vie quotidienne», 1995–1997. Pour son projet «Metro-
Net. Subway Around the World», 1993–1997, Kippenberger installa
en différents endroits de la terre (par exemple dans l'île de Syros ou à
Dawson au Canada), des bouches de métro pour un métro imaginaire.
A l'occasion de «Skulptur. Projekte in Münster», il exposa dans un pré
une immense bouche d'aération d'où l'on entendait sortir de temps à
autre la rumeur de rames de métro. A l'occasion de la documenta X, il
conçut une autre entrée mobile pour un métro imaginaire dont le réseau
couvrait la totalité de la terre. Y. D.

MARTIN KIPPENBERGER

SELECTED EXHIBITIONS: *1994* Museum Boijmans Van Beuningen, Rotterdam, The Netherlands /// *1995* Hirshhorn Museum and Sculpture Garden, Washington, D.C., USA /// *19* Skulptur. Projekte in Münster 1997, Münster, Germany /// documenta X, Kassel, Germany /// *1998* Kunsthalle Basel, Basle, Switzerland /// Kunsthaus Zürich, Zurich, Switzerla
SELECTED BIBLIOGRAPHY: *1991 I Had a Vision*, San Francisco Museum of Modern Art, San Francisco (CA), USA /// *1994 Martin Kippenberger: The Happy End of Franz Kafka's Amerika*, Museu Boijmans Van Beuningen, Rotterdam /// *1996 Kippenberger Géricault, Memento Metropolis*, Copenhagen, Denmark /// *1997 KIPPENBERGER*, Cologne, Germany

04

04 BETTY FORD KLINIK, 1985. Oil on canvas, 125 x 150 cm. 05 STAMMHEIM, 1985. Oil, lacquer on canvas, 125 x 150 cm. 06 JÜDISCHE GRUNDSCHULE, 1985. Oil on canvas, 125 x 150 cm. 07 PORTRÄT PAUL SCHREE 1994. Oil, silkscreen, plexiglass on canvas, 240 x 200 cm.

05

06

KNOWBOTIC RESEARCH

1962 birth of all members of Knowbotic Research
(Hübler, Tuchacek, Wilhelm) / **1991** foundation / founder-member
Christian Hübler, Alexander Tuchacek, Yvonne Wilhelm

"Our plea is for experiments that do not generate new systems but lie temporally between widely differing existing systems and open up fields of action with variable rules: that generate ephemeral zones of difference, confrontation and intensification and go beyond the purely communicative, indexed exchange of information." **« Nous plaidons en faveur d'expériences qui ne créent pas de nouveaux systèmes mais qui existent chronologiquement entre les systèmes les plus divers et qui ouvrent des champs d'action avec des règles variables : zones éphémères de la différence qui produisent confrontation et intensification, et qui vont au-delà de la simple communication, de l'échange indexé d'informations. »**

One of the most promising achievements of the new media lies in the linking of artistic and philosophical perceptions with scientific findings. Connections that hitherto could not be realised visually or physically can now be presented in a new way. Since 1993, the three-man group Knowbotic Research, has been developing large, walk-through digital installations. These have been continually refined over the years, but can still be seen for only a few days at a time because of their expensive use of computer technology. For the work "Dialogue with the Knowbotic South", data has been sent from research stations in the Antarctic since 1994 to a computer that presents it visually and aurally on a large screen as individual particles whirling in space. By pressing a button the user can call

up data with a similar content, and simultaneously enter the eddies of da three-dimensionally. Without knowing exactly what is going on, we sens that scientific data is suddenly accessible to us, even if in a limited way. The project "IO_dencies – questioning urbanity" was first realised in Toky in 1997 and is concerned with the planning of crowded urban districts. Users are provided with small hand-held monitors, and as they walk rour the room, details of a particular district appear on the screen. Further information can be accessed on the Internet. Here too, the essential poi is the dislocation of customary processes of communication. The advar tage of presenting such experiments as art lies in the fact that there is r need for their validity to be immediately proved.

Dans le domaine des nouveaux médias, de grands espoirs sont fondés sur la mise en rapport des connaissances artistiques et philosophiques et des résultats scientifiques. Certaines corrélations qui ne pouvaient à ce jour être saisies visuellement ou physiquement doivent être représentées de manière nouvelle. Depuis 1993, Knowbotic Research, un groupe de trois artistes, a développé à cet effet de grandes installations qui sont améliorées au fil des ans, et qui ne peuvent être visitées que quelques jours chacune en raison de l'énorme infrastructure informatique mise en œuvre. Pour le travail « Dialogue with the Knowbotic South », des données de stations d'observation et de recherche situées dans l'Antarctique sont envoyées depuis 1994 à un ordinateur qui visualise et rend audibles les données sur un écran comme des éléments isolés virevoltant dans l'espace. Un menu de données permet à l'utilisateur de faire assembler des données de nature approchante et de se déplacer en

même temps en trois dimensions entre des nébuleuses de données. Sans qu'on sache exactement de quoi il retourne, cet ensemble de données si objectives semble soudain perceptible sur la base de critères déterminés. Présenté pour la première fois en 1997 à Tokyo, le projet « IO_Dencies – questioning urbanity », s'intéresse aux modifications et aux planifications dans les zones à forte densité démographique. Pendant que l'utilisateur muni de petits écrans portatifs évolue dans la salle des associations concernant un quartier particulier apparaissent à l'écrar D'autres informations peuvent être obtenues sur Internet. Ici encore, l'aspect essentiel est la rupture avec les modes de communication ordinaires, auxquels on oppose une expérience inhabituelle. L'avantage de la réalisation dans le domaine de l'art réside dans le fait que la valeur pratique de ce type d'expériences n'a pas besoin d'être préalablement démontrée. C. E

shinko halls

01 / 02 DWTKS – DIALOGUE WITH THE KNOWBOTIC SOUTH. Walk-through data chamber. Installation view, "Interface", Kunstverein in Hamburg, Hamburg, Germany, 1995.
03 IO_DENCIES 98. Urban action model (Internet interface).

KNOWBOTIC RESEARCH

SELECTED EXHIBITIONS: *1995* "Goethe on the Highway", Exploratorium, San Francisco (CA), USA /// "Interface", Kunstverein in Hamburg, Hamburg, Germany /// *1996* "Digital Territories", DEAF 1996, Rotterdam, The Netherlands /// "Electra", Henie-Onstad Kunstsenter, Oslo, Norway /// *1997* "Artlab 7 – IO_dencies", Hillside Plaza, Tokyo, Japan /// *1998* "The best of 2 worlds", Arco electrónico, Madrid, Spain **SELECTED BIBLIOGRAPHY:** *1997* Knowbotic Research, "Dialogue with the Knowbotic South", in: *Jenseits von Kunst*, Vienna, Austria /// Knowbotic Research: "The Urban as a Field of Action", in: *Technomorphica*, Rotterdam /// Knowbotic Research: "Discovering Cyber Antartic", in: *Digital Delirium*, New York (NY), USA /// Knowbotic Research: "Under Construction", in: *Lab 3*, Cologne, Germany

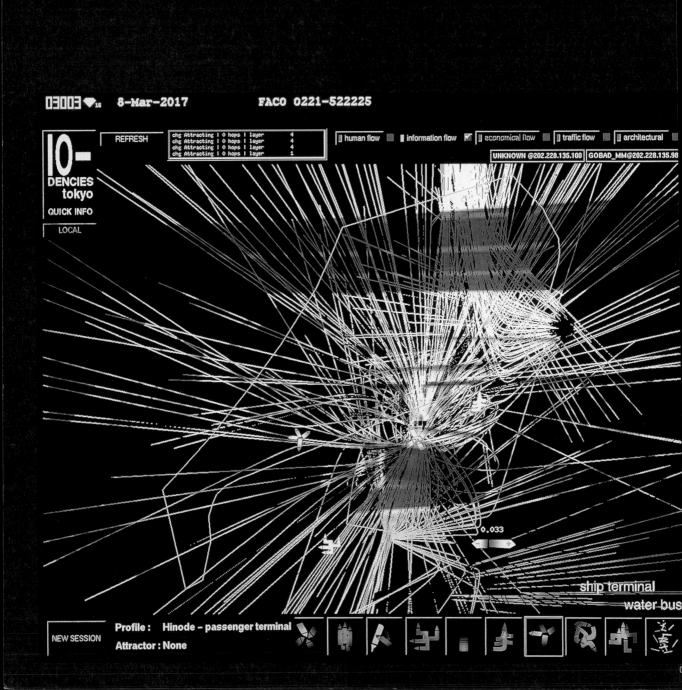

04 IO_DENCIES 98. Urban action model (Internet interface). **05 / 06 SMDK – SIMULATIONSRAUM – MOSAIK MOBILER DATENKLÄNGE**.
Walk-through data base. Installation view, Mediale, Hamburg, Germany, 1993. **07 / 08 / 09 DWTKS – DIALOGUE WITH THE KNOWBOTIC SOUTH**.
Installation view, Wilhelm Lehmbruck Museum, Duisburg, Germany, 1997.

JOACHIM KOESTER

1962 born in Copenhagen, Denmark / lives and works in New York (NY), U:

"It is this seamless merger between the fictional and the real that I return to again and again." « C'est cette transition infiniment fluide entre le fictif et la réalité à laquelle je reviens sans cesse. »

What are the criteria for the narration of a given theme? How does an act of documentation relate to perception and the modalities of storytelling? In his work, Joachim Koester investigates the narrative conditions of culture, staging their obvious as well as their unexplored aspects. In "Day For Night, Christiania 1996", the photographic instant is displaced by means of an optic filter that renders the motif a twilight blue. The photographs of architecture and empty spaces in the anarchistic free state of Christiania, in the centre of Copenhagen, are thereby made fundamentally equivocal. The retelling of the subject matter is structured around sequencing and repetition, overlaid and proportioned by recollections and previous representations. This description of Christiania problematises the act of depiction, simultaneously presenting day and night, site and non-site, palpable reality and social utopia. Fictional retelling and the presence of the spectator in space are the pivotal poin of "Pit Music", 1996, a video of a string quartet performing a piece by Shostakovich in a gallery space. Spectators and musicians are arranged around a stage-like orchestra-pit, in a way that attracts equal attention to performers and onlookers. Importantly, the filming and editing of the video is structured around the disjuncture between time in the image a on the soundtrack. In this way "Pit Music" speaks of the complementar nature of reality and fiction, space and image, spectator and work. On another level, the work toys with the limitations of recounting the real b commenting on the fact that a multitude of artistic works, actions and performances have been viewed through documentation, rather than witnessed in real time, in a given place. Thereby the art work, as art work, is posited as the real object of its own documentation.

T MUSIC, 1996. Video stills, video 14 mins. Video installation with projection, stage and pit. Galleri Nicolai Wallner, ...nhagen, Denmark, 1996. **02 UNTITLED (GALLERI NICOLAI WALLNER),** 1994. Boarded-up window. Installation view, ...n in Reality", Galleri Nicolai Wallner, Copenhagen, 1994.

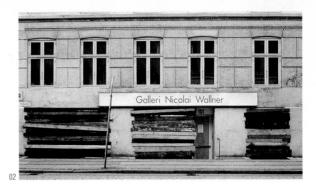

02

Quels sont les critères de la présentation narrative d'un thème ...né? Comment un acte documentaire déterminé se relie-t-il à la per-...tion et aux modalités du récit? Dans son œuvre, Joachim Koester ...amine les conditions narratives des éléments culturels préexistants ...eprésente à la fois leurs aspects patents et leurs aspects inexplorés. ...ns «Day or Night, Christiana 1996», le sens de l'instantané photo-...aphique est altéré par un filtre optique qui restitue le motif dans une ...hombre bleue, de sorte que les photos d'immeubles et d'espaces ...serts de l'Etat anarchiste de Christiana, au centre de Copenhague, ...paraissent comme indéterminées. Christiana est représentée de jour ...mme de nuit, à la fois comme lieu et non-lieu, réalité tangible et utopie ...ciale. Dans «Pit Music», 1996, les lignes directrices de l'œuvre sont ...fiction relatée et le moment présent du spectateur dans l'espace d'exposition. La vidéo montre un quatuor à cordes jouant une pièce de Chostakovitch dans une galerie. Le public et les interprètes sont assis autour d'une fosse d'orchestre qui fait office de scène et répartit l'attention uniformément entre les instrumentistes et le public. La prise de son et le traitement de la vidéo illustrent l'incohérence du temps au niveau de l'image et de la bande-son. Ainsi, «Pit Music» met en évidence la complémentarité de la réalité et de la fiction, de l'espace et de l'image, du spectateur et de l'œuvre. En commentant le fait que la réception de l'œuvre d'art passe par la documentation du travail, des actions et des performances, et non pas par la perception de l'événement réel en temps réel et dans un lieu donné, Koester pose la question de la restitution de la réalité. De ce fait, l'œuvre d'art en tant que telle se définit comme objet de sa propre documentation. L. B. L.

JOACHIM KOESTER

SELECTED EXHIBITIONS: *1996* "Pit Music", Galleri Nicolai Wallner, Copenhagen, Denmark /// *1997* Greene/Naftali Gallery, New York (NY), USA /// Johannesburg Biennial, Johannesbu[rg], South Africa /// documenta X, Kassel, Germany /// *1998* UWM, Institute of Visual Arts, Milwaukee (WI), USA. **SELECTED BIBLIOGRAPHY:** *1994 Stain in Reality*, Galleri Nicolai Walln[er], Copenhagen /// *Alternating Realities*, Galleri Nicolai Wallner, Copenhagen

03 DAY FOR NIGHT, CHRISTIANIA 1996. C-prints, 66 x 98 cm (ea[ch]

JEFF KOONS

1955 born in York (PA) / lives and works in New York (NY), L

"Art is communication – it's the ability to manipulate people. The difference with show business or politics is only that the artist is freer." « **L'art est communication – il est la faculté de manipuler les gens. La différence avec le show-business ou la politique réside uniquement dans le fait que l'artiste est plus libre.** »

Jeff Koons, the nice boy from next door, who earned the money for the production of his first works of art as a successful stockbroker, was the absolute superstar of the hectic art scene of the 1980s. First, he placed brand-new vacuum cleaners ("The New", 1980) in glass cases that looked clinically clean and were illuminated with cold neon lighting. The "Equilibrium Tanks" followed in 1985. These were filled with water like an aquarium, and basketballs floated in the middle of them. One year later, he surprised the art market with figures of shiny high-quality steel. At the pinnacle of his fame (1991), Koons married the Italian porno star Cicciolina. The "Made in Heaven" series (1989 onwards) testify to the joys of sex with her, reproducing the delightful event down to the last detail in gigantic pictures and sculptures. Still a media star, Jeff Koons continues to attr the attention of the art world today. His works are perfectly executed with no expense spared. They display a sophisticated mix of kitsch, modernity and sex. They upset taboos, but not so much to shock as reveal the beauty in the provocation. Jeff Koons hit the taste of a new rich yuppie generation better than anyone. After 1992 the fuss died down and the marriage with Cicciolina also hit the rocks. For some tin Koons has in fact been working on a new project. "Celebration" compri twenty large sculptures and huge paintings. It will be presented in Nev York's Guggenheim Museum in 2000.

JPPY, 1992. Live flowering plants, earth, wood, steel, 12.4 x 8.3 x 9.1 m. Installation view, "Made for Arolsen", Schloß Arolsen, en, Germany, 1992. **02 ILONA WITH ASS UP,** 1990. Oil inks on canvas, 243 x 366 cm. **03 ONE BALL TOTAL EQUILIBRIUM TANK LDING DR. J 241 SERIES),** 1985. Glass, steel, sodium chloride reagent, distilled water, 1 basketball, 165 x 78 x 35 cm. EW HOOVER CONVERTIBLE, 1980. 1 Hoover convertible, plexiglas, florescent lights, 142 x 57 x 57 cm.

Jeff Koons, le gentil voisin de palier qui gagna l'argent de ses mières productions artistiques en réussissant comme agent de nge, a été la superstar indiscutée de la scène artistique très animée années 80. Dans un premier temps, il exposa des aspirateurs ruti- s neufs (« The New », 1980), dans des vitrines d'une propreté asepti- , éclairées par une froide lumière au néon. En 1985 suivirent les quilibrium Tanks », caissons remplis d'eau comme des aquariums s lesquels flottent des ballons de basket. Un an plus tard, il surprend marché de l'art avec des figures en acier poli inoxydable. En 1991, sommet de la gloire, Jeff Koons épouse Cicciolina, la star du porno en. Dès 1989, le cycle d'œuvres « Made in Heaven », dont les immen- tableaux et sculptures relataient l'événement charnel jusqu'aux moin-

dres détails, avaient témoigné de l'ivresse des délices sexuels éprouvés avec elle. Jeff Koons est resté jusqu'à ce jour une star des médias, et il continue de fasciner la scène artistique dans cette même mesure. Ses œuvres toujours travaillées à grand renfort de perfection, dénotent un subtil mélange de kitsch, de modernité et de sexe. Elles touchent aux tabous, non pour choquer, mais pour transformer la provocation en beauté. Comme aucun autre artiste, Jeff Koons a su toucher ainsi le goût d'une génération de « golden boys » parvenus. Après 1992, un cer- tain silence s'est fait autour de lui. Le mariage avec Cicciolina a lui aussi été rompu. « Celebration » comprend 20 grandes sculptures et d'immen- ses peintures dont la présentation est prévue pour l'an 2000 au Musée Guggenheim de New York. C. B.

JEFF KOONS

SELECTED EXHIBITIONS: *1991* "Made in Heaven", Galerie Max Hetzler, Cologne, Germany /// *1992* "Jeff Koons Retrospective", San Francisco Museum of Modern Art, San Francisco (C
USA /// "Jeff Koons Retrospective", Stedelijk Museum, Amsterdam, The Netherlands /// *1993* "Jeff Koons Retrospective", Walker Art Center, Minneapolis (MN), USA /// "Jeff Koons Retrospectiv
Aarhus, Denmark /// *1995* "Jeff Koons: Puppy", Museum of Contemporary Art, Sydney, Australia /// *1997* "Jeff Koons: Puppy", Guggenheim Museum Bilbao, Bilbao, Spain /// *2000* Solomon
Guggenheim Museum, New York (NY), USA /// *2001* Musée national d'art moderne, Centre Georges Pompidou, Paris, France **SELECTED BIBLIOGRAPHY:** *1992 Jeff Koons Retrospect.*
San Francisco Museum of Modern Art, San Francisco /// *Jeff Koons Retrospective*, Stedelijk Museum, Amsterdam /// *Jeff Koons*, Cologne /// *The Jeff Koons Handbook*, New York

BARBARA KRUGER

1945 born in Newark (NJ) / lives and works in Los Angeles (CA) and New York (NY), US

"I try to deal with the complexities of power and social life, but as far as the visual presentation goes, I try to avoid a high degree of difficulty. I want people to be drawn into the work." « Je tente de travailler sur les rapports complexes entre le pouvoir et la vie en société, mais pour ce qui est de la présentation visuelle, je tâche d'éviter un haut degré de difficulté. Je souhaite que les gens soient attirés vers l'intérieur de l'œuvre. »

Advertising, propaganda and missionary appeals work like magnets. If they are successful, they catch the masses by the throat, draw them close and do not let them go again. Barbara Kruger emulates hackneyed messages of this kind to consumers and the masses, to those seeking a meaning: "pray like us", "fear like us", "believe like us". The slogans are frequently articulated as appeals that Kruger mounts in strong, usually white and red inscriptions. Her combination of typography with black and white photography, a symbol for the positive-negative schema of the quoted messages, has become her trademark. She has mass-produced posters, T-shirts and shopping bags, stuck posters on outside walls and advertising spaces. Ever since her first texts in Times Square annoyed the people of New York in 1983 ("I am not trying to sell you anything"), Kruger's concept has been both public and political. For

instance, she designed the poster for the women's rights demonstration in Washington of 1989 ("Your Body is a Battleground"), wrote a feminist pamphlet translated into many languages ("We do not need any new heroes") and published various books on such themes as discrimination against minorities and AIDS. In the 1990s concrete opposition has given way to a deeper thoughtfulness, which highlights the history of mass propaganda and new strategies of psychological persuasion. Currently Kruger's work is multimedia. She supplements written messages with acoustics, and photography with video projection. Back in the exhibition room, she encircles the public ("YOU") with a powerful show of targeted attacks. Confrontation has become claustrophobia. In "Power Pleasure Desire Disgust", 1997, Kruger no longer attacks the public's attitudes but their zones of intimacy.

Pages 290/291: **01 WE DON'T NEED ANOTHER HERO,** 1987. Silkscreen on plastic, 275 x 400 cm. **02 UNTITLED (YOU CAN'T DRAG...),** 1990. Photographic silkscreen, vinyl, 277 x 389 cm. **03 INSTALLATION VIEW,** Mary Boone Gallery, New York (NY), USA, 1991. Pages 292/293: **04 POWER PLEASURE DESIRE DISGUST,** 1997. Multi media installation, Deitch Projects, New York, 1997.

02

La publicité, la propagande et les discours missionnaires agis-
t comme des aimants. Ceux qui sont voués au succès agressent les
es, les fascinent et ne les lâchent plus. Barbara Kruger copie ce type
clichés lancés au consommateur, au peuple, aux chercheurs de sens :
ie comme nous », « Aie peur comme nous », « Crois comme nous ».
a parole agit toujours comme une accroche élaborée par Kruger en
actères durs, le plus souvent rouges et blancs. Ainsi, la combinaison
e typographie et photo noir et blanc, image du schéma positif/néga-
des messages employés, est devenue peu à peu le signe distinctif de
travail. Kruger a réalisé des posters, des T-shirts et des sacs de
visions comme productions de masse, mais aussi des murs d'affi-
s et des surfaces publicitaires. Depuis que ses premiers textes de
33 ont mis en émoi les New-Yorkais de Times Square (« Je ne cherche
à vous vendre quelque chose »), le concept de Kruger est resté

aussi public que politique. Elle a par exemple conçu l'affiche de la mani-
festation pour les droits de la femme à Washington en 1989 (« Your
Body is a Battleground »), un pamphlet du féminisme traduit en de nom-
breuses langues (« Nous n'avons pas besoin de nouveaux héros ») et
divers titres de livres ayant pour sujet la discrimination des minorités ou
le Sida. Dans les années 90, la résistance concrète a cédé la place à
une réflexion plus profonde, qui éclaire par exemple l'histoire de la pro-
pagande de masse ou les nouvelles stratégies de suggestion psycholo-
gique. Le travail de Kruger est aujourd'hui multimédiatique : elle complète
le message écrit par des messages acoustiques, la photo par la projec-
tion vidéo. De retour dans la salle d'exposition, elle assaille le public
(« YOU ») avec un déluge d'attaques ciblées. La confrontation s'est faite
claustrophobie. Dans « Power Pleasure Desire Disgust », 1997, Kruger
n'attaque plus les attitudes du public, mais les zones de l'intimité. S. T.

BARBARA KRUGER

SELECTED EXHIBITIONS: *1985* Los Angeles County Museum of Art, Los Angeles (CA), USA /// *1990* Kölnischer Kunstverein, Cologne, Germany /// *1996* Museum of Modern Art at Hei Melbourne, Australia /// *1997* Deitch Projects, New York (NY), USA /// *1999* The Museum of Contemporary Art, Los Angeles **SELECTED BIBLIOGRAPHY:** *1983 We Won't Play Nature to Your Cultu Works by Barbara Kruger,* Institute of Contemporary Arts, London, England; Kunsthalle Basel, Basle, Switzerland /// *1987 Barbara Kruger,* Mary Boone Gallery, New York /// *1988 Barbara Krug National Art Gallery, Wellington, New Zealand /// *1990 Love for Sale: The Words and Pictures of Barbara Kruger,* New York /// *1999 Barbara Kruger,* The Museum of Contemporary Art, Los Ange

n't stand it wh

away. You're so

one knows wha

e, so obvious. S

ody else, okay

PETER LAND

1966 born in Aarhus, Denmark / lives and works in Copenhagen, Denm.

"Video allows me to use myself as different figures. In front of the camera, I'm able to enact a private fantasy as a social statement." **« La vidéo me permet de me présenter dans différents rôles. Face à la caméra, la possibilité m'est donnée de représenter un fantasme personnel comme une déclaration sociale. »**

At the beginning of Peter Land's early video performances there stands the cryptic comment: "What would be the last thing in the world I'd be ready to do, I wondered. How could I put myself in doubt?" His answer was total exposure, which he carried out in two experiments on himself. In the first, he endeavoured to tempt two strippers to his sex show in his sitting room in front of a running camera ("Peter Land the 6ᵗʰ of February", 1994), while in the second he filmed an amateurish performance of himself as a striptease dancer ("Peter Land the 5ᵗʰ of May" 1994). This endless, alcohol-soaked, anything but erotic display of his own naked-ness made Land known overnight. Since then, his work has been domin-ated by startlingly touching and often embarrassing pictures in which he presents prototypical situations of degradation and defeat. In unending repetition, he puts before us a variety of sequences of scenes that go to extremes to conjure up a condition of self exposure and failure, in great detail and with total inevitability. Land's videos are reminiscent o' the sitcom of silent films and slapstick, but are so precisely construct¢ that the neuralgic point of downfall stands only for itself, thereby be-coming a statuesque image. His plots supply interpretations that allow for both general human identifications as well as reflections of art image External falls are guided inwards in melodramatic fashion, often exagge rated by music, as for example in the relentlessly repeated plunge dow a staircase ("The Staircase", 1998), which against the contrast of a dark starry sky appears like plunging out of the world itself.

A l'origine des premières performances vidéo de Peter Land, il y avait l'abyssale question : « Je me demandais quelle serait la dernière chose au monde que je serais prêt à faire ? Comment pourrais-je me remettre en question moi-même ? » La réponse fut la représentation d'une mise à nu totale que l'artiste concrétisera dans deux expériences menées sur sa propre personne. Dans la première, devant une caméra mobile, Land tentait de faire entrer deux strip-teaseuses dans son sex-show personnel se déroulant dans son salon (« Peter Land the 6th of February »). Dans la seconde, il filmait une performance d'amateur : lui-même en strip-teaseuse (« Peter Land the 5th of May »). Land devint ainsi célèbre du jour au lendemain par ces interminables exhibitions aux relents d'alcool – anti-érotiques au possible – de sa propre nudité. Depuis, son œuvre est dominée par des images touchantes au début, souvent embarrassantes, dans lesquelles il présente les prototypes de situations de dégradation et d'échec : dans des séquences inlassable-ment répétées, Land décline des scènes traumatiques qui exploitent tr explicitement et à grand renfort de détails, inéluctablement, un état de mise à nu et d'échec. Les vidéos de Land rappellent le comique de sit *tion du film muet et du film à sketchs, mais elles sont construites avec une telle précision que le point névralgique de l'effondrement se trouve isolé pour lui-même en une image statuaire. Ses schémas fournissent des interprétations permettant aussi bien l'identification générale que l réflexion sur des images d'artiste. Les chutes extérieures sont ramené vers l'intérieur sur un mode mélodramatique souvent exacerbé par l'ac compagnement musical, comme par exemple dans l'implacable répétit on d'une chute dans un escalier (« The Staircase », 1998), que sa juxta position avec un ciel étoilé transforme en chute hors du monde lui-même. S. T.*

01

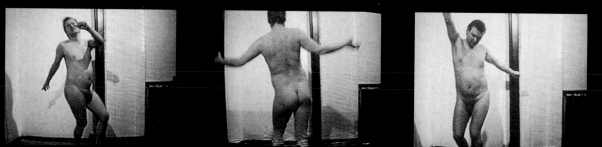

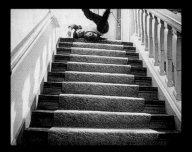

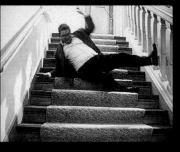
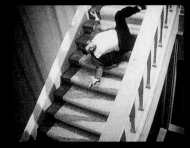
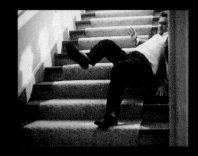

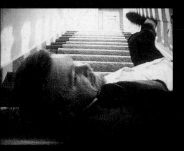
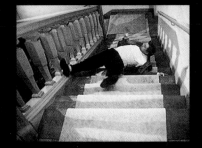
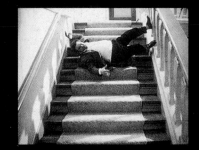

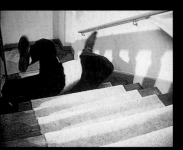
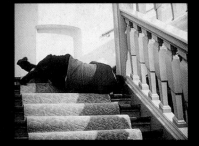
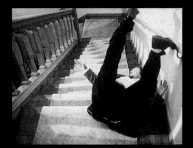

02

01 PETER LAND THE 5TH OF MAY 1994, 1994. Video stills, video 25 mins. 02 THE STAIRCASE (THE STAIRCASE), 1998. Double video projection,
video stills.

PETER LAND

SELECTED EXHIBITIONS: *1996* "NowHere", Louisiana Museum of Modern Art, Humlebæk, Denmark /// *1997* Galleri Nicolai Wallner, Copenhagen, Denmark /// Wiener Secession, Vienna, Austria /// *1998* Museum of Modern Art Chicago, Chicago (IL), USA /// Manifesta 2, Luxembourg, Luxemburg /// *1999* "Bahnwärterhaus", Galerie der Stadt Esslingen, Esslingen/N., German **SELECTED BIBLIOGRAPHY:** *1997 Peter Land, Idiot*, Wiener Secession, Vienna /// *1998 Exhibition catalogue*, Manifesta 2, Luxembourg

03 THE CELLIST, 1998. Video stills, video 9 mins. **04 DOUBLE DIAMOND,** 1994. Video stills, video 25 mins. **05 PINK SPACE,** 1995. Video stills, lo plays continously. **06 STEP LADDER BLUES,** 1995. Video stills, video 7 mins.

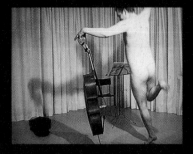
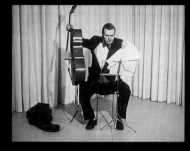
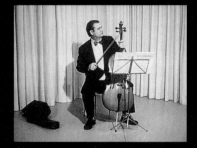

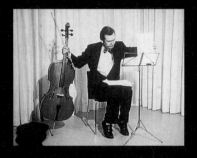
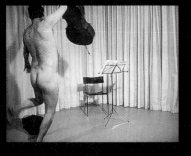

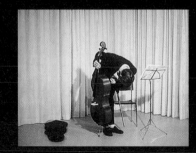

04

05

06

SEAN LANDERS

1962 born in Palmer (MA) / lives and works in New York (NY), US

"My original idea was to make conceptual art entertaining and funny. Over the years I got so far out on that conceptual limb that I went around full circle and became a traditional artist again. I figure it's better to be a sucker who makes something than a wise guy who is too cautious to make anything at all." « A l'origine, mon idée était de faire un art conceptuel divertissant. Au fil des années, je me suis tellement penché par cette fenêtre conceptuelle que j'ai fait un tour complet et que je suis redevenu un artiste traditionnel. Je pense que mieux vaut être un idiot qui fait quelque chose qu'un bon gars, trop prudent pour faire quoi que ce soit. »

Self-confidence is not Sean Landers' strong point. His art is marked by an ironically pathetic narcissism that displays a tendency towards self-doubt and self-accusation. He has found many diverse images for this sense of himself, which is sometimes formulated cynically, sometimes affectionately. They include a depiction of the artist and man as a bronze monkey in the sculpture "Singerie: Le Sculpteur", 1995; as an "Idiot", as he calls himself occasionally in his autobiographical book "[sic]" of 1993; as a model ironically overvaluing himself in the video "Italian High Renaissance and Baroque Sculpture", 1993; or as a naively drawn, seventeenth-century Irish drunkard in the sequence of paintings "A Midnight Modern Conversion (An Altercation)", 1996. Instead of striving for "masterly genius" in one art form, Landers continually changes media, thus denying himself a professional specialisation. Through the imitation of different historical models, he also expresses his scepticism about autonomous expertise in modern art when compared to historical art: "Nothing, not even the TV, is as good as it used to be", he claims. Landers doesn't even trust the fixed, completed form of a work of art. He first presented his three sculptures "The Celtic, Paris, Hero", 1993 in unfired clay, only casting them in bronze after the exhibition. In order to prevent cracks and tears or a smoothing away of the contours, gallery staff had to pour water over them. Just like the artist's self-image, the sculptures were unstable, threatened and subject to unpredictable change.

02

NYMPHAS AND SHIPWRECK, 1995. Oil on linen, 213 x 310 cm. **02 SINGERIE: LE SCULPTEUR,** 1995. Bronze, 2 x 113 x 61 cm. **03 INSTALLATION VIEW,** Andrea Rosen Gallery, New York (NY), USA, 1992.

La confiance en soi ne compte pas parmi les atouts majeurs de Sean Landers. Son art est plutôt empreint d'un narcissisme ironique et pathétique, toujours caractérisé par une nette tendance à douter de soi, et ce jusqu'à l'auto-accusation. Pour traduire cet état de conscience formulé tantôt en termes cyniques, tantôt de manière aimante et intimiste, Sean Landers a trouvé toutes sortes d'images : l'homme et artiste comme singe de bronze dans la sculpture « Singerie : Le Sculpteur », comme « Idiot » tel qu'on le trouvait récemment dans son livre autobiographique [sic] », 1993, comme mannequin arrogant portant un regard ironique sur lui-même dans la vidéo « Italian High Renaissance and Baroque Sculpture », 1993, ou encore comme buveur irlandais du XVIIe siècle peint dans un style naïf, tel qu'on le voit dans la série de peintures « A Midnight Modern Conversion (An Altercation) », 1996. Plutôt que de recher-

cher la « géniale maîtrise » d'une forme artistique, Sean Landers change donc sans cesse de médium et se refuse à toute spécialisation professionnelle. L'imitation de différents modèles historiques exprime également le scepticisme de Landers à l'égard de la virtuosité de l'art contemporain. « Rien n'est aussi bien qu'autrefois, pas même la télévision », regrette-t-il en jetant un regard comparatif sur l'histoire de l'art. Landers ne fait pas davantage confiance à la forme ferme et définitive de l'œuvre d'art : ses trois sculptures « The Celtic, Paris, Hero », 1993, ont ainsi été présentées en argile brute, n'étant coulées en bronze qu'après l'exposition. Pour éviter les fissures, mais aussi l'érosion des contours, les œuvres devaient être humectées par le personnel du musée. Tout comme l'autoportrait de l'artiste, ces sculptures étaient, elles aussi, instables, fragiles et soumises aux changements imprévisibles. R. S.

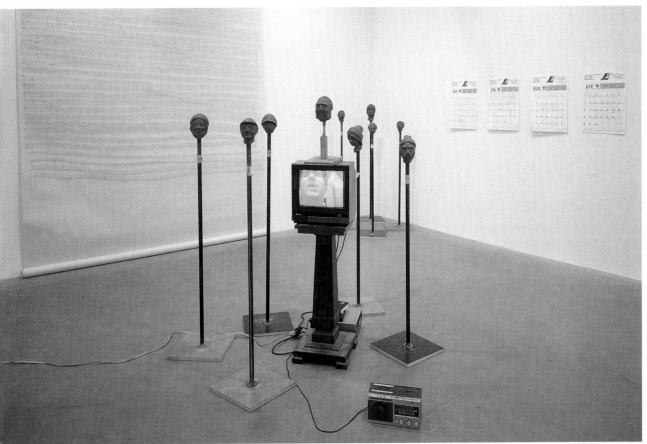

SEAN LANDERS

SELECTED EXHIBITIONS: *1990* "Work in Progress? Work?", Andrea Rosen Gallery, New York (NY), USA /// Postmasters Gallery, New York /// *1993* "Standards", Aperto 93, XLV Esposizione Internationale d'Arte, la Biennale di Venezia, Venice, Italy /// *1993–1994* "Backstage", Kunstverein in Hamburg, Hamburg, Germany; Kunstmuseum Luzern, Lucerne, Switzerland /// *1996* "Young Americans: New American Art in the Saatchi Collection: Part I", Saatchi Gallery, London, England /// *1996–1997* Contemporary Fine Arts, Berlin, Germany /// *1998* Taka Ishii Gallery, Tokyo, Japan /// *1999* Andrea Rosen Gallery, New York **SELECTED BIBLIOGRAPHY:** *1996 wunderbar*, Kunstverein in Hamburg, Hamburg /// *Young Americans: New American Art in the Saatchi Collection, Part I*, Saatchi Gallery, London /// *1998 Blimey! From Bohemia to Britpop: The London Artworld form Francis Bacon to Damien Hirst*, Cambridge, England

04

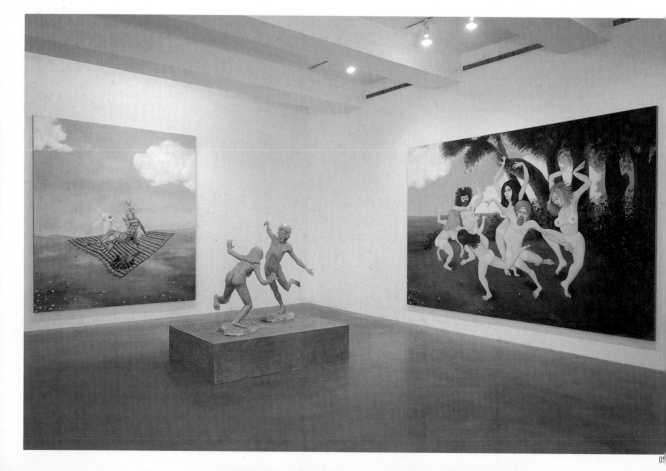

04 ALONE, 1996. Oil on linen, 183 x 244 cm. **05** From left to right: **ROBOT AND BUNNY/ME AND MICHELLE,** 1997. Oil on linen, 274 x 244 cm. **CANDLES IN THE WIND,** 1997. Beeswax; man, 116 x 61 x 97 cm; woman, 97 x 84 x 69 cm; overall dimensions, 116 x 157 x 97 cm. **DANCE OF LIFE,** 1997. Oil on linen, 244 x 366 cm. Installation view, Andrea Rosen Gallery, New York (NY), USA, 1997. **06 REMISSIONEM PECCATORUM,** 1994 (background). Colour video, video 1 hour. Front, from left to right: **PARIS,** 1993. Bronze, 86 x 40 x 36 cm. **HERO,** 1993. Bronze, 65 x 40 x 30 cm. **THE CELTIC,** 1993. Bronze, 96 x 30 x 30 cm. Installation view, "esprit d'amusement", Grazer Kunstverein, Graz, Austria, 1994.

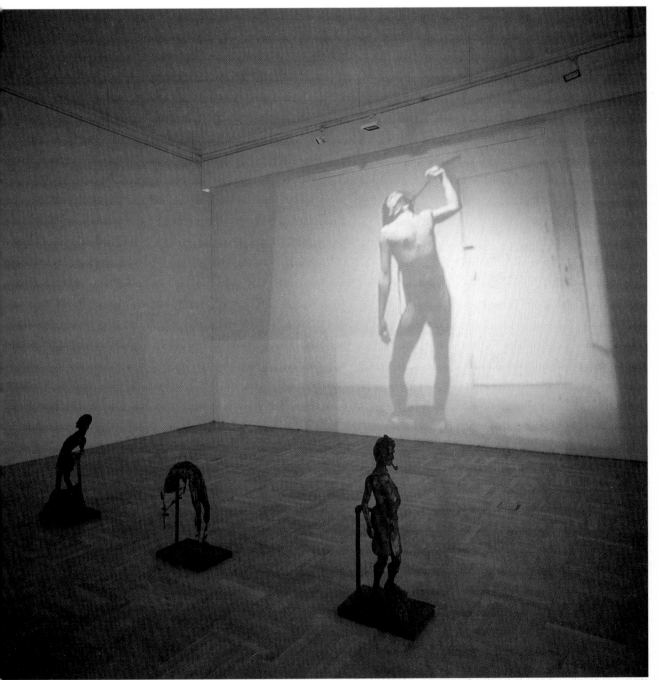

LOUISE LAWLER

"Why I resist interviews: they foreground the artist – tell too much about what wouldn't be known when confronting the work." **« Pourquoi je m'oppose aux interviews ? Elles mettent l'artiste au premier plan – elles révèlent trop de choses que personne ne saurait en étant seulement confronté à l'œuvre. »**

According to Louise Lawler, art is created through a collective process. Not only artists, but also critics, curators, dealers and collectors participate in the creation of aesthetic value and significance. Since the late 1970s, Lawler has focused on the apparently tangential mechanisms of the presentation and marketing of art: the institutional framework. Her initial, often ephemeral projects, such as the "Book of Matches" and her later photographs, gallery and museum installations, examine individual elements of the cultural apparatus – invitation cards, lighting, captions, installation photos – shifting their meanings through subtle modifications. Lawler often combines her own works with those of other artists, as she did in 1982 in the New York gallery Metro Pictures. By taking on "curatorial" tasks there, she removed the customary division of duties between gallery owner and artist. She saw the works of art as aesthetic signs that could take on other meanings according to their context. Her "Arrange-

ments of Pictures" thus depict art works in private and corporate collections as well as in auction houses, indicating their function as commodities, luxury goods and status symbols. She uses inscriptions which are sometimes stamped on the passe-partouts, to reveal further interpretations. For instance, in a work of 1988, she annotates two of Warhol's photographs "Round Marilyn" with the questions "Does Andy Warhol make you Cry?" or "Does Marilyn Monroe make you Cry?", an ironic allusion to the emotional expectations that are often associated with the reception of art. Often, instead of putting her name in the foreground as the determining factor in the valuation of her art, she inscribes the name of a curator, art adviser or a museum or administrative employee. The autograph as the essence of authorship is decentralised, and with it the idea of artistic autonomy as a requirement for the circulation of art.

01 ...EXHIBITION, 1987. Printed glasses with text "You Could Hear A Rat Piss On Cotton. Charlie Parker", ...ss shelves, paint, 2 cibachrome photos of The Museum of Contemporary Art, Los Angeles (CA), USA.
...UNTITLED (MARTIN AND MIKE), 1992. Cibachrome, felt, crystal, 5 cm (h) x ø 9 cm. 03 UNTITLED (SALON ...DLER), 1992. Cibachrome, felt, crystal, 5 cm (h) x ø 9 cm. 04 WORDS BEND EMOTIONS LIKE A TWIG IN ...TER, 1995. 80 printed glasses with text "word", glass shelves, 3 theatrical lights suspended from ...ling, 52 x 418 x 10 cm.

02　　　　　　　　　　　　　　03

Selon Louise Lawler, l'art est le fruit d'un processus collectif. Les ...tistes ne sont pas seuls impliqués : les critiques, les conservateurs, les ...archands et les collectionneurs participent eux aussi à la création de ...leurs et de significations (esthétiques). Depuis la fin des années 70, ...awler place au centre de son travail les mécanisme apparemment les ...us banals de la présentation et de la commercialisation de l'art, à ...avoir le « cadre » institutionnel. Souvent Lawler associe ses œuvres à ...elles d'autres artistes, comme elle le fit en 1982 dans la galerie new-...orkaise Metro Pictures. Elle y accomplissait des tâches de « conserva-...on », inversant la répartition habituelle des rôles galeriste/artiste. De ...us, elle travaillait ses œuvres comme des signes esthétiques sujets ...changement de sens selon le contexte. Ainsi, les « Arrangements of ...ctures » de Lawler montrent des œuvres d'art dans des collections ...ivées, des collections de grandes entreprises, ou dans des hôtels de vente, renvoyant à leur fonction de valeur d'échange, d'article de luxe et de signe extérieur de richesse. Par le biais des légendes – dont certaines sont gravées dans le passe-partout –, Lawler ouvre ses images à de nouvelles associations sémantiques. A deux prises de vues de « Round Marilyn » de Warhol, elle ajoutait ainsi la question « Does Andy Warhol make you Cry ? », ou « Does Marilyn Monroe make you Cry ? », 1988, allusion ironique à l'attente affective qui accompagne souvent la réception de l'art. Il n'est pas rare que les inscriptions de Lawler citent aussi des noms de conservateurs, de conseillers artistiques, d'employés de musées et de bureau au lieu de mettre en avant ceux des artistes, ordinairement cités comme facteur déterminant pour l'évaluation de l'art. La signature, identité de l'auteur, se trouve littéralement décentrée, et avec elle, c'est aussi l'idée de l'autonomie de l'artiste, si déterminante pour la circulation de l'art, qui se trouve décentrée.　　　　　A. W.

LOUISE LAWLER

SELECTED EXHIBITIONS: *1989* "A Forest of Signs: Art in the Crisis of Representation", The Museum of Contemporary Art, Los Angeles (CA), USA /// *1990* "The Enlargement of Attention, No One Between the Ages of 21 and 35 is Allowed", Connections: Louise Lawler, Museum of Fine Arts, Boston (MA), USA /// *1996* Sydney Biennial, Sydney, Australia /// *1997* "Monochrome", Hirshhorn Museum and Sculpture Garden, Washington, D.C., USA **SELECTED BIBLIOGRAPHY:** *1986 What is the Same*, Maison de la Culture et de la Communication de Saint-Etienne, Saint-Etienne, France /// *1995 A Spot on the Wall*, Kunstverein München, Munich, Germany /// *1998 Louise Lawler, A Spot on the Wall*, Cologne, Germany

"NT REMAINS TO BE SEEN", installation view, Metro Pictures, New York (NY), USA, 1987. **06 POLLOCK AND TUREEN (ARRANGED BY MR. AND MRS. BURTON TREMAINE,** **NECTICUT),** 1984. Colour photo, 41 x 51 cm. **07 PRODUCED IN 1988, PURCHASED IN 1989; PRODUCED IN 1989, PURCHASED IN 1993,** 1995. Cibachrome (museum box), x 149 cm. **08 I–0,** 1993–1998. Cibachrome (museum box), 50 x 59 cm. **09 PINK,** 1994/95. Cibachrome, 120 x 151 cm.

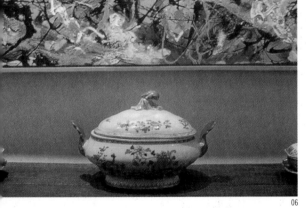

06

07

08

09

ZOE LEONARD

"You would like to contribute to making a world in which you can just sit around and think about clouds. That should be our right as human beings."
« Tu voudrais contribuer à créer un monde dans lequel tu pourrais tout simplement être assis et rêver aux nuages. Cela devrait être notre droit en tant qu'êtres humains. »

The work of the photographer Zoe Leonard stands between two poles whose opposition to one another almost dissolves in her hands – the ostentatious language of political activism and the sensitive tonality of poetic fiction stand side by side and equal. As a lesbian feminist she is committed to the struggle for freedom and the recognition of marginal groups. At the same time, her photographic view of the world is an extremely dreamy one, as is seen in her wave pictures "Water #1 + #2" of 1988. Leonard created one of her best-known works as a member of the artist collective "Gang" – the poster "Read My Lips", 1992, which depicts a woman's vagina accompanied by the sentence: "Read my lips before they are sealed." The text alluded to a law forbidding American doctors to use the word "abortion". The fact that a lesbian feminist put the vagina ostentatiously but apparently without emotion at the centre of the picture, raises further questions: who has control over the femal body and over pictures of women? What is achieved by the censorship homoerotic subjects? How can a female sex organ be represented with out eroticism effect? The role of women also stands at the centre of th photo series "Fae Richards Photo Archive", 1993–1996. The artist has lovingly compiled the fictitous biography of a black Hollywood actress a the beginning of the twentieth century. Role allocation and mechanisms for the exclusion of blacks prove to be social constructs, in which the lightning and settings of well-known film stills are utilised. Why, for instance, are pictures of black actresses usually underexposed while white men are brightly lit? But for all the political rhetoric, the work is also fascinating because of its occasionally sentimental nostalgia – th objective of all battles is simply "winning back beauty".

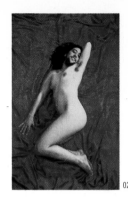

02

Le travail de la photographe Zoe Leonard se situe dans le champs ension entre deux pôles : le langage lapidaire de l'activisme politique s sensibles tonalités de la fiction poétique. En tant que féministe et ienne, Zoe Leonard poursuit une lutte très engagée pour la liberté et connaissance des minorités marginales. En même temps, le regard tographique qu'elle jette sur le monde est un regard extrêmement ur, comme le montrent par exemple ses photos de vagues « Water + #2 », 1988. Elle a réalisé une de ses œuvres les plus célèbres en lité de membre du collectif d'artistes « Gang » : il s'agit de l'affiche ad my Lips », 1992. On peut y voir un vagin accompagné de la phra- « Read my lips before they are sealed ». Le texte fait référence à un et interdisant aux médecins américains d'utiliser le mot « avorte- t ». Le fait que cette protectrice des droits de la femme mette dé- strativement au centre de l'image un vagin apparemment « dénué

d'émotion », soulève d'autres questions : qui exerce un contrôle sur le corps de la femme et l'image des femmes ? Comment représente-t-on un sexe féminin sans qu'il soit d'un effet érotique ? Le rôle de la femme est aussi le thème central de la série photographique « Fae Richards Foto Archives », 1993–1996. Avec amour, l'artiste a reconstitué la biographie fictive d'une actrice hollywoodienne noire du début du 20e siècle. La répartition des rôles et les mécanismes d'exclusion des noirs y appa- raissent comme construits de toutes pièces par la société, à quoi con- tribuent l'éclairage et la mise en scène des « stills« célèbres du cinéma. Pourquoi les actrices noires sont-elles le plus souvent sous-exposées tandis que les acteurs blancs bénéficient d'un éclairage précis et écla- tant ? Malgré la rhétorique politique mise en œuvre, ce travail fascine aussi par une nostalgie presque sentimentale parfois – le but de toute lutte étant précisément « la reconquête de la beauté ». R. S.

ZOE LEONARD

SELECTED EXHIBITIONS: *1992* documenta IX, Kassel, Germany /// *1993* "Zoe Leonard Photographs", The Renaissance Society at the University of Chicago, Chicago (IL), USA /// *1997* Wie Secession, Vienna, Austria /// Kunsthalle Basel, Basle, Switzerland /// Museum of Contemporary Art, North Miami (FL), USA /// *1999* "Sculpure – Figure – Women", Kunstsammlungen Chemn Chemnitz, Germany /// "The Museum as Muse: Artists Reflect", The Museum of Modern Art, New York (NY), USA **SELECTED BIBLIOGRAPHY:** *1991 Information*, Galerie Gisela Capit Cologne, Germany /// *1995 Strange Fruit, Zoe Leonard*, Paula Cooper Gallery, New York /// *1997 Zoe Leonard, Secession*, Wiener Secession, Vienna /// *Zoe Leonard*, Kunsthalle Basel, Basle

04

05

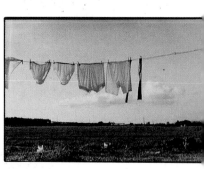

04 **EFFIGY,** 1995. Gelatin silver print, 18 x 13 cm. **05 FALSE TOOTH,** 1993/94. Gelatin silver print, 12 x 9 cm. **06 LAUNDRY – PORTUGAL 1994,** 1994/95. Gelatin silver print, 13 x 18 cm. **07 NEST NO. 8,** 1994–1998. Gelatin silver print, 33 x 47 cm. **08 / 09 STRANGE FRUIT (FOR DAVID),** 1992–1997 (details). Different formats, 297 elements: peels of oranges, lemons, grapefruits, avocados and bananas; thread, needles, zips, buttons, wax, plastic, hook, string, fabric.

07

08

09

SHERRIE LEVINE

1947 born in Hazleton (PA) / lives and works in New York (NY), l

"I am interested in that infra thin difference between what was decided on but does not make its way into the work, and what makes its way into the work but was not decided on." « **Je m'intéresse à cette imperceptible différence entre ce qui avait été voulu sans être finalement entré dans l'œuvre, et ce qui est entré dans l'œuvre sans avoir été voulu.** »

Sherrie Levine is the key representative of Appropriation Art, a critical re-adaptation which has constituted a strand of contemporary art since the 1980s. Levine imitates well-known handwritings and subjects, quotes outstanding works and presents the copy as the object of a new perception. The history and myth of avant-garde art become themes: the originality of its works, the history of its breaches of taboo, the legendary individualism and radicalism of its makers. Levine's artistic departure point was the awareness of coming too late. Too late to have a part in this history, and too late to take it forward. Her series reflect strategies of desire by copying drawings by Matisse or Willem de Kooning, or reproducing original photographs by Walker Evans and Karl Blossfeldt. Levine exploits the ambivalence of a procedure that fits slickly into

Modernism's mechanism of success, consumerism and reproduction. frequently repeated printing of the same theme (Manet's "Absinthe Drink asserts on the one hand the replacement of the original by the media though on the other hand an imitated style also alludes to the numerous repetitions, serial reproductions and self-copies made by the artists themselves. Levine formulates a detachment from artistic modernism th has decisively influenced Post-modern criticism. But she also advocates a new way of looking. In the early 1990s, in series like "Newborn" or "After Duchamp", she plays with the facts of history, bringing togeth Brancusi and Duchamp, antipodes in the history of art, in a sensual bronze urinal called "Fountain (After Duchamp)" of 1991.

Sherrie Levine est une représentante majeure de l'«Appropriation Art», une réappropriation critique appliquée à l'art moderne depuis les années 80. Levine imite des écritures et des motifs célèbres, cite des œuvres uniques et transforme la copie en un regard nouveau par le biais de sa mise en scène. L'histoire et le mythe de l'avant-garde deviennent thème: l'originalité des œuvres, l'histoire des tabous brisés, le mythe de l'individualisme et le radicalisme de ses créateurs. Le point de départ artistique de Levine a été la conscience de venir trop tard. Trop tard pour prendre part à cette histoire, trop tard pour pouvoir la poursuivre. Ses séries reflètent ainsi les stratégies du désir en copiant des dessins de Matisse, de Willem de Kooning, ou encore en reproduisant des photographies originales de Walker Evans et de Karl Blossfeldt. Levine met à profit l'ambiguïté d'un procédé qui s'intègre pleinement dans les méca-

nismes du succès, de la consommation et de la reproduction de l'art moderne. L'incessante réimpression d'un même motif («La Buveuse d'absinthe» de Manet) désigne d'un côté le remplacement de l'origina par les médias; d'un autre côté, une écriture peinte renvoie, il est vra aussi aux nombreuses reproductions, aux tirages sériels et aux auto-copies réalisées par les artistes. La distance que Levine formule à l'égard de l'art moderne a joué un rôle déterminant dans la critique po moderne, mais elle vise aussi à une nouvelle prise de conscience. Da des séries comme «Newborn» ou «After Duchamp», Levine joue dep le début des années 90 avec l'histoire des historiens et ses intentions mettant sur un même plan Duchamp et Brancusi – deux antipodes de l'histoire de l'art – avec un sensuel urinoir en bronze: «Fountain (After Duchamp)», 1991. S

01 NEWBORN INSTALLATION, 1993. Cast crystal, 13 x 20 cm. Installation view, Philadelphia Museum Art, Philadelphia (PA), USA, 1993. **02 HOBBYHORSE,** 1996. Cast aluminium, 9 parts, 69 x 89 x 48 cm (9 pedestals. Installation view, "Museum Vitale: Work in Progress. Zur Tradition und Zukunft einer Institu Städtisches Museum Schloß Morsbroich, Leverkusen, Germany, 1996.

SHERRIE LEVINE

SELECTED EXHIBITIONS: *1988* Hirshhorn Museum and Sculpture Garden, Washington, D.C., USA /// *1991* San Francisco Museum of Modern Art, San Francisco (CA), USA /// *1995* Museum of Contemporary Art, Los Angeles (CA), USA /// *1997* Casino Luxembourg, Luxembourg, Luxemburg /// *1998* Kunstverein in Hamburg, Hamburg, Germany **SELECTED BIBLIOGRAP** *1991 Sherrie Levine*, Kunsthalle Zürich, Zurich, Switzerland /// *1993–1994 Sherrie Levine. Newborn*, Philadelphia Museum of Art, Philadelphia (PA), USA; Portikus, Frankfurt/M., Germany /// *19 Exhibition catalogue*, Städtisches Museum Schloß Morsbroich, Leverkusen, Germany

03 AFTER WALKER EVANS #19. B/w photograph, 36 x 28 cm. **04 BUDDHA,** 1996. Cast bronze, 48 x 41 x 36 cm. **05 LA FORTUNE (AFTER MAN RAY),** 1990. Felt, mahogany, resin, 84 x 279 x 152 cm (each). Installation view, Kunsthalle Zürich, Zurich, Switzerland, 1991/92.

03

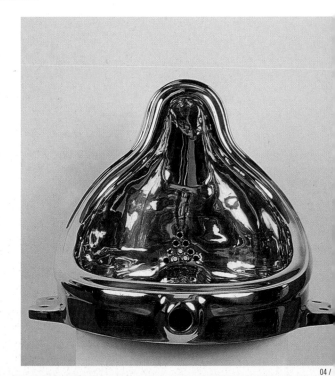

04 /

ATELIER VAN LIESHOUT

Established in
Joep van Lieshout: **1963** born in Ravenstein, The Netherl…
lives and works in Rotterdam, The Nethe…

"I couldn't care less what people call it, as long as we can make what we want." « **Tant que nous pouvons faire ce que nous voulons, rien ne m'est plus indifférent que le nom qu'on veut donner à ce que nous faisons.** »

Founder and source of ideas for the Atelier van Lieshout is the artist Joep van Lieshout. He has adopted the term "Atelier" since 1994, to stress that his works are created in cooperation with many collaborators. His workshop supplies not only standard shelves, tables and chairs; the business is also geared up to fitting out entire bathrooms or kitchens. Van Lieshout's furniture and architecturally fitted furnishings are intended to be understood and used as part of everyday culture. As good value for money produced rapidly in unlimited quantities, they are spared any snooty upmarket aura. Along with furnishings for the home, van Lieshout is best known for his mobile homes. In addition to these, he makes weapons, distills alcohol and is a racing driver. His liberal concept of 'art' also extends to his equipment for slaughtering animals. At exhibitions, he displays photos of the slaughtering process and preserved or smoked meats as well as a visual representation of self-catering and the slaught… ritual. All in all, with his furniture, sanitary units and sleeping accommo… tion, van Lieshout's artistic output covers everything that you need in l… – or to survive. Many of his works are charged with sexual innuendos. This applies not only to the early "Biopimmel" (Biowillie), 1992, but also to the great beds or the "Wohnmobile für Liebesspiele" (Mobile Homes … Love Play). Van Lieshout's lockable enclosures are intended to enhanc… people's sexual energy and derive, like his "Sensory Deprivation Hel-mets", from the work of the psychologist and sexologist Wilhelm Reic… Lieshout's work follows Reich's theory in acclaiming libidinous needs and seeing a comprehensive, cosmic life force in them.

Le fondateur et la source d'idées de l'Atelier van Lieshout est l'artiste Joep van Lieshout. Depuis 1994, il s'est adjoint le terme « atelier » pour souligner le fait que ses œuvres sont créées avec le concours de nombreux collaborateurs. Son atelier ne se contente pas de produire des bibliothèques, des tables et des chaises standardisées, l'entreprise réalise aussi sur commande des salles de bains ou des cuisines entière-ment équipées. Les meubles et les équipements architecturaux réalisés par Van Lieshout doivent être compris et utilisés comme une partie de la culture quotidienne. La production rapide, bon marché, le tirage illimité de nombre de ses objets préserve ceux-ci de toute aura de sublimité. A côté des aménagements de l'habitat, ce sont surtout ses caravanes qui ont rendu l'artiste célèbre. Au-delà de ce domaine d'activité, Van Lieshout construit des armes, distille de l'alcool et participe à des courses auto-mobiles. Son concept élargi de l'art s'exprime aussi à travers ses dispo-sitifs d'abattage. Dans ses expositions, il montre en outre des photos … la procédure d'abattage et des viandes fumées ou en conserve, repré-sentation visualisée de l'autosuffisance alimentaire et du rituel d'abatta… Avec ses meubles, ses aménagements sanitaires et ses literies, l'œuv… de Van Lieshout produit tout ce dont l'homme a besoin pour vivre, ou plutôt pour survivre. Beaucoup de ses œuvres sont chargées d'allusio… sexuelles. Ceci vaut pour l'une des premières, « Bite bio », 1992, com… pour les grands lits ou les « Caravanes pour jeux amoureux ». Les habi-tacles clos de Van Lieshout doivent augmenter l'énergie sexuelle des gens. De même, les « Sensory Deprivation Helmets » se réfèrent eux aussi au psychanalyste et sexologue Wilhelm Reich. L'œuvre de Liesho… suit la théorie de Reich en approuvant les besoins libidineux et en y voyant une force universelle de vie cosmique. Y.…

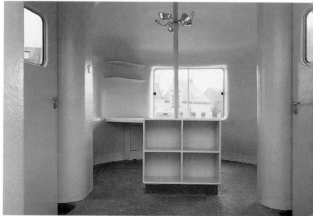

03

04

05

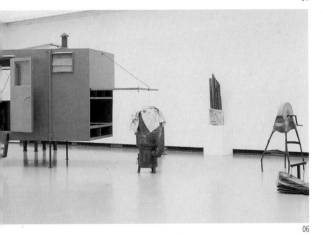

06

07

2 CASTMOBILE, 1996. Interior, mixed media, 320 x 1130 x 950 cm. **03 / 04 / 05 / 06 / 07 INSTALLATION VIEWS,** m Boijmans Van Beuningen, Rotterdam, The Netherlands, 1997.

ATELIER VAN LIESHOUT

SELECTED EXHIBITIONS: *1997* "Hausfreund I", Kölnischer Kunstverein, Cologne, Germany /// Museum Boijmans Van Beuningen, Rotterdam, The Netherlands /// Skulptur. Projekte Münster 1997, Münster, Germany /// *1998* Sprengel Museum Hannover, Hanover, Germany /// *1999* University of South Florida Contemporary Art Museum, Tampa (FL), USA /// Espace Jules Verne Centre d'Art et de Culture, Brétigny-sur-Orge, France /// Migros Museum für Gegenwartskunst Zürich, Zurich, Switzerland **SELECTED BIBLIOGRAPHY:** *1990 Collectie 1989–1990*, Rotterdam /// *1991 Collection 1991*, Rotterdam /// *1995 1993–1995*, Rotterdam /// *1996 Collection '96: Notes from the catwalk / Time Machines*, Rotterdam /// *1997 Atelier van Lieshout – Manual / Ein Handbuch*, Stuttgart, Germany /// *1998 The Good, The Bad + The Ugly – Atelier van Lieshout*, Migros Museum für Gegenwartskunst Zürich, Zurich; Rotterdam

08 AUTOCRAT, 1997. Exterior, mixed media, 310 x 700 x 225 cm. **09 MODULAR HOUSE MOBILE,** 1995/96. Exterior, mixed media, 310 x 215 x 700 cm.
10 MOBILE HOME FOR KRÖLLER-MÜLLER, 1995. Exterior, mixed media, 300 x 800 x 700 cm.

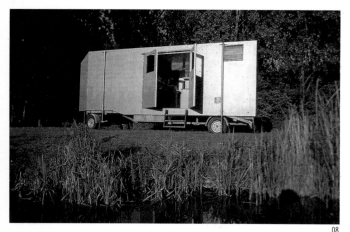

08

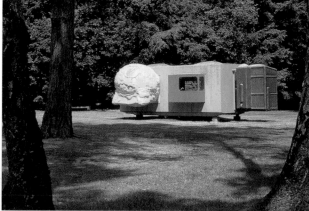

11

12

13

14

15

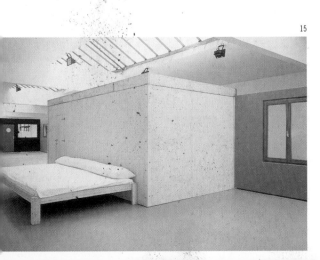

11 / 12 / 13 / 14 / 15 "HAUSFREUND I", installation views, Kölnischer Kunstverein, Cologne, Germany, 1997.

THOMAS LOCHER

1956 born in Munderkingen, Germany / lives and works in Cologne, Germa

"Eventually the infinite that surpasses the idea of the infinite challenges the spontaneous freedon in us. It dominates that freedom, passes judgment on it and guides it towards the truth. The analysis of the idea of the infinite to which there is access from a self goes ultimately beyond the subjective." **« Il arrive que l'infini qui dépasse l'idée de l'infini remette en question la liberté spontanée en nous. Il la domine et la juge et la conduit à sa liberté. En définitive, l'analyse de l'idée de l'infini, à laquelle on a accès à partir d'un moi, va au-delà du subjectif. »**

Words appear on furniture, figures on parts of doors and windows, texts from law tomes extend over a whole exhibition room. Since the late 1980s, following the demands of Conceptual Art that language and communication should be analysed as strictly as the images of the media-dominated present, Thomas Locher has been exhibiting conceptual, grammatical and political processes of reflection. At first he covered ordinary tables, chairs, beds and cupboards, or simple mass-produced stools, windows and doors, with a series of concepts and fragments of text. Often, these were brought together to form larger interiors, which asked abstract questions about everyday language. Next came large tables bearing declensions, conjugations, semantic fields and grammatical rules.

Finally, he produced large displays with titles such as "Diskurs$_1$" or "Diskurs$_2$" on which weighty socioligical texts – the European Human Right Convention or the Basic Law of the Federal Republic of Germany – wer presented and discussed. Locher dismantles the superficial clarity of language and lays out its rules and conventions, possibilities and alternatives. His dry, schematic method ensures that individual works stand as numbing symbols of bureaucracy, politics, order and power, but in consequence, discloses their ambiguity all the more compellingly, unleashing linguistic dramas. The rules of language are questioned, and reading becomes a new kind of critically unresolved process.

01

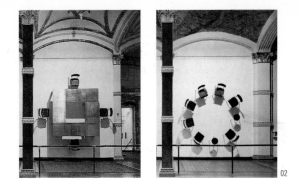

Z, 1988. Silkscreen on wood, 160 x 137 x 6 cm. **02 "DEUTSCHLANDBILDER"**, installation views, Martin-Gropius-[B]erlin, Germany, 1997. **03 1–14**, 1995. Astralon on wood, 150 x 150 x 7 cm.

02

Des mots sur des meubles, des chiffres sur des blocs-portes ou [des] fenêtres, des textes de loi répandus dans toute une salle d'exposition. [Pr]enant à son compte un aspect majeur de l'art conceptuel, qui invite [à l'a]nalyse rigoureuse du langage et de la communication, aussi bien [que] des images de l'ère médiatique contemporaine, Thomas Locher met [en s]cène depuis la fin des années 80 des processus de réflexion con-[cept]uelle, grammaticale et politique. Dans un premier temps, ce furent [de s]imples tables, des chaises, des lits et des armoires, ou encore des [tabo]urets, des fenêtres ou des portes issus de la production de masse [anon]yme, objets qu'il couvrait de séries de termes et de fragments de [texte]. Souvent agencés en de vastes intérieurs, les meubles présentaient [des] remises en cause abstraites du langage quotidien. Il y eut ensuite [de g]rands tableaux avec des déclinaisons, des conjugaisons, des mots [appa]rtenant au même champ sémantique et des règles grammaticales.

Pour finir, on vit de grands panneaux de texte portant des titres comme « Discours 1 » ou « Discours 2 », sur lesquels étaient présentés et débat-tus des réalisations importantes de la société : la Convention Européenne des Droits de l'Homme ou la loi fondamentale de la République fédérale d'Allemagne. Locher décompose la transparence superficielle de la lan-gue, il présente ses règles et ses conventions, ses possibilités et ses alternatives. Il procède pour cela de manière si sèche et schématique que certaines œuvres deviennent des symboles figés de la bureaucratie, de la politique, de l'ordre et du pouvoir, dont la duplicité apparaît alors de manière d'autant plus brutale. Les discours de Locher suscitent des drames linguistiques. Les contraintes imposées par le langage devien-nent thème de l'œuvre, la lecture se transforme en processus inédit proposant une approche critique. *S. T.*

03

THOMAS LOCHER

SELECTED EXHIBITIONS: *1992* "Wer sagt was und warum", Kölnischer Kunstverein, Cologne, Germany /// *1995* Kunstverein München, Munich, Germany /// National Gallery Contemporary Art Zacheta, Warsaw, Poland /// *1996* "Öffentlich/Privat", Künstlerhaus Stuttgart, Stuttgart, Germany (with Peter Zimmermann) /// *1998* Klemens Gasser & Tanja Grunert, New Y[..] (NY), USA /// *1999* "Never", Aachener Kunstverein, Aachen, Germany /// Galerie 20/21, Essen, Germany **SELECTED BIBLIOGRAPHY:** *1992 Thomas Locher*, Stichting De Appel, Amsterda[..] The Netherlands /// *1993 Wörter Sätze Zahlen Dinge – Tableaus, Fotografien, Bilder*, Kunsthalle Zürich, Zurich, Switzerland /// *Thomas Locher*, Kunsthalle Düsseldorf, Düsseldorf, Germany

04 "WÖRTER, SÄTZE, ZAHLEN, DINGE", installation view, Kunsthalle Zürich, Zurich, Switzerland, 1993. **05 MARKIERUNG ETIKETTIERUNG,** 1989. Installation view, Galerie Tanja Grunert, Cologne, Germany, 1989.

04

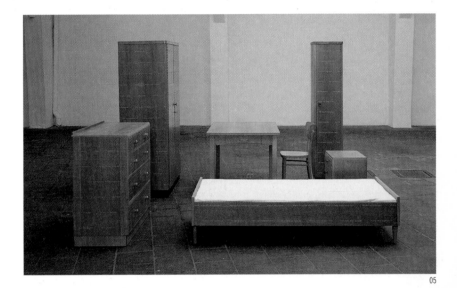

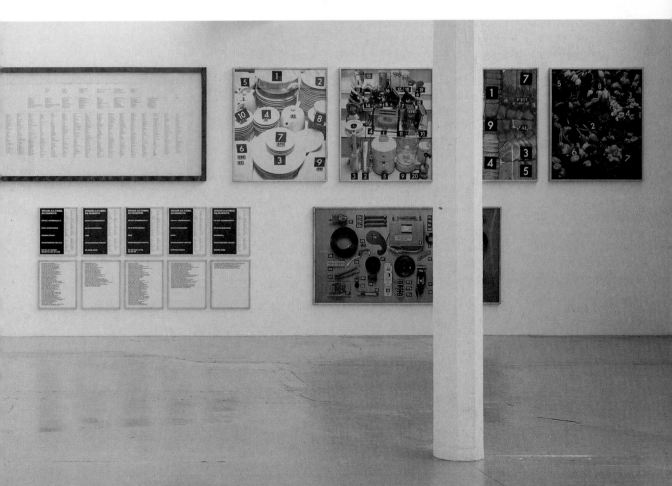

SHARON LOCKHART

1964 born in Norwood (MA) / lives and works in Los Angeles (CA), U

In her films and photos Sharon Lockhart often works with allusions to film classics, and many of her photographs have the atmosphere of film stills. The photo series "Shaun", 1993, which was made in connection with her film "Khalil, Shaun, A Woman Under the Influence", 1994, is distinguished by a perceptible discrepancy between the visible surface and the psychological content. The boy's unconcerned facial expression contrasts with the wounds – applied by a mask-maker – that cover his body. Lockhart often works with young people who are in the transitional stage between childhood and puberty or puberty and adulthood. Lockhart presents scenes in which the actors' characterization does not accord with the actions performed. For instance, the age of the mutually embracing and kissing children from her photo series "Audition", 1994, in which Lockhart presented a scene from "L'Argent de Poche" (Small Change) of 1975 by François Truffaut, does not fit the action reproduc and lends these works an ambivalent atmosphere. In her 63 minute-long film "Goshogaoka", 1997, she observes from a stationary camer position girls of a Japanese basketball team exercising. For all the doc mentary dominance there increasingly evolves a choreography over a ground of the noises of body movements and later computer music. Lik many of her works, "Goshogaoka" is conditioned by the simultaneous emphasis on formal aspects (narrative structure) and on themes (repre sentation).

Dans ses films et ses photos, Sharon Lockhart travaille souvent avec des références aux classiques du cinéma, et nombre de ses photographies font songer à des arrêts sur image. La série photographique « Shaun », 1993, réalisée dans le cadre de son film « Khalil, Shaun, A Woman Under the Influence », 1994, se distingue par une dichotomie sensible entre la surface visible et le contenu psychologique. L'insouciante expression du visage du garçon contraste avec les blessures (réalisées par un maquilleur de théâtre) qui couvrent son corps. Souvent Lockhart travaille avec des jeunes qui se trouvent au passage de l'enfance à la puberté ou de l'adolescence à l'âge adulte. Lockhart met en scène des situations dans lesquelles la caractérisation des acteurs n'est pas en accord avec les scènes jouées. Ainsi l'âge des enfants qui s'embrassent dans la série photographique « Audition », 1994, dans laquelle Lockhar reconstitué une scène de « L'argent de poche », 1975, de François Tru faut, ne correspond pas à l'action représentée et confère à ces œuvre une atmosphère équivoque. Dans son film de 63 minutes « Goshogaoka 1997, à partir d'un point de vue fixe, l'artiste observe l'entraînement d'une équipe de basketteuses japonaises. Malgré la prédominance du caractère documentaire, on voit se développer peu à peu une chorégr phie soutenue d'abord par le bruit des mouvements corporels, puis pa une musique d'ordinateur. Comme beaucoup des œuvres de Lockhart, « Goshogaoka » est déterminé aussi par le soulignement simultané des aspects formels (structure narrative) et du contenu thématique (représentation). Y.

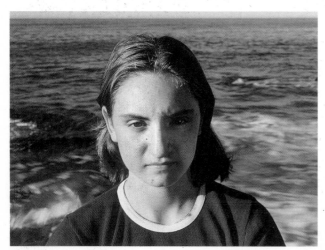

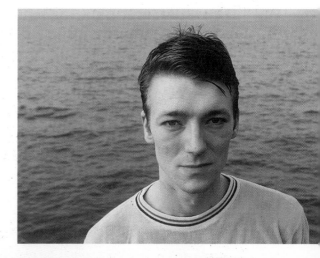

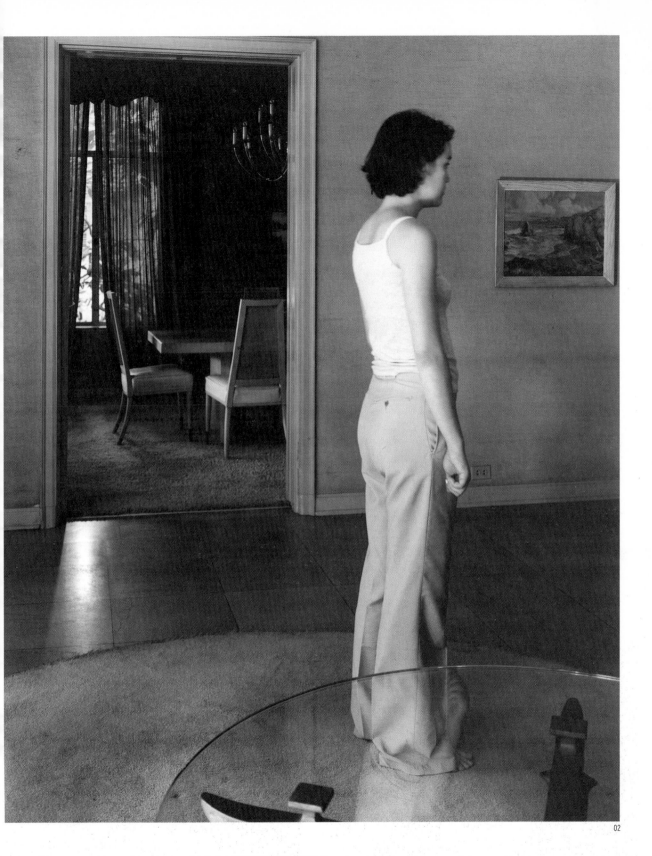

MILY (APPROXIMATELY 8 AM, PACIFIC OCEAN), 1994 (left); JOCHEN (APPROXIMATELY 5 PM, NORTH SEA), 1994 (right).
prints, 79 x 229 cm. **02 UNTITLED,** 1996. C-print, 130 x 104 cm.

SHARON LOCKHART

SELECTED EXHIBITIONS: *1995* Künstlerhaus Stuttgart, Stuttgart, Germany /// *1998* "Goshogaoka", The Museum of Contemporary Art, Los Angeles (CA), USA /// *1999–2000* Kun halle Zürich, Zurich, Switzerland /// Museum Boijmans Van Beuningen, Rotterdam, The Netherlands /// Kunstmuseum Wolfsburg, Wolfsburg, Germany **SELECTED BIBLIOGRAPH**
1995 Album, The Photographic Collection of Museum Boijmans Van Beuningen, Rotterdam /// *1996 Persona*, Kunsthalle Basel, Basle, Switzerland /// *Art and Film since 1945*. The Muse of Contemporary Art, Los Angeles; New York (NY), USA /// *1998 Tell Me a Story. La Narration dans la Peinture et la Photographie Contemporaines*, Le Magasin – Centre d'Art Contempor de Grenoble, Grenoble, France /// *Sharon Lockhart*, Blum & Poe, Santa Monica (CA), USA; Wako Works of Art, Tokyo, Japan

03 ON KAWARA: WHOLE AND PARTS, 1964–95, MUSEUM OF CONTEMPORARY ART TOKYO JANUARY 24 – APRIL 5, 1998, 1998. 4 C-prints, 164 x 125 cm (e

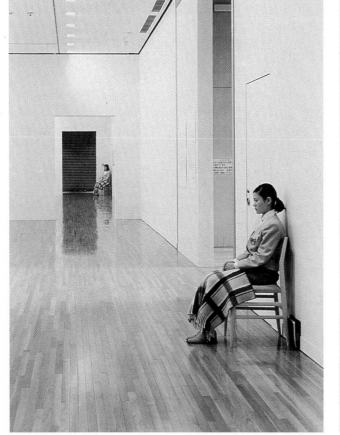 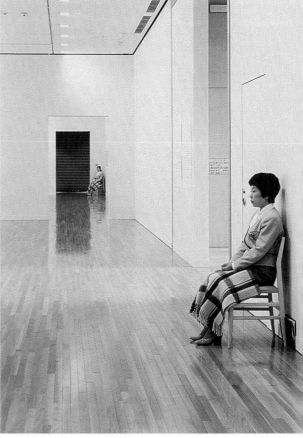

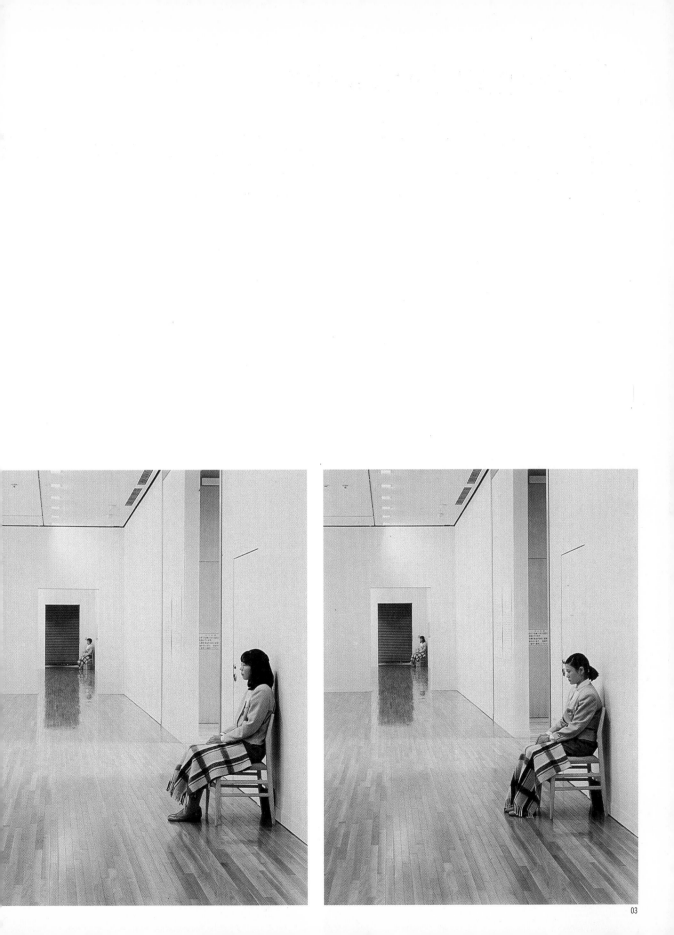

SARAH LUCAS

"It's a bit like 'Escape from Alcatraz', you have to get a nail-file if you can get hold of one, saw the bars through. You have to use what you've got, and either it does the job or it doesn't. It is articulating your way out of something." « **C'est comme les évadés d'Alcatraz: il faut se procurer une lime à ongles, si jamais il s'en présente une, et scier les barreaux. Il faut se servir de ce qu'on a. Ça passe ou ça casse. Il s'agit d'articuler sa sortie de quelque chose.** »

Sarah Lucas first came to prominence with her large-scale collages consisting of photocopies and cuttings from newspaper articles. She combines page-three girls from the tabloid press with the grotesque headlines of sensational journalism. In some of these works, she integrates the self-portraits that have become one of her trademarks. She photographs herself in assumed masculine poses: sitting on a staircase with her legs spread; wearing a leather jacket, sunglasses and stout shoes; or suggestively eating a banana. Items of food and everyday objects are arranged as still lifes or photographed, quite often taking on sexual connotations. In one of her best-known works, "Au Naturel", 1994, for example, a cucumber protudes from an old mattress flanked by two

oranges; a female counterpart is provided by a battered metal bucket and two melons. Lucas often creates a crude effect, communicating an unflinching, sometimes aggressive directness in her handling of themes like sexism or violence through abstruse or outrageous images. At the beginning of her career she was regarded as a feminist artist, but her installations "Is Suicide Genetic?", 1996, or "Car Park", 1997, demonstrate her interest in a wide range of social problems, such as genetic research and the social causes of vandalism. Lucas once said in an interview that her work is about the possibility of describing the world, a claim borne out by the diversity of her themes.

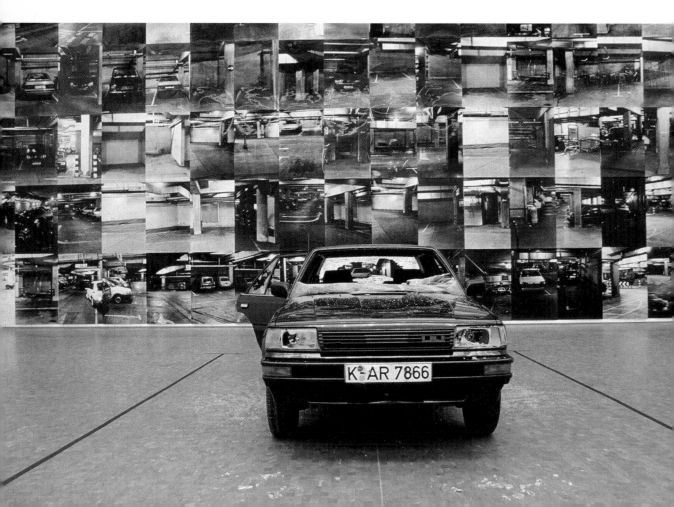

02

Sarah Lucas s'est fait connaître par ses collages grand format
mposés de photocopies et de coupures d'articles de presse, dans
squels elle combine les pin-up des revues triviales avec les gros titres
otesques de la presse à sensation. Il lui est aussi arrivé de faire entrer
s autoportraits dans quelques-unes de ces œuvres, autoportraits qui
nt devenus une sorte de logo de son travail. Lucas se photographie
ns des poses soi-disant masculines : assise sur un escalier les jambes
artées, vêtue d'une veste de cuir, portant des lunettes de soleil,
aussures grossières aux pieds, ou encore en train de manger une
nane avec un regard entendu. Il n'est pas rare que dans son travail,
s aliments et les objets quotidiens arrangés en natures mortes soient
argés d'une connotation sexuelle. Ceci vaut par exemple pour son
otyque « Au Naturel », 1994, œuvre dans laquelle elle a fiché un con-

combre dans un vieux matelas en posant deux oranges à côté. Comme
pendant féminin, on trouve sur le matelas un seau en fer cabossé et
deux melons. Les œuvres de Lucas sont souvent d'un effet cru et il en
émane une grande immédiateté, voire une agressivité, avec laquelle elle
traite des sujets tels que le sexisme ou la violence dans des images
abstruses ou grotesques. Au début de sa carrière, Lucas était souvent
considérée comme une artiste féministe. Mais ses installations « Is
Suicide Genetic ? », 1996, ou « Car Park », 1997, témoignent aussi de
son intérêt pour des interrogations sociales pertinentes, comme la
recherche génétique ou les causes sociales du vandalisme. Dans une
interview, Lucas a déclaré que son travail représentait pour elle une
possibilité de décrire le monde, une revendication à laquelle elle tente
de rendre justice par sa grande diversité thématique. Y. D.

03

SARAH LUCAS

SELECTED EXHIBITIONS: *1995* "Supersensible", Barbara Gladstone Gallery, New York (NY), USA /// *1996* Portikus, Frankfurt/M., Germany /// *1997* "Bunny Gets Snookered", Sadie Col▮ HQ, London, England /// "Car Park", Museum Ludwig, Cologne, Germany /// "Sensation", Royal Academy of Art, London **SELECTED BIBLIOGRAPHY:** *1996 Sarah Lucas*, Museum Boijma▮ Van Beuningen, Rotterdam, The Netherlands /// *1997 Sarah Lucas*, Portikus, Frankfurt/M. /// *Car Park*, Museum Ludwig, Cologne

04 IS SUICIDE GENETIC?, 1996. Chair, polystyrene, cigarettes, 100 x 85 x 65 cm. 05 AU NATUREL, 1994. Mattress, melons, oranges, cucum▮ water bucket. 06 "THE LAW", installation view, St. Johns Lofts, St. John Street, London, England, 1▮

04

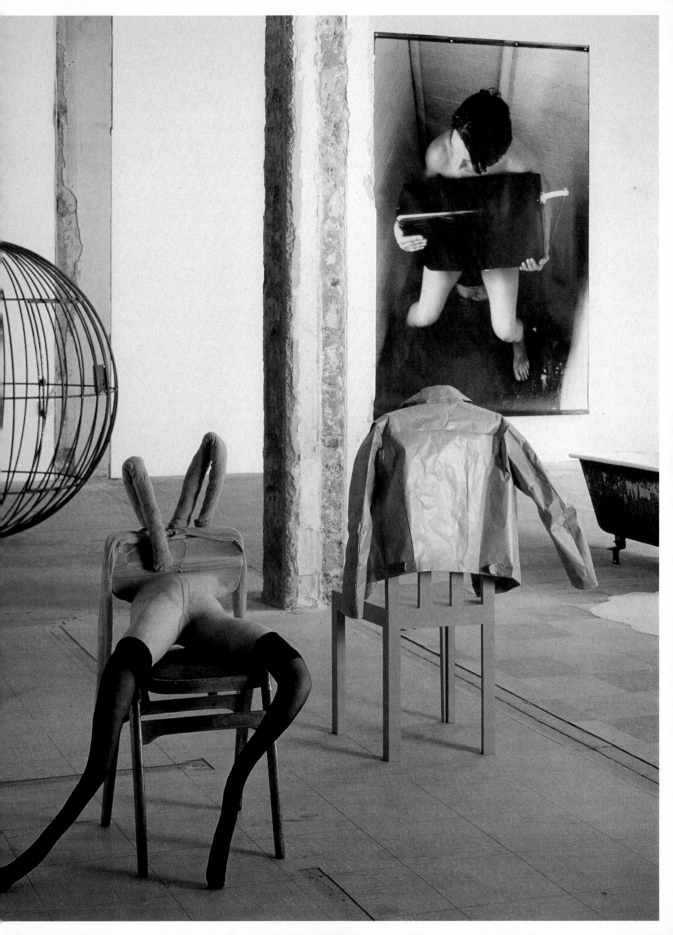

MICHEL MAJERUS

1967 born in Esch, Luxemburg / lives and works in Berlin, German

"My work operates precisely on the assumption that every claim to 'authentic' culture and lifestyles is illusionary." « **Mon travail fonctionne précisément parce que toute revendication d'une culture ou d'un mode de vie ‹ authentique › est présupposé comme illusoire.** »

Michel Majerus's exhibitions are concentrated charges of quotations, styles and images. At first glance, it is not easy to grasp their point. The structures are classical enough: regular rectangles or ceiling-high formats like those utilised by Modernism at its most self-assured. But their use seems sacrilegious, an injury to the dignity of these forms. Majerus quotes classic painters, particularly the heroes of the large format – American Modernists such as Frank Stella, Ellsworth Kelly, Andy Warhol or Jean-Michel Basquiat – and Donald Judd, Robert Morris and Lawrence Weiner. Alongside these, he places functional aesthetic forms, print media and rapidly painted signs. Majerus is no longer concerned with the introduction of the real and banal into art, nor with that battle against the end of painting that jumps out at us from each of Gerhard Richter's painting for example. From Majerus's perspective, all visual media have acquired equal value and should simply be viewed as co-existing simultaneously. In his first major exhibition, in 1996, the exhibition space itself was part of the thesis. In contrast to the gilded rooms of the Basle Kunsthalle, he laid metal grilles on the floor, positioning his pictures inside them like a backdrop, or painting them directly on the walls. This produced a new dimension of perception. The museum ceased to be a place of the pa of nostalgic memories and conservation, and authorship lost its import ance: the pictures were available in the here and now.

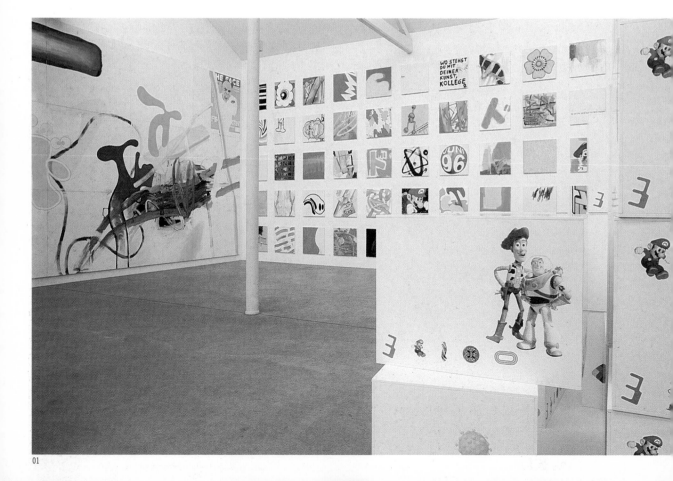

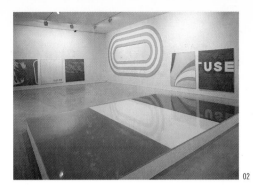

02

Les expositions de Michel Majerus sont des charges concentrées e citations, de styles et de motifs iconiques. Et au premier regard, on écèle à peine ce qui les suscite. Les supports de l'image sont classi- ues : carrés conséquents ou formats de la hauteur du mur, tels qu'ils nt régné souverainement au plus fort de l'art moderne. Mais leur emploi essemble à un sacrilège, une atteinte à leur dignité. Majerus cite bien es classiques, surtout ceux de l'art moderne américain, véritables éros du grand format, tels que Frank Stella, Ellsworth Kelly ou Andy Varhol (entre autres avec Jean-Michel Basquiat), mais aussi Donald udd, Robert Morris ou Lawrence Weiner. A côté de ces objets, il installe e l'esthétique fonctionnelle, des médias imprimés et des signes peints 'un geste rapide. La stratégie iconique de Majerus n'est pas nouvelle, lle a été utilisée par la plupart de ceux qu'il a lui-même choisis. Mais lle a aujourd'hui un tout autre effet et peut être employée différemment.

Le propos de Majerus n'est plus l'entrée historique du réel et de la bana- lité dans l'art, pas plus que la lutte contre la fin de la peinture, telle qu'elle semble s'embraser dans chacune des peintures de Gerhard Richter. Du point de vue de Majerus, tous les médiums visuels sont devenus équivalents et doivent être considérés dans leur simultanéité. Dans sa première grande exposition en 1996, la salle d'exposition faisait elle aussi partie de la thèse : par contraste avec les salles feutrées de la Kunsthalle de Bâle, Majerus avait jonché le sol de grilles métalliques parmi lesquelles ses tableaux se dressaient comme des décors de théâtre. Ou bien les œuvres étaient peintes à même le mur. Il ressort de ce travail une perception nouvelle. Le passé est extrait des souvenirs sentimentaux et des conservations muséales, la paternité artistique perd de son importance, les tableaux deviennent disponibles pour l'instant présent. S. T.

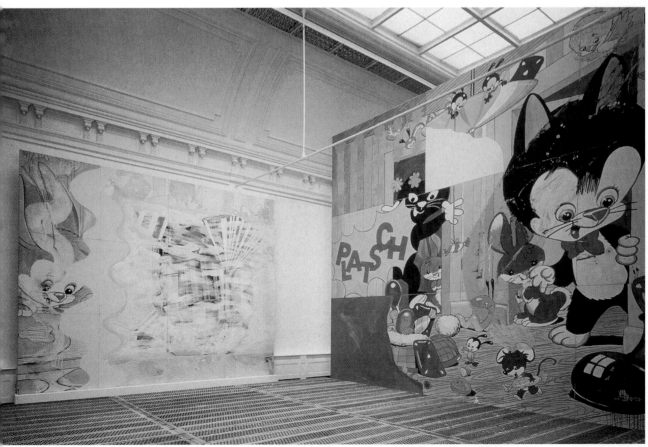

03

MICHEL MAJERUS

SELECTED EXHIBITIONS: *1996* "Aesthetic Standard", Grazer Kunstverein, Graz, Austria /// Kunsthalle Basel, Basle, Switzerland /// "Aquarell", Kunstverein in Hamburg, Hamburg, Germany /// *1998* Manifesta 2, Luxembourg, Luxemburg /// "100 Jahre Wiener Secession", Wiener Secession, Vienna, Austria **SELECTED BIBLIOGRAPHY:** *1996 Exhibition catalogue,* Kunsthalle Basel, Basle /// *wunderbar,* Kunstverein in Hamburg, Hamburg /// *1998 Exhibition catalogue,* Le Magasin – Centre National d'Art Contemporain, Grenoble, France

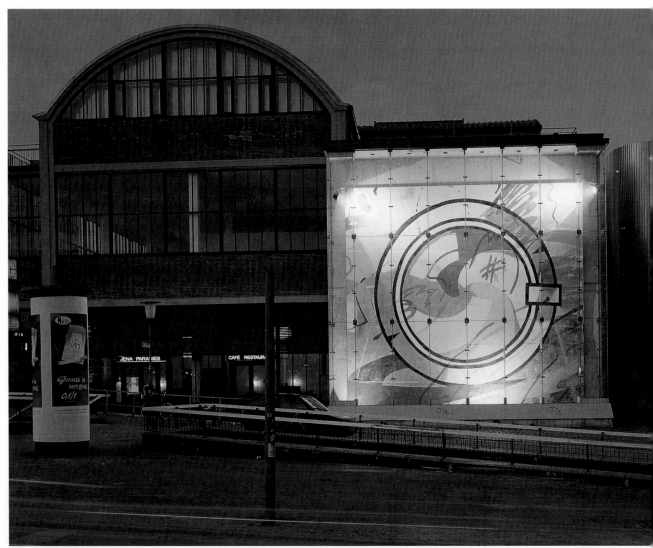

04 "AQUARELL" PROJEKT IN DER GLASWAND, 1996. Installation view, "Aquarell", Kunstverein in Hamburg, Hamburg, Germany, 1996.
05 SPACE-SAFARI, 1997. Installation view, Anders Tornberg Gallery, Lund, Sweden, 1997. **06 "FERTIGGESTELLT ZUR ZUFRIEDENHEIT ALLER, DIE BEDENKEN HABEN",** installation view, neugerriemschneider, Berlin, Germany, 1996.

PAUL McCARTHY

"I have always had this fascination with film and television, but I never wanted to become a part of the industry: my interests are more directed towards a parody or mockery of it." « J'ai toujours connu cette fascination pour le cinéma et la télévision, mais je n'ai jamais voulu faire partie de l'industrie : mes pôles d'intérêt sont plutôt orientés vers leur parodie ou leur dérision. »

Since the late 1960s Paul McCarthy has been using a variety of different media. He employs "painting as action", performance, installations that comprise the spatial context of his actions, and the camera and video camera as instruments that steer the viewer's sometimes voyeuristic attention. In "Bavarian Kick", 1987, McCarthy extended his formal repertoire with sculptures, partly equipped with motors, which act on his behalf. At the centre of his performances stand the conflicts or "dilemmas" of the hybrid and cliché-ridden characters which he assumes with the help of masks and disguises: a politician ("Carter Replacement Mannequin", 1980), a housewife ("Mother Pig", 1983) or an artist ("Painter", 1995). McCarthy's actions are always sexually loaded and are drastically theatrical stagings of processes and deeds that are occasionally taboo, like birth and death, coitus, sodomy and masturbation. Frequently, as in "Bossy Burger", 1991, or "Heidi", 1992 (with Mike Kelley), they identify to the patriarchal family structure as a source of profound disturbances. Unlike Viennese Actionism, with which McCarthy's works are sometimes associated, he is not concerned with the authenticity of suppressed feelings. His theme is the moulding of individual behaviour through the mass media and social structures. The body is one of the focal points where these influences pile up. McCarthy's points of reference are the simulacra of a normal, or abnormal, world such as Disneyland, B-movies, TV series and comics. His obsessive use of manufactured fluids like ketchup or mayonnaise as a substitute for bodily fluids is a mark of the thoroughly alienated condition of the (American) individual. He stages hopeless situations that reflect social power relations in order to subject them to his "tasteless", symbolic and tragicomical ravages.

Depuis la fin des années 60, Paul McCarthy se sert d'un grand nombre de médiums : il s'intéresse à la « peinture comme action », à la performance, à l'installation, qui constitue le contexte spatial de ses actions, et à la caméra (vidéo), qui lui permet d'orienter le regard (voyeur) du spectateur. Avec « Bavarian Kick », 1987, McCarthy augmentait son répertoire formel avec des sculptures partiellement motorisées agissant en son nom et lieu. Au centre des performances de McCarthy, on trouve les conflits ou les « Dilemmes » des personnages hybrides, proches du cliché, qu'il endosse en se servant de masques et de déguisements : politiciens (« Carter Replacement Mannequin », 1980, maîtresse de maison (« Mother Pig », 1983), ou encore l'artiste lui-même (« Painter », 1995). Les actions de McCarthy, qui comportent toujours une connotation sexuelle, sont des mises en scène théâtrales et drastiques de processus et d'agissements partiellement tabou tels que la naissance et la mort, le coït, la sodomie et la masturbation ; elles renvoient souvent à l'ordre patriarcal, lieu de désordres profonds, comme dans « Bossy Burger », 1991), ou « Heidi » (avec Mike Kelley, 1992). Le propos de McCarthy n'est cependant pas la vérité des sentiments refoulés. Son thème est l'impact des médias et des structures sociales sur le comportement individuel. Le corps est une des scènes privilégiées où se projettent et se superposent ces influences. Les références de McCarthy sont les simulacres d'un monde (mal)sain tels que nous les offrent Disneyland, les séries B, les séries télévisées et les bandes dessinées. Son utilisation obsessionnelle de liquides industriels comme le ketchup ou la mayonnaise, substituts de fluides corporels, désigne l'état totalement dépersonnalisé de l'individu (américain) : McCarthy met en scène des situations sans issue qui reflètent des rapports de force sociaux, pour les soumettre à ses ravages « de mauvais goût », symboliques et pour une bonne part tragi-comiques. A. W.

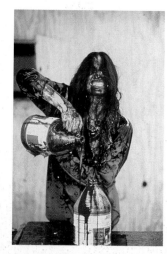

1 / 02 / 03 / 04 SANTA CHOCOLATE SHOP, 1997. Film stills. **05 BARTENDER WITH PIG HEAD.** Mixed media, 353 x 485 x 279 cm. Installation
iew, "SALOON", Luhring Augustine, New York (NY), USA, 1996. **06 DANCE HALL GIRL, COWBOY (GUNFIGHTER).** Mixed media, 353 x 485 x 279
m. Installation view, "SALOON", Luhring Augustine, New York, 1996.

05

06

PAUL McCARTHY

SELECTED EXHIBITIONS: *1995* Hamburger Kunsthalle, Hamburg, Germany (with Mike Kelley) /// "Tomato Head", Künstlerhaus Bethanien, Berlin, Germany /// "Painter", The Museum of Modern Art, New York (NY), USA /// *1997* 4ᵉ Biennale de Lyon, Lyons, France /// Biennial Exhibition, Whitney Museum of American Art, New York **SELECTED BIBLIOGRAPHY:** *1992 Helter Skelter: L. A. Art in the 1990s*, The Museum of Contemporary Art, Los Angeles (CA), USA /// *1993 Post Human*, Musée d'Art Contemporain, Pully/Lausanne, Switzerland /// *1995 Cocido y Crudo*, Museo Nacional Centro de Arte Reina Sofía, Madrid, Spain /// *1996 Paul McCarthy, Ralph Rugoff, Kristine Stiles, Giacinto, Di Pietrantonio*, London, England /// *1997 Sunshine & Noir: Art in LA 1960–1997*, Louisiana Museum of Modern Art, Humlebæk, Denmark

07

07 **TOMATO HEADS,** 1994. Installation view, Rosamund Felsen Gallery, Los Angeles (CA), USA, 1994.
08 / 09 **PINOCCHIO PIPENOSE HOUSEHOLDDILEMMA,** 1995. Installation view, Luhring Augustine, New York (NY), USA, 1995.

08 / 09

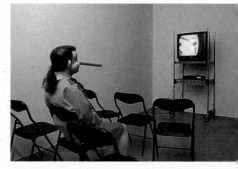

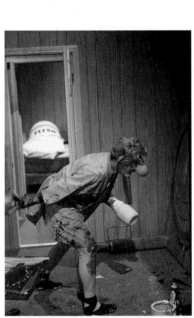

10

12

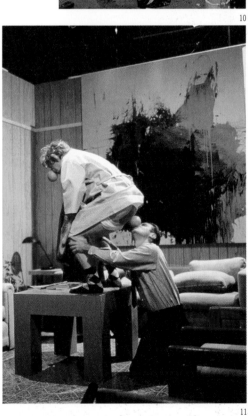

11

13

10 PAINTER, 1995. Video, mixed media. Still from performance. **11 PAINTER,** 1995. Video, mixed media. Installation view of stage set. The Museum of Modern Art, New York (NY), USA, 1995. **12 PAINTER,** 1995. Video, mixed media. Still from performance. **13 PAINTER,** 1995. Video, mixed media. Installation view of stage set. The Museum of Modern Art, New York, 1995.

ALLAN McCOLLUM

1944 born in Los Angeles (CA) / lives and works in New York (NY), U

"I like creating a display that could be any number of different kinds of display, so you start recognizing that all incidences of display share some kinds of characteristics, of meanings." « J'aime créer des ‹ displays › qui pourraient représenter n'importe quel nombre de displays différents, de sorte qu'on reconnaît que tous les modes de display ont des caractéristiques et des significations communes. »

Allan McCollum's objects possess all the essential defining characteristics of the traditional work of art. They are originals, signed by the artist, which exhibit a consistent style. And yet his series "Surrogate Paintings", 1987–1991, "Perfect Vehicles", 1985/86, or "Individual Works", 1987/88, give the impression of industrial mass production. All the individual pieces in a series differ only in minor distinctions of colour, size and composition – a feature that can be appreciated only when they are presented in groups. Through the reduction of individual qualities McCollum's "surrogates" attain the function of universal signs for pictures ("Surrogate Paintings" and "Plaster Surrogates", 1982), photographs ("Glossies", 1980), drawings ("Drawings", 1988–1991) and sculptures ("Perfect Vehicles"). They are "perfect" objects onto which the viewer can project his expectations of art, but he may perhaps be disappointed by the absence of the customary artistic "added value" – expressivene transcendence, content etc. This hardly seems to threaten the value c art as a means of social distinction, as McCollum shows with subtle humour in "Surrogates on Location", 1981/82. These photographs fro (TV) films and magazines show artworks as the marks of a social cla to which most artists do not belong. To back inflationary abundance rather than exclusivity can only signify a criticism of what is, from this point of view, alienated artistic work. McCollum's recent groups, "The Dog from Pompeii", 1990, or "Lost Objects", 1991, differ from the earlier ones in their reference to natural history. But the attempt to preserve the past in collections is carried to absurdity here through the serial principle: the rare relic of antiquity is endlessly repeated in countless ranks and rows.

Les œuvres d'Allan McCollum possèdent toutes les principaux signes distinctifs de l'œuvre d'art traditionnelle : originaux signés par l'artiste, on peut y reconnaître une écriture artistique récurrente. Mais les séries des « Surrogate Paintings », 1987–1991, des « Perfect Vehicles », 1985/86, ou des « Individual Works », 1987/88, suscitent le sentiment de productions de masse réalisées industriellement. Ainsi les pièces d'une même série ne se distinguent plus que par d'infimes différences de teinte, de taille, de forme. Du fait de la réduction des caractéristiques individuelles, les « Surrogates » de McCollum deviennent des signes universels du tableau (« Surrogate Paintings » et « Plaster Surrogates », à partir de 1982), de la photo (« Glossies », 1980), du dessin (« Drawings », 1988–1991) et de la sculpture (« Perfect Vehicles »). Ils se présentent comme de « parfaites » surfaces de projection pour des spectateurs dont les attentes se voient éventuellement déçues par l'art, car toute « valeur ajoutée » artistique convenue – expressivité, transcendan contenu etc… – y fait défaut. Ceci ne semble cependant menacer que de manière très limitée la valeur de l'art en tant que moyen de distinction sociale, comme l'expose McCollum avec un humour subtil dans « Surrogates on Location », 1981/82 : dans ces « stills », photos de filr (télévisés) et de revues, les œuvres d'art sont présentées comme les signes distinctifs d'une classe sociale à laquelle la plupart des artistes n'appartiennent pas. Miser sur une profusion inflationniste plutôt que s l'exclusivité devient alors aussi une critique d'un travail artistique détour dans ce sens. Les travaux plus récents de McCollum, « The Dog from Pompeii », 1990, ou « Lost Objects », 1991, se différencient de l'œuvre antérieur par des références à l'histoire naturelle. Une fois encore, la tentative de conserver le passé dans des collections est poussée à l'absurde, l'objet rare étant répété dans d'innombrables séries. A.

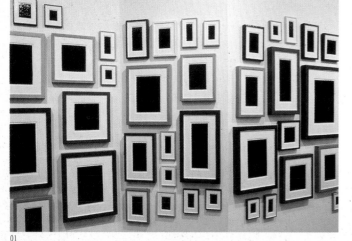

01

02

PLASTER SURROGATES, 1982–1984 (detail). Enamel on solid-cast hydrostone. Installation view, Cash/Newhouse Gallery, New York (NY), USA, 1985.
PERFECT VEHICLES, 1988. MoorGlo on cast concrete. Installation view, Aperto 88, XLIII Esposizione Internationale d'Arte, la Biennale di Venezia,
e, Italy, 1988. 03 NATURAL COPIES FROM THE COAL MINES OF CENTRAL UTAH, 1995. Enamel on polymer-reinforced gypsum. Installation view,
Weber Gallery, New York (NY), USA, 1995. 04 OVER 10,000 INDIVIDUAL WORKS, 1987/88. Enamel on solid-cast hydrocal. Installation view,
elijk Van Abbemuseum, Eindhoven, The Netherlands, 1989.

ALLAN McCOLLUM

SELECTED EXHIBITIONS: *1989* Biennial Exhibition, Whitney Museum of American Art, New York (NY), USA /// "Individual Works, Perpetual Photos", Kunstverein für die Rheinlande Westfalen, Düsseldorf, Germany /// *1990* Serpentine Gallery, London, England /// *1995–1996* "Allan McCollum: Natural Copies", Sprengel Museum Hannover, Hanover, Germany /// *1998* M d'Art Moderne du Nord, Villeneuve d'Ascq, France **SELECTED BIBLIOGRAPHY:** *1989 Allan McCollum*, Stedelijk Van Abbemuseum, Eindhoven, The Netherlands /// *Individual W Perpetual Photos*, Kunstverein für die Rheinlande und Westfalen, Düsseldorf /// *1990 Allan McCollum*, Serpentine Gallery, London /// *1995–1996 Allan McCollum: Natural Copies*, Sprengel Mus Hannover, Hanover /// *1996 Allan McCollum*, Los Angeles (CA), USA /// *1998 Allan McCollum*, Musée d'Art Moderne du Nord, Villeneuve d'Ascq

05 LOST OBJECTS, 1991. Enamel on cast concrete. Installation view, "Carnegie International", Carnegie Museum of Art, Pittsburgh (PA), USA, 1991.
06 DRAWINGS, 1988–1991. Artist's pencil on museum board. Installation view, Centre d'Art Contemporain, Geneva, Switzerland, 1993.

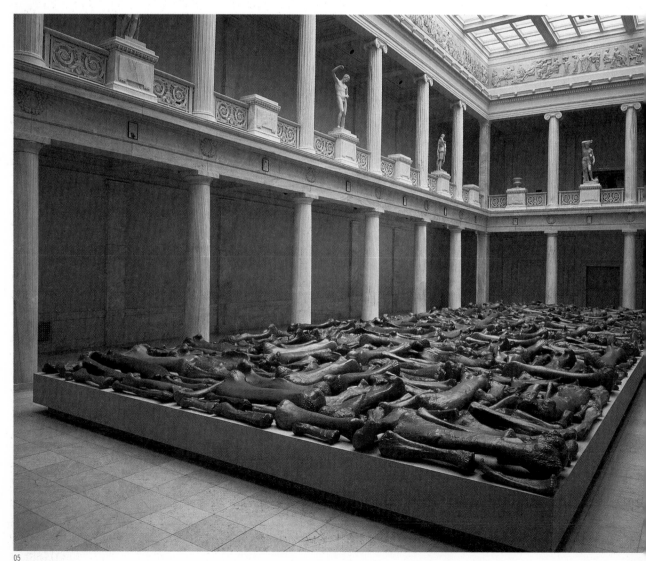

GERHARD MERZ

1947 born in Mammendorf/Munich; lives and works in Berlin, Germany, and Pescia, I

"Putting up with futility is what it's about. Beauty is dumb and void, it's the illusion of a burnt-out classicism." **« Il s'agit d'endurer l'absence de sens. Le beau est muet et vide, c'est l'idée d'un ‹ classicisme brûlé ›. »**

Gerhard Merz started off by drawing free-hand lines, millimetre by millimetre, from one side of the white canvas to the other. Subsequently, he began to produce single-colour pictures in car paint. More mono-chrome picture surfaces followed, inscribed with brief captions like "I love my time", 1982, or with logos and symbols such as the Olympic Games rings. Then came canvases of Saint Sebastian, architectural motifs, nudes and still lifes. The works of the mid-1980s, mounted in massive frames of wood or metal, were hung on coloured walls at each exhibition as though they provided the only possible solution for that particular room. Gradually, it became clear that for Gerhard Merz, who has now followed his own uncompromising path for almost thirty years, there is only one standard that counts – the highest. In the last ten years he has devoted

himself single-mindedly to a combination of art and architecture. In thi the emphasis is not on the purpose, or even the relative importance art or architecture, but on the solution provided by the totality of both His most consistent "archipittura", as he calls his combinations of pain and architecture, was made in 1997 for the German pavilion at the Ver Biennale. He constructed the largest possible block for the inner room surrounded by nothing but white plastered walls and two strips of neo light running along the whole length of the room at a height of ten metre This work functionalised the pavilion to the maximum extent, creating total divorce between the showy exterior and its interior, which had ne appeared so pure and clean.

NTITLED, 1992. Bench, concrete, 48 x 1160 x 60 cm; special steel rod, 300 x 10 x 10 cm, wall painting (cadmium black) on wall, dimensions variable. Installation "Archipittura", Los Angeles County Museum of Art, Los Angeles (CA), USA, 1992. 02 UNTITLED, BERLIN, 1996. Pigment (cadmium orange) on canvas, 360 x 720 cm; ded rods (steel), 360 x 1050 cm. Installation view, Galerie Max Hetzler, Berlin, Germany, 1996.

Gerhard Merz a commencé par tirer des lignes à main levée, milli-tre par millimètre, d'un bord à l'autre de la toile blanche. Il a ensuite é des tableaux ne comportant qu'un unique ton de couleur peint au nis automobile. Sont ensuite apparus les tableaux aux surfaces mono-omes sur lesquelles on pouvait lire de brefs énoncés comme « I love time », 1982, ou qui portaient des pictogrammes et des symboles s que les anneaux olympiques. Puis il y a eu les toiles montrant saint bastien, puis des motifs architecturaux, des nus et des natures mor-. Sur des murs de couleur, les œuvres pourvues d'imposants cadres bois ou de métal étaient mises en scène pour chaque exposition mme s'il s'agissait de l'unique solution valable pour un espace donné. ut ceci se passait au plus fort des années 80, et peu à peu, on s'a-rçut très clairement que pour Gerhard Merz, qui poursuit son itinéraire uis bientôt trente ans sans le moindre compromis, il n'existe qu'une

seule revendication : la plus haute. Au cours des dix dernières années, cette démarche a conduit de manière très ciblée à un lien entre l'art et l'architecture. La question primordiale n'est pas seulement celle de l'uti-lité ni même celle de la part de l'art ou de l'architecture, mais unique-ment la réponse par la forme de l'ensemble. La plus cohérente de ses « Archipittura » – nom que Merz donne à sa combinaison entre art et architecture – est à ce jour sa réalisation de 1997 pour le pavillon alle-mand de la Biennale de Venise. Merz y a construit le plus grand parallé-lépipède rectangle possible dans le volume intérieur, dans lequel il n'y avait dès lors plus rien que deux murs enduits et deux bandes de néon à dix mètres de hauteur sur toute la longueur de la salle. Cette vision représentait l'objectivation maximale du pavillon allemand, dont le pom-peux extérieur n'avait plus rien à voir avec l'intérieur. Jamais on ne l'avait vu de manière plus claire ni plus belle.

C. B.

GERHARD MERZ

SELECTED EXHIBITIONS: *1987* documenta 8, Kassel, Germany /// *1992* "Archipittura", Los Angeles County Museum of Art, Los Angeles (CA), USA /// Deichtorhallen Hamburg, Hamb[ur]g, Germany /// documenta IX, Kassel /// *1997* XLVII Esposizione Internationale d'Arte, la Biennale di Venezia, Venice, Italy, German Pavilion (with Katharina Sieverding) /// *1998* Helmhaus Zür[ich], Zurich, Switzerland **SELECTED BIBLIOGRAPHY:** *1987 Gerhard Merz*, Staatliche Kunsthalle Baden-Baden, Baden-Baden, Germany /// *1988 Gerhard Merz, Inferno MCMLXXX*, Staatsgalerie moderner Kunst, Munich, Germany /// *1990 Den Menschen der Zukunft – Gerhard Merz*, Kunstverein Hannover, Hanover, Germany /// *1995 Gerhard Merz – Berlin*, Kunst-Werke Be[rlin], Berlin, Germany /// *1997 Gerhard Merz – Biennale Venedig 1997*, Zurich; Munich/New York (NY), USA

03 LUSTGARTEN, 1994. Table, matt-grey, varnished, 85 x 240 x 60 cm; model, 9 x 126 x 60 cm; monochrome on canvas, 200 x 200 cm.
04 POTSDAMER PLATZ, BERLIN, AUGUST MCMXCVI, 1996. Sculpture in light.

TRACEY MOFFATT

1960 born in Brisbane, Australia / lives and works in Sydn
Australia, and New York (NY), U

"Images: colour, light, surface, composition, design; subject matter being secondary." « **Les images : couleur, lumière, structure, composition, dessin, le sujet y étant secondaire.** »

The half-aboriginal film-maker and photographer Tracey Moffatt was adopted by a white family as a baby, and grew up in an Australian workers' settlement. Her knowledge of visual culture was derived from television. Soap operas, talk shows, American films and sports programmes contributed in equal measure to her view of the world, as did her sense of being an outsider in her own family. Both experiences find expression in her art. Highly poetic, almost surreal moments together with banal clichés and political statements constitute an exciting mix. For instance, in her early short film "Night Cries: A Rural Tragedy" of 1989, Moffatt uses theatrically stylised images to tell the story of a coloured daughter looking after her dying adoptive mother, while torn this way and that between feelings of affection and rage. The assimilation of the ab-

origines and education according to white values is handled here with t devices of Hollywood mother-daughter melodramas. But the artist also uses avant-garde techniques in the film, such as the constant shifting narrative levels and an almost photo-realistic focus. "Night Cries" is th as consciously "torn apart" as the artist's multicultural identity. It is th simultaneity of poetic atmosphere, artificial composition and political controversy that lends Moffatt's later photo series their power. In "Gua (Goodlooking)", 1995, she shows female roller-skaters participating in special kind of race, the point of which is to knock one's opponents o of the contest. Crude violence, seemingly weightless motion and the reversed cliché of the weaker sex combine to form a dramatic allege that is not intended to be open to straightforward interpretation.

Doll Birth, 1972 His mother caught him giving birth to a doll.
He was banned from playing with the boy
next door again.

Birth Certificate, 1962 During the fight, her mother threw her birth certificate at her.
This is how she found out her real father's name.

Tracey Moffatt

Tracey Moffatt

SCARRED FOR LIFE, 1994. From left to right: **DOLL BIRTH**, ...2; **BIRTH CERTIFICATE,** 1962; **JOB HUNT,** 1976; **UNLESS,** 1974. ...es of 9 offset prints, 80 x 60 cm (each). **02 GUAPA (GOOD-** ...KING) 1,** 1995 (left); **GUAPA (GOODLOOKING) 6,** 1995 (right). ...0 x 110 cm (each).

02

La cinéaste et photographe Tracey Moffatt, une aborigène métis-
...e, a été adoptée par une famille blanche et a grandi dans une cité
...vrière australienne. C'est surtout par la télévision qu'elle s'est familia-
...ée avec la culture (de l'image) : les soap operas, les talkshows, les
...ns américains et les émissions de sport ont marqué l'image du monde
...Tracey Moffatt, de même que son existence d'«étrangère» au sein
...«sa» famille. Ces deux expériences se retrouvent dans son art, où
...éléments poétiques, presque surréalistes, les clichés sentimentaux
...kitsch et les prises de position politiques forment un mélange passion-
...nt. Il en est de même de son premier court métrage : «Night Cries : A
...ral Tragedy», 1989. Avec des images théâtrales et stylisées, Tracey
...offatt raconte l'histoire d'une fille de couleur déchirée entre des senti-
...nts de colère et de tendresse, et qui prend soin de sa mère adoptive
...urante. L'assimilation des aborigènes, leur éducation selon les valeurs

des blancs y sont illustrées dans les termes du mélodrame hollywoodien
de la relation mère-fille. Mais l'artiste s'est également servie d'éléments
avant-gardistes tels que la constante alternance entre les positions
narrative et photo-réaliste. «Night Cries» est un film aussi déchiré que
l'identité multiculturelle de l'artiste. La simultanéité de l'atmosphère
poétique, la composition artificielle et la pertinence politique donnent
aussi toute leur force aux séries photographiques ultérieures. Dans
«Guapa (Goodlooking)», 1995, l'artiste nous montre des patineuses par-
ticipant à une course de rollers d'un genre très particulier, le jeu consis-
tant à évincer les concurrentes de la compétition. La violence brute, les
mouvements apparemment dénués de pesanteur et le contre-cliché du
«sexe faible» s'agencent en une métaphore dramatique qui se soustrait
délibérément à toute interprétation univoque. R. S.

Tracey Moffatt

Job Hunt, 1976

After three weeks he still couldn't find a job.
His mother said to him, 'maybe you're not good enough'.

Tracey Moffatt

Useless, 1974

Her father's nickname for her was 'useless'.

TRACEY MOFFATT

SELECTED EXHIBITIONS: *1997* Dia Center for the Arts, New York (NY), USA /// XLVII Esposizione Internationale d'Arte, la Biennale di Venezia, Venice, Italy /// *1998* Kunsthalle Wien, Vienna, Austria /// Fundació "La Caixa", Barcelona, Spain /// "Foto-Triennale Esslingen", Esslingen/N., Germany **SELECTED BIBLIOGRAPHY:** *1990 Twenty Contemporary Australian Photographers*, National Gallery of Victoria, Melbourne, Australia /// *1992 Tracey Moffatt – Framed*, Centre for Contemporary Arts, Glasgow, Scotland /// *1998 Free Falling*, Dia Center for the Arts, New York /// *Echolot*, Museum Fridericianum, Kassel, Germany /// *Tracey Moffatt*, Kunsthalle Wien, Vienna; Vorarlberger Kunstverein, Bregenz, Austria; Württembergischer Kunstverein, Stuttgart, Germany

03

MARIKO MORI

"My work is a revelation of thought. Also, I enjoy projecting the esoteric gesture through the inner world." **« Mon travail est une révélation de la pensée. J'éprouve un grand plaisir à projeter l'attitude ésotérique à travers le monde intérieur. »**

In the mid-1990s, Mariko Mori landed on the art scene like a seductive being from a world yet to come. She appears in her photographs dressed like a futuristic comic-book figure who refuses to be anywhere but in the appropriate surroundings. She celebrates herself as an art product, as a star born out of the worlds of both music and fashion, who well knows that stardom is usually of short duration. After the performance shoots, her costumes are sealed in large Plexiglass capsules that will remain unopened for at least 25 years. Mori's works are becoming increasingly extravagant: first they developed into pictures with several layers that gave the impression of movement, then they became video played out to insistent music, and finally a 3-D film has emerged. Most recently she has stylised herself from her star act to a kind of supernatural being surrounded by little flying Buddhas. She cleverly succeeds in mixing visions of fashion and architecture in the style of the 1960s and 70s with the technical perfection of the 90s. Her message is the necessity of believing in utopias, conveyed in works that are neither ironic nor naïve but try to indicate in an optimistic and interesting way that it is pointless to attempt to stop time. The overall impression of fun is inescapable.

ST DEPARTURE, 1996. Cibachrome print, aluminium, wood, smoke aluminium, 18 x 30 x 8 cm.
PTY DREAM, 1995. Cibachrome print, aluminium, wood, smoke aluminium; 6 panels, 2.7 x 7.2 m
(each). 03 ENTROPY OF LOVE, 1996. Glass with photo interlayer; 5 panels, 305 x 610 x 2 cm;
panel, 305 x 122 x 2 cm.

Au milieu des années 90, Mariko Mori atterrissait dans la scène
tique tel un être séduisant venu d'un monde encore à venir. Ses pho-
la montrent elle-même, vêtue comme une figure de bande dessinée
riste, qui n'apparaît d'ailleurs normalement que dans l'environnement
ui correspond. Elle se célèbre comme un produit artistique, comme
star qui pourrait être issue tout aussi bien de la musique que de la
de, et qui n'ignore nullement que l'existence d'une star est générale-
t de courte durée. Après les prises de vues de ses performances,
costumes sont scellés dans de grandes capsules en plexiglas qui ne
ront être ouvertes que dans 25 ans au plus tôt. Les œuvres récentes
Mariko Mori ont été de plus en plus fastueuses : les photos sont

devenues des images en plusieurs strates, elles semblent bouger ; on
a ensuite vu apparaître des vidéos avec une musique entêtante et pour
finir un film en 3D. Du rôle de star, elle s'est stylisée dernièrement en
une sorte d'être surnaturel entouré de petits bouddhas volants. Mariko
Mori sait associer de manière très habile les visions de la mode et de
l'architecture dans le style des années 60 et 70 et la perfection techni-
que des années 90. Son message est la nécessité de croire à des uto-
pies. Les œuvres ne sont ni ironiques, ni naïves ; par une atmosphère
aussi optimiste qu'intéressante, elles tentent d'indiquer qu'il est vain de
vouloir arrêter le cours du temps. Il est impossible de ne pas percevoir
que cela pourrait même être divertissant.

C. B.

MARIKO MORI

SELECTED EXHIBITIONS: *1996* "MADE IN JAPAN", Deitch Projects, New York (NY), USA /// *1997* XLVII Esposizione Internationale d'Arte, la Biennale di Venezia, Venice, Italy, The Internatio Pavilion and The Nordic Pavilion /// "Ein Stück vom Himmel – Some Kind of Heaven", Kunsthalle Nürnberg, Nuremberg, Germany; South London Gallery, London, England /// *1998–1999* Muse of Contemporary Art, Chicago (IL), USA; Serpentine Gallery, London; Kunstmuseum Wolfsburg, Wolfsburg, Germany **SELECTED BIBLIOGRAPHY:** *1995* MADE IN JAPAN, Shiseido Gal Tokyo, Japan /// *1996* MARIKO MORI, Le Magasin – Centre National d'Art Contemporain, Grenoble, France /// *1997* Concentrations 30: Mariko Mori, Play with Me, Dallas Museum of Art, Dallas (USA /// *Ein Stück vom Himmel – Some Kind of Heaven*, Kunsthalle Nürnberg, Nuremberg /// *Lust und Leere: Japanische Photographie der Gegenwart (The Desire and the Void: Art & Photogra in Japan)*, Kunsthalle Wien, Vienna, Austria /// *1998 Mariko Mori*, Museum of Contemporary Art, Chicago /// *1999 Esoteric Cosmos*, Kunstmuseum Wolfsburg, Wolfsburg; Stuttgart, German

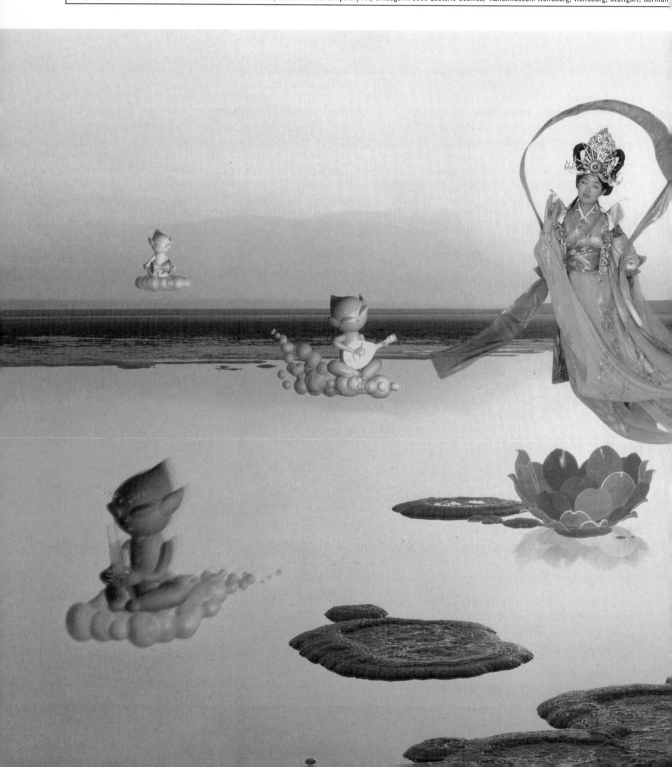

04 PURE LAND, 1996—1998. Glass with photo interlayer; 5 panels, 305 x 610 x 2 cm; 1 panel, 305 x 122 x 2 cm.

04

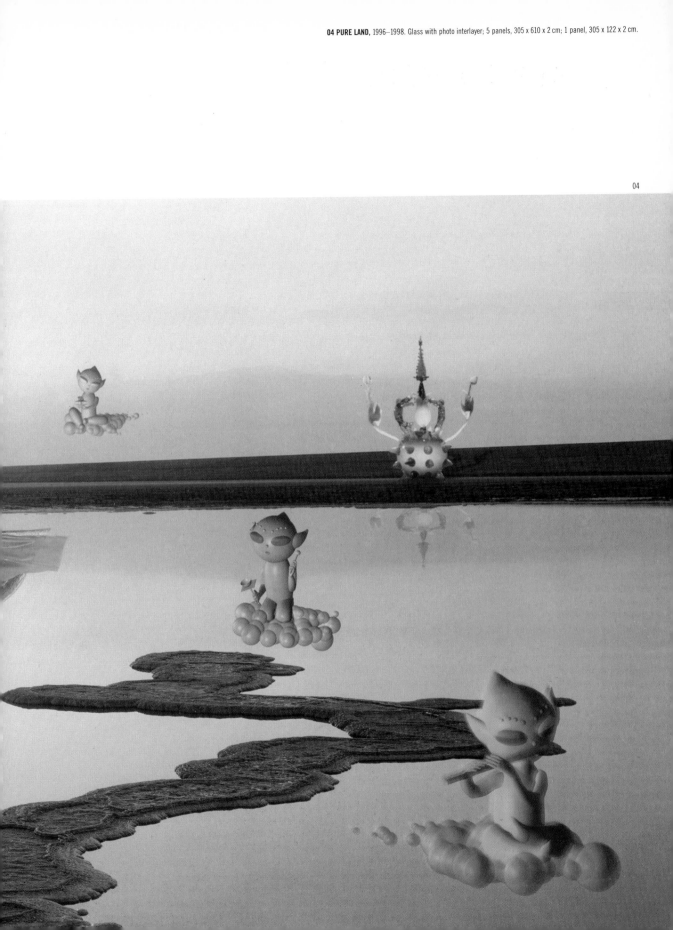

MATT MULLICAN

1951 born in Santa Monica (CA) / lives and works in New York (NY), US

« La réalité est subjective. Tout est personnel. Tout est filtré de ma propre histoire vers ma propre psychologie. »

Matt Mullican's work has its origins in the 1970s, when a sensibility towards perception, the body and the environment was dominant in art. From these beginnings, it is exciting to trace Mullican's highly individual development, which soon led from the representation of basic experiences to that of the signs and symbols purveyed by the media. The concentrated, signal-like meaning of everyday pictograms, flags, direction signs and diagrams is the central element in his handling of their geometrical or figural schemata and colours, which convey verbal or nonverbal messages. His concept has broadened from the analysis of the meaning of signs to an investigation of their spatial dimensions, initially through projects for public spaces that set down the symbols Mullican invented down amid the reality of real urban signs. This idea was developed in a more targeted way in his "City Project", elaborated over

several years, which outlined virtual urban areas by means of drawings, walk-through installations, and videos. Master plans for cities from classical to modern times emerge. Here too, he is concerned with schematic forms, simple patterns and clearly realisable designs and symbols, which convey a certain power that sometimes relates to the past, sometimes to the present. Mullican uses old-fashioned concepts of the world and the heavens: "cosmology", "universe" and "symbol", illustrated with drawings, slide projections and documents, and becoming multifaceted images of the imagination, utopian ideals that move between the ages. The artificial simulations which Mullican now generates on computer, are also imbued with the melancholy realisation of the loss of faith in an all-embracing order.

Le début de l'œuvre de Mullican remonte aux années 70, lorsque dominait la sensibilisation de la perception, du corps et de l'environnement. Il est passionnant de suivre le parcours individuel de Mullican depuis ces débuts, parcours qui, des premières expériences, mène bientôt aux expériences des signes et des symboles communiquées par les médias. Le contenu concentré, signalétique, des pictogrammes quotidiens, drapeaux, panneaux de signalisation ou diagrammes, constitue le noyau central de sa confrontation avec leurs couleurs et leurs schémas géométriques ou figuratifs, codes de messages verbaux ou non. Partant de l'analyse des signes, le concept de Mullican allait s'étendre à des dimensions spatiales, d'abord avec des projets destinés à l'espace public, projets qui plaçaient les signets inventés par Mullican dans la réalité même des signes urbains, puis de façon plus ciblée avec un projet conçu sur

plusieurs années, le « City Project », qui thématise des espaces urbains virtuels à travers des dessins, des installations ouvertes et des vidéos. Les maîtres-plans pour des villes allant de l'Antiquité à l'époque moderne apparaissent alors. Ici encore, il s'agit de formes schématiques, de motifs simples et de projets clairs et compréhensibles ayant un contenu symbolique. Il en émane, il est vrai, une grande puissance, qui semble passée pour une part, mais d'autre part aussi totalement présente. Mullican parle de « cosmologie », d'« univers » et de « symbole ». Illustré par des dessins, des projections de diapositives et des documents, ces anciens concepts voyagent entre les différentes époques, toutes les simulations que Mullican peut aujourd'hui réaliser par ordinateur étant empreintes de la nostalgie de la foi – perdue – en un ordre universel.

S.

01 UNTITLED, 1986. Computer generated image. Optomistic Studios, Los Angeles (CA), USA.
02 UNTITLED, 1995. Nylon Banners. Neue Nationalgalerie, Berlin, Germany, 1995. **03 UNTITLED,** 1986. Nylon Banners. Installation view, Bahnhof Alexanderplatz, Berlin, 1995.

MATT MULLICAN

SELECTED EXHIBITIONS: *1994* Wiener Secession, Vienna, Austria /// Kunstverein in Hamburg, Hamburg, Germany /// *1995* Neue Nationalgalerie, Berlin, Germany /// IVAM, Centre d Carme, Valencia, Spain /// *1997* Stedelijk Van Abbemuseum, Eindhoven, The Netherlands (with Lawrence Weiner) /// documenta X, Kassel, Germany /// *2000* Oxford Museum of Modern A Oxford, England /// Fundaçao de Serralves, Oporto, Portugal **SELECTED BIBLIOGRAPHY:** *1990* Matt Mullican: The MIT Project, MIT-List Visual Arts Center, Cambridge (MA), USA *1993* Matt Mullican World Frame, University of South Florida Contemporary Art Museum, Tampa (FL), USA /// *Matt Mullican Works 1972–1992*, Cologne, Germany /// *1995* Matt Mullican, IVAL Centre del Carme, Valencia /// *1997* Matt Mullican in der Neuen Nationalgalerie Berlin, Berliner Künstlerprogramm DAAD, Berlin

04 INSTALLATION VIEW, 1994. Mixed media. Wiener Secession, Vienna, Austria, 19
05 UNTITLED (THE NOMADIC PAVILION), 1993. Mixed media. Installation view, Kunstmuseum Luzern, Lucerne, Switzerland, 19

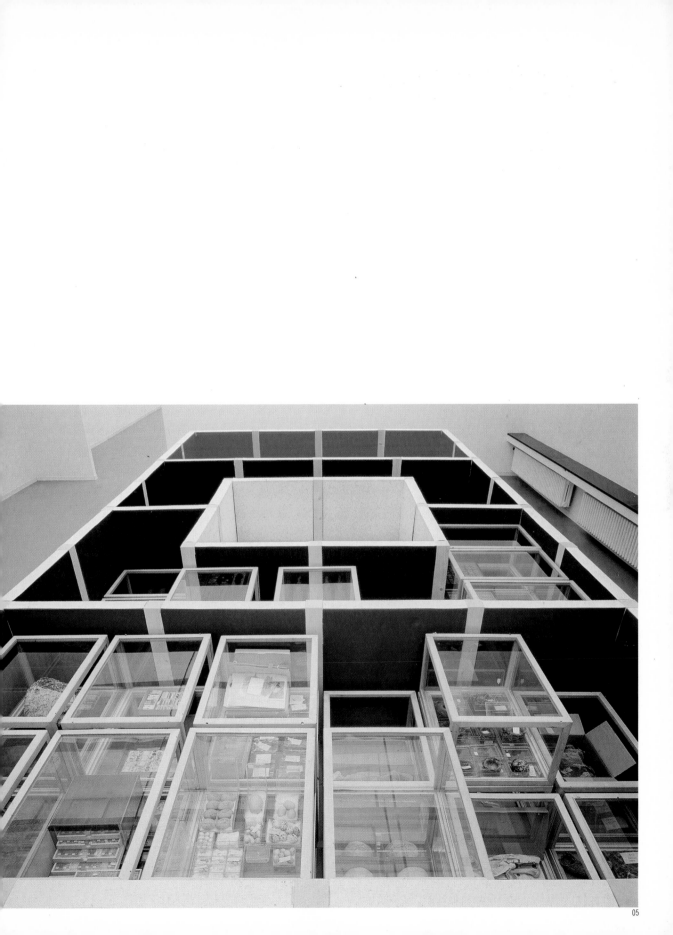

CADY NOLAND

1956 born in Washington, D.C. / lives and works in New York (NY), US

"I'm interested in the difference and similarities between blank identity and iconography as well as anonymity and fame." **« Je suis intéressée par la différence et les similitude** **entre identité nue et iconographie, de même qu'entre anonymat et célébrité. »**

Cady Noland works three-dimensionally and spatially with ready-made objects and photos from the mass media. Her works make the point that these representations have taken the place of historical images from the past. The ideals and symbols of the American Dream are dumped together on heaps of sundry detritus: the US flag, basketball baskets, car tyres and neon advertising signs. To these are added control mechanisms, which may again include flags and portraits of politicians, but also barriers, bars, chains, handcuffs, pistols and instruments of torture. Noland's configurations are deliberately hard, martial, metallic and cold. This is the case even when the pioneering idyll of the early settlers is alluded to, as in the blockhouse with flags of "Log Cabin", 1990. She

offers concrete signs recalling media events and personalities of rece American history, for instance the trauma of the Nixon era ("Sham Deat 1993/94); the media tycoon William Randolph Hearst and the exposure of his granddaughter Patty Hearst as a terrorist ("Press Czar", "Patty Hunting", "SLA Group Shot"); the idols of American society – such as Jackie Kennedy; and its anti-idols – the Kennedy assassin Lee Harvey Oswald or the mass killer Charles Manson. Noland's work brings togeth national pride, everyday reality and the media. Today's sensationalist media, a kind of extension of American vaudeville farce, now write and record history, not the matrixes of yesteryear.

UR AMERICAN COUSIN, 1989. Poles, barbecue, walkers, bed frame, license plates, hamburger
, beer cans, car bumper, car parts, bungee cords, tow strap, misc., metal, 108 x 254 x 254 cm.
ORRAL GATES (foreground). Aluminium pipe, bullets and horse equipment. Installation view,
ria Massimo de Carlo, Milan, Italy, 1989. **03 INSTALLATION VIEW.** Scaffolding, beer cans, car parts,
et. Mattress Factory, Pittsburgh (PA), USA, 1989.

Cady Noland travaille en trois dimensions, spatialement, avec
s objets ready-mades et des photos issues des médias ; et dans ses
vres, on peut voir que ce type de représentations a remplacé les
leaux d'histoire du passé. Les idéaux et les réalités de l'« american
am » se retrouvent sur des amoncellements de décors et de reliquats :
peau américain, paniers de basket, pneus de voitures, canettes de
re, enseignes de néon et portraits de politiciens auxquels s'ajoutent
« organes de contrôle », eux-mêmes pourvus de drapeaux ou de por-
ts de politiciens, mais aussi de grilles et de tiges, de chaînes et de
nottes, de pistolets et d'instruments de torture. Les constellations de
and sont dures à l'extrême, martiales, métalliques et froides, même
sque l'artiste suggère l'idylle d'un camp de pionniers (blockhaus avec
peaux, « Log Cabin », 1990). Elles sont concrètes aussi, elles rappel-

lent les événements médiatiques de l'histoire américaine récente comme
le traumatisme de l'ère Nixon (« Sham Death », 1993/94), l'empereur des
médias William R. Hearst et l'apparition de sa petite-fille Patty Hearst
comme terroriste (« Press Czar », « Patty Hunting », « SLA Group Shot ») ;
elles rappellent les idoles de la société américaine (épouses de prési-
dents comme Jackie Kennedy) et leurs antihéros (l'assassin de Kennedy,
Lee Harvey Oswald, le tueur en série Charles Manson). L'œuvre de
Noland est une scène où sont confrontées la fierté nationale et la réalité
quotidienne et médiatique. Les attractions du théâtre de vaudeville
américain d'antan ont été les précurseurs des sensations médiatiques
d'aujourd'hui. Et ce sont précisément ces dernières – et non plus les
tableaux d'histoire d'autrefois – qui écrivent et décrivent l'histoire. S. T.

CADY NOLAND

SELECTED EXHIBITIONS: *1992* documena IX, Kassel, Germany /// *1994* Paula Cooper Gallery, New York (NY), USA /// *1998* "Scratches on the Surface", Museum Boijmans Van Beuninge Rotterdam, The Netherlands /// "Unfinished History", Walker Art Center, Minneapolis (MN), USA /// *1999* Migros Museum für Gegenwartskunst Zürich, Zurich, Switzerland /// *2000* "Over th Edges", Ghent, Belgium **SELECTED BIBLIOGRAPHY:** *1992 Post Human*, Musée d'Art Contemporain, Pully/Lausanne, Switzerland /// *1993 Live in Your Head*, Hochschule für Angewand Kunst in Wien, Vienna, Austria /// *1995 Temporary Translation(s): Sammlung Schürmann*, Deichtorhallen Hamburg, Hamburg, Germany /// *Public Information: Desire, Disaster, Document*, Sa Francisco Museum of Modern Art, San Francisco (CA), USA /// *1996 Exhibition brochure*, Hartford (CT), USA

04 THE POSTER PEOPLE, 1994. B/w ink on aluminium, 170 x 177 x 17 cm. **05 PUBLYCK SCULPTURE,** 1993/94. Aluminium over wood, chains, white wall tires and steel plates, 300 x 480 x 76 cm. **06** On platform: **GIBBET (WITH FLAG).** Aluminium stocks and stools. **YOUR FUCKING FACE.** Right wall: **TOWNE SQUARE.** Panel with brick pattern. Installation view, Paula Cooper Gallery, New York (NY), USA, 1994.

ALBERT OEHLEN

1954 born in Krefeld, Germany / lives and works in Hamburg and Cologne, Germa[ny]

Developing in the area of tension between figurative and abstract art, Albert Oehlen's work and is subject to continual change. In his paintings, collages and drawings he demystifies art, rendering his artistic methodology transparent. His painting is the expression of his thoughts on art as a medium, a criticism of its veneration and an analysis of its artistic and social capabilities. This was already true of his early figurative works, which in the 1980s were identified as belonging to the "New Wild Painting", and of the following cycle "Farbenlehre" (Colour Theory), in which he reduced his palette to the three primary colours: red, yellow and blue. This limitation of subjective colour selection finds its counterpart in Oehlen's deliberate renunciation of any moral or artistic evaluation of his themes and subjects, whether he is dealing with a portrait of

Adolf Hitler, representations of animals, or portrayals of everyday situations. In his works made between 1985 and 1988 he put texts in hist-icised script opposite figurative objects and people, thus creating an additional level of content. Often, the smudged and glazed patches of colour that dominated his abstract pictures in the late 1980s appear in the background of these works. In the early 1990s, Oehlen began to u[se] a computer-painting programme. By this means he not only extends hi[s] formal repertoire but also offers additional comments on the theme of artistic authorship. This also applies to his current coloured computer collages, which are similar in character to his early provocative and iro[nic] oil paintings.

L'œuvre d'Albert Oehlen est soumise à une permanente transformation et se développe dans le rapport de tensions entre les représentations abstraite et figurative. Dans ses tableaux, collages et dessins, Albert Oehlen démystifie l'art et rend sa démarche transparente. Sa peinture est à la fois expression d'une réflexion sur le médium, critique de son prestige et analyse de ses possibilités (artistiques, sociales). Ceci vaut déjà pour ses premières œuvres figuratives, classées dans la mouvance des « Nouveaux sauvages » dans les années 80, de même que pour le cycle suivant, la « Théorie des couleurs », dans lequel il réduisait sa palette aux couleurs primaires rouge, jaune, bleu. Cette réduction à un choix de couleurs subjectif se retrouve dans l'utilisation corollaire de différents motifs : portrait de Hitler, représentations animalières et situations quotidiennes. Oehlen renonce en cela consciemment à tout juge-

ment de valeur moral ou artistique du motif. Entre 1985 et 1988, il fai[t] cohabiter dans ses tableaux des textes de style historisant et des obje[ts] et figures représentés sur un mode figuratif, produisant ainsi un niveau sémantique supplémentaire. Souvent on voit déjà surgir à l'arrière-plan de ses tableaux ces surfaces de couleur brouillées et appliquées au glacis qui marquent ses travaux abstraits de la fin des années 80. Au début des années 90, Oehlen crée ses premières œuvres pour lesque[l]les il se sert d'un logiciel de peinture. Il développe ainsi son répertoire formel et offre des facettes supplémentaires au thème de la paternité artistique. Ceci s'applique d'une façon similaire aux collages chromatiques qu'il réalise aujourd'hui par ordinateur et qui possèdent un carac[tère] tère d'interpellation comparable à celui de ses premières œuvres prov[o]cantes, ironiques, réalisées à l'huile. Y.

01

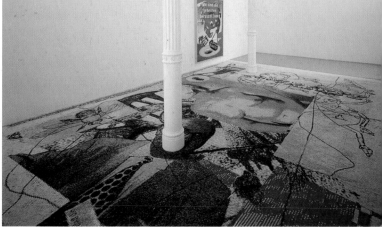

02

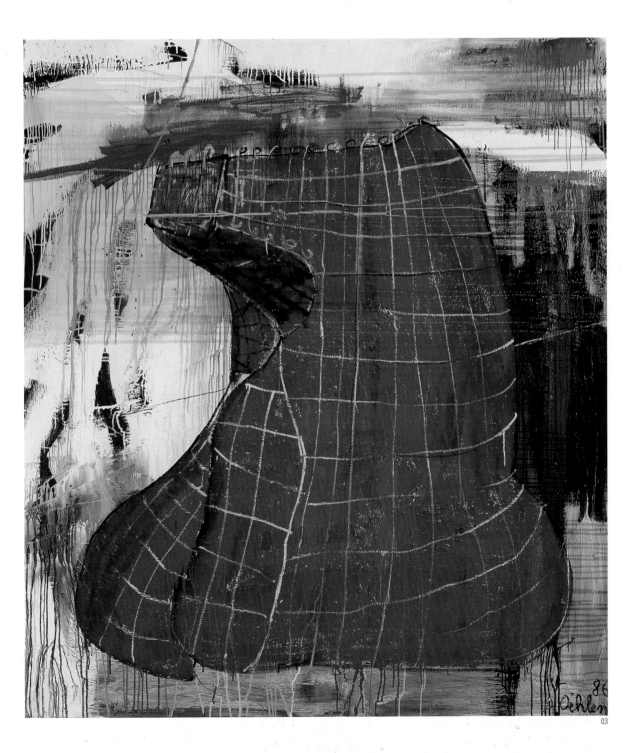

PLAKAT, 1998. Ink Jet Plot, 186 x 151 cm (framed). **02 LORDS,** 1997. Mosaic on floor, 587 x 849 cm. **03 VERGITTERT,** 1986. Oil, gloss on canvas, 180 x 160 cm.

ALBERT OEHLEN

SELECTED EXHIBITIONS: *1994* Villa Arson, Nice, France /// "Malerei", Deichtorhallen Hamburg, Hamburg, Germany /// *1995* "Recent Paintings", The Renaissance Society at t█ University of Chicago, Chicago (IL), USA /// *1996* IVAM, Centre del Carme, Valencia, Spain /// *1997* Kunsthalle Basel, Basle, Switzerland /// *1998* Galerie Max Hetzler, Berlin, Germany (with Geo█ Herold) /// INIT Kunst-Halle Berlin, Berlin **SELECTED BIBLIOGRAPHY:** *1987 Der Übel*, Grazer Kunstverein, Graz, Austria /// *1995 Albert Oehlen*, Cologne, Germany /// *Malerei*, Deichtorhalle█ Hamburg, Hamburg /// *1996 Albert Oehlen*, IVAM, Centre del Carme, Valencia /// *1997 Albert Oehlen – Albert vs. History*, Kunsthalle Basel, Basle

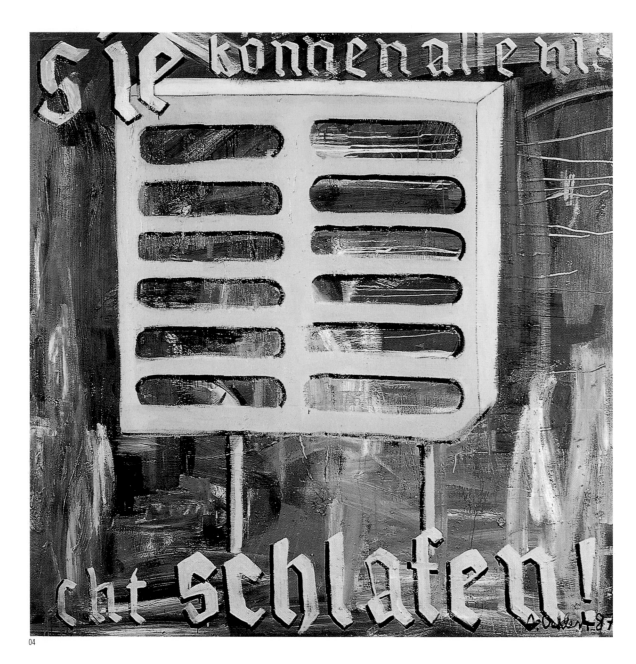

04

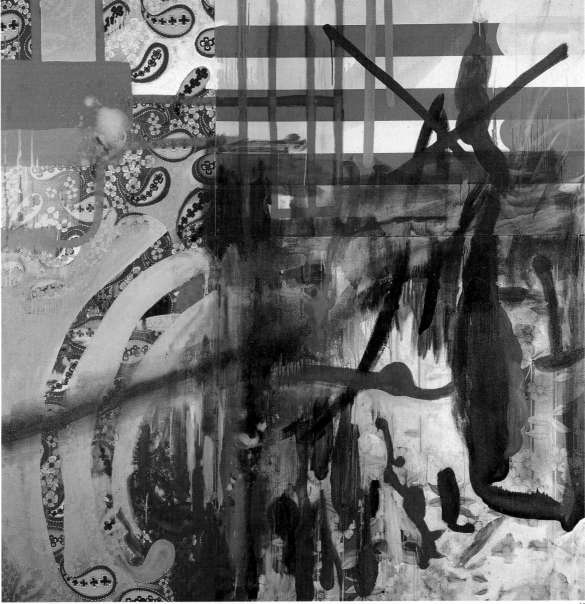

GABRIEL OROZCO

1962 born in Jalapa, Veracruz, Mexico / lives and works in Mexico and New York (NY), US

"First of all I'm a recipient and second I'm a producer. Sculpture is that, a recipient." **« Je suis d'abord un ‹ récepteur › et ensuite un producteur. La sculpture, c'est ça : un réceptacle. »**

Gabriel Orozco is a precise and yet poetic recorder of the fleeting and the mundane. His installations, objects and photographs emphasise, in an unpretentious and yet precise way, moments of displacement and the disappearance of space and time. In this way, he "delocalises" his sculptures, as it were, and yet casts a permanent spell over them. Probably his best-known work is "La D.S.", 1993, in which he cut a Citroen lengthwise and put it back together again after removing the centre third of the car. This "slimming cure" lends the Citroen an unexpectedly streamlined shape. But although the car is certainly more elegant in appearance, instead of becoming faster it is dysfunctional. This work is a witty comment both on art and on our faith in technological progress. Reducing the interior of his "Elevator", 1994, likewise prevents motion in an otherwise unaltered readymade. Move-

ment and space are also the two coordinates for Orozco's project "Unt You Find Another Yellow Schwalbe", 1995. During a long stay in Berlin the artist drove through the city on a yellow Schwalbe motor scooter. Whenever he saw another "Yellow Schwalbe" beside the road, he stood his own alongside it and photographed the pair, so that stasis and dynamics enter into a site-specific dialogue. Other photo works are also concerned with this relationship. For example, his "Leaves on Car", 199 shows autumn leaves on a car's windscreen, evoking the lapidary every day lyricism of nature and technology, movement and transience. In his as yet unrealised project "Ferris Wheel, Half Sunk in the Ground", 199 we should be able to experience the "shadowy underworld" and "heaven heights" in just one revolution of the Ferris Wheel in an infinite "Divine Comedy".

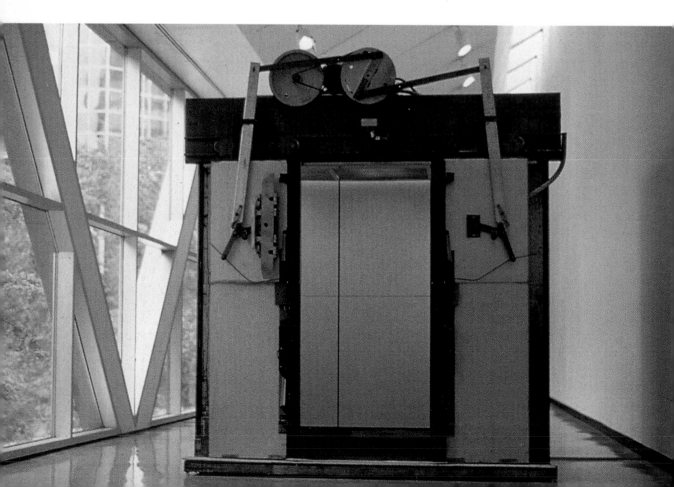

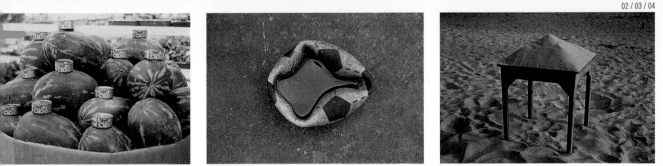

ELEVATOR, 1994. Altered elevator cabin, 240 x 240 x 150 cm. **02 CATS AND WATERMELONS,** 1992. C-print, 55 x 70 cm. **03 PINCHED BALL,** 1993.
achrome, 55 x 70 cm. **04 SAND ON TABLE,** 1992. Cibachrome, 55 x 70 cm. **05 LA D. S.,** 1993. Sutured car: metal, leather, coated fabric, 140 x 480 x 114 cm.

Gabriel Orozco est un observateur précis et poétique de l'éphé-
re et du quotidien. Ses installations, objets et photographies souli-
ent sans prétention, mais avec vigueur, le moment du décalage et de
disparition de l'espace et du temps. Orozco «délocalise» en quelque
rte ses sculptures, les investissant ainsi d'un charme durable. Son
uvre la plus célèbre est sa «D.S.», 1993, coupée dans le sens de la
gueur et reconstituée après suppression du tiers médian. Cette «cure
maigrissement» confère à la voiture une fluidité inattendue. Mais si
e est plus élégante à regarder, au lieu d'être plus rapide, elle se trouve
sormais dépossédée de sa fonction – commentaire ironique de l'art et
la croyance au progrès technologique. D'une façon similaire, la réduc-
n de l'espace intérieur empêche tout mouvement dans «Elevator»,
74, un ready-made autrement inchangé. Le mouvement et l'espace
nt également les deux coordonnées du projet d'Orozco «Until You

Find Another Yellow Schwalbe», 1995). Lors d'un séjour prolongé à
Berlin, l'artiste s'est promené dans la ville avec un scooter jaune de la
marque «Schwalbe». Lorsqu'il apercevait un autre «Schwalbe» jaune, il
plaçait le sien à côté et prenait les deux jumeaux en photo. Statique et
dynamique entretiennent un dialogue lié au lieu. Les autres œuvres pho-
tographiques de l'artiste illustrent également ce lien, comme c'est le cas
de «Leaves on Car», 1992: avec un lyrisme très lapidaire du quotidien,
des feuilles d'automne sur un pare-brise parlent de la nature et de la
technique, du mouvement et de l'impermanence. Dans le projet non
réalisé à ce jour «Grande Roue de foire à moitié enfouie dans le sol»,
1997, on pourrait faire l'expérience du «monde des enfers» et des
«hauteurs célestes» en un seul tour de roue – une éternelle «divine
comédie» (Dante). R. S.

05

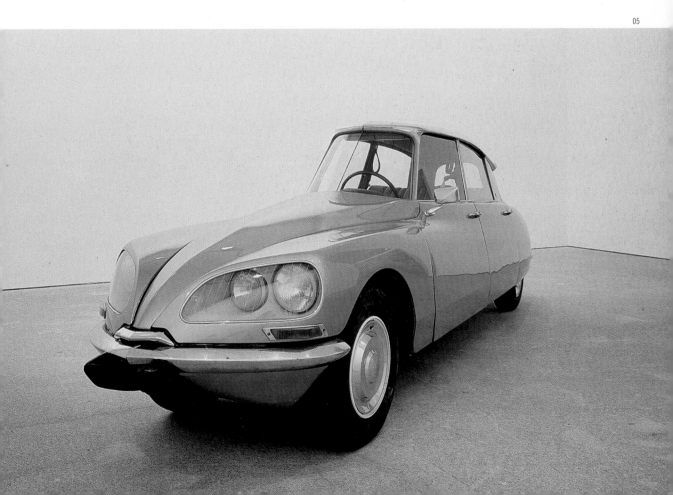

GABRIEL OROZCO

SELECTED EXHIBITIONS: *1993* "Projects 41: Gabriel Orozco", The Museum of Modern Art, New York (NY), USA /// *1996* Kunsthalle Zürich, Zurich, Switzerland /// "The Empty Club", A Angel Project, London, England /// documenta X, Kassel, Germany /// *1998* Musée d'Art Moderne de la Ville de Paris, Paris, France **SELECTED BIBLIOGRAPHY:** *1993* The Kanaal A Foundation, Kortrijk, Belgium /// *1996 Exhibition catalogue*, Kunsthalle Zürich, Zurich; Institute of Contemporary Arts, London; daadgalerie, Berlin, Germany /// *1998 The Empty Club*, Art Ange London /// *Clinton is Innocent*, Musée d'Art Moderne de la Ville de Paris, Paris

OVAL BILLIARD TABLE, 1996. Wood, slate, mixed media, 89 x 309 x 229 cm. **07 HAMMOCK AT MOMA GARDEN,** 1993.
pachrome, 33 x 86 cm. **08 EXTENSION OF REFLECTION,** 1992. C-print, 55 x 70 cm.

07

08

TONY OURSLER

"... people are most attracted to the face." « ... c'est toujours le visage qui attire le plus les gens. »

Tony Oursler's figures sometimes have a hard time of it. They are squashed under sofas, chair legs and mattresses, shut up in suitcases and trunks, sometimes hang head-first from the ceiling, or are even speared, lamenting their suffering in semi-darkness. They are made of fabric, but they seem to be alive. Little video projectors give them a living face, and from loudspeakers there sounds an even more insistent voice that complains, calls out for help or simply gives a death rattle. Since 1992 Oursler has in this way been combining features of the theatrical stage so cleverly with those of video art that this has become his unmistakable trademark. It is as though monitors and canvas had suddenly assumed bodily form. Oursler's figures swiftly became the darlings of the public. In a completely different part of his operations he has been very active in working with the Internet. In a recent series the projector's beam impinges on large fibreglass spheres and simply shows an eye looking from side to side. Should the viewer at first believe that he might be the object of attention, it becomes clear as he comes nearer that in reality a television programme is being followed. The monitor is reflected as a small blurred picture in the eyeball, and this corresponds to the movements of the pupil. Without knowing exactly what it is all about, one feels fear and excitement. But actually the person to whom the eye belongs could feel bored. In this way Oursler demonstrates the mechanisms of the media and at the same time exposes our belief in them.

Les personnages de Tony Oursler ont parfois une rude existence. Coincés sous des sofas, des pieds de chaises ou des matelas, enfermés dans des valises ou des malles, mais aussi accrochés tête en bas au plafond, voire empalés, ils geignent dans la pénombre. Ils sont en tissu, mais semblent vivre. De petits projecteurs vidéo leur confèrent un visage vivant et des hauts parleurs émettent une voix plus vivante et insistante encore, voix qui accuse, qui appelle au secours ou se limite à un simple râle. Depuis 1992, Oursler combine ainsi des moments de théâtre avec ceux de la vidéo, et il le fait de manière si habile que cet aspect est devenu son signe distinctif. C'est comme si des moniteurs et des toiles s'étaient soudain incarnés. Très vite, les figures d'Oursler qui, dans un autre domaine de son travail, a aussi travaillé de manière intensive avec le médium Internet, sont devenues les chouchous du public. Dans une série plus récente, le projecteur est dardé sur de grandes boules de fibre de verre et ne montre qu'un seul œil roulant de droite et de gauche. Si dans un premier temps le spectateur pense encore que c'est peut-être lui qu'on observe, en s'approchant, il s'aperçoit que ce que regarde l'œil est en fait un programme de télévision. Un téléviseur se reflète comme une image floue dans le globe oculaire, les mouvements de la pupille réagissent aux événements diffusés. Sans savoir exactement de quoi il retourne, on a l'impression de déceler de la peur et de l'excitation. Mais en fait, le propriétaire de cet œil pourrait tout aussi bien s'ennuyer. Oursler met ainsi à nu les mécanismes des médias et démasque notre croyance en eux.

C. B.

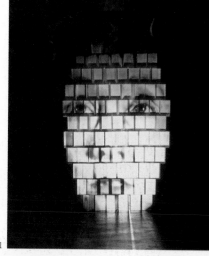

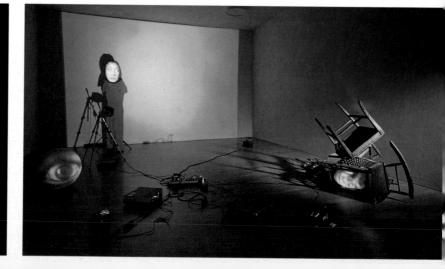

370/371: **01 DIGITAL 3,** 1998. Projector, VCR, videotape, 128 plexiglass cases, 228 x 163 x 15 cm. Performance: Constance DeJong. Installation view, Kunst-Hannover, Hanover, Germany, 1998. **02 CRIMINAL EYE; SKETCHY BLUE; BROKEN.** Video, mixed media, dimensions variable. Installation view, "Matthew Barney – ursler – Jeff Wall", Sammlung Goetz, Munich, Germany, 1996/97. **03 SUBMERGED,** 1996. Projector, VCR, videotape, tripod, wood, plexiglass, ceramic, water, 8 x 28 cm (plus equipment). Performance: Tracy Leipold. Pages 372/373: **04 INSTALLATION VIEW,** Metro Pictures, New York (NY), USA, 1996.

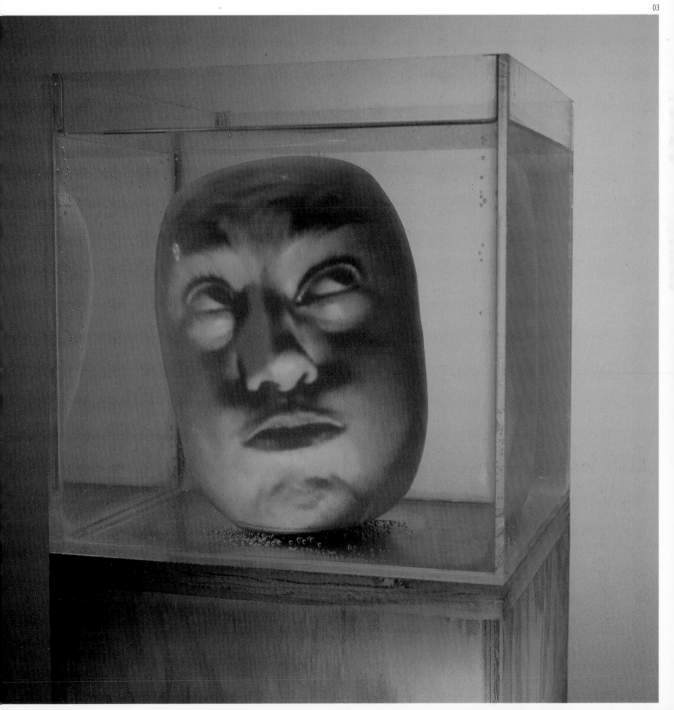

TONY OURSLER

SELECTED EXHIBITIONS: *1982* Walker Art Center, Minneapolis (MN), USA /// *1986* "Spheres of Influence", Musée national d'art moderne, Centre Georges Pompidou, Paris, France // *1989* Museum Folkwang Essen, Essen, Germany /// *1992* documenta IX, Kassel, Germany /// *1995* Wiener Secession, Vienna, Austria **SELECTED BIBLIOGRAPHY:** *1986 Spheres of Influence*, Musée national d'art moderne, Centre Georges Pompidou, Paris /// *1989 Exhibition catalogue*, Museum Folkwang Essen, Essen /// *1993 White Trash and Phobic*, Centre d'Art Contemporain, Geneva, Switzerland /// *Dummies, Dolls, and Poison Candy*, Ikon Gallery, Birmingham; Bluecoat Gallery, Liverpool, England /// *1998 Exhibition catalogue*, Kunstverein Hannover, Hanover, Germany

JORGE PARDO

1963 born in Havana, Cuba / lives and works in Los Angeles (CA), USA

"There is a lot of more interesting stuff around here than my work, but my work is a model to look at this stuff." « Il y a bien des choses plus inté-ressantes que mon œuvre, mais mes œuvres sont un modèle pour regarder ces choses. »

In many of his works Jorge Pardo makes explicit reference to the material situation of an exhibition. We can therefore see his landing-stage "Pier" of 1997 in Münster both as a sculpture in its own right and as an allusion to the tradition over many years of observing the locality of the exhibition. Another example of dealing with the exhibition venue is his design of the exterior façade and the office furniture of the gallery in Berlin that represents him. With other works of Pardo's, too, the utilitarian aspect is in dialogue with genuine artistic enquiry. His lamps, with which he occasionally harks back to the design of the early seventies, his seatings and other items of furniture, facilitate an easy approach to the work through their smooth surfaces, organic forms and evocative colours. At the same time Pardo uses his furniture objects to illustrate the distinc-tion between art and design. Pardo designs most of these objects him-self, but in some installations he integrates well-known "design classics". The meaning of the supposedly familiar is altered through new associ-ations, and different possibilities are offered to the viewer for his inter-pretation. His most ambitious project is his own house, which was built in connection with his exhibition organised by the Museum of Contemporary Art in Los Angeles and which for the duration of the exhibition served the museum as an annexe. It was at one and the same time a private dwelling, an exhibition venue and an exhibit. Pardo is interested in the institutional problems connected with this, and also in fundamentally investigating the characteristics of exhibition situations.

Nombreuses sont les œuvres de Jorge Pardo qui font explicite-ment référence à la situation concrète de l'exposition. Ainsi, on peut interpréter son embarcadère exposé à Münster, 1997, tant comme une sculpture autonome que comme un renvoi à la longue tradition et au parti pris de contextualité de l'exposition décennale « Skulptur. Projekte in Münster » (« Sculpture. Projets à Münster »). Un autre exemple de confrontation avec le site d'exposition est la décoration de la façade extérieure et des meubles du bureau de la galerie qui le représente à Berlin. D'autres œuvres encore marquent un dialogue entre leur caractère utilitaire et des interrogations proprement artistiques. Les lampes pour lesquelles Pardo s'appuie en partie sur le design du début des années 70, les fauteuils et autres objets d'aménagement intérieur avec leur sur-face lisse, leurs formes organiques et leurs couleurs suggestives, facili-tent l'accès direct à l'œuvre. En même temps, Pardo thématise avec ses meubles-objets la différence entre l'art et le design. La plupart de ces objets sont dessinés par Pardo lui-même ; dans certaines installations, il intègre en revanche des « classiques » célèbres du design. Le sens de certains objets prétendument familiers est modifié par de nouvelles mises en contexte, et le spectateur se voit proposer différentes possibilités de réception. Le projet le plus ambitieux de Pardo est sa propre maison, qui a vu le jour dans le cadre de l'exposition organisée par le Museum of Contemporary Art à Los Angeles, et qui sert de dépendance au musée pour la durée de l'exposition. Il s'agit tout à la fois d'un espace d'habita-tion privé, d'un lieu et d'un objet d'exposition. Pardo s'intéresse ici à des problèmes institutionnels ainsi qu'à l'analyse fondamentale des facteurs qui caractérisent les situations d'exposition. Y. [

01 UNTITLED, 1997. Skulptur. Projekte in Münster 1997, Münster, Germany, 1997.
02 INSTALLATION VIEW, Neue Messe Leipzig, Leipzig, Germany, 1996 (permanent installation).

JORGE PARDO

SELECTED EXHIBITIONS: *1993* "Backstage", Kunstverein in Hamburg, Hamburg, Germany /// *1997* "Lighthouse", Museum Boijmans Van Beuningen, Rotterdam, The Netherlands /// Skulptur. Projekte in Münster 1997, Münster, Germany /// *1998* Le Consortium, Dijon, France /// The Museum of Contemporary Art, Los Angeles (CA), USA **SELECTED BIBLIOGRAPHY:** *199...* *Exhibition catalogue*, Person's Weekend Museum, Tokyo, Japan /// *1997 Jorge Pardo,* The Museum of Contemporary Art, Los Angeles; Museum of Contemporary Art, Chicago (IL), USA

03 **LEESZAAL/READING ROOM,** 1997. Installation view, "Lighthouse", Museum Boijmans Van Beuningen, Rotterdam, The Netherlands, 1997. **04 UNTITLED,** 1997. Sailboat. Installation view, Museum of Contemporary Art, Chicago (IL), USA, 1997. **05 "LIGHTHOUSE",** installation view, Museum Boijmans Van Beuningen, Rotterdam, 1997. **06 INSTALLATION VIEW,** neugerriemschneider, Berlin, Germany, 1996.

03

04

05

goethestr.73.10625 berlin.tel.fax.312 08 60.di-sa 11.00-18.00 uhr

PHILIPPE PARRENO

1964 born in Oran, Algeria / lives and works in Paris, Franc

Philippe Parreno's art primarily explores the territory between fiction and reality. Images familiar from television or the cinema, such as the town-sign of "Twin Peaks" or the balloon from "Batman", crop up in his exhibitions. In one piece, the characteristic rasping voice of the film director Jean-Luc Godard makes the assertion that a Christmas tree is a work of art: "For 11 months, I was right ... this Christmas tree was a work of art for eleven months, and in the twelfth month it was no longer art, it was Christmas." In "Listen to the Picture", 1998, Parreno masked the upper and lower edges of a Taiwanese-language film in black so that only a broad middle section remained visible. The film is thus seen anew, several scenes moreover being accompanied by subtitles. Whether these subtitles correspond to what is happening in the film or reflect a subjective assessment, remains open. The film is also being constan interrupted by a fictitious advertising spot promoting a Walkman-like apparatus called "Noise Man", which converts loud environmental noise into pleasant melodies. Parreno draws on already existing material, enriching it with his own, mostly narrative ideas. He gives the stories a ne setting, focusing our attention on particular aspects, and thus redescribe his own experiences as a recipient. This individual view is presented by Parreno on a highly intellectual and yet entertaining plane. The works ma seem skittish at first sight, but after a few moments one senses their profundity.

L'art de Philippe Parreno explore avant tout le champ entre la fiction et la réalité. Les images qu'on connaît de la télévision et du cinéma, le panneau de « Twin Peaks » ou le ballon de « Batman » par exemple, apparaissent soudain dans les expositions. Ou bien la voix grinçante, si caractéristique du réalisateur Jean-Luc Godard, parle de l'art et avance la thèse selon laquelle l'arbre de Noël serait une œuvre d'art : il aurait alors raison onze mois, cet arbre de Noël serait une œuvre d'art pendant onze mois, le douzième mois, il ne serait plus une œuvre d'art, ce serait Noël. Dans « Listen to the Picture », 1998, Parreno a occulté les bords supérieur et inférieur d'un film, de manière à ne plus montrer qu'une longue frange horizontale. Le film en langue taïwanaise apparaît alors sous un nouveau jour, certaines scènes étant en outre ponctuées par des sous-titres. La question de savoir si ces sous-titres correspondent bien au déroulement du film ou s'ils traduisent une impression subjective demeure entière. De plus, le film est sans cesse interrompu par un spo publicitaire fictif vantant les mérites du « Noise Man », un appareil apparenté au walkman et qui transforme les agressions phoniques de l'environnement en agréables mélodies. Parreno fait appel à un matériau existant et l'enrichit de ses idées personnelles, le plus souvent anecdotiques. Il remet en scène ces histoires, concentre le regard sur des aspects particuliers et se retrouve ainsi dans le rôle d'un spectateur décrivant les expériences de son rôle comme récepteur de l'art. Cette vision personnelle, Philippe Parreno l'associe à un niveau intellectuel à la fois élevé et divertissant, qui confère à ses œuvres un caractère au premier abord un peu ludique. Mais après quelques instants déjà, le spectateur perçoit leur profondeur. C. ‹

01 NO MORE REALITY (TWIN PEAKS), 1991. Acrylic on wood, two wooden posts, 180 x 250 x 320 (h) Installation view, "No Man's Time", Villa Arson, Nice, France, 1991. **02 NO MORE REALITY (BATMAN RETURN)**, 1993. Vinyl ball, acrylic lacquer, nylon thread, ø 300 cm. Installation view, "Le principe réalité", Villa Arson, Nice, 1993.

PHILIPPE PARRENO

SELECTED EXHIBITIONS: *1993* "Standards", Aperto 93, XLV Esposizione Internationale d'Arte, la Biennale di Venezia, Venice, Italy /// *1994* "La nuit des héros", Musée national d'a
moderne, Centre Georges Pompidou, Paris, France /// *1995* "Snow dancing", Le Consortium, Dijon, France /// "While ... ", Kunstverein in Hamburg, Hamburg, Germany /// *1998* Musée d'A
Moderne de la Ville de Paris, Paris **SELECTED BIBLIOGRAPHY:** *1991* L'amour de l'art, 1° Biennale de Lyon, Lyons, France /// *1993* Backstage, Kunstverein in Hamburg, Hamburg A
1995 Lost Paradise: Positionen der 90er Jahre, Stuttgart, Germany /// *1996* Traffic, capc Musée d'art contemporain, Bordeaux, France

03

04

05

NOW DANCING – DIJON 1997–1995, 1997. Handle of door (blown glass). Installation view, Air de Paris, Paris, France, 1997. 04 UNTITLED (JEAN-LUC GODARD), 1993.
...stmas tree, stools, receiver, tape, cassettes. Installation view, "Backstage", Kunstverein in Hamburg, Hamburg, Germany, 1993. 05 SPEECH BUBBLES, 1997. Mylar balloons
...helium. Installation view, Robert Prime, London, England, 1997. 06 WERKTISCHE I UND II (MADE ON THE 1ST OF MAY), 1995. 2 tables, ø 160 cm each, 8 teddy bears, video
...ctor, video cassette, screen. Installation view, "Traffic", capc Musée d'art contemporain, Bordeaux, France, 1996.

MANFRED PERNICE

1963 born in Hildesheim, Germany / lives and works in Berlin, Germa

"To start with, the three-dimensional object is, fortunately, there – but then, as a relative, puzzled-up location it dissolves in contradictions and disappears." « **Fort heureusement, la figure plastique est préexistante – comme un lieu relatif, énigmatique, elle se dissout dans ses contradictions pour disparaître.** »

Manfred Pernice builds places. The largest of them, like "Sardinien" (Sardinia), 1996, or "Platz" (Place), 1998, take up an entire exhibition room. Alongside these, he is constantly turning out little pocket-sized models that could be designs for other room-sized projects. The size of Pernice's places is irritating in both cases. However much they are bound by realistic details – the façade of a building complete with posters and hoardings, or the interior wall with wallpaper, picture frames and shelves, for example – they remain models, illusions. That is because Pernice twists familiar facts, makes interiors and exteriors mutually contradictory and distorts real-life scales and relationships. Pernice often refers to places he has seen, but always refashions them to his own ideas. In the case of "Sardinien", before the observer takes in the title reference to the holiday island, the illusion is communicated of an interior turned inside out, where wallpaper, picture frames and shelves are fixed to outer walls, to make what ends up to some extent like a highly tumoro form of architecture. Yet in his objects, Pernice succeeds in communica ing a profound insight into the nature of building, living and experiencin – in the crazy details and myths of modern living accommodation. The "Platz" that Pernice installed in a small gallery room in 1998 constitute his most comprehensive metaphor in this regard: it features a rough plywood sheet and four boarded stumps of columns, whose perforate structures appear to sum up basic questions about constructional engineering. Pernice's big idea is the portable place, or the place you can build or erect at home on your shelf. Each functions like a three-dimensional picture postcard of a virtual and yet very real world.

Manfred Pernice construit des lieux. Ses plus grandes réalisations dans ce domaine, par exemple « Sardaigne », 1996, et « Place », 1998, occupent toute une salle d'exposition. Parallèlement, Pernice réalise sans cesse de petites maquettes en format de « poche », qui pourraient être des études pour des projets de plus grande envergure. Dans les deux cas, la taille de ces lieux a de quoi irriter. Quelle que soit leur fidélité au détail réaliste – façade d'immeuble avec réclame et affiche publicitaire ou mur intérieur couvert de papier peint, avec cadre de tableau et console – ils demeurent illusoires et conservent leur caractère de maquette. Pernice récupère en effet à son profit des données familières, il joue sur la contradiction entre l'intérieur et l'extérieur, distord les échelles et les rapports de proportions. Pernice se réfère souvent à des lieux visités, mais il les reconstitue chaque fois à sa manière. Ainsi, avant d'être perçu comme une allusion à une île pour vacanciers, « Sardaigne » communique l'illusion d'un espace intérieur tourné vers l'extérieur. Et à l'endroit où de papiers peints, des cadres de tableaux et des consoles sont fixés contr un mur extérieur, l'œuvre devient une architecture en partie extrêmeme ampoulée. Par le biais de ses objets, Pernice parvient à nous communi quer une vision plus profonde de la construction, de l'habitat et de la réalité vécue – des détails les plus fous et des mythes véhiculés par l'habitat d'aujourd'hui. A cet égard, la « Place » installée en 1998 dans une petite galerie constituait la métaphore la plus ambitieuse : une pla que en aggloméré et quatre fûts de colonnes couverts de planches dor la structure trouée semble résumer des problèmes fondamentaux de la construction en hauteur comme en profondeur. Le concept de Pernice est le lieu qu'on peut emporter, construire ou monter dans sa bibliothèqu Chacun de ces lieux fonctionne comme la carte tridimensionnelle d'un monde virtuel et pourtant formidablement réel. S.

01

02
04
06

01 WEINBERG, 1997. Wood, laminated fibre sheet, paint, 110 x 270 x 295 cm. **02 UNTITLED,** 1996. Painted cardboard, 8 x 10 x 10 cm. **03 UNTITLED,** 1996. Painted cardboard, 12 x 16 x 10 cm. **04 UNTITLED,** 1997. Painted cardboard, 12 x 7 x 7 cm. **05 UNTITLED,** 1997. Painted cardboard, 12 x 12 x 7 cm. **06 UNTITLED,** 1996. Painted cardboard, 7 x 12 x 6 cm. **07 KORREKTURDOSE,** 1995. Painted cardboard, 7 x 7 x 12 cm.

MANFRED PERNICE

SELECTED EXHIBITIONS: *1997* 4° Biennale de Lyon, Lyons, France /// "Fiat", Künstlerhaus Stuttgart, Stuttgart, Germany /// "surprise II", Kunsthalle Nürnberg, Nuremberg, Germany *1998* Musée d'Art Moderne de la Ville de Paris, Paris, France /// "Platz", Galerie NEU, Berlin, Germany **SELECTED BIBLIOGRAPHY:** *1997 Fiat*, Städtisches Museum Zwickau, Zwick Germany /// *surprise II*, Kunsthalle Nürnberg, Nuremberg /// *Exhibition catalogue*, 4° Biennale de Lyon, Lyons /// *Unbuilt Roads*, *107 unrealized projects*, Stuttgart

08 SARDINIEN, 1996. Installation view, Galerie NEU/Art Forum Berlin, Berlin, Germany, 1996. **09 ONKEL,** 1997. Various kinds of wood, 80 x 40 x 28 cm. **10 AM BRUNN** 1996. Various kinds of wood, 350 x 160 x 30 cm. **11 PLATZ,** 1998. 70 x 45 x 45 cm; 53 x 45 x 45 cm; 390 x 90 cm. Installation view, Galerie NEU, Berlin, 1998.

09

11

DAN PETERMAN

"What interests me in recycled plastic is a certain quality of flow. In our society, plastic generally implies a way of thinking in which all things are disposable. And yet it features in the majority of our most highly prized possessions." **« Ce qui m'intéresse dans le plastique recyclé, c'est une certaine qualité de flux. Dans notre société, le plastique implique généralement un mode de pensée dans lequel toutes choses sont jetables. Et pourtant, il entre dans la plupart de nos propriétés les plus chères. »**

Dan Peterman's projects and sculptures – the latter technically oriented to Minimal Art – are an expression of the way he confronts problems of our post-industrial society, such as consumerism, affluence, ecological pollution and homelessness. For his seemingly interventionist work "Chicago Compost Shelter", 1988, Peterman had a scrapped VW minibus covered with biological waste. The warmth coming from the compost heats the interior of the vehicle, which can then be used in winter as a dwelling by a homeless person. Since the beginning of the 1990s Peterman has been making benches and tables from recycled plastic containers. These are constructed from standardised modules and can be combined at will in different forms. One of his works made using this method is "Running Table", 1997, which Peterman erected in a Chicago park. Not only does it provoke debate on themes such as "Art in Public Places", but it also functions as a social meeting place, raising questions about the social function of art. Whether Peterman constructs a wall from used batteries ("Spending Energy Storing Energy Spent", 1993); purchases the right – under an emission law passed in the USA in 1990 – to discharge a certain quantity of sulphur dioxide into the atmosphere ("Sulfur Cycle", 1994); or has a solar-powered car driven round a park threatened by the building of museum extension ("Run Unt Dead", 1998), his interest transcends the depredation of the environment. He is also concerned with the social consequences of intervention in the eco-system and their relationship to financial and symbolical values.

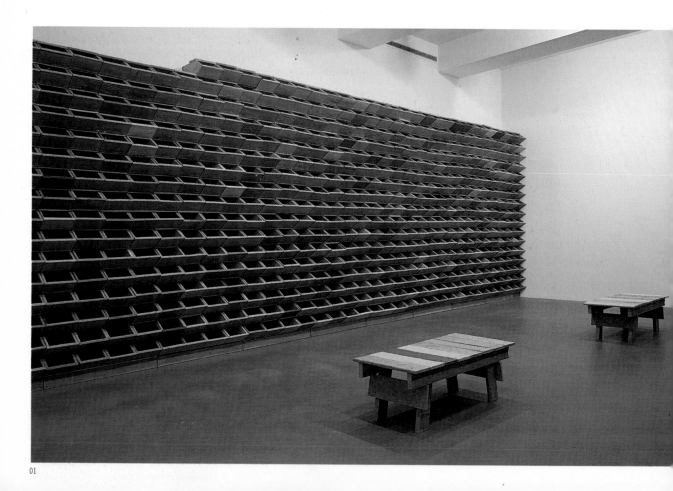

TON VERTICAL STORAGE, 1996. Vertical storage system of post-consumer, reprocessed
stic, zinc plated screws, dimensions variable. Installation view, Andrea Rosen Gallery,
York (NY), USA, 1996. **02 I–BEAM (BAR),** 1995. Reprocessed post-consumer plastics,
x 178 x 46 cm. **BLUEBAGWARE (CHICAGO),** 1996. Reformed Chicago recycling bags,
x 102 x 14 cm. Installation view, Feigen, Chicago (IL), USA, 1996. **03 BLUEBAGWARE
(CAGO),** 1996 (detail). Reformed Chicago recycling bags, 91 x 102 x 14 cm. Installation
v, Feigen, Chicago, 1996. **04 4 TON VERTICAL STORAGE,** 1996 (detail). Vertical storage
em of post-consumer, reprocessed plastic, zinc plated screws, dimensions variable.
allation view, Andrea Rosen Gallery, New York, 1996.

02 / 03

Dérivés du Minimal Art sur le plan formel, les projets et sculptu-
s de Dan Peterman sont l'expression de son travail sur des problèmes
la société postindustrielle tels que la consommation, la surabondance,
ollution de l'environnement et le dénuement. Pour son travail de ten-
nce interventionniste « Chicago Compost Shelter », 1988, Peterman
vait couvrir un minibus de déchets biologiques. La chaleur dégagée
r la fermentation du compost chauffant l'intérieur du véhicule, celui-ci
uvait servir de logis à des sans-abri. Depuis le début des années 90,
terman réalise ses bancs et ses tables composés de modules stan-
rdisés fabriqués à partir de récipients recyclés en plastique et pouvant
e combinés au gré des besoins. Un travail résultant du même principe,
unning Table », 1997, que Peterman a dressé dans un parc de Chicago,

ne suscite pas seulement une réflexion sur le thème « l'art dans l'espace
public », mais fonctionne aussi comme point de rencontre social et sou-
lève des questions sur le rôle de l'art dans la société. Au-delà du thème
de la pollution de l'environnement, qu'il construise un mur de piles élec-
triques usagées (« Spending Energy Storing Energy Spent », 1993), que
dans le cadre d'une loi sur les émissions polluantes votée en 1990 aux
Etats-Unis, il s'achète la possibilité de rejeter une quantité déterminée de
dioxyde de soufre dans l'espace aérien (« Sulfur Cycle », 1994), ou qu'il
fasse rouler une voiture fonctionnant à l'énergie solaire (« Run Until Dead »,
1998), dans un parc menacé par la construction d'une annexe à un musée,
Peterman est intéressé par les effets sociaux des interventions dans
l'écosystème et leur rapport aux valeurs financières et symboliques. Y. D.

DAN PETERMAN

SELECTED EXHIBITIONS: *1993* Aperto 93, XLV Espozione Internationale d'Arte, la Biennale di Venezia, Venice, Italy /// *1994–1995* "Options 48: Dan Peterman: 'Sulfur Cycle'", Museum Contemporary Art, Chicago (IL), USA /// *1997* "Running Table and Chicago Ground Cover", Grant Park, Chicago /// "Home Sweet Home", Deichtorhallen Hamburg, Hamburg, Germany /// *1998* "Current 73: Dan Peterman", The Saint Louis Art Museum, Saint Louis (MO), USA /// "Dan Peterman und Tobias Rehberger", Kunsthalle Basel, Basle, Switzerland **SELECTED BIBLIOGRAPH** *1994–1995 Options 48: Dan Peterman: "Sulfur Cycle",* Museum of Contemporary Art, Chicago /// *1998 Currents 73: Dan Peterman,* The Saint Louis Art Museum, Saint Louis /// *Dan Peterma* Kunsthalle Basel, Basle

05 PETERMAN BUSINESS MILES: OCTOBER 94 – PRESENT (MARCH 96) AND 1992, 1996. Conservation of carbon contained in wood as offset to automobile emissions, dimensions variable. Installation view, Feigen, Chicago (IL), USA, 1996. **06 ACCESSORIES TO AN EVENT,** 1996. Dimensions variable. Installation view, Galerie Helga Maria Klosterfelde, Hamburg, and Galerie Klosterfelde, Berlin, Germany, 1996.

RAYMOND PETTIBON

1957 born in Tucson (AZ) / lives and works in Hermosa Beach (CA), US

"I have never really thought of the possibility of people looking at my work expecting to find some ultimate meaning, because it's not what the intention is." « Je n'ai jamais vraiment envisagé la possibilité que les gens puissent regarder mon travail en pensant y trouver quelque sens ultime, parce que cela ne correspond pas à mon intention. »

Raymond Pettibon's illustrative ink drawings, videos, books and wall paintings are all presentations of a complex mentality and relation to reality. Neither the extensive ramifications of Pettibon's countless drawings nor the relationship between elements of text and picture within the individual works lend themselves to an unambiguously logical consideration. They are pinned to the wall close to one another and above one another, so that their presentation underlines the impression of fundamental inconclusiveness. Pettibon makes an arbitrary combination of writers like Henry James or Marcel Proust, also using his own texts with themes from everyday life on the American west coast, politics, the media, comics, film, the world of art and the hippie and punk movements of the late sixties and seventies. It is a fragmentary, freely associative and sometimes contradictory interpretation of reality. In particular, the videos of 1988/89, "Weathermen", "The Book of Manson", "Sir Drone" and "Citizen Tania" make pointed comments on the political concerns and conflicts of sub-culture movements. According to them, the utopia of the sixties ended in violence, as in Charles Manson's serial killings. These themes and figures also recur in Pettibon's sharply contrasted black and white drawings. Like other subjects – surfers, electric light bulbs, trains, phalluses, clouds etc. – these allusions also serve as literal material for an obsessive treatment of reality. This includes drastic shift of mood as well as black humour and a certain scepticism. For when a speech balloon in a drawing of 1991 announces the desire to integrate "poor little fragmentary ism" in a more comprehensive pictorial language this does not necessarily correspond to the artist's own intention. It is rather one of the many voices that find utterance in Pettibon's pictures.

Les dessins à l'encre de Chine illustratifs de Raymond Pettibon, ses vidéos et ses peintures murales sont les mises en scène complexes du rapport à la réalité et de la pensée. Les développements infinis des innombrables dessins de Pettibon, mais aussi le rapport entre les éléments textuels et iconiques à l'intérieur d'une même œuvre échappent à toute logique patente. Punaisés côte à côte au mur, leur présentation souligne le parti pris d'inachèvement. D'une manière très personnelle, Pettibon associe des citations littéraires – d'Henry James, de Marcel Proust ou de lui-même – avec les motifs quotidiens de la Côte Ouest tirés du monde politique, des médias, des bandes dessinées, du cinéma, du marché de l'art et des mouvements hippie et punk de la fin des années 60 et 70 : une interprétation fragmentaire, associative, procédant par sauts, parfois contradictoire, de la réalité. En particulier les vidéos de 1988/89 : « Weathermen », « The Book of Manson », « Sir Drone », et « Citizen Tania », sont un commentaire très ciblé des propos et des conflits politiques drainés par les évolutions de la subculture. Selon cette interprétation, les utopies des années 60 ont débouché sur la violence avec le tueur en série Charles Manson par exemple : thèmes et figures récurrentes des dessins en noir et blanc – le plus souvent durement contrastés – de Pettibon. Comme d'autres motifs – surfeurs, ampoules électriques, trains, phallus, nuages etc... –, ces références servent elle aussi de matériel littéraire pour un travail obsessionnel sur la réalité. Ce travail inclut des changements d'humeur drastiques autant qu'un humour noir et un certain scepticisme : dans un dessin, quand une bulle de bande dessinée affirme vouloir intégrer « son pauvre isme fragmentaire » dans un langage iconique plus vaste, ce type de déclaration ne traduit pas forcément le propos de Pettibon, elle n'est qu'une des nombreuses voix qui trouvent la parole dans ses tableaux. A.

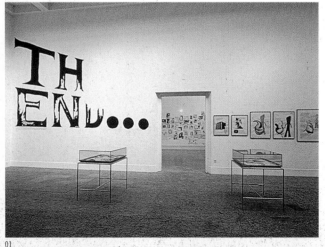

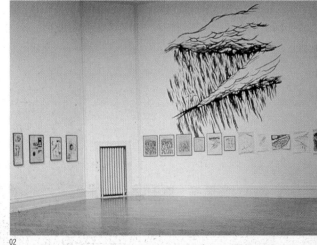

03

04

01 / 02 INSTALLATION VIEWS, Kunsthalle Bern, Berne, Switzerland, 1995. 03 NO TITLE (HUNG UP BY HIS), 1990. Pen and ink on paper, 28 x 22 cm. 04 NO TITLE (SHE SUDDENLY WANTED...), 1990. Pen and ink on paper, 44 x 29 cm. 05 INSTALLATION VIEW, Collection Volkmann, Berlin, Germany, 1998.

05

RAYMOND PETTIBON

SELECTED EXHIBITIONS: *1994* "Mapping", The Museum of Modern Art, New York (NY), USA /// *1995* Kunsthalle Bern, Berne, Switzerland /// *1997* "Sunshine & Noir: Art in LA 1960–1997 Louisiana Museum of Modern Art, Humlebæk, Denmark /// *1998–2000* The Renaissance Society at the University of Chicago, Chicago (IL), USA /// The Drawing Center, New York /// The Museu of Contemporary Art, Los Angeles (CA), USA **SELECTED BIBLIOGRAPHY:** *1995 Raymond Pettibon*, Kunsthalle Bern, Berne /// *It's Only Rock and Roll: Rock and Roll Currents in Contempora Art*, Munich, Germany /// *1997 Michael Craig-Martin und Raymond Pettibon, Wandzeichnungen*, Kunstverein für die Rheinlande und Westfalen, Düsseldorf, Germany /// *1998 Raymond Pettibon: Reader*, Philadelphia Museum of Art, Philadelphia (PA), USA /// *Raymond Pettibon: Thinking of You*, The Renaissance Society at the University of Chicago, Chicago

06

07

08

09

10

11

12

14

06 NO TITLE (EVEN THE MOON...), 1992. Ink on paper, 56 x 43 cm. **07 NO TITLE (O-GASM...)**, 1994. Ink on paper, 64 x 49 cm. **08 NO TITLE**, 1990. Ink on paper, 20 x 13 cm. **09 NO TITLE**, 1992. Ink on paper, 22 x 29 cm. **10 NO TITLE (BASKING IN THE...)**, 1990. Ink on paper, 57 x 76 cm. **11 NO TITLE (TO DO WHAT)**, 1995. Pen and ink on paper, 127 x 97 cm. **12 NO TITLE (WALT'S WORSE)**, 1985. Pen and ink on paper, 32 x 22 cm. **13 NO TITLE**, 1987. Ink, mixed media on paper, 36 x 28 cm. **14 NO TITLE (WHAT CROPPED UP)**, 1991. Pen and ink on paper, 39 x 29 cm.

ELIZABETH PEYTON

1965 born in Danbury (CT) / lives and works in New York (NY), US

"I always paint for myself." « Je peins toujours pour moi-même. »

In her drawings, watercolours and oil paintings Elizabeth Peyton combines aspects of popular culture with those of classical portraiture. On this point, she once stated that music magazines are just as important for understanding her work as, for instance, the writings of Marcel Proust. Her subjects have included pop singers, friends and acquaintances, and also historical personalities such as Napoleon Bonaparte or Ludwig II of Bavaria. Irrespective of the actual relationship between artist and model, all her portraits imply a high degree of intimacy. Her friends are represented in similarly introverted, often melancholy moods, as are the elegiacally portrayed figures of the pop world or certain protagonists from world history known for their eccentric behaviour. Peyton's sitters often have the aura of cult figures. This applies to the pictures of Kurt Cobain, who died in a tragic suicide, and also to those of Jarvis Cocker, the singer with the English group Pulp, and the Punk Rocker Sid Vicious. As a ru Peyton confines herself to small formats. She adds further emphasis to the private nature of her pictures by giving most of them only the su ject's first name as a title. Peyton stylises the members of the British royal family in the same androgynous and glamorous manner as the singers and actors she paints. Her traceable brush strokes and running patches of transparent paint suggest an intuitive technique, reinforcing the impression of immediacy and emotionality. She thus manages to pro vide her public personalities with the appearance of private persons, a to create the intimate, sensitive atmosphere that is so characteristic of her pictures.

Dans ses dessins, aquarelles et peintures à l'huile, Elizabeth Peyton allie des aspects de la culture populaire avec ceux de la représentation dans le portrait classique. C'est dans ce sens qu'elle a pu déclarer que les revues de musique étaient tout aussi importantes pour la compréhension de son travail que la littérature d'un Marcel Proust. Parmi les personnes qu'elle représente, on compte des chanteurs pop, des proches ou des connaissances, mais aussi des personnages célèbres tels que Napoléon ou Louis II de Bavière. Au mépris de la réalité, tous ses portraits comportent une forte charge d'intimité. Les amis de l'artiste sont représentés dans des atmosphères aussi introverties, souvent mélancoliques, que les figures du monde pop représentées sur un mode élégiaque, ou certains protagonistes de l'histoire du monde connus pour leur attitude particulièrement excentrique. Souvent les personnes représentées par Peyton ont l'aura d'une figure de culte. Ceci vaut aussi bien pour ses portraits de Kurt Cobain, mort tragiquement à la suite d'un suicide, que pour ceux de Jarvis Cocker, le chanteur du grou anglais Pulp, et du rocker punk Sid Vicious. En règle générale, Peyton limite aux petits formats et souligne le caractère privé de ses tableaux en ne leur donnant le plus souvent pour titre que le prénom de la personne représentée. Les membres de la maison royale d'Angleterre son stylisés d'une façon tout aussi androgyne et « glamour » que les chanteurs et les acteurs. Le tracé du pinceau, qu'on suit sans difficulté, ma aussi les fondus de couleurs transparentes, suggèrent une technique intuitive et renforcent le sentiment d'immédiateté et d'émotionnalité. Peyton parvient ainsi à doter des personnages officiels d'une apparenc de privauté et à générer l'atmosphère toute de sensibilité et d'intimité caractéristique de ses tableaux. Y.

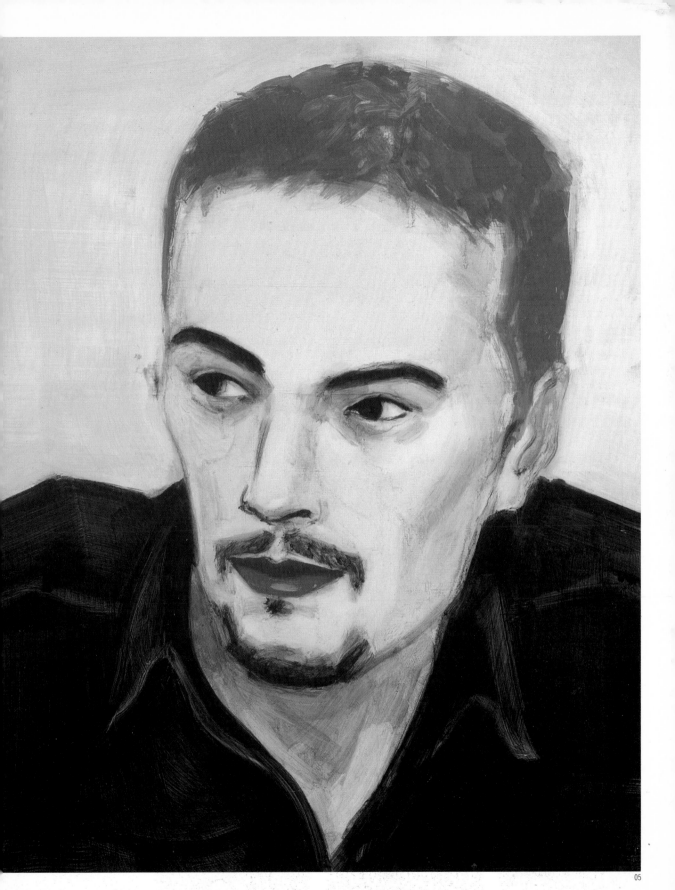

CRAIG, 1997. Watercolour on paper, 26 x 18 cm. **02 BLUE LIAM,** 1996. Oil on masonite, 43 x 36 cm. **03 BLUR KURT,** 1995. Oil on masonite, 36 x 28 cm.
DAVID HOCKNEY, 1997. Watercolour on paper, 26 x 18 cm. **05 JAKE CHAPMAN,** 1995. Oil on masonite, 43 x 36 cm.

ELIZABETH PEYTON

SELECTED EXHIBITIONS: *1997* "Currents 71: Elizabeth Peyton", The Saint Louis Art Museum, Saint Louis (MO), USA /// *1998* Seattle Art Museum, Seattle (WA), USA /// Museum für Gegenwartskunst Basel, Basle, Switzerland /// Kunstmuseum Wolfsburg, Wolfsburg, Germany **SELECTED BIBLIOGRAPHY:** *1997 Ein Stück vom Himmel – Some Kind of Heaven*, Kunsthalle Nürnberg, Nuremberg, Germany /// *LIVE FOREVER*, Tokyo, Japan /// *1998 Craig/Elizabeth Peyton*, Cologne, Germany

06 PIOTR ON COUCH, 1997. Oil on board, 23 x 31 cm. **07 MAXI,** 1996. Oil on board, 31 x 23 c

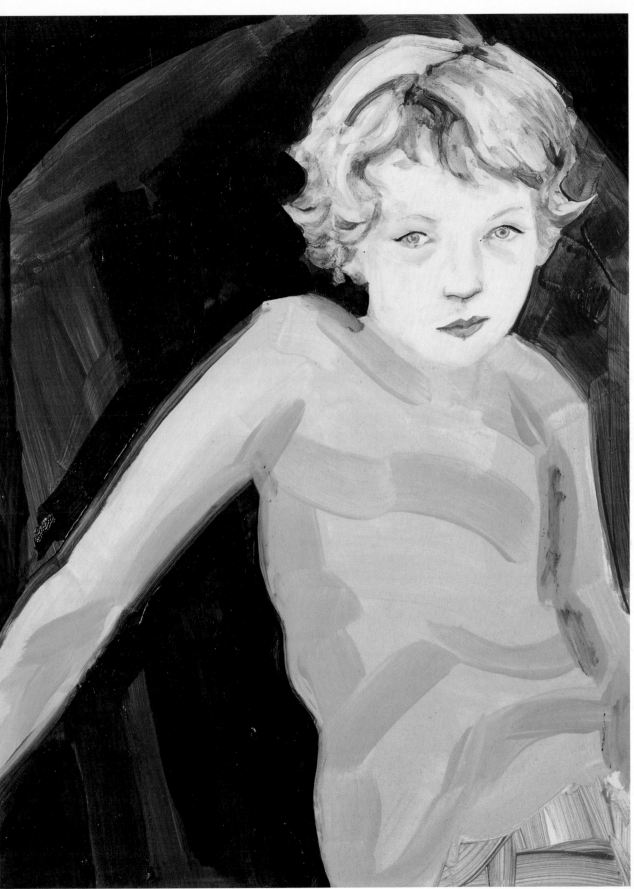

JACK PIERSON

1960 born in Plymouth (MA) / lives and works in New York (NY) and Provincetown (MA), USA

"Certain words aren't good when you describe artwork – like 'sentimental', 'romantic', 'poetic', and 'pretty'. But those are my favourite qualities of anything." **« Certains mots sont mal vus quand on décrit une œuvre d'art – par exemple ‹ sentimental ›, ‹ romantique ›, ‹ poétique › et ‹ joli ›. Mais ce sont là mes qualités préférées pour toute chose. »**

Jack Pierson became known mainly for his empathetic photographs of young men and women, his melancholic representations of landscapes, and his still lifes. He transfers some of these photographs into acrylic paint on canvas, using a special process, thus tackling the relationship of photography to painting. The often unfocused pictures, with their over- and underexposure and seemingly fortuitously trimmed negative area, have the effect of snapshots. Reminiscent of film stills from a road movie they evoke romance, uniting the sadness of the everyday with the glamour of Hollywood. Pierson studied at the Massachussetts College of Arts, and is often associated with the "Boston School" – a group of photographers trained in Boston, including Mark Morrisroe, Philip Lorca DiCorcia, Nan Goldin and David Armstrong.

However, in his photographs, drawings and installations Pierson is less concerned with the documentation of actual lives than with references to stories he has invented. These fictitious accounts can provide the viewer with a foil for his or her own wishes and longings. A spectacular example of this methodology is his video "Ad O'Toole, March 25th 1997 N.Y.C.", which shows a naked young man masturbating. In the style of Warhol, Pierson points the camera directly and bluntly at his subject. The lens feels its way gently round certain parts of the body and, in spite of the obvious offensiveness, creates a sensual atmosphere. Like his videos, his "wordpieces" – loose plastic letters which Pierson assembles on the wall to make complete words or whole sentences – deal with the desires, fears and dreams of human existence.

01

02

Jack Pierson s'est surtout fait connaître par ses photographies
de jeunes hommes et femmes pleines de sensibilité, ses représentations
de paysages et de natures mortes mélancoliques. Grâce à un procédé
spécial, l'artiste transpose certaines de ces prises de vues sur la toile,
avec de la peinture acrylique. Dans ces œuvres, il thématise ainsi le rap-
port entre la photographie et la peinture. Avec leurs cadrages apparem-
ment fortuits, ces images sous-exposées ou surexposées, souvent
floues, font l'effet d'instantanés. Elles s'apparentent aux séquences d'un
road-movie et évoquent des sentiments romantiques, unissant la grisaille
quotidienne et le glamour hollywoodien. Pierson, qui a fait ses études au
Massachusetts College of Art, est souvent cité en relation avec le con-
cept de « Boston School » et d'autres photographes ayant été formés à
Boston, comme Mark Morrisroe, Philip Lorca diCorcia, Nan Goldin et
David Armstrong. Dans ses photographies, ses dessins et ses installa-

tions, le propos est pourtant moins de documenter des biographies réel-
les que de s'appuyer sur des histoires inventées de toutes pièces. Ces
narrations fictives peuvent servir au spectateur de toile de projection
pour ses fantasmes personnels. Un exemple spectaculaire de ce type de
démarche est donné par la vidéo « Ad O'Toole, March 25th 1997 N.Y.C. »,
qui montre un jeune homme nu se masturbant. Dans une manière rappe-
lant Warhol, Pierson dirige son objectif directement et sans ménagement
sur l'acteur. Avec tendresse presque, l'appareil photo suit à tâtons diffé-
rentes parties du corps, générant une atmosphère de sensualité malgré
le caractère agressif de la représentation. Un peu comme ses vidéos,
ses « Wordpieces » – différentes lettres en plastique que Pierson agence
au mur en mots ou en phrases complètes – traitent également des
désirs, des angoisses et des rêves de l'être humain. Y. D.

01 WHAT THE FUCK, 1997. Sign lettering, 77 x 445 x 10 cm. **02 AMERICAN DREAMING.** Installation view, "American Dreaming: The Work of Edward
Hopper and Jack Pierson", Whitney Museum of American Art, New York (NY), USA, 1994.

JACK PIERSON

SELECTED EXHIBITIONS: *1994* "American Dreaming: The Work of Edward Hopper and Jack Pierson", Whitney Museum of American Art, New York (NY), USA /// *1995* "Traveling Show" Museum of Contemporary Art, Chicago (IL), USA /// Biennial Exhibition, Whitney Museum of American Art, New York /// *1997* capc Musée d'art contemporain, Bordeaux, France /// Frankfurte Kunstverein, Frankfurt/M., Germany /// *1998* "Emotions & Relations", Hamburger Kunsthalle, Hamburg, Germany **SELECTED BIBLIOGRAPHY:** *1995 Jack Pierson: Traveling Show*, Museum of Contemporary Art, Chicago /// *1996 Jack Pierson, The Lonely Life*, Ursula Blickle Stiftung, Kraichtal, Germany; Frankfurter Kunstverein, Frankfurt/M.; Zurich, Switzerland /// *1998 Emotions & Relations*, Benedikt Taschen Verlag, Cologne, Germany

03 I NEVER DREAMED YOU'D LEAVE IN SUMMER, 1994. Acrylic lacquer on canvas, 152 x 213 cm. **04 CLAYTON AT THE DAVID,** 1992. Colour photo, 102 x 76 cm. **05 LOST,** 199 Sign lettering, dimensions variable. **06 ANGEL YOUTH,** 1990. Colour photo, 76 x 51 cm. **07 CHANTAL AT DAWN,** 1990. Colour photo, 76 x 51 cm.

03

05

06

07

STEVEN PIPPIN

1960 born in Redhill, England / lives and works in London, England, and Berlin, Germany

"I have become fascinated with the idea of constructing … an instrument designed with the intention of recording its own mechanism and features."
« Je suis fasciné par l'idée de construire… un instrument conçu avec l'intention d'enregistrer ses propres mécanismes et caractéristiques. »

Steven Pippin is the nostalgic melancholic of media art. By avoiding state-of-the-art technology in his objects and installations, he succeeds in recalling for a brief moment those sentimental hopes that were once placed in photography and television. The fundamental, fascinating processes of media technology can be re-experienced in this technical reduction, while a melancholy wink announces the profanity of their actual application. For instance, a late-nineteenth-century aura pervades "Wardrobe Obscura", 1986, for which the artist converted a wooden bathing-cabin, like those found in English seaside resorts, into a camera. There are no intimate pictures on view, as might be expected of a changing-cabin transformed into a photo kiosk. The photos that are exposed and developed here are blurred and apparently covered with a patina.

In their poetic lack of focus, they refer back to the medium's birth pangs. Subsequently, this DIY enthusiast and puzzle-freak converted washing-machines, toilets and even a house into cameras. The result is a tautology – photo technology that reproduces only the process of photographing. In later works Pippin examines the media world from the point of view of its reception. The "Geo-Centric T.V." of 1998 consists of a rocket-like stand on which a monitor revolves on two axes; a globe is visible on the screen. Instead of moving pictures consumed worldwide by passive viewers in front of a stationary TV set, the artist has constructed a moving television set with a stationary picture of the world; perhaps Pippin is suggesting that a reversed view of the world is the only true version.

Parmi les artistes travaillant sur les médias, Steven Pippin est l'artiste de la mélancolie et de la nostalgie. C'est précisément parce que ses objets et installations ne font pas appel aux dernières nouveautés technologiques que Pippin parvient à ressusciter un instant les espoirs sentimentaux investis naguère dans la photographie et la télévision. Les processus fondamentaux si fascinants des différents médias redeviennent efficients grâce à la réduction des techniques. En même temps, un clin d'œil mélancolique nous révèle le caractère profane de l'utilisation réelle qui en est faite. La « Wardrobe Obscura », 1986, de Pippin est entourée de l'aura du 19e siècle finissant : l'artiste y a transformé une cabine de plage – comme on en voyait couramment dans les stations balnéaires anglaises – en appareil photo. On ne voit pas d'images intimes, telles qu'on les attendrait en principe d'une cabine de plage conçue comme un appareil photo ; les prises de vues qui y sont développées

sont plutôt floues, elles ont pris un semblant de patine. L'atmosphère poétique du flou les rattache ainsi aux origines du médium. Par la suite, le bricoleur Pippin a également procédé à la transformation de machines à laver, de toilettes et même d'une maison toute entière. Le résultat tient de la tautologie absolue, technique photographique ne représentant plus rien d'autre que le processus photographique. Dans ses œuvres récentes, Pippin étudie le monde des médias du point de vue de celui qui les reçoit. La « Geocentric T.V. », 1998, par exemple, est constituée d'un piétement apparenté à une fusée, sur lequel un moniteur tourne sur deux axes. Au lieu d'images animées consommées dans le monde entier par des spectateurs passifs devant un appareil statique, l'artiste a donc construit un téléviseur mobile présentant une image statique du monde. Le monde à l'envers serait-il le seul vrai ?

R. S.

01 / 02 / 03 / 04 **LAUNDROMAT-LOCOMOTION (RUNNING NAKED)**, 1997. B/w contact prints made from original paper negatives, 12 parts, 81 x 81 cm (each).
05 **GEOCENTRIC T.V.**, 1998. Aluminium, monitor. Installation view, Kunsthistorisches Institut der Friedrich-Schiller-Universität Jena, Jena, Germany, 1998.

01 / 02 / 03 / 04 05

STEVEN PIPPIN

SELECTED EXHIBITIONS: *1993* "Projects 44: Steven Pippin, Sarah Lucas", The Museum of Modern Art, New York (NY), USA /// Aperto 93, XLV Esposizione Internationale d'Arte, la Biennal di Venezia, Venice, Italy /// "Introspective", Institute of Contemporary Arts, London, England /// *1994* "Addendum", Portikus, Frankfurt/M., Germany /// *1997* Tel Aviv Museum of Art, Tel Aviv, Israel /// *1998* "Laundromat Locomotion", San Francisco Museum of Modern Art, San Francisco (CA), USA　　**SELECTED BIBLIOGRAPHY:** *1994 Migrateurs*, Musée d'Art Moderne de la Ville de Paris, Paris, France /// *1995 Addendum*, Portikus, Frankfurt/M. /// *1996 Life/Live*, Musée d'Art Moderne de la Ville de Paris, Paris /// *Playpen & Corpus Delirium*, Kunsthalle Zürich, Zurich, Switzerland /// *The Cauldron*, The Henry Moore Studio, Halifax, Canada /// *1998 Laundromat Locomotion*, daadgalerie, Berlin, Germany; San Francisco Museum of Modern Art, San Francisco

06

STEPHEN PRINA

"The meaning of an artwork cannot be reduced to the ideas that generate it." **« La signification d'une œuvre d'art ne peut être réduite aux idées qui ont présidé à sa genèse. »**

Stephen Prina's pictures, installations and musical or other performances often take as their starting point "irrevocable representations", that is, well-known artistic and musical works. The various levels of meaning in his works are often revealed only through a sequence of historical references and influences. For instance, the proportions of Prina's monochrome drawings in "Exquisite Corpse: The Complete Paintings of Manet" (from 1988 on) correspond to the measurements of Edouard Manet's total of 556 paintings. Again, in "Monochrome Painting" (1988/89) the formats of his pictures in green car paint and their subtitles are derived from modern paintings, including Kasimir Malevich's "White on White" of 1919 or Blinky Palermo's "Untitled" of 1973. Prina's projects, which are often long-term, are concerned with the reception of cultural and art history, the mechanisms of the art business (e.g. "Mailing List", 1989/90)

and the history of his own exhibitions ("Retrospection under Duress", 1996). Duplicating his models' individual features, analysing their material data, and then reconstructing them, Prina examines the ritual of creating cultural value, and shakes its foundations – questioning issues such as originality, autonomy and authorship. In "Dom Hotel, Room 101", 1994, he takes up the monologue of a character in one of Heinrich Böll's novels and the novel's adaptation by the film-makers Jean-Marie Straub and Danièle Huillet. Here, too, the process of appropriation, emphasis and fade-out plays a central role. In this, Prina's sometimes ironically exaggerated analyses do not simply deliver a detailed record of his methodology: they introduce an arbitrary factor in his seemingly self-reflective systems, opening them up to other interpretations.

Les tableaux, installations et performances (musicales) de Stephen Prina prennent souvent comme matériau de départ des « représentations irrévocables », à savoir des œuvres d'art ou des compositions musicales. Les différents niveaux de sens de ses œuvres n'apparaissent souvent qu'à travers toute une série de références et d'influences inhérentes à l'histoire de l'art ou à l'histoire tout court. Ainsi les proportions des dessins monochromes dans « Exquisite Corpse : The Complete Paintings of Manet » (à partir de 1988) correspondent-elles aux formats des 556 peintures d'Edouard Manet. Dans « Monochrome Painting », 1988/89, en revanche, les dimensions et les sous-titres des tableaux réalisés avec de la laque automobile sont dérivés de certains modèles de l'art moderne (de « Blanc sur blanc » [Malévitch 1919] ou de « Sans titre » [Blinky Palermo 1973] par exemple). Souvent conçus pour une réalisation sur le long terme, les projets de Prina s'inscrivent dans la réception de l'histoire de

l'art et de l'histoire culturelle, dans les mécanismes du marché de l'art (par exemple « Mailing List » [1989/90]) et dans l'histoire des exposition. de l'artiste (« Retrospection under Duress » [1996]). Par le redoublement de certains aspects de ses modèles, la prise en compte des conditions matérielles et leur reconstitution ultérieure, Prina analyse les rituels de la genèse artistique. Dans « Dom Hotel, Chambre 101 », 1994, œuvre dans laquelle Prina se sert à la fois du monologue d'un personnage de Heinric Böll et de l'adaptation cinématographique du même roman par Jean-Marie Straub et Danièle Huillet, le processus de l'assimilation, de la mise en valeur et de l'atténuation joue une fois de plus un rôle prépondérant. Les calculs parfois ironiquement exagérés ne livrent pas seulement le protocole détaillé de sa propre démarche, ils introduisent aussi un aspect arbitraire dans des systèmes (sémantiques) se référant apparemment à eux-mêmes et les ouvrent à d'autres interprétations. A. W

01 WHAT'S WRONG? OPEN THE DOOR! WHAT'S WRONG? OPEN THE DOOR! ... I WAS SCARED. WHAT HAPPENED? ... YOU CAN'T LIE UNDER WATER LIKE ON A BED AND THEN JUST WAIT. YOU CAN'T LIE UNDER WATER LIKE ON A BED AND THEN JUST WAIT. ... IT'S IMPOSSIBLE. ... WAIT FOR WHAT? ... IDIOT! DO YOU KNOW THE MESS YOU CAN TAKE ME INTO? (CLEAR/RAMIN), 1996. 35 frames, 80 x 63 cm (each Installation view, "Retrospection Under Duress (Reprise)", Galerie Gisela Capitain, Cologne, Germany, 1996. **02 / 03 MONOCHROME PAINTING.** Installation views, P.S.1, Long Island City (NY), USA, 1990.

STEPHEN PRINA

SELECTED EXHIBITIONS: *1992* "It was the best he could do at the moment", Museum Boijmans Van Beuningen, Rotterdam, The Netherlands /// documenta IX, Kassel, Germany // *1996* "Retrospection Under Duress (Reprise)", daadgalerie, Berlin, Germany /// *1998* "2 or 3 Things I Know About Her (Second Investigation): Stephen Prina's Monochrome Painting", Musée d'Ar Moderne et Contemporain, Geneva, Switzerland /// *1999* Frankfurter Kunstverein, Frankfurt/M., Germany **SELECTED BIBLIOGRAPHY:** *1988 The BiNational: American Art of the Late 80's* The Institute of Contemporary Art; Museum of Fine Arts, Boston (MA), USA /// *1992 It was the best he could do at the moment*, Museum Boijmans Van Beuningen, Rotterdam /// *Dirty Data Sammlung Schürmann*, Ludwig-Forum für Internationale Kunst, Aachen, Germany /// *Aesthetic of Absence: Pictures Between Presence and Absence*, Munich, Germany /// *1998 Recycling A History*, Pittsburgh Center for the Arts, Pittsburgh (PA), USA

TOP THIRTEEN SINGLES FROM BILLBOARD'S HOT 100 SINGLES CHART FOR THE WEEK ENDING FEBRUARY 20, 1993, 1993. The first in a series of 10 unique works, enamel [al]uminium, acrylic, electrical hardware, ø of clockface 90 cm. **05 EXQUISITE CORPSE: THE COMPLETE PAINTINGS OF MANET, 75 OF 556** (left). Ink wash on rag barrier paper, [...]4 cm. **COMBAT DE TAUREAUX (LE TOREADOR MORT), (BULLFIGHT [THE DEAD TOREADOR]), 1864** (right). Offset lithography on paper, 65 x 83 cm. Installation view, National [...] Washington, D.C., USA, 1989. **06 "THE BINATIONAL: AMERICAN ART OF THE LATE 80'S",** installation view, Kunstverein für die Rheinlande und Westfalen, Düsseldorf, [German]y, 1988/89.

RICHARD PRINCE

"I want the best copy. The only copy. The most expensive copy. I want James Joyce's 'Chamber Music'. [...] I want the earliest copy on record. I want the copy that is rarer than anyone had previously dreamt of. I want the copy that dreams." **« Je veux la meilleure copie. La seule copie. La copie la plus chère. Je veux la ‹ musique de chambre › de James Joyce. [...] Je veux la copie la plus ancienne copie qui soit. Je veux la copie la plus rare qu'on ait jamais rêvé. Je veux la copie qui rêve. »**

The principle of appropriation was originally developed by Marcel Duchamp at the beginning of the century, reaching a climax in the 1960s with Pop Art. At the end of the 1970s it came back into fashion and, even more so than in Pop Art, pictures from advertising or television were adopted wholesale by artists for use in their own work. Richard Prince was one of the first, and one of the most provocative practitioners. At that time, he was working for the cuttings service of *Time Life* publications in New York, and therefore had access to thousands of magazines, in most of which only the advertisement pages remained intact. He began to photograph these advertisements, and then to compose his own pictures from the photos, finding that the detail, colour and angle of vision were changed if the camera was not held straight. For instance, in the series "Cowboys", 1980–1987, what at first seems to be an exact copy of a Marlboro advertisement is soon revealed – through such details as an intentional lack of focus, special emphasis on the figure, or its particular arrangement – as an artistic treatment. The synthetic, perfect world of advertising was not imitated but rather returned to imperfect reality. Pop Art's homage to advertising and consumerism was thus brought to an end. When Prince later produced large canvases displaying often coarse visual and written jokes, he was making an allusion to an ancillary aspect. The advertising world is a substitute world, and so is that of the joke. Both make similar use of clichés and wishes that cannot be fulfilled.

Le principe de l'appropriation inventé par Marcel Duchamp au début du siècle et poussé à son apogée par le Pop Art dans les années 60, devait connaître un regain d'actualité à partir de la fin des années 70. Plus encore que dans le Pop Art, des images de la publicité ou de la télévision furent utilisées par des artistes pour leur propre travail, apparemment sans aucune modification. L'un des premiers artistes de cette tendance, mais aussi l'un des plus provocants dans sa pratique, a été Richard Prince. Il travaillait à l'époque au service de découpage des éditions Time-Life à New York, ce qui lui donnait accès à des milliers de revues découpées, dont seules les pages d'annonces étaient le plus souvent encore entières. Il commença à photographier ces publicités et à composer des images personnelles à partir de ces photos. La découpe, le chromatisme, mais aussi l'angle de vue se trouvaient altérés lorsque l'appareil était tenu de biais. Dans la série « Cowboys », 1980–1987, ce qui apparaît au premier abord comme une copie conforme de la publicité Marlboro, s'avère bientôt être un travail artistique en raison de détails tels que l'imprécision volontaire ou le soulignement particulier de la figure mais aussi par les particularités de l'agencement. Le monde synthétique et parfait de la publicité n'était pas imité, mais ramené dans la réalité imparfaite. Richard Prince mettait ainsi un terme aux hommages à la publicité et à la consommation qu'on pouvait encore déceler dans le Pop Art. Plus tard, en produisant de grandes toiles avec des plaisanteries dessinées et écrites, souvent passablement truculentes, Richard Prince faisait appel à un aspect supplémentaire. Tout comme celui de la plaisanterie, l'univers de la publicité est un monde de substitution. Dans l'un comme dans l'autre, on travaille avec des clichés, mais aussi avec des désirs irréalisables.

C. E

01 UNTITLED (GIRLFRIEND), 1993. Ectacolour print, 163 x 112 cm. **02 UNTITLED (GIRLFRIEND)**, 1993. Ectacolour print, 112 x 163 cm. **03 UNTITLED**, 1989. Acrylic, silkscreen on canvas, 229 x 147 cm.

"I understand your husband drowned and left you two million dollars. Can you imagine, two million dollars, and he couldn't even read or write."
"Yeah, she said, and he couldn't swim either."

RICHARD PRINCE

SELECTED EXHIBITIONS: *1992* Whitney Museum of American Art, New York (NY), USA /// *1993* "Richard Prince: Fotos, Schilderijen, Objecten", Museum Boijmans Van Beuningen, Rotterdam, The Netherlands /// San Francisco Museum of Modern Art, San Francisco (CA), USA /// Kunstverein für die Rheinlande und Westfalen, Düsseldorf; Kunsthalle Düsseldorf, Düsseldorf, Germany /. *1994* Haus der Kunst, Munich, Germany /// *1997* Museum Haus Lange – Museum Haus Esters, Krefeld, Germany **SELECTED BIBLIOGRAPHY:** *1989 Spiritual America*, IVAM, Centre de Carme, Valencia, Spain; New York /// *1992 Richard Prince*, Whitney Museum of American Art, New York /// *1993 Richard Prince Girlfriends*, Museum Boijmans Van Beuningen, Rotterdam /// *199. Richard Prince: Photographs 1977–1993*, Kestner-Gesellschaft Hannover, Hanover, Germany /// *1995 Richard Prince Adult Comedy Action Drama*, New York

Man walking out of a house of questionable repute, muttered to himself, "Man, that's what I call a business…you got it, you sell it, and you still got it."

05

THE LITERATURE RACK, 1994. Acrylic, silkscreen on canvas, 345 x 244 cm. **05 UNTITLED (BR100CO),** 1989. Oil, autobody compound, fibreglass over
...od. **06 UNTITLED (COWBOYS),** 1980–1984. Ectacolour print, 69 x 102 cm. **07 UNTITLED (COWBOYS),** 1980–1986. Ectacolour print, 69 x 102 cm. **08 UNTITLED
...OWBOYS),** 1980–1984. Ectacolour print, 69 x 102 cm. **09 UNTITLED (COWBOYS),** 1980–1986. Ectacolour print, 76 x 114 cm.

07

09

CHARLES RAY

1953 born in Chicago (IL) / lives and works in Los Angeles (CA), U

More than the work of practically any other artist, Charles Ray's figures provide stark evidence of the return of the real into art. He began working at the time when Minimal and Body Art were prevalent, presenting issues related to the body in abstract or performative pieces. When he started to make casts of his own body, and then introduced shop-window mannequins into his works, he brought a disturbing immediacy into sculpture whose effect was almost psychotic. His figures are distorted versions of humanity that at first seem familiar: the beautiful woman, the handsome male model, the unremarkable, average man in his forties – Ray himself. But these smooth, stereotyped mannequins are often too big or too small to be truthful representations. There is something oppressive in the monumentality of the mega-woman who emasculates every man who approaches her, degrading him to the size of a child ("Fall", 1992), or in the four family members, all scaled to the same size

so that the parents are proportionately tiny while the children are blown up into monsters ("Family Romance", 1993). Ray's traumatic realism al embraces everyday items – the "minimalistic" cube, cutlery that revolve on a table ("How a Table works", 1986), or an ambulance as a sculptur object ("Unpainted Sculpture", 1997). With these nightmarish allegories he activates contemporary associations and social references. The squashed car of 1997, for instance, makes us think of Lady Di's accide while in 1992, numerous art critics interpreted the sex orgy "Oh! Charle Charley, Charley..." as a metaphor for the AIDS era. But Ray deals with more petty emotional and mental conditions – narcissism, the longing for love and beauty – which are re-evaluated in his more recent themat works about fashion and models, including a video of a revolving mann quin or a photographic series on "the most beautiful woman in the world". S.

IRETRUCK, 1993. Mixed media, 3 x 13.7 x 2.4 m. **02 TUB WITH BLACK DYE,** 1986. Tub, glass test tubes, pipe, dye, 150 x 76 cm. **03 HOW A TABLE WORKS,** 1986. Steel with metal box, thermos, plastic cup, terracotta pot with synthetic plant, ted metal can, 112 x 117 x 81 cm.

02

Plus crûment sans doute qu'aucune autre œuvre, les figures de arles Ray témoignent du retour du réel dans l'art. Son œuvre a comncé par l'assimilation du Minimal Art et du Body Art ; dans un premier nps, l'artiste exposera le moulage de son propre corps, puis un manne-n d'étalage venant se substituer aux anatomies de tendance abstraite actionniste. Cette évolution fit entrer dans la sculpture une présence n effet psychotique et inquiétant. Les figures de Ray sont les repré-ntants caricaturaux de personnes qu'on croit connaître : la jolie fille, la mille sympathique, le jeune homme bien sous tous rapports qu'on peut ontrer en société, le quadragénaire moyen qui passe inaperçu (Ray lui-ême). Ils sont lisses, stéréotypés et souvent trop grands ou trop petits ur être vrais. On est oppressé par la monumentalité de cette méga-mme (« Chute », 1992), ou par la taille identique des quatre membres ne famille qui rend les parents minuscules et gonfle les enfants jusqu'à

en faire des monstres (« Family Romance », 1993). Le réalisme trauma-tique de Ray inclut aussi les objets quotidiens : cube « minimaliste », couverts en rotation sur une table (« How a table works », 1986, objet sculptural d'une voiture accidentée (« Unpainted Sculpture », 1997). Ray provoque des associations et des métaphores cauchemardesques, il instaure des rapports sociaux très actuels. Ainsi, en 1997, sa voiture accidentée faisait songer à l'accident de Lady Di, tandis qu'en 1992, de nombreux critiques d'art avaient interprété l'orgie « Oh ! Charley, Charley, Charley... » comme un symbole de l'ère du Sida. Ray lui-même ne connaît pour sa part que les sentiments et les états d'esprit provocateurs, le narcissisme, le désir d'amour et de beauté, qui prennent un nouveau poids dans la thématique la plus récente de son travail : la mode et les top models – avec sa vidéo des déambulations d'un mannequin ou sa série photographique sur « La Plus Belle femme du monde ». S. T.

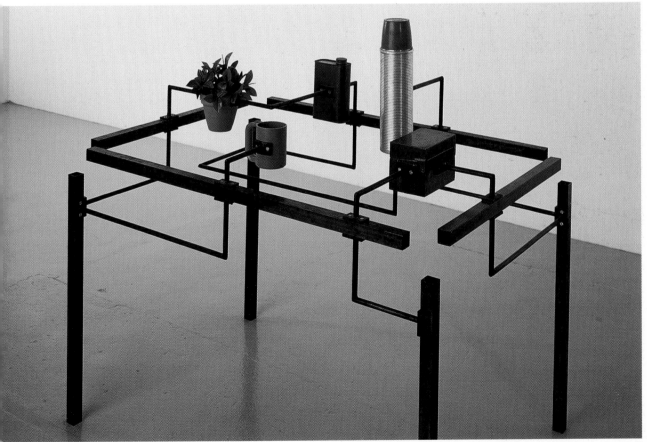

03

CHARLES RAY

SELECTED EXHIBITIONS: *1992* documenta IX, Kassel, Germany /// *1994* Rooseum – Center for Contemporary Art, Malmö, Sweden /// *1995* "Feminin –masculin: le sexe de l'art", Mus[...] national d'art moderne, Centre Georges Pompidou, Paris, France /// *1997* "Sunshine & Noir: Art in LA 1960–1997", Louisana Museum of Modern Art, Humlebæk, Denmark /// *1998–1999* Whit[...] Museum of American Art, New York (NY); The Museum of Contemporary Art, Los Angeles (CA); Museum of Contemporary Art, Chicago (IL), USA **SELECTED BIBLIOGRAPHY:** *1990 Char[...] Ray*, The Newport Harbor Art Museum, Newport (CA), USA /// *1994 Charles Ray*, Rooseum – Center for Contemporary Art, Malmö /// *1998 Charles Ray*, The Museum of Contemporary Art, L[...] Angeles; Zurich, Switzerland

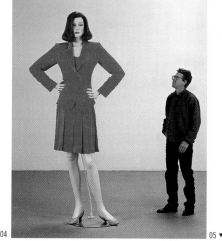

04 FALL '91, 1992. Mixed media, overall dimensions, 244 x 66 x 91 cm. **05 OH! CHARLEY, CHARLEY, CHARLEY ...,** 1992. Mixed media, 183 x 457 x 457 cm. **06 FASHIONS,** 1996. 16 mm colour film, 12 mins. **07 UNPAINTED SCULPTURE,** 1997. Fibreglass, paint, 152 x 198 x 434 cm. 04 05 ▼

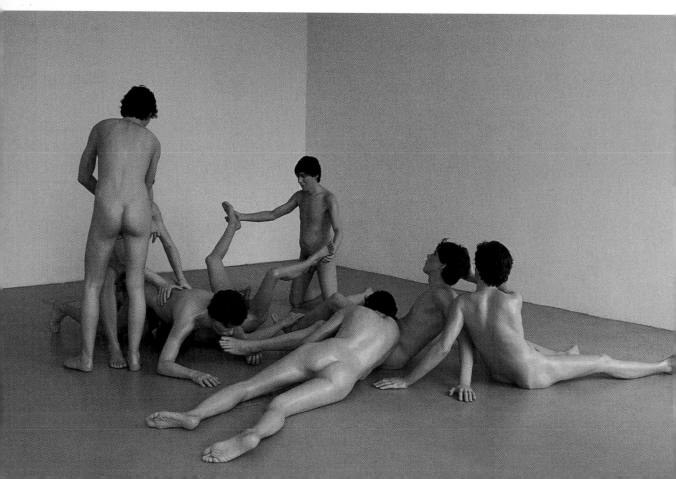

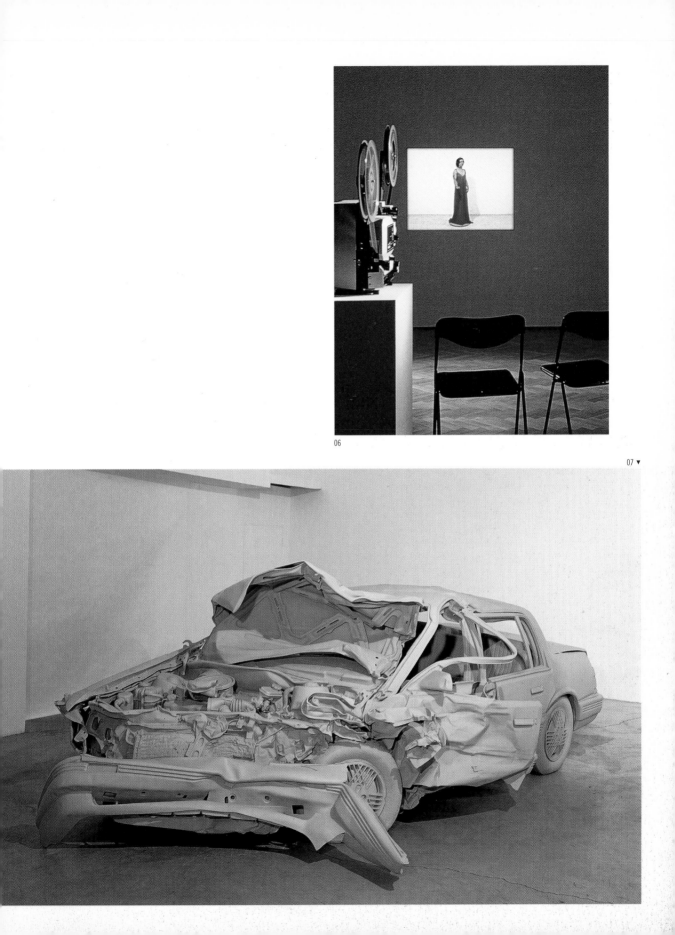

TOBIAS REHBERGER

1966 born in Esslingen/N., Germany / lives and works in Frankfurt/M., Germany

"Everyone sees art differently. I only make suggestions." « Chaque personne a sa manière de voir l'art, je me contente de faire des propositions. »

A blue ashtray and two television sets within outsize "tennis balls" hang above a pair of yellow armchairs. This arrangement, entitled "No Need to Fight about the Channel. Together. Leant Back", is part of Tobias Rehberger's installation "Fragments of Their Pleasant Spaces (In My Fashionable Version)", 1996. This is what resulted when the artist asked his friends to come up with ideas for the ultimate in comfortable interior design. Rehberger then translated the answers into his own "fashionable" interpretations. The work exemplifies his key strategies: collaboration, a working method related to space, and a questioning of the limits of art, fashion and design. Clichés and expectations are also playfully queried. In 1997 he designed an advertisement for a Berlin gallery, which appeared in art magazines. He then presented the advertisement to a knitter, who used it as a pattern for garments worn by gallery staff during an art fair. Subsequently, the gallery used the advertisement as a model for the exhibition "Brancusi". The two-dimensional layout was translated spatially onto three-dimensional surfaces. These could be read as 1970s-style furniture but as well as autonomous sculptures. In this "three-piece", Rehberger renounces his authorship, concentrating like a manager on co-ordinating different processes and thus reducing hierarchies, including those between artist and mediators. Also characteristic is the way in which he introduces unfamiliar relationships to ensure that his collaborators have their own freedom of interpretation: an advertisement is just as unsuitable for a knitting pattern as it is for the plan of an exhibition.

Deux fauteuils jaunes, un cendrier bleu et deux téléviseurs suspendus au plafond dans des « balles de tennis » surdimensionnées, c'est là un arrangement de l'environnement « Fragments of Their Pleasant Spaces (In my Fashionable Version) », 1996, de Thomas Rehberger. Pour cette œuvre, l'artiste a interrogé des amis afin de savoir comment il convenait d'aménager des pièces pour qu'on s'y sente aussi bien que possible. Rehberger a ensuite traduit leurs réponses dans son interprétation « à la mode ». Une de ces réponses est l'arrangement « No Need to Fight about the Channel. Together. Leant Back ». D'une façon emblématique, on y relève les principales stratégies mises en œuvre par l'artiste : coopération communicative, travail sur l'espace et interrogation des limites de l'art et de la mode, ou encore du design. De plus, Rehberger joue avec des clichés et des attentes qu'il remet en question avec un plaisir manifeste de la provocation. En 1997, l'artiste devait réaliser pour une galerie berlinoise une annonce qui fut insérée dans des magazines d'art. Il la donna également à une brodeuse qui s'en servit comme modèle pour des sous-pulls. Ceux-ci furent ensuite portés par les galeristes lors d'une foire. Plus tard, les galeristes s'en servirent comme modèle pour l'exposition « Brancusi » : la mise en page bidimensionnelle fut transposée dans les trois dimensions de l'espace et pouvait être lue comme des meubles dans le style des années 70, mais aussi comme des « sculptures autonomes ». Dans ce « triptyque », Rehberger abandonne largement sa propre paternité artistique, se concentrant sur la manière de coordonner différents processus – à l'instar d'un manager – et abolissant ainsi les hiérarchies, notamment celles qui existent entre les artistes et les présentateurs de l'art. Un autre aspect très caractéristique de Rehberger est aussi la manière dont l'artiste incorpore à ses œuvres des indéfinitions qui ménagent à ses partisans un espace d'interprétation propre. R. S

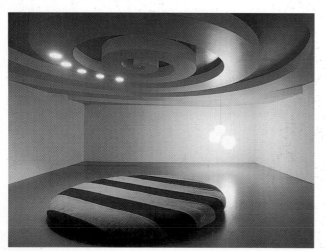

VORSCHLAG FÜR DIE DECKE EINES GEMEINSCHAFTSRAUMS (FRAU SIEVERT & FRAU ECKARDT-SALAEMAE), 1997. Painted wood, chipboard, glass piles integrated lamps, acrylic lacquer, foam plastic, synthetic cover, 728 x 548 x 172 cm. Installation view, "Home Sweet Home", Deichtorhallen Hamburg, nburg, Germany, 1997. **02 "CHRISTIAN", SITZGELEGENHEITEN,** 1996. Laminated fibre sheet, cardboard, 4 x ø 50 cm, 2 x ø 100 cm, 1 x ø 170 cm. allation view, "Suggestions from the Visitors of the Shows #74 and #75", Portikus, Frankfurt/M., Germany, 1996. **03 "ONE",** installation view, gerriemschneider, Berlin, Germany, 1995.

TOBIAS REHBERGER

SELECTED EXHIBITIONS: *1993* "Backstage", Kunstverein in Hamburg, Hamburg, Germany /// *1995* "canceled projects", Museum Fridericianum, Kassel, Germany /// *1996* "Suggestions from the Visitors of the Shows #74 and #75", Portikus, Frankfurt/M., Germany /// *1997* Skulptur. Projekte in Münster 1997, Münster, Germany /// *1998* Sprengel Museum Hannover, Hanover, Germany /// *1999* Galerie für zeitgenössische Kunst Leipzig, Leipzig, Germany **SELECTED BIBLIOGRAPHY:** *1994 Rehbergerst*, Galerie Bärbel Grässlin, Frankfurt/M. /// *1995 Rehberger*, Museum Fridericianum, Kassel /// *1996 Heetz, Nowak, Rehberger*, Städtisches Museum Abteiberg, Mönchengladbach, Germany /// *1999 Exhibition catalogue*, Moderna Museet, Stockholm, Sweden

FRAGMENTS OF THEIR PLEASANT SPACES (IN MY FASHIONABLE VERSION), 1996. Installation view, Galerie Bärbel Grässlin, Frankfurt/M., ermany, 1996. **05 UNTITLED,** 1997. Wool in various colours. **06 BRANCUSI.** Wallpainting, 5 seats, 3 lamps, wooden floor, 11 original works sundry artists. Installation view, neugerriemschneider, Berlin, Germany, 1997.

05

JASON RHOADES

1965 born in Newcastle (CA) / lives and works in Los Angeles (CA), USA

"All good thoughts and all good works of art run on their own as a perpetual motion machine, mentally and sometimes physically; they are very alive."
« Toutes les bonnes pensées et toutes les bonnes œuvres d'art ont leur propre moteur comme un mouvement perpétuel, mentalement, et parfois physiquement : elles sont très vivantes. »

Jason Rhoades creates large artworks, often spread out on the floor in many parts and occupying whole rooms. Lights flash, music plays and sometimes a video runs on a tiny television. Rhoades is blessed with the skill of the tinkerer, constructing machines that make chips, manufacture doughnuts, scatter, emit smoke or simply produce a noise. This jolly yet serious artist from Los Angeles has made an important contribution to the redirection of art world attention in the late 1990s from New York to the American west coast. Rhoades's creations set up systems of relationships between reality, experience and the media. The viewer browses through a network of objects and contemplates the associations arising from them. Sometimes Rhoades takes a basic motif, such as the 1970s film "Car Wash", from which colour and architectural features emerge. The car wash in Rhoades's "Uno momento/the theatre in my dick/a look to the physical/ephemeral" of 1996 turns out to be a phallus shape of about twenty metres in length. But even those who do not immediately recognise the connections will feel the continuous and harmonious inducement to look around them. Rhoades reacts to the thousands of impressions that we all receive every day. His works create in the viewer the same compulsiveness or indifference as the temporary offerings of daily media and happening culture, which one can either share or reject. Rhoades repeatedly turns this process into art.

Ses œuvres sont grandes, souvent éparpillées à même le sol dans plusieurs pièces ; des lumières fusent soudain, on entend de la musique ; parfois aussi, une vidéo passe sur un minuscule écran. De plus, Jason Rhoades est un bricoleur de génie. Il construit des machines qui projettent des frites, fabriquent des beignets, crachent de la saleté, produisent de la fumée ou simplement font du bruit. Rhoades est un artiste à la fois gai et sérieux de Los Angeles, et il a contribué de façon décisive à ce qu'à la fin des années 90, le marché de l'art tourne son regard moins vers New York et plus vers la Côte Ouest des Etats-Unis. Les mises en scène de Rhoades constituent des systèmes de références entre réalité, expérience et médias. Le regard du spectateur se fraye un chemin à travers une trame d'objets et les associations qu'ils déclenchent. Parfois, on relève aussi un motif fondamental, comme le film des années 70 « Car Wash », dont on voit réapparaître plus tard certains effets de couleur et des aspects architecturaux. Dans son œuvre « Uno momento/the theatre in my dick/a look to the physical/ephemeral », 1996, à la fin, la station de lavage se transforme en une forme phallique de quelque vingt mètres de long. Mais même lorsqu'on ne reconnaît pas d'emblée ces correspondances, on ne peut manquer de remarquer l'attrait visuel constant et harmonieux qui incite aux sauts de pensée. Rhoades réagit aux milliers d'impressions que chaque homme reçoit quotidiennement. Ses œuvres sont des propositions qui travaillent avec le même engagement et le même désengagement que les offres de la culture de l'événement. Toutes ces offres et propositions éphémères déclenchent des sentiments qu'on peut suivre ou non, et c'est très précisément ce processus que Rhoades transforme constamment en art. C. E

1 THE CREATION MYTH. Installation view, Galerie Hauser & Wirth 2, Zurich, Switzerland, 1998. **02 MY BROTHER/BRANCUZI,** 1995.
arpet, wood, steel, doughnut machine, doughnut mix, small gasoline engines, various tools, plastic, drill, whisk, etc., 183 x 366 x 732 cm.
nstallation view, Epicenter Ljubljana, Moderna Galerija, Ljubljana, Slovenia, 1997.

02

JASON RHOADES

SELECTED EXHIBITIONS: *1997* "Deviations in Space, Various Virgins", David Zwirner Gallery, New York (NY), USA /// XLVII Esposizione Internationale d'Arte, la Biennale di Venezia, Venice, Italy /// Biennial Exhibition, Whitney Museum of American Art, New York /// *1998* "The Purple Penis and the Venus", Kunsthalle Nürnberg, Nuremberg, Germany /// *1998–1999* "The Purple Penis and the Venus (and Sutter's Mill) for Eindhoven: A Spiral with Flaps and Two Useless Appendages after the Seven Stomachs of Nuremberg as Part of the Creation Myth", Stedelijk Van Abbemuseum, Eindhoven, The Netherlands **SELECTED BIBLIOGRAPHY:** *1995 This is the Show and the Show is Many Things*, Museum van Hedendaagse Kunst, Ghent, Belgium /// *1996 Jason Rhoades*, Kunsthalle Basel, Basle, Switzerland /// *1997 Deep Storage*, Munich, Germany /// *1998 Jason Rhoades. Volume. A Rhoades Referenz*, Kunsthalle Nürnberg, Nuremberg; Stedelijk Van Abbemuseum, Eindhoven; Cologne, Germany

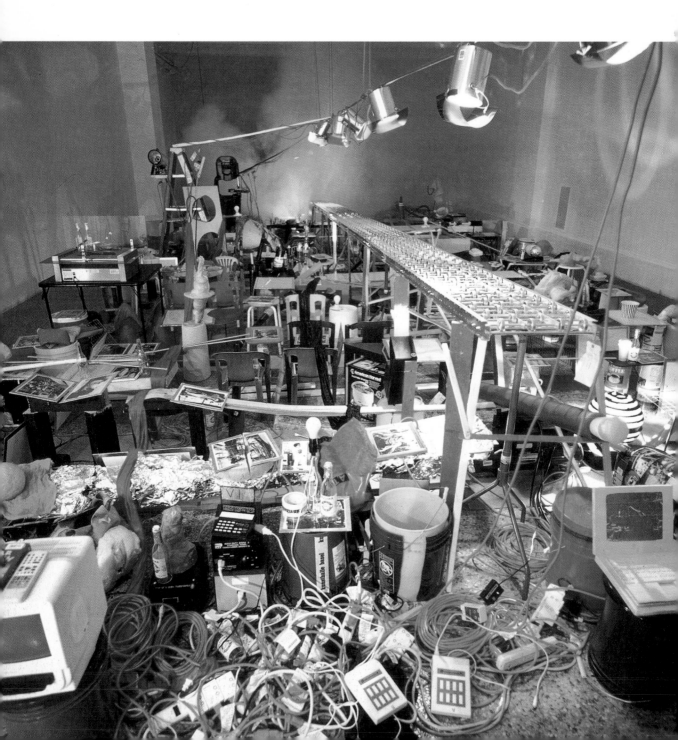

03 UNO MOMENTO/THE THEATRE IN MY DICK/A LOOK TO THE PHYSICAL/EPHEMERAL, 1996. Various materials. Installation view, Kunsthalle Basel, Basle, Switzerland, 1996. 04 / 05 DEVIATIONS IN SPACE, VARIOUS VIRGINS, 1996/97. Various materials including 11 brown metal boxes of various dimensions, 5 neon "sculptures", numerous plastic buckets, 2 riding saddles, urinal, numerous extension cords, plastic laminator, 3 television monitors, 3 VCRs, 6 digitally produced paintings on canvas, pottery wheel, clay, slide projector, Yamaha electronic keyboard, felt, wooden rings, air tanks, etc., dimensions variable. Installation view, "La Modernité et la Côte d'Azur", Villa Arson, Nice, France, 1997.

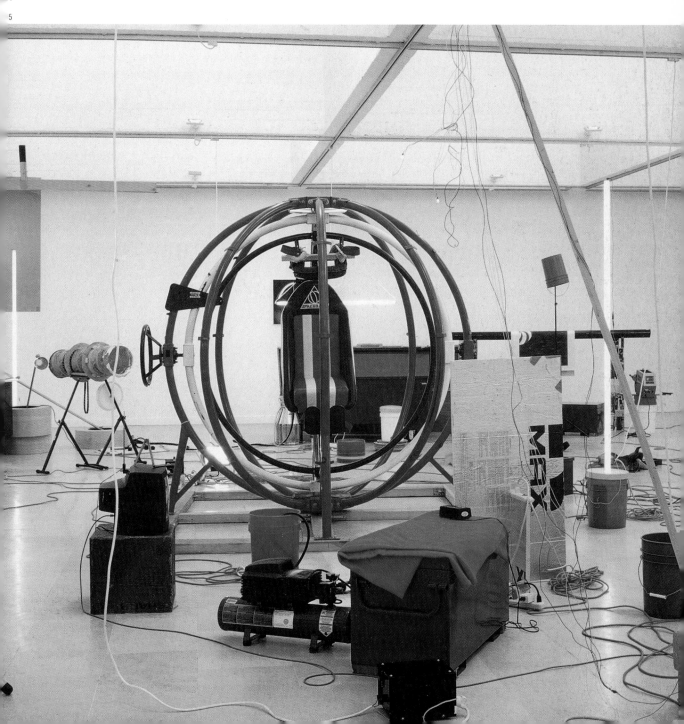

PIPILOTTI RIST

1962 in Grabs, Switzerland / lives and works in Zurich and Neuenburg, Switzerland

"Messages that are conveyed emotionally and sensuously can break up more prejudices and habitual behaviour patterns than umpteen pamphlets and intellectual treatises." « **Les messages véhiculés sur le mode émotionnel et sensuel peuvent briser plus de préjugés et d'habitudes que des dizaines de pamphlets et de traités intellectuels.** »

The work of video artist Pipilotti Rist is flashy, colourful, cheeky and self-confident. As a result, she swiftly conquered the art world, proving that it is possible to rival the mass of music videos with work on a higher plane. Having played in a band for years, she understands the aesthetics of pop culture, and seems to have noticed that this element was rather under-represented in the art of the early 1990s. At first, her strident videos were somewhat off-putting, seeming banal, stagey and whimsical. She often included herself in the work, but this by no means dominated the content. Rist spoke once of the "raging class war between the literate and those brought up on pictures (e.g. through TV)". How she saw the former was evident in her installation "Das Zimmer" (The Room), 1994.

Huge red armchairs were grouped round a small television set, occupied by adults goggling at the videos on the screen, wide-eyed like young children. The public was thus presented with its own inadequacy, but so subtly that it did not even notice. Thematically, Rist depicts in increasingly large-scale video projections the daily madness of unsolved problems, though without lapsing into despair. In "Ever is Over All", 1997, a young woman runs down the street cheerfully smashing the windscreens of parked cars. A second projection alongside shows flower-filled meadows. A policewoman turns up and warmly greets the hooligan. Rist thus presents new alliances in her work that could hardly be conveyed through text, but can easily be read as pictures.

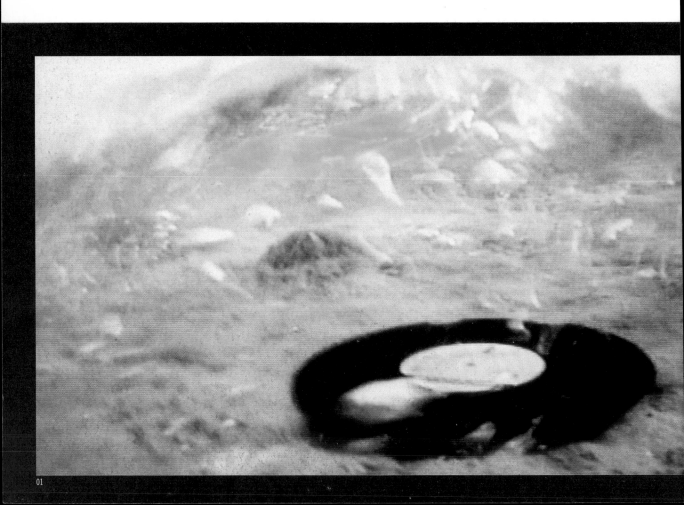

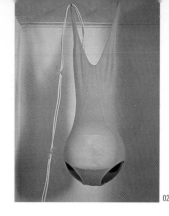

02

Haute en couleurs, insolente, sûre d'elle-même, la vidéaste Pipi-otti Rist a rapidement conquis la scène artistique, prouvant en même temps qu'il est tout à fait possible d'opposer à la masse des clips vidéo une production qui se situe à un niveau supérieur. Rist a elle-même fait partie d'un groupe musical pendant quelques années et connaît de ce fait l'esthétique de la culture pop. A un moment donné, elle a dû remar-quer que celle-ci était plutôt sous-représentée dans l'art au début des années 90. Au début, ses vidéos criardes irritaient encore, elles étaient trop kitsch, trop pleines d'effets, trop oniriques. On y voyait souvent l'ar-tiste, mais cet état de fait n'occultait en rien le contenu. Rist a parlé de a « lutte des classes qui fait rage entre la culture de la parole et celle de l'image ». En 1994, son installation « La Chambre » montrait claire-ment qui elle considérait comme les représentants de la culture de la parole. Autour d'un petit écran de télévision sont groupés d'immenses meubles et des fauteuils rouges dans lesquels des adultes étonnés sont noyés comme de petits enfants, le regard fasciné fixant l'écran. L'artiste montrait ainsi ses déficiences au spectateur, qui ne s'en aperçut pas, tant la manière de faire était subtile. Sur le plan du contenu, Rist décrit dans ses projections vidéo de plus en plus grandes la démence quoti-dienne des problèmes en suspens, mais sans jamais s'adonner au déses-poir. Dans « Ever is Over All », 1997, une jeune femme marche dans la rue et brise joyeusement les vitres des voitures garées le long du trot-toir. A côté, une deuxième projection montre des prés en fleurs. Une femme-policier apparaît et salue courtoisement la vandale. Dans ses œuvres, Pipilotti Rist met ainsi en scène de nouvelles alliances telles qu'un texte ne pourrait guère les communiquer, mais qu'on peut fort bien lire dans les images.

C. B.

03

PIPILOTTI RIST

SELECTED EXHIBITIONS: *1996* "Slept in, had a bath, highly motivated", Chisenhale Gallery, London, England /// Museum of Contemporary Art, Chicago (IL), USA /// *1998* "Remake of the Weekend in Berlin", Nationalgalerie im Hamburger Bahnhof Berlin, Berlin, Germany /// "Remake of the Weekend à Grenoble", Le Magasin – Centre National d'Art Contemporain, Grenoble, France /// *1999* "Remake of the Weekend in Zurich", Kunsthalle Zürich, Zurich, Switzerland **SELECTED BIBLIOGRAPHY:** *1994 Minima Media. Medienbiennale Leipzig. Handbuch zur Medienbiennale Leipzig 94*, Leipzig, Germany /// "Sinnliche Welten/Die Videos von Pipilotti Rist" in: *Blaue Wunder – Neue Filme & Videos von Frauen 1984–1994*, Hamburg, Germany /// *Suture – Phantasmen der Vollkommenheit*, Salzburger Kunstverein, Salzburg, Austria /// *1997 Ein Stück vom Himmel – Some Kind of Heaven*, Kunsthalle Nürnberg, Nuremberg, Germany; South London Gallery, London /// *1998 Exhibition catalogue*, Nationalgalerie im Hamburger Bahnhof Berlin, Berlin

04

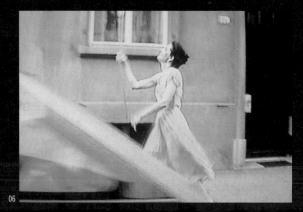

06

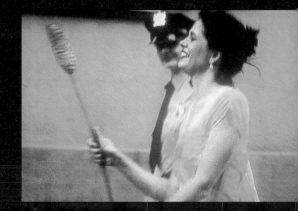

05

07

04 (ABSOLUTION) PIPILOTTI'S MISTAKES, 1988. Video still, video 12 mins. **05 I'M A VICTIM OF THIS SONG,** 1995. Video stills, video 4 mins. **06 EVER IS OVER ALL,** 1997. Video stills. **07 PIMPLE PORNO,** 1992. Video still, video 12 mins.

GERWALD ROCKENSCHAUB

1952 born in Linz, Austria / lives and works in Vienna, Austria

"My concern is with the definition and structuring of a social playing field that shows actions through their execution." « **Mon intérêt porte sur la définition et la structure d'un champ social qui présente ses actions par leur accomplissement.** »

At the centre of Gerwald Rockenschaub's artistic methodology stands the "White Cube" as the setting, essence and premise of modern art. Rockenschaub became known in the early 1980s with his geometrically abstract pictures reminiscent of pictograms. Towards the end of the 1980s, he began to express his reflections on the status and social place of art in three-dimensional form. Adopting the idiom of Minimal Art, his artistic endeavours aim to examine and restructure the visual focus and behavioural norms defined by the context of each work. Rockenschaub uses laconic allusions to the architecture of the exhibition space to create a dynamic relationship between artist, work and viewer. He steers the attention to the parameters of presentation, transforming the art institution into a kind of backdrop setting. The beholder becomes an actor, and like the exhibition space, an object viewable by other visitors. In

1989, Rockenschaub clad a wall of the Paul Maenz Gallery in Cologne with transparent plexiglass panels. Two years later he divided two exhibition rooms in the Lucerne art museum with a transparent synthetic sheet. In the Metropol Gallery he did this with a cord, and he guided visitors to the Austrian pavilion in Venice (1993) across a construction like a gangplank. As in his earlier projects, the attention of visitors was steered through the windows to the outside. In Zurich (1994) and Linz (1995), Rockenschaub returned to this dialogue between the art interior and the urban exterior. He showed photographs of Zurich and also a video that explored first the administration wings of the museum and then the city centre of Linz. As with the events at which Rockenschaub appears as a DJ, there is here a merging of areas that are socially different. Their boundaries become visible but also open.

INSTALLATION VIEW. 36 acrylic glass plates,
[?]0 x 100 x 1 cm (each), mounted on the wall with
[m]etal screws and washers. Galerie Paul Maenz, Cologne,
[G]ermany, 1989. **02 1997.** 3 digital prints, 55 x 90 cm,
[5]5 x 45 cm, 55 x 90 cm. **03 3 INFLATABLE PVC OBJECTS,**
[19]97. 2 inflatable walls, PVC, c. 220 x 450 x 35 cm
[e]ach); inflatable sofa, PVC, 50 cm (h), ø 200 cm.
[In]stallation view, Mehdi Chouakri, Berlin, Germany, 1997.

02

Au centre de la démarche artistique de Gerwald Rockenschaub,
[il] y a le «White Cube», lieu, essence et condition de l'art moderne.
[R]ockenschaub, qui s'est fait connaître au début des années 80 avec des
[t]ableaux géométriques abstraits rappelant des pictogrammes, devait
[t]ransposer dans la troisième dimension ses réflexions sur le statut (d'au-
[t]onomie) et l'espace social de l'art. Dans le prolongement du Minimal
[A]rt, ses interventions artistiques visent à une analyse et à une restructura-
[ti]on d'un regard et de normes de comportements définis par leur contexte.
[P]ar des interventions restreintes dans l'architecture de l'espace d'expo-
[s]ition, Rockenschaub dynamise le rapport entre l'artiste, l'œuvre et le
[s]pectateur. Il dirige l'attention sur les paramètres de la mise en scène et
[t]ransforme l'institution artistique en une situation spatiale qui tient du
[d]écor : le spectateur devient acteur et, tout comme la salle d'exposition,
[d]evient lui-même objet de regard pour d'autres spectateurs. En 1989,

Rockenschaub recouvrait ainsi un mur de la galerie Paul Maenz de pla-
ques de plexiglas transparentes ; en 1991, il séparait deux salles d'expo-
sition du Kunstmuseum de Lucerne avec une bâche plastique ou une
corde – comme dans la Galerie Metropol à Vienne –, ou encore, à Venise,
il faisait passer les visiteurs du pavillon autrichien par une rampe, 1993.
Comme cela avait déjà été le cas dans des projets antérieurs, des fenê-
tres dirigeaient le regard des visiteurs vers l'extérieur. A Zurich, 1994, et
à Linz, 1995, Rockenschaub devait reprendre ce dialogue entre espace
intérieur de l'art et espace urbain extérieur. Il présentait ainsi des photos
de Zurich et une vidéo qui exploraient les couloirs de l'administration du
musée, puis le centre-ville de Linz. Un peu comme lors des manifesta-
tions dans desquelles Rockenschaub apparaît comme DJ, on assiste ici au
regroupement de domaines sociaux définis comme séparés : leurs limi-
tes respectives apparaissent, mais deviennent aussi perméables. A. W.

03

GERWALD ROCKENSCHAUB

SELECTED EXHIBITIONS: *1992* Villa Arson, Nice, France /// *1993* XLV Esposizione Internationale d'Arte, la Biennale di Venezia, Venice, Italy, Austrian Pavilion (with Andrea Fraser and Christian Philipp Müller) /// *1993-1994* "Backstage", Kunstverein in Hamburg, Hamburg, Germany; Kunstmuseum Luzern, Lucerne, Switzerland /// *1994* Wiener Secession, Vienna, Austria /// *1996* "Das Labor", The New York Kunsthalle, New York (NY), USA (with Matta Wagnest) /// *1998* Galerie Hauser & Wirth 2, Zurich, Switzerland /// *1999* Kunstverein in Hamburg, Hamburg
SELECTED BIBLIOGRAPHY: *1989* Gerwald Rockenschaub, São Paulo Biennial, São Paulo, Brazil /// *1991* Gerwald Rockenschaub, Galerie Metropol Wien, Vienna; Kunstmuseum Luzern, Lucerne /// *1994* Gerwald Rockenschaub, Kunst – Kontext – Kritik, Wiener Secession, Vienna

04 / 05

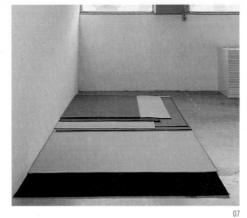

07 08

UNTITLED, 1992. Acrylic glass, Lisa blue, 57 x 45 x 4 cm. **05 UNTITLED,** 1996. Inflatable object, PVC, orange, 70 x 70 x 4 cm. **06 PLAKATWÄNDE FÜR AUSTRIAN LINES,** 1991. **07 TEPPICHE,** 1991. 456 x 206 cm. Installation view, Galerie Susanna Kulli, St. Gallen, Switzerland, 1991. **08 "BACKSTAGE",** installation view, stverein in Hamburg, Hamburg, Germany, 1993. **09 INSTALLATION VIEW,** XLV Esposizione Internationale d'Arte, la Biennale di Venezia, Venice, Italy, 1993.

THOMAS RUFF

"The difficulty with the portrait is to represent the smile." **« La difficulté dans le portrait, c'est de rendre le sourire. »**

Thomas Ruff – like Candida Höfer, Andreas Gursky and Thomas Struth – is pigeonholed with the tradition of Bernd and Hilla Becher's objective documentary photography. At first sight Ruff's various series – "Porträts" (Portraits), "Häuser" (Houses), "Zeitungsfotos" (Newspaper Photographs), and "Sterne" (Stars) – seem to fulfil the expectations of a sober recording of reality. But he is not so much concerned with copying and storing what exists as with realizing pictures from the world of his imagination, which follow strict, self-imposed rules of composition. So we find that his portrait subjects look straight into the camera, as in a passport photo, or like his "houses" are isolated from their architectural surroundings. Ruff's pictures are saturated with a fundamental scepticism as to the conceptions of truth and authenticity and any idea that they should use photography as "proof". The fact is that the technical apparatus has a decisive influence on form. By changing the parameters and employing some computer manipulation, he shows that each visual apparatus creates the reality that it claims to reveal. In this sense, his works are "documents of disbelief" (Ruff). They reflect the conditions of perception, the peculiarities of the photographic medium and the (implicit) political dimension of its use. For instance, the night pictures made during the Gulf War had a bearing on the use of military recording technology for wartime reporting – a synonym for the voyeurism of the western television viewer. Ruff's latest group of works, "Plakate" (Posters), since 1997, make this political dimension clear. In large-scale computer montages in the style of John Heartfield, he treats the self-satisfied attitudes of contemporary politicians with reductive irony, though the multi-levelled composition eludes an unambiguous interpretation.

Comme Candida Höfer, Andreas Gursky et Thomas Struth, Thomas Ruff est classé dans le sillage de la photographie objective documentaire de Bernd et Hilla Becher. A première vue, ses séries de « Portraits », de « Maisons », de « Photos de journaux » et d'« Etoiles » semblent répondre aux attentes d'un constat sobre de la réalité. Le propos de Ruff est cependant moins la représentation et l'archivage du donné que la création d'images issues de son imaginaire, et qui suivent des lois de composition rigoureuses que l'artiste s'impose à lui-même. Les personnes représentées ont ainsi le regard dirigé de face vers l'objectif – comme pour une photo d'identité –, ou bien les « Maisons » sont isolées de leur environnement architectonique. Les images de Ruff portent l'empreinte d'un scepticisme fondamental à l'égard des concepts de vérité et d'authenticité, concepts qui tendent à se servir de la photographie comme d'une « preuve ». L'outil technique exerce en effet une influence décisive sur la forme. En modifiant les paramètres et en manipulant en partie l'image sur ordinateur, Ruff nous montre que tout appareil (de prise de vues) est créateur de la réalité qu'il prétend dévoiler. En ce sens, les œuvres de Ruff sont des « documents de l'incroyance », selon les termes même de l'artiste : elles reflètent les conditions de la perception, les spécificités du médium photographique et la dimension politique implicite de son emploi. Réalisées pendant la guerre du Golfe, les photos de la série « Nuit » renvoient ainsi à l'utilisation des techniques militaires destinées aux rapports de guerre – synonymes du voyeurisme du téléspectateur occidental. « Affiches », le dernier travail de Ruff, met en évidence cette dimension politique : dans de grands montages informatiques réalisés dans le style de John Heartfield, Ruff ironise sur l'autosatisfaction des politiciens d'aujourd'hui, tandis que les multiples niveaux de la composition échappent à toute lecture univoque. A. W

THOMAS RUFF

SELECTED EXHIBITIONS: *1988* Museum Schloß Hardenberg, Velbert; Portikus, Frankfurt/M., Germany /// *1991* Bonner Kunstverein, Bonn, Germany /// "Axel Hütte: Architecture, Thomas Ruff: Portraits", The Museum of Contemporary Photography of Columbia College Chicago, Chicago (IL), USA /// *1992* documenta IX, Kassel, Germany /// *1996* Rooseum – Center for Contemporary Art, Malmö, Sweden /// *1997* "Œuvres 1979–1997", Centre National de la Photographie, Paris, France /// "Young German Artists 2", Saatchi Gallery, London, England
SELECTED BIBLIOGRAPHY: *1989 Porträts, Häuser, Sterne*, Stedelijk Museum, Amsterdam, The Netherlands; Le Magasin – Centre National d'Art Contemporain, Grenoble, France; Kunsthalle Zürich, Zurich, Switzerland /// *1996 Exhibition catalogue,* Rooseum – Center for Contemporary Art, Malmö /// *1997 Exhibition catalogue,* Centre National de la Photographie, Paris

Pages 434/435: **01 "YOUNG GERMAN ARTISTS 2"**, installation view, Saatchi Gallery, London, England, 1997. **02 11 H 12 M / -45°**, 1989. C-print, 260 x 188 cm
Pages 436/437: **03 NACHT 9 I**, 1992. C-print on plexi, 190 x 190 cm. **04 PLAKAT IV**, 1997. C-print, 225 x 180 cm.

03

SAM SAMORE

"My photographs continue the tradition of Renaissance portraiture; conceptually, they are paintings." « Mes photographies sont un prolongement du portrait de la Renaissance ; conceptuellement, ce sont des peintures. »

No one knows the people in these photographs, or when and where the photos were taken. They have no informational value and no history. And yet each one seems to tell us something about their subjects, who may be thoughtful, in a hurry, talking, or just looking past one another. Sam Samore did not take these photos himself, but commissioned professional photographers. Then he sifted through thousands of pictures before making his selections, deciding which details to enlarge. The black and white photographs are often grainy and look as though they were shot surreptitiously. It is fascinating to speculate about their sources, especially as Samore gives the images a uniform style in an attempt to wipe out any trace of their origins. Titles such as "Situations

1980s", compound the viewer's uncertainty. The overall work provides a kind of anonymous catalogue of public places, documenting exactly where people were at a particular time. Only once did Samore wield the camera himself, when he produced photos for the series "Allegories of Beauty (incomplete)", which show strong affinities with historical images from art and film. In recent works, Sam Samore the narrator comes more into the foreground. The relationships between human beings, which he had previously presented visually, are now described in the form of fairy tales transmitted over loudspeakers set in the midst of groups of plants. Again, the identity of those presented is left open. The stories sound so generalised, and yet one feels one knows the situation described.

Des photos dont personne ne sait qui elles montrent, où et quand elles ont été prises, des photos qui n'ont pas la moindre valeur informative, qui ne recèlent aucune histoire. Et pourtant chacune semble raconter quelque chose de ces hommes pensifs, pressés, conversant ou passant les uns à côté des autres sans échanger un regard. Sam Samore n'a pas pris ces photos lui-même mais les a commandées à des photographes professionnels. Après en avoir examiné des milliers, après avoir effectué un deuxième tri, il a choisi de faire agrandir telle ou telle image, tel ou tel détail. Ces photos en noir et blanc présentent souvent un grain grossier, elles donnent l'impression d'images prises à la dérobée, ce qui rend leur histoire éventuelle d'autant plus passionnante. Entre autres parce que Sam Samore est aussi parvenu à conférer à ses œuvres un style homogène et à faire disparaître toute trace de leur genèse. Même

le titre constant « Situations 1980s » laissait le spectateur dans le vague. Dans l'ensemble, c'est une sorte de catalogue anonyme qui a ainsi vu le jour, catalogue qui dresse un constat très précis des états d'âme humains dans les lieux publics à une époque donnée. Une fois seulement, Sam Samore est lui-même passé de l'autre côté de l'objectif en produisant pour la série « Allegories of Beauty (incomplete) » des photos qui dénotent de fortes affinités avec l'histoire de l'art et du cinéma. Dans ses œuvres récentes, le narrateur Sam Samore se fait plus présent. Le rapport entre les hommes, qu'auparavant il visualisait, est aujourd'hui décrit sous forme de contes diffusés par des haut-parleurs disposés dans des ensembles végétaux. Une fois de plus, la question reste posée de savoir de qui parlent ces histoires. Elles semblent si anonymes et pourtant, on a le sentiment de connaître les situations. C. E

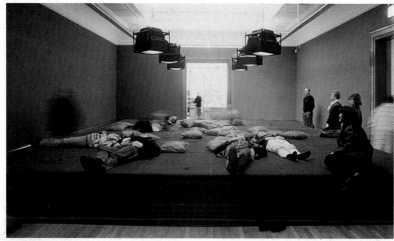

01 THE MAGIC BED, 1995/96. Installation view, "The Peace Process", Ferens Art Gallery, Hull, England, 1995. **02 ALLEGORIES OF BEAUTY (INCOMPLETE)**, 1995. B/w photography, 106 x 214 cm. **03 ALLEGORIES OF BEAUTY (INCOMPLETE)**, 1996. B/w photography, 112 x 213 cm. **04 ALLEGORIES OF BEAUTY (INCOMPLETE)**, 1995. B/w photography, 118 x 211 cm.

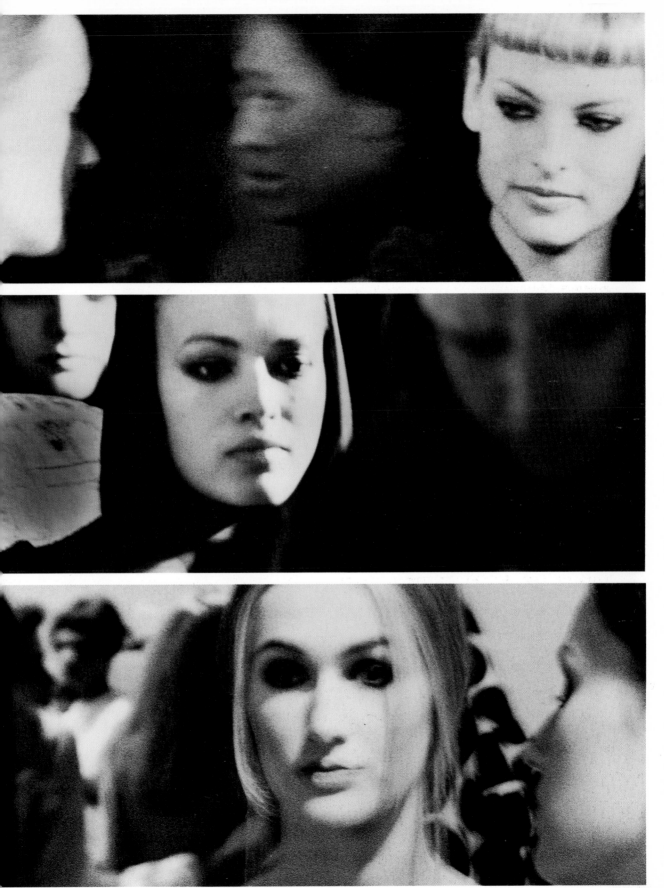

SAM SAMORE

SELECTED EXHIBITIONS: *1994* "Situations", Kunsthalle Zürich, Zurich, Switzerland (with Harald F. Müller) /// *1996* "Allegories of Beauty (incomplete)", daadgalerie, Berlin, Germany /// Ecole des Beaux-Arts de Nîmes, Nîmes, France /// *1997* "Fictions", Centre National de la Photographie, Paris, France /// *1999* Centre d'Art Contemporain, Tours, France **SELECTE**
BIBLIOGRAPHY: *1990 Situations*, Graz, Austria /// *1994 Tangled web of erotic savage cunning*, Stichting De Appel, Amsterdam, The Netherlands /// *1996 Allegories of Beauty (incomplete)*, daad galerie, Berlin /// *1998 Sumptous Fire of the Stars*, Cologne, Germany /// *Forest of Schizophrenic Love Stories*, Galerie für zeitgenössische Kunst Leipzig, Leipzig, Germany

JÖRG SASSE

1962 born / lives and works in Düsseldorf, Germa

"It is not what is portrayed with reference to reality that makes a photograph autonomous but how it is portrayed." « Ce n'est pas la chose représentée avec référence à la réalité qui confère son autonomie à une photographie, mais la manière dont elle est représentée. »

We normally talk about a photographer's good eye through the viewfinder, but in Jörg Sasse's case it is more to the point that he has a good eye in front of the computer screen. Since 1994 he has rarely worked with material photographed himself, using amateur photographs instead, which he subjects to digital adaptation according to artistic criteria. These photos are skilfully manipulated into sensitively composed pictures of everyday reality, similar to Impressionist works of a century ago. Sasse adjusts proportions and colours with an assiduous attention to detail that requires considerable digital experience. He removes objects and introduces new ones, creating movement or introducing close-ups and long-shots. In this way, versions of situations emerge that could never have been photographed before, because they do not exist. But all this is visible only to the knowing eye, for Sasse's subjects tend to be totally unspectacular. His pictures are absolutely credible at first glance whether they show boulders in the forest, a car race, high-rise buildings a beach; there is no room for suspicion of falsification. It is not until we take a second look that a fine pattern of precisely planned lines appear Walls, or the shores of a lake, are aligned across the picture, a chimney takes up the line of a stairwell, an unfocused fence in the foreground corresponds in its gentle curve to the undulation of the hills in the distance. Sasse never overdoes these pictorial features, but brings then out so that they cannot be overlooked, so long as one is prepared to le one's gaze range sensitively over his pictures.

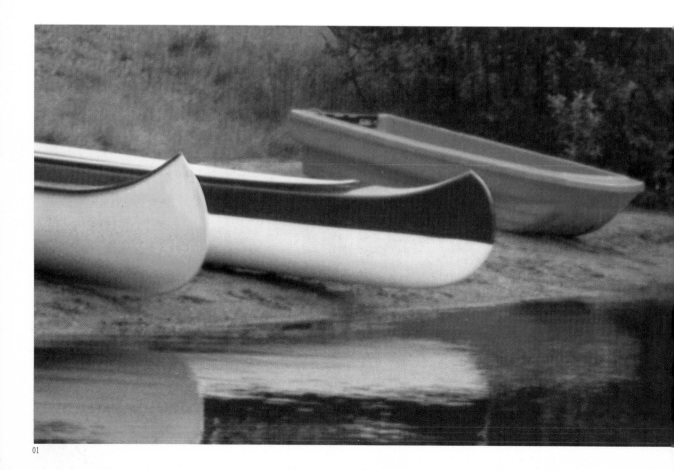

7341, 1996. 93 x 150 cm. **02 4328,** 1995 (left); **8087,** 1995 (right). 83 x 116 cm (each). Installation view, Galerie Wilma Tolksdorf,
ımburg, Germany, 1995. **03 3502,** 1995. 37 x 55 cm.

Si l'on parle ordinairement pour un photographe d'un bon coup
œil à travers le viseur, il convient d'attribuer en outre à Jörg Sasse un
il assuré sur le moniteur. Depuis 1994, l'artiste ne travaille plus guère
effet sur son propre matériel photographique. Il se sert de photos
amateurs qu'il soumet au traitement digital d'un point de vue purement
tistique. Les images sont pour cela manipulées d'une façon si habile
'il en résulte des compositions subtiles de la réalité quotidienne, pres-
e comme aux temps de l'impressionnisme, voici une centaine d'années.
r un menu travail de digitalisation souvent fastidieux et qui exige une
ande expérience, Sasse recale les proportions et les couleurs, ôte des
jets, en introduit de nouveaux, génère un mouvement, recrée une pro-
mité ou un éloignement. Il en résulte des reproductions de situations
i n'auraient jamais pu être photographiées ainsi parce qu'elles ne se
ésentent jamais telles quelles dans la réalité. Mais seul le spécialiste

peut s'en rendre compte, car les sujets de Sasse tendent à l'absence
totale de spectaculaire. A première vue, l'image est totalement crédible,
qu'il s'agisse de grands blocs de pierre dans une forêt, d'une course
automobile, de gratte-ciel ou bien d'une plage, et aucun soupçon ne
s'éveille quant à une quelconque manipulation. C'est seulement en y
regardant plus longuement qu'on voit se dégager tel ou tel motif subtil
de lignes disposées avec une grande exactitude. Les murs ou les riva-
ges d'un lac traversent très parfaitement l'image, une cheminée prolonge
les lignes d'une cage d'escalier, au premier plan, un grillage flou corres-
pond en son incurvation légère au galbe d'une colline loin à l'arrière-plan.
Sasse ne souligne jamais trop lourdement ces interventions, juste ce
qu'il faut pour qu'on les remarque. Et encore, seulement si l'on est prêt
à laisser flâner son regard et sa sensibilité. C. B.

JÖRG SASSE

SELECTED EXHIBITIONS: *1996* Kölnischer Kunstverein, Cologne, Germany /// *1997* Musée d'Art Moderne de la Ville de Paris, Paris, France /// Kunsthalle Zürich, Zurich, Switzerland *1998* Portikus, Frankfurt/M., Germany **SELECTED BIBLIOGRAPHY:** *1992 Jörg Sasse – Vierzig Fotografien,* Munich, Germany /// *1996 Jörg Sasse,* Kölnischer Kunstverein, Cologne; Kunsthalle Zürich, Zurich; Stuttgart, Germany /// *1997 Jörg Sasse,* Musée d'Art Moderne de la Ville de Paris, Paris

04

04 5127, 1995. 116 x 90 cm. **05 8034**, 1997. 84 x 120 cm. **06 4251**, 1994. 124 x 90 cm.

05

JULIA SCHER

1954 born in Hollywood (CA) / lives and works in New York (NY), US

"Power and its abuse are my most important theme: how power is abused to hurt people." **« Le pouvoir, l'abus de pouvoir, est mon thème principal : la manière dont on abuse du pouvoir pour faire du mal aux gens. »**

Julia Scher has gone deeper than any other artist in her investigation into the surveillance functions of the electronic media. Taking intercoms, video technology, different computer programmes and material from the Internet, she builds confusing installations in order to question their role in supervisory authority. But as well as analysing the problematic aspects of the exercise of power through surveillance, she explores its fascination. "There is such a thing as the desire to be supervised," she alleges, referring to the need for security and order. In 1993, Scher installed a video camera in the men's toilet during a group exhibition at the Hamburg Kunstverein. The film, shot from a viewpoint that made the most intimate details visible, was screened simultaneously on monitors in the gallery for all to see. What is normally hidden shamefully behind closed doors acquired the status of a work of art. The reactions of the people involved, including the viewers, who were surprised to become voyeurs, ranged from curiosity and amusement to furious indignation. A the same time the work posed questions about the administration of these surveillance systems: who decides what, when and where one can film and view, and why was a camera not installed in the ladies' toilet as well? In recent works Scher has also used acoustic media to focus discussion on the mechanisms of subliminal influence. In a New York disco for instance, the artist continually interrupted the self-abandoned absorp tion in the rhythmic world of sound on the dance floor with random criti cal phrases such as "your tolerance of surveillance" or "there is no privacy in this space". The self-abandoned absorption in the rhythmic world of sound on the dance floor was not actually inhibited but continually interrupted by such reflections.

Comme presque aucun autre artiste, Julia Scher s'est intéressée aux fonctions de surveillance des médias électroniques : elle met en œuvre des interphones, des techniques vidéo, différents programmes informatiques et Internet dans d'irritantes installations pour interroger leur rôle d'instance de contrôle. Mais Scher ne met pas seulement en évidence les aspects problématiques de l'exercice d'un pouvoir de surveillance, elle montre aussi la fascination qui en émane. « Il existe un désir d'être contrôlé », affirme l'artiste en évoquant le besoin d'ordre et de sécurité. En 1993, au Kunstverein de Hambourg, Scher avait installé une caméra vidéo dans les toilettes pour hommes à l'occasion d'une exposition de groupe. Les images filmées étaient présentées sur des moniteurs, et tous les spectateurs de la salle d'exposition pouvaient les voir en direct. Le cadrage était choisi de manière à montrer les aspects les plus intimes. Les réactions des personnes concernées, mais aussi celles des spectateurs devenus voyeurs malgré eux, allaient de la curio sité amusée au désarroi indigné. En même temps, ce travail posait la question des limites permises à ce type de systèmes de surveillance : qui décide de ce qui peut être filmé quand et par qui ? Et qui a le droit d'être vu ? Pourquoi une caméra n'avait-elle pas été installée également dans les toilettes pour dames ? Dans des œuvres plus récentes, Scher se sert aussi de médias acoustiques pour ouvrir le débat sur les métho des d'influence subtile et leurs mécanismes. Dans une discothèque de New York, l'artiste introduisait selon un principe aléatoire dans la musi que des bribes de phrases critiques (à l'égard des médias) comme « your tolerance of surveillance », ou encore « there is no privacy in this space ». Ainsi, sans être entravé, l'oubli de soi immergé dans l'univers sonore de la piste de danse se trouvait néanmoins sans cesse interrompu dans le sens d'une réflexion. *R.*

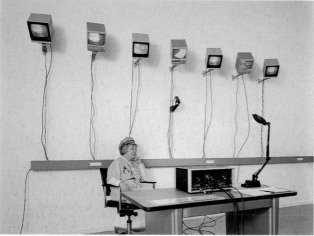

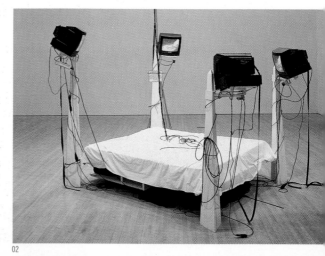

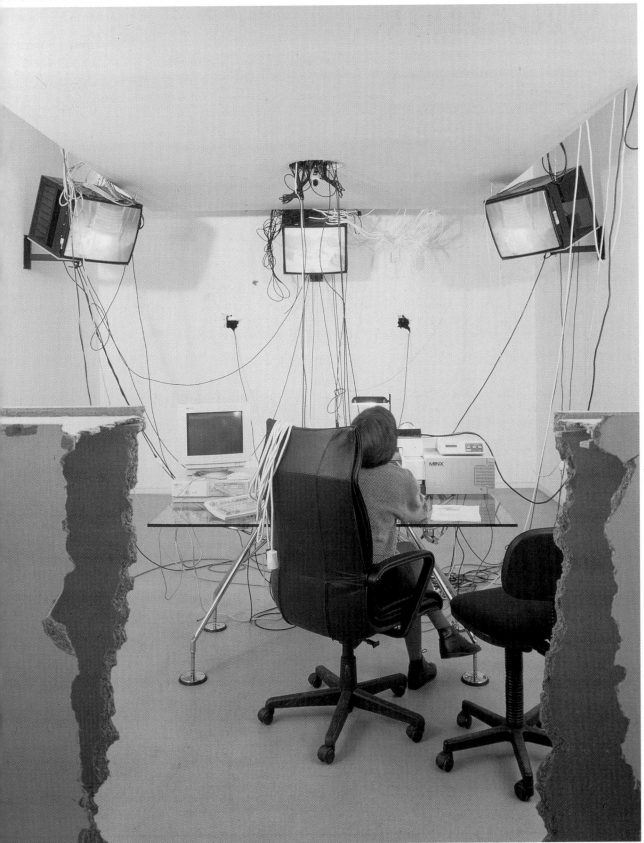

JULIA SCHER

SELECTED EXHIBITIONS: *1989–1990* "Occupational Placement: (O.P.)", Wexner Center for the Arts, Columbus (OH), USA /// *1994* "Don't Worry", Kölnischer Kunstverein, Cologne, Germany /// *1996* Fri-Art, Centre d'Art Contemporain, Fribourg, Switzerland (with Vanessa Beecroft) /// *1998* "Predictive Engineering II", San Francisco Museum of Modern Art, San Francisco (CA), USA /// "wonderland", Andrea Rosen Gallery, New York (NY), USA **SELECTED BIBLIOGRAPHY:** *1989 Exhibition catalogue*, Biennial Exhibition, Whitney Museum of American Art, New York /// *1997 Exhibition catalogue*, Fri-Art, Centre d'Art Contemporain, Fribourg /// *1998 Predictive Engineering II*, San Francisco Museum of Modern Art, San Francisco

04 WONDERLAND, 1998 (foreground). Mixed media, computer controlled installation, dimensions variable. **LENA,** 1997 (background). Duraflex, 183 x 127 cm.
05 SURVEILLANCE BED, 1994. Bed, monitors, brackets, cameras, mixed media and hardware, dimensions variable.

GREGOR SCHNEIDER

1969 born in Rheydt / lives and works in Rheydt, Germany

"The brain cuts out and the body goes on turning until it tears." « **Le cerveau reste là et le corps continue de se tordre jusqu'au point de rupture.** »

Fourteen years ago Gregor Schneider, now 30 years old, began to convert his house in Rheydt, on the lower Rhine. Since then, he has gone on with his principal work, this "ur" house in Unterheydner Strasse. He builds walls in front of existing walls which often look identical to those behind them. Frequently he puts sound-insulating materials such as sheets of lead behind the walls, which he then plasters. The result is that the rooms become smaller with each layer and their proportions alter. One physically senses the effect of an increasingly oppressive atmosphere, without at first being able to make out what has caused it. As a result of all this conversion work, Schneider can no longer reconstruct the original layout of the house. One room in the house has been revolving with imperceptible slowness on its own axis. Others may have several windows arranged behind one another, with lamps placed between the panes of glass to simulate natural light. After finishing the architectural alterations, Schneider makes photos and videos of his house. He films the interior rooms in long, motionless takes, or stumbles through the house with a hand-held camera, providing glimpses of otherwise hidden nooks and crannies. When he first began exhibiting, Schneider reconstructed the rooms of the gallery like the rooms of his house, but the conversion was not clearly visible in the end. Since 1994, therefore, he has been dismantling whole rooms from his house stone by stone and rebuilding them in museums and galleries. In this way he manages to transfer the atmosphere specific to his house into an exhibition context.

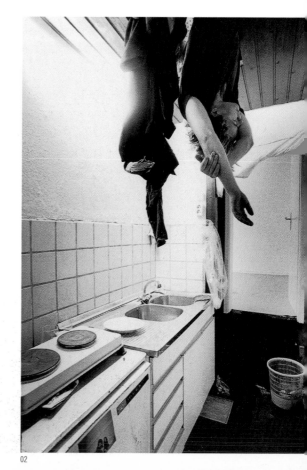

01 TOTES HAUS UR, RHEYDT 1985–1997. 02 PORTRÄT GREGOR SCHNEIDER, U7 – 10, KÜCHE, RHEYDT 1987. Installation view, "Schneider Totes Haus ur 1985/97, Rheydt", Portikus, Frankfurt/M., Germany, 1997. 03 EINGANG ZUM KAFFEERAUM. 04 UR10, DREHENDES KAFFEE-ZIMMER, RHEYDT 1993. 05 UR 10, DREHENDES KAFFEE-ZIMMER, WIR SITZEN, TRINKEN KAFFEE UND SCHAUEN EINFACH AUS DEM FENSTER, RHEYDT 1993.

03 04

Cela fait aujourd'hui treize ans que l'artiste âgé de trente ans a commencé à réaménager sa maison de Rheydt, une petite ville de Basse-Rhénanie. Depuis, il continue de travailler sur son œuvre majeure, la maison «ur» de la Unterheydner Straße. Schneider monte des murs devant des murs existants; ces murs ont parfois l'aspect de ceux qu'ils cachent. En installant des isolants acoustiques, mais aussi des plaques de plomb sous les murs avant de les enduire, les pièces de la maison changent non seulement de taille et de proportions, elles changent aussi d'atmosphère, celle-ci devenant de plus en plus étrange. Si le spectateur ressent l'oppression physiquement, il peut en même temps en percevoir directement la cause. Parfois, après une évolution de longue durée, une pièce peut faire un tour complet sur elle-même. Au-delà de ses inter-ventions purement architecturales, Schneider réalise des photos et des vidéos qui ont elles aussi pour sujet sa maison. De longs plans immobiles nous montrent l'intérieur des pièces d'aspect ordinaire, ou bien l'artiste se sert d'une caméra mobile avec laquelle il parcourt sa maison avec une démarche heurtée, donnant aussi un aperçu de certaines zones normalement fermées au visiteur. Alors qu'au début de son activité d'exposant il modifiait les galeries comme les pièces de sa maison, sans que le résultat de son intervention se remarque, dernièrement, Schneider découpe des pièces de sa maison, les expose dans des musées et des galeries, transposant ainsi l'atmosphère particulière de la demeure dans les institutions respectives. Y. D.

GREGOR SCHNEIDER

SELECTED EXHIBITIONS: *1996* Künstlerhaus Stuttgart, Stuttgart, Germany /// *1997* "Schneider Totes Haus ur 1985/97, Rheydt," Portikus, Frankfurt/M., Germany /// *1998* Städtisches Museum Abteiberg, Mönchengladbach, Germany /// Musée d'Art Moderne de la Ville de Paris, Paris, France /// Aarhus Kunstmuseum, Aarhus, Denmark **SELECTED BIBLIOGRAPHY:** *1994 Gregor Schneider, Arbeiten 1985–1994*, Museum Haus Lange, Krefeld, Germany /// *1996 Gregor Schneider*, Kunsthalle Bern, Berne, Switzerland /// *1998 Gregor Schneider, Dead House ur 1985–1997*, Städtisches Museum Abteiberg, Mönchengladbach; Galeria Foksal, Warsaw, Poland; Portikus, Frankfurt/M.; Musée d'Art Moderne de la Ville de Paris, Paris

06

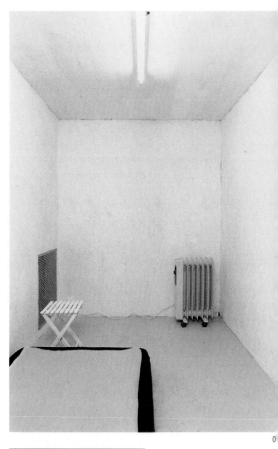

0

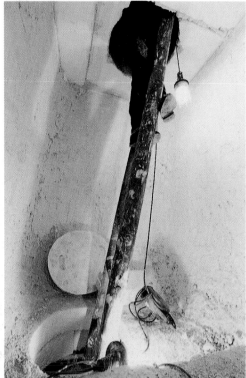

07

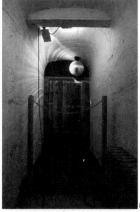

09

06 UR 1, RHEYDT 1986. 07 UR 17, IM KERN, RHEYDT 1996. 08 UR 12, TOTAL ISOLIERTES GÄSTEZIMMER, HAUS UR, RHEYDT 1995. 09 UR 18, PUFF, RHEYDT 1996. 10 UR 9, GROSSER RAUM, GALERIE LÖHRL, MÖNCHENGLADBACH 1992. Installation view, Galerie Löhrl, Mönchengladbach, Germany, 1992. 11 UR 15, KATHEDRALE, KUNSTHALLE BERN 1996. Installation view, Kunsthalle Bern, Berne, Switzerland, 1996.

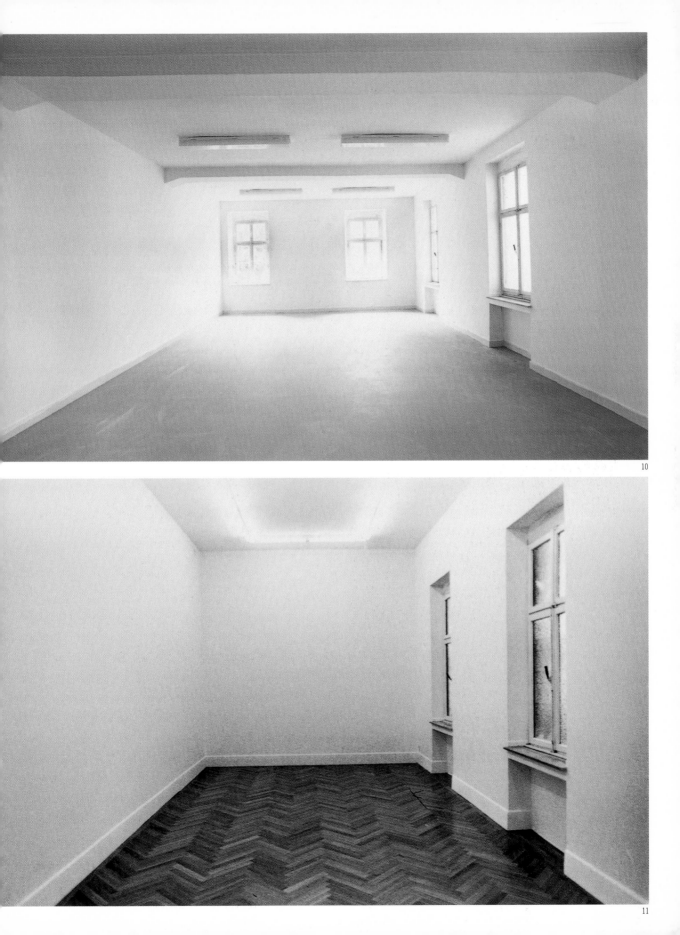

ANDREAS SCHULZE

1955 born in Hanover / lives and works in Cologne, Germany

"It is always a good sign if things go quickly." « Quand ça va vite, c'est toujours bon signe. »

Andreas Schulze is a phenomenon. He emerged in the context of the "Neue Wilde" (New Wild Ones), who, around 1980, were concerned with the rebirth of painting. He has come to the fore again in the 1990s. Schulze has developed a personal, almost Surrealistic vision of painting, which he has consistently pursued to the present day, at first in a coded way, and later in a more decipherable style. The paintings begin with real, simple subjects and forms – peas, balls, rooms, houses – but these are unravelled on to the picture area as if propelled by dreams. In recent exhibitions, Schulze has demonstrated the inner relationship between his paintings and a bourgeois, essentially German mentality, which he partly connects with himself and partly observes from a distance. For instance, he exhibited a living room in which the paintings were displayed along-side his own personal furniture – lamps, cutlery and a carpet designed by Schulze himself – to make up a complete interior. In another exhibition, an inherited Meissen soup tureen was displayed whose flower decoration had previously been used as a motif in his paintings. Another time he constructed a miniature model town that illustrates the idyll of urban Germany: post-war Modernism with neon advertisements, crumbling and restored remains of a historic city centre, and among them, building sites on one of which is a notice of the opening of a Prada boutique. Schulze's connections between art and reality anticipate the central themes of younger artists of the 1980s and 1990s: provenance and mentality, design and everyday life.

Andreas Schulze est un phénomène. Le début de son œuvre remonte à l'époque et à l'entourage immédiat des Nouveaux Sauvages, qui devaient œuvrer à la renaissance de la peinture vers 1980. Sa célébrité et l'histoire de son influence se révèlent de nouveau dans les années 90. Schulze a développé une vision très personnelle de la peinture, qu'il poursuit de façon cohérente jusqu'à ce jour – d'abord de manière cryptée, mais aujourd'hui lisible. Ses peintures semblent surréelles. Elles s'appuient sur des formes et des motifs simples tirés de la réalité et qui, comme guidés par des rêves, se poursuivent dans l'espace du tableau : petits pois, ballons, chambres, maisons... Dans ses expositions récentes, Schulze a mis en évidence le rapport sous-jacent entre sa peinture et une mentalité bourgeoise, au fond très allemande, mentalité qu'il met en rapport avec lui-même et sur laquelle il jette parfois un regard panorami-que. Il a ainsi exposé un salon dans lequel les peintures sont associées à son mobilier privé – lampes, couverts et tapisserie conçue par lui-même – pour former un intérieur complet. Dans une autre exposition, on a pu voir une soupière en porcelaine de Meissen, héritage familial dont le décor floral avait auparavant servi dans ses peintures. De plus, l'artiste construit une ville miniature qui illustre l'idylle de la ville allemande : modernisme d'après-guerre avec enseignes de néon, vestiges de la vieille ville, en ruine ou restaurée, le tout parsemé de chantiers sur lesquels on annonce par exemple l'ouverture d'une boutique. Les rapports que Schulze établit entre l'art et la réalité annoncent les thèmes centraux des jeunes artistes des années 80 et 90 : origine et mentalité, design et vie quotidienne. S. T.

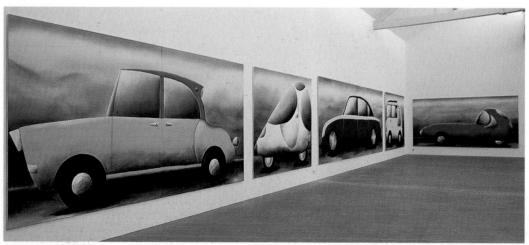

02

03

ANDREAS SCHULZE

SELECTED EXHIBITIONS: *1985* Barbara Gladstone Gallery, New York (NY), USA /// *1988* Museo de Arte Contemporáneo de Sevilla, Sevilla, Spain /// *1997* Sprengel Museum Hannover, Hanover, Germany /// "Home Sweet Home", Deichtorhallen Hamburg, Hamburg, Germany /// *1998* Monika Sprüth Galerie, Cologne, Germany **SELECTED BIBLIOGRAPHY:** *1989 Bilder 1980-88*, Kunstverein München, Munich, Germany; Fonds Regional d'Art Contemporain des Pays de la Loire Nantes & Clisson, Nantes, Clisson, France; Kunstmuseum Luzern, Lucerne, Switzerland /// *1993 Exhibition catalogue*, Kunstverein in Hamburg, Hamburg /// *1997 Exhibition catalogue*, Kunstverein Kreis Ludwigsburg, Ludwigsburg, Germany

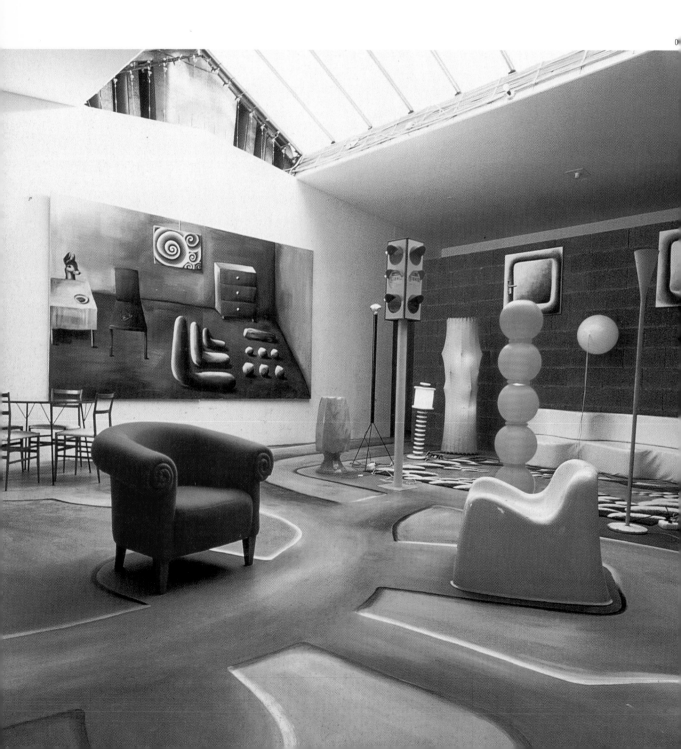

05

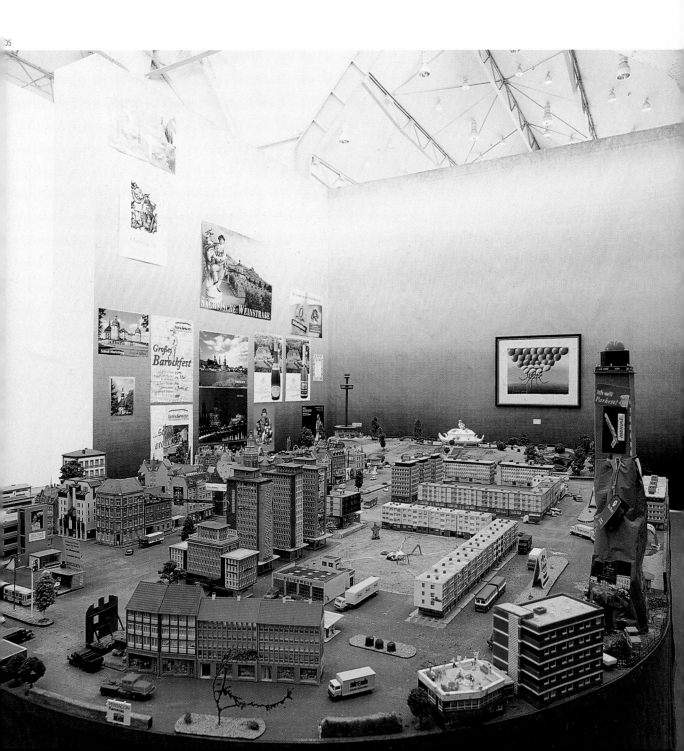

ANDRES SERRANO

"In my work I always seek the unusual, or at least what is not traditionally considered beautiful. In my work I try to find the normal in the strange, and vice-versa." « **Dans mon œuvre, je suis toujours à la recherche de l'inhabituel, ou du moins ce qui n'est pas traditionnellement considéré comme beau. Dans mon œuvre, je tâche de trouver le normal dans l'étrange et vice versa.** »

Andres Serrano became known in 1989 as a result of a cultural and political scandal when his work "Piss Christ" of 1987 caused a heated debate in the USA about the freedom of art and its state financing. Serrano's colour photograph of a Christ figure submerged in a glass of urine struck conservatives as blasphemy. But Serrano's work aimed at something more than just shock effect. "Piss Christ" combines essential aspects of his artistic purpose – the fascination that religious symbols held for him, his ambivalent relationship with the church as an institution (e.g. "Heaven and Hell", 1984), and his preoccupation with the very metaphorically and emotionally loaded bodily secretions of blood, milk, urine and sperm. In "Bodily Fluids", 1985–1990, Serrano applies these like pure colours – his close-up photographs recall monochrome pictures or works of Abstract Expressionism. The tension between photographic directness and a theatrically baroque stylization of – still provocative –

themes like religion, the body, sex and death is characteristic of Serrano's methodology. He returns to the traditional genre of the portrait in "Klan", 1990, and "The Church", 1991. Serrano represents members of the Ku Klux Klan or monks and nuns like icons in their habits in front of a monochrome background. In a similar kind of typification, portraits of the homeless become "Nomaden", 1990, and the corpses in "The Morgue", 1992, become allegories of a usually premature and violent death. "Budapest", 1994, and particularly "The History of Sex", 1997, show human sexuality in the most various and socially taboo forms. These works are much more prosaic in their subjects and in their pictorial language, which is close to the glossy aesthetic of the media. Serrano is never judgmental in his endeavour to find the "normal in the strange", and he plays with popular ideas of beauty and morals, but also with the voyeuristic curiosity of his viewers.

01

01 THE MORGUE (AIDS RELATED DEATH II), 1992. Cibachrome, 126 x 152 cm. **02 THE MORGUE (KNIFED TO DEATH I)**, 1992 . Cibachrome, 126 x 152 cm.
03 THE MORGUE (KNIFED TO DEATH II), 1992. Cibachrome, 126 x 152 cm . **04 THE MORGUE (FATAL MENINGITIS II)**, 1992. Cibachrome, 126 x 152 cm.

Andres Serrano s'est rendu célèbre en 1989 à l'occasion du scandale culturel et politique déclenché par son travail « Piss Christ », 1987, qui fut à l'origine aux Etats-Unis d'un violent débat sur la liberté de l'art et son financement par l'Etat. La photographie couleur d'une figure du Christ plongée dans un récipient rempli d'urine fut considérée comme un blasphème par les conservateurs. Mais le travail de Serrano ne visait pas seulement à produire un effet de choc. « Piss Christ » associe les aspects essentiels de sa démarche artistique : la fascination qu'exercent sur lui les symboles religieux, son rapport ambigu à l'égard de l'Eglise (par exemple dans « Heaven and Hell », 1984, et sa confrontation avec les sécrétions corporelles fortement connotées sur le plan émotionnel telles que le sang, le lait, l'urine, le sperme. Dans « Bodily Fluids », 1985– 1990, Serrano employait ces sécrétions comme de pures couleurs –

ses prises de vues rapprochées rappellent des tableaux monochromes ou des œuvres de l'expressionnisme abstrait. La tension entre l'immédiateté photographique et une stylisation baroque et théâtrale autour de thèmes – toujours provocateurs – tels que la religion, le corps, le sexe et la mort, sont caractéristiques de la démarche de Serrano. Ainsi, dans « Klan », 1990, et « The Church », 1991, il aborde le genre traditionnel du portrait : il met en scène – comme des icônes et sur fond monochrome – des membres du Ku Klux Klan assimilés à des moines et des nonnes dans leurs bures. D'une manière similaire, les sans-abri deviennent dans ses portraits des « Nomades », 1990, et les cadavres de « The Morgue », 1992, les allégories d'une mort le plus souvent prématurée et violente. Nettement plus prosaïques par leur sujet comme par leur langage iconique, « Budapest », 1994, et en particulier « The History of Sex », 1997, qui se servent de l'esthétique léchée des médias, présentent la

04

ANDRES SERRANO

SELECTED EXHIBITIONS: *1994–1996* "Andres Serrano: Works 1983–93", The Institute of Contemporary Art, University of Pennsylvania, Philadelphia (PA); The New Museum of Contemporary Art, New York (NY); Center for the Fine Arts, Miami (FL); Contemporary Arts Museum, Houston (TX); Museum of Contemporary Art, Chicago (IL), USA; Malmö Konsthall, Malmö, Sweden /// *1997* "A History of Andres Serrano: A History of Sex", Groninger Museum, Groningen, The Netherlands /// *2000* "Body and Soul", Bergen Fine Art Society, Bergen; Kristiansand Art Society, Kristiansand; Tromsø Art Society, Tromsø, Norway **SELECTED BIBLIOGRAPHY:** *1996 Andres Serrano: The Morgue*, Tel Aviv Museum of Art, Tel Aviv, Israel /// *Andres Serrano*, Malmö Konsthall, Malmö /// *1997 A History of Andres Serrano: A History of Sex*, Groninger Museum, Groningen

05 UNTITLED VII (EJACULATE IN TRAJECTORY), 1989. Cibachrome, 102 x 152 cm. **06 PISS CHRIST,** 1987. Cibachrome, 152 x 102 cm.

05

JEFFREY SHAW

1944 born in Melbourne, Australia / lives and works in Karlsruhe, Germany

"The interactive art work is a virtual space of images, sound and text, etc. which reveals itself when acted upon by a user." « L'œuvre d'art interactive est un espace virtuel d'images, de son et de texte, etc. qui se révèle avec l'intervention du spectateur. »

Jeffrey Shaw's best-known work is a bicycle made of letters of the alphabet on which one can ride through town. Houses become words, streets become sentences, and districts become paragraphs and chapters. The bicycle is real, but the picture of the town is a large-scale video projection controlled by a computer. This converts the movements of the bicycle, whether fast or slow, to the left or to the right, into real time. Shaw is the Director of the Institute for Picture Media at the Karlsruhe Centre for Art and Media Technology, and is regarded as one of the most important artists in interactive media art. As long ago as the 1960s, he was interested in the question of how the perception of an artwork can be altered by the viewer's actions. At that time, this was limited to changing projections, smoke, or large spheres full of air with which one could walk over water, but since the mid-1980s it has been realised through ever-faster computers. By the beginning of the 1990s, Shaw was specialising mainly in the creation of spatial potentialities. In 1991, one could sit in a revolving chair before a screen and rove through the rooms of a museum. The pictorial data appeared again two years later inside a gigantic dome in the form of a panoramic cinema. This time, one could move freely in the room, one's gaze steered by a movement transmitter on one's head. A further advance was made with a room that suggests a perfect three-dimensional illusion by means of several video projections. By moving a life-size articulated doll, the viewer can steer himself through changing worlds. Here too, words make their appearance, ensuring that the illusion is reinforced by language, body and space.

L'œuvre la plus célèbre de Jeffrey Shaw est cette bicyclette sur laquelle on peut circuler à travers une ville de lettres. Les maisons deviennent des mots, les rues des phrases, les quartiers des paragraphes et des chapitres. La bicyclette est réelle, l'image de la ville est une projection vidéo grand écran, asservie par un ordinateur qui transpose les mouvements du vélo, qu'ils soient lents ou rapides, qu'ils aillent à droite ou à gauche, le tout en temps réel. Jeffrey Shaw est aujourd'hui directeur de l'Institut pour les médias de l'image au Zentrum für Kunst und Medientechnologie (Centre pour l'Art et les Technologies des Médias) de Karlsruhe, et il est considéré comme l'un des artistes majeurs de l'art interactif. Dès les années 60, il s'intéressait au problème de savoir comment les actes du spectateur modifient la perception de l'œuvre. Ce qui s'obtenait à l'époque avec des projections changeantes, de la fumée ou de grandes bulles d'air permettant de marcher sur l'eau, est piloté depuis le milieu des années 80 par des ordinateurs de plus en plus puissants. Avec le début des années 90, Shaw se spécialise progressivement dans la création d'espaces virtuels. En 1991, on pouvait se déplacer assis dans un fauteuil tournant à travers les salles d'un musée apparaissant sur un grand écran dressé face au fauteuil. Deux ans plus tard, les données de l'image réapparaissent dans une immense coupole en forme de géode. Le spectateur peut désormais se mouvoir librement dans l'espace, sa vision étant dirigée par un détecteur de mouvement fixé sur la tête. A l'étape suivante, on trouve un espace suggérant une illusion tridimensionnelle intégrale obtenue par plusieurs projections vidéo simultanées. En faisant bouger un mannequin grandeur nature, le spectateur se déplace à travers des mondes changeants. Ici encore, on voit apparaître des mots, de sorte que la virtualité est déterminée à la fois par le langage, le corps et l'espace.

C. B.

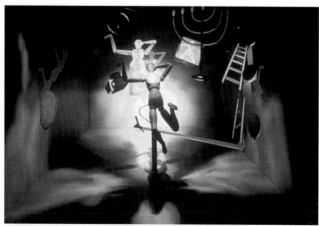

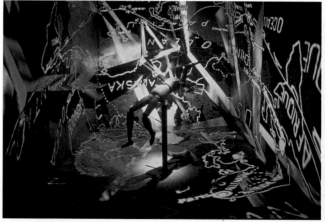

01

02

05

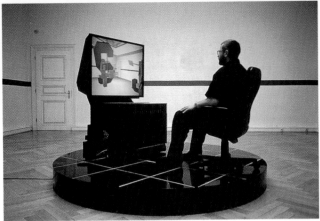

06

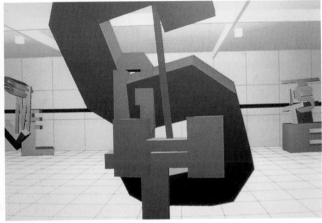

07

01 / 02 / 03 / 04 **CONFIGURING THE CAVE,** 1996 (with Agnes Hegedues, Bernd Linterman and Leslie Stuck). **05 / 06 / 07 THE VIRTUAL MUSEUM,** 1991.

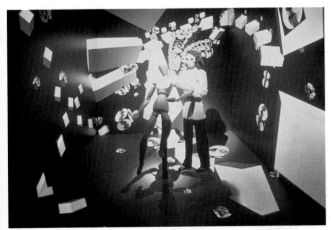

03

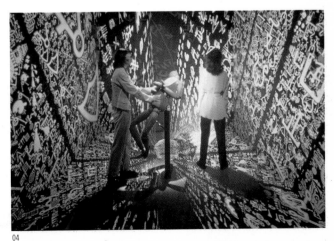

04

JEFFREY SHAW

SELECTED EXHIBITIONS: *1986* "Going to the Heart of the Center of the Garden of Delights", de Vleeshal, Middelburg, The Netherlands /// *1989* "Ars Electronica: Im Netz der Systeme", Brucknerhaus, Linz, Austria /// *1993* "MultiMediale 3", ZKM Zentrum für Kunst und Medientechnologie Karlsruhe, Karlsruhe, Germany /// *1995* "Trigon-Personale '95", Neue Galerie am Landesmuseum Joanneum, Graz, Austria /// *1996* "ConFIGURING the CAVE", NTT Intercommunication Center, Tokyo, Japan **SELECTED BIBLIOGRAPHY:** *1990 Jeffrey Shaw – Virtual World Voyaging*, BT Bijutsu Techno, Tokyo /// *1995* "Der entkörperte und wiederverkörperte Leib" in: *Kunstforum International*, Cologne, Germany /// *1996 Mediascape*, The Solomon R. Guggenheim Foundation, New York (NY), USA /// *1997 Jeffrey Shaw – a user's manual*, ZKM Zentrum für Kunst und Medientechnologie Karlsruhe, Karlsruhe; Neue Galerie, Graz; Stuttgart, Germany

08 THE NARRATIVE LANDSCAPE, 1985–1995 (with Dirk Groeneveld). **09 / 10 / 11 THE LEGIBLE CITY,** 1989–1991 (with Dirk Groeneveld).

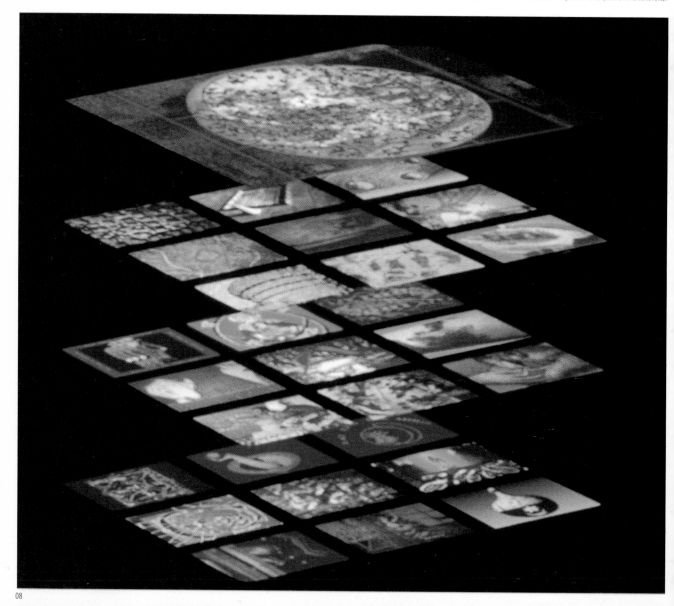

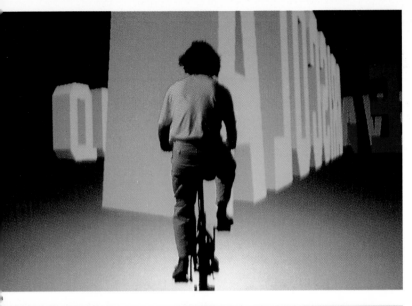

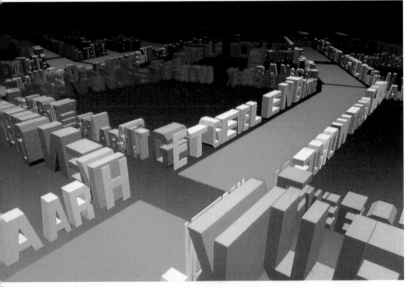

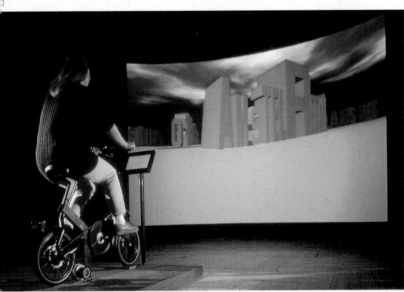

CINDY SHERMAN

1954 born in Glen Ridge (NJ) / lives and works in New York (NY), USA

"Even though I've never thought of my work as feminist or as a political statement, certainly everything in it was drawn from my observations as a woman in this culture." « Bien que je n'aie jamais considéré mon œuvre comme féministe ou comme une déclaration politique, il est certain que tout ce qui s'y trouve a été dessiné à partir de mes observations en tant que femme dans cette culture. »

Cindy Sherman once stated that her photographs are to be understood as Conceptual Art. This conceptual approach is particuary apparent in the division of her work into series. For all their variety, these reveal some constant themes such as her preoccupation with painting, which she investigates using photographic means, or the social image of women. The first photos with which Sherman shot to fame in the early 1980s were her "Film Stills". These black and white self-portraits show the artist in different situations which are reminiscent, in both technique and content, of stills from 1950s and 60s films. Subsequently, Sherman turned exclusively to colour photos. One significant series was made at the request of the New York art periodical "Artforum". The pictures are double-page spreads – a wide landscape format matching that of the magazine – often showing the artist lying down with a fixed expression on her face. Around 1983 Sherman took her first fashion photos, in which she caricatures the accepted ideal of feminine beauty. In the course of her career, from "Fairy Tales", 1985, to "Disasters" (1986 onwards), Sherman has increasingly alienated her self-portrait. The artificial body parts that she had already used in the "History Portraits", 1988–1990, assume the role of protagonists of the representations in "Sex Pictures", 1992. As with the later "Horror Pictures" (1994 onwards), the artist's body completely vanishes from the pictures, only appearing again in person from time to time in some of the more recent "Mask Pictures" (1995 onwards). In her most ambitious project to date, the horror film "Office Killer", 1997, Sherman links her concern over the social position of women with aspects of film history.

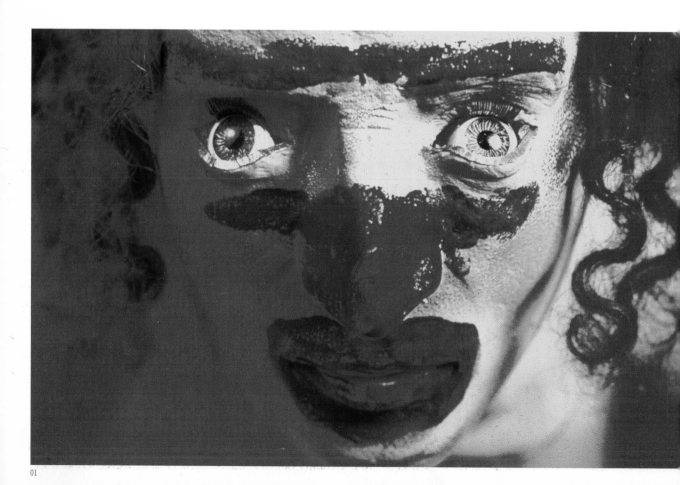

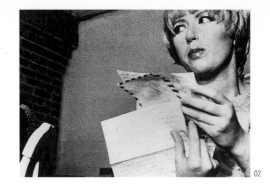

02

Cindy Sherman a pu déclarer que ses photographies devaient être comprises comme de l'art conceptuel. Le principe conceptuel de son travail apparaît par exemple dans la subdivision de ses œuvres en séries. Malgré toutes les différences qui caractérisent ces séries, on y trouve aussi des thèmes constants tels que la confrontation des moyens photographiques avec la peinture ou le travail sur l'image de la femme dans la société. Les premières photos avec lesquelles Sherman devint célèbre du jour au lendemain au début des années 80, sont comme des arrêts sur image. Dans ces autoportraits en noir et blanc, on peut voir l'artiste dans différentes situations qui rappellent formellement les photos d'acteurs des films des années 50 et 60. Par la suite, Sherman ne réalise plus que des photos couleur. Une série importante pour son œuvre fait suite à la demande du magazine d'art new-yorkais « Artforum »

en 1981. Au cours de sa carrière, Sherman travaille de plus en plus dans le sens du détournement de son autoportrait, des « Fairy Tales », 1985) aux photos « Désastres » (à partir de 1986). Les prothèses qu'elle employait déjà pour les « History Portraits », 1988–1990, prennent leur autonomie dans les « Sex Pictures », 1992), où elles deviennent les protagonistes de la représentation. Dans ces représentations comme dans les « Horror Pictures » (à partir de 1994) ultérieurs, le corps de l'artiste disparaît déjà totalement, et c'est seulement dans quelques-uns de ses « Mask Pictures » plus tardifs qu'on la voit réapparaître sporadiquement en personne. Dans son projet le plus ambitieux à ce jour, le film d'horreur « Office Killer », 1997, Sherman a concentré tout son travail sur la place de la femme dans la société et sur des aspects de l'histoire. *Y. D.*

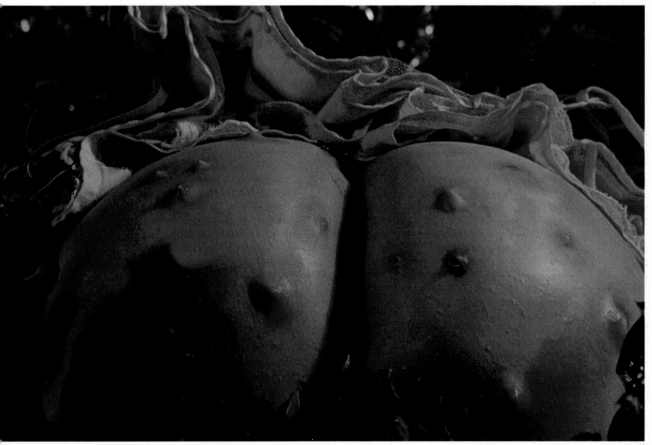

CINDY SHERMAN

SELECTED EXHIBITIONS: *1987* Whitney Museum of American Art, New York (NY); The Institute of Contemporary Art, Boston (MA); Dallas Museum of Art, Dallas (TX), USA /// *1995* "Cindy Sherman Photographien 1975–1995", Deichtorhallen Hamburg, Hamburg, Germany; Malmö Konsthall, Malmö, Sweden; Kunstmuseum Luzern, Lucerne, Switzerland /// *1996* Museum Boijmans Van Beuningen, Rotterdam, The Netherlands; Museo Nacional Centro de Arte Reina Sofía, Madrid; Sala de Exposiciones REKALDE, Bilbao, Spain; Staatliche Kunsthalle Baden-Baden, Baden-Baden, Germany /// *1997–1998* "Cindy Sherman: Retrospective", The Museum of Contemporary Art, Los Angeles (CA), USA; Galerie Rudolfinum, Prague, Czech Republic; capc Musée d'art contemporain, Bordeaux, France; Museum of Contemporary Art, Sydney, Australia; Art Gallery of Ontario, Toronto, Canada /// Museum Ludwig, Cologne, Germany **SELECTED BIBLIO-GRAPHY:** All exhibitions mentioned above were accompanied by an exhibition catalogue.

04

04 UNTITLED, 1987. Colour photogra[ph] 244 x 152 cm. **05 UNTITLED,** 1992. C[olour] photograph, 152 x 102 cm.

ANDREAS SLOMINSKI

1959 born in Meppen, Germany / lives and works in Hamburg, Germany

"Andreas Slominski would like the following two pages not to be touched." « Andreas Slominski souhaite que le lecteur ne touche pas les deux pages suivantes. »

Andreas Slominski is a hoaxer and a setter of traps. Just when one has been taken in by his aesthetic offerings, they turn out to be tricks. It is for instance impossible for the reader of this book not to touch the following two pages, because he has to turn them over before he can carry on reading. Slominski became known through his traps. He places actual animal traps in the exhibition room as readymades that really work and are set to spring, representing a real danger for the viewer. The artwork as a trap can here be seen in concrete form, but it can also be understood on a symbolic level. For if we want to interpret a work of art, we have to enter its sensory and conceptual world, but in doing so we get truly caught. If however we, so to say, remain outside it, we have the chance of being unharmed and enjoying the work's mere appearance. The traps are therefore simultaneously ordinary practical objects, conceptual art and autonomous sculptures. Another working principle of Andreas Slominski can be paraphrased with the formula "Much Ado about Nothing". In his "Golfball-Aktion" of 1995, for example, he simply displayed a normal commercial golf ball in the Museum Haus Esters in Krefeld. Then he got a local golfer to hit this ball over the roof of the museum. The ball landed on a specially parked lorry that was invisible to the golfer, and then rolled from the lorry's tipped-up loading surface, through a previously widened window, back to its destined place in the exhibition room. Economic principles such as efficiency and optimal methodology are, as so often in Andreas Slominski's work, carried to the point of absurdity with a lovingly planned but at the same time apparently fortuitous attention to detail.

01

02

01 / 02 / 03 / 04 **UNTITLED,** 1995. Andreas Slominski had a golfer strike golfballs over the roof of Museum Haus Esters until one hit the tilted ramp of a lorry parked behind the house and bounced through an open window into the museum. **05 HEIZEN/HEATING,** 1996. Stove, windmill vanes, various materials. Installation view, Portikus, Frankfurt/M., Germany, 1996.

Andreas Slominski est une sorte de poseur de pièges et de bluffeur de l'art. Le plus souvent, il émet des propositions esthétiques qui s'avèrent irréalisables au moment même où elles sont reçues. Ainsi, il est impossible au lecteur de ne pas toucher les deux pages suivantes de ce livre, attendu qu'il doit les tourner pour poursuivre sa lecture. C'est par ses «Pièges» que Slominski s'est fait connaître. Dans une salle d'exposition, l'artiste avait disposé des pièges réellement opérants et disposés de manière à «prendre au piège». Ils représentaient de ce fait un danger concret pour le spectateur. L'œuvre d'art comme piège est donc conçue de manière tout à fait concrète, mais elle peut aussi être comprise sur un plan symbolique: celui qui veut interpréter une œuvre doit en effet entrer dans son monde sensoriel et conceptuel, dont il sera d'abord prisonnier pendant la durée de la réception. Mais celui qui reste en quelque sorte extérieur a la chance pleine et intacte de jouir de sa seule apparence. Les «Pièges» se présentent donc tout à la fois comme des objets utilitaires banals, des œuvres de l'art conceptuel et des sculptures autonomes. Un autre principe artistique de Slominski pourrait être décrit par la formule «beaucoup de bruit pour rien». Une œuvre comme «Action balle de golf», exposée au musée Haus Esters (Krefeld) en 1995, ne présentait par exemple rien d'autre qu'une simple balle de golf. Mais l'artiste avait préalablement fait frapper cette balle par un joueur des environs, qui lui avait fait suivre une trajectoire par-dessus le toit du musée. La balle était tombée dans la benne levée d'un camion invisible pour le joueur, avant de rouler à travers l'ouverture d'une fenêtre préalablement démontée et de prendre son emplacement prévu dans la salle d'exposition. Les principes commerciaux tels que l'efficacité et la relativité des moyens sont poussés à l'absurde par une planification soigneuse, mais aussi par une application tout à fait fortuite.

R. S.

ANDREAS SLOMINSKI

SELECTED EXHIBITIONS: no details, at the artist's wish **SELECTED BIBLIOGRAPHY:** no details, at the artist's wish

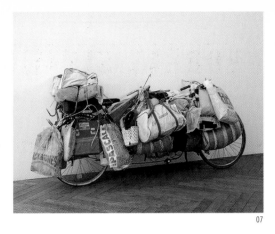

07

6 ANFEUCHTEN EINER BRIEFMARKE/LICKING A STAMP, 1996. Event in zoo with giraffe and zoo-keeper on June, 27ᵗʰ. Skulptur. Projekte in Münster 1997, Münster, Germany, 1997. 07 UNTITLED, 1994. Tandem, various materials, 125 x 260 x 90 cm. 08 FALLEN, 1986–1993.

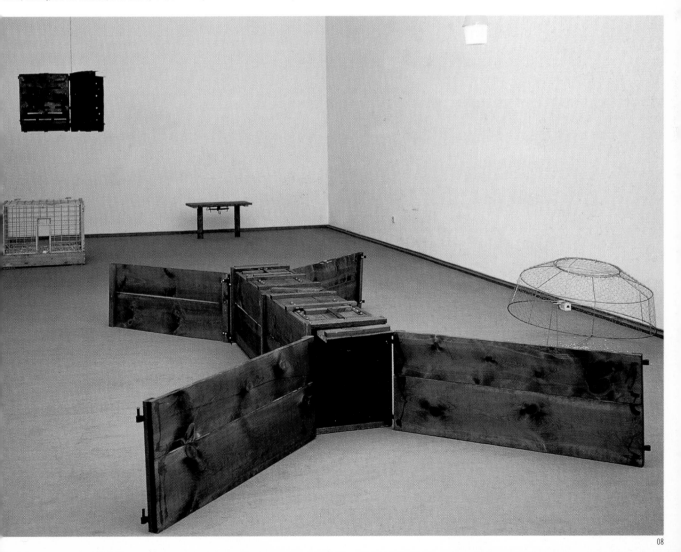

GEORGINA STARR

"I believe the magic point is situated precisely where imagination and reality come together." « Je crois que le point magique est exactement à la rencontre de l'imagination et de la réalité. »

In her work Georgina Starr rehearses the experience of being a child of the 1970s, growing up with television, comics, fashion, pop and numerous idols. She structures spaces in which longings and alternative values take over: parties in youngsters' rooms, teen-cafés or – as the symbol of freedom enjoyed to the full – a caravan (completely assembled in 1996 for "Hypnodreamdruff"). She also presents stories – written, staged and played by her – that depict fantasy lives ("Visit From a Small Planet", "The Party" – with the song "Star, that's why they call you" –, and "Drivin' On"). Two of Starr's early works, an existentialist self-presentation on video ("Crying", 1993) and the exhibited relics of clothing, souvenirs and star portraits from her own room ("The Nine Collections of the Seventh Museum", 1994) demonstrate a volte face in her message. Visions may be unattainable, media and fashions may be dangerous, and the viewer's own world may remain miles away from the idols and heroes. And yet all that secret longing and thinking about the unthinkable is nevertheless fun and has an existence of its own. Starr introduces symbols of today's youth culture, which is critised as superficial and trend-obsessed, and she uses music – which is almost omnipresent in her installations and videos – to take us back to a phenomenon of the somnambulist condition that can leap the generations

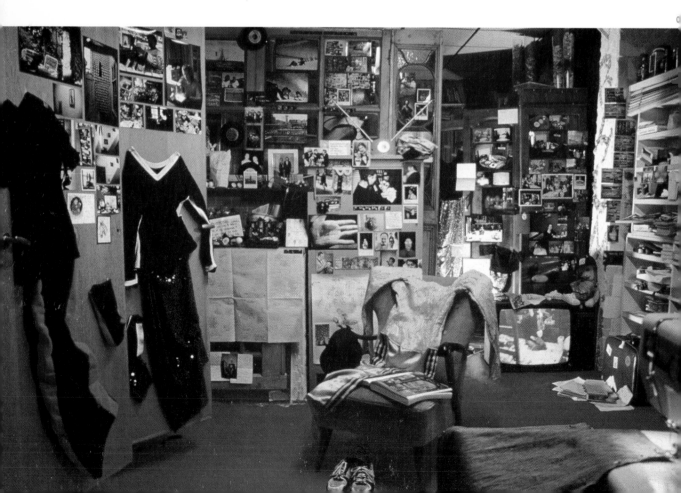

02

Dans son œuvre, Georgina Starr développe son identité de fille des années 70 ayant grandi avec la télévision, les bandes dessinées, la mode, la musique pop et d'innombrables idoles. Starr élabore des espaces dans lesquels s'étalent les nostalgies et les anti-mondes. Les chambres d'enfant et d'adolescent, les cafés d'étudiants ou encore, symbole d'une liberté vécue, une caravane (entièrement aménagée en 1996 dans Hypnodreamdruff »). Et elle présente des histoires écrites, mises en scène et jouées par elle, qui cherchent à décrire une vie plus belle à aide d'un grand nombre de visions (« Visit From a Small Planet », « The Party » – avec le tube « Star, that's what they call you », « Drivin' On »). Deux œuvres plus anciennes de Starr, une autoreprésentation existentialiste (« Crying », 1993) et l'exposition de reliques vestimentaires, de souvenirs et de portraits de star de sa propre chambre (« The Nine Collections of the Seventh Museum », 1994), marquent un tournant dans son message : les visions peuvent être inaccessibles, les médias et la mode peuvent receler un danger et la vie personnelle rester à mille lieues des idoles et des héros, mais toute cette nostalgie secrète, cette conception de l'inconcevable est amusante et possède sa propre existence. Si elle se sert aussi des symboles d'une culture jeune considérée comme superficielle et gouvernée par les tendances de la mode, avec la musique presque omniprésente dans ses installations et ses vidéos, Starr propose une prise de conscience de cet état somnambulique, qui dépasse largement le cadre d'une génération. S. T.

GEORGINA STARR

SELECTED EXHIBITIONS: *1993* Aperto 93, XLV Esposizione Internationale d'Arte, la Biennale di Venezia, Venice, Italy /// *1995* "Visit to a Small Planet", Kunsthalle Zürich, Zurich, Switzerland /// 3ᵉ Biennale de Lyon, Lyons, France /// *1996* "Hypnodreamdruff", Tate Gallery, London, England /// *1998* "Tuberama", Ikon Gallery, Birmingham, England /// *1999* Anthony Reynolds Gallery, London **SELECTED BIBLIOGRAPHY:** *1995 Visit to a Small Planet*, Kunsthalle Zürich, Zurich /// *Exhibition catalogue*, 3ᵉ Biennale de Lyon, Lyons /// *1996 "ID", an international survey of the notion of identity in contemporary art*, Stedelijk Van Abbemuseum, Eindhoven, The Netherlands /// *1997 Ein Stück vom Himmel – Some Kind of Heaven*, Kunsthalle Nürnberg, Nuremberg, Germany; South London Gallery, London

04 / 05 **TUBERAMA.** Installation views, Ikon Gallery, Birmingham, England, 1998. **06 SO LONG BABE,** 1996. Installation view, "Hypermnesiac Fabulations", The Power Plant, Toronto, Canada, 1997. **07 DRIVIN'ON,** 1996. Installation view, "The Cauldron", Henry Moore Studio, Halifax, England, 1996.

HAIM STEINBACH

1944 born in Rehovot, Israel / lives and works in New York (NY), USA

"The ever-expanding field of available objects led me to investigate what I saw as a crisis of meaning and identity by juxtaposing heterogeneous objects in a poetic, yet non-hierarchical way." « Le champ sans cesse en expansion des objets disponibles m'a conduit à explorer ce que je voyais comme une crise du sens et de l'identité en juxtaposant des objets hétérogènes d'une manière poétique, mais non hiérarchique. »

Haim Steinbach's work resembles a supermarket. Packets of cornflakes, dustbins made of refined steel, footstools from elephants' feet, chrome kettles, Nike gym shoes, electric guitars, teddy bears, ceramic beer mugs and many other trivial or luxury goods, as well as industrial objects, are carefully arranged as in a shop window. These objects are usually displayed on bevelled stands veneered with plate glass, chromium or coloured melamine. Since 1978, "shopping" has become the basis of his art, and this leads to a radically new definition of the concept of value. "If you want to take the reality of our world seriously, you must bring in the market… I use two kinds of objects. I sell one object in the artistic system, and that lends this object a certain value. And at the same time I sell objects. If someone buys one of my works,

part of the price is determined by the galleries, which say that art must be sold at this or that price. And so you sell at this price. Then the price of the objects has to be added. If these are very expensive, the total price rises greatly. If they are less expensive, even though the same shelving or an equally interesting idea is involved, then they really are far less expensive." Elevating everyday articles to the dignity of works of art is a gesture that can only cause puzzlement until one realises that, for Steinbach, the nature of art lies precisely in the sacralisation of daily life. "Art does not begin when you walk through the doors of a museum. Even in religion – and anyone who is religious can confirm this – you do not wait to enter a church to start thinking about God."

L'œuvre de Steinbach évoque volontairement le supermarché : boîtes de corn-flakes, fusils de chasse, poubelles en acier inoxydable, animaux empaillés, bouilloires en métal chromé, balayettes de WC, casques de moto, sneakers, armoires, luminaires kitsch, guitares électriques, paquets de lessive, ballons de football, casseroles en cuivre, cochons en plastique, ours en peluche… Toutes sortes de marchandises triviales ou luxueuses et d'objets industriels sont disposés méticuleusement, comme à l'étalage, dans une juxtaposition répétitive, le plus souvent sur des étagères biseautées en contre-plaqué contrecollé de miroir ou de Formica coloré. Dès 1978, le « shopping » devient la base de cet art qui engage une réflexion de fond, radicale et neuve, sur la formation de la valeur : « Si on veut être sérieux avec la réalité du monde, il faut prendre en compte le marché… J'utilise deux sortes d'objets. Je vends un objet dans le système artistique, qui confère à celui-ci une valeur ; et, dans le même temps, je vends des objets. Lorsqu'on achète une de mes œuvres, une part du prix est fixée par le système des galeristes… Ensuite, on y ajoute le prix des objets. Si les objets sont très chers, le prix global grimpe. S'ils sont bien moins chers, il peut s'agir de la même étagère ou d'une idée aussi intéressante, mais ce sera beaucoup moins cher. » Ce geste qui élève à la dignité d'œuvres d'art des objets ordinaires de la vie ordinaire demeure énigmatique, si l'on ne saisit pas qu'ici l'essence de l'art réside précisément dans la sacralisation de la vie vécue : « L'art ne commence pas aux portes du musée. Dans la religion aussi, les religieux pratiquants vous le diront, on ne commence pas à penser à Dieu seulement en entrant dans l'église. » J.-M. R.

HAIM STEINBACH

SELECTED EXHIBITIONS: *1992* "no rocks allowed", Witte de With, Center for Contemporary Art, Rotterdam, The Netherlands /// *1993* "Osmosis", Solomon R. Guggenheim Museum, New York (NY), USA (with Ettore Spalletti) /// *1995* Castello di Rivoli, Rivoli (TO), Italy /// *1997* Museum moderner Kunst Stiftung Ludwig Wien, 20er Haus, Vienna, Austria /// *1999* "Heaven", Kunsthalle Düsseldorf, Düsseldorf, Germany /// *2000* Tel Aviv Museum, Tel Aviv, Israel /// "Over the Edges", Stedelijk Museum voor Actuele Kunst, Ghent, Belgium **SELECTED BIBLIOGRAPHY:** *1988 Haim Steinbach: Recent Works*, capc Musée d'art contemporain, Bordeaux, France /// *1993 Osmosis: Ettore Spalletti & Haim Steinbach*, Solomon R. Guggenheim Museum, New York /// *1995 Haim Steinbach*, Klagenfurt, Austria /// *Haim Steinbach*, Castello di Rivoli, Rivoli (TO); Milan, Italy /// *1997 Haim Steinbach*, Museum moderner Kunst Stiftung Ludwig Wien, Vienna

04

Pages 478 / 479: **01 JACOB'S LADDER,** 1997. Steel shelving, aluminium step ladder, railroad gravel, 3 x 12.25 x 0.6 m. Installation view, Museum moderner Kunst Stiftung Ludwig Wien, 20er Haus, Vienna, Austria, 1997. **02 UNTITLED (ART DECO BUST, DISPLAY MOUNTS, NECKLACES),** 1989. Plastic laminated wood shelf, plaster bust, glass and plastic costume jewelry, velvet upholstered cardboard display stands, 32 x 262 x 27 cm. **03 SPIRIT I,** 1987. Chromed steel, vinyl, plastic, exercise machines, plastic and chrome laminated wood shelf, glass, metal, colored oil "Lava Lites", 125 x 434 x 70 cm. Installation view, capc Musée d'art contemporain, Bordeaux, France, 1988. Pages 480 / 481: **04 UNTITLED (MATTRESS, SHOPPING CART),** 1990. Plastic laminated wood box, cloth mattress, metal, plastic cart with twine and cardboard, 227 x 303 x 74 cm. **05 CHARM OF TRADITION,** 1985. Plastic laminated wood shelf, cotton, rubber, nylon; leather athletic shoes, polyester, plastic, metal lamp with deer hooves, 97 x 168 x 33 cm.

JESSICA STOCKHOLDER

1959 born in Seattle (WA) / lives and works in Brooklyn (NY), USA

"My work doesn't present a finished ideal as to how things should be, but rather a suggestion that things could shift; that things could be made that are as yet unknown." « Mon œuvre ne présente pas un idéal fini concernant la manière dont les choses devraient être, mais suggère plutôt que les choses pourraient changer : que des choses encore inconnues aujourd'hui pourraient être faites. »

Jessica Stockholder's installations are like different worlds. They overpower us with their concentrated colours, forms and liberties, which simply could not occur or exist. Essentially, we do not know why this is so fascinating, and we can only guess why the impression is so intense and incomparable. Stockholder herself calls the installations "fiction". She treats the rooms like a surface to be painted and puts the materials together as though in a picture. Wooden planks, lattice work, fabrics and cables, alongside refrigerator doors, cinema seats and plastic bags are mounted in the room, stretched to form perspectives and aligned as in a picture. Stockholder came to sculpture and installation via painting. Her rooms and also her smaller wall and floor objects achieve their effect through her painterly approach. She covers all the materials with paint or supplies compositional counterparts in pure colour, which overcome the ordinariness of objects and turn them into independent forms in their own right. Even the lighting becomes picturesque: the lamp is an element of form and its light a colour effect. Stockholder's rooms and objects have titles that accompany them like parallel fictions. And yet at the same time they convey an abstract discourse with painting. Painting has left the wall and mingles with the installation rooms and those present in them creating a usually temporary, stage-like event.

Les espaces de Jessica Stockholder sont comme d'autres mondes. Ils frappent le spectateur par la charge concentrée de couleurs, de formes et de libertés qui n'existent ni ne peuvent exister. Au fond, on ne sait pas pourquoi tout cela est si fascinant, on peut seulement supposer pourquoi l'impression est si intense et si unique. Stockholder elle-même décrit ses installations comme des « fictions ». Elle traite les espaces comme une surface à peindre, composant les matériaux comme à l'intérieur d'un tableau. Les plaques et lattis de bois, les étoffes et les câbles, mais aussi les portes de réfrigérateurs, les fauteuils de cinéma ou les sacs de mousse sont montés en termes spatiaux, tendus en perspectives qui concourent à la création d'un espace pictural. C'est par le biais de la peinture, qu'elle pratiquait initialement, que Stockholder a trouvé la voie de la sculpture et de l'installation. L'effet de ses espaces, mais aussi de ses objets muraux ou de sol, vient de ce que l'artiste continue de travailler en termes picturaux : elle couvre tous les matériaux de peinture ou réalise les équilibres de composition à l'aide de la couleur, avec un équilibrage des masses qui surmonte l'aspect quotidien des objets et les transforme en formes autonomes d'égale valeur. Dans ce type de travail, l'éclairage prend lui aussi une valeur picturale, la lampe devient élément formel et la lumière effet de couleur. Si les titres des espaces et des objets de Stockholder fonctionnent certes comme des fictions parallèles, ils génèrent également une confrontation abstraite avec la peinture. Celle-ci a quitté le mur et s'unifie avec les pièces et les personnes présentes – en un événement le plus souvent éphémère et scénique. S. T.

01 **INSTALLATION IN MY FATHER'S BACK YARD, VANCOUVER,** 1983. Paint on double mattress, grass & garage, cupboard door, chicken wire. Installation view, private residence, Vancouver, Canada, 1983. 02 **SKIN TONED GARDEN MAPPING,** 1991. Paint, red carpet, roofing tar, refrigerator doors, hardware, yellow bug lights and fixtures, cloth, vinyl composition floor tiles, concrete, tinfoil, space 2, 901 m². Installation view, The Renaissance Society at the University of Chicago, Chicago (IL), USA, 1991. 03 **GROWING ROCK CANDY MOUNTAIN – GRASSES IN CANNED SAND,** 1992. 23 x 12 m bathing suit fabric, sand stone native to Münster, gaseous concrete building blocks, plaster, basket material, electrical wiring, 3 small lights, newspaper glued to wall, acrylic paint, metal cables, styrofoam, room: 29 x 9 m, stepping to 13 m (w) opposite. Installation view, Westfälischer Kunstverein, Münster, Germany, 1992.

JESSICA STOCKHOLDER

SELECTED EXHIBITIONS: *1992* "Growing Rock Candy Mountain – Grasses in Canned Sand", Westfälischer Kunstverein, Münster, Germany /// "Sea Floor Movement to Rise of Fire Place Stripping", Kunsthalle Zürich, Zurich, Switzerland /// *1995–1996* "Your Skin in this Weather Bourne Eye-Threads & Swollen Perfume", Dia Center for the Arts, New York (NY), USA /// *1997* "Slab of Skinned Water, Cubed Chicken & White Sauce", Künstnernes Hus, Oslo, Norway /// *1998* "Landscape Linoleum", Open Air Museum of Sculpture Middelheim, Antwerp, Belgium
SELECTED BIBLIOGRAPHY: *1992 Jessica Stockholder*, Westfälischer Kunstverein, Münster; Kunsthalle Zürich, Zurich /// *1995 Jessica Stockholder*, London, England /// *1996 Jessica Stockholder: Your Skin in this Weather Bourne Eye-Threads & Swollen Perfume*, Dia Center for the Arts, New York /// *1998 Jessica Stockholder*, Musée Picasso d'Antibes, Antibes, France

04

05

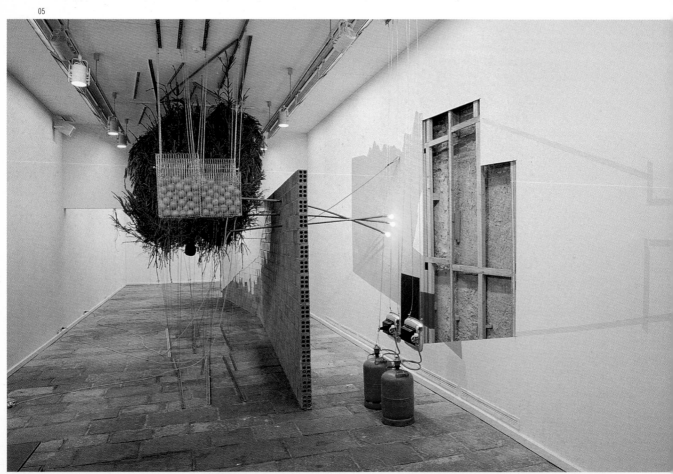

04 HOUSE BEAUTIFUL, 1994. Wood, hinges, hardware, 7 rugs, braided steel cable, fan, chandelier, green carpet, 100 balls of yarn glued together with silicone caulking, c. 13 m l, height and width variable. Installation view, "Country Sculpture", Le Consortium, Dijon, France, 1994. **05 SWEET FOR THREE ORANGES,** 1995. Paint, c. 40 Christmas trees, 50 kilos of oranges, 4 bird cages, brick wall aircraft cable, butane tanks & heaters, rope, roofing paper & tar, light bulbs & yellow electric cord, PVC piping, agle iron, room, 20.45 x 4.9 m. Installation view, Fundació "La Caixa", Barcelona, Spain, 1995. **06 SLAB OF SKINNED WATER, CUBED CHICKEN & WHITE SAUCE,** 1997. Paint, yellow Glava road insulation, Leca building blocks, plaster, carpet, linoleum, metal cables, hardware, hay bales covered in white & black plastic, green rope, 2 rooms, 32 x 8.8 m (each). Installation view, Künstnernes Hus, Oslo, Norway, 1997.

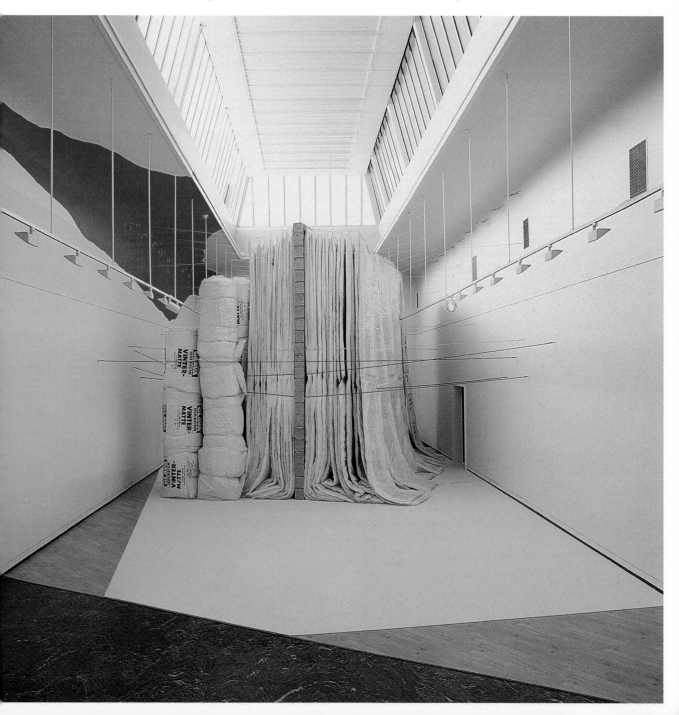

THOMAS STRUTH

1954 born in Geldern, Germany / lives and works in Düsseldorf, Germany

Recently, what has interested me is, how can I record ecstasy ... ! or: 'quietness' in a picture." **« Ces derniers temps, ce qui m'intéresse, c'est comment fixer l'extase ou le silence dans une photo. »**

"Unknown Places" was the title Thomas Struth gave to a large touring exhibition of his photographs in 1987. The name is appropriate, for Struth's towns are anonymous: sites that are decidedly urban, but which would hardly stick in the viewer's memory as individual images. His style, on the other hand, is always recognisable. Usually photographed in black and white from a central perspective, these near-empty towns show a host of details but no real focal point. The viewer feels somewhat disorientated, trying to give the place a meaning, to extract its secret. And every town, every corner of every town, possesses many secrets, as Struth has documented since his early works. The wealth of detail is continued in the later photos taken in China and Japan. Now people are present. But they do not draw attention to themselves, becoming merely additional details in the midst of a mass of advertising messages. In a further series, Struth photographed groups of people in museums. The pictures they are looking at also depict human figures, so that there is a great deal of gazing in both directions, from the pictures and into the pictures. In his latest video works, which were produced with Klaus vom Bruch, Struth still remains true to style. The camera stands statically at a certain point, but the eye is not really offered a fixed focus and there is a great deal to see. Struth points out things that we do not normally find remarkable. His theme is the ordinary day, the public space, presented so subtly that no information gets lost.

« Lieux inconscients », c'est le nom que Thomas Struth donnait en 1987 à une grande tournée d'expositions de ses photographies. Ce titre est très pertinent, car Struth photographiait des villes de manière quasiment anonyme. Des situations tout à fait citadines, mais qui ne restaient guère dans l'esprit du spectateur en tant qu'image individuelle. Ce qu'on reconnaissait en revanche toujours de manière très nette, c'était le style de Thomas Struth. Dans ses espaces urbains déserts, photographiés le plus souvent en noir et blanc et selon une perspective centralisante, on rencontre une infinité de détails, mais presque aucun point dominant. Le spectateur est en proie à une certaine inquiétude, il tente de donner un sens au lieu, de lui arracher son secret, et c'est précisément ce que Thomas Struth documentait dans ses premières photographies. Cette richesse de détails se retrouve dans les photos plus tardives prises en Chine et au Japon. On y aperçoit désormais des gens, qui n'attirent pas davantage l'attention, qui ne semblent être que des détails supplémentaires au milieu d'une multitude de messages publicitaires. Dans une autre série, Struth photographie des groupes de spectateurs dans des musées. Les tableaux que ceux-ci regardent présentent eux aussi des personnages : une pluralité de regards – sortant des tableaux et dirigés vers eux – se croisent. Dans ses vidéos récentes réalisées en collaboration avec Klaus vom Bruch, Struth demeure fidèle à son style. La caméra est implantée à un point fixe, il y a une foule de choses à voir, mais l'œil ne se voit guère offrir de point de repère. Struth voit ainsi tout ce que nous jugeons ordinairement inutile de remarquer. Son thème est le quotidien, l'espace public, qu'il maîtrise précisément parce qu'il le met en scène de façon si subtile qu'aucune information n'est perdue.

C. B.

01 LOUVRE IV 1989. C-print, 184 x 217 cm (framed). **02 CHIESA DEI FRARI, VENICE 1995.** C-print, 235 x 187 cm (framed).

THOMAS STRUTH

SELECTED EXHIBITIONS: *1993* Hamburger Kunsthalle, Hamburg, Germany /// *1995* "Thomas Struth: Straßen. Fotografie 1976–1995", Kunstmuseum Bonn, Bonn, Germany /// *1997* "Spectrum – Internationaler Preis für Fotografie: Thomas Struth: Portraits", Sprengel Museum Hannover, Hanover, Germany /// *1998* Stedelijk Museum, Amsterdam, The Netherlands /// *1999* Centre National de la Photographie, Paris, France **SELECTED BIBLIOGRAPHY:** *1992 Thomas Struth: Portraits*, Museum Haus Lange, Krefeld, Germany /// *1993 Thomas Struth: Museum Photographs*, Munich, Germany /// *1995 Thomas Struth: Straßen. Fotografie 1976–1995*, Cologne, Germany /// *1997 Luo Yong-Jin, Thomas Struth: Face to Face. Photography*, Munich /// *Thomas Struth: Portraits*, Sprengel Museum Hannover, Hanover; Munich /// *1998 Thomas Struth*, *Still*, Carré d'Art, Nîmes, France; Stedelijk Museum, Amsterdam; Centre National de la Photographie, Paris; Munich

03 LANDSCHAFT NO. 23, WINTERTHUR 1992. C-print, 118 x 137 cm (framed). **04 TOMOHARU AND KYOKO MURAKAMI, TOKYO 1991.** C-print, 104 x 126 cm (framed). **05 WANGFUJING DONG LU, SHANGHAI 1997.** C-Print, 84 x 112 cm (framed).

PHILIP TAAFFE

"I want people to see the work as something that has just happened, effortlessly, almost as an aspect of nature." « **Je veux que les gens voient mon travail comme quelque chose qui vient d'avoir lieu, sans effort, presque comme un aspect de la nature.** »

In Taaffe's paintings there is a blending of the abstract and the decorative, of quiet beholding and seduction, of the spiritual and the sensual. His productions appear as components of a pictorial language which contains truths of an everlasting validity. He forms a whole network of meanings from basic forms that as a result of their endless repetition become symbols of eternity. The structure of Taaffe's paintings with a monochrome ground evolves through several layers of colour that become brighter at the picture surface. The viewer looks from the brightest membrane down to the first layer of the picture ground, which makes the temporal intervals clearly visible. The passing moments produce the effect of a veiled mirror: colours and forms are blurred, and perception is concentrated on the riddle of time. The geometry that is fixed by repetition resists any casual interpretation. Abstract motifs are placed on top of one another in layers, and this hints at a certain objectivity. Since 1993 Taaffe has been integrating flower and animal motifs in his geometrical works. He adopts the connections of modern art with the reproductions of natural history and the ornamentation of the decorative arts. Taaffe's repertoire embraces stylised lilies, lizards, butterflies, snakes, palm leaves formed into arabesques, spirals, scrolls and flowing forms. At first sight his subjects seem like a formal spectrum of associations, which "can be understoood as a voluntary, tactical retreat into the past". This gaze into the past liberates the contemporary artist from his obligation to always be innovative, and yields him "a freedom that was never there before".

Les toiles de Taafe résultent d'une réconciliation entre abstraction et décoration, méditation et séduction, spiritualité et sensualité. La toile dessine un réseau de significations intemporelles développées à partir de formes primaires qui sont répétées sans début ni fin et deviennent autant de symboles d'éternité. La structure du tableau, dont le fond est monochrome, est composée de couches successives qui progressent vers la surface en s'éclaircissant graduellement à travers les poches de temporalité successives contenues entre chaque couche. Ces interstices temporels atténuent formes et couleurs comme un miroir voilé par l'écoulement énigmatique du temps. En 1993, les motifs floraux ou animaliers ont commencé de se mêler aux motifs géométriques, développant les liens formels que l'art moderniste avait créés entre les motifs tirés des planches d'histoire naturelle et les ornements des arts décoratifs. Ces motifs, qui répètent, comme sur une frise de patterns décoratifs, les figures graphiques et stylisées de lys, lézards, papillons, serpents, feuilles de palmier, forment d'infinies arabesques, spirales, volutes, torsades et contre-courbes répétées d'une façon organique, avec le zèle inlassable d'une décoration rappelant l'avènement de l'Art nouveau. Cette œuvre demeure une importante contribution au débat sur le postmodernisme et ouvre une fenêtre sur les possibilités de la peinture de chevalet : sa porosité à l'égard du passé ne vise qu'à libérer le présent de la recherche obligée de la nouveauté et de l'innovation.

J.-M. R.

01 BAD SEED, 1996. Mixed media on canvas, 262 x 282 cm.
02 EROS AND PSYCHE, 1993/94. Mixed media on canvas, 335 x 255 cm.

PHILIP TAAFFE

SELECTED EXHIBITIONS: *1987* Whitney Biennial, Whitney Museum of American Art, New York (NY), USA /// *1991–1992* Carnegie International 1991, The Carnegie Museum of Art, Pittsburgh (PA), USA /// *1993* Center for the Fine Arts, Miami (FL), USA /// *1996* Sydney Biennial, Sydney, Australia /// *1996–1997* Wiener Secession, Vienna, Austria **SELECTED BIBLIOGRAPHY:** *1994 Philip Taaffe*, Gagosian Gallery, New York /// *1996 Philip Taaffe's Imaginary City*, Wiener Secesssion, Vienna /// *1998 Philip Taaffe & Stan Brakhage: Composite Nature*, New York

03

04

03 VIVISECTOR, 1996. Mixed media on canvas, 297 x 160 cm. **04 ASCENDING TOTEM,** 1996. Mixed media on canvas, 361 x 165 cm.
05 CONSTELLATION ELEPHANTA, 1993/94. Mixed media on canvas, 354 x 254 cm.

SAM TAYLOR-WOOD

1967 born in London / lives and works in London, England

"I am interested in how things are offered to us, what situation people are put in who are asked to be entertained." **« Je suis intéressée par la manière dont les choses s'offrent à nous, dans quelle situation sont mis les gens qui veulent être divertis. »**

In Sam Taylor-Wood's videos and photo-panoramas there is a prevailing suspense, like the tension in a film. She puts people together and fixes a situation – in videos a scene, in photos a frozen moment. Human relations hover between fascination and destruction, represented with a remarkably intense expression of individualisation, which makes each act seem isolated. The salient force in Taylor-Wood's works is the application of a technique which rebounds from the content back on to the viewer and thence on to the psychology of perception. Her "Travesty of a Mockery" of 1995 is a ten-minute quarrel scene between a man and a woman (played by an amateur and a professional actress) in which the characters are separated from one another by two projections on two different walls. In "Atlantic", 1997, another drama of relationships, one finds oneself between three perspectives, which simultaneously show a distraught and desperate woman, a man's nervous hands, and a full restaurant surrounding them. Neurosis and psychosis are Taylor-Wood's idea of the present state of mind. She releases moments from these extremes and makes them advance on us like signals. Her own portrait came at the beginning of her work, and in this she showed a state of hurt through her own nakedness. Her recent works are a "film" composed of countless situations with different individuals. She transfers it photographically on to her stage-like 180-degree panoramas ("Five Revolutionary Seconds", 1995–1997). An all-round view like this of parallel stories can be uncommonly disturbing.

Dans ses vidéos et ses panoramas photographiques, Taylor-Wood fait régner un « suspense », une tension comme au cinéma. Taylor-Wood dispose des hommes et fixe une situation, dans les vidéos, c'est une scène, dans la photographie, un moment figé. Les rapports humains à mi-chemin entre fascination et destruction, sont représentés avec une expression étrangement intense de solitude, qui fait apparaître chaque acteur comme isolé. L'aspect le plus remarquable des œuvres de Taylor-Wood est l'intervention de la technique qui, à partir des contenus, vise le spectateur, et donc la psychologie de la perception. Dans « Travesty Of a Mockery », 1995, scène de dix minutes entre un homme et une femme (représentée par un profane et une actrice professionnelle), les personnes sont séparées l'une de l'autre par deux projections sur deux murs différents. Dans « Atlantic », un autre drame relationnel, on est placé entre deux perspectives : on peut y voir simultanément la femme défaite, désespérée, les mains nerveuses de l'homme et toute la salle du restaurant qui leur sert de cadre. Les concepts employés par Taylor-Wood pour décrire l'état d'esprit de notre époque sont ceux de névrose et de psychose. Elle isole certains instants de ces situations extrêmes et les fait ressortir de façon signalétique. Son œuvre avait démarré avec son propre portrait, dans lequel elle représentait sa vulnérabilité à travers sa nudité. Ses œuvres récentes sont un « film » composé d'innombrables situations avec différents individus. Ce film est transposé en photographie dans les panoramas à 180 degrés, proches d'une scène de théâtre (« Five Revolutionary Seconds »). Ce type de panorama ouvrant la vue sur des histoires parallèles peut s'avérer incomparablement plus oppressant que les films.

S. T.

01 HYSTERIA, 1997. Laser disc projection, 8 mins. **02 / 03 SUSTAINING THE CRISIS**, 1997. 2 screen projections and sound, 8 mins., 55 secs. **04 BRONTOSAURUS**, 1995. Video projection and sound, 10 mins. Installation view, Kunsthalle Zürich, Zurich, Switzerland, 1997.

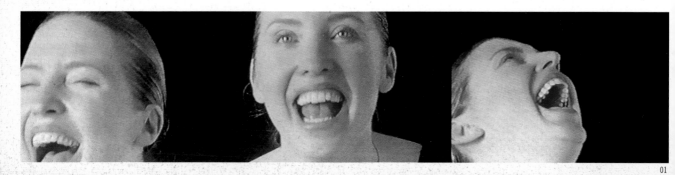

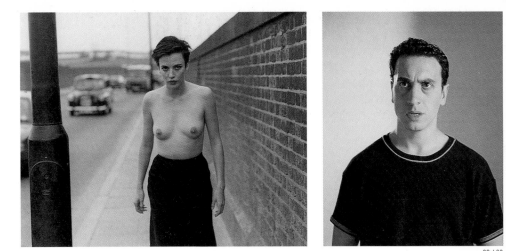

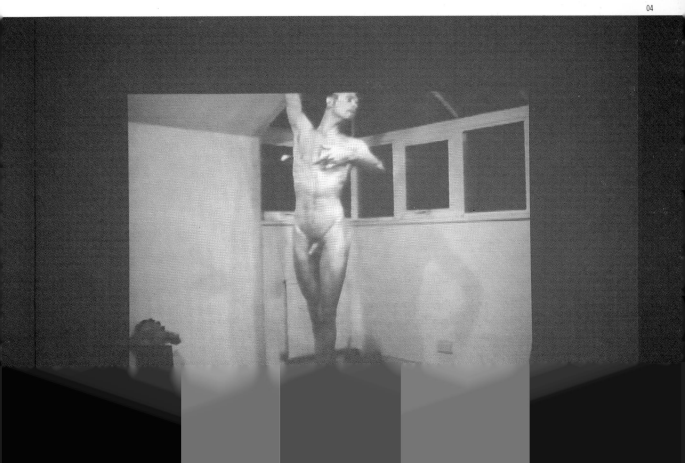

SAM TAYLOR-WOOD

SELECTED EXHIBITIONS: *1996* "Full House", Kunstmuseum Wolfsburg, Wolfsburg, Germany /// *1996–1997* "Pent-Up", Chisenhale Gallery, London; Sunderland City Art Gallery, Sunderland, England /// *1997* "Sam Taylor-Wood: Five Revolutionary Seconds", Fundació "La Caixa", Barcelona, Spain /// XLVII Esposizione Internationale d'Arte, la Biennale di Venezia, Venice, Italy /// *1997–1998* Kunsthalle Zürich, Zurich, Switzerland; Louisiana Museum of Modern Art, Humlebæk, Denmark **SELECTED BIBLIOGRAPHY:** *1994 Sam Taylor-Wood,* The Showroom, London /// *1996 Pent-Up. Sam Taylor-Wood,* Jay Jopling, London; Chisenhale Gallery, London; Sunderland City Art Gallery, Sunderland /// *1997 Sensation,* Royal Academy of Arts, London /// *Sam Taylor-Wood,* Kunsthalle Zürich, Zurich; Louisiana Museum of Modern Art, Humlebæk /// *Sam Taylor-Wood. Five Revolutionary Seconds,* Fundació "La Caixa", Barcelona

05 FIVE REVOLUTIONARY SECONDS X, 1997. Unique colour photograph on vinyl with sound, 107 x 500 cm.
06 FIVE REVOLUTIONARY SECONDS V, 1996. Colour photograph on vinyl with sound, 72 x 757 cm.

DIANA THATER

1962 born in San Francisco (CA) / lives and works in Los Angeles (CA), USA

"My work is specifically about being big, colorful and engaging, but it's about not being spectacular. It doesn't look spectacular." « **Mon travail traite spécifiquement du fait d'être grand, haut en couleurs et passionnant, mais il traite du fait de n'être pas spectaculaire. Il n'a pas l'air spectaculaire.** »

Until a few years ago, video art was imprisoned in the little box of the monitor. Since the early 1990s, it has come to occupy the whole room courtesy of large video projections. Diana Thater consistently exploits this advance, and yet she deliberately ignores the possibilities of technical perfection. Her pictures run over jutting parts of walls, sometimes overlapping by a few centimetres; they are seldom projected at exactly the right angle, their colour appears to be wrong, and several images look as if they have been projected on top of each other. But what might seem like amateur mistakes actually represent a detailed examination of the video medium. The colour tinges pick out the colours from which the picture is composed, the unpretentious presentation corresponds to the uncomplicated possibilities of this accessible form, and the over-lapping is the result of sophisticated electronic image mixing. However, these formal aspects can never dominate, for Thater is also highly concerned with content. She works with animals – a parrot, a monkey, two wolves and a herd of horses – especially trained for film takes. But instead of getting them to perform Hollywood-style tricks, she positions them in relation to the viewer. Within these works, we don't know whether the she-wolf is standing in front of us or behind us; whether the herd of horses is stamping about above or below us. Some of these works have narrative texts, but pervading all of them is the fundamental question: who dominates whom? Do the human beings control the animals, or the other way round? Does the media dominate humans or vice versa?

Si la vidéo était encore cantonnée au petit écran il y a quelques années à peine, depuis le début des années 90, les grandes projections vidéo conquièrent la totalité de l'espace. Diana Thater met à profit ce progrès d'une manière très cohérente, mais en négligeant délibérément les possibilités offertes par la perfection technique. Ses images sautent par-dessus des murs, présentent parfois des décalages de plusieurs centimètres, sont rarement dirigées exactement à angle droit sur le mur, semblent présenter des couleurs fausses ou montrer plusieurs images simultanément. Mais ce qui pourrait ne sembler être que maladresses d'amateur s'avère être en réalité une confrontation très précise avec le médium vidéo : les effets de pigmentation apparaissent dans les couleurs mêmes dont est composée l'image vidéo, la présentation sans prétention correspond aux possibilités d'emploi simples du médium, les superpositions d'image résultent d'un subtil dosage électronique. Toutefois, ces aspects formels ne prédominent jamais, car Thater propose en même temps une forte charge de contenu. Elle travaille pour cela de manière privilégiée avec des animaux spécialement dressés pour ce type de prises de vues. Mais plutôt que de présenter des numéros de cirque à la Hollywood, elle leur fait adopter dans ses œuvres une position particulière à l'égard du spectateur, qu'il s'agisse d'un perroquet, d'un singe, de deux loups ou d'un troupeau de chevaux. On ne sait pas si la louve se trouve devant soi ou derrière soi, si le troupeau de chevaux passe au-dessus ou au-dessous de soi. Indépendamment du fait que certaines œuvres sont accompagnées de textes narratifs, le travail de Thater pose sans cesse la question de savoir qui gouverne qui : les hommes gouvernent-ils les animaux, le médium domine-t-il l'homme ou est-ce l'homme qui commande malgré tout au médium ?

C. B.

Pages 498/499: **01 WYOMING ALOGON,** 1994. 3 video projectors, 3 laserdisc players, 3 laserdiscs, sync generator, window film, and existing architecture. Installation view, "Pure Beauty", The Museum of Contemporary Art, Los Angeles (CA), USA, 1994/95. **02 SCARLET MCCAW CRAYONS,** 1995. 1 video projector, 1 laserdisc player, 1 laserdisc. Installation view, "China, Crayons & Molly Numbers 1 through 10", David Zwirner, New York (NY), USA, 1996. **03 BROKEN CIRCLE,** 1997. 6 video projectors, 1 video monitor, 6 laserdisc players, 1 sync generator, 6 laserdiscs, window film, and existing architecture. Exterior view: Buddenturm, Skulptur. Projekte in Münster 1997, Münster, Germany, 1997. **04 BROKEN CIRCLE,** 1997. 6 video projectors, 1 video monitor, 6 laserdisc players, 1 sync generator, 6 laserdiscs, window film, and existing architecture. Interior view: Buddenturm, Floor #2 (view B), Skulptur. Projekte in Münster 1997, Münster, Germany, 1997. Pages 500/501: **05 CHINA (BLUE AND YELLOW WALL VIEW),** 1995. Installation view, "China", The Renaissance Society at the University of Chicago, Chicago (IL), USA, 1995.

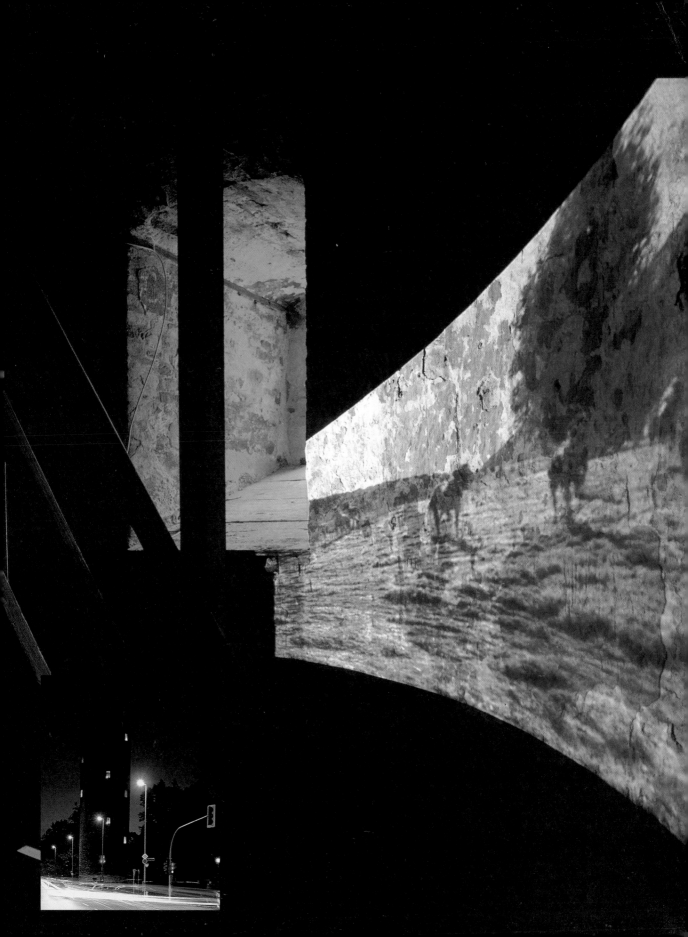

DIANA THATER

SELECTED EXHIBITIONS: *1995* "China", The Renaissance Society at the University of Chicago, Chicago (IL), USA /// *1997* "Diana Thater. Selected Works 1992–1996", Kunstverein in Hamburg, Hamburg, Germany /// "Diana Thater: Orchids in the Land of Technology", Walker Art Center, Minneapolis (MN), USA /// Biennial Exhibition, Whitney Museum of American Art, New York (NY), USA /// *1998* "Projects 64: Diana Thater, The best animals are the flat animals", The Museum of Modern Art, New York /// *1999* "The best outside is the inside", The Saint Louis Art Museum, Saint Louis (MO), USA **SELECTED BIBLIOGRAPHY:** *1995 China*, The Renaissance Society at the University of Chicago, Chicago; Le Creux de l'Enfer, Centre d'Art Contemporain, Thiers, France /// *1996 Diana Thater. Selected Works 1992-1996*, Kunsthalle Basel, Basle, Switzerland /// *1997 Skulptur. Projekte in Münster 1997*, Stuttgart, Germany /// *Temporary Contemporary*, Newcastle, England /// *1998 The best animals are the flat animals – the best space is the deep space*, MAK Center for Art and Architecture, Los Angeles (CA), USA

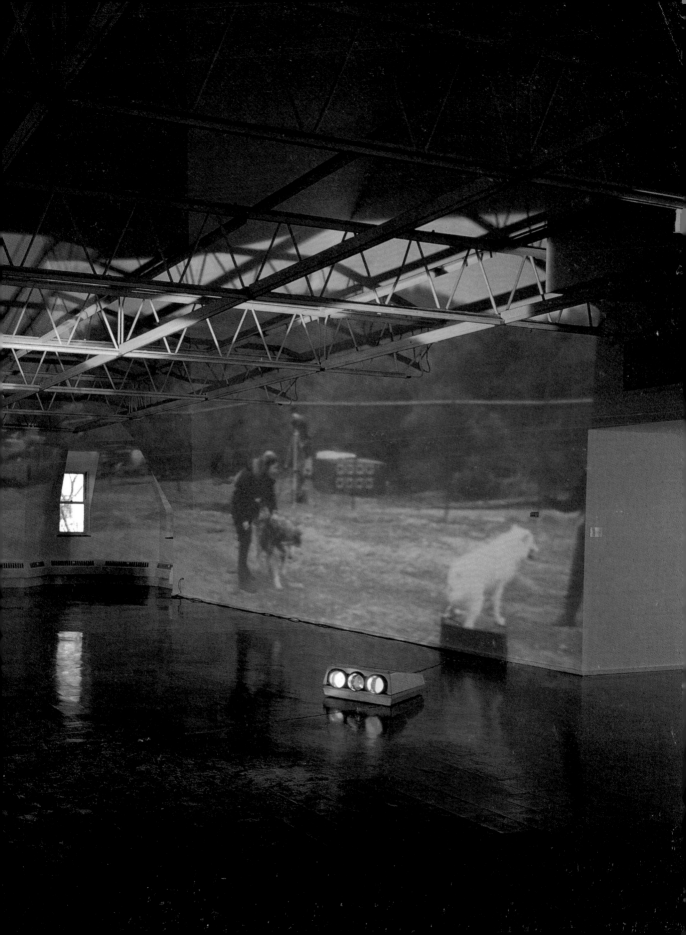

WOLFGANG TILLMANS

1968 born in Remscheid, Germany / lives and works in London, England

"I see myself as a political artist. I want to make a picture of my idea of beauty and the world I want to live in." « Je me considère comme un artiste politique. Je veux représenter mon idée de la beauté et du monde dans lequel je veux vivre. »

Wolfgang Tillmans became known in the early 1990s for his photographs of young people taken in their social environment – in clubs, on the Love Parade in Berlin, during the European Gay Pride days in London or the Protestant Convention in Munich. This resulted in his being often regarded as a documenter of his own generation. But the artistic composition of the photographs and their sometimes enigmatic content contradict an entirely documentary intention. For all the self-stylization of the young people he photographs – in their dress, accessories and poses – aspects of their personality keep shining through. Often the works also reflect the ambiguity of codes such as those of clothing, preventing his subjects from being consigned to a particular social classification. Alongside his portraits, Tillmans has concerned himself with subjects such as architecture and still life. From 1991 he made a comprehensive series on the arrangement of folds, in which, aside from the formal qualities (draping and colour composition), the items of clothing reveal a narrative potential. In his comprehensive series on the supersonic aircraft Concorde, 1997, he manages to portray the techno-mythology by reflection and atmosphere. Tillmans started early on using lifestyle and music magazines, like "ID", "Interview" or "Spex", as a forum for his artistic work. In assessing his photos he makes no distinction between free work that he exhibits in the art context and commissioned work. In some exhibitions he shows works from both spheres – unframed photos stuck to the wall with sticky tape, like reproductions just cut out of magazines.

01

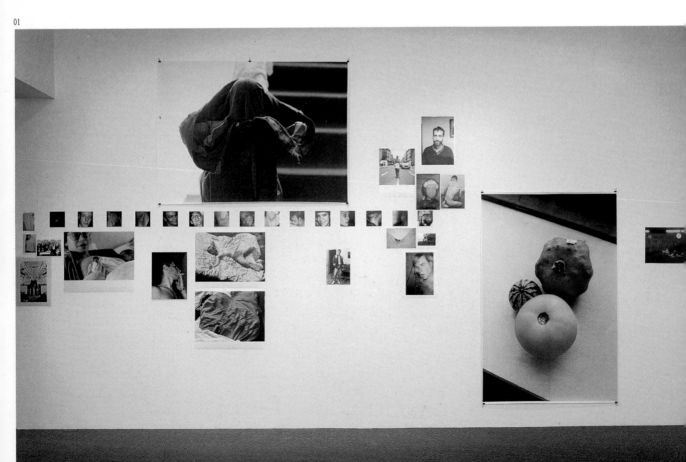

01 MOMA INSTALLATION 1986–1996, 1996. Installation view, "New Photography #12", The Museum of Modern Art, New York (NY), USA, 1996.
02 DEER HIRSCH, 1995. C-print, 31 x 41 cm, 61 x 51 cm; bubblejet-print, 120 x 170 cm. 03 STEDELIJK INSTALLATION 1988–1998, 1998.
Installation view, "From the Corner of the Eye", Stedelijk Museum, Amsterdam, The Netherlands, 1998.

02

Wolfgang Tillmans s'est rendu célèbre au début des années 90 par ses photos de jeunes fixés dans leur environnement social, lors de sorties dans des clubs, pendant la Love Parade de Berlin, durant les journées de la European Gay Pride à Londres ou à l'occasion des rencontres protestantes de Munich. Il a de ce fait été souvent considéré comme le documentariste de sa génération. La composition artistique de ses photographies et leur mise en scène parfois lourde de sens contredisent cependant le point de vue purement documentaire. Aussi « stylisés » que soient les jeunes par la tenue vestimentaire, les accessoires et les poses, on voit toujours transparaître chez eux des aspects de leur personnalité. Les photos de Tillmans réfléchissent souvent au caractère ambigu des codes (vestimentaires) et soustraient les personnes représentées à toute définition les réduisant à un groupement social déterminé.

Tillmans a ainsi réalisé une vaste série sur les drapés (à partir de 1993), série dans laquelle, au-delà des qualités formelles (drapé et composition des couleurs), les vêtements déploient un fort potentiel narratif. Dans sa vaste série sur le « Concorde », 1997, Tillmans s'entend à donner un portrait réfléchi et à traduire l'atmosphère d'un mythe technologique. Très tôt, Tillmans a su être présent dans des magazines de style ou de musique tels que « ID », « Interview » ou « Spex » et s'en servir comme forum pour son travail d'artiste. Dans l'évaluation de ses œuvres, il ne fait aucune différence entre ses œuvres libres réalisées dans le contexte de l'art et les travaux de commande. Dans certaines expositions, il installe d'ailleurs des œuvres provenant des deux domaines – photos sans cadre collées au mur avec du scotch, comme s'il s'agissait de reproductions découpées dans des revues. Y. D.

03

WOLFGANG TILLMANS

SELECTED EXHIBITIONS: *1995* Portikus, Frankfurt/M., Germany /// Kunsthalle Zürich, Zurich, Switzerland /// *1996* "Wer Liebe wagt lebt morgen", Kunstmuseum Wolfsburg, Wolfsburg, Germany /// *1997* "I Didn't Inhale", Chisenhale Gallery, London, England /// *1998* "Wolfgang Tillmans Fruiciones", Museo Nacional Centro de Arte Reina Sofía, Madrid, Spain **SELECTED BIBLIOGRAPHY:** *1995 Wolfgang Tillmans*, Cologne, Germany /// *Wolfgang Tillmans*, Portikus, Frankfurt/M.; Spex magazine, Cologne /// *1996 Wer Liebe wagt lebt morgen*, Kunstmuseum Wolfsburg, Wolfsburg /// *1997 Concorde*, Cologne /// *1998 Wolfgang Tillmans Burg*, Benedikt Taschen Verlag, Cologne

04 CONCORDE! REINA SOFÍA INSTALLATION, 1998. Installation view, "Wolfgang Tillmans Fruiciones", Museo Nacional Centro de Arte Reina Sofía, Madrid, Spain, 1998. **05 STILL HOME,** 1996. C-print, 40 x 30 cm, 61 x 51 cm, bubblejet-print, 270 x 180 cm.

RIRKRIT TIRAVANIJA

1961 born in Buenos Aires, Argentina /
lives and works in New York (NY), USA, and Berlin, Germany

"My work is about looking at the essential and what's essential to more than survival." « **Dans mon œuvre, il est question d'une contemplation de
l'essentiel, de l'essentiel qui va au-delà de l'essentiel pour survivre.** »

Rirkrit Tiravanija was born in Buenos Aires, brought up in Thailand and Canada, and currently lives in New York and Berlin. In his actions and installations he intentionally disrupts the traditional expectations of the passive exhibition visitor. In his first exhibitions, for instance, he placed the furniture and equipment from the gallery office in the exhibition room, where he also installed a temporary kitchen. Thai dishes were served, and over the meal Tiravanija chatted with visitors, as a pre-planned interaction between artist and viewer. Meanwhile, the normal business of the gallery went on, apparently undisturbed. Tiravanija designs rooms for communication and interaction. He turned the Cologne Kunstverein into a place of this kind by installing a wooden reconstruction of his New York apartment in the gallery, complete with functioning kitchen and bathroom. The Kunstverein was open day and night for the duration of the exhibition, and soon became an attractive meeting place, particularly for people who otherwise had little contact with art. In his other works, Tiravanija not only involves the public, but also presents structures in such a way that the actions of viewers comprise the artwork itself. He might install a set of drums in the gallery and ask visitors to make music, or he might rehearse a puppet play with young people. Tiravanija thus expounds his thesis – the origin of which may be traced to his cultural connection with Thailand and Buddhism – that "it is not what you see that is important but what takes place between people".

Avec ses actions et installations, Rirkrit Tiravanija, artiste né à Buenos Aires, ayant passé son enfance en Thaïlande, puis au Canada et vivant aujourd'hui à New York, contourne très consciemment les attentes traditionnelles du visiteur d'exposition passif. Ses premières expositions consistaient par exemple à vider le bureau de la galerie de son mobilier et de ses appareils et à les disposer dans l'espace d'exposition, où l'artiste installait par exemple une cuisine éphémère. Les visiteurs se voyaient servir des plats thaïlandais et pendant le repas, des conversations informelles s'engageaient entre eux et Tiravanija: l'interaction recherchée entre artiste et visiteur. En même temps, le travail de la galerie semblait se poursuivre imperturbablement. Tiravanija conçoit des espaces de communication et d'interaction. Ce fut d'ailleurs l'objet de son travail au Kunstverein de Cologne, pour lequel il devait installer dans la salle d'exposition une reconstitution en bois de son appartement newyorkais, reconstitution dont les aménagements (cuisine, salle de bains) étaient parfaitement opérationnels. Pendant la durée de l'exposition, le Kunstverein était resté ouvert de jour comme de nuit, et était devenu en peu de temps un point de rencontre attractif, et ce tout particulièrement pour les gens peu coutumiers du contact avec l'art. Dans ses autres travaux aussi, Tiravanija ne se contente pas d'intégrer le public, il conçoit des structures au sein desquelles l'œuvre proprement dite n'est produite qu'avec le concours du spectateur, qu'il s'agisse de l'installation d'une salle dans laquelle se trouve une batterie invitant le spectateur à faire de la musique, ou de la répétition d'un spectacle de marionnettes avec des jeunes. La revendication de Tiravanija – qui émane sans doute de ses attaches culturelles avec la Thaïlande et le bouddhisme – exprime toujours le fait que « l'important n'est pas ce qu'on voit, mais ce qui se joue entre les êtres ».

Y. D.

01 From left to right: **UNTITLED, 1996 (STUDIO #6), "LOUD VERSION".** Installation view, "Untitled, 1996 (Studio No. 6)", Kunsthalle St. Gallen, St. Gallen, Switzerland, 1996.
02 UNTITLED, 1996 (STUDIO #6), "SILENT VERSION". Installation view, Spiral Garden, Tokyo, Japan, 1996. **03 UNTITLED, 1996 (REHEARSAL STUDIO #6).** Installation view, "Untitled, 1996 (one revolution per minute)", Le Consortium, Dijon, France, 1996. **04 UNTITLED, 1993 (CAFÉ DEUTSCHLAND).** Building instructions (framed), certificate (framed). Installation view, Galerie Max Hetzler, Cologne, Germany, 1993. **05 / 06 / 07 UNTITLED, 1994 (FROM BARAGAS TO PARACUELLOS DE GARAMA TO TORREJÓN DE ARDOZ TO SAN FERNANDO OR COSLADA TO REINA SOFÍA).** Mixed media, dimensions variable. Installation view, "Cocido y Crudo", Museo Nacional Centro de Arte Reina Sofía, Madrid, Spain, 1994.

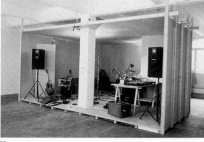

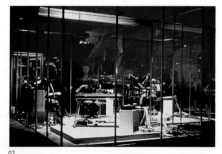

01

02

03

04

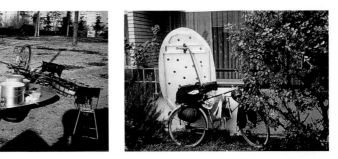

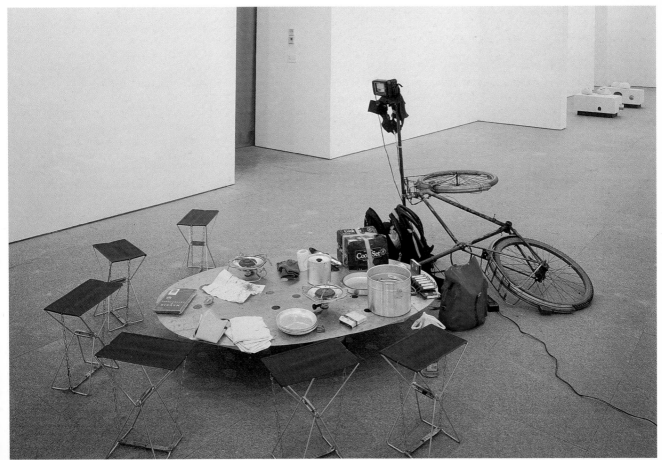

RIRKRIT TIRAVANIJA

SELECTED EXHIBITIONS: *1995* Biennial Exhibition, Whitney Museum of American Art, New York (NY), USA /// *1996* "Untitled, 1996 (tomorrow is another day)", Kölnischer Kunstverein, Cologne, Germany /// Kunstverein in Hamburg, Hamburg, Germany /// *1997* "Projects 58: Rirkrit Tiravanija", The Museum of Modern Art, New York /// *1998* "Das soziale Kapital", Migros Museum für Gegenwartskunst Zürich, Zurich, Switzerland /// Philadelphia Art Museum, Philadelphia (PA), USA **SELECTED BIBLIOGRAPHY:** *1995* Kunsthalle Basel, Basle, Switzerland /// *1996 Untitled, 1996 (tomorrow is another day)*, Kölnischer Kunstverein, Cologne /// *Untitled, 1996 (one revolution per minute)*, Le Consortium, Dijon, France /// *1997 Untitled, 1997 (Playtime)*, The Museum of Modern Art, New York; Williams College Museum of Art, Williamstown (MA), USA; Kunstverein Ludwigsburg, Ludwigsburg, Germany /// *1998 Supermarket*, Migros Museum für Gegenwartskunst Zürich, Zurich

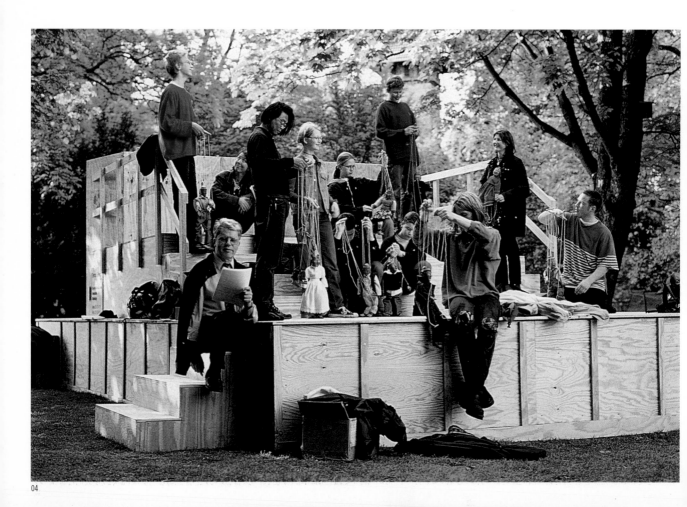

08 UNTITLED, 1997 (THE ZOO SOCIETY). Installation view, Skulptur. Projekte in Münster 1997, Germany, 1997. **09 UNTITLED, 1997 (PLAYTIME).** Mixed media. Installation views, "Projects 58: Rirkrit Tiravanija", The Museum of Modern Art, New York (NY), USA, 1997. **10 "DAS SOZIALE KAPITAL",** installation view, Migros Museum für Gegenwartskunst Zürich, Zurich, Switzerland, 1998.

ROSEMARIE TROCKEL

1952 born in Schwerte, Germany / lives and works in Cologne, Germany

"Please don't do anything to me. Come on now." **« S'il te plaît ne me fais rien, mais vite. »**

The problems evoked in Rosemarie Trockel's work are at least as numerous and diverse as the materials and techniques she employs. In her videos, sculptures, installations, drawings and photographs she tackles, among other things, themes which occupied her during her studies of anthropology, sociology, theology and mathematics. Our relationship with the human body, the role of women in society and our attitude to our dealings with animals are only some of the aspects that repeatedly crop up in her works. There are for instance her representations of animals in the form of drawings and bronze casts, but also in the form of an installation with live animals, as in her joint contribution to documenta X together with Carsten Höller "Ein Haus für Schweine und Menschen" (A House for Pigs and People). The knitted pictures, with which Trockel first became known in the 1980s, and her cooker hotplate works, are not just comments on the female production of art but can also be interpreted as an examination of Pop Art and Minimal Art. When Trockel in her knitted pictures uses emblems like the Woolmark, the Playboy rabbit and even swastikas, she is in a subtle way querying the function of symbols and their meaning in relation to art. Thus her items of clothing knitted in wool, the terrorist balaclavas, the excessively long stockings and the strange pullovers are all artistic comments on the social meaning of fashion and its sometimes restrictive effects. Trockel's works that are reminiscent of readymades are in the tradition of Marcel Duchamp, like her display case objects with which she analyses – often with an ironic undertone – the inherent laws of the art world.

Les interrogations soulevées dans l'œuvre de Rosemarie Trockel sont au moins aussi diversifiées que les matériaux et les techniques dont elle se sert. Ses vidéos, ses sculptures, assemblages, installations, dessins et photographies portent sur des thèmes qui l'intéressaient déjà à l'époque où elle étudiait l'anthropologie, la sociologie, la théologie et les mathématiques. Le rapport de l'homme avec le corps, le rôle de la femme dans la société et l'attitude à l'égard de la manière de traiter les animaux ne sont que quelques-uns des aspects récurrents dans ses œuvres. Trockel a ainsi réalisé des représentations animalières sous forme de dessins et de bronzes, mais aussi – comme dans son spectaculaire travail commun avec Carsten Höller pour la documenta X, « Une maison pour les porcs et les hommes » – sous forme d'installations comportant des animaux vivants. Les tableaux-tricots qui ont fait connaître Trockel au cours des années 80, mais aussi les « Plaques de cuisson », ne se contentent pas de gloser une production artistique prétendument féminine, on peut également y voir une confrontation avec le Pop Art et le Minimal Art. Utilisant des emblèmes tels que le sigle Woolmark, le lapin de « Playboy », voire la croix gammée, Trockel interroge de façon subtile la fonction des symboles et leur signification dans le contexte de l'art. Ainsi, ses vêtements en tricot, ses cagoules de terroristes, ses bas exagérément longs et ses étranges pull-overs sont, eux aussi, des commentaires artistiques sur la signification sociale de la mode et de ses implications parfois restrictives. Proches du ready-made, les œuvres de Trockel se situent dans la tradition de Marcel Duchamp, un peu comme les objets sous vitrine avec lesquels – non sans une connotation souvent ironique – elle jette un éclairage sur les lois qui sous-tendent le fonctionnement du marché de l'art. Y. D.

01 UNTITLED, 1991. Sheet-steel, stove-enamelled, 2 hotplates, 50 x 30 x 50 cm.
02 FREUDE, 1988. Wool (beige/blue), 200 x 175 cm.

ROSEMARIE TROCKEL

SELECTED EXHIBITIONS: *1988* The Museum of Modern Art, New York (NY), USA /// *1991* Museum of Contemporary Art, Chicago (IL), USA /// *1992* Museum Ludwig, Cologne, Germany /// *1994* Österreichisches Museum für Angewandte Kunst, Vienna, Austria /// *1997* "Ein Haus für Schweine und Menschen", documenta X, Kassel, Germany (with Carsten Höller) /// *1998* Hamburger Kunsthalle, Hamburg, Germany /// *1999* XLVIII Esposizione Internationale d'Arte, la Biennale di Venezia, Venice, Italy, German Pavilion /// *2000* Städtische Galerie im Lenbachhaus, Munich, Germany **SELECTED BIBLIOGRAPHY:** *1988 Rosemarie Trockel*, Kunsthalle Basel, Basle, Switzerland; Institute of Contemporary Arts, London, England /// *1992 Rosemarie Trockel*, Museo Nacional Centro de Arte Reina Sofía, Madrid, Spain /// *1993 Rosemarie Trockel*, City Gallery, Wellington, New Zealand /// *1994 Rosemarie Trockel*, MAK-Galerie, Österreichisches Museum für Angewandte Kunst, Vienna, Austria /// *1998 Rosemarie Trockel, Werkgruppen 1986–1998*, Hamburger Kunsthalle, Hamburg

03 FAN 1, 1993. Scanner print on canvas, 150 x 150 cm. **04 UNTITLED (MOBILE),** 1992. Wool, polystyrene, 40 x ø 16 cm. **05 LEBEN HEISST STRUMPFHOSEN STRICKEN,** 1998. Photographs, postcards, goose eggs, 12 x 86 x 132 cm.

LUC TUYMANS

"Pictures, if they are to have effect, must have the tremendous intensity of silence ... the silence before the storm." **« Lorsqu'ils fonctionnent, les tableaux doivent avoir cette terrible intensité du silence... du silence avant l'orage. »**

Content is central to Luc Tuymans' paintings. Reflection is more important for him than blatant sensuality. It is as "immaterial pictures", as Tuymans calls them, that these works acquire the power that pursues the viewer like an oppressiveness that will not go away. Although his paintings are often conceived as series, they continue to fascinate as individual pictures. Tuymans' relationship to painting is always conditioned by his experience with other media, especially film and photography. This influence finds expression in his use (and adaptation) of picture sequences from films, and in the way he deals with faded colours reminiscent of old photos. The Belgian's artistic themes range from Flemish history and American delusions of grandeur to the horror of German National Socialism. In his aesthetic enquiries, Tuymans acts not as a documenting outsider but as a participant, a fellow perpetrator. One's "own perversion" interests him, particularly when dealing with such extreme subjects as "Treblinka", 1986, or "Wiedergutmachung" (Reparation), 1987. "Wiedergutmachung" shows a row of children's limbs that had been found in the desk drawer of a former concentration-camp doctor. Tuymans neatly cut out photos of these limbs and accurately stuck them on a sheet of paper – mimetic recreation as a vain attempt at understanding. The painting "The Heritage II" of 1995 shows the US flag as a play of light disappearing into itself. This emblem of pointlessness bears witness to the fading of the American dream – and also of the failure of painting. "Every art has failed. How we fail is another matter," Tuymans confesses.

Le sens et le contenu sont au centre de la peinture de Luc Tuymans, la réflexion lui importe davantage que la pure sensualité. « Tableaux immatériels » (Tuymans), ces œuvres se chargent d'une force qui poursuit le spectateur comme un malaise sans cesse présent, et bien qu'elles soient souvent conçues à l'intérieur d'une série, elles conservent tout leur pouvoir de fascination considérées séparément. La manière dont Tuymans travaille la peinture est toujours marquée par son activité dans d'autres médiums, et plus particulièrement le cinéma et la photographie, cette influence se manifestant par l'emploi et le détournement de séquences filmées, mais aussi dans le maniement de couleurs en quelque sorte passées, telles qu'elles apparaissent dans les vieilles photos. L'éventail thématique de cet artiste belge va de l'histoire flamande et de la « mégalomanie » américaine aux horreurs du nazisme. Dans son analyse esthétique, Tuymans n'intervient pas en qualité d'observateur extérieur, mais toujours comme participant, comme acteur. Sa « propre perversion » (Tuymans) intéresse l'artiste précisément lorsqu'il se penche sur des motifs aussi brûlants que « Treblinka », 1986, ou « Les Réparations », 1987. Ainsi, « Les Réparations » montre une série de membres enfantins découverts dans le tiroir d'un médecin de camp de concentration. Tuymans a découpé les photos de ces membres et les a collées soigneusement sur une feuille de papier – répétition mimétique en vue d'une (vaine) tentative de compréhension. Une peinture comme « The Heritage II », 1995, présente le drapeau américain comme un jeu de lumière se résorbant en lui-même. Totalement vidé de son sens, ce tableau témoigne du ternissement du rêve américain – et de l'échec de la peinture : « Tous les arts ont échoué. Quant à la manière dont on échoue, c'est un autre problème », professe Luc Tuymans. *R. S.*

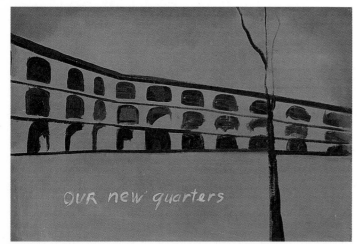

01 OUR NEW QUARTERS, 1986. Oil on canvas, 81 x 120 cm.
02 DER DIAGNOSTISCHE BLICK IV, 1992. Oil on canvas, 57 x 38 cm.

LUC TUYMANS

SELECTED EXHIBITIONS: *1992* documenta IX, Kassel, Germany /// *1994* "Superstition", Portikus, Frankfurt/M., Germany /// *1995* De Pont, Tilburg, The Netherlands /// *1996* Albertinum, Dresden, Germany /// *1997* "Future, Present, Past", Corderie dell'Arsenale, Venice, Italy /// The Museum of Modern Art, New York (NY), USA /// *1998* "Privacy. Luc Tuymans, Miroslaw Balka", Fundaçao de Serralves, Oporto, Portugal /// *1999* Bonnefantenmuseum, Maastricht, The Netherlands **SELECTED BIBLIOGRAPHY:** *1993 Der Zerbrochene Spiegel. Positionen zur Malerei*, Kunsthalle Wien, Vienna, Austria; Deichtorhallen Hamburg, Hamburg, Germany /// *1995 Luc Tuymans*, Art Gallery of York University, Toronto, Canada; The Renaissance Society at the University of Chicago, Chicago (IL), USA; Institute of Contemporary Arts, London, England; Goldie Paley Gallery, Moore College of Art, Philadelphia (PA), USA /// *1996 Luc Tuymans*, London /// *Face à l'Histoire*, Musée national d'art moderne, Centre Georges Pompidou, Paris, France /// *1997 Premonition. Zeichnungen, Drawings*, Kunstmuseum Bern, Berne, Switzerland

03

04

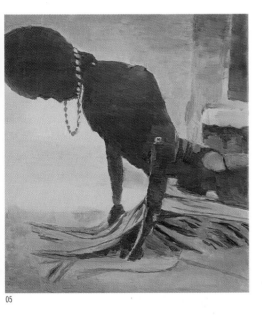

05

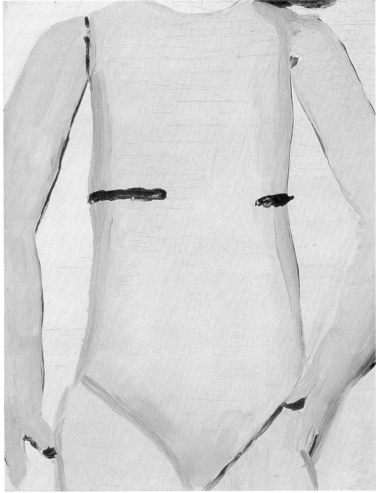

06

03 SCHWARZHEIDE, 1986. Oil on canvas, 60 x 70 cm. **04 THE HERITAGE II,** 1995. Oil on canvas, 143 x 73 cm.
05 G. I. JOE, 1996. Oil on canvas, 69 x 62 cm. **06 BODY,** 1990. Oil on canvas, 49 x 35 cm.

BILL VIOLA

1951 born in New York (NY) / lives and works in Long Beach (CA), USA

"I do not distinguish between the environment as the physical world out there (the 'hard' stuff) and the mental image of that environment (the 'soft' stuff)." « Je ne fais pas de différence entre... l'environnement en tant que monde matériel là dehors (le ‹ hard stuff ›) et l'image spirituelle de cet environnement (le ‹ soft stuff ›). »

Bill Viola is one of the international stars of the video art scene, and his works have made video art popular among a wide public. One reason for this might be that Viola intended from the start to continue the traditions of painting by means of modern video and computer technology. His works offer a perfect frenzy of colour, in which the effects are never purely sensational but serve a choreographic composition. They are often presented as projections in several parts, like enlarged altar paintings. The images build up, become quicker or slower, bigger or smaller; they disappear altogether only to reappear again, renewed and in another form, partly controlled by random generators. As for the content, Viola is concerned with fundamental themes such as birth and death, human relations or the role of the individual in today's information society. All this makes his works directly accessible, and they are becoming more and more technically sophisticated. In one of his latest works ("The Tree of Knowledge", 1997), the growth process of a tree is manipulated by the viewer, depending on how he moves in a corridor in front of it. The light in which the tree appears corresponds to the time of day. As the system reacts very sensitively, each person sees his tree somewhat differently. Just as each life develops differently, so here each viewer is offered a different version of transience. With his fundamental themes and the fascinating application of technology, Bill Viola is well set to create the modern style of a twenty-first century picture gallery.

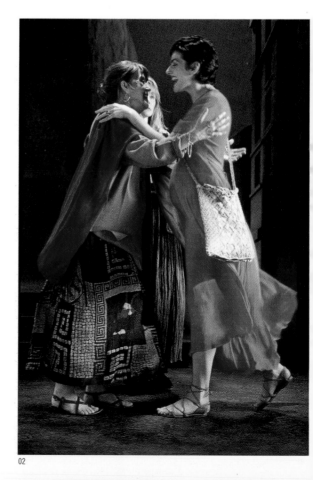

01

02

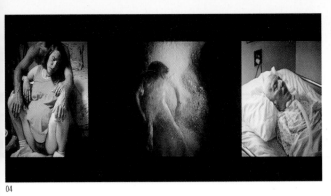

04

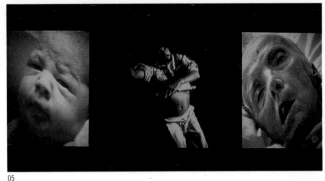

05

Bill Viola est une des stars internationales de la vidéo d'art, et ses œuvres ont popularisé cette tendance auprès d'un large public. L'une des raisons en est sans doute le fait que dès le début, Bill Viola a cherché à poursuivre les traditions de la peinture en se servant des moyens techniques modernes de la vidéo et de l'informatique. Ses œuvres présentent une parfaite griserie chromatique dont les effets ne se cantonnent cependant jamais dans le domaine des pures sensations, mais sont toujours au service d'une composition chorégraphique. Souvent elles sont présentées sous forme de projections simultanées qui rappellent les immenses panneaux d'un retable. Les images se construisent, s'accélèrent ou se ralentissent, grandissent ou rapetissent, disparaissant pour réapparaître sous une autre forme selon un rythme généré en partie par un algorithme informatique. Sur le plan du contenu, Viola s'intéresse à des thèmes fondamentaux comme la naissance et la mort, les rapports humains ou le rôle de l'individu dans la société d'information actuelle. Tout ceci a pour effet qu'on trouve toujours un accès très direct à ses œuvres. Au fil du temps, Viola affine de plus en plus sa technique. Dans une de ses dernières œuvres, « The Tree of Knowledge », 1997, la croissance d'un arbre est régie par le spectateur en fonction de la manière dont il se déplace devant l'arbre dans un corridor. De plus, la lumière dans laquelle on voit l'arbre correspond au moment de la journée. Dans la mesure où le système réagit de façon très sensible, chacun voit son arbre d'une manière un peu différente. De même que le déroulement de chaque vie est différent, de même il est offert à chaque spectateur une évolution différente de la fugacité. Avec cette thématique fondamentale et un emploi passionnant de la technique, Bill Viola est en bonne voie pour créer le type moderne d'une galerie de peintures du 21e siècle.

C. B.

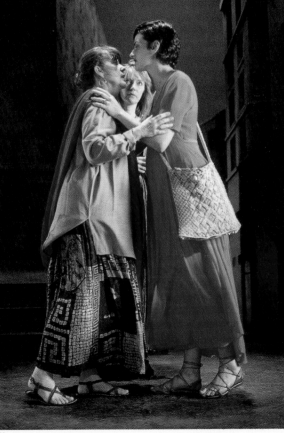

03

Pages 518/519: **01 / 02 / 03 THE GREETING**, 1995. Production stills. Video/sound installation, XLVI Esposizione Internationale d'Arte, la Biennale di Venezia, Venice, United States Pavilion, Italy, 1995. **04 / 05 NANTES TRIPTYCH**, 1992. Video/sound installation. Pages 520/521: **06 / 07 THE CROSSING**, 1996 (details). Video/sound installation.

BILL VIOLA

SELECTED EXHIBITIONS: *1992–1993* "Slowly Turning Narrative", The Institute of Contemporay Art, University of Pennsylvania, Philadelphia (PA); Virginia Museum of Fine Arts, Richmond (VA), USA; Musée d'Art Contemporain, Montreal, Canada /// "Unseen Images", Kunsthalle Düsseldorf, Düsseldorf, Germany; Moderna Museet, Stockholm, Sweden; Museo Nacional Centro de Arte Reina Sofía, Madrid, Spain; Tel Aviv Museum of Art, Israel /// *1995* "Buried Secrets", XLVI Esposizione Internationale d'Arte, la Biennale di Venezia, Venice, Italy, United States Pavilion /// *1997* "Fire, Water, Breath", Guggenheim Museum SoHo, New York (NY), USA /// *1997–1998* Whitney Museum of American Art, New York; Los Angeles County Museum of Art, Los Angeles (CA), USA
SELECTED BIBLIOGRAPHY: *1995 Buried Secrets*, Arizona State University Art Museum, Tempe (AZ), USA /// *Reasons for Knocking an Empty House: Writings 1973–1994*, Anthony d'Offay Gallery, London, England; Cambridge (MA), USA /// *1997 Bill Viola*, Whitney Museum of American Art, New York

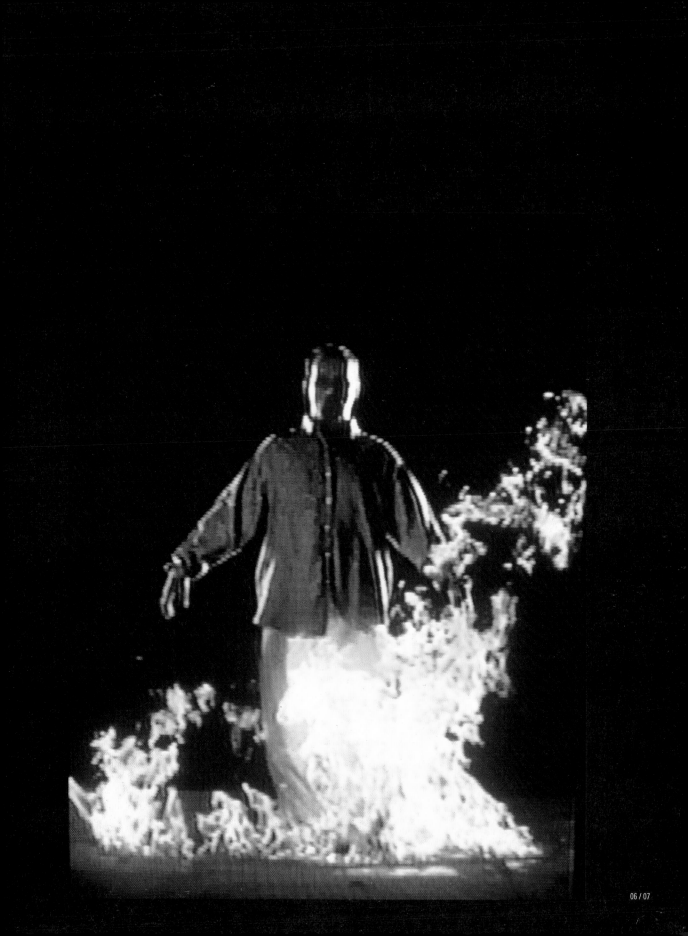

JEFF WALL

1946 born in Vancouver / lives and works in Vancouver, Canada

"The experience of the beautiful is always associated with hope and art, as Stendhal said, a promise of happiness, a 'promesse de bonheur'."
L'expérience du beau est toujours associée à l'espoir et comme le dit Stendhal, l'art est une promesse de bonheur. »

Jeff Wall seems to fulfil this promise of happiness. The large-format colour slides presented in light-boxes with which he made his name in the 1970s, seduce the viewer with their surface brilliance and perfection of composition. And yet their "beauty" proves fragile. Gradually, disruptive factors appear on the scene – references to overt or latent violence, as in "Mimic", 1982, or grotesque details, as in "Dead Troops Talk", 1991/92. Wall sees himself, following Charles Baudelaire, as a "painter of modern life". He draws on the methods and pictorial resources of photography, film and (pre-)modern art in order to follow the "The Crooked Path", 1991, of genre, landscape, portrait and historical painting and paint his fictions of modern, mostly urban life. Nothing is left to chance: in the studio, Wall uses actors to stage tableaux full of art historical references, which he then partially synthesises on a computer. Here, he relies particularly on pictorial concepts from the beginnings of

Modernism, where the unity of a picture was no longer taken for granted – as in his allusion to Manet in " Woman and her Doctor", 1980/81, for example, or to Cézanne in "The Drain", 1989. The controllability of the composition corresponds to the sense of oppression that often accompanies Wall's representation of social relationships. And yet his protagonists are not bound by one particular form of behaviour or role. Like the worker in "Untangling", 1994, they are usually shown in a moment of hesitation or of enforced waiting before a decisive occurrence which, like the wind in "A Sudden Gust of Wind (after Hokusai)", 1993, can give an unexpected twist to events. Subsequent developments are normally left unresolved. Wall's latest series of black and white photographs also follow this principle of suggestion. The stories that go with the pictures spring from the viewer's imagination, guided by Wall's transformation of our collective pictorial archive.

01

01 DEAD TROOPS TALK (A VISION AFTER AN AMBUSH OF A RED ARMY PATROL, NEAR MOQOR, AFGHANISTAN, WINTER 1986), 1991/92. Transparency in light box, 229 x 417 cm. **02 INSTALLATION VIEW**, Art Tower Mito, Mito, Japan, 1997. **03 A SUDDEN GUST OF WIND (AFTER HOKUSAI)**, 1993. Transparency in light box, 229 x 337 cm.

Jeff Wall semble parvenir à réaliser cette promesse. Ses grandes diapositives couleur présentées dans des boîtes à lumière, qui le firent connaître dans les années 70, séduisent le spectateur par la brillance de la surface et la perfection de la composition. Mais leur « beauté » s'avère précaire. Peu à peu, leur mise en scène révèle des éléments perturbateurs : références à une violence déclarée ou structurelle comme dans « Mimic », 1982, détails grotesques comme dans « Dead Troops Talk », 1991/92. Par référence à Charles Baudelaire, Wall se considère comme un « peintre de la vie moderne ». Il fait appel aux méthodes et au fonds d'images de la photographie, du cinéma et des débuts de l'art moderne pour raconter sa fiction de la vie moderne, le plus souvent urbaine, sur le « Sentier sinueux », 1991, de la peinture de genre, de paysages, d'histoire et de portrait. Rien n'est laissé au hasard lorsque Wall se sert d'acteurs dans un studio pour mettre en scène ses tableaux riches en allusions à l'histoire de l'art et qu'il les synthétise en partie sur ordinateur, s'appuyant sur les concepts iconiques des prémisses de l'art moderne, où l'unité du tableau n'est plus considérée comme une évidence – sur Manet dans « 2 Woman and her Doctor », 1980/81, ou sur Cézanne dans « The Drain », 1989. Ses protagonistes ne sont pas réduits à un mode d'action ni à une identité de rôle. Comme l'ouvrier dans « Untangling », 1994, ils sont montrés dans un moment d'arrêt, de tranquillité (forcée) face à un événement décisif qui, comme le coup de vent de « A Sudden gust of Wind (after Hokusai) », 1993, peut donner à l'événement une tournure inattendue. La suite de l'événement demeure ouverte. Réalisées en noir et blanc, les dernières séries de Wall, se servent elles aussi du principe de l'allusion : les histoires en rapport avec les images naissent dans l'imagination du spectateur, dirigées par ce qu'on peut qualifier de transformation des archives de l'image collective. A. W.

JEFF WALL

SELECTED EXHIBITIONS: *1993* Kunstmuseum Luzern, Lucerne, Switzerland; Irish Museum of Modern Art, Dublin, Ireland /// *1995* Galerie Nationale du Jeu de Paume, Paris, France /// *1996* Whitechapel Art Gallery, London, England /// Städtische Galerie im Lenbachhaus, Munich, Germany /// *1997* Hirshhorn Museum and Sculpture Garden, Washington, D.C.; The Museum of Contemporary Art, Los Angeles (CA), USA; Art Tower Mito, Mito, Japan **SELECTED BIBLIOGRAPHY:** *1993 Dead Troops Talk*, Kunstmuseum Luzern, Lucerne; Irish Museum of Modern Art, Dublin; Deichtorhallen Hamburg, Hamburg, Germany /// *1995 Exhibition catalogue*, Galerie Nationale du Jeu de Paume, Paris /// *1996 Jeff Wall: Space and Vision*, Städtische Galerie im Lenbach-haus, Munich /// *Jeff Wall*, London /// *1997 Jeff Wall*, The Museum of Contemporary Art, Los Angeles

04 PASSERBY. B/w photograph, 229 x 335 cm. **05 THE DRAIN,** 1989. Transparency in light box, 229 x 289 cm.

GILLIAN WEARING

"I'm always trying to find ways of discovering things about people, and in the process discover more about myself." « **Je cherche toujours à trouver des moyens d'en savoir plus sur les autres, et, dans ce processus, d'en savoir plus sur moi-même.** »

An important source of inspiration for Gillian Wearing came from the English TV serial "Family", a fly-on-the-wall-documentary in which a "real" family acted itself. According to Wearing, an incredible process of exposure took place in this series: "... the Wilkins family seemed so naive in front of the camera, and once they appeared on the screen the commonest situations suddenly became terrifying – their whole life was displayed." In Wearing's work this disclosure is repeated afresh: complete strangers reveal their dreams and innermost longings and thus surrender themselves to a disturbing form of portraiture. At first, she used the simple tactic of interviewing her subjects, posing certain questions and making series of works from the answers. In 1992/93 she asked passers-by in London to write on placards the exact thought that was passing through their head and then photographed each person holding up their sign ("Signs that..."). Others replied to an advertisement in the paper and agreed to speak in front of Wearing's video-camera about their lives ("Confess all on video", 1994). Subsequently, her concepts became more complex. She creates tensions through the medium she employs that alienate the portraiture. A group picture of a police team thus becomes a numbingly long video, a prolonged photo ("Sixty Minutes, Silence", 1996). The video "Sasha and Mum", 1997, runs alternately forwards and backwards, so that the quarrel between mother and daughter becomes an endless battle of love and hatred. The dubbed montage "10 – 16", 1997, is also an accomplished allegory in which the voices of youngsters issue from the mouths of adults. The personal histories of the teenagers penetrate the grown-up faces, becoming fateful projections of past and future.

01

02

01 / 02 / 03 / 04 SIGNS THAT SAY WHAT YOU WANT THEM TO SAY AND NOT SIGNS
THAT SAY WHAT SOMEONE ELSE WANTS YOU TO SAY, 1992/93. C-type print mounted on
aluminium, 40 x 30 cm (each). 05 / 06 10 –16, 1997. Video projection, c. 15 mins.

05 06

L'une des sources d'inspiration importantes pour Gillian Wearing a été la série de la télévision anglaise «Family», premier soap opera dans lequel une «vraie» famille joue son propre rôle. Dans cette série, selon Wearing, on assistait à une incroyable mise à nu: «... Devant la caméra, la famille Wilkins semblait si naïve, et une fois portées à l'écran, les situations les plus banales devenaient soudain terrifiantes – toute leur vie était étalée au grand jour.» L'œuvre de Wearing reproduit ce même dévoilement: de parfaits étrangers nous révèlent leurs rêves et leurs désirs les plus intimes, se livrant ainsi à une forme inquiétante du portrait Wearing s'est d'abord servi de stratégies simples de l'interrogation et leur a donné la forme de séries. En 1992/93, elle demandait ainsi aux passants de Londres d'écrire très exactement les pensées qui leur passaient par la tête à cet instant («Signs that...»). D'autres personnes ont répondu à des petites annonces, parlant de leur vie devant la caméra vidéo («Confess all on video», 1994). Les projets de Wearing sont aujourd'hui plus complexes. Par le biais du médium employé, elle met à jour des tensions qui dépersonnalisent le portrait. Ainsi, le portrait de groupe d'une unité de police est une vidéo d'une longueur paralysante avec un interminable plan fixe, une photo prolongée («Sixty Minutes, Silence», 1996). La vidéo «Sasha and Mum», 1997, se déroule alternativement d'avant en arrière et inversement, ce qui fait de la confrontation entre la mère et la fille une lutte sans fin d'amour et de haine. Une autre allégorie parfaite est aussi donnée dans «10–16», 1997, un montage synchro dans lequel des voix d'adolescents sortent de la bouche de modèles adultes. Les histoires personnelles des jeunes entrent dans les visages des adultes et deviennent les projections inéluctables du passé et de l'avenir. S. T.

03 04

GILLIAN WEARING

SELECTED EXHIBITIONS: *1995* "Western Security", Hayward Gallery, London, England /// "Campo", XLVI Esposizione Internationale d'Arte, la Biennale di Venezia, Venice, Italy /// *1997* Kunsthaus Zürich, Zurich, Switzerland /// Wiener Secession, Vienna, Austria /// *1998* Centre d'Art Contemporain, Geneva, Switzerland /// *1999* Maureen Paley Interim Art, London
SELECTED BIBLIOGRAPHY: *1996 Made in London*, London /// *NowHere*, Louisiana Museum of Modern Art, Humlebæk, Denmark /// *1997 Gillian Wearing*, Wiener Secession, Vienna /// *Signs that say what you want them to say and not signs that say what someone else wants you to say*, Maureen Paley Interim Art, London

07

07 **SIXTY MINUTES, SILENCE,** 1996. Video back projection, 1 hour, 38 x 33 cm. 08 **DANCING IN PECKHAM,** 1994. Videotape, 25 mins. 09 **THE UNHOLY THREE,** 1996.
Installation view, "Pandaemonium, London Festival of Moving Images", Institute of Contemporary Arts, London, England, 1996.

FRANZ WEST

"Take a chair off the shelf, use it for its purpose and then put it back again." **« Prenez une chaise sur l'étagère, faites-en un usage conforme à sa fonction et remettez-la en place. »**

Most of Franz West's works are intended to be actively experienced with the body. With his so-called "fitting-pieces" from the 1980s, he envisages the viewer's physical participation. These amorphous sculptures with rough, crusted surfaces are meant to be laid against the body. Their curious shapes compel one to adopt extraordinary postures. West documented many of these actions by means of videos or photos. In his emphasis on body involvement and performance West comes close to Viennese Actionism, but his characteristic irony eschews their heavy pathos. His metal chairs and couches, which are covered with fabric or carpet, are a logical development of the "fitting-pieces". His furniture sculptures are also meant to be used by the exhibition visitor. Among other things, he made striking seating arrangements for the sun roof of the New York Dia Art Foundation, the open-air cinema of documenta IX and the great hall at documenta X. With these he demonstrated his work's intermediate position between an autonomous work of art and an object of use. Or his couches may be interpreted as an allusion to Sigmund Freud, whose writings West has studied intensively. West has also co-operated with friends in writing texts in which he reflects the thoughts of theoreticians like Wittgenstein or the French philosophers Roland Barthes, Gilles Deleuze or Jacques Lacan. From time to time, artist friends help to produce West's works. This enables him to defy the romantic myth of the autonomous artistic genius, and to widen his work with additional facets of content and style.

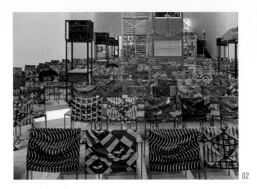

01 MOON PROJECT, 1997. 6 benches, metal, foam and fabric (aluminized 19 gunge carbon kevlar), each bench, 76 x 88 x 110 cm. Installation view, "Projects 61: Franz West", The Museum of Modern Art, New York (NY), USA, 1997. **02 DOKUSTUHL,** 1997. 300 chairs (metal, foam) covered in Senegal fancy print. Installation view, documenta X, Kassel, Germany, 1997. **03 CLAMP,** 1995; **PAPILLE,** 1995. Installation view, "Franz West. Proforma", Kunsthalle Basel, Basle, Switzerland, 1996.

La plupart des œuvres de Franz West sont destinées à être éprouvées activement avec le corps. Dans les années 80, avec ses «Accolements», West prévoyait déjà une participation physique du spectateur. Ces sculptures amorphes présentant une texture de surface rugueuse, croûteuse, sont destinées à être appliquées contre le corps. Leurs formes insolites obligent à prendre des poses inhabituelles. West a documenté nombre de ces actions par des vidéos et des photos. En mettant l'accent sur l'intervention du corps et la performance, West se situe dans le sillage de l'actionnisme viennois. Il est vrai cependant qu'avec l'ironie qui lui est propre, West sait éviter le sérieux et le pathétique de ce mouvement. Les chaises et les fauteuils de relaxation métalliques, tendus de tissu ou de tapis, constituent une évolution cohérente des «Accolements». Ses sculptures-meubles sont elles aussi conçues pour être utilisées par le visiteur. West a confectionné entre autres ses sièges très caractéristiques pour le solarium de la DIA Art Foundation de New York ou le cinéma de plein air de la documenta IX, de même que pour la grande halle de la documenta X. Il s'en sert pour thématiser la position intermédiaire de son travail entre l'œuvre d'art autonome et l'objet utilitaire. Au-delà de cet état de fait, les divans de West peuvent être interprétés comme des allusions à Freud, dont il a intensivement étudié les écrits. En collaboration avec des amis, West a de plus écrit des textes de réflexion sur la pensée de théoriciens comme Wittgenstein, les philosophes français Roland Barthes, Gilles Deleuze ou le psychanaliste Jacques Lacan. Certaines de ses œuvres naissent dans le cadre d'une participation d'autres amis artistes. West se tourne ainsi contre le mythe romantique du génie artistique autonome et élargit son œuvre en lui ajoutant de nouvelles facettes sémantiques et stylistiques. Y. D.

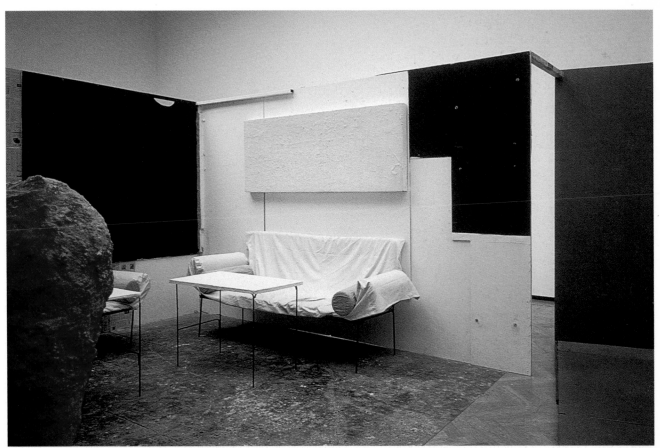

FRANZ WEST

SELECTED EXHIBITIONS: *1992* documenta IX, Kassel, Germany /// *1996* "Franz West. Gelegentliches", Städtisches Museum Abteiberg, Mönchengladbach, Germany /// *1997* "Projects 61: Franz West", The Museum of Modern Art, New York (NY), USA /// documenta X, Kassel /// *1999* The Renaissance Society at the University of Chicago, Chicago (IL), USA **SELECTED BIBLIO- GRAPHY:** *1989* Museum Haus Lange, Krefeld, Germany /// *1990 Exhibition catalogue,* XLIV Esposizione Internationale d'Arte, la Biennale di Venezia, Venice, Italy, Austrian Pavillion /// *1996 Franz West. Proforma,* Museum moderner Kunst Stiftung Ludwig Wien, 20er Haus, Vienna, Austria /// *Franz West. Gelegentliches,* Städtisches Museum Abteiberg, Mönchengladbach /// *1998 Exhibition catalogue,* Fundação de Serralves, Oporto, Portugal

05

04 **AUTOSTAT,** 1996. Painted sheet steel, 160 x 260 x 100 cm. Installation view, Skulptur. Projekte in Münster 1997, Münster, Germany, 1997.
05 **LISA DE COHEN MIT PASSSTÜCK,** c. 1983. 06 **SYNTAGMA,** 1998. Wood, gauze, papier-mâché, paint, plaster, 140 x 50 x 30 cm, 165 x 38 x 38 cm. Installation view, "Das Jahrhundert der künstlerischen Freiheit", Wiener Secession, Vienna, Austria, 1998.

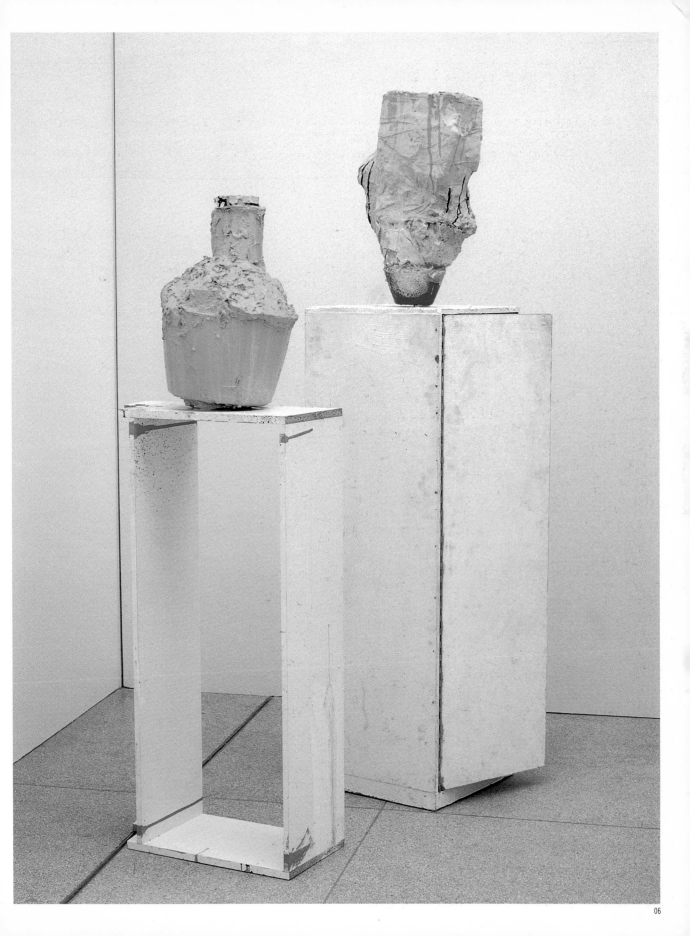

RACHEL WHITEREAD

1963 born in London / lives and works in London, England

"I look like the you I turned into, being your imprint. You are exactly what is lost since only you would fit the mould which I have become." « Etant ton empreinte, je ressemble à toi en qui je me suis transformée. Tu es exactement ce qui est perdu dans la mesure où toi seul corresponds au moule en quoi je me suis transformée. »

In 1993 Rachel Whiteread exhibited a spectacular outdoor sculpture that excited a good deal of media attention; in the same year she won the prestigious Turner Prize. "House" was a cast in poured concrete of the inside of a deserted house in a poor area of London, which made the whole district appear like a gigantic memento mori. The work epitomised this area before the assault of demolition and speculation, and made a strong emotional appeal as a symbol of the destruction of the past. This temporary monument, which for eight months stood on the site of the old building before being demolished in its turn, is, like all her other works, a simulacrum. It is a significant representation of an everyday object that reveals elements rarely noticed in the familiar original – feelings, memories, personal associations and archetypal relationships with life and death. Her first, sooty cast of a room, "Ghost", 1990, produced a similar effect, as did the numerous plaster, resin or latex casts of mattresses, pillows, doors and bath tubs. All these objects are weighed down with the past, and the casts provide a space for the expression of their history. The power of this kind of sculptural negative-positive form was evident once again when Whiteread made plans for another project for the open air, this time taking up the theme of political rather than private history. She won the competition for the Holocaust Memorial in Vienna by proposing to cast the interior of a destroyed library. This spectral revival of the past aroused such traumatic debate from the moment the design was presented that the project's realisation still remains disputed.

En 1993, Rachel Whiteread dressait dans l'espace public une sculpture spectaculaire qui déclencha une violente tempête médiatique et lui valut la même année le célèbre Prix Turner. « House », l'empreinte en béton d'un immeuble petit-bourgeois à Londres, avait transformé tout l'îlot en memento mori. Cet action frappait en plein cœur une zone touchée par la démolition et la spéculation immobilière ; signe d'un passé détruit, elle émouvait et irritait à la fois. Comme toutes les « empreintes » de Whiteread, ce monument éphémère, qui resta huit mois sur l'emplacement de l'ancien immeuble avant d'être à son tour démoli, est un simulacre, représentant important d'un objet quotidien qui fait apparaître ce que l'« original » familier ne permettait guère de voir : des sentiments, des souvenirs, des associations personnelles et des liens archétypaux avec la vie et la mort. C'est ainsi que fonctionnait déjà le premier coulage spatial « Ghost », 1990, ainsi que les nombreux moulages de matelas, de coussins, de portes et de baignoires réalisés en plâtre, en résine ou en latex. Et sur tous ces objets plane un lourd passé, le moulage instaurant formellement un espace pour leur histoire. La puissance de ce type de forme positive/négative devait également sauter aux yeux lorsque Whiteread conçut un nouveau projet pour l'espace public, projet qui thématisait une histoire non plus privée, mais politique. L'artiste a en effet remporté le concours pour le monument à l'holocauste à Vienne en proposant le moulage d'une bibliothèque détruite. Actualisation du passé par le biais de l'empreinte, ce projet a déjà déclenché par sa seule présentation des débats si traumatiques que l'exécution en reste à ce jour controversée.

S. T.

RACHEL WHITEREAD

SELECTED EXHIBITIONS: *1992* "Rachel Whiteread: Sculptures", Stedelijk Van Abbemuseum, Eindhoven, The Netherlands /// documenta IX, Kassel, Germany /// *1994* "Rachel Whiteread: Skulpturen/Sculptures", Kunsthalle Basel, Basle, Switzerland /// *1996* "Rachel Whiteread: Shedding Life", Tate Gallery Liverpool, Liverpool, England /// *1997* Museo Nacional Centro de Arte Reina Sofía, Madrid, Spain /// XLVII Esposizione Internationale d'Arte, la Biennale di Venezia, Venice, Italy, British Pavilion /// *1998* Anthony d'Offay Gallery, London, England **SELECTED BIBLIOGRAPHY:** *1993 Rachel Whiteread: Sculptures*, Stedelijk Van Abbemuseum, Eindhoven /// *1994 Rachel Whiteread: Sculptures/Skulpturen*, Kunsthalle Basel, Basle; The Institute of Contemporary Art, Boston (MA); The Institute of Contemporary Art, University of Pennsylvania, Philadelphia (PA), USA /// *1995 House*, London /// *1997 Shedding Life*, Tate Gallery Liverpool, Liverpool /// *1998 Claustrophobia*, Ikon Gallery, Birmingham, England /// *Displacements*, Art Gallery of Ontario, Toronto, Canada

PAGES 534/535: **01 TABLE AND CHAIR (CLEAR),** 1994. Resin, 69 x 102 x 75 cm. **02 UNTITLED (RESIN CORRIDOR),** 1995. Resin, 22 x 136 x 389 cm. Installation view, "Untitled (Floor)", Karsten Schubert, London, England, 1995. **03 HOUSE 1993,** 1993. Installation view, Corner of Grove Road and Roman Road, London, England, 1993. PAGES 536/537: **04 TWENTY FIVE SPACES,** 1995. Cast resin (25 blocks), 43 x 30 x 30 cm (each). **05 UNTITLED (PAPERBACKS),** 1997. Plaster and steel, dimensions variable. Installation view, XLVII Esposizione Internationale d'Arte, la Biennale di Venezia, Venice, Italy, British Pavilion, 1997.

04

CHRISTOPHER WILLIAMS

1956 born in Los Angeles / lives and works in Los Angeles (CA), USA

"Show me an angel and I will paint one." « Montre-moi un ange et j'en peindrai un. »

How photographs influence our view of reality is a question that has preoccupied Christopher Williams since the early 1980s. Initially, he worked with material from photo archives of museums, libraries, magazines or agencies. Towards the end of the 1980s, he began to produce photographs that frequently refer to existing cultural images. Detailed captions indicate possible selection criteria, connections and genealogies. Thus the caption to "Bouquet, for Bas Jan Ader and Christopher D'Arcangelo", 1991, is to be understood not only as homage to these Conceptual artists. We are also told in the caption that the bouquet was arranged from plants of countries mentioned in an earlier work by Williams, namely "Brazil", 1989. In the nine-part exhibition series "For Example: Die Welt ist schön" from 1993–1997, Williams continues this game of references. The title itself alludes to the famous photo book by Albert Renger-Patzsch, "Die Welt ist schön" (The World is Beautiful) of 1928. As a representative of New Objectivity, Renger-Patzsch tried to capture the "essence" of structures and phenomena of the visible world and to set them in order. Williams's objectively distanced photographs of animals, plants, industrial products, Modernist architecture and people pick up not only Renger-Patzsch's pictorial style but also something of his aesthetic approach, such as the isolated presentation of individual objects. But Williams introduces subtle elements of disruption into these apparently objective illustrations, which often evoke colonialist associations. There is a scarcely perceptible shift in the angle of vision and moment of exposure when Williams uses a second camera in photographing Japanese models at fashion shows or young printers in Dakar, Senegal. The result is an alienated and alienating view of things that shows any objective recording of the world to be an illusory venture.

01

01 "VALENTINE" TYPEWRITER 1969, PLASTIC (ABS), DESIGN ETTORE SOTTSASS JUN., PERRY KING, MANUFACTURE, ING. C. OLIVETTI & CO. SPA ITALY, H. 11.5 CM INV. NO. V 6,3 – 393, (NR.1-4), 1996. Dye Transfer Prints, 64 x 75 cm (framed). 02 3 WHITE (DG'S MR. POSTMAN), FOURTH RACE PHOENIX, GREYHOUND PARK PHOENIX ARIZONA, AUGUST 22, 1994, 1994. Gelatin silver print, 64 x 75 cm (framed).

02

La question de savoir comment l'image photographique conditionne notre vision de la réalité occupe Christopher Williams depuis le début des années 80. Dans un premier temps, Williams devait travailler en se servant de matériaux iconologiques empruntés à des musées, des bibliothèques, des revues ou des agences. Vers la fin des années 80, il commence en revanche à réaliser des photos dans lesquelles on trouve de fréquentes allusions à des images culturelles existantes. Des légendes détaillées renvoient à de possibles critères de choix, à des références, à des généalogies. Ainsi, le titre de « Bouquet, for Bas Jan Ader and Christopher D'Archangelo », 1991, ne doit pas seulement être compris comme un hommage à ces artistes conceptuels. La légende indique aussi au spectateur que le bouquet de fleurs a été arrangé à partir de plantes provenant des pays évoqués dans « Brazil », une œuvre datant de 1989. Représentant de la Nouvelle Objectivité, Renger-Patzsch avait tenté de classer et de fixer dans leur essence les structures et les phénomènes du monde visible. Les prises de vue objectives et froides d'animaux, de plantes, de produits (industriels), d'architectures modernes et d'hommes réalisées par Williams ne reprennent pas seulement le genre iconique de Renger-Patzsch, mais aussi certaines de ses propositions esthétiques comme la représentation isolée de certains objets. Mais dans ces représentations apparemment « objectives », Williams introduit de subtiles perturbations qui suscitent fréquemment des réminiscences colonialistes. Insensiblement, l'angle de vue et le moment de la prise de vue se déplacent, lorsque Williams fait photographier des mannequins japonais par un deuxième appareil pendant des séances photo de mode ou de jeunes imprimeurs sénégalais : vision des choses étrange et troublante qui met en évidence le caractère illusoire d'une approche objective du monde.

A. W.

CHRISTOPHER WILLIAMS

SELECTED EXHIBITIONS: *1993* "For example: Die Welt ist schön (First Draft)", Kunstverein München, Munich, Germany /// "Temporary Translation(s)", Sammlung Schürmann, Kunst der Gegenwart und Fotografie, Deichtorhallen Hamburg, Hamburg, Germany /// *1995* "Oehlen Williams 95", Wexner Center for the Arts, Columbus (OH), USA (with Albert Oehlen) /// *1997* "For example: Die Welt ist schön, A retrospective from first draft to final draft", Museum Boijmans Van Beuningen, Rotterdam, The Netherlands /// "Archäologie, Beaux-Arts, Ethnographie, Théâtre-Vérité, Varietes", Kunstverein in Hamburg, Hamburg **SELECTED BIBLIOGRAPHY:** *1989 A Forest of Signs: Art in the Crisis of Representation*, The Museum of Contemporary Art, Los Angeles (CA), USA /// *1995 Oehlen Williams*, Wexner Center for the Arts, Columbus /// *1996 Araki, Clark, Struth, Williams*, Kunsthalle Basel, Basle, Switzerland /// *1997 Christopher Williams. For example: Die Welt ist schön (Final Draft)*, Museum Boijmans Van Beuningen, Rotterdam; Kunsthalle Basel, Basle; Kunstverein in Hamburg, Hamburg

04

03 BOUQUET, FOR BAS JAN ADER AND CHRISTOPHER D'ARCANGELO, 1991. C-print, 41 x 51 cm. 04 (SUPPLEMENT*) 1, CYPRUS, 1990, 1785, 8809, BURHINUS
OEDICNEMUS, STONE CURLEW, BURHINIDAE 9.11.82, PRESENTED BY PHILIP WAYRE, NORFOLK WILDLIFE PARK, GREAT BRITAIN. Gelatin silver print, 81 x 86 cm (framed).
05 TENEBRIONIDAE, ASBOLUS VERRUCOSUS, DEATH FEIGNING BEETLE, SILVER LAKE CALIFORNIA, OCTOBER 1, 1996, (NR. 2), 1996. Gelatin silver print, 64 x 75 cm (framed).

◄ 03

JANE & LOUISE WILSON

1967 born in Newcastle, England / live and work in London, England

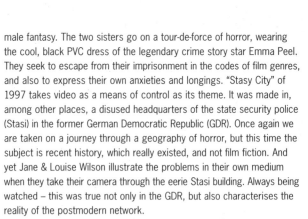

„Most of the photographic work is deliberately unpeopled and is presented in as near as possible 1:1 scale. It is up to the viewer to adopt the acting role in the pictured scene." « La plus grande partie de notre œuvre photographique est délibérément exempte de présence humaine et est présentée grandeur nature dans toute la mesure du possible. C'est au spectateur de prendre le rôle d'acteur dans la scène de l'image. »

Jane & Louise Wilson are two of the Young British Artists involved, above all, in the media reality of pop culture. The functioning mechanisms of film, TV, music and advertising, and their influence on the recipients, occupy the foreground of their aesthetic research. One particular focus is the role of women. The twins mainly use video for their art, but also bring in photography and three-dimensionally presented architectural objects. In the video "LSD" of 1994, the Wilsons let themselves be put into a trance by a hypnotist whose voice is heard off-stage. It is not the spectators but the two actors, or actresses, themselves who are being put under a spell, and the seductive power of mass-media suggestion comes under scrutiny. Jane & Louise Wilson examine typical scenes from horror and action films in "Crawl Space", 1994/95, and "Normapaths", 1995. In both works, the female body features as an object of hysterical male fantasy. The two sisters go on a tour-de-force of horror, wearing the cool, black PVC dress of the legendary crime story star Emma Peel. They seek to escape from their imprisonment in the codes of film genres, and also to express their own anxieties and longings. "Stasy City" of 1997 takes video as a means of control as its theme. It was made in, among other places, a disused headquarters of the state security police (Stasi) in the former German Democratic Republic (GDR). Once again we are taken on a journey through a geography of horror, but this time the subject is recent history, which really existed, and not film fiction. And yet Jane & Louise Wilson illustrate the problems in their own medium when they take their camera through the eerie Stasi building. Always being watched – this was true not only in the GDR, but also characterises the reality of the postmodern network.

Jane & Louise Wilson font partie des Young British Artists, qui travaillent avant tout sur les réalités médiatiques de la culture populaire. Les mécanismes fonctionnels du cinéma, de la télévision, de la musique et de la publicité, leur influence sur ceux qui les reçoivent sont au premier plan de leur recherche esthétique. Une attention particulière porte en cela sur le rôle de la femme. Pour leur art, les jumelles se servent surtout du médium de la vidéo, mais aussi de la photographie et des objets architectoniques posés dans l'espace. Dans une vidéo comme « LSD », 1994, les sœurs Wilson se faisaient mettre en transe par un hypnotiseur dont on peut entendre la voix off. Aux lieu et place du spectateur, ce sont donc ici les actrices elles-mêmes qui sont « sous le charme », tandis que la séduction suggestive des médias entre dans le champ de vision du spectateur. Dans « Crawl Space », 1994/95, et « Normapaths », 1995, Jane & Louise Wilson analysent les facteurs stylistiques des films d'horreur et d'action. Dans ces deux œuvres, le corps féminin intervient comme objet du fantasme hystéro-masculin : vêtues de la tenue décontractée en skaï noir d'Emma Peel, l'héroïne de la série culte du petit écran, les deux sœurs abordent un tour de force de l'horreur. Prisonnières des codes des genres cinématographiques, elles cherchent une échappatoire, mais aussi toujours une articulation de leurs propres angoisses et désirs. « Stasy City », 1997, illustre l'emploi de la vidéo comme moyen de contrôle. Ce film a été tourné entre autres dans un quartier général désaffecté de la sûreté intérieure de l'ex-RDA. Il s'agit là encore une fois d'un voyage à travers une géographie de l'horreur ; c'est cependant ici l'histoire réelle, concrète, récente, et non l'action cinématographique, qui sert de sujet. Et pourtant, avec les étranges itinéraires de la caméra dans l'édifice de la Stasi, Jane & Louise Wilson posent le problème de leur propre médium : ne jamais être hors champs. *R. S.*

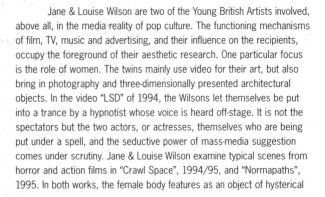

01 RED ROOM, 1995. C-type print, 180 x 180 cm. **02 DEN**, 1995. C-type print, 230 x 180 cm.

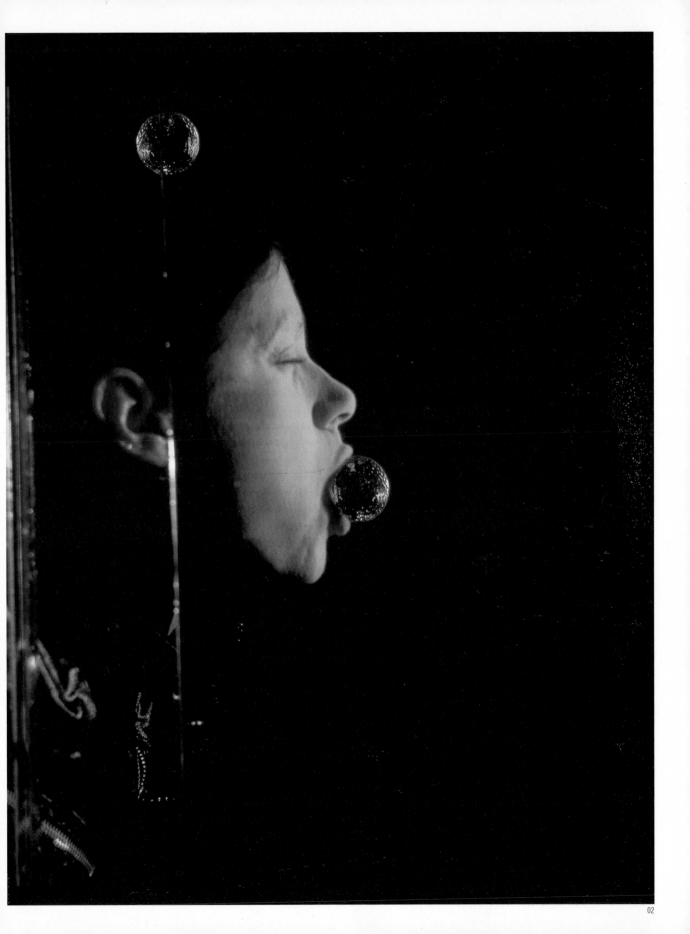

JANE & LOUISE WILSON

SELECTED EXHIBITIONS: *1995* "Normapaths", Chisenhale Gallery, London; Berwick Gymnasium Gallery, Berwick-upon-Tweed, England /// *1996* "NowHere", Louisiana Museum of Modern Art, Humlebæk, Denmark /// "Full House", Kunstmuseum Wolfsburg, Wolfsburg, Germany /// *1997* "Ein Stück vom Himmel – Some Kind of Heaven", Kunsthalle Nürnberg, Nuremberg, Germany /// "Stasi City", Kunstverein Hannover, Hanover, Germany **SELECTED BIBLIOGRAPHY:** *1995 General Release*, British Council selection for Venice Biennale, Scuola San Pasquale, Venice, Italy /// *Exhibition catalogue*, Chisenhale Gallery, London /// *1996 Co-operators*, Southampton City Art Gallery, Southampton; Huddersfield Art Gallery, Huddersfield, England /// *NowHere*, Louisiana Museum of Modern Art, Humlebæk /// *1997 Ein Stück vom Himmel – Some Kind of Heaven*, Kunsthalle Nürnberg, Nuremberg; South London Gallery, London

03

04

05

06

03 **STASI CITY (INTERVIEW CORRIDOR),** 1997. C-type print on aluminium, 180 x 180 cm. **04 STASI CITY (OPERATING ROOM),** 1997. C-type print on aluminium, 180 x 180 cm. **05 STASI CITY (1),** 1997. C-type print on aluminium, 180 x 180 cm. **06 STASI CITY (10),** 1997. C-type print on aluminium, 180 x 180 cm. **07 NORMAPATHS,** 1995. Set and projection with 1 screen showing 16mm film (2 U-matic, 3 mins., 40 secs., loop), projection of 335 x 427 cm; film set, 244 x 488 x 488 cm. Installation view, Chisenhale Gallery, London, England, 1995. **08 NORMAPATHS,** 1995. Installation view, Chisenhale Gallery, London, 1995.

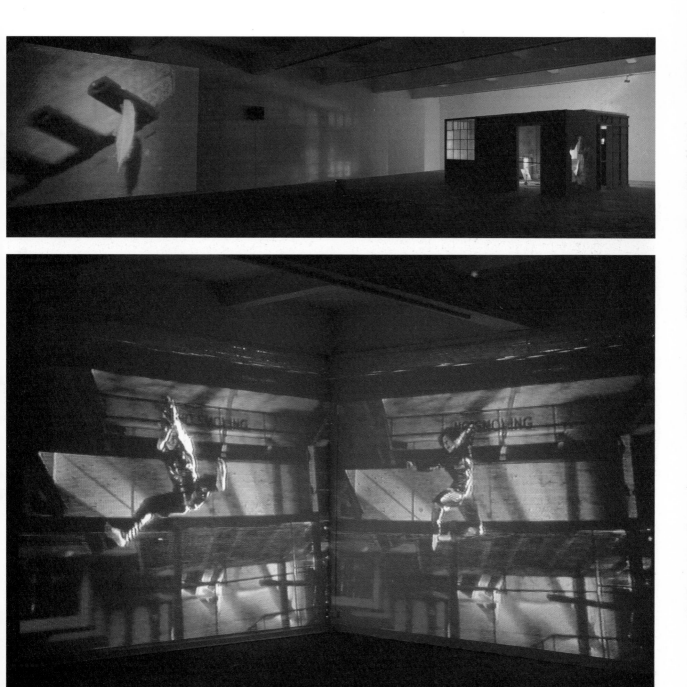

TERRY WINTERS

1949 born in Brooklyn (NY) / lives and works in New York (NY), USA, and Geneva, Switzerland

"For me, the painting process is cumulative and non-linear – it's a free-flowing set of interpretations. Painting can make unconscious patterns visible." « Pour moi, l'action de peindre est cumulative et non linéaire – c'est un ensemble d'interprétations au libre va-et-vient. La peinture peut rendre visible des modeles de l'inconscient. »

Since the early 1980s Terry Winters has staked out his artistic terrain in the frontier marches between abstraction and figuration. As a painter, graphic artist and engraver, he has always been less interested in the expressive portrayal of the human situation than in a sensitive, reciprocal interchange between science and art. Whereas in the early years of his career it was biological phenomena he reflected and translated into painting, more recently it has been the worlds of chaos theory and computer technology that have commanded Winter's attention and set the scope of his artistic output. One basic notion however runs through all his work: pondering the aesthetic means is not a self-referential 'art for art's sake' process but serves to formulate non-artistic problems. When we examine Winters' picture "Insecta" (1985), for example, we see various insects juxta- and superimposed, amongst which ants

and beetles can readily be made out. How they are placed is at once both a reference to and analysis of scientific classifications. The artist is moreover searching here for a formal, abstract visual language using amorphous forms, pastose explosions of colour and the interplay of fili-gree lines to suggest further structural similarities between painting and biology. The later woodcut "Graphic Primitives, 3" (1998) in contrast, with its self-encapsulating sequences, is at first glance more reminiscent of computer circuit diagrams or even town-planning diagrams. They appear now more technoid and mechanical, so that a personal style is no longer evident. Even here the work is both abstract and figurative at the same time, apparently as decorative as it is cryptic and critical. "Full of ominous references", the work thus bears witness to the appeal but also the two-edged nature of modern technology.

Depuis le début des années 80, Terry Winters situe le champ de son travail plastique à la limite entre l'abstraction et la figuration. Mais le propos du peintre, dessinateur et graveur est toujours moins la repré-sentation expressive des états humains que la sensible interpénétration entre la science et l'art. Si au début de sa carrière c'étaient les phéno-mènes biologiques qui faisaient l'objet d'une réflexion transposée en peinture, ce sont les mondes de la théorie du chaos et de l'informatique qui conditionneront sa création artistique. Mais toutes les phases de son œuvre sont marquées par une idée fondamentale : l'importance donnée aux moyens esthétiques n'est pas un « art pour l'art » auto-référencé, elle sert plutôt la formulation de problèmes, extra-artistiques. Lorsqu'on regarde un tableau comme « Insecta », 1985, on y voit différents insectes juxtaposés ou superposés : le fourmis ou les coléoptères s'identifient aisément. Leur répartition renvoie aux classifications scientifiques – tout

en les remettant en question. De plus, l'artiste recherche un langage pictural formel-abstrait en se servant de formes amorphes – explosions de couleur pâteuse et jeux de lignes filigranes – pour suggérer d'autres similitudes de structure entre la peinture et la biologie. Au premier abord les imbrications séquentielles d'une sculpture sur bois plus tardive, « Graphic Primitives, 3 », 1988, rappelle en revanche des schémas de montage informatiques, mais aussi des plans d'urbanisme. Ils présentent aujourd'hui un aspect plus technoïde et mécanique, on n'y décèle plus aucune trace d'écriture personnelle. Ici encore, l'œuvre est donc à la fois figurative et abstraite, elle apparaît aussi décorative que cryptée et critique. Ce travail « plein de funestes correspondances » témoigne donc à la fois de la fascination exercée par la technologie, mais aussi de son ambivalence.

R. S.

01 **FACTORS OF INCREASE,** 1988. Oil on canvas, 268 x 383 cm.
02 **BLACK AND WHITE MANIFOLD,** 1988. Oil on canvas, 300 x 204 cm.

TERRY WINTERS

SELECTED EXHIBITIONS: *1990* "Terry Winters Paintings", Sonnabend Gallery, New York (NY), USA /// *1992* Whitney Museum of American Art, New York /// *1994* Galerie Max Hetzler, Berlin, Germany /// *1997* "Terry Winters Recent Works", School of the Museum of Fine Arts, Boston (MA), USA /// *1999* The Whitechapel Art Gallery, London, England **SELECTED BIBLIO-GRAPHY:** *1985 Terry Winters*, Kunstmuseum Luzern, Lucerne, Switzerland /// *1991 Terry Winters*, The Museum of Contemporary Art, Los Angeles (CA), USA, Whitney Museum of American Art, New York /// *1997 Terry Winters: Recent Works*, School of the Museum of Fine Arts, Boston

CHRISTOPHER WOOL

1955 born in Chicago (IL) / lives and works in New York (NY), USA

Christopher Wool adopts the 1950s and 60s style of all-over painting. Initially, he used a pouring technique that revived Jackson Pollock's dripping method in a mechanical and controlled way. Later, he employed repeating floral patterns that recall Andy Warhol's silkscreens. Finally he used stencil-like letters that are always appropriate to the format of the picture, which paradoxically – however stereotyped and anonymous they might be – became his signature. Wool's all-over painting is hard in appearance, and the aluminium support and the coldly glowing enamel paint, make his work seem far removed from the conventional idea of a painting. They have provoked many contradictory yet relevant interpretations. On the one hand, the letters form clear patterns, flattened to the status of ornaments and composed surfaces. They appear as definitive denials of pictures, finding their climax in linguistic concepts ("RIOT", "RUN", "DOG") and finally in chopped-up words ("THE SHOW I SOVER"). On the other hand, this cold refusal opens up through the uneven, proliferating print of the patterns or the dripping contour of the letters, whose inference is retained in spite of coding , such as "TRBL" (trouble). What was devoid of meaning becomes overloaded with it, both in terms of concept and in a decorative sense. For many years Wool's work achieved its effect through a reflective distancing, whereby street themes and thoughts on the end of painting were simultaneously embraced. But in the more recent, often manically thick, layered applications, calculated disruptions appear. Artistic gestures, pictorial subjects and common noun titles become the counterpart of rational cognition.

Christopher Wool a adopté le all-over utilisé dans la peinture des années 50 et 60. Dans un premier temps, il a travaillé sur des structures de gouttes pour lesquelles il s'est servi de la technique du dripping de Pollock, mais contrôlée mécaniquement, puis sur des motifs floraux récurrents rappelant les sérigraphies d'Andy Warhol, et pour finir sur ces lettres évoquant le pochoir, toujours adaptées au format du tableau et qui, paradoxalement, si stéréotypées et anonymes qu'elles soient, sont devenues l'écriture de Wool. Le all-over de Wool est dur. Avec la présence d'un fond aluminium et de couleurs émaillées au rayonnement froid, il semble bien loin de ce qu'on imagine habituellement être une peinture. Ses œuvres ont suscité des interprétations aussi contradictoires que pertinentes. D'un côté, les motifs, mais aussi les lettres, constituent de purs motifs banalisés en ornements et en compositions planes. Ils se présentent comme des refus définitifs du tableau qui culmineront dans des concepts verbaux (« RIOT », « RUN », « DOG ») et pour finir dans des mots hachés (« THE SHOW I SOVER »). D'un autre côté, le refus froid éclate avec l'irrégularité des motifs, et aujourd'hui leur pullulement, ou encore avec les coulures au contour des lettres, dont le message demeure malgré le cryptage : « TRBL » (trouble). L'absence de sens devient surcharge, dans le concept comme dans l'ornement. L'œuvre de Wool a longtemps fait effet par la distanciation réfléchie avec laquelle l'artiste traitait tout aussi bien des thèmes de la rue que ceux de la fin de la peinture. Dans les œuvres récentes, souvent des empilements d'une densité obsessionnelle, on voit en revanche apparaître des perturbations calculées. Les poses artistiques, les sujets picturaux et les titre accrocheurs deviennent le contrepoids de la connaissance rationnelle. S. T.

01

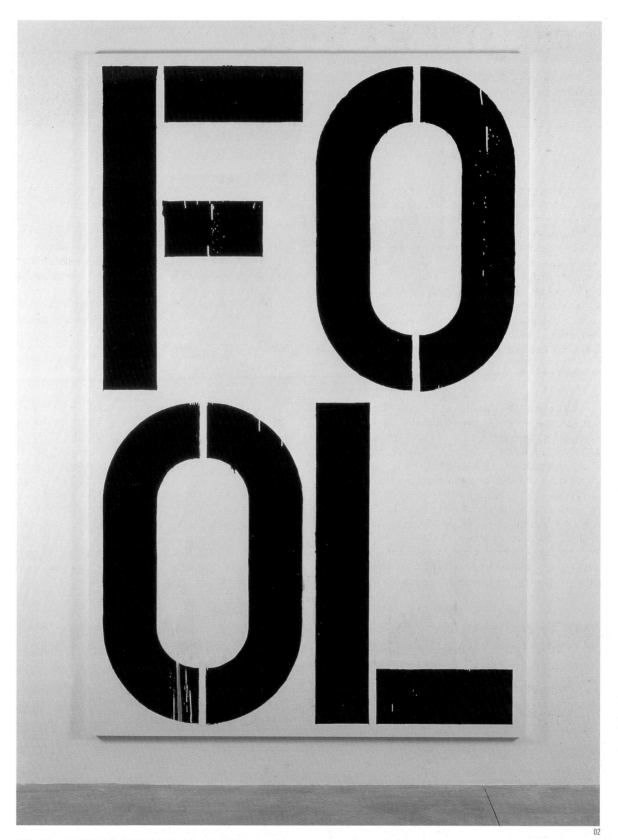

01 From left to right: **FUCKEM,** 1992; **IF YOU,** 1992; **HOLE,** 1992; **UNTITLED,** 1991. Installation view, Luhring Augustine, New York (NY), USA, 1992.
02 UNTITLED, 1990. Enamel on aluminium, 274 x 183 cm.

CHRISTOPHER WOOL

SELECTED EXHIBITIONS: *1989* "New Work: Christopher Wool", San Francisco Museum of Modern Art, San Francisco (CA), USA /// *1991* Museum Boijmans Van Beuningen, Rotterdam, The Netherlands /// Kölnischer Kunstverein, Cologne, Germany /// Kunsthalle Bern, Berne, Switzerland /// *1992* documenta IX, Kassel, Germany /// *1998* The Museum of Contemporary Art, Los Angeles (CA), USA /// *1999* Centre d'Art Contemporain, Geneva, Switzerland **SELECTED BIBLIOGRAPHY:** *1989 Christopher Wool, New Work*, San Francisco Museum of Modern Art, San Francisco /// *1991 Cats in Bag Bags in River*, Museum Boijmans Van Beuningen, Rotterdam /// *1993 Absent without Leave,* daadgalerie, Berlin, Germany /// *1997 Birth of the Cool: American Painting from Georgia O'Keeffe to Christopher Wool,* Kunsthaus Zürich, Zurich, Switzerland /// *1998 Christopher Wool,* The Museum of Contemporary Art, Los Angeles; Zurich

03

04

03 **UNTITLED**, 1990. Alkyd, acrylic on aluminium, 275 x 183 cm. 04 **UNTITLED**, 1990/91. Enamel on aluminium, 274 x 183 cm.
05 **UNTITLED**, 1996. Enamel on aluminium, 229 x 152 cm. 06 **UNTITLED**, 1995. Enamel on aluminium, 213 x 152 cm.

05

06

ANDREA ZITTEL

1965 born in Escondido (CA) / lives and works in Altadena (CA), USA

"I want to show people that it is possible to become your own expert, to try to create your own experiments and to understand the world in your own way." **« Je veux montrer aux gens qu'il leur est possible de devenir leur propre expert, d'essayer de créer leurs propres expériences et de concevoir le monde à leur façon. »**

Andrea Zittel's "A–Z Administrative Service" was founded at the beginning of the 1990s. It is presented as a service enterprise that introduces new products at regular intervals and offers them for sale and individual use. The objects Zittel creates are supposed to function and be useful in everyday living in contrast to the classical idea of a work of art. Moreover, her objects can scarcely be termed beautiful or even valued as designs. They arise from an artistic impulse which, to a certain extent, reacts to contemporary design, defines it anew and tries to improve it. Thus "A–Z Production" began with the "Living Unit", a completely functional dwelling unit reduced to 4 square metres, which initially organized the congestion of Zittel's own living conditions and then appeared in exhibitions in diverse variants as a product for sale ("A–Z Comfort Work", "A–Z Selected Sleeping Arrangements"). Zittel's puritanically practical designs, in which everything has a sensible function, recall the social utopias of the early avant-garde, especially their drive towards optimization and their promise of happiness. She speaks of a "tiny seed of perfection", which can impinge on present-day shoppers as a consciously selected experiment. In the meantime her scope has widened. In 1997 at documenta X Zittel showed spherical caravans that could be entirely appointed to suit individual taste as personal refuges ("Escape Vehicles"). In connection with "Skulptur. Projekte in Münster 1997" she presented floating, brilliant-white groups of seats, which are no longer practical designs but sheer models of longing – like nostalgic Hollywood swinging seats.

01

02

Créé au début des années 90, le « A–Z Administrative Service » d'Andrea Zittel se présente comme un prestataire de services qui propose périodiquement de nouveaux produits à la vente et à l'utilisation individuelle. Les objets de Zittel doivent fonctionner, être utiles et servir à l'habitat quotidien. Ils sont donc en contradiction avec l'idée classique d'œuvre d'art. De plus, ils ne peuvent guère être qualifiés de beaux. Ils ne peuvent pas davantage entrer dans la catégorie « design ». Ils naissent d'une pulsion artistique qui – en quelque sorte de l'extérieur – réagit au design de l'époque contemporaine, qui le redéfinit et travaille à son amélioration. La « A–Z Production » a ainsi commencé avec la « Living Unit », une unité d'habitation réduite à 4 mètres carrés, fonctionnant à la perfection, et qui dans un premier temps cherchait à organiser l'exiguïté des conditions de vie de l'artiste avant d'entrer dans des expositions sous forme de produit commercialisé en différentes variantes (« A–Z Comfort Work », « A–Z Selected Sleeping Arrangements »). Les projets puritains et fonctionnels de Zittel, dans lesquels chaque millimètre répond à une fonction rationnelle, font songer aux utopies sociales des débuts de l'avant-garde, à leur tendance à l'optimisation et à leurs promesses de bonheur. L'artiste elle-même parle d'un « petit grain de perfection » dont l'expérience peut apparaître aux acheteurs d'aujourd'hui comme consciemment choisie. Entre-temps, le propos premier de Zittel a évolué. En 1997, à la documenta X, elle présentait en effet des caravanes de forme sphérique, pouvant être aménagées de manière totalement individuelle comme des rêves d'évasion (« Escape Vehicles »). En 1997 également, à l'occasion de « Skulptur. Projekte in Münster » (« Sculpture. Projets à Münster »), elle présentait des îles flottantes d'un blanc éclatant permettant de s'asseoir dans l'eau et qui ne sont plus des projets pratiques, mais de pures concrétisations de désirs.

S. T.

03

ANDREA ZITTEL

SELECTED EXHIBITIONS: *1995-1996* "New Work: Andrea Zittel", San Francisco Museum of Modern Art, San Francisco (CA), USA /// *1996* "The A–Z Travel Trailer Units", Louisiana Museum of Modern Art, Humlebæk, Denmark; daadgalerie, Berlin, Germany /// *1996-1997* "Andrea Zittel – Living Units", Museum für Gegenwartskunst Basel, Basle, Switzerland /// *1997* "Andrea Zittel – Living Units", Neue Galerie am Landesmuseum Joanneum, Graz, Austria /// documenta X, Kassel, Germany **SELECTED BIBLIOGRAPHY:** *1996 The A–Z Travel Trailer Units*, San Francisco Museum of Modern Art, San Francisco (CA), USA; Louisiana Museum of Modern Art, Humlebæk; daadgalerie, Berlin /// *1996–1997 Andrea Zittel – Living Units*, Museum für Gegenwartskunst Basel, Basle; Neue Galerie am Landesmuseum Joanneum, Graz, Austria

04 CARPET FURNITURE: BED WITH TWO NIGHT STANDS; CARPET FURNITURE: SMALL DESK AND CHAIR; CARPET FURNITURE: CHAIR WITH TABLE,
all 1993. Silk and wool dye on wool carpet, set of 3: bed with two night stands, 244 x 244 cm; small desk and chair, 120 x 120 cm; chair with table, 270 x 120 cm; overall dimensions and arrangements are variable. **05 A–Z DESERTED ISLANDS I–X,** 1997. 10 islands, fibreglass, wood, plastic, floatation tank, vinyl seat, vinyl logo, c. 91 x 229 x 229 cm (each). Outdoor installation view, Skulptur. Projekte in Münster 1997, Münster, Germany, 1997.
06 A–Z BREEDING UNIT FOR AVERAGING EIGHT BREEDS, 1993. Steel, wood, glass and electronics, 183 x 434 x 46 cm.

04

HEIMO ZOBERNIG

1958 born in Mauthen, Austria / lives and works in Vienna, Austria

An essential aspect of Heimo Zobernig's work is the analysis of the way in which art is presented and its relationship to the development of theories. A clearly defined conceptual framework forms the basis of each of his paintings, sculptures, videos, performances and architectural undertakings, and yet in their execution he is also guided by the given spatial and material conditions. We often notice in Zobernig's objects traces of their genesis. This is worth mentioning because his works frequently show formal similarities with Minimal Art, but by means of deliberate carelessness Zobernig counteracts any aura of solemnity. Furthermore, a large number of his works display a functional use alongside what at first glance appears to be an autonomous sculptural presence. Some of his objects, made from inexpensive materials – paper, card-

board, plaster, chipboard, concrete or polystyrene – are intended for use as furniture and therefore provide the setting for social interaction. His contribution to documenta X was the design of the hall where the "100 Tage 100 Gäste" (100 Days 100 Guests) lectures were held. He designed a low platform and banners bearing the names of the participants. He also sited monitors in the room, fitted all the other technical apparatus into a standard container, and got his artist colleague Franz West to produce the seating. In his poster walls for "Skulptur. Projekte in Münster 1997", Zobernig worked with graphic elements. Here, as often in his work, the utility aspect of his works enters into dialogue with their purely artistic characteristics.

01

01 INSTALLATION VIEW, INIT-Kunst-Halle Berlin, Berlin, Germany, 1998. **02 UNTITLED**, 1994. Acrylic on canvas, 124 x 118 cm. **03 UNTITLED**, 1989. Oil on canvas, 150 x 150 cm.

Un aspect essentiel de l'œuvre de Heimo Zobernig est l'analyse de la présentation de l'art et son rapport avec la formation de théories. Zobernig fonde ses peintures, sculptures, vidéos, performances et interventions architecturales sur un concept clairement défini, tout en s'appuyant pour l'exécution sur les données spatiales ou matérielles du site. Dans ses objets, on trouve souvent encore les traces du processus de réalisation. Ceci mérite d'autant plus d'être mentionné que ses œuvres présentent fréquemment des ressemblances formelles avec celles du Minimal Art. Par une fabrication volontairement négligée, Zobernig refuse cependant toute aura du sublime. A cela s'ajoute qu'au-delà d'une présence sculpturale autonome au premier regard, une grande partie de ses œuvres ont souvent une utilité fonctionnelle. Certains de ses objets réalisés en matériaux bon marché – papier, carton, plâtre, panneaux d'aggloméré, béton ou polystyrène – sont destinés à servir comme mobilier et constituent ainsi la panoplie d'une interaction sociale. Lors de la documenta X, la contribution de Zobernig a été la décoration de la grande halle, où se donnait un cycle de 100 conférences à raison d'une conférence par jour. Zobernig devait réaliser une tribune basse et des transparents portant les noms des participants. Il installa en outre des moniteurs dans la salle, fit entrer le reste de l'appareillage technique dans un container standard et réaliser l'ensemble des sièges par son collègue Franz West. Pour ses panneaux d'affichage réalisés dans le cadre de « Skulptur. Projekte in Münster » (« Sculpture. Projets à Münster »), Zobernig a également travaillé avec des éléments graphiques. Au-delà de ces considérations, comme souvent dans son œuvre, le caractère utilitaire de ses travaux entre en dialogue avec leurs caractéristiques originellement artistiques.

Y. D.

HEIMO ZOBERNIG

SELECTED EXHIBITIONS: *1988* Aperto 88, XLIII Esposizione Internationale d'Arte, la Biennale di Venezia, Venice, Italy /// *1992* documenta IX, Kassel, Germany /// *1995* Wiener Secession, Vienna, Austria /// *1996* The Renaissance Society at the University of Chicago, Chicago (IL), USA /// *1997* documenta X, Kassel /// *1998* Bonner Kunstverein, Bonn, Germany
SELECTED BIBLIOGRAPHY: *1993 Heimo Zobernig*, Neue Galerie am Landesmuseum Joanneum, Graz; Salzburger Kunstverein, Salzburg, Austria /// *1994 Heimo Zobernig*, Kunsthalle Bern, Berne, Switzerland /// *1995 Heimo Zobernig*, Wiener Secession, Vienna /// *1996 Heimo Zobernig*, The Renaissance Society at the University of Chicago, Chicago /// *1997 Heimo Zobernig*, Villa Merkel, Esslingen/N., Germany /// *1998 Text und Kunst*, Bonner Kunstverein, Bonn

04

04 UNTITLED, 1992. Silkscreen on paper, 238 x 672 cm. Installation view, "Amerikaner", Steirischer Herbst 92, Forum Stadtpark, Graz, Austria, 1992. **05 UNTITLED,** 1997. Installation view, documenta X, Kassel, Germany, 1997. **06 BETONPLATTE,** 1990. 0.15 x 18.27 x 36.57 m. Schloßpark Jöss, Jöss, Austria.

Tierno Monénembo
Carlos Monsivais
Valentin Y. Mudimbe
Jean-Luc Nancy
Heinz Neumann-Riegner
Stanislas Nordey
Michael Oppitz
Ulrike Ottinger
Christos Papoulias
Raoul Peck
Marko Peljhan
Claus Philipp
Michelangelo Pistoletto
Philip Pocock
Otto E. Rössler
Suely Rolnik
Raoul Ruiz
Mikhail Ryklin
Edward Said
Saskia Sassen
Walter Seitter
Wolf Singer
Abderrahmane Sissako
Edward Soja
Alexandr Sokurov
Wole Soyinka
Gayatri C. Spivak
Sophia Silva Telles
Ritsaert ten Cate
Theaterskizzen
Rosemarie Trockel
Tunga
V2
Mayrbek Vatchagaev
Jeff Wall
Peter Weibel
Lois Weinberger
Florian Wenz
Lilian Zaremba
Francois Zourabichvili

APPENDIX

GLOSSARY *GLOSSAIRE*

APPROPRIATION ART In Appropriation Art, objects, images and texts are lifted from their cultural context and placed unchanged in a new one. They thus become charged with new significance. **ASSEMBLAGE** A three-dimensional picture made of different materials, usually of everyday use. **AURA** The radiance that renders a person or work of art subject to veneration. People or works of art possessing an aura are at once remote and approachable. They fascinate by their precious uniqueness. **AUTONOMY** Condition of self-reliance and independence. In art, autonomy means freedom from any conditioning by non-artistic objectives. **BODY ART** Art that takes the body for its subject and makes it the object of performances, sculptures or videos. **CAMP** Persons or objects whose appearance is exaggeratedly stylised are called camp. Admiration for them generates a mocking and at the same time emotion-laden cult of artificiality. **CATALOGUE RAISONNÉ** Annotated catalogue of an artist's work, with a claim to completeness. **CIBACHROME** A colour print (usually large format) made from a slide. **CODE** Sign system providing the basis for communication and conveying information. **COMPUTER ANIMATION** Apparently three-dimensional models produced on a computer which can be "walked through" or seen from different perspectives by the user; or virtual figures which move on the screen. **COMPUTER-GENERATED** Produced by computer. **CONCEPTUAL ART** Conceptual Art emerged in the 1960s. It gives primacy to the basic idea of a work's content. This is often revealed in language alone , i.e. texts or notes. The actual execution of the work is considered secondary and may be totally lacking. **CONTEXT ART** Context Art criticises the art business and its institutions. Power structures are disclosed,

ANIMATION *Module d'apparence tridimensionnelle produit par ordinateur et pouvant être « parcouru » par le spectateur – en fait : pouvant être vu sous des points de vue changeants ; figures virtuelles qui se meuvent sur un écran.* **APPROPRIATION ART** *Des objets, des images, des textes sont extraits de leur contexte culturel pour être transplantés tels quels dans un nouveau contexte, où ils se chargent d'une nouvelle signification.* **ART CONCEPTUEL** *L'art conceptuel, qui a vu le jour dans les années 60, met au premier plan le contenu de l'œuvre, dont la conception n'est souvent présentée que par des textes ou des notes, la réalisation concrète étant déclarée secondaire, voire éludée.* **ART CONTEXTUEL** *L'art contextuel critique le marché de l'art et ses institutions : les structures du pouvoir sont mises en évidence, les mécanismes de distribution et les formes d'exposition remises en cause sous l'angle de leur fonction politique. Des moyens d'expression aussi différents que la performance, l'installation ou l'art de l'objet y sont employés pour présenter cette critique.* **ART DE L'OBJET** *On peut y classer toutes les œuvres d'art entièrement composées ou comportant des objets ou des matériaux préexistants (Cf. Ready-made).* **ART DIGITAL** *Art s'appuyant sur les moyens offerts par les nouveaux médias tels que l'informatique ou l'internet.* **ART INTERACTIF** *Art qui prévoit une intervention directe du spectateur dans l'œuvre. Le plus souvent, cette intervention est rendue possible par des techniques s'appuyant sur l'informatique.* **ASSEMBLAGE** *Image en trois dimensions composée de matériaux divers issus le plus souvent de la vie courante.* **AURA** *L'aura désigne le rayonnement qui rend une personne ou une œuvre d'art digne d'admiration. Les personnes ou les œuvres d'art douées d'une aura sont à la fois distantes et accessibles, elles fascinent par leur incomparable unicité.* **AUTONOMIE** *État d'indépendance. Dans le contexte de l'art, l'autonomie signi-*

distribution mechanisms and exhibition forms are investigated for their political function. Various artistic means of expression are adopted to present this criticism, such as performances, installations and Object Art. **C-PRINT** A colour print from a photographic negative. **CROSSOVER** Crossover refers to crossing the boundaries between art and popular culture and between different cultures; also to the inclusion of music, design and folklore etc in artistic work. **CULTURAL STUDIES** A new trend in Anglo-American quasi-academic studies that is concerned with the examination of popular culture. Cultural studies pay particular attention to the influence of ratial, class or gender factors on cultural expression. **CURATOR** A curator decides what exhibitions are about, and selects the participating artists. **DECONSTRUCTION** Deconstruction is a means of interpretation that regards a work not as a closed entity but as an open and many-layered network of the most varied elements in form and content. These elements, their functions and contradictions, are revealed by deconstruction. **DIGITAL ART** Art that makes use of new digital media such as computers and the Internet. **ECLECTICISM** A common resort of postmodernism, characterised by extensive quotation from largely historical styles and other artists' works. **ENTROPY** A concept derived from heat theory signifying the degree of disorder in closed systems. Total entropy would be reached when a system collapsed in chaos. By analogy, entropy indicates the informational value of news. The ultimate here would be a meaningless rushing noise. **ENVIRONMENT** An interior or exterior space entirely put together by the artist which integrates the viewer in the aesthetic experience. **FICTION** A picture or a story is a fiction when it is based on free invention.

fie la liberté à l'égard de tout conditionnement par un propos extra-artistique. **AUTO-RÉFÉRENCÉ** Se dit d'un art qui se réfère exclusivement à ses propres propriétés formelles et qui rejette ainsi tout caractère représentatif. **BODY ART** Art qui prend le corps pour thème et qui en fait l'objet central de performances, de sculptures ou d'œuvres vidéo. **CAMP** Personnes ou objets dont la manifestation visuelle est exagérément stylisée. L'admiration dont ils bénéficient débouche sur un culte de l'artificiel à la fois ironique et chargé d'émotion. **CATALOGUE RAISONNÉ** Liste commentée des œuvres d'un artiste, avec une recherche d'exhaustivité. **CIBACHROME** Tirage papier d'une diapositive, le plus souvent en grand format. **CODE** Système de signesqui sous-tend la communication et la transmission d'informations. **COMMISSAIRE** Le commissaire d'une exposition fixe le contenu d'une présentation et procède au choix des artistes participants. **C-PRINT** « Colour-print », tirage papier à partir d'un négatif. **CROSSOVER** Dans le Crossover, les limites entre l'art et la culture populaire, ainsi qu'entre les différentes cultures, sont rendues perméables. La musique, le design, le folklore etc. y sont intégrés dans le travail artistique. **CULTURAL STUDIES** Dans les sciences humaines anglo-saxonnes, courant récent qui étudie la culture populaire. Un domaine de recherches particulier des Cultural Studies consiste à déterminer jusqu'à quel point les manifestations culturelles sont conditionnées par la race, l'appartenance à une classe sociale et à un sexe. **CULTURE POP** La culture pop trouve son expression dans des biens culturels répandus en masse et issus de domaines tels que la mode, la musique, le sport ou le cinéma. Au début des années 60, le monde de la culture pop devait entrer dans l'art par le biais du Pop Art. **DÉCONSTRUCTION** Mode d'interprétation qui ne considère pas l'œuvre comme une unité finie, mais comme un ensemble d'éléments formels

GLOSSARY *GLOSSAIRE*

GENDER SURFING The confusing game with sexual roles whose point is to mix them up, to humorous effect. **GLOBALISATION** Globalisation means that economic or cultural processes increasingly have worldwide implications. **HAPPENING** An artistic action in front of a public that normally becomes involved in what happens. **HETEROGENEITY** Basic difference in kind or species. **HIGH AND LOW (HI 'N' LO)** A complex of themes concerning the influence of trivial culture (low art) on modern art (high art). The concept derives from an exhibition assembled by Kirk Varnedoe in 1990 at the New York Museum of Modern Art. **HYBRID** Of many forms, mixed, incapable of single classification. **ICONOGRAPHY** The language of images or forms that is typical of a particular cultural context; for example, the iconography of advertising, the western, postmodern architecture etc. **ICONOLOGY** The interpretation of the content of a work of art, based on its iconography. **ICON** Image or person venerated by a cult. **INSTALLATION** A work of art that integrates the exhibition space as an aesthetic component. **INTERACTIVE ART** Works of art intended for the viewer's direct participation. Normally this participation is made possible by computer technology. **LOCATION** Site of an event or exhibition etc. **MANGA** Comics and cartoon films, the most popular type of reading matter in Japan, where manga is produced and consumed in large quantitites. **MEMENTO MORI** An event or object reminding one of death. **MINIMAL ART** Art trend of the 1960s that traces scuptures and pictures back to clear basic geometric forms and places them in a concrete relation to the space and the viewer. **MIXED MEDIA** Combination of different media, materials and techniques in the production of a work of art.

et signifiants les plus divers, et qui met en évidence leurs fonctions et leurs contradictions. **ECLECTISME** *Procédé courant dans l'art postmoderne et qui se caractérise par la citation généreuse d'œuvres et de styles (historiques) d'autres artistes.* **ENTROPIE** *Concept issu de la thermodynamique, où il désigne l'état de désordre dans les systèmes clos. L'entropie totale serait ainsi atteinte lorsqu'un système se dissout en chaos. Par analogie, l'entropie indique la valeur informative d'une nouvelle. L'entropie totale serait atteinte par un bruit de fond vide de sens.* **ENVIRONNEMENT** *Espace intérieur ou extérieur entièrement formé par l'artiste et intégrant le spectateur dans l'événement esthétique.* **FICTION** *Une image ou une histoire est une fiction lorsqu'elle repose sur l'invention libre.* **GENDER SURFING** *Jeu troublant sur les rôles des sexes, et qui vise à la voluptueuse transgression de leurs limites.* **GÉNÉRÉ PAR ORDINATEUR** *Produit à l'aide de l'ordinateur.* **GLOBALISATION** *La globalisation renvoie au fait que certains processus économiques ou culturels ont de plus en plus fréquemment des répercussions au niveau mondial.* **HAPPENING** *Action artistique menée en présence du public, qui est le plus souvent intégré à l'événement.* **HÉTÉROGÉNÉITÉ** *Opposition inconciliable.* **HIGH AND LOW (HI ‹ N › LO)** *Complexe thématique dans lequel l'influence de la culture triviale (Low Art) éclaire l'art moderne (High Art). Ce concept remonte à une exposition organisée par Kirk Varnedoe en 1990 au Museum of Modern Art de New York.* **HYBRIDE** *Multiforme, mixte, qui ne peut être classé clairement.* **ICÔNE** *Image ou personne faisant l'objet d'une vénération ou d'un culte.* **ICONOGRAPHIE** *Vocabulaire d'images ou de formes caractéristiques d'un contexte culturel déterminé. Ex.: l'iconographie de la publicité, du western, de l'architecture postmoderne...* **ICONOLOGIE** *Science de l'interprétation du contenu d'une œuvre sur la base de son iconogra-*

MONTAGE Joining together pictorial elements or sequences in photography, film and video. **MULTIPLE** In the 1960s, the classical concept of a work of art came under fire. Instead of a single original, works of art were produced in longer runs, i.e. as 'multiples'. The idea was to take art out of museums and galleries and make it more available. **NARRATION** Telling a story in art, film or literature. **NEO-GEO** 1980s style of painting that operates highly objectively with geometric patterns and colour compositions. **NEW AGE** A form of alternative culture that believes in the beginning of a new age. **OBJECT ART** All works of art that contain already existing objects or materials, or are entirely composed of them (cf. readymades). **OP ART** A type of 1960s abstract art that played with optical effects on the eye. **PERFORMANCE** Artistic work performed in public as a (quasi-theatrical) action. The first performances took place during the 1960s in the context of the Fluxus movement, which tried to widen the concept of art. **PHENOMENOLOGY** A branch of philosophy which examines the way external reality appears to humans. **PHOTOSHOP** Computer program that enables pictorial material to be edited. **POLITICAL CORRECTNESS (PC)** A socio-political attitude particularly influential in the USA. The purpose of Political Correctness is to change public language. The principal requirement is to refer to social 'minorities' in a non-judgmental way. **POP CULTURE** Pop culture finds its expression in the mass circulation of items from areas such as fashion, music, sport and film. The world of pop culture entered art in the early 60s, through Pop Art. **POST HUMAN** A complex of themes centering on the influence of new technologies – such as computers, genetic engineering etc - and the influence of a media-based

phie. **INSTALLATION** *Œuvre d'art qui intègre l'espace d'exposition comme une composante esthétique.* **MANGA** *Bandes dessinées et dessins animés, littérature populaire privilégiée du Japon, où elle est produite et consommée en grande quantité.* **MEMENTO MORI** *Evénement ou objet qui rappelle la mort.* **MINIMAL ART** *Courant artistique des années 60 qui réduit les sculptures et les tableaux à des formes géométriques clairement définies et qui les place dans un rapport concret avec l'espace et le spectateur.* **MIXED MEDIA** *Mélange de différents médias, matériaux et techniques dans la production d'une œuvre d'art.* **MONTAGE** *Agencement d'éléments visuels ou de séquences d'images dans la photographie, le cinéma et la vidéo.* **MULTIPLE** *Au cours des années 60 est apparue une attitude critique à l'égard de la notion classique d'œuvre : au lieu d'un original unique, les œuvres furent produites en tirages plus élevés (comme « multiples » précisément), ce qui devait permettre à l'art de quitter les musées et les galeries et d'être accessible à un plus grand nombre.* **NARRATION** *Récit dans l'art, le cinéma et la littérature.* **NÉO-GÉO** *Tendance de la peinture des années 80 qui travaille d'une façon extrêmement concrète avec les motifs géométriques et les compositions chromatiques.* **NEW AGE** *Mouvement ésotérique qui croit à l'avènement d'une ère nouvelle.* **OP ART** *Courant artistique des années 60 dont les représentants travaillent sur le jeu visuel des lignes, des surfaces et des couleurs. Ces artistes composent des motifs déterminés visant à produire des effets d'optique.* **PERFORMANCE** *Travail artistique présenté à un public sous la forme d'une action (théâtrale). Les premières performances furent présentées pendant les années 60 dans le cadre du mouvement Fluxus, qui visait à l'élargissement du concept d'art.* **PHÉNOMÉNOLOGIE** *Domaine de la philosophie qui étudie la manière dont la réalité extérieure apparaît à l'homme.*

GLOSSARY *GLOSSAIRE*

society on the human body. "Post Human" was the title of an exhibition put together by Jeffrey Deitch in 1992. **POSTMODERNISM** Unlike modernism, Postmodernism starts from the assumption that grand utopias are impossible. It accepts that reality is fragmented and that personal identity is an unstable quantity transmitted by a variety of cultural factors. Postmodernism advocates an irreverent, playful treatment of one's own identity, and a liberal society. **POST-STRUCTURALISM** Whereas structuralism considers sign systems to be closed, post-structuralism assumes that sign systems are always dynamic and open to change (cf. structuralism). **READYMADES** A readymade is an everyday article which the artist declares to be an artwork and exhibits without major alterations. The idea derives from the French artist Marcel Duchamp, who displayed the first readymades in New York in 1913, e.g. an ordinary urinal or a bottle drier. **SELF-REFERENTIAL ART** Art that refers exclusively to its own formal qualities and so rejects any idea of portrayal. **SEMANTICS** The study of the significance of linguistic signs, i.e. the meaning of words. **STEREOTYPE** A standardised, non-individual image that has become generally accepted. **TRASH** Trash – the US word for "rubbish" – aims at a level below accepted aesthetic and qualititative norms, with ironic intent. **REPRESENTATION** The showing of a person, object or condition that fulfils a representative function. **SIMULACRUM** An illusionary image which is so seductive that it can supplant reality. **SOCIAL WORK** Art here is understood as a service that quite deliberately accepts socio-political functions. **STILL** A single photograph from a film. **STRUCTURALISM** Structuralism systematically examines the meaning of signs. The purpose of structuralism is to explore the rules

PHOTOSHOP *Logiciel informatique permettant le traitement des images.* **POLITICAL CORRECTNESS** *Attitude engagée particulièrement influente aux Etats-Unis, et qui se fixe pour but de relever les standards moraux de la vie publique. Une revendication majeure en est le traitement plus juste des minorités sociales.* **POST HUMAN** *Complexe thématique dans lequel l'influence des nouvelles technologies – informatique, manipulation génétique, etc. – et de la société médiatique sur le corps humain, est au centre du propos artistique. Ce concept remonte au titre d'une exposition organisée en 1992 par Jeffrey Deitch.* **POSTMODERNISME** *Par opposition à l'art moderne, le postmodernisme postule l'impossibilité des grandes utopies. Il accepte la réalité comme étant éclatée et l'identité personnelle comme une valeur instable fondée par un grand nombre de facteurs culturels. Le postmodernisme plaide en faveur d'un maniement ironique et ludique de l'identité personnelle et pour une société libérale.* **POST-STRUCTURALISME** *Tandis que le structuralisme conçoit les systèmes de signes comme des systèmes clos, le post-structuralisme suppose que les systèmes de signes sont toujours dynamiques et sujets à modification (Cf. Structuralisme).* **READY-MADE** *Un ready-made est un objet quotidien déclaré œuvre d'art par l'artiste et exposé comme tel sans changement notoire. Le terme remonte à l'artiste français Marcel Duchamp, qui présenta les premiers ready-mades – par exemple un urinoir du commerce ou un porte-bouteilles – en 1913 à New York.* **RÉALITÉ VIRTUELLE** *Monde artificiel généré par ordinateur (Cf. Généré par ordinateur, Animation).* **REPRÉSENTATIVITÉ** *Caractère d'une personne, d'un objet ou d'un état qui remplit une fonction médiatrice.* **SÉMANTIQUE** *Etude de la signification des signes linguistiques.* **SIMULACRE** *« Mirage » que sa séduction met à même de se substituer à la réalité.* **STÉRÉOTYPE** *Idée qui a acquis droit de cité sous forme de cliché.* **STILL** *Image*

of different sign systems. Languages and even cultural connections are seen and interpreted by structuralism as sign systems. **TRANSCENDENCY** In philosophy and religion, transcendency is what is beyond normal human perception. In the extraordinary experience of transcendency, therefore, the boundaries of consciousness are crossed. **URBANISM** The subject of town construction and living together in towns. **VIRTUAL REALITY** An artificial world created on computer (cf. computer-generated, computer animation). Hence a 'virtual' street, house etc. **WHITE CUBE** The neutral white exhibition room which in modern times has succeeded older forms of presenting art, e.g. hanging of pictures close to each other on coloured wallpaper. The white cube is supposed to facilitate the concentrated and undisturbed perception of the work of art. **YOUNG BRITISH ARTISTS (YBA)** Group of young British artists who since the beginning of the 1990s have created a furore with object and video art inspired by pop culture.

d'un film fixée dans une photo. **STRUCTURALISME** *Le structuralisme étudie systématiquement la signification des signes. Il a pour but d'étudier les facteurs qui régissent différents systèmes de signes. Les langues, mais aussi les contextes sociaux y sont compris et interprétés comme des systèmes de signes.* **TRASH** *Trash – à l'origine : « ordure, déchet » – est l'abaissement ironique des normes esthétiques et qualitatives.* **TRAVAIL SOCIAL** *L'art y est compris comme une prestation de service qui se propose de remplir très concrètement des tâches socio-politiques.* **TRANSCENDANCE** *En philosophie et en religion, terme employé pour désigner l'au-delà de la perception humaine ordinaire. Dans l'expérience inhabituelle de la transcendance, les limites de la conscience sont donc transgressées.* **URBANISME** *Réflexions sur la construction des villes et la vie urbaine.* **WHITE CUBE** *Terme désignant la salle d'exposition blanche, neutre, qui dans l'art moderne remplace des formes plus anciennes de présentation, par exemple l'accrochage dense de tableaux sur des papiers peints de couleur. Le White Cube propose une perception concentrée et non troublée de l'œuvre d'art.* **YOUNG BRITISH ARTISTS (YBA)** *Groupe de jeunes artistes anglais qui depuis les années 90 fait parler de lui avec son art de l'objet et ses vidéos inspirés du Pop Art.* R. S., J. V.

PHOTO CREDITS *CRÉDITS PHOTOGRAPHIQUES*

Unless otherwise specified, copyright on the works reproduced lies with the respective artists. **LE COPYRIGHT DES ŒUVRES REPRODUITES EST DÉTENU PAR LES ARTISTES RESPECTIFS, À MOINS QU'IL EN SOIT SPÉCIFIÉ AUTREMENT CI-DESSOUS. ABSALON:** Portrait: © Florian Kleinefenn, Paris, 1993; 01–02: Photo: Alexander Troehler, Zurich; 03: Photo: Florian Kleinefenn, Paris; Courtesy Galerie Chantal Crousel, Paris; 04–05: Courtesy Galerie Chantal Crousel, Paris **ACKERMANN,** Franz: Portrait: © Albrecht Fuchs, Cologne; 01–02, 06: Courtesy Portikus, Frankfurt/M.; 03–04: Courtesy neugerriemschneider, Berlin; 05, 07: © Albrecht Fuchs, Cologne; Courtesy Neuer Aachener Kunstverein, Aachen, Germany **AHTILA,** Eija-Liisa: 01–02, 04: © Crystal Eye Ltd., Helsinki, Finland; 01–04: Courtesy Klemens Gasser & Tanja Grunert Inc., New York **ALTHOFF,** Kai: 01: Courtesy Galerie Christian Nagel, Cologne; 02: Photo: Lothar Schnepf, Cologne; Collection of Daniel Buchholz, Cologne; 03: Courtesy Galerie Christian Nagel/Galerie Daniel Buchholz, Cologne; 04–05: Courtesy Lukas & Hoffmann, Cologne; 06: Courtesy Galerie NEU, Berlin **ANTONI,** Janine: 01–06: Courtesy of Luhring Augustine Gallery, New York; 01–03: Photo: Scott Cohen and John Bessler; 04–06: Photo: Ellen Silverman; 07: Photo: Javier Campano; 08: Photo: Prudence Cumming Associates **ARAKI,** Nobuyoshi: 01, 03–04: © Nobuyoshi Araki and © Jens Rathmann, Hamburg; 02: © Nobuyoshi Araki and © Margherita Spiluttini, Vienna; Courtesy Wiener Secession, Vienna; 05: Courtesy Kunstmuseum Wolfsburg, Wolfsburg, Germany **ARMLEDER,** John M: Portrait: Photo: Ilmari Kalkkinen,Geneva; Courtesy Staatliche Kunsthalle Baden-Baden, Baden-Baden, Germany; 01: Courtesy Galerie Tanit, Munich; 02: Photo: Jens Ziehe, Berlin; Courtesy Mehdi Chouakri, Berlin; 03: Courtesy Galerie Susanna Kulli, St. Gallen, Switzerland; 04: Courtesy the artist; 05: Photo © Tom Warren, New York; Collection of Bo Alveryd, Vaumarcus **ART CLUB 2000:** 01–14: Courtesy American Fine Arts, Co., Colin de Land Fine Art, New York **BAECHLER,** Donald: Portrait: Photo: Stephen Barker; 02: Courtesy Bernd Klüser; 03: Collection of the artist; 04: Private collection, Cologne; 05: Stephanie Seymour Collection; 06: Courtesy Tony Shafrazi Gallery, New York; 08: Gianluzo Sperone, Rome **BALKA,** Miroslaw: Portrait: © Mathias Johansson,Stockholm; 01: Private collection; 02: Collection of Malmö Konsthall, Malmö, Sweden; 03: Collection of Muzeum Sztuki, Lódz, Poland; 04: Private collection; 06: © Joël Damase; Collection of Tate Gallery, London **BALKENHOL,** Stephan: Portrait: Photo: M. Moser; 01–05: © VG Bild-Kunst, Bonn, Germany, 1998; 01: Photo: Stephan Balkenhol; Collection of Emanuel Hofmann-Stiftung Basel, Basle; 02: Photo: Helge Mundt, Hamburg; Elisabeth Ruhland Collection, Düsseldorf; 03: Photo: Artangel; 04: Courtesy Mai 36 Galerie, Zurich; 05: Courtesy Johnen & Schöttle, Cologne; Private collection, Cologne **BARNEY,** Matthew: 01–03: Courtesy Barbara Gladstone Gallery, New York; 01: Photo: Photo: Michael James O'Brien; © 1994 Matthew Barney; 02: Photo: Michael James O'Brien; © 1997 Matthew Barney; 03: Larry Lame; 04: Photo: © Matthias Herrmann; Courtesy Kunsthalle Wien, Vienna; 05: Photo: Öffentliche Kunstsammlung Basel/Martin Bühler (1998); Courtesy Emanuel Hofmann-Stiftung, Depositum im Museum für Gegenwartskunst Basel, Basle **BASQUIAT,** Jean-Michel: Portrait: Photo: Courtesy Galerie Bruno Bischofberger, Zurich; 01–05: © VG Bild-Kunst, Bonn, Germany, 1998; Courtesy Galerie Bruno Bischofberger, Zurich; Private collection **BEECROFT,** Vanessa: Portrait: Photo: Armin Lanke; 01–04: Courtesy Deitch Projects, New York **BICKERTON,** Ashley: 01–03, 06: Courtesy Sonnabend Gallery, New York; 04–05: Photo: Stephen White; Courtesy Jay Jopling, London/Sonnabend Gallery, New York **BLECKNER,** Ross: 03–04: Photo © 1994: Dorothy Zeidman; Courtesy Mary Boone Gallery, New York **BONIN,** Cosima von: 01: Photo: J. Brasille; 01–03, 05–08: Courtesy Galerie Christian Nagel, Cologne; 03: Photo: Wolfgang Vollmer, Cologne; 04–08: © Andrea Stappert, Berlin **BULLOCH,** Angela: 01: Photo: Mancia/Bodmer; © FBM studio, Zurich; Courtesy Galerie Hauser & Wirth 2, Zurich/Schipper & Krome, Berlin; 02: © Photo: Lothar Schnepf, Cologne; Courtesy Schipper & Krome, Berlin; Gaby & Wilhelm Schürmann Collection, Herzogenrath, Germany; 03: Photo: Mancia/Bodmer; © FBM studio, Zurich; Courtesy Galerie Hauser & Wirth 2, Zurich; Collection of Südwest LB, Stuttgart, Germany, Michael Trier, Cologne, Migros Museum für Gegenwartskunst Zürich, Zurich; 04: Photo: André Morin; Courtesy Robert Prime, London; Private collection, Turin; 05: Photo: Fredrik Nilsen; Private collection, London **BUSTAMANTE,** Jean-Marc: Portrait: Photo: Mark Lyon; 01–04: © VG Bild-Kunst, Bonn, Germany, 1998; 01: © Stichting Kröller-Müller Museum, Otterlo, The Netherlands; 02: © Jean-Marc Bustamante; Courtesy Galerie Xavier Hufkens, Brussels; 03: Photo: Helge Mundt **CALLE,** Sophie: Portrait: Photo: Joachim Magreaw; 01–04, 06: Courtesy Galerie Chantal Crousel, Paris; 05: Photo: Florian Kleinefenn, Paris; 05: Photo: Daniel Rückert; Courtesy Galerie Arndt & Partner, Berlin **CATTELAN,** Maurizio: 01: Photo: Masotti – Galleria d'Arte Moderna di Bologna, Bologna, Italy; Courtesy De Carlo, Milan; 02: © Roman Mensing; Courtesy Westfälisches Landesmuseum, Münster, Germany; 03: Photo: Maranzano; Courtesy Minini, Brescia, Italy; 04: Photo: Forneaux; Courtesy Perrotin, Paris; 05: Photo: TKD; Courtesy Genillard, London **CHAPMAN,** Dinos & Jake: 01, 03–04: Courtesy Victoria Miro Gallery, London; 02: Photo © Stephen White; Boros Collection **CLARK,** Larry: Portrait: Photo © Johannes Wohnseifer, Cologne; 01–07: Courtesy of Luhring Augustine Gallery, New York **CLEGG & GUTTMANN:** Portrait: Courtesy Galerie Christian Nagel, Cologne; 01–03, 06: Courtesy Galerie Christian Nagel, Cologne; 04–05: Courtesy Kunsthalle Basel, Basle; 06: Photo: Claus Friede **CURRIN,** John: Portrait: Courtesy Andrea Rosen Gallery, New York; 01–10: Courtesy Andrea Rosen Gallery, New York; 01: Photo: Marc Domage/Tutti; 02, 04–05, 07–10: Photo: Fred Scruton; 03, 06: Peter Muscato **DELVOYE,** Wim: 01: Collection Delfina, London; 02: Collection of the artist; 03: Collection of Museum van Hedendaagse Kunst, Ghent, Belgium; 04: Courtesy Galerie Ghislaine Hussenot, Paris; 08: Collection of Museum of Sculpture Middelheim, Antwerp **DEMAND,** Thomas: Portrait: © Christian Borchert; 01–05: © VG Bild-Kunst, Bonn, Germany, 1998; 01–03: Courtesy Victoria Miro Gallery, London; 01: © Thomas Demand 1997; 02: © Thomas Demand 1994; 03: © Thomas Demand 1996; 04: © Thomas Demand 1996; Courtesy Schipper & Krome, Berlin; 05: © Thomas Demand 1995; Courtesy Galerie Monika Sprüth, Cologne **DIJKSTRA,** Rineke: Portrait: Photo: Paul Andriesse, Amsterdam; Courtesy Galerie Paul Andriesse; 01–10: Courtesy Galerie Paul Andriesse, Amsterdam **DION,** Mark: Portrait: Photo: Georg Kargl, Vienna, 1994; Courtesy Georg Kargl, Vienna; 01–05: Courtesy American Fine Arts, Co., Colin de Land Fine Art, New York **DOUGLAS,** Stan: Portrait: Photo: Chick Rice; Courtesy David Zwirner, New York; 01–05: Courtesy David Zwirner, New York; 03: Photo: Richard-Max Tremblay **DUMAS,** Marlene: Portrait: Photo: Helena van der Kraan, 1993; Courtesy Galerie Paul Andriesse, Amsterdam; 01–05: Courtesy Galerie Paul Andriesse, Amsterdam; 01–02, 04–05: Photo: Peter Cox, Eindhoven, The Netherlands; 01: Collection of De Pont Foundation, Tilburg, The Netherlands; 02: Collection of Stedelijk Van Abbemuseum, Eindhoven, The Netherlands **EDMIER,** Keith: 01–05: Courtesy Friedrich Petzel Gallery, New York; 04: © Larry Lamay, New York; Courtesy neugerriemschneider, Berlin **ELIASSON,** Olafur: 01–04: Courtesy Kunsthalle Basel, Basle; 05: Courtesy Kjarvalstadir Museum Iceland, Iceland; 06: Courtesy Kunstverein in Hamburg, Hamburg; 07: Courtesy Louisiana Museum, Humlebaek, Denmark; 08: Courtesy Neue Galerie, Graz, Austria; 09: Photo: Ingrid Nilsson; © Malmö Museer, Malmö, Sweden; Courtesy Tanya Bonakdar Gallery, New York **EMIN,** Tracey: Portrait: Photo: Johnnie Shand-Kydd; Courtesy Jay Jopling, London; 01–06: Courtesy Jay Jopling, London; 01: Photo: Stephen White; 04: Photo: Stephen White; 05: Photo: Carl Freedman; 07: Photo: Stephen White; Boros Collection; 09: Courtesy Kölnischer Kunstverein, Cologne **FISCHLI/WEISS,** Peter/David: © Kunstmuseum Wolfsburg, Wolfsburg, Germany; 01: © Andrea Stappert, Berlin; Collection of Hessisches Landesmuseum Darmstadt, Darmstadt, Germany; 02–03, 05–09: Courtesy Monika Sprüth Galerie, Cologne; 02: Photo: Öffentliche Kunstsammlung Basel/Martin Bühler; Courtesy Emanuel Hoffmann-Stiftung, Depositum im Museum für Gegenwartskunst Basel, Basle **FLEURY,** Sylvie: 01–03: Courtesy of the artist; 04–05: Courtesy Mehdi Chouakri, Berlin; 06–07: Courtesy Galerie Philomene Magers, Cologne, Munich; 07: Photo: Nic Tenwiggenhorn, Düsseldorf; 08: © Stefan Rötheli, Zurich; Courtesy Bob van Orsouw Gallery, Zurich **FÖRG,** Günther: Portrait: Courtesy Galerie Max Hetzler, Berlin; 01: Courtesy Galerie Max Hetzler, Berlin; Private collection, Cologne; 02: Photo: Rudolf Nagel; 03: Photo: Nic Tenwiggenhorn, Düsseldorf; Courtesy Kunstverein Hannover, Hanover, Germany; Collection of the artist; 04: Courtesy Galerie Max Hetzler, Berlin; Private collection, Cologne; 05: Photo: Nic Tenwiggenhorn, Düsseldorf; Courtesy Kunstverein Hannover, Hanover; Collection of the artist **FRITSCH,** Katharina: 01–05: © VG Bild-Kunst, Bonn, Germany, 1998; 01–02, 04–05: Courtesy Matthew Marks Gallery, New York; 01: Photo: Rudolf Wakonigg; 02: Photo: Nic Tenwiggenhorn, Düsseldorf; Dauerleihgabe der Dresdner Bank, Frankfurt/M., an das Museum für Moderne Kunst, Frankfurt/M.; 04–05: Photo: Nic Tenwiggenhorn, Düsseldorf **GENERAL IDEA:** 01–02: Courtesy Galerie Daniel Buchholz, Cologne; 03: Photo: Wim Riemens; 04: Private Collection, Chicago; 05: Photo: Cheryl O'Brien **GENZKEN,** Isa: 01–05: Courtesy Galerie Daniel Buchholz, Cologne; 01: © Jens Willebrand, Neuss, Germany; 02: © Roman Mensing; Courtesy Westfälisches Landesmuseum, Münster, Germany; 03: © Jens Willebrand, Neuss, Germany 04: Photo: Werner Kaligofsky; 05: Burda Collection, Baden-Baden, Germany **GILLICK,** Liam: Courtesy Robert Prime, London; 01: Courtesy Schipper & Krome, Berlin; 02: Courtesy Basilico Fine Arts, New York; 03: Courtesy Schipper & Krome, Berlin; 04, 06–07: Markus Keibel; 04: Courtesy Robert Prime, London; 05: Courtesy Basilico Fine Arts, New York, and Robert Prime, London; 08: Sammlung **FER GOBER,** Robert: Portrait: Photo: Sam Gordon; Courtesy of the artist; 01–03: Courtesy of the artist and Paula Cooper Gallery, New York, New York; 01: Photo: Jannes Linders, Rotterdam, The Netherlands; 02: Photo: Geoffrey Clements; 03: Photo: Andrew Moore; 04–05: Courtesy of the artist; 04: Photo: Bill Jacobson; 05: Photo: Joshua White **GOLDIN,** Nan: Portrait: © Christine Fenzl; 01–02, 04–06: © Nan Goldin, New York; 03: Courtesy Matthew Marks Gallery, New York **GONZALEZ-TORRES,** Felix: Portrait: David Seidner © 1994; Courtesy Andrea Rosen Gallery, New York; 01–06: Courtesy Andrea Rosen Gallery, New York; 01: Exhibition by

PHOTO CREDITS *CRÉDITS PHOTOGRAPHIQUES*